A Concise History of Indian Art

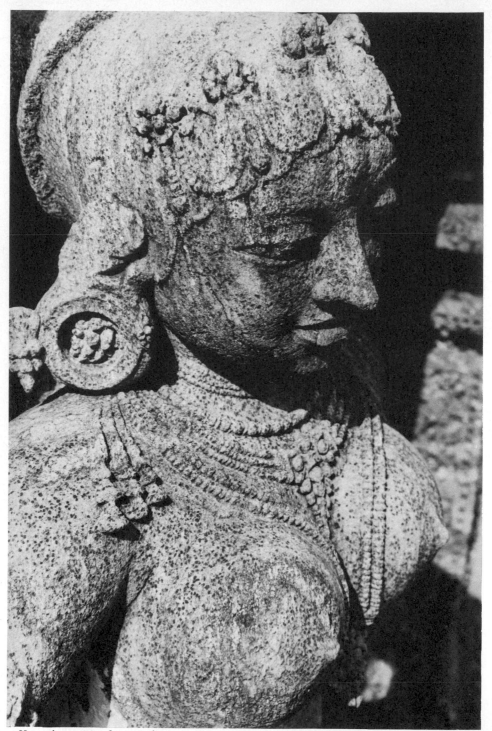

1 *Konarak, musician figure on the Surya Temple. Eastern Ganga, c. 1240*

A Concise History of
INDIAN ART

ROY C. CRAVEN

NEW YORK AND TORONTO
OXFORD UNIVERSITY PRESS

*This book is dedicated to my students, who
helped give form and purpose to its pages*

Library of Congress Catalogue Card Number 75-37027

All Rights Reserved

Printed in Great Britain

Contents

Introduction 7

CHAPTER ONE
Harappan culture: beginnings on the Indus 9

CHAPTER TWO
Historical and religious origins 27

CHAPTER THREE
The Mauryan period: the first imperial art 35

CHAPTER FOUR
The Shunga dynasty: chaityas, viharas and stupas 51

CHAPTER FIVE
The Andhra period: the 'world mountains' 67

CHAPTER SIX
The Kushan period: Gandhara and Mathura 81

CHAPTER SEVEN
The Gupta and Post-Gupta periods 111

CHAPTER EIGHT
South India: Pallavas, Cholas and Hoysalas 145

CHAPTER NINE
The Medieval period in North India 167

CHAPTER TEN
Islamic India: architecture and painting 195

CHAPTER ELEVEN
Jain, Rajasthani and Pahari painting 219

Epilogue 245

Bibliography 246

Acknowledgments for illustrations 248

Index 249

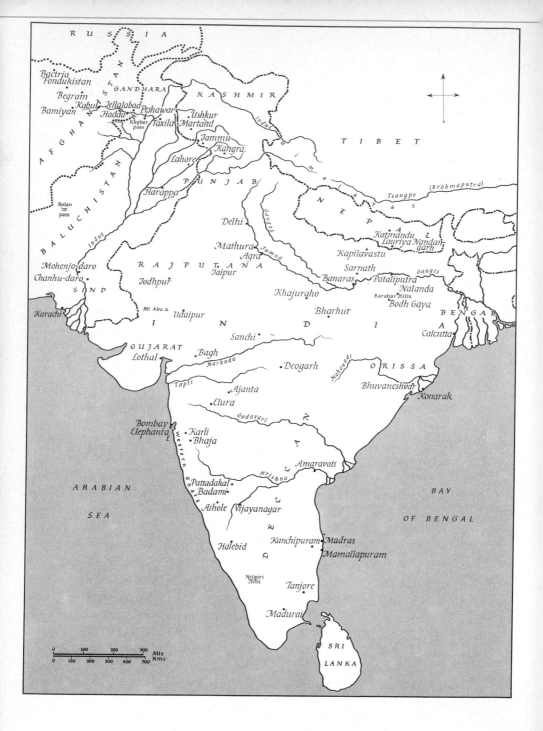

Introduction

The undertaking of this book was approached with considerable trepidation. From the first, I was more than aware of the hazards inherent in the attempt to frame the rich, complex history of India's art within the limited dimension of a single book. Because this is a general introductory survey, the scholar will find nothing unknown to him here, and in fact he will be aware of omissions. I have deferentially followed in the footsteps of numerous scholars in attempting to construct this basic image of Indian art, and if I have succeeded here it is due primarily to their labours.

Much of what is known of the history of Indian art is of comparatively recent scholarship, and even more work awaits future studies. The work which defined the field was Ananda K. Coomaraswamy's *History of Indian and Indonesian Art*, published in 1927. Though the book is now somewhat outdated, anyone involved with the art of India owes a fundamental debt to Coomaraswamy and must ultimately come to regard him as their scholarly patriarch. This I feel deeply but I am also further aware of my immense debt to legions of others who have opened various vistas for me. This is especially true of Dr W. G. Archer, whose scholarship has for many years illumined my paths of study and who, with typical enthusiasm and generosity, not only encouraged the undertaking of the present volume, but most helpfully read and commented upon its pages.

I am further indebted to numerous friends and colleagues who have encouraged me in this project by providing suggestions and illustrations, and I am deeply grateful to the University of Florida for allowing me the leave time which made it possible to produce this manuscript.

To my wife Lorna I express my love and appreciation for not only typing this demanding manuscript, but also for continuing to sustain me in all involvements of life.

Here at the beginning it is important that I caution the reader regarding the terms 'art' and 'artist' in relation to Indian culture. For convenience I shall use them; but most of the objects to be met are devotional in nature, created with religious and utilitarian rather than aesthetic motives; and they were fashioned by craftsmen who worked in a tradition which dictated strict canons of iconography and manufacture, and who could never have understood the meaning of the word 'artist' as it is used today.

Despite such a cultural matrix, or perhaps because of it, Indian craftsmen produced objects which can only be described as masterpieces. Such achievements are difficult to resist and I am confident that the reader will be inspired, moved and excited by the virtues of each unique creation with which he is about to be confronted.

<div align="right">

R.C.C.
University of Florida

</div>

The transcription of Indian words for the general English reader has always presented difficulties. Here the attempt is made to simplify the matter as much as possible by making the pronunciation more or less phonetical. Diacritical marks are omitted; for example, sh is used for ś and ṣ (Ashoka for Aśoka, and yakshi for yakṣi). The only exception has been in the case of Sri Lanka – pronounced Shri Lanka, but universally known in one spelling only.

Harappan culture: beginnings on the Indus

The evidence of India's historical beginnings, so many thousands of years ago, has only been provided by archaeology in recent times. Hints of a glorious past have always been at hand in the ancient myths and epics of India, and the Vedic texts (*c.* 1500–900 BC) intriguingly describe how remote nomadic invaders conquered mighty citadels. Under the banner of their God, Indra, lord of the heavens and 'Hurler of the Thunderbolt', fierce Aryan warriors stormed the ancient 'cities' of the hated 'broad-nosed' *Dasas*, the dark-skinned worshippers of the phallus, and subdued them. In the great *Rigveda*, the first of the four sacred books of the Aryans, the praises of Indra are sung for rending the Dasas' fortresses 'as age consumes a garment'. But who were the Dasas (a term later to mean slave) and where were their 'cities'? Had the earth swallowed up such citadels and left no trace, or was the substance of their ramparts only that of poetic metaphor?

At the mouth of the mighty Indus river in Pakistan sprawls the modern city of Karachi. If a person stands on the sandy beach to the north and turns from the blue waters of the Arabian Sea to look inland, he will be overwhelmed by a vast scrub desert that stretches beyond the horizon to the east. For almost a thousand miles up the broad but sparsely watered plains of the Indus valley the vast wasteland spreads, until it ultimately revives in the greenery of the Punjab, 'the Land of the Five Rivers', at the foothills of the Himalayas. Here in 1856, during the construction of a railway, at a spot six miles from the modern bank of the river Ravi the workmen came upon a crumbling hill of fire-baked brick. This they quickly robbed for the railway's ballast. In the process of digging out the brick, they found small square steatite (soapstone) seals intricately carved with images of animals and a curious glyphic *5–7* script (see pp. 14–15). Amazingly, in an area where few blades of grass and only dwarfed trees were growing, early craftsmen had fashioned images not only of bulls but of elephants, tigers, rhinoceros, and water-buffalo.

9

Sir Alexander Cunningham, the father of Indian archaeology, later inspected the site and the seals and realized their antiquity, but he could only confirm the enigma of their presence. He did at least realize that the maimed hill of brick, now named Harappa after a near-by village, was the ruin of an ancient city.

Little remains today at Harappa to interest the average visitor, but certain basic features were identified: a high citadel, some fifty feet above a lower city proper, a great waterproofed tank or bath, and a granary. It was also established that six levels of occupation occurred at the site, and that the whole complex was contained within a three-mile circumference.

These first facts were the result of a systematic excavation of Harappa in 1921. A year later, however, a more important discovery was made almost four hundred miles farther south on the Indus in the district of Sind. It was the site which became known as Mohenjo-daro (place or hill of the dead). Here, on a rise of land, some 210 miles from the sea, an archaeologist investigating an ancient Buddhist mound (*stupa*) of the second century AD realized that an older and more important site lay beneath it. Unlike Harappa, Mohenjo-daro was unmolested, and soon Sir John Marshall and his staff began an excavation which they knew would rewrite history.

Today this Indus valley civilization, or Harappan culture, can be defined as an early urban civilization existing in full flower at the end of the third millennium BC. It was primarily situated within the Indus river basin but it also appeared along the Arabian coast, spreading north and south from the Indus delta. Sites have been identified inland as far as the Himalayan foothills and in Rajasthan, not far from Delhi, while later sites have been discovered and investigated in Saurashtra, along the coast of Kutch, and the Gulf of Cambay.

The civilization's two major cities appear to have been Mohenjo-daro and Harappa. It has been estimated that at its greatest extent Mohenjo-daro had about 35,000 inhabitants, and the same would be true of Harappa. Both are distinguished by advanced urban planning. Most of Mohenjo-daro was built of kiln-fired brick, and the buildings were massed into 'super-blocks' of 600 by 1200 feet. The major streets are 33 feet wide and run north–south intersecting subordinate ones, running east–west, at right angles. Neighbourhoods within the super-

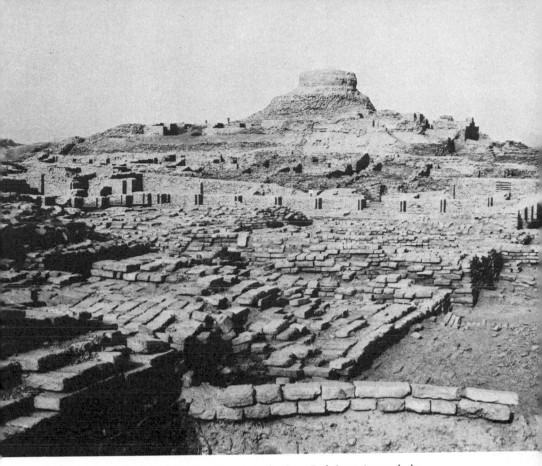

3 Mohenjo-daro, view of the citadel looking across the Great Bath (centre) towards the ruined stupa; c. 2300 BC and later

blocks are reached by lanes, 5 to 10 feet wide, which run at right angles to the streets. These lanes are frequently interrupted by small dog-leg corners, and many times contain capped stone sewer lines with inspection traps. Also present are the remains of shops, and of structures so substantial as to suggest temples or religious buildings.

The most dramatic characteristic of the two cities, and to a degree of other Harappan sites, is a commanding citadel. At Mohenjo-daro it is a massive, mud-filled brick embankment which rises 43 feet above the lower city. On its summit are the remains of several impressive structures of which the most prominent is the so-called Great Bath. The pool,

3

4

surrounded by a paved courtyard, is 39 feet long (north to south), 23 feet wide, and 8 feet deep. It was entered at each end by steps, and its bottom of sawed and fitted brick was sealed watertight by bitumen. Its purpose can only be guessed. Archaeologists generally agree that it must have been associated with some sort of bathing ritual, and this strongly recalls later Hindu practices and concepts of pollution. A similar construction in Indian villages today catches and retains monsoon rains, and is used for practical as well as ritual bathing.

On the citadel to the west of the Great Bath at Mohenjo-daro are the remains of twenty-seven brick foundations which have been identified as remains of a sophisticated granary complex. The citadel at Harappa also displays a Great Bath and a granary but of slightly different design.

At a lower level at Harappa, below the granary platforms and the citadel, were crowded, single-celled dwellings, which have suggested slave habitats elsewhere in the ancient world. The uniqueness of the citadel structures and their physical relationship to the lower city at Harappa and Mohenjo-daro dramatically hint at a social and religious structure with precedents for later Indian society. Assuredly the height of the citadel also had a practical purpose, in that it remained dry during seasonal floods. It is important to remember that Mohenjo-daro shows nine levels of occupation towering over 30 feet above the present flood plain. These nine levels represent a period of more than seven hundred years. Recent borings have also disclosed that an additional 39 feet of occupational levels exist below the present flood plain, and these illuminate a continuing struggle with flooding which occurred in antiquity. A number of these lower levels predate the earliest levels at Harappa.

Beyond the impressive, practically planned but dull physical remains of these cities, what do we know about Harappan culture and art, and what were the people's origins and ultimate fate? It appears, from seals and inscriptions found at Ur and other sites in Mesopotamia, and datable to *c.* 2400–2000 BC, that there was trade between the empires of Mesopotamia and the Harappan culture. A vital link in the trade was almost certainly the island of Bahrein; for there archaeologists have found evidence of extensive copper industries and, even more significantly, many round seals with Harappan motifs and glyphs. Only a few of these so-called 'Persian Gulf seals' have so far been found in India.

The site of Lothal in Saurashtra is also interesting in the context of trade, since it displays a unique and elaborate brick-lined dock, 710 feet long.

The dates of the Harappan civilization remain somewhat vague, but carbon-14 datings of *c.* 2300 to 1750 B C generally confirm Sir Mortimer Wheeler's round bracketing of *c.* 2500 to 1500 B C.

It can be generally stated that on the Iranian plateau during the fourth and third millennia B C diverse nomadic peoples tended to settle and form societies marked by a mixed technology of stone and bronze. Engaging in minimal agriculture and animal husbandry, they gradually evolved a basic culture which spread first south-west into the Fertile Crescent and later south-east across the Baluchistan hills into the Indus basin, and gave birth – first in Mesopotamia and later along the Indus – to new and comparatively sophisticated urban civilizations.

4 Mohenjo-daro, the Great Bath. Harappan culture, c. 2300–1750 BC

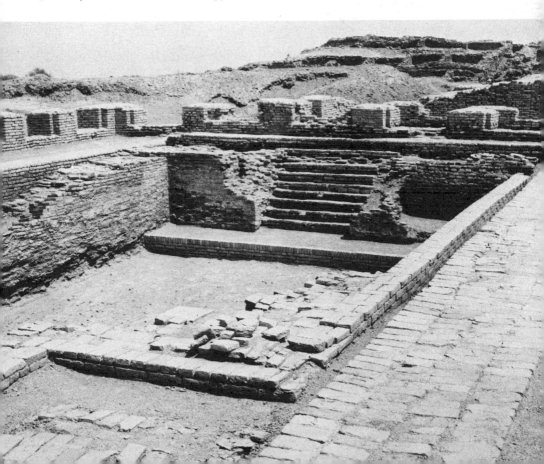

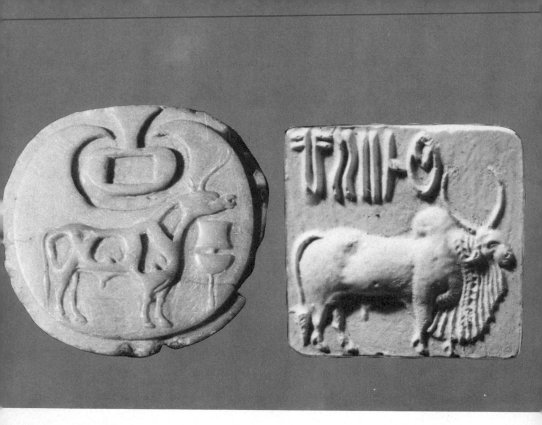

6, 7 The steatite seals remain the most impressive and enigmatic artefacts from the Harappan civilization. Thousands have now been recovered, and their physical character is fairly consistent. In size they range from $\frac{3}{4}$ inch to $1\frac{1}{2}$ inches square. In most cases they have a pierced boss at the back to accommodate a cord for handling or for use as personal adornment. When the carving was complete the objects were covered with an alkali covering and fired, producing a fine lustrous white finish. Although the pictographic symbols remain one of archaeology's great mysteries, the variety of the text on the seals seems to suggest personal identities rather than religious phrases, which undoubtedly would recur. Such repetitions are exceptions.

The diversity of the animals depicted on the seals is astounding, and the beauty of their execution is impressive. The frequent occurrence of bulls and also of grotesque multi-headed or composite animals suggests that they must be religious symbols. Some human forms are present, but these, which will be discussed shortly, are generally more primitive,

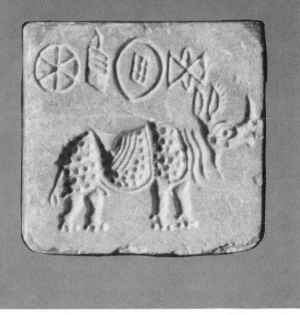

and less successfully realized than the animals. Also, some of the seals
display plain linear symbols, such as multiple circles, crosses, dots,
swastikas, and the leaves of the sacred pipal tree.

Among the creatures included in the engravers' repertory are the
tiger, elephant, one-horned Indian rhinoceros, hare, crocodile, antelope, 7
Brahmani bull, composite animal forms, and a curious single-horned ox 6
which is the most frequently depicted subject. This humpless animal is 5
sometimes referred to as a 'unicorn' bull, because its two horns seen in
profile merge into one. It is frequently associated with an unidentified
object which has been variously identified as an incense-brazier, an
altar, and a manger.

The seals might be considered the first art objects in India. In them we
already find, superbly contained within a format less than two inches
high, features that were to be hallmarks of Indian art throughout
history – a love of animals combined with a keen sense of observation
and craftsmanship, creating a vital reality.

An outstanding icon in Indian art appears in Harappan culture
8 for the first time, on a famous seal from Mohenjo-daro. This seal
is highly important for many reasons, chief among them being that
it bears the first anthropomorphic representation of a deity in India, and
that it shows the concept of yoga to have been present in Harappan
culture. It appears to delineate (as Sir John Marshall observed in his
report of 1872–3 for the Archaeological Survey of India) a prototype
for the later Indian god Shiva.

The seal shows a central figure seated upon a low throne in a yogic
position. The arms, which are covered with bangles, are extended
outward over the knees in a way reminiscent of the pose seen in later
Chola bronzes of meditating Hindu gods. The figure is further dis-
tinguished by having a multiple visage (variously interpreted as three
faces or a mask), crowned by a large horned head-dress whose shape
suggests the trident symbol of Shiva. The head-dress definitely marks
the image as a sacred one, and the obsequious animals further emphasize
this aspect and hint at a fertility rite. The fertility symbolism is also
underlined by the prominent display of the deity's phallus. Along with
the elephant, tiger, rhinoceros, buffalo, and deer appear what may be
two exceedingly stylized human figures. One stands on the right edge
of the seal, just behind the tiger, and there appears to be another in the
upper left corner, though it may be part of the glyphic inscription
which occupies the top edge. Another interesting detail which relates
to the later iconography of Buddhism is the two deer under the throne.
A set of deer, flanking a central wheel on the Lord Buddha's throne,
became universally understood as the symbol for the first sermon in the
54 Deer Park of Sarnath (see p. 32). A throne supported by lions also became
59 common both to Buddha images and to those of the Jain saints
(*Tirthankaras*).

The vehicle or mount of Shiva in later Hinduism is a bull, and thus
he becomes confused with the Vedic god Rudra who is sometimes
referred to in Vedic verse as a bull. It is interesting to remember the
6 prevalence of bull seals in Harappan culture, in concert with this present
image and with the fact that great numbers of stone phalli (*lingams*),
another symbol of Shiva, have also been discovered in the Indus valley
ruins. It seems that Shiva, by whatever name he was known on the banks
of the Indus, was a dominant presence.

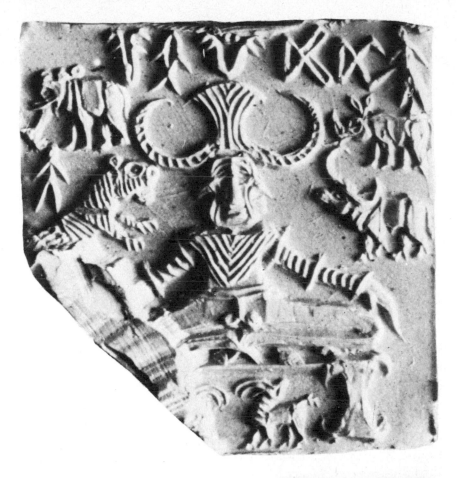

8 Impression and seal (right, actual size) from Mohenjo-daro showing a seated 'yogi' figure surrounded by animals. Harappan culture, c. 2300–1750 BC. Steatite seal, W. 1⅜ in. (3.5 cm). National Museum of Pakistan, Karachi

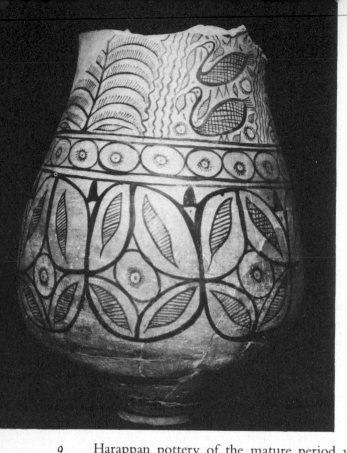

9 *Large earthenware jar painted with designs including birds, a stylized tree and leaves, from Lothal. Harappan culture, c. 2300–1750 BC*

9 Harappan pottery of the mature period was in keeping with the logical and ordered mentality that conceived the efficient urban planning and drainage systems of the Indus cities. It consists chiefly of wheel-turned items of a wide variety, which show the consistent characteristics and standards of an organized manufacturing system. Among the various shapes created are huge tall decorated storage jars, strainers, bowls with a pedestal (common to all ancient Asian cultures), pointed goblets which stood in the ground on their points (unique to Indus sites), some of which appear to carry what may be the potter's stamp, and many other utilitarian forms.

The ware consists of a pinkish-buff body, coated with red slip and painted with black lines. The designs range from simple horizontal stripes of varying thickness to elaborate patterns, such as checks or overlapping rows of circles. Descriptive elements occasionally include bulls, peacocks, pipal leaves, fish, and – rarely – crudely defined human

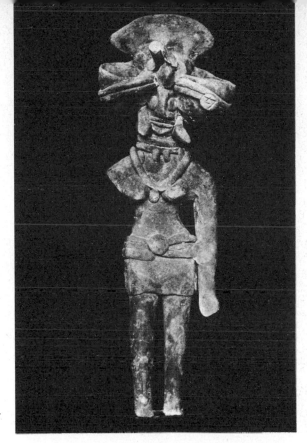

10 Terracotta 'mother goddess' figurine from Mohenjo-daro. Harappan culture, c. 2300–1750 BC. National Museum of Pakistan, Karachi

figures. Some of these motifs also appear on pottery from earlier pre-Harappan settlements in northern Baluchistan, and especially Mundigak in Afghanistan. It seems probable that, as G.F. Dales suggests, they moved down from sites in the Indus foothills, such as Amri, before actually reaching the proto-Harappan settlements in the Indus valley.

More engaging are the small terracotta toys, votive animals, and figurines. Here the ancient craftsmen relaxed and became more spontaneous, diverse, and even humorous, revealing, in the animals, a keen perception which recalls the vividness of the seals. The terracottas include great numbers of 'mother goddess' images, not too different *10* from those found in other early cultures. Displaying wide hips and ample breasts, bedecked with heavy jewellery, they are an early manifestation of that Indian idealized feminine beauty which will be met again and again. Their heads generally support huge flared head-dresses which, in some cases, provide cavities for votive lamps.

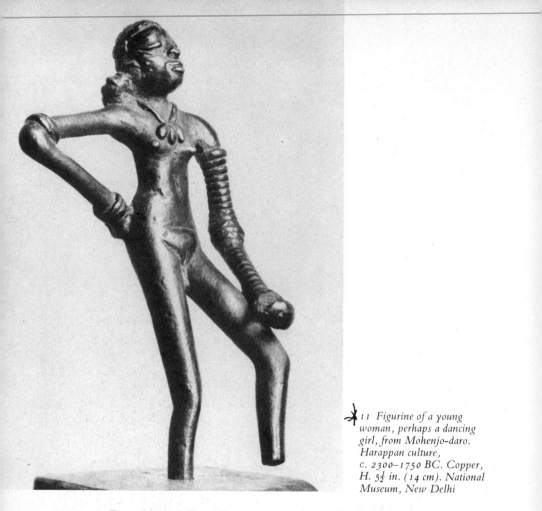

11 *Figurine of a young woman, perhaps a dancing girl, from Mohenjo-daro. Harappan culture, c. 2300–1750 BC. Copper, H. 5¼ in. (14 cm). National Museum, New Delhi*

11 Even more impressive is a unique small copper sculpture of a young woman, perhaps a dancing girl, from Mohenjo-daro. This jewel of realism is completely urban in pose and hauteur. Standing nude except for a brief necklace and an arm completely ringed with bangles, her relaxed body twists so that one hand rests on her right hip while the other holds a small bowl against her left leg. Her negroid features identify her as one of the Dasas described in the *Rigveda*. So far this figure is the single major metal sculpture from Harappan sites: the other known bronze and copper items are several miniature animal figures, corroded almost beyond recognition, and utilitarian objects such as axe-heads and fishing-hooks.

We find a more readily identifiable dancing figure in an incomplete 12
male torso in grey stone from Harappa. The body is twisted into a pose
which has invited comparisons with the great Chola icons of Shiva 117
Nataraja. The figure's legs are broken; drilled sockets at the shoulders
and neck must originally have been fitted with separately carved but
now lost arms and head. The nipples of the breasts were also fashioned
separately and still remain cemented into place. A large cavity in the
groin indicates that the figure was originally of an ithyphallic nature.

12 Torso of a male dancing figure from Harappa. Probably Harappan culture,
c. 2300–1750 BC. Grey limestone, H. 4 in. (10 cm). National Museum, New Delhi

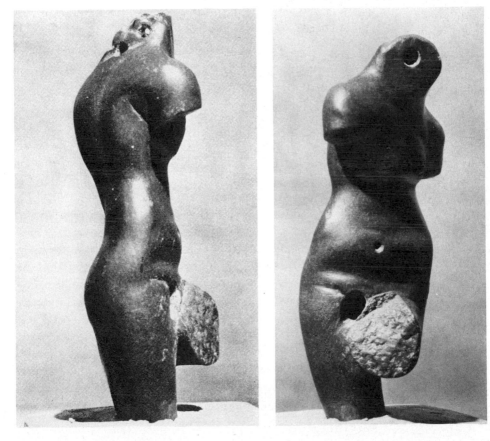

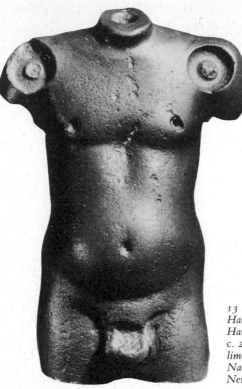

14 (opposite) Bust of a
priest-king or deity from
Mohenjo-daro. Late
Harappan culture,
c. 2000–1750 BC.
Steatite, H. 6⅞ in.
(17.5 cm). National
Museum of Pakistan,
Karachi

13 Male torso from
Harappa. Probably
Harappan culture,
c. 2300–1750 BC. Red
limestone, H. 3½ in. (9 cm).
National Museum,
New Delhi

13 Despite the fact that some scholars have challenged the origin of a
small male torso of red limestone it is obviously the most interesting and
sophisticated Harappan image we have seen so far. Despite its small size
it has a monumentality which suggests life-size or even larger. Because
of this a few scholars have suggested that it is an importation from the
later Mediterranean world, which through some quirk of fate became
deposited in the debris of Harappa. Its presence there is scientifically
shaky since it was unearthed only a few feet below the surface, and was
only vaguely documented, but a claim of foreign origin seems extreme.
One must agree with Benjamin Rowland that the work is stylistically
and conceptionally clearly an Indian creation, since the figure's life
comes more from internal dynamics than from any anatomical accuracy.
Instead of Hellenistic realism, we see a later Indian concept of yogic
breath control (prana) used in sculpture to signify inner life and vitality.

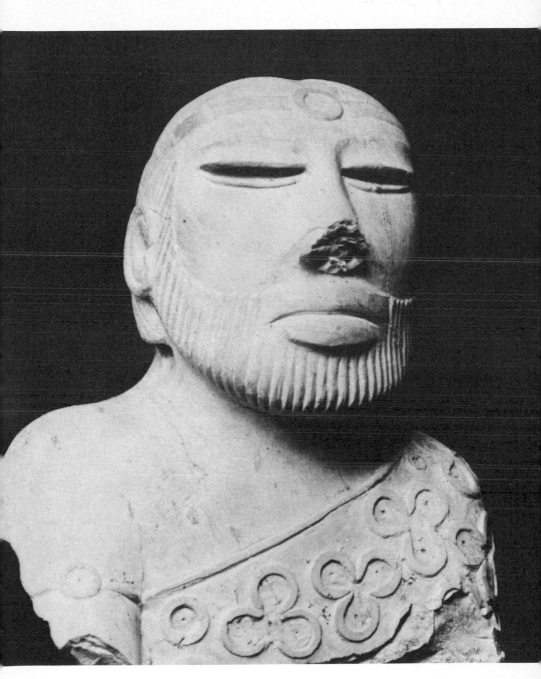

This image's prominent belly is also an Indian element, symbolizing physical and spiritual well-being. Similar nude male figures are common later as icons representing Jain Tirthankaras. The Jain figures consistently display a *shrivasta* jewel on their chests as a mark of physical and spiritual purity; but because of this figure's small scale and the fact that it is damaged, one cannot be sure if such a sign was ever present. A last fact which tends to support the contention that it was later deposited at Harappa concerns the strangely oversized drill-holes on the front of each shoulder. Some have suggested that these were executed to accommodate some sort of inlay decoration. They are aesthetically and technically out of character with the figure, and suggest a crude later attempt at reworking the piece for a new purpose.

Perhaps the most remarkable of all known Harappan creations is a small bust depicting a priest-king or deity, a late work carved in steatite, found at Mohenjo-daro. The face sports a carefully barbered beard, the upper lip is shaved and the hair is gathered in a bun behind the head. The wide headband has in its centre a flat circular ornament which is duplicated on the bangle worn high on the right arm. We know that the eyes were originally inlaid with shell, since one eye still retained its inset when found.

The priest-king's thick lips and wide nose distinguish him as one of the Dasas. His robe or toga-like garment, decorated with trefoil designs, falls diagonally across the upper chest and leaves the right shoulder bare. Originally the trefoil forms and the spaces around them must have been filled with coloured paste, to suggest the fabric more vividly. The trefoil symbol was known and used as a sacred sign early in Egypt, Crete, and Mesopotamia, representing various deities and celestial bodies. It has also been found on Harappan beads, pottery, and what may be a stone altar.

As yet no Harappan wooden artefacts or wall-paintings have been found. It is hard to believe that they did not exist, because both media are central to later Indian artistic expression. We can hope that archaeology will one day fill this gap.

The demise of the Harappan civilization must have followed a long period of decay, aided by various accidental acts of man and nature. Important environmental changes have recently been shown to have contributed to the decline. It was found that several Harappan sites on the Makran coast of Iran, far north-west of Karachi, which are now

14

8 to 35 miles inland, were once probably coastal stations related to seagoing trade, and hydrological studies have confirmed that during the later Harappan period a tectonic shift slowly took place along the coast of the Indus delta. A steady upthrust of the earth extended the shores and changed and blocked the river's flow. This created wide, long-lasting floods that varied with the seasons, and with a steady accumulation of silt Mohenjo-daro slowly became a city in a marshy lake. Each year the city-dwellers were forced to raise their structures higher and higher. Gradually their culture declined, and finally it was eclipsed by the new aggressive barbarians from the north. With their chariots, bronze weapons and Vedic religion, they brought a vigorous new culture which eventually moved beyond the Indus and the Punjab to spread across all of India.

Only to the south, at such Saurashtrian sites as Lothal, did the Harappan culture outlive the Indus valley cities. There, where it had arrived late, it continued to 'shade off' (in Wheeler's phrase) until it lost its identity by being suffused with elements of the later cultures of Central India.

Even so, one is haunted today by the yogi image on the seal and by the vision of sun-splashed waters in the baths on the citadels. Was the Harappan culture completely lost, or did some of its elements survive through time subtly to touch each epoch of Indian history? We will do well to carry this question with us through the chapters ahead.

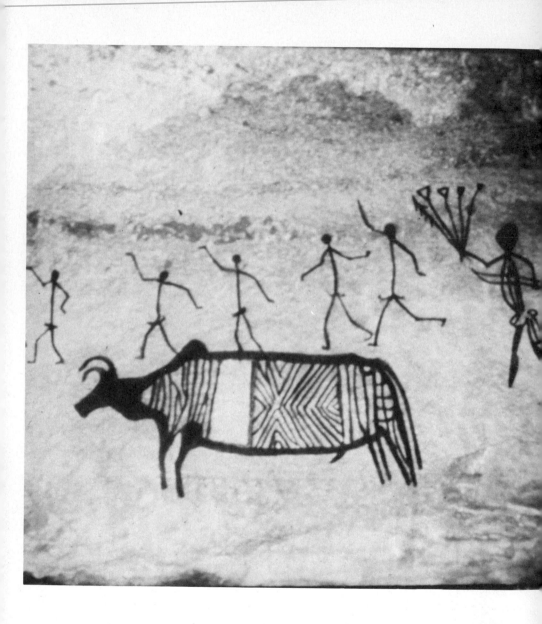

15 *Bhimbetka, Deccan, painting in a Mesolithic rock shelter showing a hunting dance, c. 5500 BC or later. H. about 20 in. (50·8 cm)*

Historical and religious origins

Knowledge of man's beginnings in India is still imperfect, and we cannot say how he originally came to occupy the greater part of the subcontinent. The small aboriginal peoples of the South, as a whole, belong to the proto-Australoid or Veddoid group and, except for their short height, resemble the Australian bushmen. Indeed, it is believed that India was once directly connected by a giant landbridge with the Indonesian islands and Australia. The rise in sea-level at the end of the last glacial age cut the overland contacts and left related bodies of ancient peoples widely scattered. Small remnants of these remote, mostly hill-dwelling people have maintained their archaic forest societies intact into the twentieth century, and today are among the so-called 'scheduled castes' of modern India.

The very first works of visual art created on the Indian subcontinent were primitive cave- or rock-paintings. Many hundreds are known, but the largest concentrations appear in Central India, on sandstone rock shelters within a hundred-mile radius of the city of Bhopal. None are as ancient as the cave-paintings of Europe: carbon-14 datings place the oldest at c. 5500 BC. In many cases the older images are overlaid with later paintings and graffiti, continuing down to modern times. 15

The paintings most often depict animals, either singly or along with stylized humans in hunting or magical scenes. Some tableaux seem to show such activities as hunting or perhaps bull-jumping, and figures with bows and arrows; other paintings, evidently later, show humans on horseback carrying swords and shields, which are obviously Iron Age objects. There are also rare examples of 'x-ray imagery', where a cow's unborn calf appears inside the animal or the internal organs of an antelope are charted, very much in the style of paintings made by the contemporary Australian bushmen.

The pigments used are all natural mineral colours and range in hue from dark reds and purples through terracotta creams, pinks, and oranges, to blues and greens and white ochres outlined in red. The paintings are executed in solid areas or lines of colour and attempts at tone and value are rare. According to Robert Brooks, some pigments were applied directly with the fingers, while others were apparently brushed on with a frayed palmetto stem or some other crude brush-like object. The pictures drawn in outline appear to be the most recent of these ancient works: they can be dated roughly to the fourth century A D.

Although Neolithic culture persisted for over three millennia, down to the beginning of the Christian era, it was overlaid by varying elements of Iron Age culture, starting about 1000 B C. The greatest pressure occurred about the third century B C when established Iron Age cultures of North India, in the Gangetic plain, began extending their influence into the South. Iron Age culture may also have arrived earlier in South India through maritime contacts with the Middle East.

The chief physical remains of Dravidian societies in South India, except for rock-paintings, are comparatively late in date, and consist of megalithic tombs – primitive burial cist or pit mounds covered and circled with stones. Found chiefly south of the Godavari river, the tombs have yet to be accurately dated, but they appear to have originated chiefly during the last two or three centuries B C. They contained simple iron items such as tools, weapons, ceremonial axes and tridents, and horse-trappings.

Also found in these burials were typical items of Iron Age black-and-red ware pottery. In some cases this pottery was scratched with what have been called 'owner's marks', but these graffiti are startlingly reminiscent of glyph designs found on Harappan seals. It must also be noted that the stone-circle, dolmen-type burials are obviously primitive relations of the Buddhist stupas, of which the earliest were being erected elsewhere at the same time. When a king or holy man was interred in such a mound it was enlarged. This natural process of elaboration eventually led to architectural structures that became places of reverence for both Buddhists and Jains.

Unfortunately, no sophisticated art remains to document one of the most important epochs of Indian history – between the period of Aryan conquest, *c.* 1500 B C, and the advent of the historical Buddha (566?–

37, 43

c. 486 BC). We know from literary sources, however, that all the arts were practised. They were, moreover, central to the education and life style of society's élite. Elaborate palaces of kings and town-houses of the wealthy are described as being embellished with wall-paintings and ornate wood-carvings. Major and minor arts were enhanced with accents of pigment, ivory, silver, gold, and precious stones, and miniature paintings were also known. But all was ephemeral and now appears lost forever. Slight suggestions of this lost art may be glimpsed in stone sculptures of the third and second centuries BC, and in the later cave-paintings at Ajanta, executed during the Gupta period in the fifth century AD.

Once the Aryans had settled in North India, an acculturation sequence began which saw a slow amalgamation of Vedic culture with that of the conquered, dark-skinned Dravidians. At first, as separate tribes, the Aryans herded cattle and waged wars both with the Dasas and among themselves. Eventually, however, they settled down, turned to cultivation, and began to intermarry with the native Indians. Before too many years had passed, small urban centres grew up and became the focus of kingdoms which consolidated tribal groups. The Aryans had spread south-east from the original areas first conquered in the Indus valley and the Punjab, and the chief arena for their development now became the Doab, or the plains adjacent to the Jumna and Ganges rivers.

The Aryans had brought to India the concept of religious worship centred upon sacrifice to deities who were the personification of the forces of nature. Their social structure, which grew out of their religious practices, consisted of a hierarchy which has come to be called the caste system. Actually our word comes from the Portuguese word *castas*, which was first used in the sixteenth century; the Aryans used the Sanskrit word *varna*, meaning colour.

There were (and are) four basic social classes. The priests, or *brahmans*, were the most exalted since they performed the Vedic sacrifice and, with their knowledge of the Vedic texts and rites, functioned as inter-mediaries between the gods and man. Second in importance were the *kshatriyas*, who constituted the warrior class and were the kings and administrators. Then came the *vaishyas*, or merchants and tradesmen. Last were the labourers, or serfs, the *shudras*. Outside this structure were the people who belonged to no caste, the 'outcastes', the impure, the

untouchables. This was the group to which the conquered dark-skinned Dasas belonged. The word was no longer just a term in the *Rigveda* describing the despised 'broad-nosed' defenders of the Indus cities, but now had the definite connotation of slave.

The first and chief book of the Vedas is the *Rigveda*, which was compiled some time between 1500 and 1000 B C. It is the oldest religious text in the world and contains 1028 hymns to various deities. Hymns were especially directed towards Indra, the god of the heavens, the warrior-king who rode a white elephant and threw the thunderbolt. Varuna, next in importance to Indra, was the feared and mysterious deity who not only created the cosmic order, *rita*, but maintained it from heaven. The cosmic order governed the rhythms of nature and man, and could be disrupted by man's sinful acts of lying and drunkenness. Varuna's presence (or that of his spies) was therefore always felt ('Wherever there are two, a third also is there'). Other Vedic deities were Agni, the god of fire, who on the Vedic altar consumed the sacrifice for the gods and was associated with the sun and lightning; Surya, the Sun God proper, whose chariot was daily pulled by stallions across the heavens; and Yama, the god of death.

Of particular interest is *soma*, which was both a substance vital to the Vedic ritual and the personification of this drink as a god. At a sacrifice a plant (probably a mushroom, according to R. G. Wasson) was pressed between rocks and mixed with milk or curd. The person who consumed it then had vivid and pleasant hallucinations. With soma as part of the ritual, the brahmans had a potent device for convincing the worshippers that Indra came down and caroused with them within the sacred grass-strewn compound of the sacrifice.

The three later Vedas, *Sama*, *Yajur*, and *Atharva*, which date from some time between 900 and 600 B C, contain instructions for performing sacrifices, magic formulae, and spells. After the tenth century B C, as the Vedas became more obscure, the *Brahmanas* and the later mystical *Upanishads* were appended as commentaries. The Sanskrit of the *Rigveda* is one of the earliest known languages derived from the ancient Indo-European, parent of so many of today's languages.

The great epic poems of India, the *Ramayana* and the *Mahabharata*, were conceived in classical Sanskrit and were formulated about 400 B C. The *Ramayana* is the older of the two, but the *Mahabharata* is the longest

28

28, 64

poem in the world, containing 90,000 verses or *slokas* formalized into a gigantic omnibus of sub-stories, myths, and legends (the *Bhagavad Gita*, for example). It is a veritable Hindu manual for social, ethical, and religious traditions.

These vast epics, and the four 'books' of the Vedas, were originally transmitted by a phenomenal human chain of memory, and only written down centuries after their actual compilation. This oral tradition still exists in India today. It is not unusual even now for scholars to discover and record a previously unknown ancient Sanskrit text that is being correctly chanted by an illiterate holy man.

As briefly indicated above, the Aryan tradition through the centuries was shaped by contact with the indigenous cultures of the subcontinent. By the beginning of the Christian era, it had changed so completely from its original Vedic character that we can begin to recognize in it clear qualities of the later Brahmanism. In fact, some time after the first century A D a doctrine based upon the *Upanishads* had codified into what is called *Vedanta*. *Vedanta* actually means 'the end of the Vedas', and its texts, the *Brahma Sutras*, containing the seeds of modern intellectual Hinduism, are still revered and studied in India today.

At this time we also see other important new elements beginning to emerge. Already present were the concepts of *bhakti*, or devotional love of the deity (later an important aspect of the Krishna cult); *jnana*, or knowledge of spiritual texts; and *yoga*, which was a system of gaining knowledge through asceticism and physical control of the body's senses. This last development was most significant because it revealed that the Vedic tradition of ritual sacrifice, necessary to maintain the universe, had been displaced by the concept of self-denial and penance which the Lord Shiva performs, meditating forever, in the far Himalaya. Shiva, the Hindu god of fertility and regeneration, associated in these early times with the Vedic god Rudra (see p. 16), was traditionally aided in his cosmic task by his human devotees, who also followed him in an ascetic path to mysticism. We might here recall the seated yogi figure on the seal from Mohenjo-daro to note how within two millennia the indigenous cultures, present and active in early Harappan times, have significantly penetrated the Vedic traditions.

The mystical practice of yoga was eventually accepted as an orthodox element of Brahmanism's social structure and was made an important

component of the four prescribed states of life recognized by a devoted Hindu. These are the celibate student, the married householder, the ascetic forest hermit, and, finally, the old homeless pilgrim. Asceticism was also an important element in the earlier schisms away from Vedic Brahmanism such as Jainism and Buddhism.

Buddhism, one of the world's great religions, originated with a historical personage, Siddhartha, born about 556 BC into a warrior caste (kshatriya) family in the Nepalese foothills. He was raised as a prince in the city of Kapilavastu, but at twenty-nine he renounced the world to seek spiritual truth. His family's clan name was Shakya and when he became the Buddha (the Enlightened or Awakened One) he was called Shakyamuni, the sage of the Shakyas.

After six years of attempting to gain salvation through self-denial, Siddhartha resolved to sit immersed in contemplation under the Bodhi tree at Bodh Gaya near Banaras until he achieved enlightenment. At the end of forty-nine days of meditation, salvation came, and he rose and went to the Deer Park near Sarnath, where he preached his first sermon to his former companions in austerities.

For the next fifty years the Buddha travelled over a good part of the Gangetic basin, teaching and converting regardless of caste, peasants and princes alike. He organized the original Buddhist order of monks and shared with thousands the wisdom of his 'Four Noble Truths' and the 'Noble Eightfold Path' or 'Middle Path' to liberation, or *nirvana* (literally 'extinction', blowing out the flame).

The Four Noble Truths are: 1. life is suffering; 2. the reason for suffering is desire; 3. suffering must be caused to cease by overcoming desire; and 4. suffering will cease if one finds the path to deliverance, which is the Eightfold Path. The elements of the Eightfold Path are: 1. right knowledge or understanding; 2. right purpose or resolve; 3. right speech; 4. right conduct or action; 5. right occupation or a livelihood conducive to salvation, preferably the monastic life; 6. right effort; 7. right awareness or self-mastery; and 8. right meditation.

It is doubtful that the historical Buddha looked upon his philosophical teachings as a formal religion. He did organize a society of monks, but his last message to them as he lay dying (*c.* 486 BC) was to 'work out your own salvation with diligence'. Undoubtedly among the main

factors which originally led to the popularity of Buddhism as a religion were its lack of priests and its disregard of caste.

One other important religious movement in India at this time was Jainism, whose concepts seem to have originated in India before the arrival of the Aryans. The religion was dedicated to asceticism and the sacredness of all life, its chief concept being *ahimsa* or non-violence. The apparent founder of Jainism was an individual called Mahavira, or Great Spirit (*c.* 599–527 BC). He was a contemporary of Buddha, and was even mentioned several times in the Buddhist canons. Mahavira was either the first or, as the Jains claim, the last of twenty-four great Jain saints called Tirthankaras, 'the ones who lead to the other shore'. By their ascetic example the Tirthankaras show all souls how to achieve release from the cycle of endless rebirth by the complete purification of their minds and bodies. The Jains are strict vegetarians and consider death by starvation meritorious. The Tirthankaras are also called *jinas* (victors or heroes), and their followers therefore are called Jains, or the sons of victors.

The Jains conceive the universe as an exceedingly complex living organism made of imperishable particles, some too small to be seen, all of which have souls. This fact accounts for the Jain aversion to violence. Today in India one sees Jain monks and nuns wearing gauze masks over their mouths to safeguard the unseen living organisms in the air. They also carry small brooms to sweep minute creatures from their paths as they walk.

The Jains were originally organized into two main sects, the Shvetambaras, or 'white-garmented ones', and the Digambaras, or 'space-garmented ones', who considered clothing to be a manifestation of involvement with the world and so went about garbed only in air. (Alexander the Great encountered Digambaras when he arrived in North India in 326 BC, and called them gymnosophists, or 'naked philosophers'.) As we will shortly see, the Jains, like the Buddhists, were eventually responsible for some of India's major works of art.

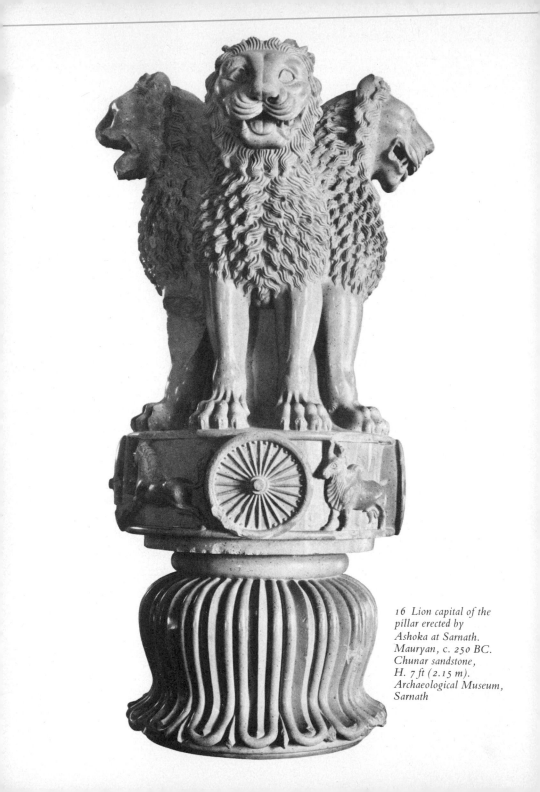

16 Lion capital of the
pillar erected by
Ashoka at Sarnath.
Mauryan, c. 250 BC.
Chunar sandstone,
H. 7 ft (2.15 m).
Archaeological Museum,
Sarnath

The Mauryan period: the first imperial art

In 326 BC the army of the young Macedonian adventurer who had
conquered the Mediterranean world and the great Persian empire of
Darius III crossed the Indus river and moved on to the plains of India.
Alexander the Great's desire to conquer all the lands of the Persian
empire, of which he had now become emperor, had brought him to its
richest satrapy – to the region of Gandhara and the friendly city of
Taxila, whose king had solicited his aid in attacking a rival ruler. Soon,
on the banks of the Hydaspes (the river Jhelum), Alexander and his
phalanxes were to fight one of their last and most brilliant battles against
the heroic Raja Poros's 50,000 troops and 200 elephants. But even in
victory, the homesick and exhausted Macedonians soon persuaded
Alexander to leave India and turn west, back towards Ionia.

Although the brief and dramatic phenomenon of a Greek invasion
of North India had few lasting qualities it did create a political vacuum
from which rose the first great historical Indian empire, that of the
Mauryas.

After Alexander's death his conquered lands in the East were held by
isolated Greek colonies under the tenuous command of Seleucus
Nicator, one of his generals. This arrangement did not last long because
another young adventurer, an Indian named Chandragupta Maurya,
came forward to take advantage of the disrupted situation.

Chandragupta Maurya's origins are obscure, but as a youth during
the time of the Greek invasion he seems to have been active in North
India as a marauding guerrilla on horseback. In fact, it is apocryphally
claimed that he and Alexander actually met for an uncomfortable
moment at one of the latter's camps in the Punjab. In any case, in such
unsettled conditions Chandragupta Maurya was able to gain strength
and successfully depose the last king of the Nanda dynasty at Pataliputra

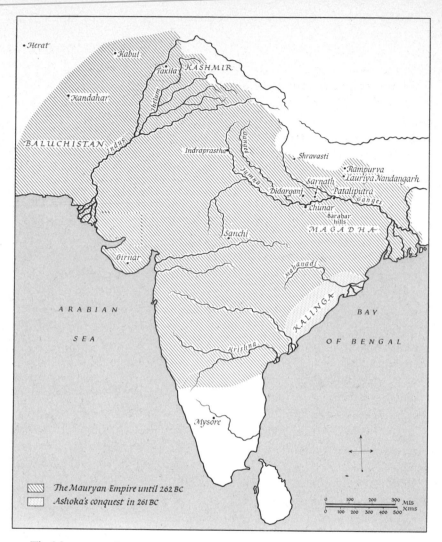

The Mauryan Empire until 262 BC
Ashoka's conquest in 261 BC

17 The Mauryan empire

(near the modern city of Patna) and establish his domain over Magadha in north-eastern India. He then quickly moved north-west into the Punjab where he overthrew the remnants of Greek power, and by 305 BC he had added western India and the Indus valley to his holdings. At this point Seleucus Nicator decided to challenge Chandragupta; but he was defeated and forced to relinquish the Greek satrapies of Kabul,

Herat, Kandahar and Baluchistan, and was further humbled into forming a matrimonial alliance with the Maurya clan.

As the first true emperor of India, Chandragupta Maurya successfully reigned from his capital at Pataliputra for twenty-four years (*c.* 322–298 BC) over an empire which covered all of North India, from the Ganges to the Indus and into the mountains of the Hindu Kush. Because he maintained diplomatic relations with Seleucus Nicator, we have the first clear picture of events in Indian history, recorded by the Greek diplomat Megasthenes. The Mauryan capital of Pataliputra is described as a city stretching nine miles along the banks of the Ganges, with mighty wooden walls pierced by 64 gates and surmounted by 570 towers. Megasthenes also relates, significantly, that the palace of the Mauryan emperor exceeded in grandeur those of Persia at Susa and Ecbatana. Little is to be seen today on the site of Pataliputra, at the confluence of the Ganges and Son rivers, but excavations did recover from the river sand remains of gigantic wooden walls or palisades.

Chandragupta's son Bindusara extended the empire into the Deccan as far south as the area of Mysore, and then he was succeeded by the most famous and greatest Mauryan emperor of all, Ashoka.

Little is known of the early part of Ashoka's long reign of forty years (*c.* 273–232 BC), except that the eighth year was a pivotal one. This was the year of his successful, but bloody, attack on the region of Kalinga, where, according to one of his edicts (translated by Nikam and McKeon), 'one hundred and fifty thousand persons were carried away captive, one hundred thousand were slain, and many times that number died'. The emperor, we can assume, had up to that time enjoyed all the royal pleasures of his kingdom, which of course included hunting and warfare, but after his great victory he was overcome with deep regret and looked upon violence with abhorrence. An edict carved upon a rock at the boundary of the ancient Kalinga country, south of Orissa on the Bay of Bengal, documents not only Ashoka's conversion, but also his missionary zeal for the non-violence of Buddhism.

Immediately after the Kalingas had been conquered, King Priyadarśī [Aśoka] became intensely devoted to the study of Dharma [Buddhism], to the love of Dharma, and to the inculcation of Dharma.

The Beloved of the Gods, conqueror of the Kalingas, is moved to remorse now. For he has felt profound sorrow and regret because of

37

the conquest of a people previously unconquered involves slaughter, death and deportation . . . King Priyadarśī now thinks that even a person who wrongs him must be forgiven . . . King Priyadarśī considers moral conquest [that is, conquest by Dharma, *Dharmavijaya*] the most important conquest. He has achieved this moral conquest repeatedly both here and among the peoples living beyond the borders of his kingdom . . . Even in countries which King Priyadarśī's envoys have not reached, people have heard about Dharma and about His Majesty's ordinances and instructions in Dharma. . . . This edict on Dharma has been inscribed so that my sons and great-grandsons who may come after should not think new conquests worth achieving. Let them consider moral conquest the only true conquest.

Actually Ashoka's kingdom lasted hardly more than fifty years beyond his death, but thanks to his dedication to Buddhism the sect became a major world religion and the dominant one of Asia.

Ashoka's missionaries travelled out from India in all directions. Among them were his son and a daughter, who carried to Sri Lanka the word of Dharma and, reputedly, a branch of the sacred Bodhi tree under which the Buddha was enlightened. In fact, a great deal of what we know of Ashoka today was preserved in the Pali Buddhist texts of Sri Lanka.

During the Mauryan period many stupas containing holy relics were raised by Ashoka to mark the sites sacred to the imperial Buddhist faith. Before this time, eight stupas had reputedly been used to enshrine the last possessions and remains of the Buddha. Then Ashoka, according to legend, further divided the relics and erected 84,000 stupas to commemorate various events of the saint's life. Subsequently stupas were erected to memorialize such things as the Buddha's enlightenment, miracles, death, or even a footprint, and to house the sacred texts, the 'word body' of the Buddha. Some stupas were solely objects of worship, such as the solid stone ones in *chaitya* halls (p. 52); later they were also used for the remains of holy monks.

It is, however, the numerous edicts cut into rocks, caves, and stone pillars across his empire, expounding the virtues of Dharma, that provide us with a penetrating insight into Ashoka's personality. The polished stone columns, erected at places associated with events in the

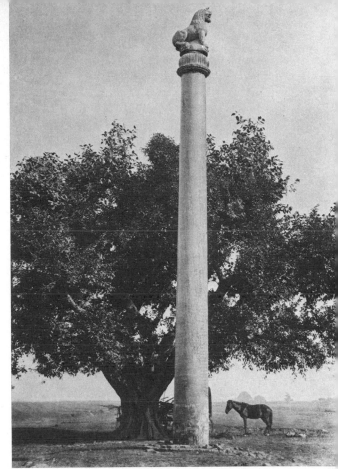

18 *Lauriya Nandangarh, edict
pillar erected by Ashoka.
Mauryan, c. 242/241 BC*

Buddha's life or marking pilgrim routes to holy places, are of special
interest for their capitals which provide us with the best remaining
examples of Mauryan imperial art. Nothing so substantial has survived
from an earlier period, no doubt because major works of art had been
created chiefly of wood, but in the Mauryan period stone sculpture
dramatically emerges to become the medium *par excellence* of Indian
artists. The practice of erecting monumental columns may be indigenous
to India: recently strong evidence has been presented by John Irwin to
suggest that the Ashokan columns may be the culmination of an ancient
pre-Buddhist religious tradition in India of a cult of the cosmic pillar,
or *Axis Mundi*.

The best preserved of all the Ashokan edict columns, dating from
c. 242/241 BC, still stands at Lauriya Nandangarh in Bihar State near the

16, 18

18

Nepalese border. Its form is typical: topped by a seated lion, the solid shaft of polished sandstone rises some thirty-two feet in the air and projects a mood of grandeur which must have characterized many other columns now lost, fallen, or shattered. The engineering skill required to position a monument that might weigh up to fifty tons ranks with the aesthetic achievement of the columns' capitals.

The finest and most famous of all the capitals is the one at Sarnath. The formality of its design makes its height of seven feet appear deceptively small in a photograph; however, the precision of execution and the unique surface gloss, known as the 'Mauryan polish', can easily be seen. The distinctive material used here, as in all the known Ashokan capitals, is a singularly handsome tan sandstone called Chunar after the quarry of its origin, upriver near Banaras.

The capital is composed of three diverse elements. A fluted bell supports a circular abacus, on which four royal animals and four wheels are carved in relief, and the dominant upper unit displays a quartet of alert lions, back to back, carved in the round. As excellent as this totality is, it is incomplete, for the work originally terminated with a large stone wheel supported on the shoulders of the four lions.

To understand the symbolism of the Sarnath capital, which has been adopted as the emblem for the modern Republic of India, we must consider a number of facts. The capital was found at Sarnath, the holy site where the Buddha first preached the doctrine of Dharma and thus put the Wheel of the Law into motion. In the earliest works of Buddhist art the image of Buddha himself is never depicted, but the events of his life are represented by various signs. The solar disc or wheel was an ancient Middle Eastern symbol for the Supreme Deity and/or knowledge, but in Buddhist nomenclature the wheel (*chakra*) came to be used and read universally as the Wheel of the Law (Dharma Chakra), symbolic of Dharma.

In the Sarnath capital a dominant wheel was supported by four lions and echoed by the four subordinate wheels on the abacus. Lions, which roamed the jungles of India until recent years, were considered in those days to be the kings of the animal world. Thus, the Buddha was a lion among spiritual teachers, and his sermon prevailed to all the four corners of the world just as the lion's roar established his authority in the forest. The four animals on the abacus – an elephant, a horse, a bull, and a lion –

40

illustrate the extent and persuasive command of the Buddha's sermon. In India since the Vedic period each of these beasts has symbolized one of the four quarters of the world. The elephant is the east, the horse is the south, the bull is the west, and the lion is the north. Each animal here alternates with a solar wheel to signify the true Law projected out to all four corners of the world, and thus combined they provide the base for the ultimate cosmic roar of Dharma which rises above.

This magnificently executed work is not only an exceedingly effective symbol for the Buddha's cosmic preaching of the Law: it is also an illustration of what must have been Ashoka's attitude towards his imperial status as an enlightened world-ruler. Here again we are dealing with an ancient Middle Eastern concept whose origins reach back to Babylon. The universal ruler, or *Chakravartin* in Indian terminology, is 'the holder of the wheel' or solar symbol of divine knowledge and authority. The Chakravartin is depicted in Indian art as possessing the Seven Treasures or Jewels, the light-giving Wheel, a loving queen, a steward, and a prime minister. A relief from the stupa at Jaggayyapeta *44* shows a Chakravartin, attended by the royal white elephant and horse, and extending his hand into the clouds to receive the rain of wealth (depicted as ancient square punch-marked coins) which falls in blessing on his kingdom. With this symbolism in mind, it is hard not to see the Sarnath capital as having an additional meaning – to represent Ashoka as an earthly Chakravartin, propagating the true Dharma and serving the holy Chakravartin, the Buddha.

Turning to the sculptural detail and technique of the capital, we find strong evidence of Persian or, more exactly, Achaemenid influence. The elongated petals which form the fluting on the bell, the bell itself, the realism of the animals portrayed on the abacus, the stylized and strained muscles and deep-carved claws of the four tense lions – all these features are duplicated on Achaemenid sculptures from the great capital city of Persepolis. It is important to remember that the Mauryan empire came into being as the result of Alexander's invasion of North India and following his destruction of Persepolis: the Persian sculptors who had worked for Darius were thus in need of new patronage.) The Sarnath capital is vivid evidence that either Persian or Persian-trained Greek sculptors were at work in Ashoka's Chunar atelier. The very fact that a school of art, fully mature and creating lasting monuments in stone,

suddenly appeared and changed forever the quality and direction of sculpture in India proves that it was an alien importation. The non-Indian form of the Sarnath capital, and the precise and elegant carving technique and uniquely polished finish which are obviously not the product of a wood-carving tradition, all confirm the arrival of a new, sophisticated art.

We must not forget Megasthenes' report that Pataliputra exceeded in grandeur the Persian cities of Susa and Ecbatana. These few souvenirs in stone are enough to give substance to his remarks. Another

19 capital which speaks directly of Pataliputra's grandeur was discovered at the city's site during the first casual excavation in 1886. It too prominently features palmette motifs centred on the flat open faces of its stepped impost block. Four cylindrical volutes project from the block's sides, and the two highest support the top abacus which features a running row of rosettes. These volutes, which recall those of Ionic capitals, join with the palmettes to document an Indian interpretation of Hellenic and Iranian motifs, which again confirms an Achaemenid influence and taste operative in Mauryan art.

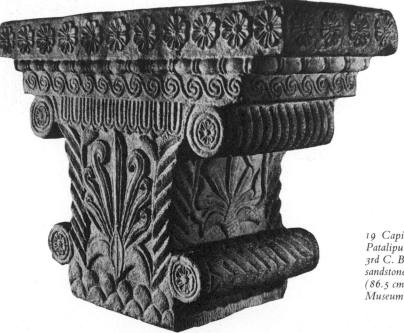

19 Capital from Pataliputra. Mauryan, 3rd C. BC. Buff sandstone, H. 34⅛ in. (86.5 cm). Patna Museum

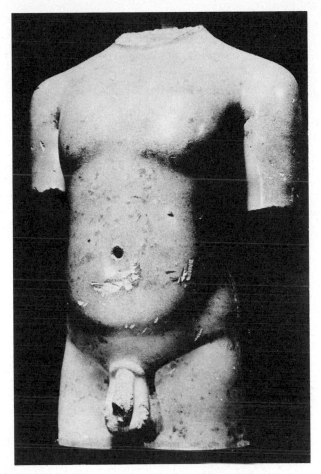

20 Torso of a Tirthankara from Lohanipur. Mauryan, 3rd C. BC. Buff sandstone, H. 26⅜ in. (67 cm). Patna Museum

Although no other capitals have yet been retrieved from the unstable river sands, the stumps of many polished stone columns were discovered, giving credence to the account of a Mauryan thousand-columned hall at Pataliputra.

Only a very few Mauryan figure sculptures have so far come to light, and these again are generally identifiable by their 'Mauryan polish' surfaces. Two headless male torsos, one with the imperial polished finish, have been found at Lohanipur, a site near modern Patna. They are of extreme interest because they are the earliest known sculptures of Jain Tirthankaras.

20

43

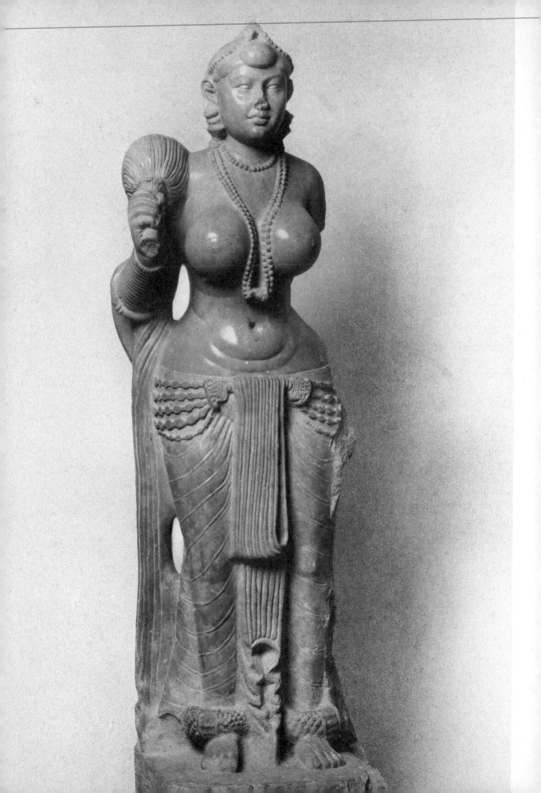

Perhaps the two most impressive examples of free-standing Mauryan sculptures are the figures of a *yakshi*, or female earth-spirit, from Didarganj near Patna, and a *yaksha* (male earth-spirit) from Patna. There is a continuing debate concerning the dating of these two figures, since some scholars see them as post-Mauryan, especially the yakshi, whose physical attributes, jewellery, and dress resemble those of the yakshi figures on the gates of the Great Stupa at Sanchi. The time-span involved is not more than a hundred years, however, so it is still possible to look at the works within the Mauryan context. In fact they display major characteristics of the Mauryan style.

21, 22

38

First and immediately notable is the monumentality of each image. Like the animals on the capitals, they seem to be emerging into reality from a melting volume of stone. The carving is voluptuously realistic and each turn or fold of the indicated flesh has a slightly inflated sensuousness which paradoxically invests the heavy stone with lightness. This quality is heightened by the smooth, glossy surfaces which are contrasted with the meticulously carved details of the jewels and fabrics which clothe the figures.

Since the Mauryan gloss quickly disappeared from Indian art, its presence here tilts the scales in favour of a Mauryan origin for these two figures. The sculptors of the succeeding Shunga dynasty appear not to have given such a gloss to their carvings, and it was only much later, in certain post-Gupta and Medieval sculptures, that a polished stone surface again became conspicuous in Indian art.

These two massive images bring us face to face with the universal divinities of fertility, for they are personifications of the primordial forces of the soil. For aeons back into dim history, even before the advent of the Harappan culture in the third millennium BC, the aboriginal peoples of India worshipped the spirits of trees, waters, serpents, and earth. Some of these spirits took on human forms. As Zimmer writes in *The Art of Indian Asia,*

> yaksas, no less than nāgas [serpents], must have been very popular in the pre-Āryan tradition, to judge from the frequency of their occurrence on early Buddhist monuments and later Indian art. Dwelling in the hills and mountains, they are guardians of the precious metals, stones, and jewels in the womb of the earth, and so are bestowers of

21 Yakshi from Didarganj. Probably late Mauryan, c. 200 BC. Chunar sandstone, H. 5 ft 4 in. (1.63 m). Patna Museum

riches and prosperity. Two yakṣas commonly are represented standing at either side of doors, carved on door-posts, as the guardians of the welfare of the home, and, according to Buddhist literary sources, a common feature in the inner yard of the ancient Hindu household was the standing figure of a gigantic yakṣa as the tutelary god of the house.

22 Even though the male figure is more damaged than the female and has lost its head and parts of both arms, we can see that each image once held a fly-whisk made of a yak's tail. The fly-whisk is, like the umbrella, a sign of honour; its presence suggests that these earth-spirits were worshipped, or perhaps stood as a guard of honour to a shrine or to a carved symbol of the Buddha. We may be seeing an attempt to placate the humbler citizens of Mauryan times by associating representations of their divinities with the State-endorsed Buddhist faith, even though Ashoka had curtailed the festivals and ceremonies of popular religion. We will shortly see at Bharhut and Sanchi actual examples of tree spirits taking on dominant roles by attending portals of Buddhist sanctuaries.

Our last Mauryan/Shungan figure of a yaksha well illustrates how a style of sculpture other than that of the imperial atelier was flourishing closer to the people. It is a giant image (over 8 feet high) of cream sandstone, found at Parkham, near Mathura.

This image is more damaged and weathered than either of the two previous ones, but it is not difficult to see that it is conceived and executed in a more vital and primitive style. Its almost savage frontality marks it as an icon for humble reverence and suggests a long wood-carving tradition. Adapted to a newly evolving technique of stone-carving, the yaksha is like a huge gingerbread man, cut from a flattened mass with little back or side articulation. The major sculptural manipulation occurs on the front, where a huge belly dominates. The prominent belly immediately suggests that the figure might represent Kubera, king of yakshas and deity of wealth and the north, but certain identification is impossible. Such a sculpture may indicate that once the dominant personality of Ashoka was missing, Dharma could no longer maintain its dominance over the religions of the soil.

The earliest surviving examples of Indian architecture date from the period of Ashoka, and their longevity also comes from the fact that

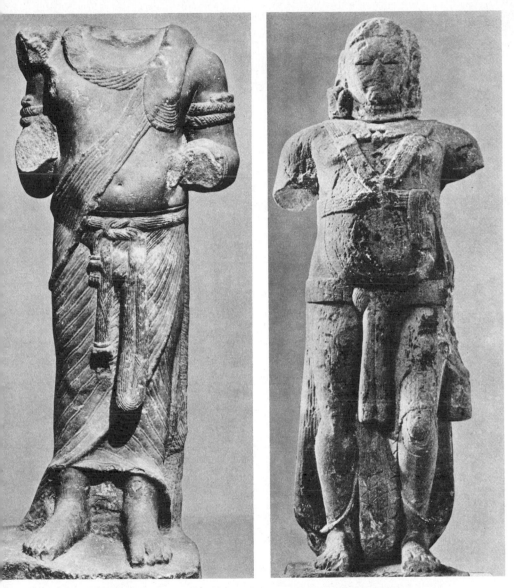

*22 (left) Yaksha from Patna. Probably late Mauryan, c. 200 BC. Chunar sandstone,
H. 5 ft 5 in. (1.65 m). National Museum, New Delhi*

*23 (right) Yaksha from Parkham. Mauryan or Shunga, 2nd C. BC. Sandstone,
H. 8 ft 7½ in. (2.62 m). Archaeological Museum, Mathura*

they are cut from solid rock. Here again we see a Persian mentality at work on Mauryan imperial attitudes, since royal rock-cut tombs were well known in Persia centuries before they were created in India.

As a gesture of religious piety and tolerance, Ashoka had a series of chambers, duplicating wood and thatch construction, carved into several boulder masses in Bihar for the Ajivika ascetics. There are a number of examples in the area, but those in the Barabar Hills about nineteen miles north of Bodh Gaya are the finest. Traditionally during the monsoon season monks of various sects ceased their wandering and withdrew to retreats. There, generally under the sponsorship of a local king, they meditated and prepared themselves for their spiritual duties back in the world of men when the rains ended. The Ashokan chambers carved into the living rock emulated the humble and temporary shelters of the transients, but as they were fashioned from stone, they obviously provided a permanent and continuing retreat for the monks of this non-Buddhist sect.

The two most noteworthy wood-imitating chambers are the Lomas Rishi and Sudama caves. Both of them have barrel-vaulted interiors, about 12 feet high and 32 feet long, but Sudama also contains a stone replica of a circular hut with a 12-foot domed and 'thatched' roof. Its internal walls are also vertically grooved to give the impression of upright wood members, and all surfaces are polished to a glassy smoothness.

24 Lomas Rishi is, however, even more impressive because its entrance, on the face of the boulder, is carved as a faithful imitation of a wooden building with a free-standing barrel roof supported on posts and beams. Among its various 'wooden' details are three smooth curved bands which arch above the $7\frac{1}{2}$-foot high doorway and span the space between the two major vertical members 'supporting' the structure. The space between the two upper bands is filled by a lattice screen which emulates a bamboo prototype that would have admitted light and air into a real building. The lower space has been magnificently carved with a procession of elephants showing reverence to three stupas. Except for a few cracks, all remains as crisp and clear as the day the sculptor stepped down from his scaffolding.

These third-century BC rock-cut chambers mark the beginning of a great tradition which would span more than a thousand years and, as we shall see, would serve all of India's religious communities.

24 Lomas Rishi cave, Barabar Hills. Mauryan, 3rd C. BC

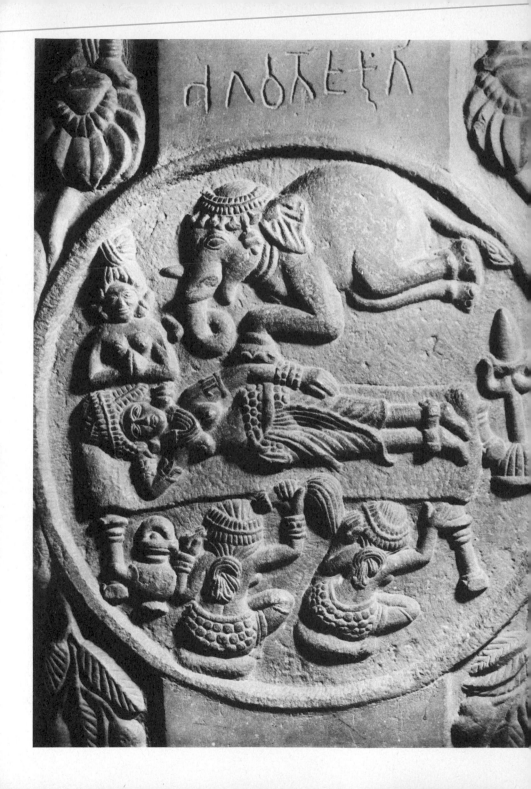

The Shunga dynasty: chaityas, viharas and stupas

When the Emperor Ashoka died in 232 BC, the Mauryan empire was divided between two of his grandsons. Administrative strength soon eroded, as many areas of the empire broke away to become independent. In 185 BC the last Mauryan emperor was killed by one of his brahman generals who then became the ruler and gave his name of Shunga to the new dynasty. During the 112-year rule of the Shungas the dominance of Buddhism as the imperial religion slipped, and its followers were even reputedly oppressed. During these times, moreover, many followers of Dharma were converted to Brahmanism. Such events, however, did not mean that Buddhism was completely eclipsed. The finest monuments of the Shunga period are, in fact, Buddhist creations.

Undoubtedly one of the most impressive monuments remaining from the late Shunga period is the rock-cut Buddhist worship hall (*chaitya*) *26, 27* at Bhaja, which dates from about the middle of the second century BC. More than twelve hundred such rock-cut chambers, large and small, were to be carved by Buddhists, Jains, and Brahmans in the centuries to come, and these monuments constitute a unique episode in Indian art.

The greatest number of these sanctuaries, both early and late in date, are to be found in western India. The plan of the twenty-nine *viharas* *81* (monasteries) and *chaityas* at Ajanta, famous for its wall-paintings which will be discussed later, gives a dramatic idea of how elaborate such rock-cut complexes can be. There, in what today is Maharashtra, the monuments are concentrated on the escarpments rising from the streams that lace the Western Ghats. Aware of the need for wealthy patrons, the holy orders also carved their retreats near ancient trade routes which passed from the inland centre of Ujjain through the Ghats to the western seaports.

25 Queen Maya's dream, railing medallion from the Bharhut stupa. Shunga, 2nd C. BC. Red sandstone, D. about 21¼ in. (54 cm). Indian Museum, Calcutta

At this period the stupa emerged as the central focus of Buddhist worship. It is in its simplest form a hemispherical burial-mound, and as a final receptacle for man's earthly remains it was easily identifiable as the symbol for release or nirvana. Thus it represented the Buddha's *Parinirvana*, his passage from the world of pain and illusion to the world of bliss and true reality. The stupa symbolized the goal of every devout *31* Buddhist, and as such it became an integral element of the chaitya hall.

The term *chaitya* means 'place of worship'. (A chaitya can in fact, as Coomaraswamy noted, be a building, a stupa, an altar, or even a tree.) Not unlike the Roman basilica, which was emerging concurrently in *26, 31* the West, the chaitya hall is a long apsed chamber divided longitudinally by two rows of columns which create a broad central nave flanked by two narrow aisles. In the apse the two aisles meet and curve around the stupa, which, when seen from the entrance door, is centred dramatically at the nave's end. The nave is covered with a curved 'vault'.

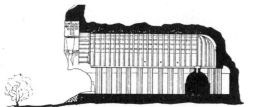

27 (opposite) Bhaja, façade of the chaitya hall and adjoining vihara. Shunga, mid-2nd C. BC

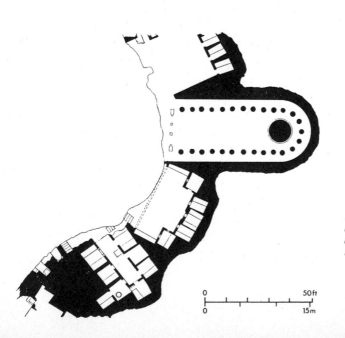

26 (left) Bhaja, section of the chaitya hall and plans of the chaitya hall and viharas. Shunga, mid-2nd C. BC

0 50ft
0 15m

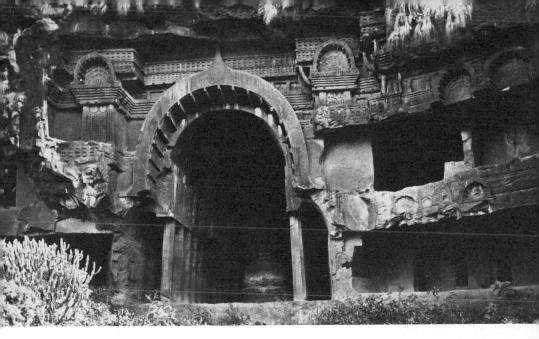

Generally the main feature of a chaitya hall's façade is a huge horseshoe-shaped window, surmounted by a peak, which pierces the stone wall above the doorway and provides the chief source of daylight for the hall. This architectural feature evolved from the stylized view of the end of a barrel-vault, first seen at the Lomas Rishi cave. Many centuries later the distinctive shape of the chaitya window or chaitya arch was still visible, as a sculptural motif on the towers of Medieval Hindu temples.

29, 86

24

134, 135

Bhaja appears to be one of the earliest attempts to create a large chamber from living rock, and it lacks a sophisticated stone façade. Mortise holes cut into the stone surrounding the entrance indicate that an elaborate wooden screen was added to the chamber after its completion. We can gain some impression of its appearance from the pattern of chaitya arches and uprights on either side of the vast entrance. Wood was not used only for the façade. The roof ribs were augmented by wooden members inset into the high vault, and wood formed the umbrella of the stupa as well as the small square railing on the stupa's crown. The scale of the chamber is remarkable: it is 55 feet long and 26 feet wide, and the vault rises to a height of 29 feet.

27

Because of the absence of a screen, the dominant chaitya arch is immediately revealed, along with the nave which is divided from its aisles by massive octagonal pillars that tilt inward, imitating the thrust

needed to support vaulting in a built structure. On either side of the opening we can still observe details of smaller chaitya-arch motifs, latticing and 'timbered' walls, all carved in imitation of a free-standing wooden building.

The chaitya chambers are not really buildings at all, but spectacular examples of giant sculpture. Nor are they caves, as they are sometimes called, even though the Indian mentality which created them undoubtedly associated them with a traditional religious practice of using caves and grottoes for ascetic retreats.

One must constantly recall that these chambers were excavated solely by human labour, which carved the cliff's face away foot by foot. After the master craftsman had laid out the dimensions and design of the planned space on the rock wall, the sculptors first carved into the upper façade by cutting a rough opening which eventually would become the finished ceiling. This permitted them to work back and down through hundreds of square yards of solid stone, ultimately to the chamber's floor. Heavy iron picks first removed the unwanted rock and shaped the rough forms of the 'architectural' details, and then the workmen executed the subtle finishing with chisels, some of them as small as a quarter of an inch wide.

26, 82 The viharas or monasteries which were carved out in association with the chaitya halls were generally designed as open square halls, approached by a doorway through a vestibule or porch and encircled by small cells for the monks carved deeper into the rock. Here the brotherhood lived, meditated, and slept in close proximity to their holy chaitya, where the ritual included the circumambulation of the stupa.

26 At Bhaja the monks' cells are located to the east of the chaitya hall, and here, on a porch some distance from the worship hall, are found several low reliefs unexpectedly depicting non-Buddhist subjects. Flanking a 28 cell's plain doorway are carved two Vedic deities in shallow relief which are reminiscent of the small mould-formed terracottas of the period. On the viewer's right, the god Indra is shown mounted on his cloud elephant, Airavata, who flourishes in his trunk a tree which has been uprooted from the landscape depicted below. There an enthroned king can be seen, with people worshipping a sacred tree covered with garlands, and also there another holy tree is apparently hung with human bodies. An attendant clings to the elephant's back, holding the Lord of the Heavens'

54

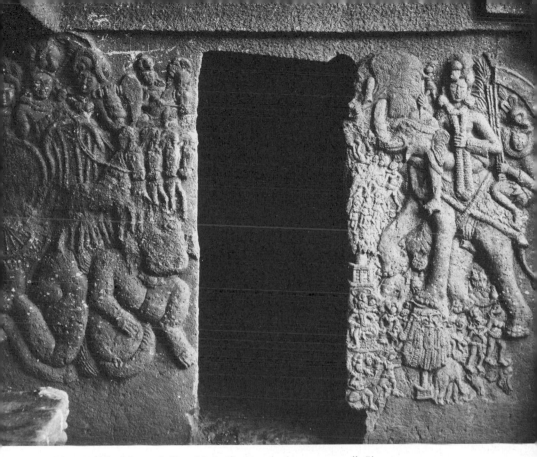

28 Bhaja, reliefs of Surya (left) and Indra flanking the doorway to a cell. Shunga, mid-2nd C. BC

banner and weapons. The relief on the left features Surya, the Sun God, accompanied by an attendant bearing an umbrella and a fly-whisk, subduing the monstrous forces of darkness. His chariot is pulled across the skies by four horses which rudely subdue the 'inflated' demons of night who roll and fall beneath the attack. The tableau must have been even more impressive in its original painted state. These reliefs featuring the older deities in heroic roles again underline early Buddhism's tolerance and its ability at integration – perhaps designed to avoid alienating the common people.

A short distance from Bhaja, and about a hundred miles south-east of Bombay, the greatest example of the rock-cut chaitya hall is found at Karli. Even though this is a later work of the Andhra dynasty, apparently *31*

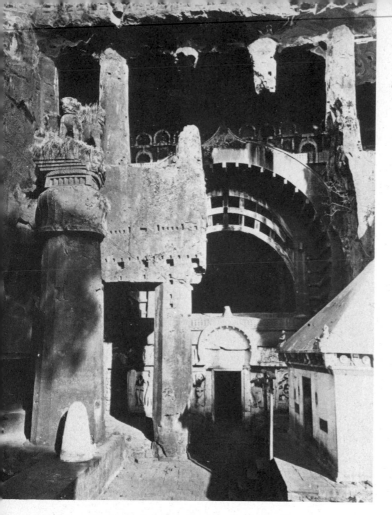

29 *Karli, façade of the chaitya hall. Andhra, late 1st–early 2nd C. AD*

30 (opposite) *Karli, mithuna couple near the entrance to the chaitya hall. Andhra, late 1st–early 2nd C. AD*

excavated from the late first to the early second century AD, it will be advantageous to discuss it here with Bhaja.

29 Today as one approaches the monument, it appears informally disposed because a modern Hindu shrine occupies space on the right side of its outer porch. Originally, however, it had a formal plan dramatically fronted by two huge stone columns. Only one, that on the left, remains today; about 38 feet high, it is a massive faceted shaft topped by a bell-shaped abacus and a capital with a grouped lion motif. Originally it supported a metal wheel and rose in height to over 50 feet. Even with its heavy design, the capital is reminiscent of the earlier Ashokan lion capital from Sarnath.

56

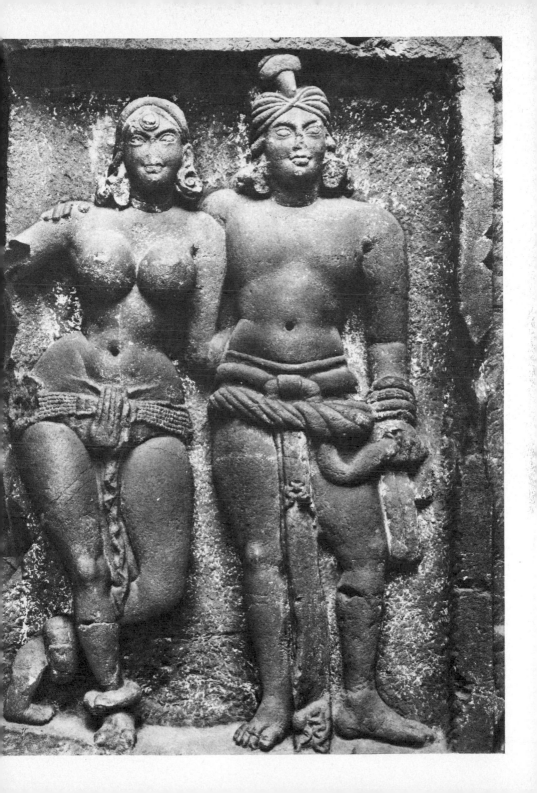

Almost immediately behind this column stand the equally massive but plain remains of a stone screen carved with supporting columns and surmounted by a pillared clerestory. The screen's main component was a central façade about 15 feet high, and judging by the presence of numerous mortise holes it must have originally supported a wooden gallery which was suspended like a decorative band across the whole front of the vestibule.

Inside the vestibule a second stone screen wall is dominated by the huge horseshoe-shaped chaitya window carved above three entrance doors which are separated by various relief carvings. Some of these reliefs are contemporary with the hall, but a number of them are seventh-century additions. The side walls are elaborately carved with small chaitya arches rising in four tiers above three half-life-sized elephants, which face forward and support the towering architectural fantasies. The elephants were originally fitted with ivory tusks and metal ornaments. The central doorway is the largest of the three doors, and was approached by a slightly inclined ramp fashioned from the living rock floor. This entrance was obviously reserved for the chief monks and persons of rank. In contrast, the two smaller side doors were approached only through shallow foot-baths which ritually washed the feet of the devotees entering the sanctuary.

30 Carved on either side of the vestibule's central entrance are several conspicuous reliefs, previously thought to show donor figures. They were conceived not as anatomical studies of the human body, but rather as essays in stylizing the symbolic essence of human life at its most vital apogee. These idealized bodies are full-figured and firmly fleshed, and they graphically display the Indian quality of inner breath (*prana*) which grants them complete harmony with the robust fertility of all nature and the earth. Here again we are in the presence of the ancient yaksha and yakshi (see pp. 45–6), which now, however, have developed into what is known in Indian art as *mithuna*. The term refers to an auspicious erotic couple, to be found from this time onward on both Buddhist and Hindu structures. It was such figures that shocked Victorian art critics and led them to denigrate Indian art.

31 The hall at Karli is 124 feet long, 46½ feet wide, and 45 feet high. The nave is flanked by thirty-seven closely set octagonal columns which run around the plain stupa at the far end in the apse. Thirty of these columns

58

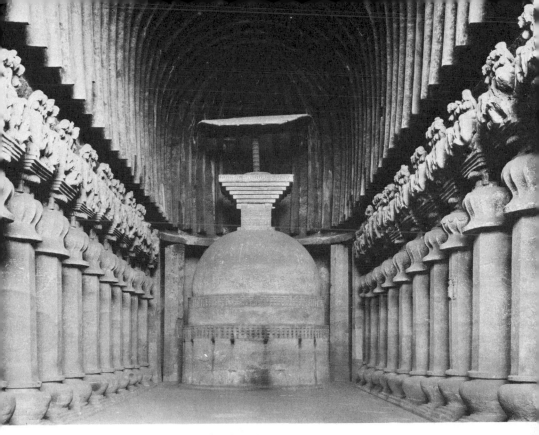

31 Karli, chaitya hall. Andhra, late 1st–early 2nd C. AD

have capitals and vase-shaped bases which stand on square three-tiered plinths. The seven remaining columns which surround the stupa are completely plain, except for their octagonal shafts. In contrast to the shafts at Bhaja, there is no slant; the columns stand completely vertical in recognition of their decorative, not pseudo-structural, function. The capitals are composed of a faceted bell-shaped abacus topped by kneeling elephants surmounted by deeply carved regal couples which, like the column bases, are also supported by tiered plinths. The rich sculptural qualities of these capitals and the close spacing of the columns combine to create the effect of a continuous high relief running down each side of the nave. The sides of the capitals towards the aisle are also carved with royal figures, but here their mounts are horses.

The light coming from the chaitya window has been carefully orchestrated to focus softly on the climax of the chamber, the stupa.

Also, since the columns are closely spaced, the light glows gently on them, but hardly beyond, creating the illusion that these shafts confine a sacred glowing space within the dark unlimited heart of the mountain.

Our attention can now return to a Shunga monument which, even in a ruined state, is more elaborate than any other thus far encountered. In 1873, about a hundred miles south-west of Allahabad, not far from the Son river in the north-eastern corner of Madhya Pradesh, Sir Alexander Cunningham (who had investigated Harappa) discovered in an open field the ruins of a Buddhist stupa known as Bharhut. The stupa itself had unfortunately been completely despoiled by the local people, who were quarrying its brick for village constructions. Stupas had by Shunga times evolved into major religious structures; the stupa at Bharhut was in addition enclosed within a circular stone fence dominated by four gateways. These embellishments, of dark red sandstone, were luxuri-

32–34 ously carved with reliefs. Fortunately the weight of these stones prevented the villagers from successfully removing many of them, but scores were broken in the attempt.

We can understand basically how Bharhut looked by referring to the

37 Great Stupa at Sanchi. The elaborate enclosures serving to define the sacred precinct of the stupa obviously evolved, as did the rock-cut chaitya halls, from wooden predecessors. This kinship is evident not

33–37 only from the slotted construction of the railing and the gate's post-and-lintel assembly, but also from the profusion of carving on all the surfaces (see below, p. 62).

The reliefs at Bharhut depict, in the fashions and settings of Shunga times, the numerous birth stories of the Buddha's previous existence (*Jatakas*) and the significant events of his life as Shakyamuni. The Buddha's figure never appears, however: he is always represented by one of a series of symbols that allude to major events in his life (see

32 p. 32). The symbolic vocabulary includes such signs as the wheel, representing the first sermon of the Law; the Bodhi tree, representing the Enlightenment; and the stupa, representing the Buddha's Great Release or Parinirvana. A riderless horse recalls the departure of the young Buddha-to-be from his father's royal house; a set of footprints displays the auspicious symbols of a spiritual Chakravartin (see p. 41); a royal umbrella over a vacant space proclaims his holy presence. Each of these symbols established a focus for a pictorial event.

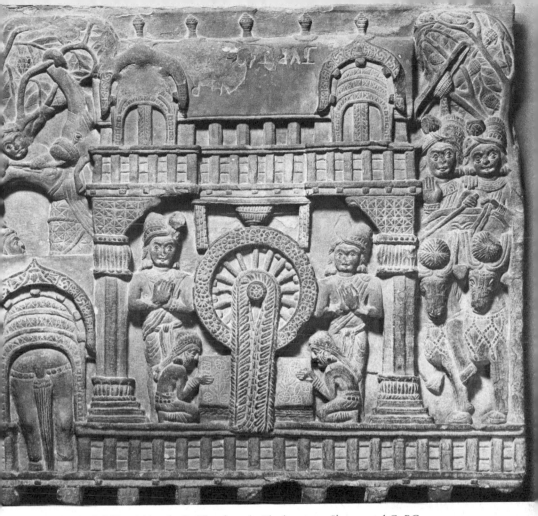

32 King Vidudabha visiting the Buddha, from the Bharhut stupa. Shunga, 2nd C. BC. Red sandstone, H. 18⅞ in. (48 cm). Courtesy of the Smithsonian Institution, Freer Gallery of Art, Washington, D.C.

An outstanding relief features the Buddha 'turning the Wheel of the *32*
Law'. In a vaulted building with columns, upper railings and chaitya arches, four devotees pay homage to the preaching Buddha who is here represented as a giant wheel. The episode has been identified as the visit by King Vidudabha to the Buddha in a story related to the history of the Shakya clan. The Buddha's throne is strewn with flowers, and his presence is further established by the umbrella festooned with flower garlands. The large central wheel is also embellished with a garland of

such size and location, on the wheel's hub, that we of a more mechanically oriented age are almost immediately inclined to see the Chakra not as a symbol of the Buddha, but as a central fly-wheel in a dynamic power-house. Later, when images of the Buddha in human form became permissible under Mahayana Buddhism, this aspect of 'turning the Wheel of the Law' would be represented by a seated ascetic holding his hands in the position or *mudra* known as Dharma Chakra mudra.

Of great visual delight here is the genre setting among activities common to the daily lives of second-century Indians, but of unique, if not exotic, interest to viewers two thousand years later. On the left the rear of a horse has all but disappeared through a chaitya-arched gateway, while beyond the wall a mahout struggles to refrain his elephant from breaking a branch from a blossoming mango tree. To the right of the shrine we are confronted with an onrushing chariot bearing two turbaned figures. The occupant to the driver's right appears to be the king, Vidudabha. An honorific umbrella is held above his head, and he raises one hand in greeting, while with the other he steadies himself on the shoulder of the driver. The two bullocks wear oversized pompoms and with raised hooves seem to be approaching at a fast trot.

All units in this vertical composition slide upward on the picture plane and enhance the quality of action. Background details also seem more crisply defined than those in the foreground, and figures appear to grow larger as they move deeper into the setting. The composition is thus flattened out, taking on the quality of a modern photograph made with a telephoto lens, whose nature is to enlarge objects proportionately to their greater distance from the camera.

Such a shallow-relief technique had its origins in wood-carving, and the sculptures at Bharhut are so close to the edge of that tradition that we can imagine and lament the quantities of wooden art works lost to us from the previous centuries. Also, one must remember that these sculptures were undoubtedly painted when new, and so were the earlier wooden works.

The episodes depicted were all well known to the Buddhist devotees, but the reliefs at Bharhut are carved with identifying inscriptions. In fact, most of the worshippers must have been illiterate and such captions would have been meaningless to them. The relief of the Buddha's sermon originally had such an inscription on the roof of the shrine, but

most of the characters have now been lost through the stone's flaking.

Important elements in the decoration of the Bharhut railing are the large round medallions on both the vertical posts and the heavy horizontal slats. It has been suggested that they are derived from the heads of brass pins or nails which held the joints in earlier wooden railings. Their designs are rich and varied and range from purely geometric and floral designs to settings for 'portrait' heads, animals, and complex narratives.

An excellent example of the narrative scenes is the renowned relief depicting the dream of Queen Maya, or the conception of Buddha. The Buddhist legend relates that when it came time for the *Tathagata* ('He – the Buddha – who comes in truth') to descend to the world of man for the last time, he took the form of a white elephant and entered the womb of a virtuous royal queen. The miracle depicted here, in direct and economic means, shows Queen Maya lying on a bed in the palace, attended by her ladies-in-waiting. As the lamp flickers at the foot of her bed, a large but gentle white elephant hovers momentarily

33 Railing from the Bharhut stupa; at the right, the yakshi Chulakota Devata standing on an elephant. Shunga, 2nd C. BC. Red sandstone, H. about 7 ft (2.15 m). Indian Museum, Calcutta

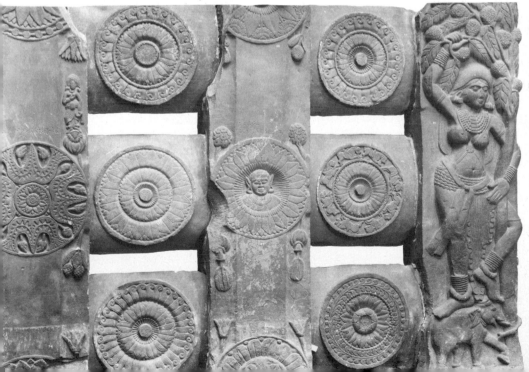

above her in her dream, before descending into her side. The medallion is only 19 inches high, but the sculptor easily accommodated all the necessary details within the circular shape, and even had room to spare. Each figure has a distinctive coiffure and pose, and the queen's jewellery is shown in exact detail, as are the lamp and water-urn next to her bed. Her sleeping figure is the obvious centre of interest, and the sculptor has used the thrust of the arm under her head and the other curving along her body as a compositional device. These curves not only echo the curved back of the elephant above, but also draw the two figures below into a related tension with the upper unit. A compositional problem is simply and neatly solved.

Elaborate monuments like the Bharhut stupa were often commissioned by a single royal patron to acquire religious merit, but here we know from inscriptions on many of the sculptures that they were paid for by various patrons. This would account for the general lack of continuity between related episodes: units in a story sequence are often not next to one another. (The practice of gaining merit by making gifts is seen in the West as well, for instance when a parishioner dedicates a window or a pew in a church. In India the tradition survives in the humble contributions of inscribed flagstones set in the floors of modern Hindu temples.)

The horizontal coping-stones on the railing are elaborately carved with individual Jataka scenes intertwined with a voluted vine pattern. This motif is in perfect harmony with Bharhut's rich surfaces, and contributes to the over-all mood of pulsating life which relates the shrine to other vital qualities of the earth. To complete this harmony, the yakshas and yakshis are out in force, especially stationed at the gateways, blessing the stupa with their protection and fertility and blessing those who pass through the gates into the holy enclosure.

34 To the left of the north gate, the railing post is fittingly carved with a figure of the yaksha Kubera, who we may recall is the deity of the north. He is immediately attended by the bejewelled yakshi Chandra, who sensuously clings to a flowering tree. Her regal bearing is complemented by her elaborate head-dress, her braided hair, her ankle and arm bracelets, her multiple necklaces, her girdle, and the auspicious marks tattooed on her cheeks. She is in fact portrayed as a queen of the Shunga period, but she is primarily a queen of fertility. Her languorous pose, with an arm grasping the blossoming branch above and her leg em-

bracing the tree-trunk below, identifies her with the *shalabhanjika* – a beautiful woman who can, by the mere touch of her foot, cause a tree to bloom. The iconographic form of this ancient fertility concept undoubtedly originated with the early yakshi figures. Chandra stands on an early form of a *makara*, a mythical beast associated with waters and fertility, which is part fish or crocodile and is usually shown with an elephant's head.

Many varied examples of the shalabhanjika and *naga* (an anthropo- 33, 34 morphic serpent figure) appear on the railing posts at Bharhut, and invariably they are supported by various symbolic animals. Hindu deities all eventually became associated with animal vehicles (*vahanas*) which both symbolize and support them; but it is at Bharhut that the earliest examples of this imaginative form occur.

Bharhut is one of India's earliest and most significant monuments. It is important as a 'library' of Buddhist mythology, but it is also of prime value because it preserves early iconographic motifs which matured in the centuries to follow, in both Buddhist and Brahmanical art.

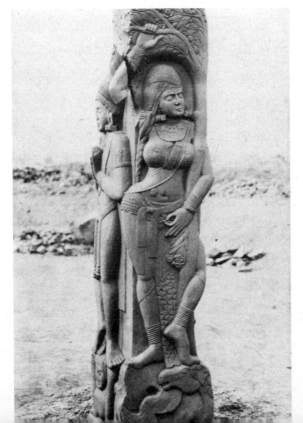

34 North gate-post of the Bharhut stupa, showing the yakshi Chandra and (to the left) the yaksha Kubera. Shunga, 2nd C. BC. Red sandstone, H. about 7 ft (2.15 m). Indian Museum, Calcutta

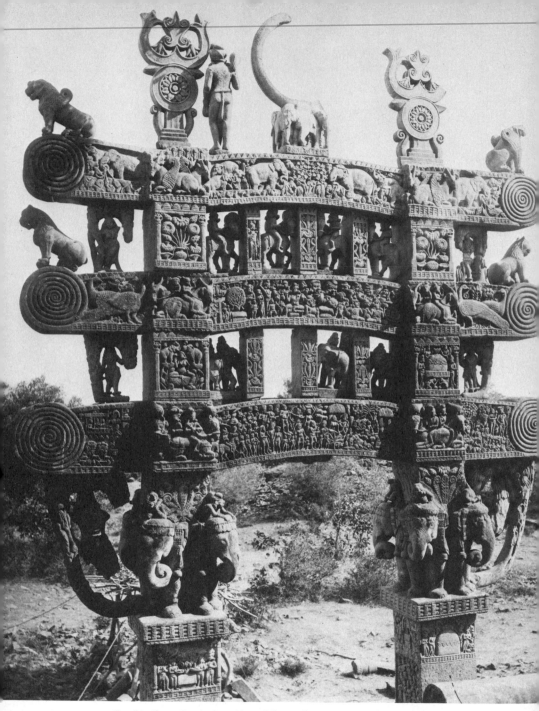

35 *Sanchi, Great Stupa, inner face of the north gate. Andhra, late 1st C. BC–early 1st C. AD. Sandstone, total H. of gate 34 ft (10.35 m)*

The Andhra period: the 'world mountains'

For most of their rule of more than a hundred years, the Shungas were involved in warfare. During that time north-west India was invaded by the Bactrian Greeks, who penetrated even the Doab. Also, the Kalingas, still smarting from their defeat by Ashoka, momentarily gained power and broke out to raid the Greeks in the north and the Pandyan kingdom far to the south. At the same time in Central Asia remote events were occurring which would drastically affect the course of Indian history in the early centuries of the Christian era.

The remnants of Alexander's Greeks who had clung to power in Bactria, between the Oxus river and the Hindu Kush mountains, had survived Parthian pressures in the west, but in the first century BC began to be subdued by nomadic tribes from the Steppes. First to come were the Scythians, or, as the Indians called them, the Shakas; they were soon followed by a group from southern Mongolia called the Yueh-Chi. These last barbaric nomads were a portion of several hordes of people who had pressed in on the western frontier of Imperial China during the third century BC, and were at last checked by the construction of the Great Wall. Under pressure from the Han dynasty, they were decisively driven away, and by the first century BC they had arrived far west in Parthia. There they displaced the Shakas and the Greeks, and soon, about the time of Christ, they invaded Gandhara (see p. 82).

Meanwhile, to the south an obscure tribal people, mentioned as subjects of Ashoka's empire, rose to power in the Deccan and assumed there the Mauryan mantle of power. These were the Satavahanas from West Central India. Later, in the *Puranas* of the Gupta period, they are called the Andhras. Eventually they also ruled the eastern Deccan, and the memory of this rule contributed their name to the area, Andhra Pradesh. By the second century AD they had reached the zenith of their power and dominated the central Deccan from coast to coast and controlled most of India's rich trade routes and seaports.

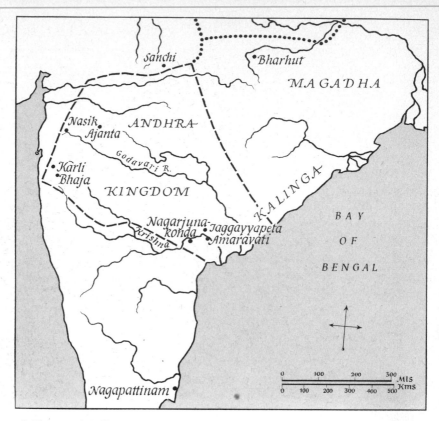

36 *The area of Andhra dominance*

In the centuries preceding the Christian era, as we have seen, the stupa had become, for the growing Buddhist faith, a focus for religious reverence. Among the 84,000 stupas reputedly erected in the Mauryan period by the great Ashoka was one located in Central India about *37* forty miles from Bhopal. Here at Sanchi, on the site of an early monastery, Ashoka constructed a stupa which measured about 60 feet in diameter and was some 25 feet high. In the middle of the second century BC his stupa was doubled in size and its older wooden railings (*vedikas*) were replaced with new, massive, plain ones of stone, 9 feet high.

At this time an ambulatory passage was raised up round the stupa's base or drum to a height of 16 feet above the ground, and a double stairway up to the passage was added on the south side. The whole

68

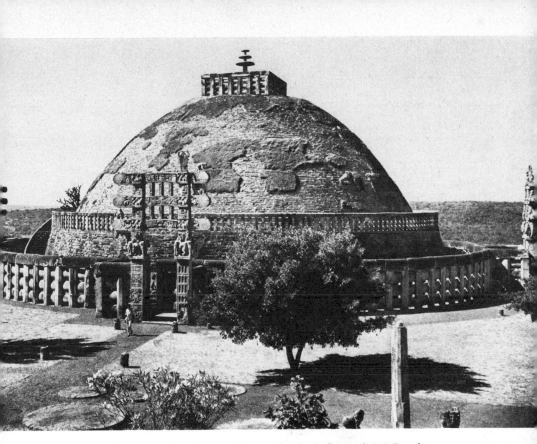

37 Sanchi, Great Stupa, seen from the east. Shunga and early Andhra, 3rd C. BC–early 1st C. AD

spherical body of the dome (*anda*) was covered with roughly finished stone blocks, and a three-tiered umbrella (*chattra*) was placed on its flattened top. The three elements of the umbrella represented the Three Jewels of Buddhism: the Buddha, the Law, and the community of monks. The umbrella stood within a square railed enclosure (*harmika*) derived from the ancient tradition of enclosing a sacred tree with a fence.

Near the end of the first century B C the Andhras arrived at Sanchi to begin their significant stone renovations, which resulted in the stupa becoming the greatest Buddhist monument in India.

The major features of the new work are the four gloriously carved stone gates (*toranas*), 34 feet high, which were begun in the later years *35, 37* of the first century B C and completed during the lifetime of Christ. The

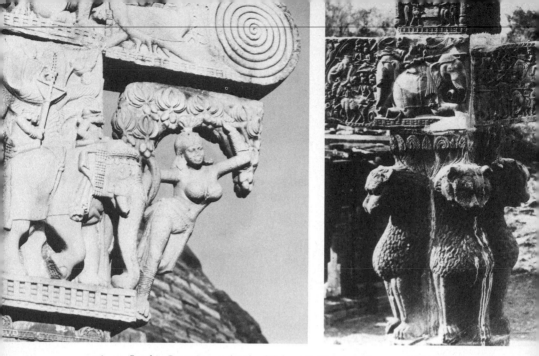

38, 39 Sanchi, Great Stupa, details of the east (left) and south gates. Andhra, late 1st C. BC–early 1st C. AD

39 sculptors were, at least in one instance – recorded by an inscription on the southern gate – ivory craftsmen from the near-by town of Beshnagar. That might account for the fact that the carving on the toranas is much more sophisticated than the construction methods, which still treat stone like wood.

Here at Sanchi, as at Bharhut, the Buddha's presence is still represented by symbols – empty thrones, footprints, umbrellas, and the like. The earth spirits are also here, and in fact the stone brackets carved in the *38, 40* shape of yakshis are the most beautiful creations at Sanchi. Perhaps not *34* even a hundred years separate the Bharhut yakshi from her sister at Sanchi, but in the interim the shalabhanjika had breathed deeply and stepped from her block of stone. No longer is the figure a formalized symbol for the human body, whose angled arms and legs imitate motion; here the yakshi moves free in space and stands in the classical three-body-bends pose (*tribhanga*) which will characterize Indian sculpture from this moment on.

70

On the square columns and cross-members of the gates are depicted various events from the life of Shakyamuni and from the Jatakas. These are complemented by various sculptures in the round of other yakshis, fly-whisk-bearers, wheels, *trishulas* (trident shapes symbolizing the Three Jewels of Buddhism), elephants, peacocks, solar discs, and other subjects. This complex stone gallery is inhabited by the creatures of the seen and unseen worlds, who in some cases are carved with double faces to allow the devotee to see them as he approached the gate and again as he circumambulated the stupa.

The ritual of circumambulation was performed by entering the precinct through the east gate and walking clockwise. This direction related the devotee's movements with the passage of the sun (east, south, and west) and put him in harmony with the cosmos. In fact, his involvement with the stupa was a bodily engagement within a gigantic three-dimensional *mandala*, or sacred diagram of the cosmos, which slowly and systematically transported him from the mundane world into the spiritual one.

40 *Two addorsed shalabhanjika images from Stupa I at Sanchi. Andhra, c. AD 10–25. Sandstone, H. 25 in. (63.5 cm). Nasli and Alice Heeramaneck Collection, Los Angeles County Museum of Art*

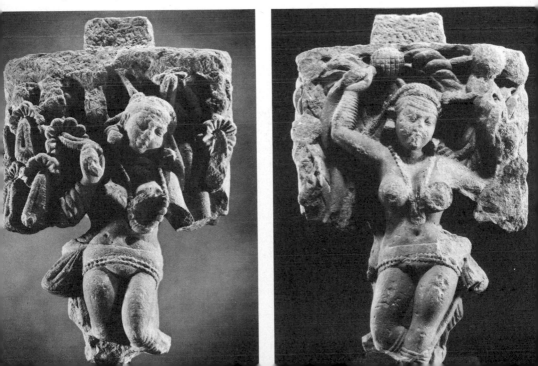

37 Here at Sanchi the ancient burial-mound had been completely trans-figured into a 'world mountain', oriented by its four gates to the four quarters of the universe. The tiered umbrella, housed within its holy compound, rose as the sacred tree to Heaven, and in so doing it joined by its shaft the celestial powers with the fertile soils of the earth. Within the deep centre of the solid hemispherical mass, called the egg, and directly beneath the umbrella, resided the reliquary containing the relic which was referred to as the seed. As the devotee approached the sacred compound and passed through the east gate, he was caught up in a psychological state which grew in intensity as he moved closer to the holy relic, until he momentarily became transfixed by the experience of being moved by the sight or presence of a sacred person or object (*darshana*). Excavations into the body of several stupas have revealed that the internal construction sometimes took the form of auspicious or magical designs, such as a wheel or a swastika, all hidden from view but exercising the power of their holy essence on the stupa's nature as a mandala.

 The stupa, central to Buddhist ritual, was exported with the faith beyond India to evolve into different forms in new lands – the pointed pagoda of Burma, the stacked *chorten* of Tibet, the tiered tower pagoda of China, and the mammoth 'world mountain' of Borobudur in Central Java, the greatest of all Buddhist stupas.

40, 30 Several small but notable footnotes to Andhran sculpture, particularly related to the yakshi bracket figures at Sanchi and the couples at Karli, are two small ivory-carvings discovered outside India. The first and
41 most dramatically found is an ivory mirror-handle carved with a figure of a yakshi or a courtesan, which was recovered from the volcanic ash of Pompeii. Obviously it had arrived in Italy before AD 79, when Vesuvius erupted. Its stylistic details mark it as a product of the very late first century BC or the very early first century AD. Some of the statuette's jewellery recalls items seen at Bharhut, but the natural stance and elaborate hair arrangement on the figure's back relate it more closely to the yakshis at Sanchi. These qualities, added to the Roman setting, strongly point to an Andhran origin – made even more probable by the fact that the Andhras at this period controlled the trade routes which flowed from India through Alexandria in Egypt and ultimately to Rome.

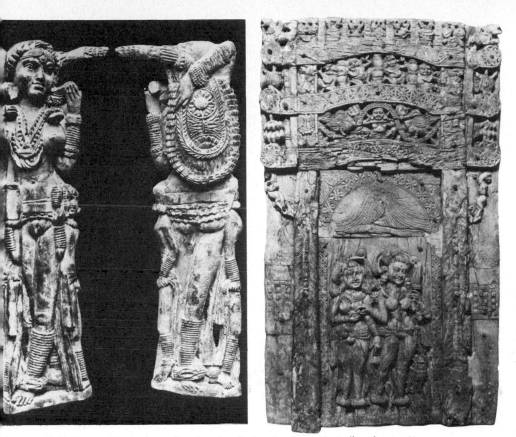

41 (left) Front and back views of a mirror-handle found at Pompeii. Andhra, late 1st C. BC–early 1st C. AD. Ivory, H. 9½ in. (24 cm). Museo Nazionale, Naples

42 (right) Plaque from Begram. Andhra, 1st C. AD. Ivory, H. 16½ in. (41 cm). Kabul Museum

A second fine ivory-carving which must be an Andhran product of a slightly later period, probably the first century A D, is a plaque which originally formed a decorative panel on a throne. Along with many other ivory fragments and luxury items, it was discovered in 1937 by a French expedition led by the Hackins in a cache at Begram in Afghanistan. Begram lay on a major trade route to Central Asia which joined the Chinese Silk Road with Indian trade centres and seaports in the Deccan. The plaque shows two bejewelled women standing under a torana of the type we have noted at Bharhut and at Sanchi. We should recall the inscription on the south gate at Sanchi recording that it was created by the ivory-carvers of a near-by town.

42

35

South in the Deccan, in an area between the Krishna and the Godavari rivers, the Andhras were also responsible, from the second century BC through the third century AD, for a series of significant Buddhist complexes. Today crumbled brick remains are all one can see at the sites of at least eleven once highly embellished stupas, which included the renowned monuments of Jaggayyapeta, Nagarjunakonda, and Amaravati. Fortunately, many reliefs and a number of sculptures in the round have survived as testimony of the greatest flowering of Andhran sculpture, in what is generally known as the Amaravati School.

Although long abandoned, the stupas at Amaravati, encased by slabs of a distinctive white-green marble, had survived into the early nineteenth century. Then they were all but destroyed by a greedy landowner who saw their ample supply of carved marble as a source for plaster and began reducing it in lime-kilns. A desperate last-minute rescue took place, and most of the surviving sculptures are now in the Madras Museum and in the British Museum in London.

The Great Stupa at Amaravati was the most splendid and the largest of the Andhran stupas in the Deccan. It was begun as a brick-cored shrine at about the time of Christ, but received its final carved facings and railings from about AD 150 to 200. Its representation on numerous reliefs gives an impression of its elaborate qualities. The drum below the dome was 162 feet in diameter, and was encircled at a distance of 15 feet by an outer railing, making a total diameter of 192 feet. As we can see from the panel reproduced, this railing was richly carved both inside and out. Reliefs also covered a projecting base around the drum, the top of which provided a second, higher, level for circumambulation. This upper processional path, embellished with an additional sculpture gallery, stood about 20 feet above the ground and was interrupted at each of the four railing entrances by an offset panel unit surmounted by five lofty columns. The columns in effect take the place of toranas, which were absent.

The earliest Andhran sculptures, which date from the first century BC, are very close to those seen in North India at Bharhut. A good example of their somewhat stiff and angular style is the relief from Jaggayyapeta depicting a Chakravartin (see p. 41).

The mature art of the Amaravati region is one of India's major and distinct styles, considered by many critics to be the finest school of

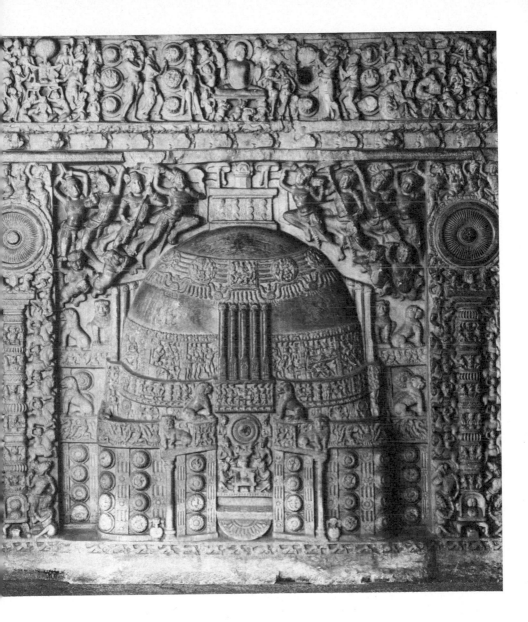

43 *The Great Stupa at Amaravati, represented on a slab from its casing. Andhra,*
c. AD 150–200. Marble, H. 6 ft 2 in. (1.88 m). Government Museum, Madras

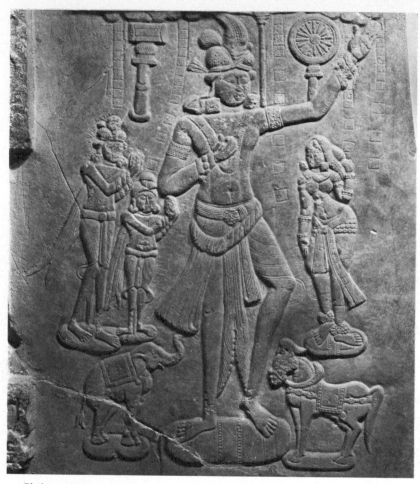

44 Chakravartin, from the Jaggayyapeta stupa. Andhra, 1st C. BC. Marble, H. 4 ft 3 in. (1.30 m). Government Museum, Madras

Indian sculpture. Even a non-partisan viewer can easily appreciate the reliefs, peopled by a host of graceful, elongated figures who imbue the sculpted scenes with a sense of life and action that is unique in Indian art. Not only is each figure animated by an internal vitality, but the quality of the surfaces further enhances the action by having a fluid quality reminiscent of water-worn pebbles.

45 *Women adoring the Buddha symbolized by a throne and footprints, from the Great Stupa at Amaravati. Andhra, c. AD 140. Marble. H.16 in. (40.6 cm). Government Museum, Madras*

As in other early Buddhist sculpture, the Buddha's presence is at first only symbolized. A relief of about A D 140 from the Great Stupa shows female devotees paying homage to an empty throne marked with the Lord's footprints. Very shortly afterwards, however, about A D 180–200 – perhaps due to influences from Mathura in the North (pp. 102, 106–9) – the figure of the Buddha suddenly appears at Amaravati.

45

46

46 A roundel from one of the Great Stupa's railings, dating from the beginning of the third century A D, shows the Buddha in human form subduing a maddened elephant which had been sent by his jealous cousin, Devadatta, to attack him. The narrative includes both the enraged elephant's charge, tossing bystanders aside with its trunk, and the scene where it kneels humbly, pacified before the sacred presence of the Buddha. The work is a superb example of the mature Amaravati School: the representation of action is remarkable, as is the organization of space which amply accommodates the story and the wealth of architectural and human detail. The figure of the Buddha indicates cultural and

48 theological influence from the Kushans, who were now the dominant dynasty in Northern India.

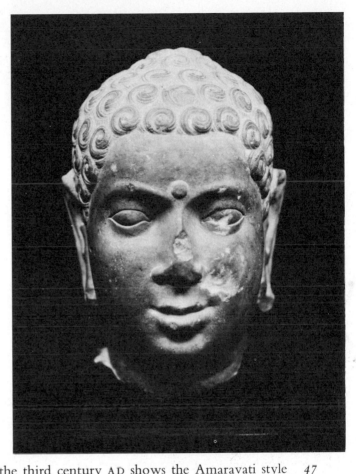

47 Head of the Buddha
from Amaravati.
Andhra, 3rd C. AD.
Marble. Musée Guimet,
Paris

A marble head of the third century AD shows the Amaravati style 47
applied to sculpture in the round. It is a sophisticated production by a
master sculptor; and the slight damage in no way detracts from the sure
and subtle modulation of the flowing sculptural volume and the illusion
of life, both hallmarks of late Andhran art.

With the decline of Andhra power in the Deccan, Brahmanism
would again dominate the South, and the voice of Dharma would only
continue to be heard in a few centres, such as Nagapattinam farther
down the eastern coast. But now our attention must return to the North,
where the Kushans have moved centre stage, and Buddhist religion
and art are undergoing far-reaching changes.

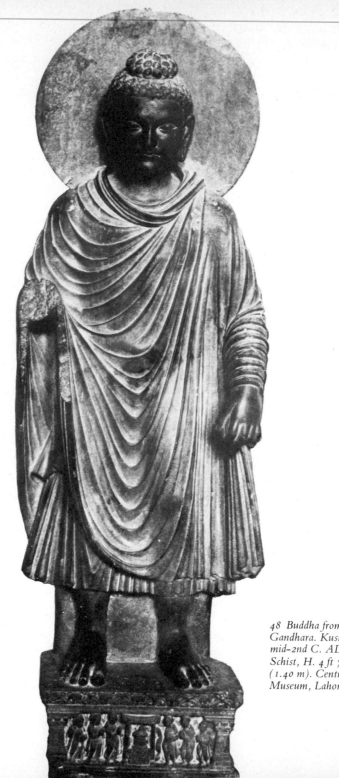

48 *Buddha from Gandhara. Kushan, mid-2nd C. AD or later. Schist, H. 4 ft 7½ in. (1.40 m). Central Museum, Lahore*

The Kushan period: Gandhara and Mathura

At the beginning of the Christian era Northern India provided the panoramic backdrop for a series of evolutions in history and art which would modify not only the future culture of India but also that of Greater Asia. Indeed, from an Asian point of view this might be considered the time and place of the 'millennium'. The Buddhist church in Gandhara was beginning a mutation which would ultimately move its simpler monastic form of *Hinayana* ('Little Vehicle') towards a broader and more humanistic faith called the *Mahayana* ('Larger Vehicle'). Within this new Buddhist climate the focus would shift away from the closed community of monks towards an open religious atmosphere with greater participation by the lay community. Devotees in turn would look more and more towards an evolving cosmology of merciful saints (*Bodhisattvas*), who on the threshold of nirvana would hold out *55, 62* their compassionate hands to bridge the gulf between the illusionary *67, 68* world (*maya*) and the eternal bliss of true reality. Central to the new cosmology was the Buddha, who originally was only a revered human being commanding the devotee to work out his own salvation with diligence, but who ultimately became a saviour and a god. The Buddhist church therefore needed an icon, and soon an image of a new deity would be created (see pp. 84–6).

At this very time Roman trade with Asia was almost at its peak, and the great Silk Road, spanning a quarter of the globe, brought the luxuries of Cathay to the villas of Rome. The bustling trade routes streamed westward from the environs of modern Peking across Western China, through Persia and the Levant to the shores of the Mediterranean. Other connecting routes dropped from the high plateaus of Central Asia down through the towering snow-covered passes of the Himalayas and out on to the hot plains of India to find Roman sail waiting in west

coast ports. As the Parthians became increasingly hostile towards Rome, trade through the Levant was cut off, and the mountain passes of India became the highways for the diverted camel caravans *en route* to the sea.

This elaborate conduit carried commercial currents two ways. Asian silks and spices reached the Western world, and objects of gold, glass, and other prized Roman creations were eagerly imported by the élite of the Orient. Adventurers and artisans also moved along these highways and a desire for profit and new opportunity saw them at work in far exotic lands. If the Andhras were to flourish from this profitable trade in the Deccan, the Yueh-Chi, soon to be known as the Kushans, were to prosper even more in Northern India.

Following their subjugation of Central Asia, the Yueh-Chi settled first in the region of the Oxus river. Then in the second century BC they moved into Bactria and there learned to use a form of the Greek alphabet. In the next century the five Yueh-Chi tribes were unified into one Kushan nation by their leader Kujula Kadphises, and during the early years of the first century AD he led them south across the mountains into Gandhara, where he established his court at Kabul. His son Vima
63 Kadphises, who succeeded him about the middle of the century, was the first Indian ruler to strike coins of gold in imitation of the Roman *denarii* exchanged along the caravan routes, and this very use of gold in coins attests to the prestige and power achieved by the Kushans. Under Vima coins also began to show Indian influence, but it was during the
50, 65 rule of his successor, the great Kanishka, that the most dramatic developments occurred.

The Kushan dynasty reached the summit of its grandeur under King Kanishka. His realm extended from Gandhara and Kashmir south as far as Sanchi and east to Banaras. Peshawar, not far from the Khyber Pass, was Kanishka's capital, and Mathura appears to have been a second capital to the south. The date of Kanishka's accession is unfortunately still in dispute, with speculations ranging generally from AD 78 to 144. The date AD 78 is attractive because it appears to fit the Kushans' dynastic chronology and also marks the beginning year of the important Shaka era. It also coincides with the fourth Buddhist council. This event, which followed the demise of the Buddha by five hundred years, was looked upon as a critical turning-point because the Buddha himself had prophesied that Dharma would endure for only five centuries.

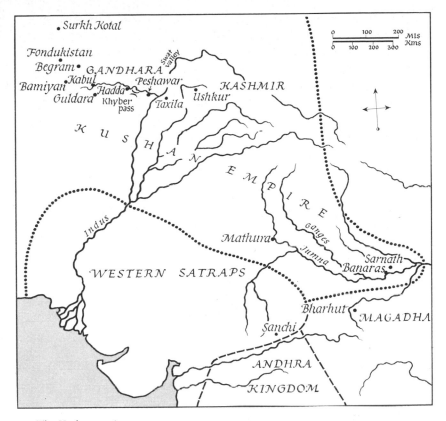

49 *The Kushan empire*

On mounting the Kushan throne, Kanishka found himself the ruler of
a flourishing nation strategically located to control the gates to the rich
network of trade crossing Asia. He not only succeeded in maintaining
control over vital sections of this profitable trade system, but even sent
an envoy to the Emperor Trajan in Rome. Kanishka's coins also vividly
display his desire to live harmoniously with the various peoples and
religions within his domain and beyond it. The elaborate pantheon
struck on the face of his coins illustrates particularly the various religions
practised beyond Gandhara in related regions of foreign trade. The
deities of Persia dominate; the gods of Rome, Alexandria, and the
Hellenized Orient include Herakles, Helios, Serapis, and Victory;
Shiva and Skanda-Kumara represent Brahmanical India.

50

50 The most remarkable image to appear on a gold coin of Kanishka is, however, a standing figure of the Buddha. The image of the Buddha as a god, which here emerges for the first time, is already sophisticated and well developed. Its iconographic features were soon to be found on larger and more complete stone images.

 The figure on the coin is dressed in the *sanghati*, or monastic robe. Clearly seen are several of the Buddha's distinctive features, which are among the thirty-two marks of Buddhahood: a halo behind the head; a cranial protuberance (*ushnisha*), representative of super-spiritual knowledge, shown here as a chignon at the top of the skull; and elongated earlobes, extended by the weight of jewels when the Buddha was still Prince Siddhartha. In addition, the body is surrounded by a halo. The monastic robe is worn high in a collar-like roll around the neck. The left hand grasps the hem of the robe, while the right hand appears to be performing *abhaya* mudra, the gesture of benediction. On the right side, between the aureole and the coin's beaded edge, is Kanishka's distinctive monogram. An inscription in Greek characters conclusively identifies the central figure as the Buddha.

 A full-length portrait of Kanishka pouring an offering on a fire altar appears on the coin's obverse side. This representation of the king contrasts dramatically with the Buddha image on the reverse: it is more stylized and primitive, but it affirms power and authority. Bearded, wearing a crown and holding a spear, the king stands with his feet splayed outward, in long baggy trousers and heavy soft boots. His long tunic flares to the knees and is gathered at the waist by a belt. This nomadic garb, rather similar to that of the modern gaucho, suggests a foreign origin, such as Parthia. The fire altar is of Persian origin, as are the small flames of regal identity on the king's shoulders. Fire worship was to remain central to the imperial Kushans even after Kanishka became a 'second Ashoka' in his patronage of Buddhism.

 The minuscule image on the coin might be compared with a later
48 stone figure at Lahore. The stone is a blue-grey schist flecked with mica, which is as distinctive a fabric of Gandharan sculpture as Chunar sandstone was of Mauryan creations. The figure is again clothed in a long, flowing, toga-like robe. He stands barefooted on a base carved with six small devotees worshipping a stupa. The generally static style and the illustrative base suggest a date later than the mid-second century A D,

84

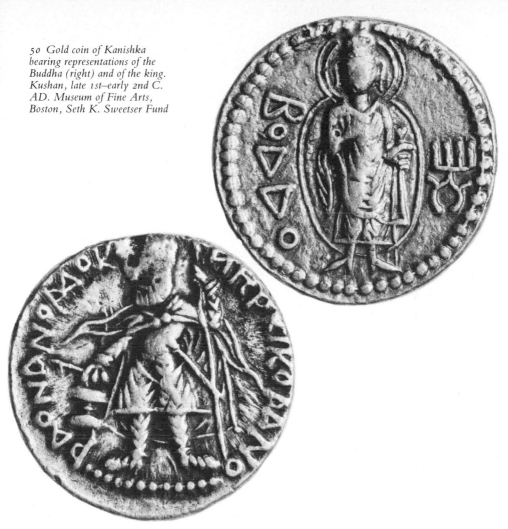

50 Gold coin of Kanishka bearing representations of the Buddha (right) and of the king. Kushan, late 1st–early 2nd C. AD. Museum of Fine Arts, Boston, Seth K. Sweetser Fund

but the chronology of Gandharan sculpture, like the dates of Kanishka, is still uncertain. The figure's left hand holds the hem of his robe, lower than on the coin. The right hand, which was carved separately and attached into a slot on the arm, is missing, but undoubtedly performed the gesture of abhaya mudra. An additional feature seen here is the dot or whorl of hair between the Buddha's eyebrows, representing a third eye of spiritual vision (*urna*).

The realism of the drapery and the body-enveloping robe is un-Indian in concept and execution, though the figure's stance and the flow

85

of the drapery are already more formalized than in earlier examples. Remembering Gandhara's position on the trade routes brings the realization that Gandharan sculpture, like the imperial Mauryan stonework, was an art which originated with alien craftsmen. This statue is an Indian product, possibly created by an itinerant provincial Roman sculptor, but it owes its origin to the repertory of a Graeco-Roman style.

When Hellenized stone-carvers from the West were commissioned by the Kushans to produce an icon for a changing Buddhist religion, they naturally drew directly upon their past experiences in providing standing portraits of nobility, fashioned after images of the emperor in Rome. It is known that Roman workshops, especially in Alexandria, maintained reserves of headless stone sculptures which were fitted with portrait heads only when the subjects were known. The Gandharan solution was merely one of practical adaptation and elaboration. First the Persian solar disc, as a halo of deification, was applied, then the unique identifying signs of the Buddha were added and last the hands were positioned into the various symbolic mudras. (A similar process led to the creation of the Christ icon in the West.)

Simultaneously with the appearance of the Buddha icon in Gandhara, Buddha 'portraits' based upon yaksha models began to be created in the southern workshops at Mathura. This fact has led to a scholarly debate which attempted to establish primacy for one or the other of these two centres. Since each of these two Kushan schools soon began influencing the other the exact moment of historical origin quickly became obscured, and the question remains unsettled.

The impact of the provincial Hellenized Roman art style and imagery in Gandhara was exceedingly strong, and sculptures from the area – for instance stone stair-risers displaying sea or river deities, carved in Gandhara during the last part of the first century AD – would not look too much out of place in Rome, or at least in one of the Roman provincial cities on the eastern limits of the empire.

Perhaps one of the loveliest Gandharan sculptures reflecting a Western subject is a figure of Athena or Roma at Lahore. Probably dating from the late second century, it is carved in fine-grained blue-grey schist and shows a young woman wearing a helmet and carrying a spear, now broken. The figure has also been identified as a city or river goddess, and as a foreign female bodyguard for an Indian king.

51

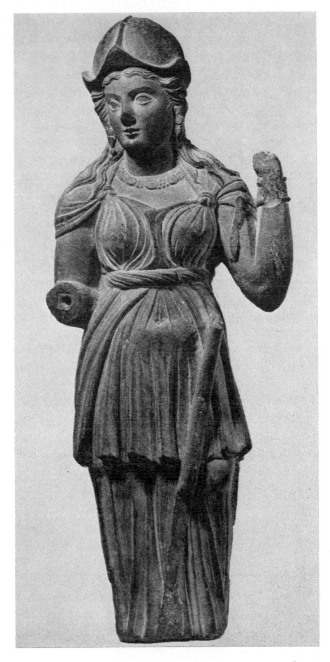

51 *Athena or Roma,
from Gandhara.
Kushan, late 2nd C.
AD. Schist, H. 32¾ in.
(83 cm). Central
Museum, Lahore*

52–54 A remarkably well-preserved schist relief in Washington depicts the four major events of the Buddha's life. Its excellent condition and craftsmanship and detailed iconography combine to make it a major example of Gandharan sculpture. Of particular interest, beyond the central events portrayed, is the immediate clarity of the individuals and their costumes, which brings the second century A D in Gandhara dramatically alive before the viewer's eyes. The four events, from left to right, are 1. the Buddha's birth in the Lumbini grove; 2. the assault of Mara's host on the Buddha under the Bodhi tree; 3. the first sermon in the Deer Park at Sarnath; and 4. the death of the Buddha.

52 Central to the birth scene is the figure of Queen Maya, who grasps a tree branch as a miniature haloed Buddha emerges from her side. Her familiar pose can be recognized as that of the yakshi figures on the gates at Sanchi and Bharhut, and it well illustrates how the primitive earth spirits continued to be woven into the fabric of evolving art forms. Equally interesting are the two figures to Queen Maya's right, who represent a Brahmanical presence at the holy miracle. The crowned figure receiving the sacred babe on a cloth is the god Indra, the worshipful holy man with matted hair Brahma. Their attendance and Queen Maya's

33, 34 shalabhanjika pose (see p. 64) seem to endow the reformed Buddhist church and its new god with the sanctions of ancient tradition.

 Two ladies attend the queen on the extreme right. One carries a round box and a fan made of peacock feathers, and a second holds a mirror. All three women are dressed as ladies of rank, and their costumes are especially intriguing in that they appear to reflect a cosmopolitan taste related to the trade routes. Similar attire was worn far to the west by contemporary noblewomen in Palmyra, and the distinctive rolled headpiece is duplicated on Palmyran grave stele portraits carved in the second to third centuries A D.

53 The next scene of the relief depicts the onslaught of Mara's demons who are attempting to drive the Buddha from beneath the Bodhi tree and from the ultimate enlightenment. Among the demonic hosts the sculptor has clearly recorded a variety of types and individuals from his own day undoubtedly as he saw them on the streets of Peshawar or Taxila. The soldiers with their broad swords and armour, the goitred porter carrying a drum, the camel, a horse – all writhe in an attempt to distract the Buddha from his cosmic mission. Below the Buddha's throne

52, 53 Sections of a frieze from Gandhara showing the birth of the Buddha (above) and the assault of Mara's host. Kushan, 2nd C. AD. Courtesy of the Smithsonian Institution, Freer Gallery of Art, Washington, D.C.

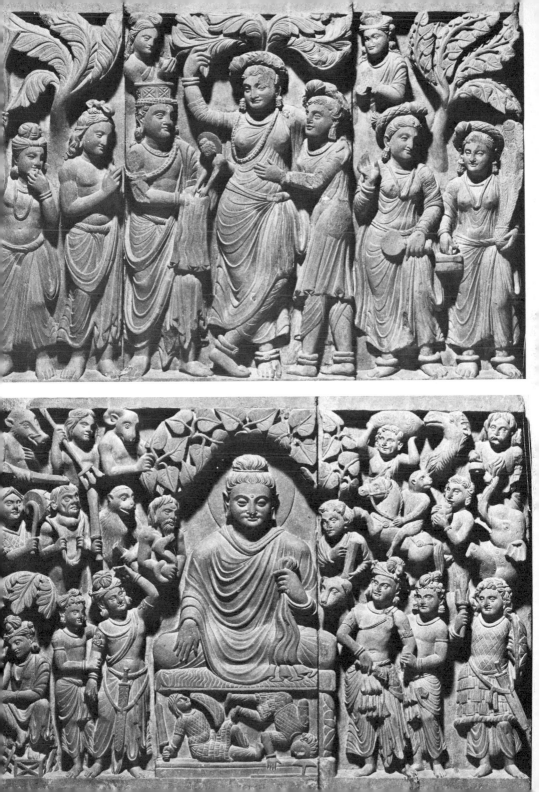

two warriors in armour fall stunned, symbolic of Mara's defeat, which is about to be accomplished when the Lord calls on the earth to witness his right to occupy the Bodhi seat of knowledge. The Buddha's right hand is in the act of reaching down and touching the earth to dismiss the tumultuous throng and restore solitude to his meditations. This hand position of touching the earth (*bhumi sparsha* mudra) is common in Buddhist art from this time forward.

54 The third tableau of the relief shows the Buddha blessing a group of monks and devotees. One can be confident that the scene is a representation of the first sermon because the Buddha's throne depicts the Wheel of the Law flanked by two deer. Of considerable interest in the scene is the moustached and bearded figure at the Buddha's right shoulder, who is identified as Vajrapani, or 'bearer of the thunderbolt'. He is a Bodhisattva (see below) and is the constant attendant of the Buddha in Gandharan art, where he is invariably shown carrying a large bone-shaped thunderbolt.

The last scene of the relief is incomplete, but the central motif of the Buddha's demise is intact. The Lord, as if sleeping, lies dying among lamenting monks and devotees. The diminutive figure stoically seated before the couch is generally interpreted as the Buddha's last convert, the monk Subhadra.

Thus the sculptors of Gandhara supplied the newly emerging faith with a Buddha icon. They also contributed significantly to the development of the Bodhisattva image, another feature of Mahayana Buddhism (see pp. 81, 172). The appearance of these saintly beings seems to have been related, as Rosenfield points out, to the yaksha cults which had been particularly strong in the Gandharan area before the advent of Buddhism. A Bodhisattva is a 'Buddha-to-be', a being capable of enlightenment, who in compassion for mankind delays his entry into the state of Buddhahood in order to minister to others striving for that goal. Before

67 meditating under the Bodhi tree and attaining enlightenment, Siddhartha himself was a Bodhisattva.

55 Such a holy being is seen in the handsome standing figure in St Petersburg, Florida. Unlike the Buddha, who has rejected the world, the Bodhisattva is here embellished with symbols of worldly involvement: long and dressed hair, moustache, elaborate jewellery, sandals on his feet, and rich non-monastic clothing.

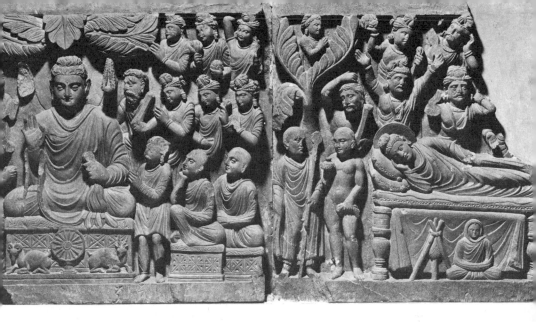

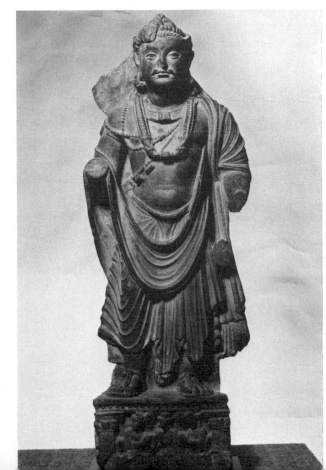

54 *Detail of a frieze from Gandhara showing the first sermon in the Deer Park and the death of the Buddha (see ills. 52, 53)*

55 *Bodhisattva from Gandhara. Kushan, c. AD 150–200. Schist, H. 22 in. (56 cm). Museum of Fine Arts, St Petersburg, Fla.*

52 Just as the elegant ladies at the birth of the Buddha were dressed as Kushan nobility, this figure portrays a Kushan prince in all his finery. His damaged halo marks him, however, as a spiritual prince and not a temporal one. The right hand, which was separately carved, is missing: it must have performed the abhaya mudra of benediction. The left hand and the object it held have also been broken off. The nature of these fractures suggests that the figure originally held a globular vial containing

68 the elixir of immortality which is the symbol of the Bodhisattva Maitreya, or the 'Buddha of the Future'. The realistic treatment of the body, the draped cloth, and the illustrative base suggest the figure should be dated in the second half of the second century AD. Obviously such Bodhisattva figures affirm the strength of the merchant lay community, who were more attracted by worldly goods and display than by the austere and humble occupations of monastic life.

The great abundance of Gandharan sculpture is solid testimony of the proliferation of religious buildings under the Kushans. This industry might be explained by a number of factors, but foremost among them are the wealth of the Kushans and Kanishka's royal patronage of the changing Buddhist faith. As Gandhara grew, its importance as a religious region was enhanced by being associated, apocryphally, with events and miracles of the Buddha's previous lives. Monks from the Doab, the actual homeland of Buddha, were attracted north to the cooler centres in Gandhara where they lived comparatively sedentary lives and required more substantial and permanent monasteries. The monasteries and their stupas provided endless galleries for rows of sculptured reliefs and standing figures of Buddhas and Bodhisattvas. The sculptures were invariably stuccoed and painted, and would originally have appeared much more vivid than they do today.

56 A large Gandharan stupa and monastery survive as ruins at Guldara in Afghanistan. The remains of pilasters on the stupa's ground floor and the collar of arches around its drum still convey, even in ruin, a mood of complex opulence. When new, fully decorated with tiers of painted sculptures, such a monument must indeed have been as magnificent as the early Chinese pilgrims reported. We can gain a better idea of its

57 original appearance by comparing it with a small stone sculpture from the Swat valley which suggests how a stupa complete with its sculptural decoration would have looked. The miniature also helps us to understand

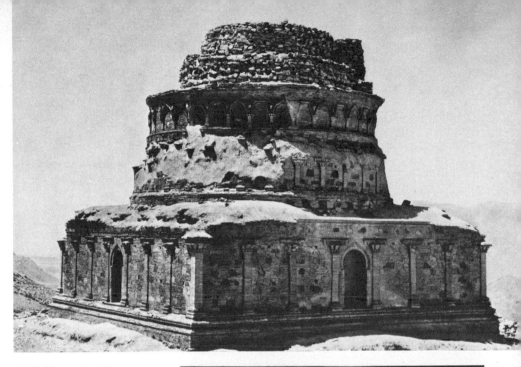

56 Guldara, ruins of a
Gandharan stupa

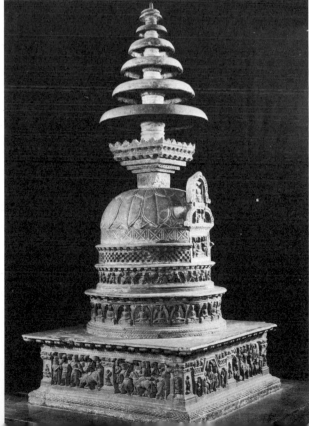

57 Votive stupa from Loriyan
Tangai, Swat valley, Gandhara.
Kushan. Schist, H. 4 ft 9 in.
(1.45 m). Indian Museum,
Calcutta

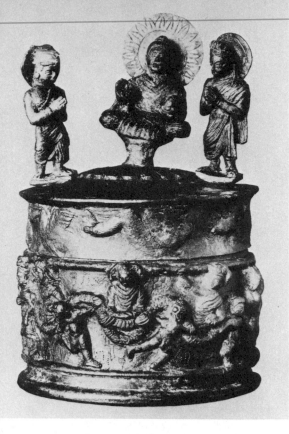

58 'Reliquary of Kanishka' from
Shah-ji-ki-Dheri, Gandhara. Late
Kushan. Bronze, H. 7¾ in. (19.5 cm).
Peshawar Museum

the tremendous production of the Gandharan ateliers and to realize the great human effort that would have been required to produce all the sculpture needed for a comparable full-sized stupa.

Of equal interest is the evolution of the stupa form in Gandhara, and its departure from the type of the lower, hemispherical, domed structure *37* represented by the Great Stupa at Sanchi. The dome grew taller, and the square railing at its summit was enlarged and elaborated. The most dramatic change, however, is to be seen in the flowering of the tiered umbrella unit, which grew until it towered over the entire structure.

The greatest of all Gandharan stupas was that erected by Kanishka at Shah-ji-ki-Dheri, just outside the gates of modern Peshawar. Rising from a plinth whose diameter was nearly 300 feet, it reached a height of over 700 feet and was crowned with a tower of thirteen gilded umbrellas. Nothing remains today except a few foundation stones, but from the *58* original excavation in 1908 a famous bronze reliquary was recovered.

This remarkable cylindrical box, known as the Reliquary of Kanishka, is about 5 inches in diameter and 4 inches high; the three figures on the lid bring the total height to almost 8 inches. An amalgamation of various art styles, the reliquary illustrates the cosmopolitan nature of Kushan culture. It is punched with a dotted Kharoshthi inscription, but this obscures rather than clarifies the identity of its donor and its period. It was first thought to be a reliquary of the great Kanishka himself, installed at the time of the stupa's dedication; but it was found not in the heart of the stupa but to one side, indicating that it was perhaps inserted during one of the numerous restorations carried out in later Kushan times. Since the Great Stupa was associated with a monastery and surrounded by hundreds of other smaller stupas, a later origin seems plausible.

The three figures on the lid of the reliquary represent the seated Buddha flanked by standing figures of Indra and Brahma. The side of the lid, which fits over the box, is decorated with flying geese, which in Buddhism are symbolic of the wandering monks who carry the word of Dharma to distant shores. During the Kushan period geese were also dynastic emblems. (The goose as a symbol is discussed in detail by J. P. Vogel.)

The relief on the face of the lower part of the casket depicts an almost Hellenistic scene with *putti* supporting a serpentine garland on which are seated Buddhas, anthropomorphic sun and moon figures, and a standing Kushan king. The king's costume of heavy boots and long tunic contrasts markedly with the other figures; it is the royal dress already encountered on Kanishka's coins. He is flanked by figures of the sun and moon, which definitely indicate Iranian influence. The seated Buddhas wear a high-necked sanghati with a distinctive 'apron' flap over the crossed legs, a style duplicated on the three-dimensional Buddha on the lid. The apron flap, the rounded facial features, and the arrangements of the hair and ushnishas are closely related to early Gandharan stone reliefs which appear to be contemporary with Kanishka. So are the two standing deities. A small metal disc rimmed with pointed lotus petals was found near the casket and has been interpreted as either a halo or an umbrella. The disc does indeed resemble a nimbus found on several stone Bodhisattvas from Gandhara. Despite its yet unresolved date and its unremarkable craftsmanship, the reliquary remains iconographically one of the most intriguing objects to emerge from Gandhara.

50

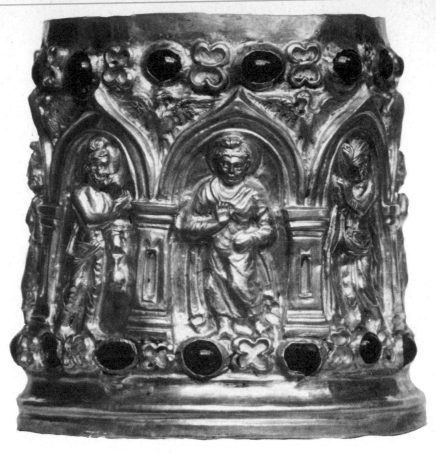

59 In striking contrast is an elegant gold repoussé reliquary from Bimaran in Afghanistan. Here a series of figures are contained within an arcade, a Western motif directly adapted from Roman sarcophagi of the first and second centuries A D. Spread-winged eagles fill the triangular spaces between the arches, which have the shape of chaitya windows. Inset rubies alternate with small rosette shapes at the top and bottom. The reliquary provides strong documentation for the origin of the rows of *56, 57* arches on the stupa drums and monastery walls of Gandhara, which provided settings for sculpture. Seen in a museum, far from its place of origin, it might immediately be taken to be a precious object from the European Middle Ages.

96

These few select objects from Gandhara can only begin to hint at the scope and vitality of the Buddhist church during Kushan times. This high point of activity was a powerful stimulus for propagating the faith beyond Gandhara, and just as Indian monks journeyed to alien shores, foreign devotees were attracted to the 'golden holy land'. The Chinese monks came in great numbers, and to several of them we owe a great debt for their chronicles documenting the early Buddhist periods of Indian history.

By the middle of the third century East–West trade had been seriously interrupted. The Sassanians had overthrown the Parthians in Persia, and then had conquered Peshawar and Taxila, weakening Kushan power. Religious activities were, however, not noticeably disturbed, and Buddhism continued to flourish in Gandhara and beyond. The real disaster came at the end of the fifth century, when the so-called White Huns or Hephthalites from northern Central Asia descended through the mountain passes and ravaged Gandhara. Even then a second school of 'Gandharan' art lingered on in Afghanistan and Kashmir, to produce some of the most provocatively beautiful works associated with the style.

The extreme north-west area of Gandhara extended through the mountain passes and into the valleys of what is now Afghanistan. In this peripheral zone Gandharan-style religion and art continued at least into the eighth century. It was here, also, on the caravan route joining Taxila with Bactria, that one of Buddhism's greatest monastic centres flourished – in the narrow jade-green valley of Bamiyan, hemmed in by towering rock cliffs below the high snows of the Hindu Kush. The monks honeycombed the valley's walls with sacred grottoes, lavishly decorated with stucco sculpture and paintings which show a mixture of *60* provincial styles from both India and Iran.

The grottoes of Bamiyan are remarkable for a number of reasons. The paintings include motifs adapted from Sassanian fabric designs, and what may be the earliest depiction of *Vajrayana* (the esoteric and magical 'Thunderbolt Vehicle' or 'Diamond Vehicle') or Tantric Buddhist concepts (see pp. 171–2).

The most spectacular creations carved from the cliffs at Bamiyan are three colossal standing figures of the Buddha. The largest of these rises majestically to 175 feet in its stone niche at the western end of the valley. *61*

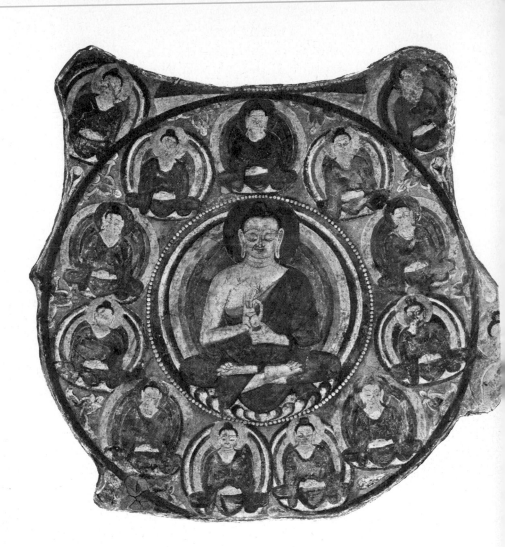

60 *Mandala painting from the dome of a cave-shrine at Bamiyan, Afghanistan, showing the Buddha surrounded by Bodhisattvas. Kushano–Sassanid, 5th–6th C. Paint on clay, D. 36¼ in. (92 cm). Kabul Museum*

61 *(opposite) Bamiyan, Afghanistan, colossal rock-cut Buddha. Gupta style, early 5th C. H. 175 ft (53 m)*

Rough-hewn from the rock and finished with lime plaster, the image reflects the Gupta style of the early fifth century. Its details include string-like folds in the sanghati, based upon ropes pegged into the stone and covered with plaster and paint. Above the figure's head, in a trefoil niche, are fragments of painting related to those created in India by Gupta Buddhists at Ajanta.

The second largest image, 120 feet high, closely resembles the Gandharan Buddha figures of the early second century, though it may actually date from a later period. The soffit of its niche also retains a significant fragment of painting depicting the chariot of the Hindu Sun God, Surya, which may indicate not only the solar aspect of the Buddha carved here but also his supreme cosmic nature. In fact, the framing of the colossal central figure between painted celestial beings above and rows of meditating Buddhas below creates a mandala which elevates the Buddha above the status of a mere mortal teacher and strongly suggests, as Rowland notes, the concept of the universal Buddha, characteristic of the esoteric sects of Buddhism.

After the eighth century the grottoes were empty and the valley quiet. Later, with the advent of Islam in Central Asia, these huge icons, offensive to Muslim eyes, became targets, first for Mongol arrows and later for Mughal cannon. Even so, their colossal ruins have survived as mute testimony to the energy and creativity of the early Buddhist church in Afghanistan.

Probably because North India and Afghanistan had maintained trade contacts with Alexandria, where gypsum was widely used in sculpture as a substitute for costly marble, plaster had been used in all periods of Gandharan art, both independently and in association with stone sculpture. Many of the surviving examples of plaster sculpture were found in Afghanistan. The Afghan heads are especially notable for their fluid spontaneity and sensitive interpretation of reality. The prolific use of stucco for architectural ornament in Afghanistan may however have been due to strong Sassanian influence, from the mid-third century to the advent of the White Huns at the end of the fifth century.

Hadda in Afghanistan, at the western end of the Khyber Pass, was the site of the ancient sanctuary which held the relic of the Buddha's skull, and was noted for its beautiful stucco sculptures. Farther west, at Fondukistan, there was a monastery complex elaborately decorated

62 Bodhisattva from Fondukistan (detail). Late Gandhara style, probably 7th C. Painted terracotta, H. of seated figure 28¾ in. (72 cm). Musée Guimet, Paris

with brightly painted niches containing assemblies of terracotta figures *62* whose poses and graceful hand gestures constitute a 'mannerist' style of exaggerated elegance. Similar works were created in the sixth or seventh centuries far to the east in the mountains of Kashmir, at Ushkur (described by Charles Fabri), and the style moved to China along the trade routes to reach an artistic climax at the great oasis of Tun-Huang.

In Afghanistan late in the first century Kanishka had a remarkable shrine erected at Surkh Kotal. It is of immense interest because it has a parallel in another Kushan shrine 2,000 miles to the south, on the plains at Mathura.

At Surkh Kotal a complete hill has been transformed into a giant fire altar. Five terraces display a number of shrines, which include the fire altar, a fire temple, a temple of Ahura Mazda in Parthian style, and, particularly interesting, dynastic cult images of the Kushan rulers in the guise of or in association with Mithraic deities. Such a dynastic sanctuary, joined with the fire worship, shows a strong Parthian influence which undoubtedly grew out of the early Kushan experience when they, as the Yueh-Chi, confronted Persian civilization in Bactria in the first century BC. A parallel example of a regal shrine is the Commagene memorial of Antiochus I, far to the west in Anatolia, at Nimrud Dagh, where in the first century BC Antiochus had colossal images of himself and his gods carved and assembled on the top of a mountain.

Surkh Kotal, according to several variously interpreted Greek inscriptions found on the site, appears to have been founded during the reign of Kanishka, and repaired and extended at the time of Huvishka in the late second century. It cannot be determined exactly when the royal portrait statues, now badly mutilated, were first installed. Their fragments, carved from a yellowish limestone, show that they were conceived with a strong frontality and are related to the splay-footed pose of the statue of Kanishka at Mathura and the portrait figures on Kushan coins. In any case this distinctive dynastic style is autonomous, more strongly linked to Parthian portrait sculpture than to Gandharan or Mathuran iconography.

65
50

Mathura, 85 miles south of Delhi on the Jumna river, was a religious centre before the arrival of the Kushans. The Jains appeared early, and their activity continued alongside that of the Buddhists in the Kushan and Gupta periods. Later Mathura was also to be intimately associated with the Lord Krishna of the Hindus. Some scholars believe that the Mathuran workshops, schooled in the production of Jain art, created a Buddha icon at least as early as did Gandhara (see pp. 84–6). Certainly in Kushan times contact between the two centres resulted in the exchange and adaptation of iconographic subtleties.

The ruined site of Mat, a Kushan dynastic shrine near Mathura, is a southern parallel to Surkh Kotal. Here at Mat – or Tokri Tila as it is called by the local villagers, who have through the centuries robbed it of building materials – stood a sanctuary consisting of stone figures of Kushan rulers and deities on a brick-paved plinth. The plinth, originally

100 by 59 feet, held a circular sanctum towards its north-west end which echoes the design of Mauryan rock-cut shrines in the Barabar Hills. Nothing remains today but a sunlit wasteland of tangled underbrush and the sounds of crickets, but the mutilated sculptures retrieved there provide the Mathura Museum with some of its prize possessions. Like others originating at Mathura, they are carved from Sikri sandstone, which is red mottled with cream spots, and is unique to the area.

Mat's two most intriguing pieces are fragmentary portraits of an enthroned King Vima Kadphises and a standing King Kanishka. The *63, 65* huge Vima Kadphises (even now 6 feet 10 inches high) is headless, shattered across the knees, and completely fractured through the waist. Vividly intact, however, is the regal presence, which is emphasized by an impatient left arm angled to the waist and a right arm posed to the upper chest. The high, heavy boots and long tunic unmistakably mark the figure as Kushan. Such details as the alert lions flanking the throne and the elevated foot-rest contribute to the image's royal authority.

63 Enthroned figure of King Vima Kadphises from the dynastic shrine of Mat (Tokri Tila), Mathura. Kushan, late 1st–early 2nd C. AD. Red Sikri sandstone, H. 6 ft 10 in. (2.08 m). Archaeological Museum, Mathura

The distinctive red sandstone has been carved with a direct simplicity that imbues the figure with a primitive vigour which is the constant characteristic of Mathuran sculpture. One feels, however, that the artist has created, or perhaps copied, an unfamiliar icon: this is most obvious in the treatment of the heavy clothing, seemingly alien to a sculptor raised under the warm Indian sun.

65 These stylistic characteristics are also present in the towering and also headless figure of Kanishka. The King's arms are lost but the broken hands remain positioned on the waist, aggressively holding a sword and massive club. The long coat falls stiffly from the waist and spreads almost to the ankles. There thickly padded boots emerge, splayed outward, on a plinth upon which rests Kanishka's heavy club, ending in a makara (p. 65). The rippling folds across the front of the inner tunic are a completely stylized motif which reveals that the sculptor misunderstood the problem; or perhaps the solution was not included in his carving repertoire. Across the lower area, composed of the tunic and coat flaps, is carved a Kharoshthi inscription reading 'the great King, the King of Kings, the Son of God, Kanishka'.

Many other regal Kushan figures are known to have originated in and around Mathura. A second Kushan dynastic shrine, Gokarneshvara, on the northern limits of the city, has yielded sculptures that include a beautiful torso of a Kushan prince. Another site, Kankali Tila, which has been identified as the location of a great Jain stupa during Kushan times, was the source of a number of inscriptions as well as of an important

64 image of a squatting figure in buff sandstone. The sculpture shows a moustached figure dressed in Scythian costume which includes a long tunic and a rolled head-dress. He grasps a short sword attached to his belt and holds a small baton-like object (lotus bud?) against his right shoulder. A heavy necklace and high boots complete his costume, and he has a *tika* dot on his forehead. The figure was formerly considered to be a portrait of a Kushan prince, but Rosenfield has now identified it as an extremely early votive icon of a Brahmanic deity with Vedic origins, the Sun God Surya. There is indeed a small fire altar, carved in shallow relief on the plinth of the sculpture, and the flanking figures of horses are associated with the god's celestial chariot. The figure originally had a halo, which is now damaged. Considering the importance of fire and of the Mithraic ritual at Surkh Kotal, the depiction of a solar deity in

64 *(right) Squatting figure of Surya from Kankali Tila, Mathura. Kushan, late 1st–early 2nd C. AD. Buff Sikri sandstone, H. 24 in. (61 cm). Archaeological Museum, Mathura*

65 *Standing figure of King Kanishka from the dynastic shrine of Mat (Tokri Tila), Mathura. Kushan, late 1st–early 2nd C. AD. Sikri sandstone, H. 5 ft 7½ in. (1.70 m). Archaeological Museum, Mathura*

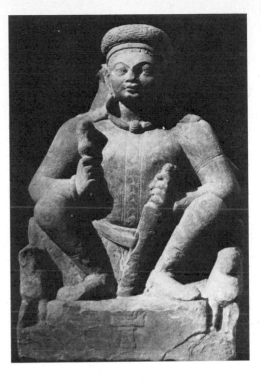

the guise of a Kushan prince can hardly be doubted. Indeed, it seems that a duality was deliberately intended. The message is clear: a solar deity is a Kushan prince, and a Kushan prince is the same as a deity. It is interesting to note that the later Hindu *Puranas* describe Surya as being dressed like a 'northerner' and explain his strange un-Indian boots by a myth which blames their presence on the malpractice of Vishvakarma, the Hindu artificer of the gods, who did not finish making the god's legs.

66 Buddhist sculpture of the Kushan period from Mathura includes many standing yakshi figures, such as we have already encountered on railings and gates of early Shunga and Andhra monuments. At first glance these second-century yakshis appear to match those at Bharhut. On closer observation, however, they seem more vivacious and Amazonian in nature, and their smooth, inflated voluptuousness gives them buoyancy and life. They seem about to spring from the backs of their supporting dwarfs and away from the vertical stone railing posts which back them. They, too, have the monumental frontality which is characteristic of Mathuran sculpture.

Nagas (anthropomorphic serpent figures) and yakshas abound at Mathura, and they too assert their ancient ancestry and their direct descent from Shunga originals. Now, however, the yaksha figure was to be transformed to serve Buddhism as the Bodhisattva icon, and the great number of them found at Mathura suggests a local cult.

68 A particularly clear example of the transformation of a fertility spirit into a compassionate Buddhist saviour is a mid-second-century statue which is perhaps the earliest known representation of the Bodhisattva Maitreya. The figure is still basically a yaksha, but a number of specific details have been added that cast it in the role of a Bodhisattva. Immediately noticeable is the typical large nimbus with its sun rays, stylized into a continuing scallop motif around the edge. The right hand is held in the abhaya mudra of benediction, while the left holds the water-flask symbolic of the Buddha of the Future. A disc symbolic of Dharma appears on the palm of the right hand. The halo and stylized curls show how Gandharan features were transferred south to Central India. Completely frontal, the tense body and the expressive face again combine to convey a sense of suspended action which is recognized as one of the virtues of Mathuran sculpture.

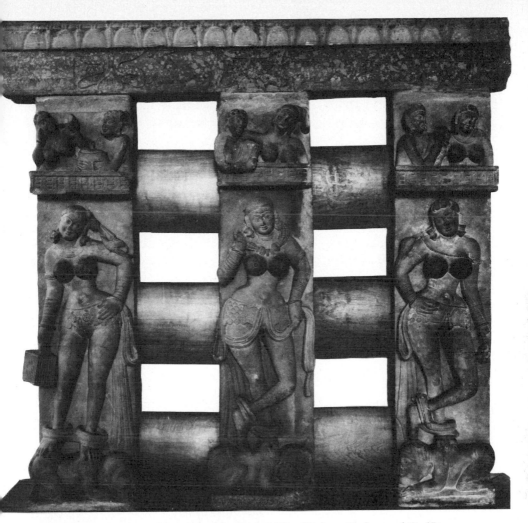

66 *Railing pillars with standing yakshis from Kankali Tila, Mathura. Kushan, 2nd C. AD. Sikri sandstone, H 4 ft 2¾ in. (1.29 m). Indian Museum, Calcutta*

Another related example of a Mathuran Bodhisattva from Sarnath is inscribed as having been dedicated by one Friar Bala in the third year of King Kanishka's reign. The stance is the same as in the image of Maitreya; here, however, a lion stands between the feet and indicates that the figure is Shakyamuni, 'the lion of the Shakya clan', who preached his first sermon ('the lion's roar') at Sarnath. Fragments of a ten-foot stone umbrella, which originally surmounted the saint, have also been

67

found, and they bear various ancient Indian symbols which, together with the royal and solar symbolism, proclaim the Bodhisattva as a Universal Lord. This mutilated image is interesting not only for its size (8 feet 1½ inches high) and iconography, but also for the fact that it was found at Sarnath. It is known that images from Mathuran workshops were exported throughout the Doab, but at holy Sarnath a special artistic tie with Mathura was established during the Kushan period, and was to continue on into Gupta times. Mathuran icons were imported to Sarnath; and the Mathuran styles were copied in the local cream-coloured Chunar sandstone.

69 With a seated figure of the Buddha of the mid-second century we come to what must be considered the masterpiece of Kushan sculpture at Mathura. Carved from the local red sandstone, the figure is seated on a lion throne and carries an inscription which erroneously identifies it as a Bodhisattva. It was found in the Katra mound at Mathura and is an excellent early example of an entirely Indian Buddha. Unlike
48 the majority of static Roman-influenced Buddhas of Gandhara, wrapped in their toga-like sanghatis, this Buddha of a warmer clime is dressed as a true Indian, in a transparent muslin garment that covers only one

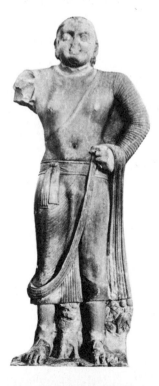
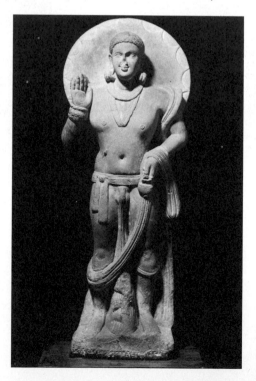

67 (opposite, left) Figure of the
Bodhisattva Shakyamuni from
Mathura, presented to the shrine at
Sarnath by Friar Bala. Kushan,
AD 131 or 147. Sikri sandstone,
H. 8 ft 1¼ in. (2.47 m).
Archaeological Museum, Sarnath

68 (opposite, right) The Bodhisattva
Maitreya, from Mathura. Kushan,
2nd–3rd C. AD. Sikri sandstone.
Archaeological Museum, Mathura

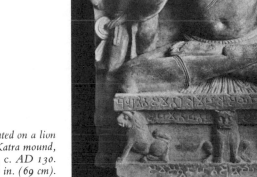

69 The Buddha seated on a lion
throne, from the Katra mound,
Mathura. Kushan, c. AD 130.
Sikri sandstone, H. 27¼ in. (69 cm).
Archaeological Museum, Mathura

shoulder and gathers in small ringed folds along the upper left arm. This
rendering of gathered, transparent textiles, which was also apparent on
the two Bodhisattva figures, is a distinctive Mathuran feature.

Seated as a yogi, on a lion throne under the Bodhi tree, the Buddha is
backed by a large scalloped halo and attended by heavenly beings and
fly-whisk-bearers. His aggressively performed abhaya mudra and the
alert angled arm, resting on his left knee, lend an air of activity to a
creation which has no parallel in Gandharan art. Wheels symbolic of
Dharma are displayed on the right palm and on the two exposed feet. Of
particular interest is the primitive form of the ushnisha, or cranial
protuberance, which has not yet been modified by Gandharan influence
and protrudes as a single massed whorl of hair.

The third century was to be a time of great upheavals in Central
India, which would result in the fall of the Andhras in the Deccan and
a drastic weakening of the Kushans. The Kushan art style at Mathura,
however, survived, and its qualities ultimately led to the supreme
development of the Buddha icon in the Gupta period.

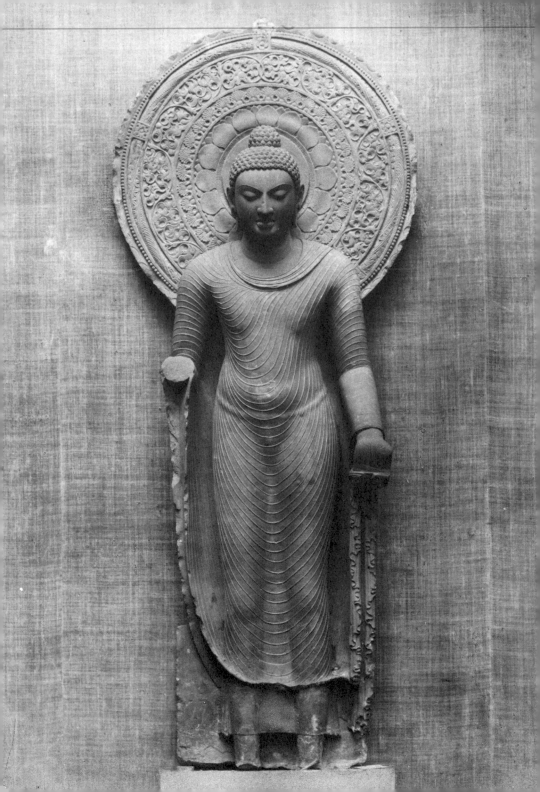

The Gupta and Post-Gupta periods

About AD 320 a powerful new empire, the Gupta, emerged in Bihar. Arising from obscure and possibly non-royal origins, the Guptas eventually dominated all of North Central India and gave their name to 71 the 'Classic' period of Indian art. Consciously emulating the ancient Mauryan empire, they established their capital at Pataliputra, where they grew in power and importance until they, along with the remnants of Kushan culture, were finally crushed by the invasion of the White Huns in the last years of the fifth century. The Gupta period, while it lasted, was one of cultured opulence resulting in an outpouring of science, visual art, music, and literature. The zenith was reached during the reign of Chandra Gupta II (AD 375–415) and its jewel was the great Sanskrit writer Kalidasa. It was also during this period that some of India's earliest surviving examples of painting were created, on the walls of the Buddhist caves at Ajanta in the Deccan.

The justly renowned Gupta sculptural style appears to have grown out of the Kushan style, which survived at Mathura (see pp. 108–9). By the end of the fourth century or the beginning of the fifth a distinctive icon had been created, and it is well represented by a red sandstone figure of a standing Buddha with an immense, decorated halo, now in 70 New Delhi. Many refinements are apparent here, but especially important are the monumental simplicity and the refined realism of the figure. The tension which activated earlier Mathuran sculptures has now given way to a mood of calm and inner tranquillity, a spiritual other worldliness which is the hallmark of the Gupta Buddhist style. The sanghati clings so close to the body that it all but disappears and is defined only by a series of string-like folds. The sole remnant of Kushan animation is perhaps the subtle cascade of folds dropping from the figure's left hand. The missing right hand undoubtedly performed the

III

70 Standing Buddha from Mathura. Gupta, late 4th–early 5th C. Red sandstone, H. 7 ft 1⅜ in. (2.17 m). National Museum, New Delhi

serene abhaya mudra of reassurance. The head and ushnisha are now completely covered with the snail-curl motif, and the heavy eyelids direct the subject's energies inward, away from the mundane world. In contrast to the stylized simplicity of the figure, a huge nimbus envelops the head with a complex riot of patterns. A circle of lotus petals forms the immediate backdrop for the head, and the petals are ringed by a row of palmette motifs recalling decorations found on the Mauryan

16 capitals of Ashoka. Beyond is a wide band of lotus buds and foliage along with a narrow twisted ring of jewels (?), carved next to the outer rim which is patterned with flattened scallops. This last simple motif, seen

68 on earlier Mathuran haloes, is here in the process of being expelled completely from the solar disc.

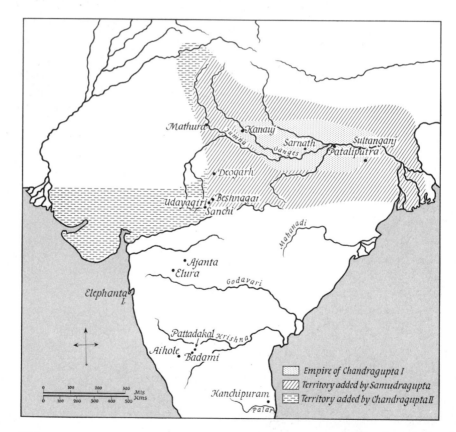

71 *The Gupta empire*

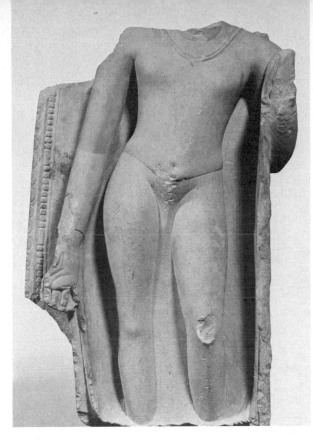

72 Torso of a standing Buddha from Sarnath. Gupta, probably 5th C. Chunar sandstone, H. 30 in. (76 cm). The Cleveland Museum of Art, Purchase from the J. H. Wade Fund

The Mathura–Gupta style was refined and perfected at Sarnath, where a great concentration of Buddhist sculptures has been unearthed. One unique group is known as the 'wet Buddhas', because the figures look as if they had been immersed in water. The Mathuran string fold motif is omitted, and the sheer muslin sanghati appears to cling to the body and reveal its basic forms. The headless 'wet Buddha' now at Cleveland displays a webbing between the fingers which is another distinguishing characteristic of Gupta sculpture. 72

The sublime example of Gupta sculpture created at Sarnath is a fifth-century figure of the seated Buddha preaching the Law, carved of Chunar sandstone. It typifies the essence of Gupta art, where a sophisticated balance was achieved between refined simplicity and the Indian love of decoration. This image affected all subsequent schools of Buddhist art within and beyond India, and also had a significant and lasting effect on Brahmanical art. 73

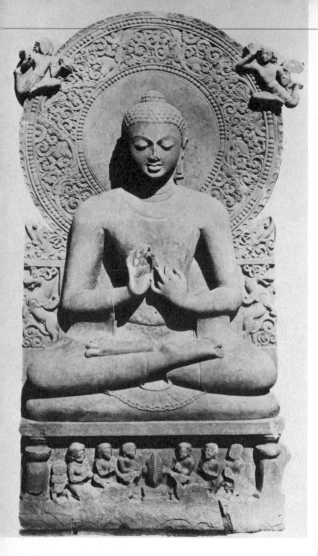

73 *The Buddha preaching the Law,
from Sarnath. Gupta, 5th C. Chunar
sandstone, H. 5 ft 3 in. (1.60 m).
Archaeological Museum, Sarnath*

74 *Standing Buddha from
Sultanganj, Bihar. Gupta, c. 500.
Copper, H. 7 ft 6 in. (2.25 m).
City Museum and Art Gallery,
Birmingham*

Backed by a huge decorated halo, the Buddha is seated as a yogi on a 73
throne and performs the Dharma Chakra mudra. His sanghati is only
subtly indicated by the hemlines at the neck, wrists, and ankles. Across
the central front edge of the cushion a mass of folds splays outward as a
lunette design, echoing the textures on the halo above. Two heavenly
beings fly in at the top of the halo, celebrating the miracle of the first
sermon at Sarnath, while on the throne's plinth six devotees pay homage
to a central wheel which is flanked by two deer, indicating that the
setting is the Deer Park. At the Buddha's sides two rampant leogryphs
define the back of the throne and symbolize, as they did on the lion
capital of Ashoka, the regal roar and authority of the Buddha's message. 16

Gupta art was produced in great quantities in a wide area across North
Central India. However, from the end of the fifth century on, at first
under the onslaught of the Huns, and later with the advent of Islam,
many of the products of Gupta art, both Buddhist and Hindu, were
destroyed. Today, happily, lost items of Gupta art continue to be un-
covered, and these recoveries expand our knowledge of the period's
rich diversity.

A remarkable piece of Gupta metal-casting, found at the end of the 74
last century at Sultanganj in Bihar, is a Buddha nearly 8 feet high, now
in Birmingham. Modelled closely on the Sarnath Buddhas, it is com-
pletely intact except for the lack of a nimbus. The sanghati folds are
concentrated at the extreme edges of the garment, except for a series of
widely spaced, stylized lines which are inscribed across the torso, arms,
and legs of the almost wet-looking figure. These elements, as well as
the slightly heavy features of the face, may indicate a date late in the
fifth or in the early sixth century.

Another metal figure of the Buddha, this time smaller and in bronze, 75
is in Kansas City. Its halo is dramatically large and drawn into rays that
terminate in small round balls. The figure was found in Uttar Pradesh,
but the fuller, more realistic folds of the sanghati suggest a connection
with bronzes from Gandhara.

A group of small ivory images of Buddhas and Bodhisattvas, believed
to have come from the Kashmir area, where they had survived in
mountain monasteries, are prime examples of late Gupta art from about
the eighth century. A sculpture now in Bombay depicts a Buddha
seated in a characteristic Kashmiri trefoil arch and surrounded by various

attending figures. The hands are held in the *dhyana* mudra of meditation and the sanghati covering the whole body gathers into a collar fold at the neck. This feature connects it with earlier Gandharan work and also anticipates later Nepalese icons.

Thus far we have concentrated on the religious and artistic developments of Buddhism; but at the same time Vedic Brahmanism had also been evolving its various icons. Now in the Gupta period Hindu art at last emerged into prominence, as Dharma began to wane in the country of its birth.

We have seen that during the Kushan period sculptures of Hindu subjects – notably of the Sun God Surya and of Vishnu, strongly associated in the Vedic tradition with the sun – were already being produced at Mathura and elsewhere (p. 104). During the Gupta period we find a major group of Brahmanical sculptures dealing with the various aspects of Vishnu.

The first and most dramatic examples of Gupta Hindu art date from AD 401–2 and are in the rock-cut shrine at Udayagiri, near Bhopal in Central India, dedicated in the reign of Chandra Gupta II. The relief to

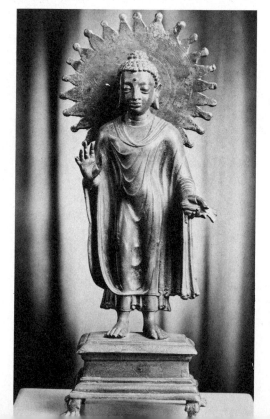

76, 77 (opposite) Udayagiri, Chandra Gupta II cave. Gupta, 401–2. Left: Vishnu as the Cosmic Boar, H. 12 ft 8 in. (3.86 m). Right: standing figure of Vishnu with personifications of his attributes

75 Standing Buddha from Banda District, Uttar Pradesh. Gupta, c. 400. Bronze, H. 14¾ in. (37 cm). Nelson Gallery-Atkins Museum, Kansas City, Mo. (Nelson Fund)

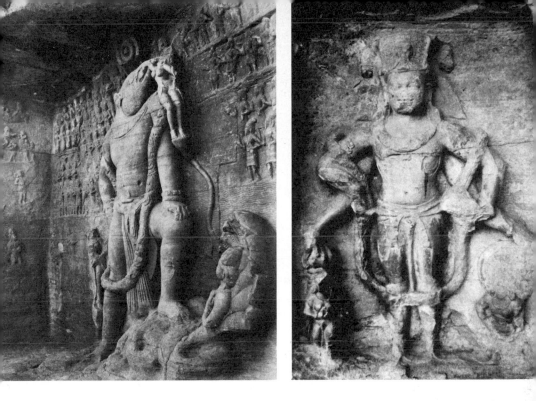

the left of the centre, carved in the living rock, is over 12 feet high. It 76
features the incarnation of Vishnu as the Cosmic Boar, Varaha, which is
his third descent (*avatara*) or manifestation as a cosmic saviour. According
to Brahmanical mythology, the creation resulted from a churning of the
milk-sea ocean (eternity) by the gods and the demons who were attempt-
ing to acquire the elixir of immortality. As the eternal sea was churned,
various auspicious objects appeared. Among these was the earth,
symbolized by a beautiful goddess. She was immediately drawn down
into the sea by the serpent power in the depths. Vishnu instantly assumed
his aspect as Varaha, rescued the goddess, and crushed the coils of the
multi-hooded serpent king under his foot. The Udayagiri relief shows
the climax when Vishnu, as a garlanded boar-headed giant, gently lifts
the goddess up to an awaiting assembly of gods and sages.

To the right of this relief is an entrance to a shrine carved more deeply
into the solid rock. Its door is flanked by two reliefs of guardian figures,
and beyond are several other relief panels. Next to the guardian on the
right is a figure of Vishnu standing in an alert frontal pose. The god 77

wears a *dhoti* (a male skirt or loin-cloth) and a jewelled crown, and his four braceleted arms hold a large garland which encircles his figure from shoulders to knees. A shrivasta jewel, the identifying symbol of Vishnu, hangs from a large heavy necklace at the centre of his chest. The upper right hand is mutilated, but it probably performed the boon-dispensing gesture (*varada* mudra). The upper left hand, also damaged, appears to hold the remnants of a conch shell to the figure's waist, an iconographic

68 gesture inherited from Kushan sculpture. One of the most interesting aspects of the sculpture, however, is the anthropomorphic representation of Vishnu's two lower attributes or symbols. His lower right arm grasps the head of a vertical mace fronted by its small female personification, and the lower left hand touches the upper rim of the disc or wheel, whose male symbol stands before it. This Gupta icon has not yet developed very far beyond the style of its Kushan model, but the outstretched arms and personified attributes hint at a new style and symbolism

121, 131 which were to develop during future centuries (see pp. 174–6).

Another combination of tradition and innovation occurs at Udayagiri in the female figures that flank the upper lintel of the doorway. They are developments of the yakshi, now transformed from tree spirit into river deity. The transformation can be more clearly seen in a figure from

78 the doorway of a Gupta temple at Beshnagar, near by. She stands upon a beast that is part crocodile and part elephant, the makara, symbolic of life-sustaining water. Woman and makara together represent the sacred river Ganges. The goddess, portrayed more realistically than the

66 Kushan yakshis, stands voluptuously in the classic *tribhanga* or three-body-bends pose, and she is adored by a small figure to her right. A second small figure below is subduing the rampant makara. At Beshnagar a similar stone on the opposite side of the lintel would have been carved with a goddess standing on a tortoise, representing the sacred river Jumna. On later Medieval Hindu temples such river-goddess figures, enlarged and placed at ground-level, stand flanking the portal to the sanctuary.

Paramount among Hindu sculptures of the Gupta period are the reliefs on the exterior walls of the ruined Dashavatara Temple at Deogarh, about seventy miles south of Jhansi in Central India. This is one of the earliest known Gupta temples in the North Indian style (*Nagara*), dating from about 425. Among the three deep-set relief panels which decorate

118

78 The river goddess Ganga standing on a makara, from the lintel of a temple at Beshnagar. Gupta, c. 500. Sandstone, H. 29⅞ in. (76 cm). Museum of Fine Arts, Boston, Charles Amos Cummings Bequest

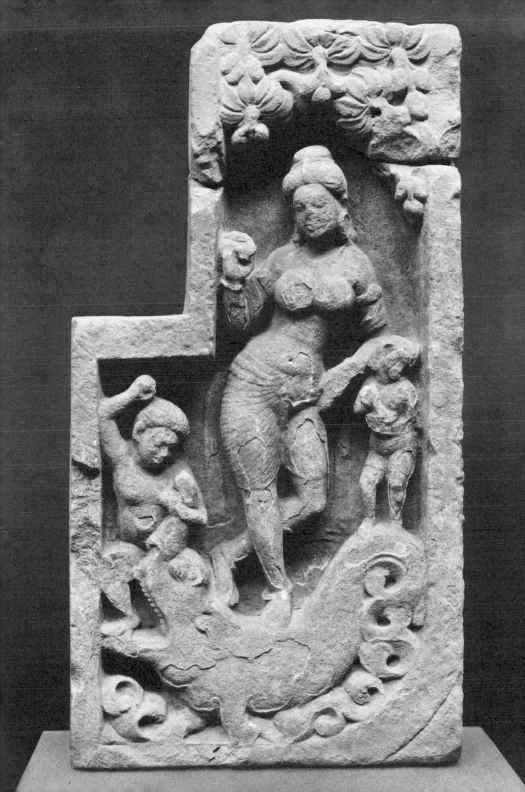

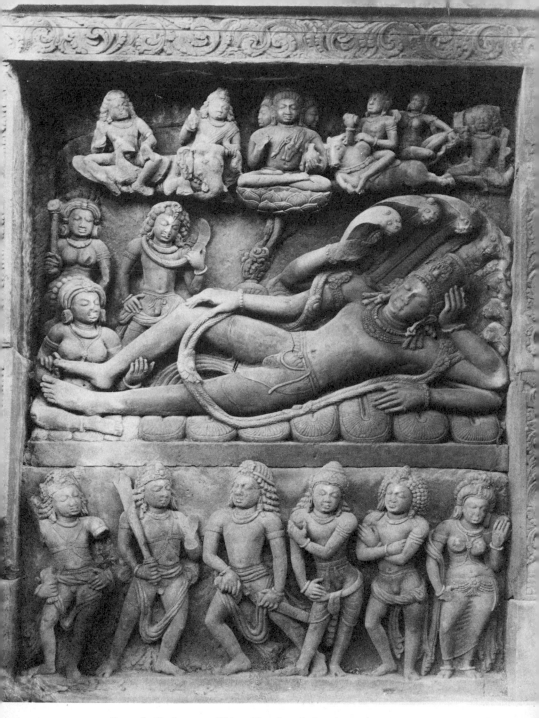

79 Deogarh, Dashavatara Vishnu Temple, relief on the south wall showing Vishnu Anantasayin. Gupta, c. 425

the walls of the square shrine is a scene depicting Vishnu *Anantasayin*.
Here in an expanded manner the Buddhist sculpture style of Sarnath is
adapted to a Hindu motif. The Lord of Preservation, Vishnu, is shown
asleep on the coils of the giant multi-headed serpent, Ananta, who drifts
endlessly on the eternal sea of milk. As the lord sleeps, he dreams the
cosmos into reality by experiencing the 'nightmare' of maya where all
beings take on their temporal forms. Normally such an iconographic
presentation would show a lotus plant blooming from Vishnu's navel,
with in its centre Brahma, the four-headed Hindu god of creation.
Here Brahma is depicted separately above, seated on a lotus blossom
and accompanied in the upper register of the relief by other deities
including Indra and Shiva. Lakshmi, as a dutiful Hindu wife, massages
her sleeping consort's legs. The panel's composition is completed at the
bottom by a row of six figures which again include the personifications
of Vishnu's symbols and two armed demons. Originally all the reliefs
and the entrance to the shrine stood behind open porticoes. Around the
base of the entire structure ran a series of reliefs depicting events from the
Vaishnava epic poem, the *Ramayana*.

AJANTA
It is the Gupta period which provides us with some of the earliest sur-
viving examples of Indian painting, found in various stages of preserva-
tion on the walls of Buddhist rock-cut sanctuaries in the north-west
Deccan. The greatest number and the best preserved are located in
the complex of twenty-nine chaitya and vihara caves (see pp. 51 ff.) at
Ajanta.
 The first Buddhist chisels probably echoed across Ajanta's horseshoe-
shaped ravine some time in the second century BC, but by the seventh
century AD they were heard no more and Buddhism was waning in
India. Abandoned, the empty stone chambers became overgrown and
lost. Then in 1817 several scarlet-coated soldiers, hunting tiger, were
led by a half-wild boy into the ravine and up to the cliff's wall. Pulling
away branches, they were confronted by a gigantic Buddha gesturing a
peaceful benediction from the elaborate stone wall pierced by a darkened
doorway. When the soldiers passed through this door the art of Ajanta
returned to the world of men.

The early investigators of the site assigned numbers to the caves
according to their sequence along the ravine's wall: obviously these
numbers have no connection with their order of creation. In fact, Cave
10, a chaitya hall, is believed to be the earliest chamber, since an inscription
appears to date it to the first half of the second century B C. It also con-
tains fragments of the oldest known examples of Indian wall-paintings.
Unfortunately, most of the painted surfaces are too fragmented to be
telling, but in one passage the patterns are complete enough to present us
with a royal scene from about the first century B C. A handsome raja and
his retinue (left) approach a garlanded tree (centre), where they are met
by a group of musicians and dancers (right). One is immediately struck
by the easy realism of the scene, a realism even more remarkable when
contrasted with the formalized sculptures at Bharhut, with which the
painting is very nearly contemporary. Each head here has a distinct
personality, and the moustached raja is especially remarkable, not only
for his good looks, but also for his stylish and elaborate hair bun bedecked
with jewels. At the right, two musicians near the sacred tree on the top
row hold long-stemmed trumpets, while below are two dancers with
exuberant gestures and expressive eyes. The general format of these

80 Ajanta, Cave 10, wall-painting of a raja, his retinue and musicians at a sacred tree. Shunga, probably 1st C. BC.

first paintings appears to indicate that they formed a continuous narration, within a narrow ribbon-like band along the wall, reminiscent of Chinese scroll-paintings.

Later paintings at Ajanta expanded in all directions to cover the whole surface of the wall, but the continuous narrative concept was retained and the resulting complexity immediately imbues the paintings of Ajanta with a crowded, throbbing vitality. The sequence is only interrupted occasionally by an architectural structure or a series of strange 'cubistic' forms which provide barriers between separate actions and even function occasionally as props for random figures. It is clear that the paintings in Cave 10, though they are the earliest examples of Indian painting that we know, had been preceded by an extended tradition, and considering the excellence of this lone example, that tradition's loss can only be lamented.

In Cave 1, a late fifth-century vihara, we see Gupta architecture *82* wrought from solid stone. The cave is also a virtual museum of Buddhist art. During the fifth century the function of the vihara was extended beyond its basic purpose of quartering and feeding the monks to make it also a place of worship. Here a cell in the back wall forms a shrine and

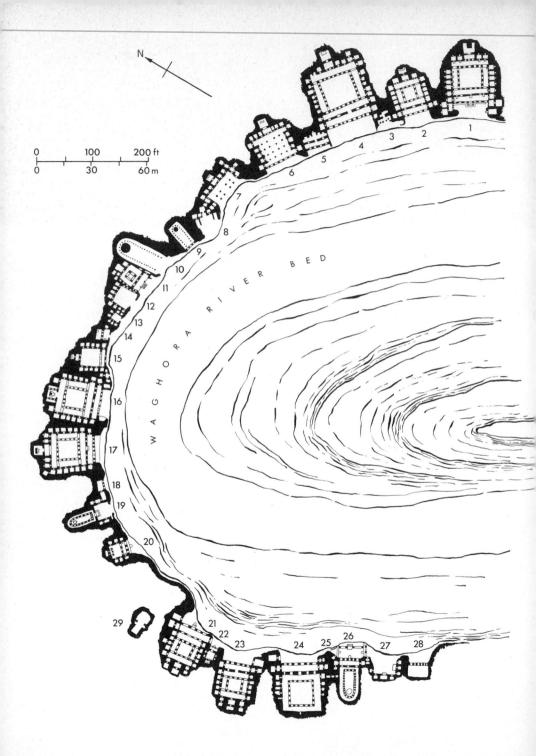

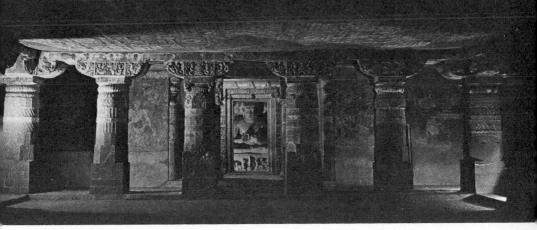

81 (opposite) Ajanta, the rock-cut chaitya halls and viharas around the gorge; 2nd C.
BC–7th C. AD. The numbers refer to the caves' sequence, not their chronology

82 (above) Ajanta, Cave 1, view from the assembly hall towards the shrine. Gupta, late
5th C.

contains an image of the Buddha. But what overwhelms us in Cave 1 is
the number and quality of the paintings which still glow from every *83, 84*
surface, and transport us into the rich and complex Buddhist world of
the late fifth century.

The subject-matter of the paintings, as of most of the surviving
examples from Ajanta, is the various lives and incarnations of the Buddha,
told in the Jataka tales. As in Flemish Renaissance paintings, the stories
are richly depicted in the settings of the artists' world. The whole mood
is one of life and activity, and a calligraphic line gives a flowing action
to the contours of the figures, whose hand positions are most expressive.

The Bodhisattva Padmapani, who stands languidly in the tribhanga *83*
pose of sculpture, holding a blue lotus, is particularly fine. The Buddha-
to-be wears a few rich pieces of jewellery, such as an elaborate pointed
crown, and a sacred cord (indicating his high caste) which is delicately
composed of many strands of small pearls. His expression of remote
calm is enhanced by the figures which crowd in from all directions and
establish him as an island of spiritual disengagement, unmoved and
unattentive to the forces and sounds of maya which engulf him. The
absence of shadows suggests an unworldly light appropriate not only to
the subject but also to its location, deep within the rock. This light is
present in all the paintings at Ajanta, and is partly the result of the tech-
niques used by the artists.

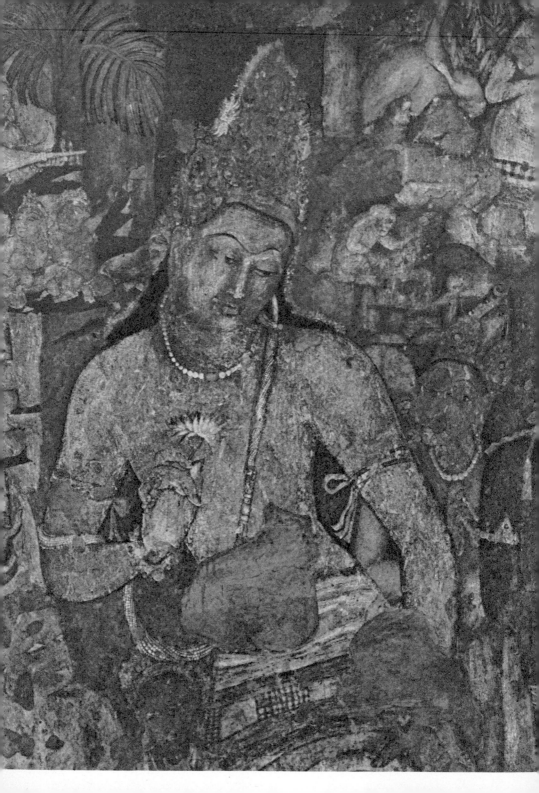

83 (opposite) Ajanta, Cave 1, wall-painting of the Bodhisattva Padmapani. Gupta, probably late 5th C.

84 Ajanta, Cave 1, detail of the painted ceiling. Gupta, probably late 5th C.

The surface of the stone was first prepared by a coating of potter's clay, mixed variously with cow dung, straw, and animal hair. Once this was levelled to a thickness of half an inch to two inches, it was coated with a smooth, fine, white lime plaster which became the actual painting surface. On the still-damp wall, the artist first laid out his composition with a red cinnabar line and then defined the subjects with an undercoat of grey or *terre verte*. This was followed by the addition of local colours, and once the whole wall was completely coloured, a brown or black line restated the drawing to finish the composition. A last burnishing with a smooth stone gave a rich lustrous surface. The colours, which were natural and water soluble, consisted of purple, browns, yellow, blue, white, green, reds, and black.

Another elegant Bodhisattva figure in Cave 1 is shown surrounded by his queen and ladies of the court. The painting re-creates an episode from a Jataka story, *Mahajanaka Jataka*, and it also provides a vivid glimpse into the regal settings which were well known to the artists. The same keen talent for observation appears in the painting of an elephant in a lotus pond, one of many small panels decorating the ceiling. *84*

127

The artist has captured the huge but deft-footed beast at the moment when it charges ashore, scattering lotus blossoms in his wake. The elephant is but one of the hundreds of animals – horses, bulls, birds, monkeys, and others – which are brightly woven through the pictorial fabric at Ajanta.

Cave 17 preserves some works also dating from the middle of the fifth century. Among them are several instances of a motif that was to be central to all Indian painting, right up to the last Rajput miniatures in the nineteenth century: two lovers in an architectural setting. The scene occurs in a fresco illustrating the story *Simhala Avadana* that covers a complete wall. The story deals with the adventures of a virtuous merchant, Simhala, who is shipwrecked on an island inhabited by ogresses. By day the ogresses are transformed by witchcraft into beautiful women, but at night they revert to cannibalistic fiends. In one detail the hero is shown in the company of one of the transformed ogresses, seated in a brightly coloured tent.

A similar scene appears in a fresco of the *Vishvantara Jataka*, when Prince Vishvantara informs his queen that he has been banished from his father's kingdom. The painting's erotic overtones, as well as its composition, link it to later Indian miniature painting. Among the clearly defined fifth-century architectural details are flat cushion-shaped capitals on columns hung with jewels. The same capitals top the stone columns used to frame a magnificently conceived royal couple carved on the left side of the porch to Cave 19. The two figures are actually a king and queen of the serpents (nagas), and, like the yakshis and yakshas, they are ancient fertility spirits of the earth who still, here in the sixth century, stand guard at the portals of the Buddha's sanctuary. Both sit naturally in a pose known as 'royal ease', with one leg pulled up close to the body and the other dropping to the floor. The naga king's head is dramatically enclosed within a multi-headed cobra hood which suggests a halo. It is curious to note that the throne on which this royal pair sit is decorated with a pattern of the same 'cubistic' motif that is used as 'set furniture' in the wall-paintings.

Cave 19 has a fully developed chaitya façade in Gupta style and forcefully proclaims, with an over-abundance of Buddha images, the triumph of Mahayana Buddhism (see p. 81), affording a dramatic contrast to the earlier and more austere chambers carved in the Shunga

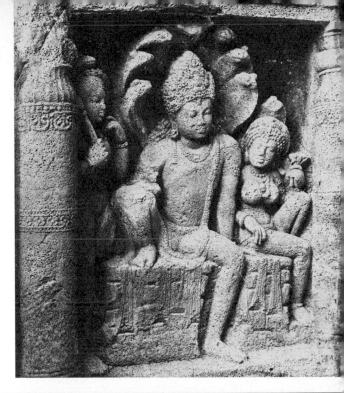

85, 86 *Ajanta, Cave 19, relief of a naga king and queen (right) and façade. Gupta, probably late 5th C.*

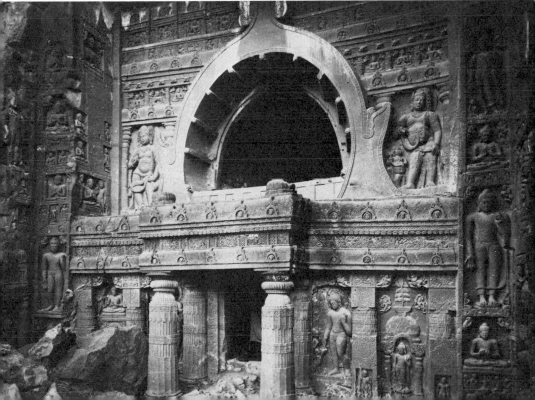

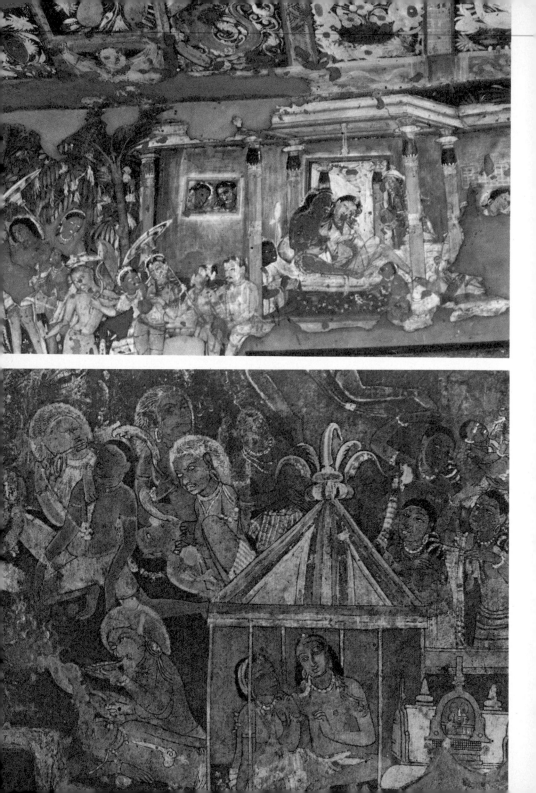

period. The theatrical lushness of Buddhist sculpture and painting, coinciding with an increase in Brahmanical sculpture, shows that the gods of Hinduism were now asserting themselves and offering a viable challenge to the Buddhist establishment. Not unlike the Roman Catholic Church in its reaction to the Reformation centuries later, Buddhism attempted to compete by beginning a transformation which would culminate in the Medieval period with a flowering of esoteric Buddhism (pp. 170–1). Ultimately Buddhism became so interwoven with Brahmanical practices that it is difficult to define the dividing line between the two. Late in the twelfth century, when Islam devastated Northern India, it was a dominant and thriving Hindu culture which received the greatest shock, while only remnants of a dying Buddhism were finally snuffed out.

POST-GUPTA PERIOD

During the sixth century the Huns, who had previously levelled Gandhara and put an end to the Gupta empire, were absorbed into the multi-stranded fabric of North India. With Gupta power gone, a new empire emerged in the Doab, ruled by the great King Harsha. Harsha was another of those impressive Indian personalities, not only a great administrator and warrior but also a poet and the author of at least three plays. One of his plays which popularized Buddhist ideals is still performed as an opera in the Bugaku theatre in present-day Japan. Favouring both Buddhism and Hinduism, he established a climate for learning and culture which rivalled that of the Guptas, who obviously were his models. Harsha's empire was centred at Kanauj, and as a cultural focus the city became one of the largest and most important in North India, lasting until the arrival of Islam in the twelfth century.

As evidenced by the remains of the Dashavatara Temple at Deogarh, embryonic stone temples dedicated to Brahmanical deities had begun to appear in Northern India and in the Deccan as early as the Gupta period. What appears to be the earliest known free-standing stone structure to have survived intact is Temple No. 17 at Sanchi, dated to about AD 415. It is a simple square cell, fronted with a porch supported by columns topped by bell and lion capitals. These capitals can be traced back to Mauryan times, but the temple's cubical severity gives it a look of Greek simplicity.

91

87, 88 Ajanta, Cave 17, wall-paintings illustrating the Vishvantara Jataka (above) and Simhala Adavana. Gupta, 5th C.

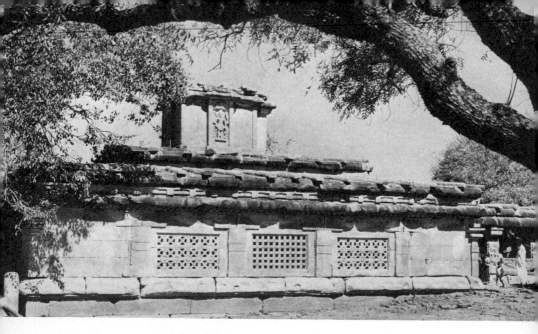

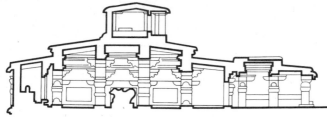

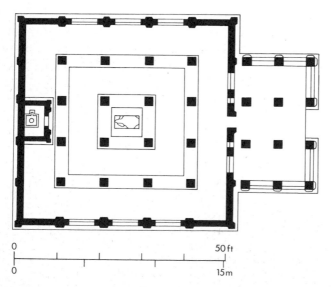

*89, 90 (above and left)
Aihole, Ladkhan Temple,
view, section and plan.
Chalukya, c. 425–50*

*91 (opposite) Sanchi,
Temple No. 17. Gupta,
c. 415*

0 50 ft

0 15 m

Much farther south, in the Deccan, a dynasty known as the Chalukyas had by the sixth century AD founded their capital at Badami. At a second location, Aihole, they had erected some of the earliest known Hindu temples evolved from previous architectural structures, such as chaitya and vihara forms. At first, Chalukyan temples were little more than simple columned halls, or *mandapas*, covered with a flat roof. The Gaudar Temple, recently excavated, may be as early as the first quarter of the fifth century. The so-called Ladkhan Temple, long considered *89, 90* the oldest Chalukyan temple at Aihole, is actually the second oldest and may (according to S. R. Rao) date from *c.* 425–50.

Ladkhan's design is based upon a square mandapa raised upon a moulded plinth, with an attached porch, an interior shrine, and a two-tiered sloping roof surmounted by a square tower (*shikhara*) – a later addition, but even so an early manifestation of what became in Medieval times the dominant feature of Hindu temples. The shikhara (unlike the *150* steeple of Christian churches) rises at the rear of the temple and marks the location of the sacred cell containing the deity. Originally the spaces between the exterior columns of a mandapa were open, but on Ladkhan they have been filled with pierced stone screens which define the structure as a walled volume. Its floor-plan, with the square columned interior, porch, and the cell standing against the back wall, is immediately reminiscent of the plan of a vihara; however, the cell contains not a *81* Buddha icon but a *lingam*, the phallus representation of the god Shiva.

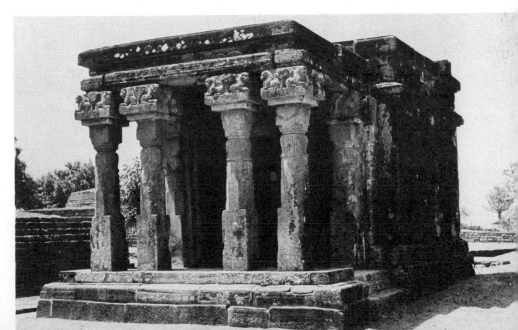

92, 93
26
The Durga Temple at Aihole, about a hundred years later in date, ends in an apse, a plan that suggests its derivation from the chaitya hall. The temple is approached at the front through a fairly large porch, and is complemented by excellent Chalukyan sculpture. A shikhara (now ruined) was subsequently added to adapt the building to later tastes.

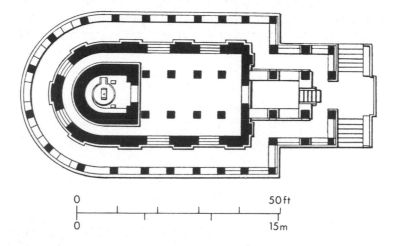

0 50 ft

0 15 m

92, 93 Aihole, Durga Temple, plan, and view of the apse. Chalukya, c. 550

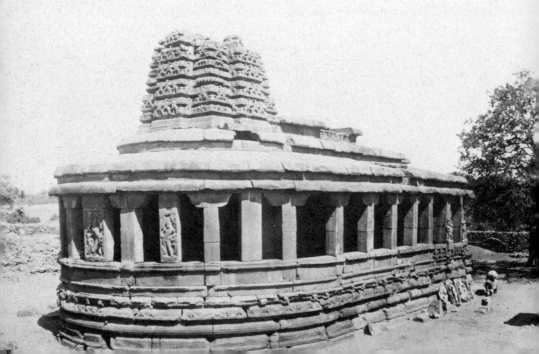

Farther south, the Chalukyan stronghold of Badami stands at the edge of a lake dominated by a rocky hill that looms above the town to the south-east. Here carved into the cliff above the town are four pillared halls. Three of these are Brahmanical caves, one dedicated to Shiva and two Vaishnava shrines devoted to Vishnu, while the fourth and later one is a Jain sanctuary. The earliest of the Vaishnava halls, Cave III, was dedicated in AD 578. The four are joined by an inclined causeway. Like the temples at Aihole, they consist of a veranda and a columned hall. A small sanctum cell is carved into the wall at the far end of each hall.

A superb sample of the sculpture found in the rock chambers at Badami is the image of a seated Vishnu on the veranda of Cave III. The *94* four-armed lord of preservation sits in relaxed ease upon the coils of the cosmic serpent, Ananta, whose many hoods hover protectively above the god's high crown. The sureness of the carving creates a series of geometric masses which combine to resolve the obdurate stone into a sensitively composed work of art. Originally the veranda of Cave III was enriched by sixth-century paintings, but unfortunately only fragments remain.

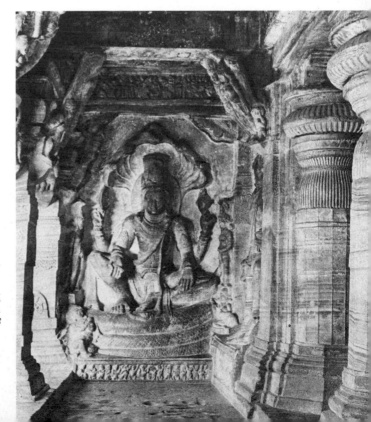

94 Badami, Cave III,
Vishnu enthroned on Ananta.
Chalukya, c. 578

95 On the north side of Badami a free-standing stone Chalukyan temple of slightly later date, the Malegitti Shivalaya, survives intact. It provides an example of Deccani architecture where the evolving North Indian style subtly mixes with that of the South; it also offers a contrast to the first Chalukyan shrines at Aihole. The temple is still basically a low rectangular structure fronted by a porch and standing on a tiered plinth. But its sides have become solidified into walls, since the pierced screens remain now only as small windows flanking panels carved in relief. The structural columns of the earlier mandapa design are retained on the exterior as decorative half-columns defining rectangular units which
93 contain reliefs and windows. The lower plinth and upper roof mouldings continue the style seen on the Durga Temple at Aihole, being ornately carved with small chaitya-arch motifs. The shikhara or tower above the sanctum (*garbhagriha*, literally 'womb-house') is still low, but more elaborately sculpted, and it is topped by a rounded dome which is echoed by two smaller domes on the temple's front corners. These elements are indicative of the South and make us aware that we are deep into the Deccan.

The Chalukyas were clearly one of the most powerful Deccani dynasties of the late Gupta period. Their founder, Pulakesin I, who founded Badami in the middle of the sixth century, exerted power over a considerable area, which included Ajanta. His fame reached Persia and even resulted in an exchange of embassies. Affluence and power did not, however, make the Chalukyas immune from the military contests which have punctuated all of Indian history. On the contrary, their wealth may have attracted attention: in the first half of the seventh century they were attacked by Harsha from the north and then by the Pallavas from the south. The Chalukyas survived both attacks; but in the middle of the seventh century a new dynasty arose in the Deccan which overthrew and scattered them, commencing a rule which would last over two hundred years. That dynasty was the Rashtrakutas.

The first Rashtrakuta raja, Dantidurga (ruled *c.* 725–60), defeated the Chalukyas at Badami in about 753 and established an empire which dominated the Deccan. His uncle who succeeded him, Krishna I (*c.* 756–74), not only enlarged the royal territory to the south but also created the most famous of all Rashtrakuta monuments, the rock-cut wonder of
96, 97 the Kailasanatha Temple at Elura.

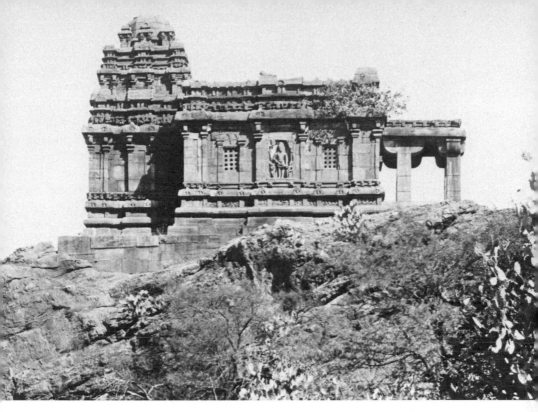

95 Badami, Malegitti Shivalaya Temple. Chalukya, c. 600

Located about fifteen miles north-east of Aurangabad, Elura has been an ancient pilgrimage centre for Buddhists, Jains, and Hindus. The site consists of a group of thirty-three shrines carved into an escarpment of volcanic stone which rises above the plain of the northern Deccan. Among the earliest, starting in Gupta times, are the twelve created by the Buddhists. The Jains were responsible for four caves, and the remaining seventeen are Hindu.

Elura is undoubtedly one of the greatest of all Indian sites for sculpture, and the masterpiece at Elura is the Kailasanatha Temple, a monolithic *96, 97* sculpture in the form of an elaborate temple of Shiva (see p. 140), carved from the hillside between *c.* 757 and *c.* 790. In its complex design it is a copy of the free-standing Virupaksha Temple at Pattadakal, of *c.* 740, which in turn was a copy of the Kailasanatha Temple at Kanchi- *108* puram, of the early eighth century.

This cultural exchange between the deep South and the Deccan was the result of wars, and the Elura shrine represents the extreme northern point of penetration by the southern architectural style.

Like its models, the Kailasanatha Temple is composed of four basic units. First there is a high entrance gate (*gopuram*) which screens the sacred precinct from the outside world. The gate is followed by a shrine for the bull Nandi, the mount of Shiva. A statue of Nandi is traditionally located before Shaivite temples where, devotedly transfixed, he contemplates the Shiva lingam in the temple's cell. At Elura the Nandi shrine is flanked by two monolithic stone shafts or towers, 60 feet high, which originally supported trident symbols of Shiva. Also near by, at either side, are carved two life-size stone elephants. Beyond the Nandi shrine, the living stone looms upward into an elaborated mass of architectural and sculptural detail. This massive, unified volume actually contains the last two of the four basic architectural units. These are the columned assembly hall and, within the highest volume of the main tower, the major sanctum. The shikhara, centred over the cell containing the lingam, rises to a climax 96 feet above the carved courtyard floor. This cell and tower unit is strikingly borne on the backs of rows of carved elephants.

The temple complex functions on two main levels, since the floors of the Nandi shrine, the assembly hall and the processional path around the major cell are all higher than the courtyard floor. These upper sacred levels are approached by two stairways on either side of the assembly hall. This device adds a dramatic element to the devotee's experience of progressing through the wonder of a world carved from the stone heart of the earth, then ascending to an even more remote level of sacredness.

The Kailasanatha Temple's courtyard is 276 feet deep and 154 feet wide, and at the back the vertical incision into the hill drops 120 feet. One can hardly disbelieve the guidebook's claim that 'approximately three million cubic feet of stone' were excavated from the hillside to create this massive work of sculpture. It demanded the most sophisticated planning, since it depended not on what was added, as in conventional architecture, but on what was removed.

The central temple complex is so awesome that the numerous shrines and relief panels cut into the side walls of the courtyard take on a secondary importance. This is unfortunate because in any other setting

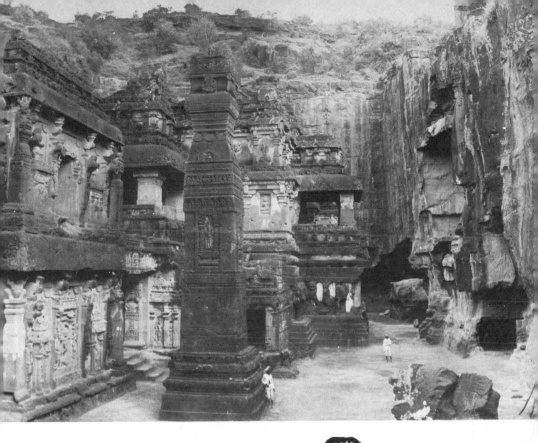

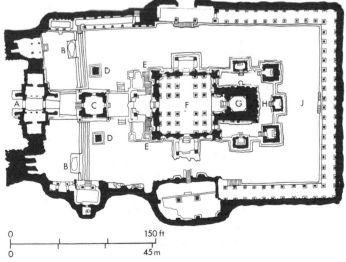

96, 97 Elura,
Kailasanatha Temple,
view from the west and
plan. Rashtrakuta,
c. 757–90.
A entrance gate,
B elephants, C Nandi
shrine, D freestanding
shafts, E stairs to the
upper level, F assembly
hall, G lingam shrine,
H processional path with
subsidiary shrines,
J courtyard surrounded by
galleries

98 Elura, Kailasanatha
Temple, sculpture in the
northern gallery showing
Ravana shaking Mount
Kailasa. Rashtrakuta, 8th C.

each would be outstanding. The Rashtrakuta Post-Gupta sculpture style
of Kailasanatha might be defined as a continuation of the Chalukyan
style, but slightly modified by a Pallava or South Indian influence.

98 Chief among the sculptures is one in the northern gallery that depicts
the demon Ravana shaking Mount Kailasa. The relief, so deeply carved
that it is almost in the round, shows Shiva and his consort, Parvati,
enthroned on their sacred Himalayan abode of Mount Kailasa (much
like the Olympus of the ancient Greeks). The name Kailasanatha means
'the holy mountain residence of the Lord Shiva', and the temple was
conceived as a mountain. Later, in Medieval times, shikharas were
coated with white stucco to further the illusion that they were shimmer-
ing snow-covered peaks of the far Himalayas.

In the relief Shiva, Parvati, and their attendants are disturbed when
the demon Ravana, who has been imprisoned beneath the mountain,
begins to shake it with his many arms. The lithe figures appear to glow
and move with each shift of reflected sunlight. Especially noteworthy
is the effect of Ravana's many arms, which are central to the animation

140

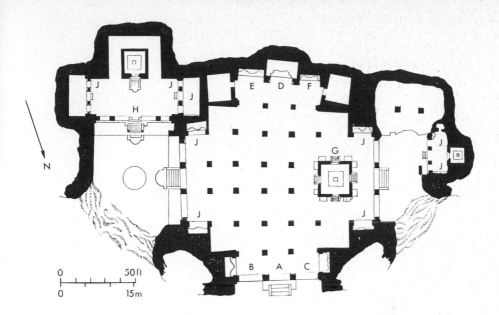

*99 Elephanta, Shiva Temple. Probably Rashtrakuta, early 7th C. A main entrance,
B Shiva Yogishvara, C Shiva Nataraja, D Shiva Mahesamurti, E Shiva
Ardhanarishvara, F Shiva Gangadhara, G lingam shrine, H subsidiary Shiva shrine,
J locations of other sculpture*

of the scene. The action is augmented by the lovely grace of Parvati's
frightened lady-in-waiting who, above, flees back from the composition
and creates the illusion of expanding space where there is only solid
rock. The decisive moment of this parable of Shiva's power occurs when
he gently presses the earth with his toe and restores all to calm and order.

A second great rock-cut shrine dedicated to Shiva is on the island of
Elephanta, about six miles offshore in Bombay harbour. There are other
rock-cut shrines on the island, but the most elaborate and important
is a large pillared excavation with more than 16,000 square feet of floor
space. It is tentatively ascribed to the Rashtrakutas, but its authorship
and its date (generally accepted as being the first quarter of the seventh
century) are under debate.

The columned chamber is oriented roughly east to west, and focuses
upon a square, four-door lingam cell at the western end. The main
entrance is through a large, carved porch on the north, but the great
hall also opens on to two courtyards, at its extreme eastern and western
ends, and each in turn contains smaller shrines. On the two side walls of

99–102

99
100

141

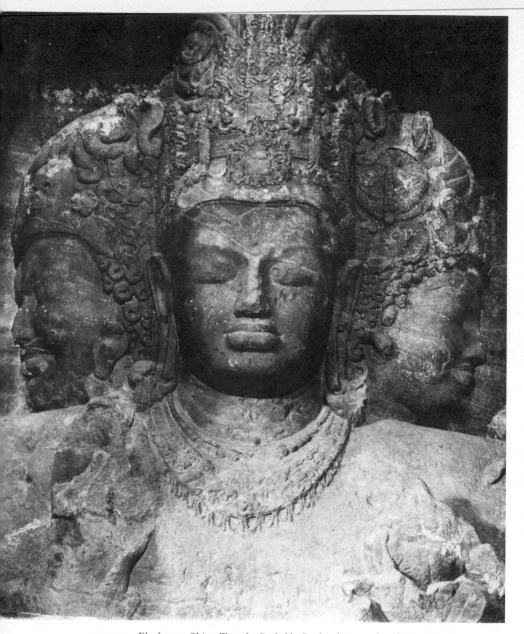

*100–102 Elephanta, Shiva Temple. Probably Rashtrakuta, early 7th C. Opposite,
above: the lingam shrine; below, Shiva Ardhanarishvara (far left) and Shiva
Mahesamurti. Above: Shiva Mahesamurti*

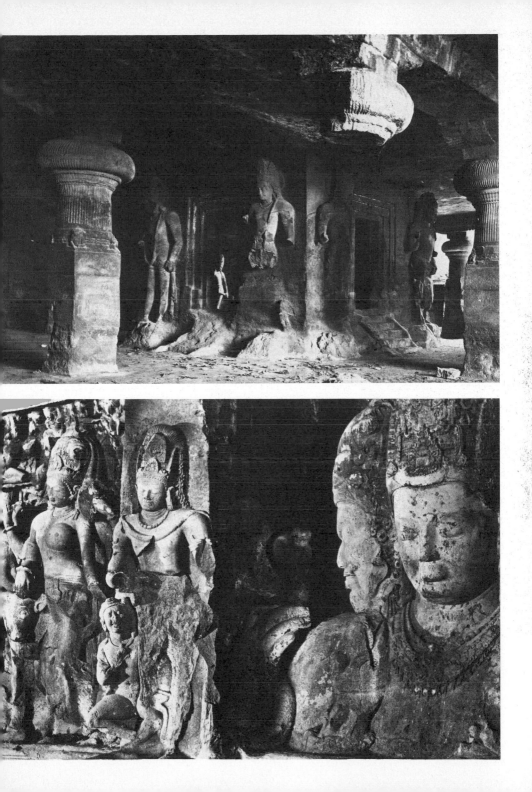

the northern porch and at seven other locations within the hall are reliefs depicting various episodes from the myths of Shiva. He is represented in numerous manifestations, such as the Great Ascetic (*Yogishvara*), Lord of the Dance or of Dancers (*Nataraja*), dual male and female aspect 101 (*Ardhanarishvara*) and the Descent of the river Ganges (*Gangadhara*).

100 Also impressive among the sculptural works found here are giant door-guardian figures who stand flanking the four portals to the lingam shrine. Unfortunately these figures, and the majority of the relief panels, have suffered extensive damage, reputedly from an early Portuguese military garrison who playfully used the hall as a shooting-gallery. Before restoration a number of the massive square pillars were completely displaced and remained only as stalagmite stumps on the floor or as stalactite fragments of capitals hanging from the ceiling.

One sculpture, carved deep into the fine dark brown sandstone of the south wall opposite the main porch, miraculously survived the fusillade and has now become almost as famous as the Taj Mahal: it 101, 102 is the giant triple-headed Shiva *Mahesamurti*. This 18-foot-high sculpture represents the supreme aspect of Shiva, which embodies not only the creator and the destroyer but also the maintainer of the cosmos. The three massive heads have been conceived as a psychological and aesthetic whole, with the central serene face providing a focus for the formal design. To the left Shiva displays his wrathful and destructive aspect (*Bhairava*), which is illustrated by the hooked nose, cruel moustached mouth, and the head-dress ornamented with a cobra and death's head. This terrifying visage is complemented on the right by the aspect of creation (*Vamadeva*), whose feminine features have a blissful softness which is enhanced by the pearls and flowers in the hair and the lotus bud in the hand. The central image of the Great God (Shiva *Mahadeva*) presents a mood which is detached and otherworldly, not unlike the Gupta Buddhas, and represents Shiva in his *Tatpurusha* aspect, which is the supreme, serene, and beneficent one.

30 This sculptural style, with its massive bodies and full lips, seems to remember the firmly fleshed mithuna figures of Karli, carved some four hundred years earlier only a hundred miles to the south-east. At Elephanta that archaic vitality has been modified by Gupta aestheticism and Chalukyan elegance to produce a provincial style which is gloriously unique.

144

South India: Pallavas, Cholas and Hoysalas

The successors of the Andhras in South-east India were the Pallavas, who are known to have existed as early as the first century BC. Originally they were Buddhists, but they were converted to Brahmanism in about the fifth century AD. From the first they seem to have been great traders and to have loved the sea: coins of the Bactrians, Andhras and Romans have been found in the sands of their chief seaport at Mamalla-puram, about 37 miles south of the present city of Madras. It was during the reign of the great Narasimha Varman I (*c.* 630) that this seaside emporium began to flower as a great artistic centre. The very name of the site perpetuates the ruler's fame, for Narasimha Varman I was also called the 'Great Wrestler', *Mamalla*. Today the name has been corrupted into Mahabalipuram ('Town of the Great Demon King Bali').

Some of the Pallavas' greatest art works at Mamallapuram, begun in the middle of the seventh century and continuing for about two generations into the eighth century, are cave temples and gigantic open-air reliefs carved into the whale-back outcroppings of granite that spine this strip of coastal land.

An immense relief which depicts the descent to earth of the sacred river Ganges, mistakenly called 'Arjuna's Penance', is the outstanding *103* work at the site. About 20 feet high and 80 feet long, it contains over a hundred figures of gods, men, and beasts. Its subject is the Shaivite myth which tells how the holy ascetic, Bhagiratha, performed great acts of austerity for a thousand years in order to persuade the gods to allow the heavenly river Ganges to flow down to earth where it would bless man. When the boon was finally granted, there was great concern lest the impact of the falling water should destroy the earth. Shiva himself stoically consented to receive the shock of the river on his own head. It then wandered for aeons through his matted labyrinthine hair, eventually meandering gently out upon the ground.

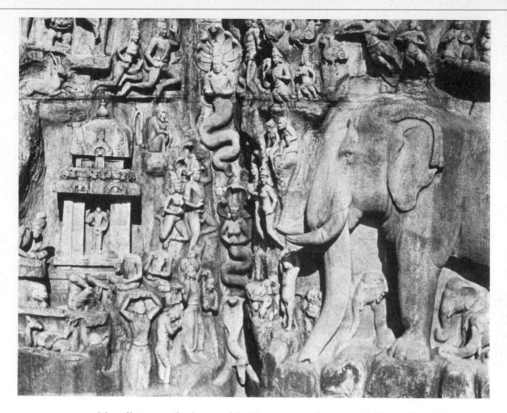

103 Mamallapuram, the descent of the Ganges (central section). Pallava, 7th–8th C.

103 The relief at Mamallapuram depicts the auspicious moment when the river finally flows on to the earth. In the central cleft the king and queen of the nagas swim up the falling stream with their many hoods in full display, while all the gods and creatures reverently face inward to witness the miracle. At the upper left, just above the serpent king, is Bhagiratha, still in an ascetic stance. At the top of the boulder, centred above the relief, is a cistern: on special occasions it released water which rushed down the cleft to give reality to the tableau. The realism and soft monumentality of the elephants standing to the composition's right are especially well defined. Their massive weight is balanced on the left side by a plain area of stone which shows just the slightest indication that a pillared shrine was about to be excavated there, but for some reason it was early abandoned.

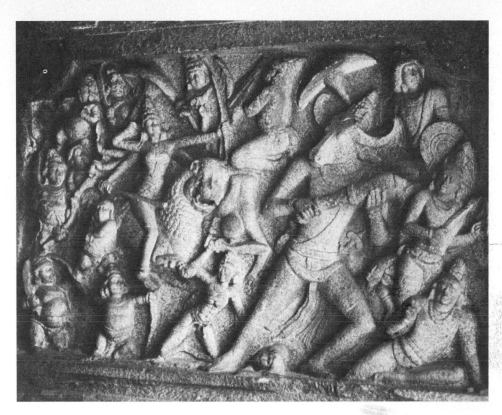

104 *Mamallapuram, Durga slaying the Buffalo Demon. Pallava, 7th–8th C.*

Farther to the left, and in the faces of adjacent boulders, are carved
mandapas, fronted by typical Pallava pillars partly composed of squat-
ting lions, and containing reliefs which illustrate Hindu mythology.
Among the familiar subjects are Vishnu as the Cosmic Boar, Varaha;
Vishnu asleep on the giant serpent, dreaming the Cosmic Nightmare
(Vishnu Anantasayin); and, perhaps the most beautiful of all, Durga *104*
slaying the Buffalo Demon.

Durga, 'She who is difficult [*dur*] to go against [*ga*]', is a feminine
aspect of Shiva. The demon of which she is ridding the world is shown
here not in its usual animal form, but as a human figure with a buffalo
head. Durga sits astride her vahana, the lion, and is attended by a host;
in her eight hands she holds the weapons given her by the gods, with
which she draws blood and eventually triumphs.

147

The Mamallapuram reliefs, as well as other Pallava sculptures, carry the memory of Andhra art and have an elongated and elegant grace which is the mark of Pallava art. It is as if the action took place behind a gossamer screen which expands with the straining forms but always holds them to a constant plane. Their contours are described in a simplified and direct way which exhibits a highly sophisticated sense of design and vital geometry. Perhaps the obdurate nature of the granite contributes to the style, but in any case the results are magnificent.

At the southern edge of Mamallapuram is a group of free-standing temples, four of them carved (like large hunks from a loaf of bread) from one long granite boulder running north–south. A fifth temple stands slightly out of line to the west, and included in the group are a

105, 106

105 *Mamallapuram, rock–cut raths of Dharmaraja, Bhima and Arjuna (from left to right), and rock–cut bull. Pallava, 7th–8th C.*

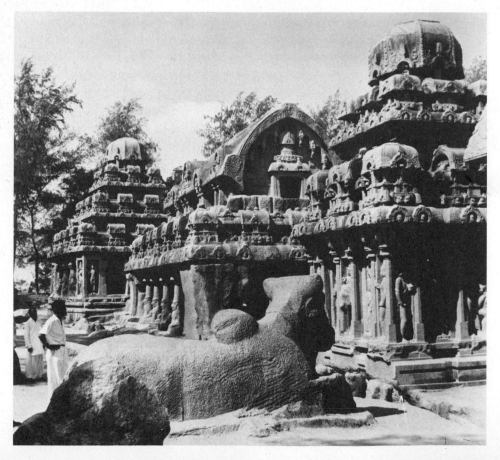

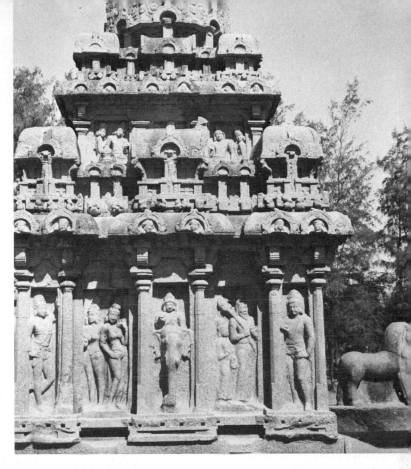

106 Mamallapuram,
sculptures on the east
front of the Arjuna
Rath, and rock-cut
lion. Pallava,
7th–8th C.

stone elephant, lion, and recumbent bull, all larger than life-size. The
five temples are detailed replicas of ancient wooden structures. They are
called *raths*, which means car or chariot, and indicates that they are
vehicles of the gods. The smallest of them, on the north, the Draupadi
Rath, reproduces a square, planed, thatched wooden temple. The next,
the Arjuna Rath, is also square, but more complex in design: it emulates
a vihara, with a pyramidal roof composed of three tiers of small pavilions
crowned by a cupola. The third, the Rath of Bhima, is the largest and is
remarkable for its oblong, barrelled chaitya-cave-type roof. The last
'structure', at the south end, is the Dharmaraja Rath. It is a larger, three-
storeyed version of the Arjuna Rath. The small fifth temple to the east,
Sahadeva, is an abbreviated version of the Bhima Rath. All these
massively carved stones have on their sides excellent Pallava sculptures. *106*

With the death of Narasimha Varman I in 668 work on the five raths stopped. However, other projects were undertaken at Mamallapuram and at the Pallava capital of Kanchipuram, thirty miles inland.

The early part of the eighth century saw the construction at Mamallapuram of the Shore Temple, so called because it stands by the sea. Since it was not carved of living rock, but was built up of granite blocks, it could be given a soaring tower. The surfaces were originally covered with carvings; but over the centuries most of them have been eroded away by the constant action of sun, wind, and salt spray, giving the temple a soft, melted look. Local legends claim that four other temples stood here, but one by one the sea claimed them.

107

107 Mamallapuram, Shore Temple. Pallava, early 8th C.

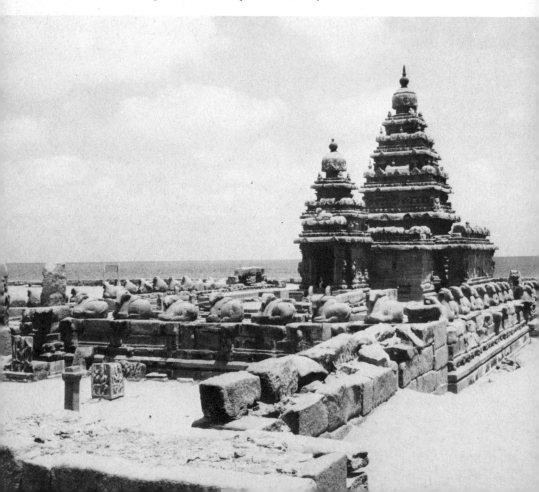

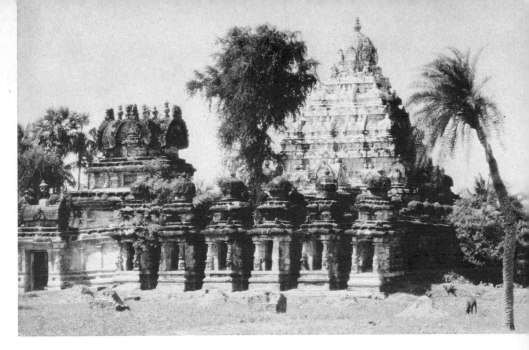

108 Kanchipuram, Kailasanatha Temple. Pallava, early 8th C.

The Shore Temple is a Shaivite shrine. The cell under the highest tower (*vimana*) opens directly on the sea, not only to permit the first eastern light of the sun to illuminate the cell but also, perhaps, to allow sailors to pay homage to the deity from their approaching boats. Directly behind the main shrine is a second cell containing a large sculpture of Vishnu Anantasayin. This cell is entered by a doorway on the south side of the temple. A second small, towered shrine completes the structure. Its cell faces west into a now ruined courtyard which is encircled by numerous small sculptures of recumbent Nandi bulls.

The design of the Shore Temple is important because it is the earliest known example of a stone-built temple in the South. It is closely related to the Kailasanatha Temple in Kanchipuram, which also dates from the *108* early eighth century and which served as a model for two major buildings farther north in the Deccan: the Chalukyan Virupaksha Temple at Pattadakal and the great Kailasanatha Temple at Elura (see p. 137). The Shore Temple also strongly influenced the architecture of the Cholas, who succeeded the Pallavas as the dominant dynasty in Tamil *110* country.

151

The last Pallava ruler, Aparajita, surrendered to the Chola raja Aditya in 897 after falling under a joint attack of the Pandyas and Cholas. Early in the tenth century the Cholas took the holy city of Madurai from the Pandyas, who had occupied the lower tip of the peninsula from early times, and then moved on to invade Sri Lanka. Their expansive nature culminated with their great king, Rajaraja I (985–1014), who not only dominated all of South India and subjugated Sri Lanka, but also successfully challenged the Chalukyas who had again

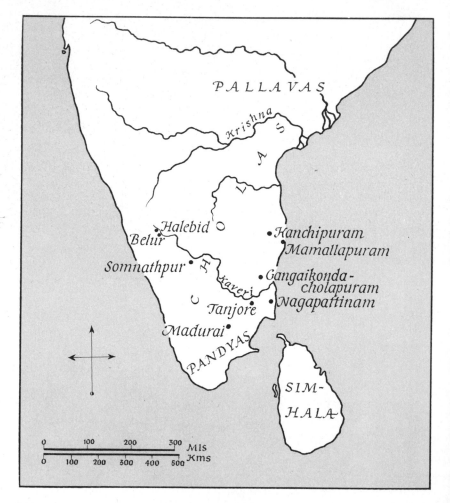

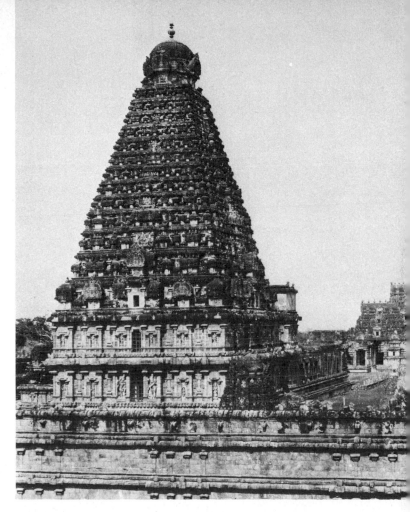

*109 (opposite)
Territory of the
Pallavas, Cholas and
Pandyas in South
India*

*110 Tanjore,
Rajarajeshvara
Temple. Chola,
c 1000*

emerged in the north-eastern Deccan. After leading his victorious army
north, Rajaraja I returned to his capital at Tanjore, and about the year
1000 built a temple of victory and dedicated it to Shiva. The Rajarajeshvara *110*
Temple is the mammoth masterpiece of South Indian architecture, and
in its basic design it displays an obvious debt to Pallava inspiration.

Contained within a walled compound, the temple is 180 feet in
length. It has a Nandi shrine, a pillared porch, and an assembly hall.
The flat-sided, but sculpturally articulated, pyramidal tower over the
main shrine rises from a base 82 feet square to a height of 190 feet, and is
topped with an 80-ton domical capstone, probably raised into position
by means of an earth ramp.

153

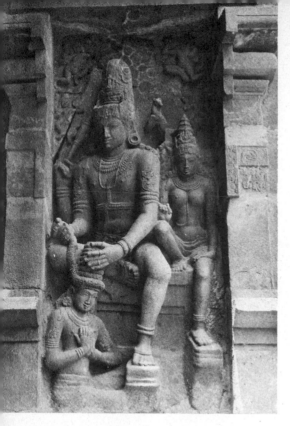

111 *Gangaikondacholapuram Shiva Temple, Rajendra Chola receiving a garland from Shiva and Parvati. Chola, c. 1025*

112 *(opposite, left) Brahmani. Chola, probably 9th C. Granite, H. 29 in. (74 cm). Asian Art Museum of San Francisco, The Avery Brundage Collection*

113 *(opposite, right) Shiva Dakshinamurti. Chola, 11th–12th C. Granite, H. 41¼ in. (1.05 m). Asian Art Museum of San Francisco, The Avery Brundage Collection*

Rajendra I (1012–44), the son of Rajaraja I, followed gloriously in his father's steps, using his naval supremacy to conquer territories as far away as Sumatra. His greatest achievement was to push his realm north to conquer in 1023 Mahipala, the king of Bengal, and to stand on the banks of the sacred Ganges with his victorious army. To celebrate this high-water mark of Chola greatness, he built his own regal city of Kumbakonam. About 1025 he constructed a new temple for Shiva there, called Gangaikondacholapuram, commemorating his march to the Ganges. In a niche beside one of the doorways a remarkable relief
111 depicts Shiva, with his consort Parvati, bestowing a floral garland of victory on Rajendra Chola. The relief also illustrates how, within two centuries, the Pallava stone sculpture style had been refined by Chola craftsmen.

A fine work from this interim period of Chola stone sculpture is a
112 figure of Brahmani, which probably dates from the ninth century and may have been created in Kanchipuram. As related in the *Markandeya*

154

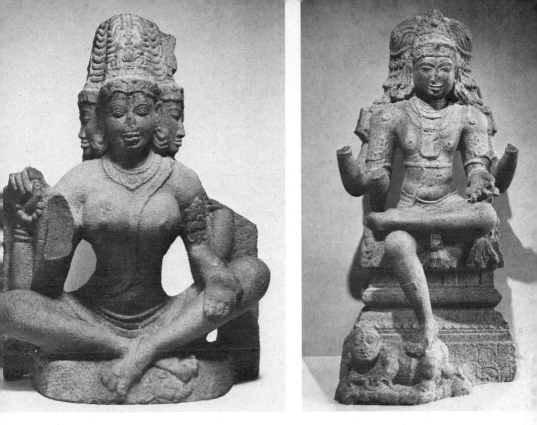

Purana, it represents the feminine energy (*shakti*) manifested by the four-headed god Brahma as an aid to Ambika (an aspect of Parvati), in the goddess's battle against the demon Sumba. The sculpture still has the contained simplicity of the earlier Pallava style, but within its elegant form resides a tension which grants the figure a feeling of latent vitality. The delicate tracery of the jewellery and other decorative elements is subtly and sensuously juxtaposed to the flowing simplicity of the body's surfaces.

A third example of Chola stone sculpture, at least two hundred years *113* later in date, represents Shiva *Dakshinamurti* (literally 'south-facing'), or Shiva as the Great Teacher. In this benign form he is the expounder of knowledge and the arts, and as such he is reputed to have taught the scriptures (*shastras*) to the ancient seers (*rishis*). Shiva's left hand still holds a small palm-leaf manuscript. His hair is handsomely arranged and he is seated in the *virasana* pose, crushing a dwarf, symbolic of ignorance, under his right foot.

115–117 Bronze was to be the Chola sculptural medium *par excellence* from the tenth to the twelfth centuries. The earliest known bronze image in
11 India is of course the famous Dancing Girl from Mohenjo-daro. Much
75 later bronze icons were created in North India during the Gupta period. In the South, the Andhras were perhaps the first to use bronze for sculpture, and there is good reason to believe that it was their style and technique which were continued by the Pallavas. The early and important Buddhist centre at Nagapattinam is also famous for bronze images. Since the Pallavas used Nagapattinam as a site for one of their dockyards, some influence could have spread from there.

114 Only a few small Pallava bronzes are known. A comparatively large and well-preserved figure of Vishnu in Pallava style, produced in the late eighth century, is therefore of importance as evidence of a sophisticated knowledge of bronze-casting in South India. The four-armed Lord of Preservation stands in a rigid frontal pose and wears a high, decorated crown above his oval face. The face has been worn down slightly by worship. His upper right hand holds the disc or wheel, and the left holds the conch. The lower left hand is held at ease on the thigh, and the lower right performs *chin* mudra, which is symbolic of the realization of the absolute. The lower body is covered by a long cloth garment decorated with bows at the waist. Outstanding among the figure's jewels are a large crescent-shaped necklace of characteristic Pallava design and a sacred cord of multi-stranded pearls. The fact that this sacred cord falls across the right forearm clearly identifies this sculpture as a creation of the Pallava period. The feature is common to both stone and bronze Pallava figures, and is not (with only a few known exceptions) found on Chola sculptures. This particular image was perhaps made by the Cheras of Kerala, who were at the time politically and culturally dominated by the Pallavas.

 The technique used to create Indian bronzes was the *cire perdue* or lost-wax process. A model of the object, complete in all details, is first made in wax. Various wax stems are then attached to it at strategic points, making it look somewhat like an arrow-impaled body, and it is coated with three layers of clay. The clay-encased wax figure is then heated. The wax melts out and leaves a cavity in the clay which exactly duplicates the original wax figure. Then the molten bronze, which in India always contained a high percentage of copper, is carefully poured

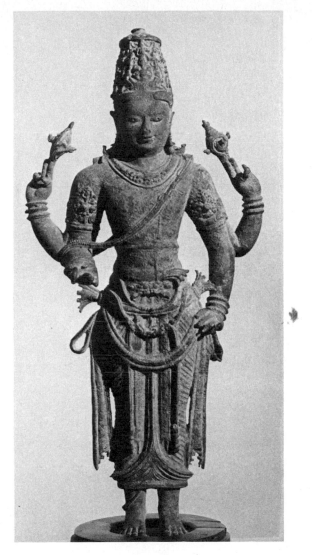

114 *Vishnu, perhaps from Kerala, late 8th C. Bronze, H. 14¼ in. (37 cm). Collection of Dr and Mrs Arthur Funk*

through the channels left by the melted wax stems. Once the bronze has cooled, the clay is broken away, the channel stems are filed off, and what is left is the complete bronze image. During Chola times the moulds were so exactly made that the objects rarely required any additional re-tooling.

Since the mould is destroyed in the *cire perdue* process, each metal icon is unique. The similarity between so many Hindu bronzes is

157

explained by the fact that the craftsmen were religiously required to follow strict canons of measurement and iconography, set out in the *shilpa shastras*, the manuals of sculpture, architecture, and other crafts. Basic to the rules were the measurements defined by the width of the craftsman's finger and the length of his palm.

116 A tenth-century Chola bronze image of Parvati shows the consort of Shiva in the likeness of a Chola queen or princess. The svelte form appears at first to be completely nude because the folds of the one lower garment are minimized as they cling to the upper legs. Even the pointed crown and the jewels appear to merge with the body and to provide only the slightest variation to the modulating contours of the whole. The absolute grace of the slight tribhanga pose, the pendant breasts, the flowing arm and hand positions, all contribute to a unified stylization of the figure and elevate it beyond its human aspect to that of a celestial manifestation. The double lotus base on which the figure stands is fitted at its corners with four square lugs, through which poles passed to support the image when it was carried in processions. The figure still retains some of the fluid grace of the Pallava stone figures on the Arjuna Rath at Mamallapuram.

115 A second fine Chola icon in bronze depicts the *Vinadhara* aspect of Shiva and dates from the eleventh or twelfth century. Although the figure is not as stylized as the Parvati image, it displays the same basic grace, and its masculine power is enhanced by the multiple arms. Shiva here is the Lord of Music and his empty lower hands are posed to hold the stringed instrument with double gourd resonators (*vina*) with which he instructs musicians in the proper forms of *ragas* (see p. 223). He wears a high crown and a short pants-like dhoti. His upper left hand holds the deer which is a symbol of his victorious encounter with a group of jealous rishis. The upper right hand would have held an axe, but this is now lost. Two casting channels, normally filed off, strangely survive on the shoulders. Such holy metal images were always cast of solid metal, and although few were ever made life-size, their weight was considerable. The larger bronze images of deities, when installed in a temple for worship are treated very much like a living king. They are awakened in the morning, bathed, fed, dressed, entertained, and so on. Most are so bedecked with rich cloth and floral garlands that their forms are all but hidden from the devotees before the shrine.

115 (below) Shiva Vinadhara.
Chola, 11th–12th C.
Bronze, H. 27⅛ in. (69 cm).
Musée Guimet, Paris

116 (right) Parvati. Chola, 10th C.
Bronze, H. of figure 36½ in. (92
cm). Courtesy of the Smithsonian
Institution, Freer Gallery of Art,
Washington, D.C.

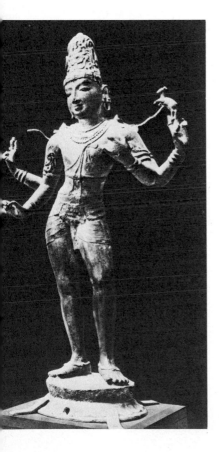

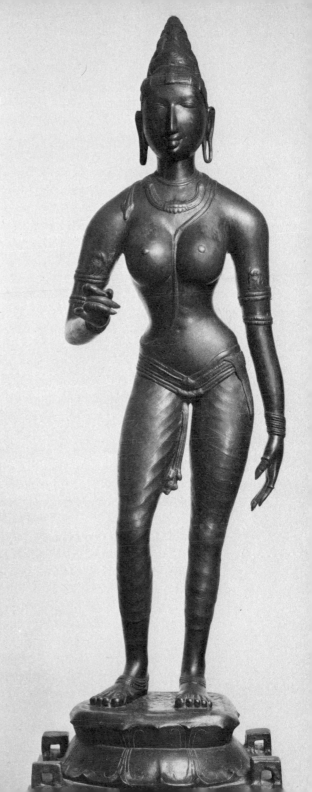

One of the most important and famous of all Hindu icons is intimately associated with Chola bronzes – the great image of Shiva Nataraja, Lord of the Dance or Lord of Dancers. Large numbers of this icon were created during the Chola period, and in South India their manufacture has continued into the twentieth century.

Shiva is depicted in the cosmic dance of creating and destroying the universe. His hair flies out wildly as he dances, transfixed by the rhythm of the small hour-glass-shaped drum held in his upper right hand. The rhythm is the heart-beat sound of the cosmos (maya), and it comes into being through the beneficent action of the creative dance. The cosmos itself is represented as the ring encircling the deity, which springs from the fertile mouths of the makaras on the sculpture's base. Complementing this moment of creation is the simultaneous destruction of the cosmos, symbolized by the flames edging the circle and the single flame held in the god's left hand. The single flame reduces all to naught: it significantly balances the creative drum in the deity's right hand. The lower right hand offers solace to his devotee by performing the reassuring abhaya mudra of benediction. The blessing is further affirmed by the lower left hand's pose of *gaja hasta*. The 'flag' position of the hand is formed by dropping the fingers into an imitation of an elephant's trunk, which here points to the left foot as it springs from the back of the dwarf of ignorance. This symbolic pose promises the devotee release from the sufferings of maya, while the right foot crushes, with the full force of the dance, the back of the dwarf. A poisonous cobra is held by the dwarf, but the same deadly serpent is worn as an ornament over Shiva's blessing right arm.

Among the many other significant details is a skull, visible at the crown of the god's tangled hair. Here also is the crescent moon which symbolizes Shiva's phased presence in and out of the cosmos: even when hidden, he is always there. In his hair, matted with the ashes of the dead, Shiva received the Ganges when it fell from Heaven (see p. 145), and a diminutive figure of the goddess Ganga stands on a strand of hair to the right. She is a hybrid mermaid figure, her female form combined with that of the makara. The symbolism (discussed in detail by Zimmer and by Coomaraswamy in *The Dance of Siva*) is endless, and to a Shaivite devotee the icon is a visual sermon expounding the unbounded compassion and universal power of the dancing creator-destroyer god.

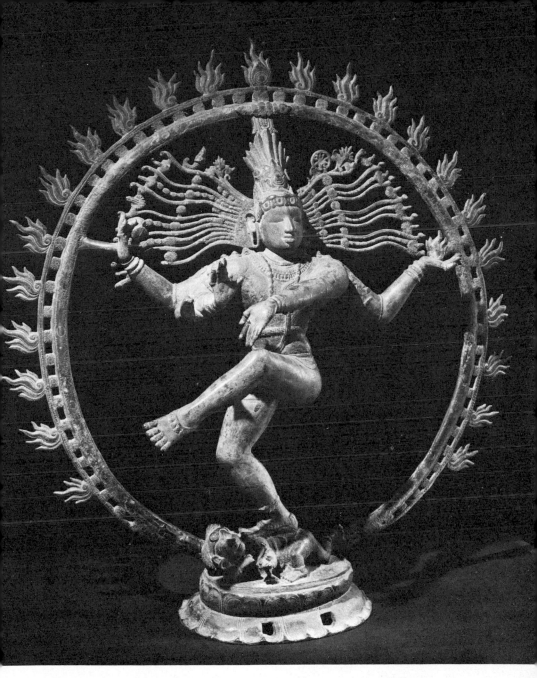

117 Shiva Nataraja. Chola, 11th–12th C. Bronze, H. 32¼ in. (82 cm). Von der Heydt Collection, Museum Rietberg, Zürich

By the middle of the thirteenth century the Cholas had been superseded by their old enemies, the Pandyas of Madurai to the south. And to the west a group of hill chieftains, the Hoysalas, who had previously been feudatories of the Chalukyas, now rose to power in the area of Mysore.

From the twelfth century through the early part of the fourteenth the Hoysalas created a series of temples in the cities of Halebid, Belur, and Somnathpur. These temples appear as low piles of filigree carvings where surface textures dominate and obscure the architectural forms. Their 'Rococo' ornateness is certainly diametrically opposed to the geometric clarity of the earlier Pallava temples.

118 The Keshava Temple at Somnathpur, the best preserved, was founded by a Hoysala general in 1268. Three star-shaped sanctuaries holding triple manifestations of Vishnu stand on a platform composed of narrow horizontal panels carved with complex reliefs. (The sculptors were able to carve such elaborate details because the material, steatite or soapstone, is soft when first quarried. After a period of exposure to the air it hardens and turns dark.) The towers over the cells are very low, and the whole temple, which is squat and intimate in scale, is cloistered within a walled compound.

118 Somnathpur, Keshava Vishnu Temple seen from the back. Hoysala, 1268

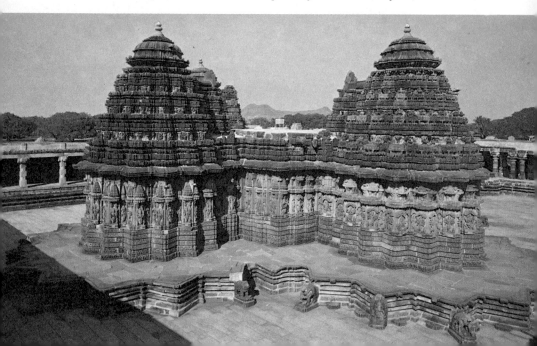

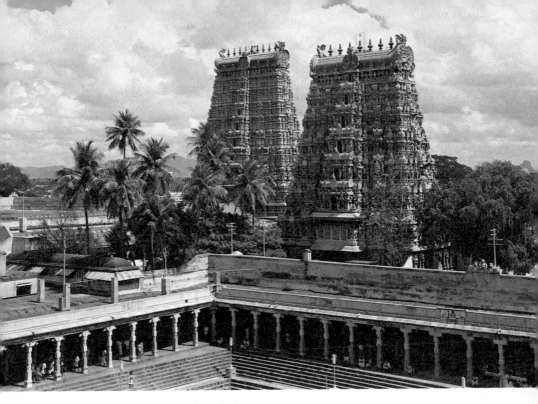

119 *Madurai, Great Temple. Nayak, 17th C.*

An excellent if relatively restrained Hoysala sculpture is a figure of *120*
Ganesha in San Francisco. The elephant-headed, 'mind-born' son of
Shiva and Parvati is shown with four arms, seated and wearing an
elaborate crown and jewels. Behind him is a highly ornate pierced stone
screen. Ganesha is lord (*isha*) of the hosts (*ganas*) of Shiva, and is the
god of prudence and sagacity. As the latter, his image is often placed
over the doors of Indian banks, shops, and libraries. He is also the 'remover
of obstacles', to be propitiated before any undertaking: his image is
painted at the front of illustrated manuscripts, he is attached to the tops
of letters, and he is also saluted before beginning a journey. The rat,
which is equally capable of overcoming obstacles, is Ganesha's vahana,
but is not included in this particular sculpture. As the son of Shiva,
Ganesha holds an axe in his upper right hand and probably once sup-
ported a Shaivite trident in the left. His lower hands hold the point of

one of his tusks, which was broken off in a mythical battle, and a bowl of sweets which he delights in eating. Among the other symbolic details are the three-headed cobra used as a waistband and the *kirttimukha* or 'face of glory' at the top of the back screen. This grotesque face is all that remains of a demon created by Shiva as the supreme destructive force in the cosmos, who with an annihilating hunger consumed his own body. Symbolic of Shiva's destructive powers, it is commonly placed over the doorways of Shaivite temples as an auspicious and protective device.

The last manifestation of Hindu temple architecture in the South is
119 represented by the temple city at Madurai. The ancient capital of the Pandayas had passed from one conqueror to the next, until it came under the sway of the Vijayanagar kingdom which established its vice-roys there about 1370. When the combined forces of the Deccani sultanates crushed Vijayanagar in 1564, the vicroys continued to hold Madurai independently as the Nayak dynasty. In the seventeenth century they transformed it into a complex temple city and enclosed its numerous shrines and huge bathing-tank within a walled compound.

The temple structures themselves are comparatively low, and the various mandapas are renowned for their many rows of elaborately carved stone columns. The largest and most famous of these is called the Hall of a Thousand Pillars.

The main feature of Madurai, however, is the tall *gopurams* or gate-ways. These flattened towers with their tiers of sculptural decoration appear to owe their origin to the shikharas of Pallava and Chola temples. Many other gopuram-dominated temple complexes are found dotted across South India.

In the fifteenth century the influence of the Islamic sultans at Delhi had begun to penetrate the Deccan. Soon after, the greater power of the Mughals would make its impact felt in the South. We must now, how-ever, return to the North, and resume the story where we left off during the Post-Gupta period in the seventh century.

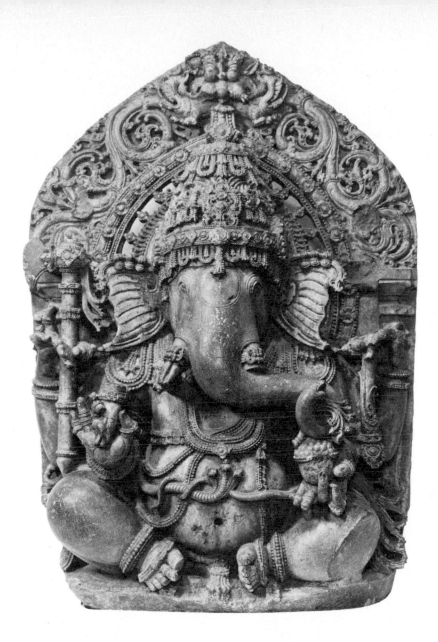

120 Ganesha. Hoysala, 12th–13th C. Chloritic schist. Asian Art Museum of San
Francisco, The Avery Brundage Collection

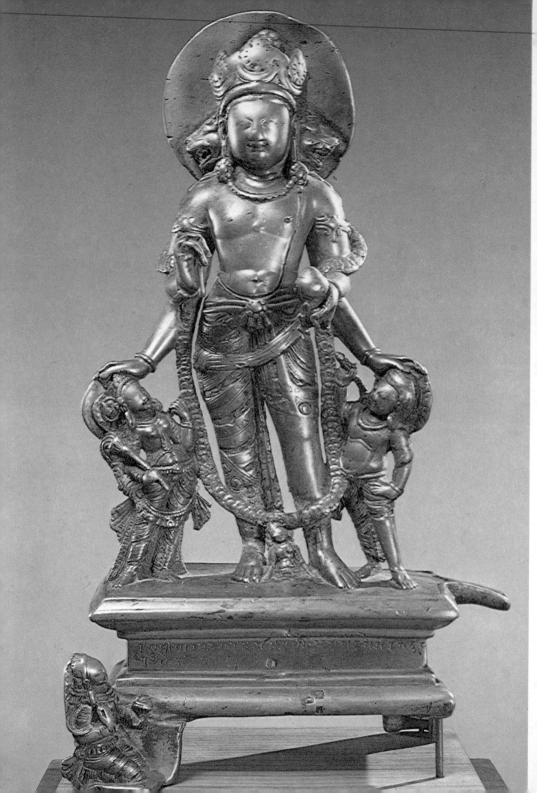

The Medieval period in North India

The use of the term 'Medieval' in Indian history is, at best, confusing. Some historians define the period broadly to include the time between the middle of the sixth and the middle of the sixteenth centuries. From the point of view of art a more logical span would be the five centuries between the appearance of Islam in the Indus delta in the early eighth century and its domination of North India and the Ganges valley during the thirteenth century. Throughout this era great works of Brahmanical and Buddhist art were created in Northern India. Afterwards Buddhism disappeared and Hindu culture slowly became coloured with Islamic influences.

In North India, beginning in the eighth century, the former royal capital city of Kanauj became the object of an obsessive power struggle between three leading kingdoms. Involved were the Deccani Rashtra-kutas, the Palas of Bengal and Bihar, and the Pratiharas from Rajasthan. The struggles eroded these major administrative powers and paved the way for the emergence of numerous small regional kingdoms in the North which were weak and jealously competitive. Also, almost unnoticed, the Arabs conquered Sind in 712, and as the quarrelling, introverted northern Hindu kingdoms continued to ignore the world beyond them, Islam gathered strength in Central Asia.

Meanwhile, Buddhism, which had been all but engulfed by a sea of Brahmanism, retracted into a select number of holy places where it would linger on until it finally fell under the sword of Islam in the late twelfth century. Sites sacred to Buddhism, such as Bodh Gaya, Sarnath and Nalanda, still functioned, and in some cases flourished, under a vacillating Indian patronage and the support of Buddhist pilgrims from South-east Asia who now flowed into India as a steady stream.

One of the major pilgrimage centres was the site of the Buddha's enlightenment at Bodh Gaya in Bihar. The Mahabodhi shrine was

167

121 Four-faced Vishnu with personifications of his attributes, from Kashmir, 9th C. Bronze inlaid with silver and copper, H. 18¼ in. (46.5 cm). Nasli and Alice Heeramaneck Collection, Los Angeles County Museum of Art

established by Ashoka in the third century BC, but the first major struc-
ture was probably erected in Kushan times. The temple we see today has
been much changed by numerous restorations, including a major one
in the nineteenth century. Its basic form dates chiefly from the seventh
or eighth century, but it was drastically repaired in the twelfth century
by the Burmese, who added four turrets at the corners. The shrine
stands on a wide square base some 20 feet high and 50 feet wide, and its
pyramidal tower rises to a height of about 180 feet. It must have repre-
sented a considerable departure from the concepts of the simpler and
smaller Mauryan and Kushan structures, which had centred on a living
Bodhi tree.

122 Medieval sites of North India

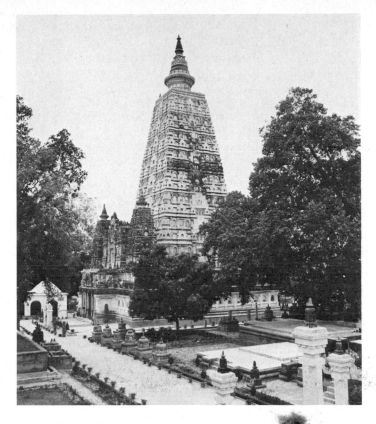

*123 Bodh Gaya,
Mahabodhi Temple.
Built in the 7th–8th C.,
altered in the 12th C.,
restored in the 19th C.*

Along with the devotees from far lands, who simply searched for *darshana* (a mysterious ecstasy generated by being in the presence of a holy person or place) – in the dusty footsteps of the Buddha, came envoys of powerful kings, who wished to aid in the support of sacred sites, repair old monuments, and pay for the construction of new monasteries. Such an act is recorded in a copper-plate inscription of the great Pala ruler Devapala, who in 850 dedicated five villages for the upkeep of a monastery at Nalanda which had been built by the Shalendra prince, Balaputradeva of Java.

Nalanda, the great university city of North India, was associated with the Buddha when a monastery was built there during his lifetime. The city reached the height of its splendour under Harsha of Kanauj (see p. 131) and began to decline in importance only in Pala times, when patronage shifted to other monastic centres. In the first half of the ninth century the famous Chinese monk Hsuan-Tsang visited Nalanda and

recorded that it then had an establishment of 10,000 students and that its lofty towers were lost in the morning mist. Today very little remains, and most of what survives can be dated close to the period of Nalanda's destruction at the end of the twelfth century. The central large stupa, now ruined, appears to be closely related to the temple at Bodh Gaya, being complemented by smaller tower-like votive stupas at its corners. The small stupas still display a number of stucco images which show how the Gupta style was perpetuated as a model into the Medieval period, a fact further illustrated by the numerous stone and bronze sculptures created at Nalanda and elsewhere throughout the Pala and Sena periods.

124
126

A fascinating small sculpture from Nalanda is a votive stupa made of bronze, which dates from the ninth century. P. Pal's recent study showed that the work is conceived as a three-dimensional mandala, related to the metaphysical structure of the world. It features on its lower corners the eight Bodhisattvas, guardians of the four cardinal and intermediate points of the compass. The upper and larger register contains the eight great events or miracles of the Buddha's life.

125

This object, with its elaborate iconography, signals that we are now

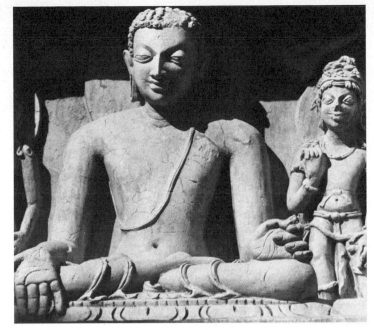

124 (far left) Nalanda, tiered votive stupa. Early Medieval, 7th–9th C.

125 (left) Small votive stupa from Nalanda. Pala, 9th C. Bronze, H. 7½ in. (19 cm). National Museum, New Delhi

126 (right) Nalanda, Buddha on a votive stupa. Probably 8th C. Stucco, H. about 24 in. (60 cm)

dealing with a new and complex form of Mahayana Buddhism. Known as Vajrayana, or esoteric Buddhism, it takes its name from the *vajra* (thunderbolt or diamond) which is its central symbol. The vajra was sometimes also seen as a bundle of arrows or a trident weapon for the gods. Later it took on the identity of the diamond, which signifies the pure indestructible virtue, or absolute knowledge or wisdom, that cuts through ignorance.

This school of Buddhism was an outgrowth of Tantric thought, which after the seventh century permeated not only Buddhist institutions but Brahmanical ones as well. Tantra, the 'doctrine and ritual of the left hand', asserted that the female principle (shakti) is the dominant force in the universe, since it alone has the power to move the dormant male force to action. Here obviously was an outgrowth, or a re-emergence, of the 'mother goddess' cults of ancient times. In Buddhism powerful 'saviouresses' called *Taras*, female counterparts of the Buddhas and Bodhisattvas, evolved. The deities of Hinduism, such as Brahma, Vishnu and Shiva, are complemented by consorts who appear even more active and powerful than they themselves. The term Tantra is also used to refer to specific texts which are collections of magical and

mystical formulae. As their use increased in Buddhism, elements of sexual symbolism and demon worship, understood only by an initiated few, became included in the ritual and served to alienate the common devotee.

22, 55
67, 68 The Bodhisattva concept, which had its iconographic origins in the ancient yaksha figures (see pp. 45–7), was well developed by Kushan times, but it was in the Vajrayana Buddhism of the Medieval period that Bodhisattvas proliferated. One of the earlier Bodhisattvas who remained important was Maitreya, the Buddha of the Future. He was directly related to and served the 'Buddha of immeasurable glory', Amitabha, who was the Buddhist Heavenly Father. The Amitabha Buddha was a product of early Gupta times, and gathered strength as the concept of *bhakti*, or devotion to a personal deity, grew in popularity. The humble devotee envisioned a blissful life following death, in the heaven of Amitabha, the 'pure land of the west', and within this context Maitreya, the Messiah, would come and save the devout of the world.

Of extreme importance also is Padmapani, 'the one who holds the lotus', who is the chief Bodhisattva of mercy. We have already seen him
83 in a wall-painting in Cave I at Ajanta. He is the same as Lokiteshvara or Avalokiteshvara, 'the Lord who looks (shines) down', and as the servant of the Amitabha Buddha he always displays a small figure of Amitabha in his head-dress or crown. Later in China he was curiously transformed into the female goddess of mercy, Kuanyin.

Two Pala period figures of Padmapani or Avalokiteshvara from Bihar well illustrate both the iconographic details of the deity and the
127 transformation of the Gupta sculptural style. The first figure, from Nalanda, dates from the ninth century. The clarity and simplification of
73, 74 form seen in fifth-century Gupta images can still be glimpsed, but they have been reduced by repetition to a formula, becoming overly stylized
128 and desiccated. In the second Bodhisattva, which dates from the tenth century, the frozen Gupta cliché has been modified, and the Pala love of ornamentation overtly manifests itself. (It should be noted that it was this sculptural style which influenced the taste of Buddhist pilgrims from South-east Asia, and is reflected in figures created in Central Java in the ninth and tenth centuries.) In the head-dress of both Bodhisattvas is the Amitabha Buddha, seated in meditation (*dhyani*), and both hold a long-stemmed lotus in their left hand. The more ornate figure is slightly

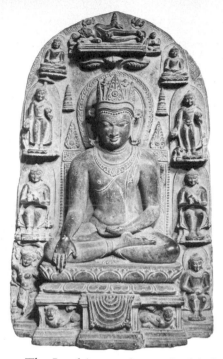

129 *Crowned Buddha surrounded by the eight great events of his life, from Bengal or Bihar. Pala, 10th C. Black basalt, H. 17¾ in. (45 cm). Rijksmuseum voor Volkenkunde, Leiden*

130 *(right) Vishnu with his consorts, from Bengal. Sena, probably 12th C. Black basalt, H. 33⅝ in. (85.5 cm). Courtesy of the Smithsonian Institution, Freer Gallery of Art, Washington, D.C.*

131 *(far right) Vishnu attended by personifications of his attributes, from Bengal. Pala period, 11th–12th C. Bronze inlaid with silver and brushed with copper, H. 17⅞ in. (45.5 cm). The Cleveland Museum of Art, Purchase from the J.H. Wade Fund*

129 The Lord is seated on a double lotus throne supported by two lions, and performs bhumi sparsha mudra (see p. 90). Behind his head is a flaming halo topped by three stylized leaves which symbolize the Bodhi tree of enlightenment. Encircling him are representations of the great events of his life. Clockwise from the lower left, they are 1. the Nativity, 2. the first sermon, 3. the descent from the *trayatrimsha* heaven (where the Buddha had ascended to teach the Law to his reborn mother), 4. the great Parinirvana (indicated by the recumbent Buddha), 5. the subduing of the maddened elephant (see p. 78), 6. the miracle of *shravasti* (where, in an apocryphal public competition with a saint of a rival sect, the Buddha gyrated in air and caused water and fire to shoot from his body), 7. the monkey's offering, and 8. the Enlightenment, represented by the large central figure. At the top, above the head and feet of the recumbent Buddha, are clouds which contain hands holding a drum and cymbals. These objects symbolize the universal rhythm (pulse of creation) and sound (the vehicle of speech). Together they can be interpreted as the divine truth of the Law which is personified by the Buddha. Also above, to either side of the Parinirvana scene, are seated meditating Buddhas which possibly combine with the work's large crowned image to

animated by a tribhanga pose. On its base a seated donor/monk burns incense at the left, and an image of the *Dharmapala* Hayagriva, one of the defenders of Dharma, stands with one foot on an axe at the right. Above, at the left, balancing the lotus blossom, is a seated Buddha figure which (according to van Lohuizen-de Leeuw) possibly represents Shakyamuni.

Not only did Vajrayana Buddhism expand the Bodhisattva pantheon, but it also elaborated the Buddha concept into numerous theological and iconographical manifestations. A tenth-century Pala sculpture shows the Buddha seated on a throne surrounded by representations of the eight great events of his life. The holy master who gave his clothes away, cut his hair, and rejected the world, and was first depicted as a humble ascetic monk (see p. 84), now calls the earth to witness his Enlightenment bedecked with a crown and jewels. The dichotomy is symbolic: jewels stress the power of an earthly ruler, and so the Buddha's yogi body is embellished to show him as an ecclesiastical Chakravartin, or as the ultimate universal king of the spiritual world. This figure obviously is no longer a compassionate image for individual devotion. It has become a formalized, impersonal cult icon, a receptacle for endless magical incantations and chanted *mantras*.

129

127 (right) Padmapani/ Avalokiteshvara from Nalanda. Pala, 9th C. Stone, H. 4 ft 7¼ in. (1.40 m). National Museum, New Delhi

128 (far right) Bodhisattva Padmapani/ Avalokiteshvara or Lokanatha, from Bihar. Pala, 10th C. Black basalt, H. 32⅝ in. (83 cm). Von der Heydt Collection, Museum Rietberg, Zürich

complete the triune manifestation of the *trikaya* iconography, in which the three figures would represent the 'Law Body', the 'Body of Bliss' and the 'Noumenal Body' of the Buddha.

By the eleventh century the forms of Buddhist icons were still indebted to the Gupta style, but they had become completely stereotyped, the only variety being in the degree of decorative detail. Despite their rich symbolism, they ultimately became cold, remote, and inhuman.

During late Pala-Sena times Buddhism felt various pressures from the surrounding Hindu community. In fact, by the twelfth century Buddhism and Brahmanism had much in common, and even the Buddha had become accepted by Hindus as the ninth incarnation or avatar of Vishnu. Brahmanical icons were created in the same style as Buddhist images. A standing figure of Vishnu and his two consorts (now in Washington, D.C.) *130* is typical. Deeply cut into the black stone, the crowned deity is shown with four arms whose hands hold a mace, a disc, and a conch. The lower right hand holds a miniature lotus as it performs the *varada* mudra of bestowing gifts. Vishnu's consorts are depicted as smaller figures, standing in graceful tribhanga poses. On his left, Sarasvati, the goddess

of learning and arts, can be identified by her vina; Lakshmi, the goddess of beauty and good fortune, holds a fly-whisk. On the legs of both is a wave-like pattern which represents the folds of a thin fabric, and is also used to indicate the dhoti of Vishnu. The wavy fabric is characteristic of both Hindu and Buddhist sculptures of this late period, and is typical of the 'Baroque' style in North India before the advent of Islam. The rest of the stele pulsates with writhing images of heavenly beings, makaras, elephants and leogryphs; at the top a 'face of glory' wards off evil.

As one might expect, during such a period of great production and high craftsmanship, many excellent metal sculptures were created. A
131 small bronze image of Vishnu almost duplicates in miniature the previous stonework, but the technique of bronze-casting allowed more elaborate detailing, even on a much-reduced scale. The images of Lakshmi and Sarasvati have been replaced by small figures representing Vishnu's conch and disc (see p. 118). The back screen is ornately pierced, and Vishnu's eyes have been inlaid with silver. Great numbers of even smaller images, many cast in silver and gold, are known. They were used as portable, personal icons.

121 A remarkable bronze, created in Kashmir in the ninth century, presents a four-faced Vishnu attended again by personifications of his attributes. Here, considerably removed from the Pala area, the Gupta influence is even more obvious, not only in the general style of the image but in its iconography as well. The multi-headed form of Vishnu occurs in stone sculptures from Mathura and other sites of the Gupta period. Here the features have been worn down by devotional prayer or *puja*. The top of the base contains a spout at the right to carry off libations, and at the left kneels a female devotee who may represent a donor. Her skirt, Vishnu's, and those of the figures personifying the disc and club are inlaid with strips of copper, and Vishnu's eyes have been inlaid with silver. His crown owes its origins to Kushan or early Gupta styles. The two animal heads on either side of the forward-looking face are references to Vishnu's manifestations as the Man-Lion (Narasimha), and as the
76 Cosmic Boar (Varaha) which rescued the earth goddess. At the back of the image's central head, unseen from the front, a demonic fourth face looks outward through the halo. It appears that Kashmir was the chief centre for the cult of the four-faced form of Vishnu and the famous temple at Avantipur was dedicated to his worship.

Perhaps the best-known early Medieval structure in Kashmir is the ruin of the Surya Temple at Martand. Built within a large rectangular courtyard (220 by 140 feet), edged by a massive stone wall, the Sun Temple is situated on a high plateau with a magnificent view of distant snow-covered mountains. A main cell with high trefoil vaults now lacks its pointed roof, but it is still fronted by a portico. The roof, undoubtedly originally of wood, may have reached as high as 75 feet. The architectural mode, with its pilasters and trefoil arches, is derived from Gandharan models (known from reliefs and from remains at Bamiyan and other sites) which were themselves adaptations of the provincial Roman style practised in Syria and elsewhere in the Middle East. On the façade and around the plinth are sculptures in a late Gupta-esque style. This majestic shrine was erected by the great Kashmiri king Lalitaditya Muktapida, who is recorded in the Kashmiri chronicle *Rajatarangini* as conquering most of Northern India and the Deccan, and as occupying about 747 the much-fought-over city of Kanauj. The riches gathered from this campaign embellished not only the Surya Temple but others in Kashmir, and later made them in turn objects of plunder.

132

132 Martand, Kashmir, Surya Temple: view (right) and sculpture of Surya in a trefoil-headed niche. Mid-8th C.

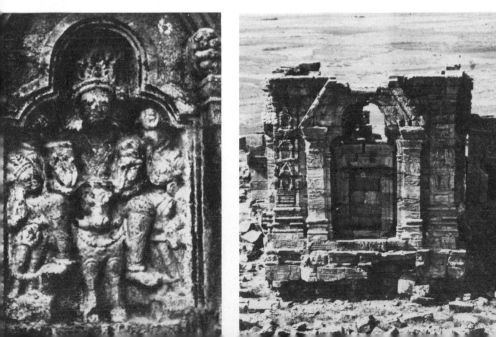

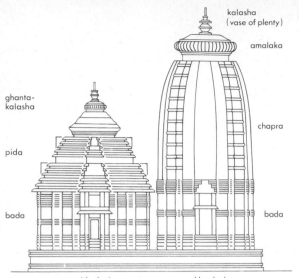

kalasha
(vase of plenty)

amalaka

ghanta-
kalasha

chapra

pida

bada

bada

pida deul

rekha deul

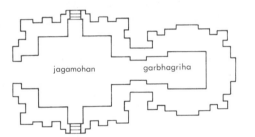

jagamohan garbhagriha

133 The principal elements
of an Orissan temple, in
elevation and plan

134 (below) Bhuvaneshvar,
Parasurameshvara Temple,
c. 750

135 (opposite) Bhuvaneshvar,
Mukteshvara Temple, c. 950
(the gateway to the enclosure
lies outside the picture to the left)

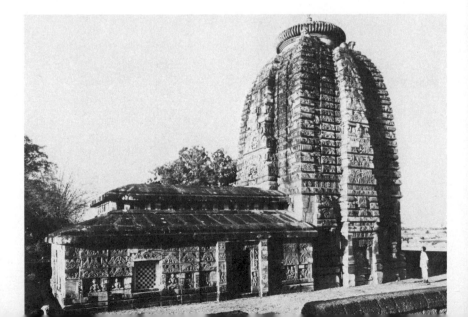

To conclude our discussion of Brahmanical art before the Muslim invasions, we must look at the evolution of the Hindu temple in the Post-Gupta period in North India. Already we have observed how the Hindu temple developed in Central India from a simple square, flat-roofed shrine, such as those at Deogarh, Sanchi, and Aihole. The climax 89, 91 of the North Indian style of temple architecture occurred, however, to the north and north-east in Bundelkhand and Orissa. 133

In the Orissan temples of the Bhuvaneshvar region we have a clear picture of the evolution of a style which begins with the Parasurameshvara 134 Temple of *c.* 750. Here the tower rises at the end of a plain, rectangular, clerestoried assembly hall (*jagamohan*) whose basic geometric qualities are simply defined. But the tower, or *deul* as it is called in Orissan texts, has already developed into a distinct form known as a *rekha*: it rises from a square base and forms a beehive-shaped structure crowned with a flat, round, ribbed capping stone and a rounded 'vase of plenty'. Rekhas are, in reality, no more than four corbelled walls whose sides curve gently inward as they reach the top. On the Parasurameshvara Temple the separate stone courses on the faces of the tower are emphasized by alternating inset courses whose shadows create strong horizontal patterns which are eventually subordinated to the mass of the whole. Among the many sculptural details found here and on other Orissan temples are small chaitya-window motifs (see p. 53) which are by now reduced to mere surface decoration or to frames for figures of humans and animals.

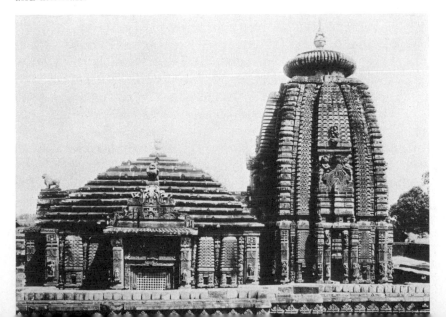

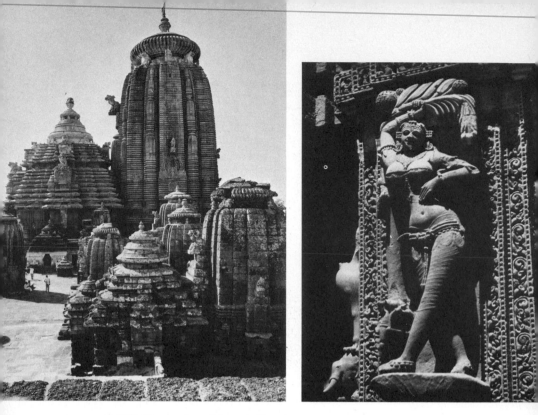

136 (left) Bhuvaneshvar, Lingaraja Temple, c. 1000

137 (right) Bhuvaneshvar, Rajarani Temple, shalabhanjika or dancer, c. 1000

135 With the Mukteshvara Temple, two hundred years later in date, the jagamohan has acquired its typical pyramidal roof. Dating from the so-called middle phase of Orissan architecture, this small shrine is completely covered with the chaitya-window motif in overlapping linear designs. The appearance of the tower has been greatly modified by the vertical ribbing carved up the four corners. The temple is enclosed within a walled compound and is approached through a rounded stone gateway, which is exceptional.

136 The largest temple at Bhuvaneshvar is the great Lingaraja Temple, which dates from about 1000. The contemporary Rajarani Temple,
137 smaller and unfinished, is noted for its superb sculpture. But it is the
138 ruined Surya Temple at Konarak, the so-called Black Pagoda, that is the masterpiece of the Medieval Orissan style.

Standing on the edge of a wide beach on the Bay of Bengal, the magnificent pile of weathered and oxidizing ferruginous sandstone (whence the name Black Pagoda) soars to a height of 100 feet, forming a landmark for sailors far out at sea. Built during the reign of Narasimhadeva I, c. 1238–64, the temple was conceived as a gigantic stone representation of the Sun God's chariot. Twelve huge wheels are carved into the plinth, and the building is preceded by seven sculptured horses.

The temple's gigantic deul was probably never completed because the sandy foundation proved incapable of supporting a tower that would have been some 225 feet high. Only the crumbling outline of its square lower cell remains, surrounded by fallen, uncarved, and roughly finished stone. All Medieval temples relied upon gravity to hold their courses of stone together, so mortar was rarely used; and carving was usually done only when the stones were in position. Such procedures were prescribed by the *shastras*, ancient manuals of building rules, which equated various parts of the Medieval temple with the human body. Excellence of construction was normally assured by threatening the limbs of the architects and donors with ills comparable to the flaws in a temple's construction.

The major unit of the Sun Temple, still intact, is the jagamohan with its pyramidal roof. The assembly hall faces the sea, and is preceded in its eastward orientation by the remaining plinth and massive square piers of a separate dancing-hall or *nata mandir*. In the nineteenth century the jagamohan threatened to collapse and was shored up, and the hall was filled with sand. This room, a cube of about 40 feet, was one of the great interiors of Indian architecture. The original builders had had difficulty with the stone corbelling that formed the room's ceiling, and had installed forged iron beams, 8 inches thick and some 35 feet long. For the thirteenth century the forging of the beams was in itself an amazing feat.

The jagamohan and nata mandir are covered with a filigree of sculpture of the highest quality that includes hosts of erotic couples (mithuna) performing every possible variety of sexual act. The mithuna couple symbolizes the ecstatic bliss experienced by the separated soul of man when reunited with the divine. It is also tied to the Tantric concept of the shakti, the female force (see p. 171). The masculine force was generally represented by Shiva, whose shakti was personified by the

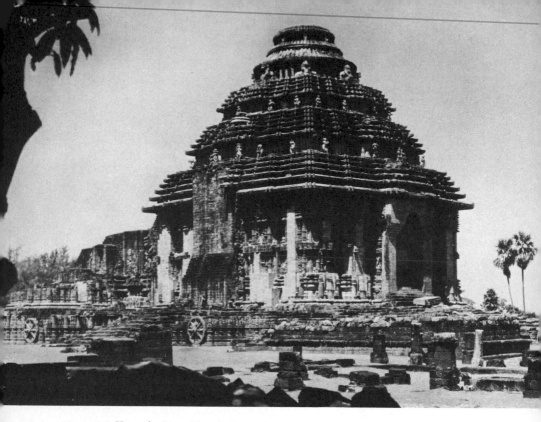

138 Konarak, Surya Temple. Eastern Ganga, c. 1240. In the centre is the jagamohan; to the left, the plinth of the garbagriha cell; to the right, ruins of the nata mandir

goddess Devi. The temple of Konarak may indeed have been a centre for a Tantric cult. Medieval Tantric cults were originally comparatively secret groups or organizations, but eventually, apparently through their erotic excesses, they were suppressed by the Hindu orthodoxy. The invading Muslims must have been particularly thorough in their destruction of temples displaying Tantric themes, for the Surya Temple and the twenty-odd shrines at Khajuraho (pp. 188–91 ff) stand almost alone as the few remaining flowers of Medieval art in North Central India. In addition to Tantric philosophies, the Konarak sculptors must have known the *Kama Sutra*, then already an ancient text on erotica, which describes, among other things, the sixty-four positions of sexual intercourse. But despite all this, the profusion of erotic sculpture at Konarak remains an enigma.

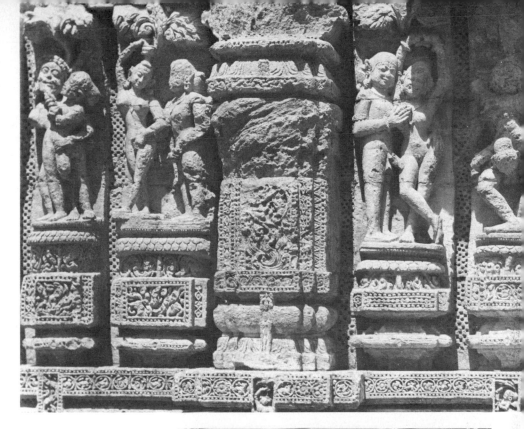

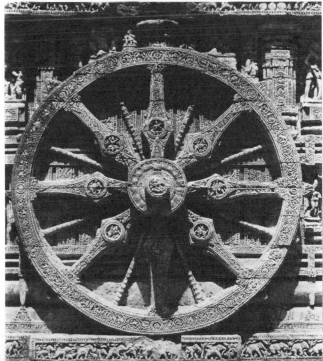

139, 140 Konarak, Surya
Temple, sculpture on the
base of the south wall of the
nata mandir (above), and one
of the wheels carved on the
plinth. Eastern Ganga, c. 1240

On the pyramidal roof of the Surya Temple two wider spaces between the narrow horizontal courses were originally lined with sculptures of female musicians, who provided music for the passage of the god's chariot through the heavens. They are some of the most impressive examples of the style of the Eastern Ganga dynasty. A separate female figure from another area of the temple's fallen façade depicts a dancer posed gracefully in the three-body-bends position which is strikingly reminiscent of the yakshis or shalabhanjika figures on ancient Buddhist gateways.

One of the life-size sculptures from the side of the temple shows the standing god Surya. Its debt to Pala-Sena sculpture is immediately noticeable, but there are other elements, including remote Gupta antecedents, all of which mix to create a viable art form. For example, the back slab of the stele is now completely pierced, and the figure stands almost clear in space. The trefoil arch at the top, an element borrowed from Kashmiri sculpture, has become a characteristic Orissan feature. Both arms of the deity are broken at the elbow, but the large lotus blossoms which originally topped the stems held by the missing hands are still intact on the slab. Below, the seven chargers which drew the Sun's radiant chariot across the heavens are held in rein by Aruna, the half-bodied god of dawn.

This image of Surya, with its monumental presence, seems classically plain when compared with two contemporary stone figures of Narasimhadeva I, the builder of the Surya Temple, where the carver's skill approaches that of a jeweller. Working the stone into such exact detail as to depict each separate link of the chain supporting the Raja's swing, the sculptor is more concerned with documenting the various details of an event than with creating an aesthetic whole. In fact, these *tour-de-force* carvings impress us more as three-dimensional snapshots than as sculptures, and they delight us with an intimate glimpse into regal life. The trefoil-arch motif appears in one sculpture at the top of the swing, and in the other as a detail on the miniature shrines at the left of the devotional scene.

The two miniature shrines are fascinating because they show ritual objects in use which are related to an important icon of the period, a bronze image of Vishnu with his consorts, standing in a space representative of the inner sanctum or cell of a temple. (Now in the Freer Gallery

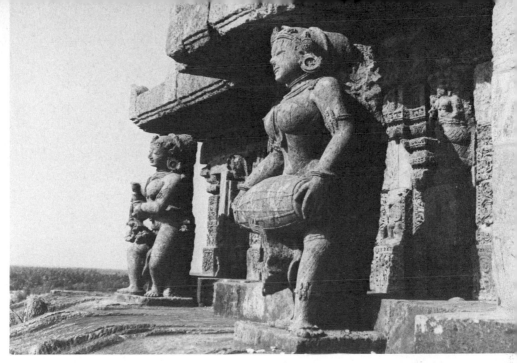

141 Konarak, Surya Temple, figures of musicians on the roof. Eastern Ganga, c. 1240

142 (right) Surya, from the Surya Temple at Konarak. Eastern Ganga, c. 1240. Green chlorite, life-size. National Museum, New Delhi

143 (far right) Dancer from the Surya Temple at Konarak. Eastern Ganga, c. 1240. Sandstone, H. 4 ft (1.22 m). Asian Art Museum of San Francisco, The Avery Brundage Collection

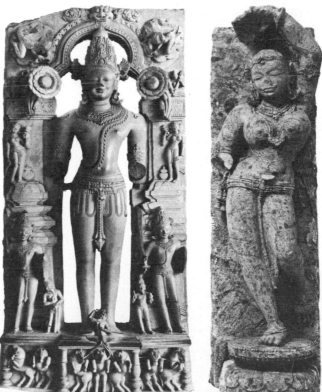

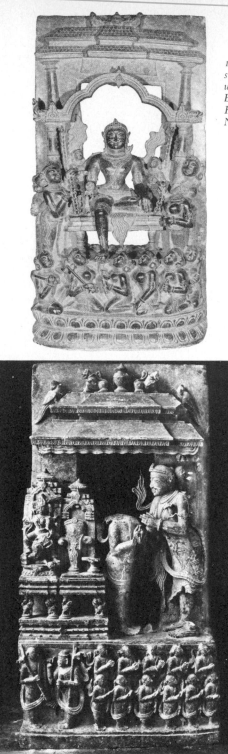

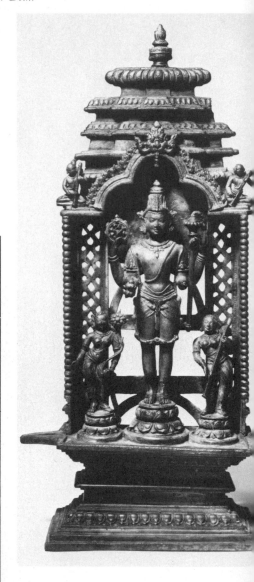

144, 145 *Raja Narasimhadeva I swinging in his harem (left) and worshipping Jaganath (below left). Eastern Ganga, mid–13th C. Stone, H. 34⅜ in. (90 cm). National Museum, New Delhi*

in Washington, this image has been the subject of a special study by *146* Sadash Gorakshkar.) The cell dominates the space below a tower, whose architectural details include the flat ribbed capping stone and 'vase of plenty' which terminate the full-scale deuls of Orissan temples. Below, the god's head is encircled by the now-expected trefoil arch topped by a face of glory. The face is almost a duplicate of the one on the stone sculpture of Surya. *142*

In the eleventh century Abu Rihan Alberuni, the Muslim historian, told of a town in North Central India called 'Khajuraha', 'the City of the Gods'. The poetic name and renowned wealth of this temple city of the Chandella kings of Bundelkhand no doubt attracted the attention of Alberuni's Afghan patron Mahmud of Ghazni, but amazingly Mahmud never raided it, though at this time other fabled cities of Hindustan – Delhi, Kanauj, Somnath, and Mathura – were falling before the iconoclastic armies of Islam. In 1193, when the forces of Muhammad of Ghor struck into the heart of India and Muslim historians gleefully recorded the devastation of temples, those in the scrub jungle of Central India were once more miraculously bypassed. Many times cities were burned, temples despoiled, and images broken down into stepping-stones for mosques. At Delhi a tower of victory and mosque were raised *147, 155* on the site of the city's largest temple (see p. 195).

146 (opposite) Vishnu with his consorts. Eastern Ganga, 13th C. Bronze, H. 17¼ in. (44 cm). Courtesy of the Smithsonian Institution, Freer Gallery of Art, Washington, D.C.

147 Delhi, Quwwat ul-Islam Mosque, plundered Jain columns incorporated in the north colonnade about 1199

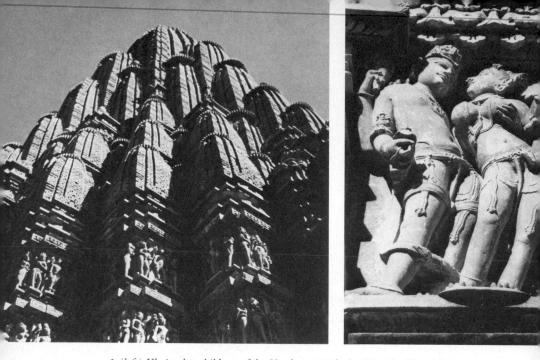

148 (left) Khajuraho, shikhara of the Kandariya Mahadeo Temple. Chandella, c. 1025–50

149 (right) Khajuraho, Parshvanatha Temple, sculpture of Vishnu and Lakshmi. Chandella, c. 950–70

Of the magnificent temples at Khajuraho, mostly built between 950 and 1050, only some twenty survive from an original total of more than eighty. But though maimed by time, they are still among the greatest examples of Medieval Hindu architecture and sculpture in North India.

Scattered today across an open and dusty landscape – once filled with the brick and wooden buildings of a thriving city – the shikharas of buff sandstone stand etched against the constant blue of the Indian sky. Their white gesso coating is gone, but they still suggest the crests of the distant Himalayas; for the Medieval Hindu temple was regarded as a 'world mountain', and its snowy whiteness fitted it to be the abode of the gods (see p. 140). The illusion is carried further in this architectural style by *148* the way in which the central shikhara is buttressed at various levels on its sides by many lesser editions of itself. These lesser towers (*urushringas*) grow from the body of the temple below, where in multi-layered bands sculptures writhe in a pulsating tableau of human and divine activity.

Inside the structure and directly beneath the shikhara is the 'holy of holies' which enshrined an image of the deity to whom the temple was dedicated. Around this central cell there is often a circumambulatory passage, and adjacent to the assembly rooms, facing the cell, are small side porches. Here a soft light filters across the surfaces of sculptured figures which overflow into the chamber from the active and textured exterior.

No imagination is needed to conjure up a vision of the temple dancers, or *devadasis*, who once swirled before the deity's cell, for the sculptors at Khajuraho have frozen their grace into the sandstone of the ceilings and walls of the various temples. In the form of *apsaras*, or heavenly nymphs, *149* their lithe bodies, highly ornamented and full-bosomed, display all the attitudes of dance and gesture. Here one applies *kohl* to her eyes, another removes a thorn from her foot. There one feeds a bird sitting on her shoulder, while a companion wrings out her hair. Multi-armed gods stand formally supporting symbols of their actions and identities, while between them fantastic monsters threaten. Elephants resplendent with harnesses of jewels proceed between stylized lotus blossoms. There is also an abundant display of erotic sculpture, for reasons which – as at Konarak – are not fully understood. Again as at Konarak (see p. 182), it may reflect the activity of Tantric cults.

The shrines at Khajuraho, unlike the multi-unit temples of Orissa, consist of one compact architectural unit standing on a high plinth. Khajuraho is further notable in that both the style and the site were shared by Vaishnavite and Shaivite sects, and even by the Jains.

Khajuraho is dominated by the great Kandariya Mahadeo Temple *150* dedicated to Shiva, built from about 1025 to 1050. Buttressed by eighty-four subordinate towers and ringed by sculptural friezes, its tower soars 102 feet into the air and is the most impressive structure at the site. Kandariya Mahadeo is matched in excellence only by the Jain temple dedicated to the twenty-third Tirthankara, Parshvanatha, which is *151* smaller and earlier (*c.* 950–70), and may in fact have served as the model for the larger temple.

The sculptures on the Parshvanatha Temple are the very finest examples of the famous Khajuraho style, which can best be described as an extension and elaboration of architectural form. The figures not only mass into unified decorative panels, to create monumental surfaces, but

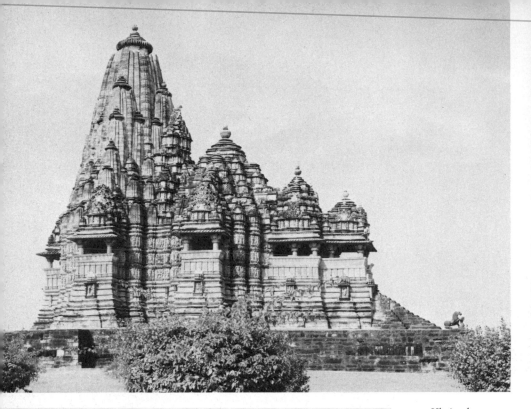

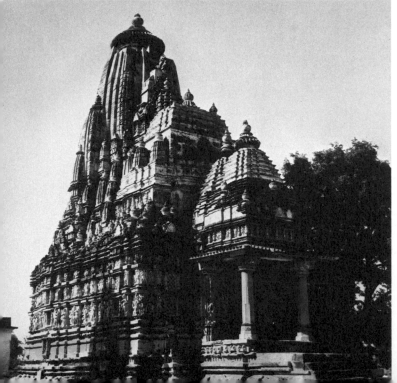

150 Khajuraho,
Kandariya Mahadeo
Temple. Chandella,
c. 1025–50

151 Khajuraho,
Parshvanatha Temple.
Chandella, c. 950–70

152 *Khajuraho,*
crowned figure of a
female deity.
Chandella, c. 950

also emerge as individual human images which are pervaded by a languid eroticism. Carved with an eye to geometric simplicity, the stone is styled into distinct angular planes (suggesting somewhat stilted actions) and rounded volumes. This can lead to clichés, but also to vivid images of grace and vitality. On the southern façade of the Parshvanatha Temple Vishnu and Lakshmi appear accompanied by a lissome apsaras *149* applying make-up to her eyelid. At ground level near by is an exceptionally beautiful crowned female deity, who radiates the sensual *152* vitality for which these Khajuraho beauties are celebrated. She is richly bejewelled, and her full, high breasts and narrow eyes combine with the tribhanga pose to suggest an almost feline movement. The grace of her pointed nose is now lost, but the full, square-set jaw is intact.

153 *Mount Abu, Vimala Sha Temple,*
1032

154 *Sarasvati, Jain statue from Pallu,*
Bikaner. Solanki, probably 12th C.
Marble, H. 37 in. (94 cm). National
Museum, New Delhi

Jainism, like Buddhism, had spread across most of India, and by the late Medieval period had attracted a strong following among the mercantile communities of Western India. In South India the sect had been persecuted out of existence, but the West became a haven for Jain monks, as wealthy merchants accrued merit by establishing temples and monasteries. Throughout Saurashtra, Gujarat and west Rajasthan are countless Jain monuments which survived the devastating Muslims or which were restored or commissioned after the invasions. Their survival testifies to a continued and impassioned support of this austere faith.

Exemplary among the numerous Medieval Jain temple complexes are the shrines of Mount Abu in south-west Rajasthan. Here in the flat, arid wastes of Western India rises a singular peak, 4000 feet high, which in ancient times, according to mythology, had been created by the gods. On this holy summit from 1032 to 1233, at the very time when the Islamic invasion was elsewhere destroying temples, the Jains brought the late Medieval architectural and sculptural styles of Western India to a last flowering. The two outstanding examples are the Vimala Sha Temple (1032) and the Tejahpala/Vastupala Temple (1233).

The Vimala Sha Temple, the earlier and more important, was dedicated *153* to the first Jain Tirthankara, Rasabhanatha. It stands in an open rectangular court defined by fifty-eight subordinate cells which contain small icons duplicating the saint's image in the main shrine. The plan is reminiscent of the Kashmiri Sun Temple at Martand. Elaborate columned porticoes surround the main shrine and front the cells lining the courtyard. Everything is carved from white marble.

From outside the temple, with its low domes, appears undistinguished; but inside a shimmering filigree of marble gathers into complex patterns of frozen beauty. The delicacy of the design makes believable the traditional account that the sculptors did not carve the marble with tools but worked it with abrasive cords, and were paid according to the amount of marble dust amassed by the end of the day.

The same sculptural style appears in an ornate free-standing image of the goddess Sarasvati, whose presence in a temple at Pallu in the desert *154* State of Bikaner, more than 300 miles north of Mount Abu, illustrates how statues were exported far beyond the places of their creation in south-west Rajasthan or Gujarat.

Sarasvati, goddess of learning and music, is of ancient origin and is mentioned in the *Rigveda* as the 'word' which bestows wealth and is the possessor of knowledge. At times she is associated with Vishnu, but she is generally acknowledged to be the consort of Brahma. Her vehicle is a swan or goose. She is especially honoured by the Jains. Her four hands hold attributes illustrating her virtues. The upper right hand supports a white lotus, which is matched in the left hand by a long palm-leaf manuscript. The lower right hand performs the gift-bestowing varada mudra, and the remaining one holds the ritual water-vessel. Sarasvati's main attribute is the classical musical instrument, the vina, which is here played by two small duplicate images of the goddess standing below and behind the worshipful donor figures seated on the base.

The figure has an almost Mannerist fluidity which is reminiscent of the work of the mystical English artist William Blake. Anatomical details are stylized and exaggerated until the body's elements seem merely symbolic, without muscle or bone. The aesthetic of polished stone surfaces, which produced the finish on Mauryan sculptures in the third century BC but is relatively rare in Indian sculpture, here re-emerges as a central aspect of late Medieval art.

The Northern Medieval sculptural styles eventually deteriorated through endless repetition, their forms becoming angular clichés devoid of life and grace. It is as if the once-breathing sculptures had flinched and frozen under the cold iconoclastic eye of Islam.

Islamic India: architecture and painting

Islam first came to India by sea when Arab traders conquered Sind in 712. The main thrusts started, however, almost three centuries later, when the banners of Islam began to be carried through the northern passes of the Hindu Kush by nomadic bandits and raiders. Eventually, when they caught the smell of empire, the Afghans, the Turks, and the Persians came to stay.

The city of Delhi had no clear history until the advent of the Muslims in the late twelfth century. It is first recorded in the late tenth century, when as Lalkot it was a provincial Rajput centre. It was in fact the ruler of Lalkot, Prithvi Raj, who rallied Rajput forces for an unsuccessful stand against Muhammad of Ghor's Afghan army in 1192.

To commemorate this decisive victory of Islam over the Hindus, Muhammad's general and viceroy, Qutb-ud-din Aibak, raised the earliest surviving mosque in India at Delhi. A mosque, or *masjid* ('place of prostration'), is a communal place of worship for Muslims and its first and most primitive forms used on the subcontinent were probably no more than open compounds defined by ropes hung with rugs, or single walls oriented (to the west in India) towards Mecca.

The magnificent Quwwat ul-Islam or 'Might of Islam' Mosque, erected on the site of Delhi's largest Hindu temple, is distinguished first by a 212 by 150-foot open rectangular courtyard. This is contained, on three sides, by rows of stone columns pillaged from some twenty-seven *147* local Hindu and Jain shrines. The western or Mecca side of the courtyard is dominated by an open cloister or hall (*iwan*) emphasized by a grandly carved arcade of five pointed arches, of which the central one is 45 feet high. To the south-east of the courtyard soars the great Qutb ('pole' or *155, 156* 'axis') Minar, which rose originally to a height of some 238 feet. It was haughtily erected as a tower of victory, and its inscriptions proclaim its purpose – to cast a long shadow of God over the conquered city of the Hindus.

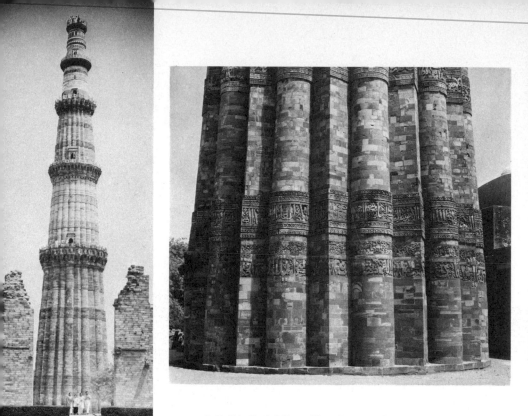

155, 156 *Delhi, Qutb Minar. Slave Dynasty, begun 1199*

The minaret appears to have originally evolved from the low square towers found on pre-Islamic temples in Syria. Later in Western Asia it seems to have been further influenced by a Persian type of burial-tower that was circular or fluted in plan. The immediate models for the Qutb Minar must have been those of Ghazni in Afghanistan, the home of the Turkish-Afghan conquerors of Delhi, which have star-shaped ground-plans.

Qutb-ud-din employed the local Hindu craftsmen of Delhi, and their beautifully detailed stonework is everywhere in evidence. The pointed arches of the mosque's western screen were constructed using only traditional Hindu corbelling techniques; and around these arches and on the decorative bands encircling the minar the craftsmen carved *156* inscriptions from the Koran, in elegant Naskhi script, interspersed with floral designs of Indian origin. Thus a new, hybrid art form was created for Islam's first major monument in India.

157 (left) Delhi, tomb of Ghiyas ud-din Tughlaq Shah I. Tughlaq, 1325
158 (right) Jaunpur, Jami Masjid. Sharqi, 1470

Between the time of the establishment of the Slave Dynasty at Delhi, early in the thirteenth century, and the arrival of the Mughals in the sixteenth century, various Muslim dynasties crossed the historical stage of North India. The Tughlaqs, later in the thirteenth century, built austere and monumental buildings in the Afghan style at Delhi. In the *157* fifteenth century their successors to the east, the Sharqis, created at Jaunpur in the Doab a group of unique mosques distinguished by lofty *158* iwan gateways whose flat, massive façades obscure their central domes. At the same time the Afghans established the Lodi sultanate at Delhi. Its rulers again cultivated a transplanted Persian culture and once more brought it to a brief but lustrous flowering in North India. They practised sophisticated courtly manners, and appreciated elegant literature and poetry. They also constructed numerous buildings around Delhi, whose low domes and thick walls significantly influenced *159* architectural tastes long after the Lodis were gone.

At the end of the first quarter of the sixteenth century the Lodis were displaced by a new invader, and the Indo-Islamic culture reached an apogee of brilliance under the early rulers of the Mughal empire at Delhi and Agra.

The blood of Timurlane and Chinghiz Khan flowed through the veins of the conqueror who founded that empire, Babur (ruled 1526–30). He was a soldier, but he was also a man tempered by a sensitivity to scholarly and aesthetic pursuits. His son, Humayun (ruled 1530–56), became its first true emperor.

In 1540 Sher Shah, an Afghan rebel from Bihar, rose and forced Humayun to flee to Persia into a fifteen-year exile. In the course of this flight across the Western Desert, Humayun's son was born – Akbar, who was to be the star of the dynasty (ruled 1556–1605). While at the Persian court of Shah Tahmasp Safavi, Humayun became enamoured of the art of miniature painting and resolved to take Persian artists back to India when he reconquered it. So when in 1555, with the aid of Shah Tahmasp, he retook Delhi, he brought to India two Persian masters, Mir Sayyid Ali and Abdus Samad. They were to become the nucleus of the new Mughal School of Indian painting.

159 Delhi, tomb of Isa Khan. Sur dynasty, in Lodi style, 1547

160 *Delhi, tomb of Humayun. Mughal, Akbar period, 1565–72*

A year after regaining his Indian empire Humayun was dead, and the fourteen-year-old Akbar sat on the Mughal throne. He never learned to read or write, but he had a great intellect and remembered every word read to him, taking great delight in this manner of instruction. As a boy with his father in Kabul, on the way back to India from exile in Persia, he had taken drawing lessons and had developed an avid love for paintings.

His curiosity was robust in matters of religion, and he eventually founded a new religion (Din-i-Illali), composed of what he considered the virtues of several religions, which he and his close associates followed, to the dismay and discomfort of the devout Muslims at court. A cardinal element in the success of the Mughal empire resulted from Akbar's policy of tolerance for his non-Muslim subjects.

It is paradoxical that such a man as Akbar, with interests in animals and outdoor life, who enjoyed such dangerous sports as elephant fighting, would delight in music, poetry, and painting. His most trusted friend was a Hindu musician, and his writers and painters were honoured for their activities.

165

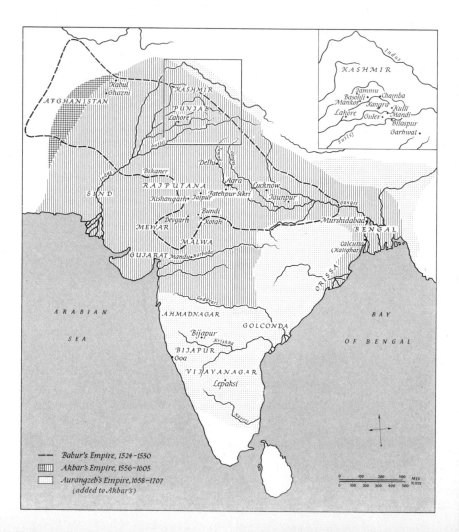

162 Fatehpur Sikri, Panch Mahal (Palace of Five Storeys). Mughal, Akbar period, begun 1571

Akbar's impassioned interests also included architecture, and this led him to build a royal city at Fatehpur Sikri, near Agra, and a fort and palace in Agra itself. In these structures Islamic and Hindu elements were deliberately blended, reflecting the emperor's desire to integrate culturally his diverse nation. *162*

One of the earliest and most significant manifestations of the new style is the design for Humayun's tomb, constructed in 1565 at Delhi by the late emperor's widow. Despite its low dome and use of red sandstone, ornamented with inlaid white marble decoration, this masculine synthesis of Persian and Indian design probably formed the basic model for a later Mughal architectural wonder, the Taj Mahal. *160* *169*

Inspired by the fulfilled prophecy of a Muslim saint who had predicted the birth of his son and heir Salim, the future emperor Jahangir, Akbar undertook the construction of a completely new city – Fatehpur Sikri – on the remote site of the holy-man's retreat, 26 miles west of Agra. For a period of about fifteen years, starting in 1571, a ceremonial capital, including elaborate palaces, formal courtyards, reflecting pools, harems, tombs, and a great mosque, was erected. Over an area two miles long and a mile wide the city rose to completion out of the feverish activity of an army of masons and stone-carvers. They had hardly completed their labours when, due to royal distractions and a lack of an adequate water-supply, the pristine stone palaces were abandoned. *162*

201

One of Akbar's most significant contributions was the creation of the Mughal School of painting. He established a State atelier where about a hundred artists, mostly Hindu, worked under the guidance of the two Persian masters brought to India by Humayun. At the time of Akbar's death in 1605 his library contained some 24,000 illuminated manuscripts.

163 The first major production of the Mughal studio was probably begun under Humayun, but was completed about 1579 under Akbar's attentive eye. This was the Persian *Dastan i-Amir Hamza* or *Romance of Amir Hamza* (also known as the *Hamza-nama*) which consisted originally of twelve unsewn folios with over 1400 individual paintings on cloth. The pictures are unusually large – over two feet high – and have the text written on the back, apparently so that they could be displayed while the romance was read aloud at court. The 'Akbari Style' was a blend of Persian art with native Indian elements, distinguished from its decorative Persian prototypes by an extended sense of space and an agitated action rarely seen in Persian art. The finest examples of Mughal painting are not only lively and realistic, but even contain elements of individual portraiture. These distinctive qualities would not only continue in later Mughal painting but would eventually affect Rajput art as well.

Early in Akbar's reign the Portuguese had established trading-posts in India, and in 1578 Akbar requested that a delegation of Jesuit Fathers from the Portuguese colony of Goa attend him in Fatehpur Sikri. As gifts for the emperor whom they hoped to convert to Christianity they brought illustrated Bibles and religious pictures. These so fascinated Akbar that he immediately instructed his own painters to emulate their qualities. Thus European realism was added to the embryonic Mughal style; and a number of miniatures even depict Christian subjects.

164 A characteristic example of this hybrid art is a page from a manuscript of the *Khamsa* of Amir Khusrau, made for Akbar about 1595. It shows an apocryphal event in the life of Alexander the Great, when he was lowered into the sea in a glass 'diving bell'. The subject is given a contemporary setting, with figures that are typical of the artist's time, including even some Europeans; but the most remarkable aspect of the painting is its subtle colour and the atmospheric treatment of the landscape. Here for all practical purposes a sixteenth-century Flemish scene, complete with aerial perspective, has been transplanted into an Indian miniature. The sure, descriptive draughtsmanship, the refined elegance

163 Gardeners beating the giant Zamurrad entrapped in a well, from the Romance of Amir Hamza. Mughal, Akbar period, 1555–79. Paint on cloth, 26⅜ × 19⅝ in. (67 × 50 cm). Victoria and Albert Museum, London

of the colour, and the imaginative organization of the composition are distinctive elements of the now-mature style. In its latest phase the style moved even further towards realism, and another late Akbari miniature, from the *Akbar-nama* or history of Akbar, depicts an action-filled incident: *165* Akbar on one elephant chases another across a pontoon bridge as the bridge collapses into the river Jumna.

Akbar's encouragement of painting, like his excursions into religious liberalism, was strongly opposed by the orthodox members of his court.

These traditionalists smeared faces on miniatures with moist thumbs in obedience to the Koranic prohibition against portraying any soul-possessing creature. But Akbar's reply was: 'It appears to me as if a painter had quite a peculiar means of recognizing God; for a painter in sketching anything that has life . . . must come to feel that he cannot bestow individuality upon his work, and is thus forced to think of God, the Giver of Life, and will thus increase in knowledge.'

Mughal painting that reflects Akbar's policies of cultural synthesis can be traced from its flat decorative beginnings through a blending with the lively Rajasthani style, and finally to its move towards realism. This last phase, stimulated, as we have seen, by European pictures, included such novel features as golden haloes and cherubs above the emperor's *167* head, shading on faces, atmosphere in landscapes, and a more frequent *164* and more accurate use of perspective.

From the study of unfinished paintings the working procedures of Mughal artists have been reconstructed. Kuhnel writes, 'On the paper which had been carefully burnished, the preliminary drawing was made with red ink – which, after necessary corrections, was restated in black. Then the sheet was coated with a thin wash of white pigment. On this surface, with gouache colours, the actual miniature was painted. Finally, gold was placed where necessary, and the complete miniature was burnished again.'

When the great Akbar died in 1605, his son became emperor as Jahangir (ruled 1605–27). Although never the giant his father had been, *167* Jahangir was a true connoisseur of art and encouraged high-quality productions from the imperial atelier. He prided himself on his ability to recognize the works of individual artists: as some specialized in certain aspects of painting (such as faces, costumes, or landscapes), one picture could contain the work of several men.

The emperor also had a great love of animals, birds, and flowers, and his artists were pressed to record the many varieties from all regions of the empire. The chenar or plane tree, which grows in Kashmir, is the *166* subject of a particularly fine painting of the Jahangir period. There the sparkling rich colours and patterned textures emulate the squirrels' agitated voices as they scatter above the fowler climbing the trunk.

Jahangir was less interested in book production, preferring portraiture and illustrations of the various events which occurred during

164 Alexander lowered into the sea, from the Khamsa of Amir Khusrau. Mughal, Akbar period, c. 1595. Paint on paper, 9⅝ × 6¼ in. (24.7 × 15.8 cm). The Metropolitan Museum of Art, New York, Gift of Alexander Smith Cochran, 1913

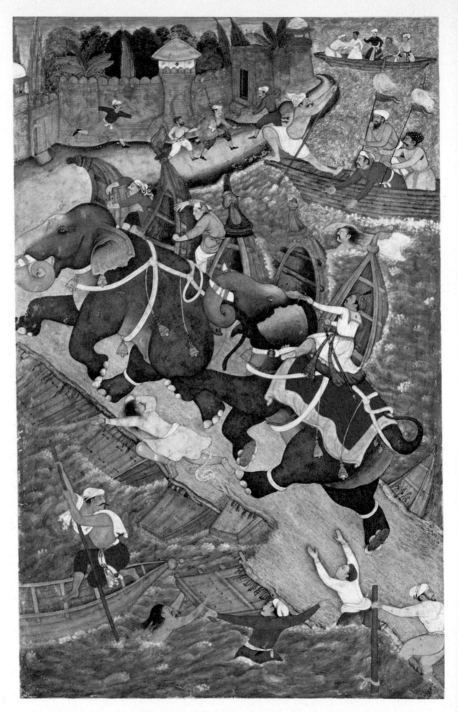

165 Miniature from the Akbar-nama of Abul Fazl. Outline by Basawan and painting by Chatai; Mughal, Akbar period, c. 1595. Paint on paper, $13\frac{7}{8} \times 8\frac{3}{4}$ in. (35.2×22.2 cm). Victoria and Albert Museum, London

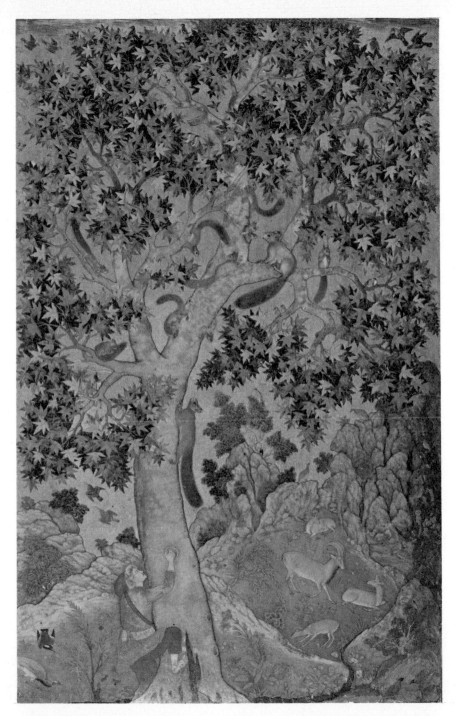

166 *Squirrels in a chenar tree. Attributed to Abul Hasan; Mughal, Jahangir period, c. 1615. Paint and gold on paper, 14⅜ × 8⅞ in. (36.5 × 22.5 cm). India Office Library, London*

his reign. His artists recorded the pomp and colour of the court, and in the end they became more accurate chroniclers of the times than were the historians with their flattery. They went on hunts and into battle; elephants, women, generals, slaves – all became subject-matter for the royal miniature paintings.

In his later years, Jahangir became less and less effective. He became addicted to wine well laced with opium, and as his physical powers slipped, so did his ability to rule effectively. A group of brilliant paintings made near the end of his reign vividly record his pitiable condition.

Richard Ettinghausen (Delhi, 1961) has perceptively discussed the amazing assemblage of symbolism which permeates one miniature. It shows Jahangir, whose name means 'the World-Seizer', enthroned on an elaborate hour-glass. He is backed by a huge halo composed of the sun and moon which in its dramatic scale is reminiscent of the large nimbuses of Mathuran Buddhas of the Gupta period. Such celestial brilliance may allude to the emperor's name of Nur ad-din (Light of Religion) since Jahangir is also shown handing a book to a bearded *mullah*, or religious teacher. An inscription suggests that the emperor is more piously concerned with spiritual matters, and that 'although to all appearances kings stand before him, he looks inwardly towards the dervishes [for guidance]'. Below the mullah are portraits of the Ottoman sultan conquered by Jahangir's ancestor Timurlane and James I of England. The figure at the bottom holding a painting may be the artist, Bichitr, who created this remarkable work. The excellent portraiture is an aspect of miniature painting that reached its peak under Jahangir. The two *putti* flying away at the top appear to lament the emperor's rejection of statesmanship in favour of religion, while larger cupids at the bottom of the throne/hour-glass attempt to counter the effect of the steady flow of the sands of time by writing over the glass, 'O Shah may the span of your life be a thousand years.'

Rich and elegant as they are, the art works of the court of Jahangir's son, Shah Jahan (ruled 1628–58), show the first signs of decline. They are perfect, but of a perfection that is beginning to become lifeless and cold. Such was the mood of the many regal buildings of white marble erected across the empire.

Even in his early years, architecture seems to have held the attention of Shah Jahan more than anything else. The central masterpiece inspired

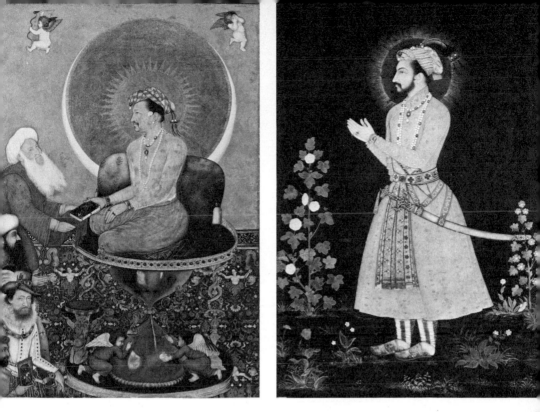

167 (left) Jahangir seated on an allegorical throne. By Bichitr; Mughal, Jahangir period, c. 1625. Paint and gold on paper, 10 × 7⅜ in. (25.3 × 18.1 cm). Courtesy of the Smithsonian Institution, Freer Gallery of Art, Washington, D.C.

168 Portrait of Shah Jahan, inscribed 'a good portrait of me in my fortieth year, by Bichitr'. Mughal, Shah Jahan period, c. 1632. Paint on paper, 8¾ × 5¼ in. (22.1 × 13.3 cm). Victoria and Albert Museum, London (Crown Copyright)

by his interest is without question the mausoleum for his queen, Mumtaz Mahal, at Agra – the Taj Mahal (1632–54) Situated in a formal garden, backed by the Jumna river, its formal white marble façades and minarets float in the shimmering Indian sunlight and project a vision of beauty and grandeur which is remote from the realities of the world. *169*

The Taj's basic plan of a faceted cube is thought to have originated with the tomb of Humayun and the now-ruined mausoleum for the Khan i-Khanan, both at Delhi. But unlike these Akbar period structures, which were finished with red sandstone, the Taj has pure white marble façades. The fabric contributes to the over-all effect of delicacy and denies the existence of the heavy rubble construction inside it. The *160*

209

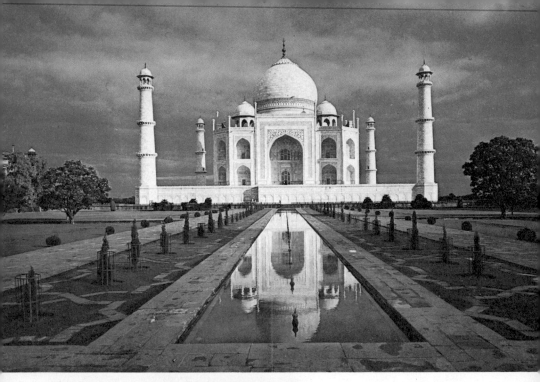

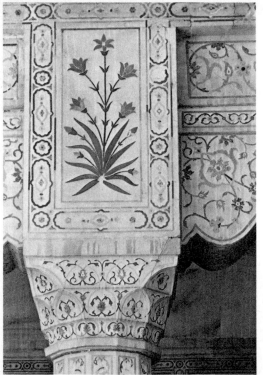

169 (above) Agra, Taj Mahal. Mughal, Shah Jahan period, completed in 1653

170 (left) Agra, Fort, pietra dura inlay in the Musamman Burj. Mughal, Shah Jahan period, c. 1637

171 (opposite) Delhi, Red Fort. Shah Jahan period, after 1638. Painting by a Delhi artist, c. 1820. India Office Library, London

translucent whiteness of the marble is subtly contrasted with a tracery of black stone, inlaid in geometric patterns and Islamic inscriptions. Additional grace is given by the dome, which rises on a high drum over a lower internal dome, as in the tomb of Timurlane at Samarkand. Ultimately the Taj Mahal must be experienced in person, not in two-dimensional photographs. Photography consorts with the building's formal geometry to deny its mammoth size and simultaneous lightness. One can only agree with a contemporary Mughal reaction that the Taj defies an 'ocean of descriptions'.

Shah Jahan also enriched the Red Fort at Agra, not only with the Moti Masjid or Pearl Mosque (1646–53), so called because of its white marble fabric, but also with a series of palaces in its western wing where their elegance strikingly separates them from their robust surroundings, built of red sandstone by his father and grandfather. *170*

He also renovated the fort at Lahore and in 1638, in anticipation of transferring the royal court from Agra to Delhi, began laying out a new walled city, Shahjahanabad (the present city of Old Delhi), along the west bank of the Jumna. There he erected another Red Fort – its *171*

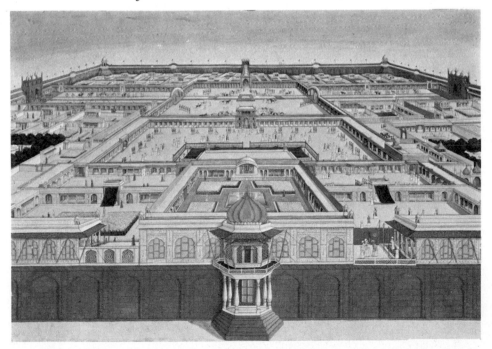

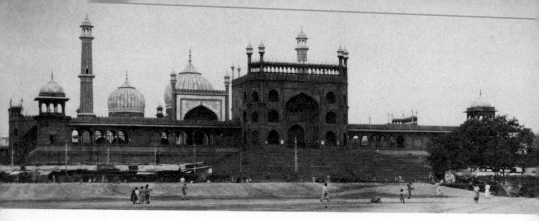

name, as at Agra, alluding to the red sandstone of its walls – and furnished it with superb white marble pavilions decorated with gold, precious stones, and inlays of *pietra dura* work. The latter, an exacting technique of creating multicoloured stone mosaics of flower patterns, etc., may have originated with Italian craftsmen working at the Mughal court. Each stone is fashioned perfectly to fit a complementary shape carved into a marble panel. When all the component pieces have been inset, the surface is polished to a glittering smoothness.

170

An integral element in the design of Shah Jahan's Delhi was the Jami Masjid, built on a high plinth not far from the palace-fortress. The largest mosque in India, it has an open courtyard enclosed by a low arcade with three grand gates at north, east, and south, approached on the exterior by stairways. On the west side three bulbous domes and two massive minarets rise above the covered iwan containing the *mihrab*, or niche which orientates the worshipper towards Mecca. This holy building provided the new city not only with an imposing place of worship but also with an imposing ceremonial centre.

172

The Mughal empire maintained its splendour and its power as long as the momentum of Akbar's strength and enlightened attitudes prevailed. The power extended through three successive reigns, but when Akbar's great-grandson, Aurangzeb (ruled 1658–1707), violently wrenched the Peacock Throne from his father, Shah Jahan, the decline could not be disguised. He reinstituted the strict orthodox laws of Islam and withdrew imperial patronage from the arts. His change of attitude had an equally devastating effect upon the hitherto tolerated Hindu subjects of the empire and upon many Mughal painters and musicians, who drifted into the service of petty nobles and of the Hindu courts of Rajasthan.

Aurangzeb, who had perhaps approached the Mughal throne with more resolve and piety than either his father or his grandfather, after twenty-four years of fruitless campaigning in the Deccan saw the empire he had so purposefully administered and sought to strengthen crumble and collapse. Following his death in 1707 the Mughal empire shrank to the environs of Delhi and began to wane into legend.

The imperial atelier, however, had not been completely disbanded during Aurangzeb's reign, and many artists were still on hand when a revival of patronage occurred under his great-grandson, Muhammad Shah (ruled 1719–48). The Mughal painting style was revitalized, and although in 1739 Delhi was sacked and its inhabitants massacred by the Persian invader Nadir Shah, an elegantly idealized depiction of *173* royal lovers, of about 1740, denies the terrors of the period in which it was created. Like others of the meticulously finished paintings of the 'Muhammad Shahi Revival', it contains certain stylistic elements, such as romantic faces and a lavish rendering of nature, which would soon infuse new refinements into the Hindu school evolving at Guler in the *192* Himalayan foothills.

Finally, in sections of the former empire, such as Murshidabad in Bengal and Lucknow in Oudh, a shadow of the former imperial style was kept alive, and subjects a hundred or more years old were copied, as if to recapture the heroic grandeurs of the past.

172 (opposite) Delhi, Jami Masjid. Mughal, Shah Jahan period, 1644–58

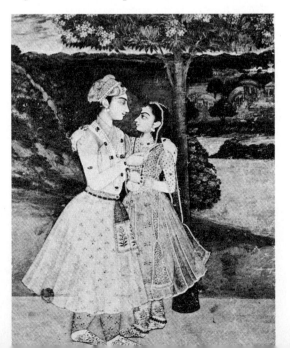

173 A Prince offering Wine to his Mistress (detail). Mughal, Muhammad Shah period, c. 1740. Paint on paper, complete miniature 5¼ × 4¼ in. (13.3 × 10.7 cm). Collection of Edwin Binney, 3rd

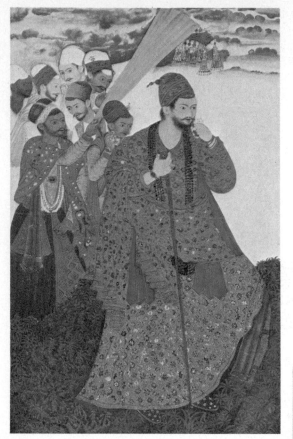

174 (left) Ibrahim Adil Shah II of
Bijapur. Deccani, Bijapur, c. 1590–95.
Paint and gold on paper. Collection of
the Maharaja of Bikaner

176 (opposite) Subduing an enraged
Elephant. Deccani, Bijapur or Golconda,
c. 1600. Paint and gold on paper,
$11\frac{1}{4} \times 8\frac{1}{4}$ in. (28.5 × 20.9 cm).
Collection of Edwin Binney, 3rd

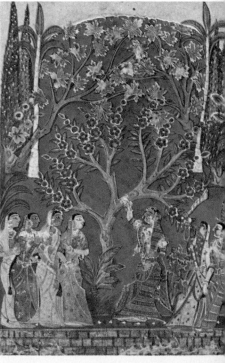

175 A Tree blossoms at the Touch of a
beautiful Woman, from the Tarif
i-Husayn Shahi. Deccani, Ahmadnagar,
c. 1565–9. Paint and gold on paper,
$7 \times 5\frac{1}{4}$ in. (18 × 13.3 cm). Bharata
Ithasa Samshodaka Mandala, Poona

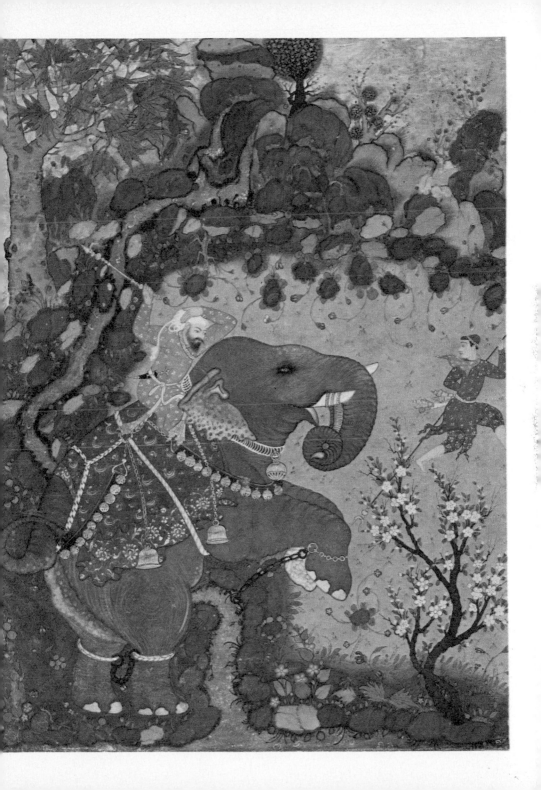

While Mughal painting was developing under Akbar, in the second half of the sixteenth century, the art form was evolving independently in the Islamic kingdoms of the Deccan.

Here in the middle of the fourteenth century the Afghan followers of Muhammad Tughlaq of Delhi had revolted to establish an independent kingdom under the Bahmani dynasty. For almost a hundred years a certain unity was maintained, but in the late fifteenth century several areas began breaking away. Finally in 1526 the Bahmani dynasty disappeared and the Muslim courts of Ahmadnagar, Bijapur, and Golconda emerged as the dominant powers in the South. There they became the effete and quarrelsome neighbours of the great Hindu kingdom of Vijayanagar. In 1565 they united briefly and destroyed the rich capital of Vijayanagar, but the alliance at once dissolved, and the three returned to their languid and introverted ways, to await the ultimate dominance of the Deccan by the Mughals.

The evolution of the Deccani painting styles and their exact provenance are still the subject of scholarly investigation. However, it is generally accepted that the earliest known Deccani miniature paintings 175 are those illustrating the Persian-style epic *Tarif i-Husayn Shahi*, which is a poetic account of the Ahmadnagar ruler Husayn Nizam Shah I (ruled 1553–65), and was commissioned by his mother when she served as regent, *c.* 1565–9. The page shown complements the text and flatters the feminine patron, while being a bold, virile work which in its totality is unlike any previous Indian creations. The elongated faces, oversize jewellery and tall, slender figures draped in saris that cross their breasts in the Southern fashion, are Deccani inventions. The same faces and large ornaments had already appeared in the *Ni'mat-nama*, painted some fifty years earlier at Malwa in Central India (see p. 225), and the elongated faces and figures are also dominant motifs in the Vijayanagar-style wall-paintings in a Hindu temple at Lepaksi, south of Ahmadnagar, created about 1540.

In general the painting styles which developed in the Deccani sultanates were marked by refined elegance, sensitivity to colour, and love of decorative detail. Beside those elements which appear to be of Hindu origin, Iranian, Turkish, and European influences seem to have arrived directly in the South through a flourishing sea trade, instead of coming

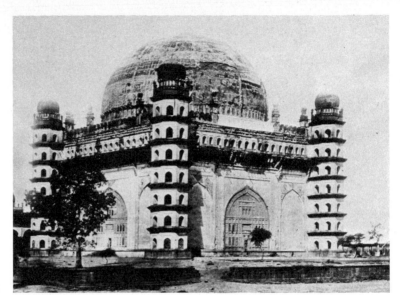

177 *Bijapur, Gol Gumbaz, left unfinished in 1660*

second-hand from the Mughals in the North. The Deccani works perhaps never reached the Mughal level of technical excellence, but they have an easy-going opulence, reflected in elaborate detail and dramatically conceived compositions, rich with gold. In fact, unlike Mughal painters, the Deccani artists from the beginning tended less to realism and more towards an idealized imagery. This suggests strongly that Hindu painters displaced from Vijayanagar after its fall in 1565 may have been leading figures in the Deccani workshops. *176*

One of the greatest of the royal Deccani patrons was Ibrahim Adil Shah II of Bijapur (1580–1626). Ibrahim was not only an accomplished musician but also a painter equal to any in his atelier. There are several famous paintings of *ragamalas* (Hindu musical modes) known to have originated at Bijapur during his reign, and one painting is believed to show him holding wooden rhythm clappers used by musicians. *174*

Ibrahim died in 1627, as did Jahangir, and that year might be said to mark the beginning of the decline of both Mughal and Deccani painting. Ibrahim was followed on the throne of Bijapur by Muhammad Adil Shah (ruled 1626–56), who is remembered chiefly for his tomb, the Gol Gumbaz. With a dome 178 feet high, the tomb is one of the world's largest domed spaces, and it is also the most significant Islamic building in the Deccan; but its architectural presence is less than distinguished – a fault that might perhaps have been remedied if it had ever been finished. *177*

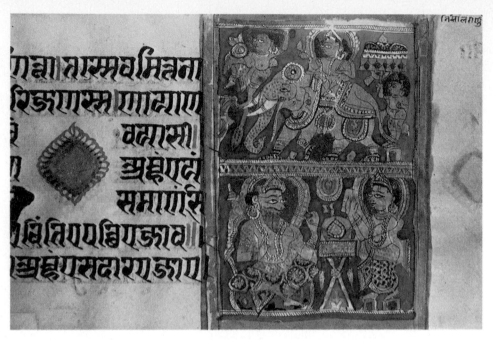

178 *Detail from a Jain Kalpa-Sutra manuscript. Western India, early 16th C. Paint on paper. Private Collection*

179 *Bilhana and Champavati, from the Chaurapanchasika series. Possibly Uttar Pradesh, c. 1525–70. Paint on paper, 6½ × 8½ in. (16.5 × 21.6 cm). N.C. Mehta Collection, Culture Centre, Ahmadabad*

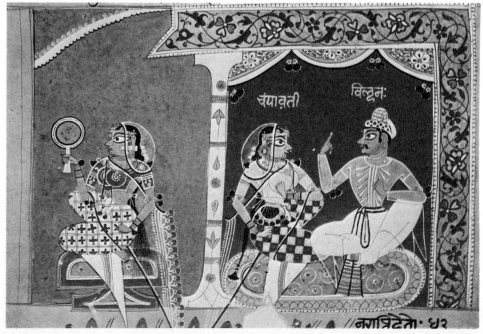

Jain, Rajasthani and Pahari painting

Long before the first century AD paintings were used in India as illustrations for volumes of sacred scripture. These first 'books' were composed of slim, delicate palm leaves, seldom more than two inches in height, *180* threaded on cords which secured them between flat wooden covers. The oldest to survive date from the eleventh century. They are the Pala Buddhist manuscripts from Bihar and Bengal and those of the Jains of Western India.

The calligrapher who dealt directly with the sacred text was considered the paramount craftsman, and (as W. N. Brown observed in his detailed studies of Jain paintings) while ruling in the guidelines for his script he indicated the area and subject-matter for the illustration. Only after he had written out the text was the leaf handed over to the painter.

The few remaining Pala palm-leaf illustrations are sophisticated in line and colour, with figures modelled closely upon the Pala sculpture of the late Medieval period. Scattered before the wrath of Islam in the late twelfth century, the Buddhist community and their Pala-style art were transplanted to Nepal and Tibet, where in remote Himalayan monasteries the style was repeated endlessly, in a static and desiccated form, down to recent times.

WESTERN INDIAN PAINTING

The 'Western Indian School' of Jain palm-leaf painting was treated *180* more kindly by history. It flourished under the patronage of the Jain merchants and shipbuilders of Gujarat, whose wealth permitted them to fill the libraries with sacred texts. The style is flat and decorative. Its early palette was generally restricted to simple reds, yellows, some blue, gold, black, and white. The vigorous quality of the drawing line is its most distinctive virtue, though even that remained formalized.

A distinguishing characteristic of early Jain painting is that in profile heads both eyes are shown – a device that anticipated twentieth-century Cubism's attempt to display all sides of an object simultaneously. The feature may be due to the artists' use as models of temple sculptures of the type seen at Mount Abu and elsewhere, which had bulging glass eyes added to enhance the realism of the image.

We know that paper came to India through Persia during the second half of the 1300s, and that the transition in Western Indian painting from palm-leaf to paper had more or less taken place by the beginning of the fifteenth century.

The same Jain trading vessels that had brought paper to India were responsible for importing blue pigment, and it too was to have an effect on Jain painting. By the sixteenth century the solid red backgrounds, traditionally used as the basic panel for each illustration, had changed
178 to blue. The change is a key factor in determining the date of Western Indian paintings. More greens and blues were added to a brightening palette, and with the adoption of a paper ground the brushwork became more elaborate and detailed than had been possible on the palm-leaf surface.

The use of paper also allowed the paintings to expand vertically, and in the vertical format they tend to have a Persian flavour. Nevertheless the artists often retained a number of strong horizontal elements inherent to the palm-leaf tradition, and at first they stacked their pictorial elements on top of one another. Unlike the earliest paintings, which
180 featured Jain saints, gods and patrons, the later works began to contain more narrative and to make wider use of foliage, animals, and elaborate architectural settings.

The gradual acceptance of the 'Persian' or vertical format is particularly noticeable in the development of Rajput miniatures, as they evolved out of Western Indian art. An example is what is believed to be a late fifteenth-century manuscript from the Uttar Pradesh area of
181 North Central India, illustrating the *Laur Chanda* (a love-romance, still popular today). The angular outlines of the bodies and two-eye profile proclaim it to be an offshoot of the Jain painting style, but its vertical format is dramatically different. A preference for that format in Indian painting was later reinforced by the influence of Mughal painting upon Rajasthani styles.

180 *Detail from a Jain palm-leaf manuscript, showing a monk and disciple. Western India, from the region of Udaipur in Mewar, 1260. H. 2 in. (5 cm). Museum of Fine Arts, Boston, Ross Collection*

181 *(below left) Page from a Laur Chanda manuscript. Uttar Pradesh (Delhi or Jaunpur?), late 15th C. Paint on paper, 7½ × 4½ in. (19 × 11.5 cm). Bharat Kala Bhavan, Banaras*

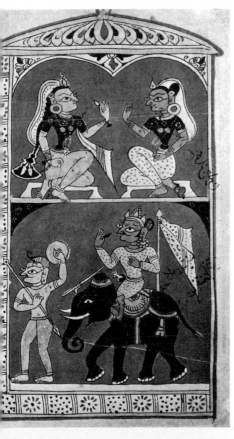

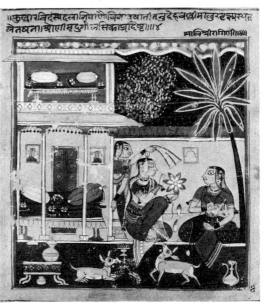

182 *Malasri Ragini. Rajasthani, from Chawand in Mewar, 1605. Paint on paper, 8⅜ × 7⅜ in. (21.2 × 18.7 cm). Nasli and Alice Heeramaneck Collection, Los Angeles County Museum of Art*

The pioneer scholar of Rajput painting, Ananda Coomaraswamy, divided the Hindu styles into two distinct schools based upon areas of provenance. These are the Rajasthani, from the Central Plains, and the Pahari, from the Himalayan foothills. The exact evolution of the Rajasthani style out of early Western Indian painting, with all its complex ramifications, and its further mutation under the impact of Mughal art, is still imperfectly understood and documented.

A very important factor which affected the early development of Hindu miniature painting in Central India was the rise of a vernacular movement. After the destruction of the Medieval Hindu kingdoms by Islam, the Sanskrit tradition had broken down, but with the rise of an indigenous literature in the fourteenth century Hinduism began to experience a renaissance. The scriptures and epics, formerly the prerogative of the priests and nobles, now became more directly available and entered the mainsteam of everyday life. The devotional (bhakti) cults grew more popular, and paramount among the personalized gods *186, 196* emerged the bucolic Radha-Krishna manifestation of Vishnu, with its setting in the world of cowherds and its erotic overtones. Religion found new life, and all the arts expanded under this revitalizing impetus.

Among the popular literary works profusely illustrated in the early Rajasthani painting styles were the *Bhagavata Purana*, the *Gita Govinda*, the *Chaurapanchasika*, the *Rasikapriya*, and the *Baramasas*. The last are descriptions of the various seasons of the year. The *Bhagavata Purana* deals with the multiple aspects of Vishnu and tells the symbolic life story of Krishna from his birth in Mathura and his adventures as a herdsman in Gokul, through a second phase as a prince ruling in the city of Dvaraka. The *Gita Govinda*, written by the twelfth-century Bengali court poet, Jayadeva, was a favourite with Rajasthani painters because it deals exclusively with the romantic exploits of Radha and Krishna in a pastoral setting. Radha, one of the loveliest of all the *gopis*, or herdswomen, was a married woman who was transfixed by a passionate obsession for Krishna and rejected her husband for him. The allegory is clear: the adoring Radha represents the soul while Krishna is God, and together they represent the ecstatic reunion of man's soul with the Godhead. *179* The *Chaurapanchasika* was also composed by a court poet, Bilhana, but in Kashmir in the eleventh century. It is a group of fifty love lyrics

reputedly composed by the poet as he was led to execution for falling in love with his ward, a princess. The king was so moved that he pardoned him and granted him his daughter in marriage.

Heroes and heroines (*nayakas* and *nayikas*) are frequently depicted in the guise of the celestial lovers, Radha and Krishna. This is especially so in the case of the *Rasikapriya*, which was composed in 1591 by the court poet of Orcha, Keshavadasa. It is a poetic catalogue of heroes and heroines and the various emotional characteristics and circumstances associated with them.

It is essential for the appreciation of Indian miniature painting to realize that while Mughal art was basically realistic, Rajput painting was – like Hindu literature – consistently symbolic and suffused with poetic metaphor. One might relate this quality to the Hindu and Buddhist concept of maya: since all life is an illusion, art, which is an interpretation of life, is valid only as a vehicle for deeper, hidden meanings. Indeed the art of painting itself, by its very nature as a visual illusion, is symbolic.

To the Rajput artist all men are symbols and all nature is symbolic. When he painted the figure of a woman, her appearance would duplicate that of other women in the picture, and they in turn were symbolic of all femininity. The artist's ultimate desire became to clarify man's relationship with God: it was recognized that the simplest manifestations of nature, everyday events, and basic drives and emotions, were all means to express noble ideas. Different colours were given distinct meanings: red connoted fury, yellow the marvellous, brown the erotic, and so on (see Mehta and Chandra, *The Golden Flute*). Colours were also used to represent specific musical notes, and this fact brings us to one of the most striking manifestations of Indian art, the *ragamala* paintings.

Ragamala means garland of melody or mode. It refers to a particular type of miniature painting in which poems dealing with musical senti-ments are illustrated by representations of specific human situations. Through the verbal imagery of a poem, the content of the musical form (*raga*) was made more exact, and the painting in turn made this imagery visible. A raga, the classical Indian musical mode, literally means some-thing that colours, that imbues the mind with a definite feeling, passion, or emotion. There are six basic male ragas with five 'wives' or *raginis* each, accounting for the total of thirty-six fundamental modes in North

Indian music. Each raga is further associated with a particular season and time of day. One speaks of a raga as being either a 'morning' or 'evening' raga. To perform one at an inappropriate time is thought to be not only unaesthetic but hazardous.

Ragas are always improvised by the performing musician from a limited number of basic notes directly related to the emotional content of the music. In order to understand this emotional content more perfectly and to assure an accurate interpretation, the performer looked to ragamala verses and paintings to reveal the distinct flavour and emotional quality of the music. Such paintings are unique in the world of art. It is only in India that painting, poetry, and music come together in such a unified and interdependent grouping.

182 An early ragamala painting, dated 1605, comes from the Rajasthani State of Mewar, which was an important seat of Rajput culture. The earliest paintings created there are Jain works in the conventional
180 Western Indian style. Even during the difficult times of Mughal harassment in the sixteenth century paintings continued to be produced: this ragamala work was painted nine years before Jahangir's final conquest of Mewar in Chawand, a small remote village at the extreme south-west edge of the State. The subject is a feminine mode which suggests longing for the missing lover. The lady waits by an empty bed plucking the petals from a lotus and wonders, 'loves me, loves me not?'. This early Rajasthani style, which shows some affinities to the *Laur*
181 *Chanda* imagery (see p. 220), is marked by a stark simplicity. Its spaces are defined by rectilinear planes of vivid red, yellow, green and black. The flat open spaces are modified by superimposed figures, animals, urns and trees which disguise the composition's geometric austerity, reminiscent of folk art.

179 A *Chaurapanchasika* illustration depicting the hero and heroine Bilhana and Champavati is thought to have been painted in Uttar Pradesh between 1525 and 1570. Here a hint of some of the sources of the early Rajasthani style is provided by two elements in the costume of the hero. One is the four pointed ends of his transparent coat (*caka dar*), and the other is his remarkable headgear, a turban with a lattice design in front and a central pointed cap (*kulah*). It has been surmised that these dress characteristics were of Afghan origin and were fashions of the Lodi and provincial sultanate courts during the pre–Mughal period

in North and Central India. The many paintings which feature them are collectively known as the Kulahdar group. The origin of this early style of painting is not yet completely certain, but Khandalavala and Chandra (in *New Documents of Indian Painting*) recently narrowed the field down to Uttar Pradesh, with a strong focus on Delhi.

In the *Chaurapanchasika* miniature Western Indian painting has clearly turned towards an entirely new form. The change was influenced not only by contemporary Islamic styles but also, one must conclude, by yet unrecovered Hindu paintings of the fifteenth and early sixteenth centuries. Early examples of Rajasthani painting are slowly being identified, and will no doubt help to clarify the situation.

Yet another of the leavening forces at work is revealed by one of the most famous Islamic manuscripts of the pre-Mughal period, the *Ni'mat-nama* or 'Book of Delicacies', a cookery book executed for *183* the sultan of Mandu in Central India about 1500–1510. The artists – undoubtedly Indian – were influenced by the Turkoman style of Persian painting.

By about 1625 Hindu miniature painting no longer showed Western Indian features, and various regional styles were developing. From the Central Indian State of Malwa comes another ragamala painting. The *185* composition is now comfortably at home in a vertical format, and the elegantly elongated trees and figure emphasize the vertical space. The colour is still applied in a flat manner, with no attempt at shading or tonality, but its mosaic-like patterns, especially on the trees, create a complex effect of variety and richness. The subject is Todi Ragini, a feminine musical mode of the rainy season – indicated by the narrow band of rain clouds boiling across the top of the picture. It appears that the youthful Todi has attracted deer out of the forest with the sweet sounds of her vina, but their presence only adds to her feeling of loneliness at being separated from her beloved during the rains. (For another use of rain symbolism, see p. 240.) The luxuriant trees with their plumes of new growth underline the ripening beauty of the heroine and add an air of agitation and suspense to the mood.

Much more than years separates *Todi Ragini* from an eighteenth-century Bundi miniature depicting Krishna approaching the tryst, *186* dressed as Radha. The style and execution have considerably advanced, and there is a sophistication which was the result of Mughal influences.

183 (left) Miniature
from the Ni'mat-nama,
showing the sultan
overseeing the preparation
of delicacies. Central
India, Mandu,
c. 1500–1510. Paint and
gold on paper, 4½ × 5 in.
(11.5 × 13 cm). India
Office Library, London

184 (opposite) Raja
Umed Singh of Kotah
shooting Tiger.
Rajasthani, Kotah,
c. 1780. Paint on paper,
13 × 15¾ in. (33 × 40 cm).
Victoria and Albert
Museum, London

Starting in the seventeenth century, the rajas of Bundi State had
been intimately associated with the Mughal court. Either Mughal
artists actually migrated to Bundi about the middle of the eighteenth
century or a group of Bundi painters fell under the spell of certain
Mughal themes and techniques of the Shah Jahan atelier. This is suggested
by a peculiar manner of rendering shadows, the quality of the paint
surfaces, and the subtle colorations which infuse certain Bundi pro-
ductions. The present miniature shows these characteristics and also
other typical Bundi elements – the lotus pool, Brahminy ducks, and
scarlet railing. The tableau is dramatically dominated by a blind sun
which casts an eerie, timeless light over the otherworldly landscape – the
enchanted land of Radha and Krishna's cosmic romance. The profuse
plantain trees, a constant trademark of Bundi art, writhe with lush
ferocity and force their presence to centre stage where they all but engulf
the hero and heroine.

186

Among the moods and attitudes of the hero and heroine described by Keshavadasa in his love poem, *Rasikapriya*, is the state of *hava*, which relates to external manifestations of the emotions of love. One such manifestation is the lovers' exchange of clothes, which is illustrated here. The miniature shows Krishna, who has just crossed a lotus pond in the small red boat, approaching Radha, who awaits him at the trysting-place. He holds a vina and has disguised himself for the journey with Radha's scarf. The poetic charm of this delightful painting is typical of many works created in Bundi in the eighteenth century. Its excellence makes it apparent why Bundi is considered a major centre of Rajasthani painting.

Since the near-by Rajput State of Kotah was ruled by the junior house of the Bundi rajas, it is not surprising that the style of painting that developed there in the eighteenth century grew out of the Bundi fashion. The Kotah style is cruder and somewhat exaggerated. It features buildings which are architectural freaks: they appear not only out of square but even unresponsive to gravity. Elements of the landscape, such as foliage, loom largely out of scale and have lush, exaggerated textures. This delightful, easily identifiable mode is well represented by *Raja Umed Singh of Kotah shooting Tiger*. Under the moon and stars of an Indian night, the raja (ruled 1771–1819), safe in his *machan* in the tree to 184

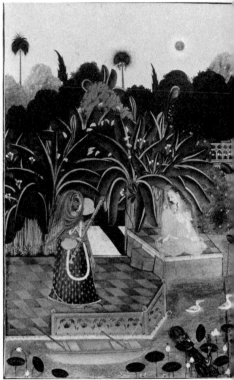

185 (left) Todi Ragini. Central India, Malwa, c. 1630. Paint on paper, $7\frac{3}{8} \times 5\frac{3}{4}$ in. (18.7 × 14.6 cm). Museum of Fine Arts, Boston, Gift of Denman Waldo Ross

186 (right) Krishna approaching the Tryst dressed as Radha. Rajasthani, Bundi, c. 1760. Paint on paper, $10\frac{1}{4} \times 7\frac{1}{2}$ in. (26 × 19 cm). Private Collection

the left, fires his musket at a tiger which has attacked the water-buffalo decoy in the jungle below. There is a direct simplicity in the delineation. The lotus, tigers, rocks, and each leaf of the trees reveal the artist's delight in rendering details, and the details in concert present us with a tapestry of richness that recalls, as W. G. Archer has observed, the canvases of the French artist Douanier Rousseau.

Another regional style evolved at Kishangarh, some 60 miles north-west of Bundi. A typical miniature gives us a startling portrait of Radha

which is believed to be also a portrait of the courtesan-poetess Bani
Thani. Raja Savant Singh of Kishangarh (ruled 1699–1764) was dispossessed by his younger brother and abdicated to become a recluse-poet at Brindaban, the holy Hindu city associated with Krishna. There he and Bani Thani lived in imitation of the divine Krishna and Radha. Already before the abdication an unusual and unmistakable style of painting had emerged that departed so drastically from the provincial Mughal style originally practised at the Kishangarh court that it must have been due to the personality of Raja Savant Singh, or rather Nagari Das, his *nom de plume* as a poet. His poems and the paintings which complement them deal with the passionate love of Radha and Krishna on the banks of the Jumna and in the dark forests of Brindaban. The face of the heroine is so singular that it suggests that the model was prescribed by Nagari Das in his description of his beloved, whose 'nose, curved and sharp like the thrusting saru cypress plant', had merged in his mind with that of Radha. (See Karl Khandalavala and Eric Dickinson in *Kishangarh Painting*, 1959.)

An unusual feature of Kishangarh paintings created at the height of the style, from about 1757 to 1770, is their large size, which may reach eighteen inches or more.

At the neighbouring Rajput court of Jaipur early paintings almost duplicated, in a Hindu idiom, the hybrid style of Mughal art. Their superb quality and draughtsmanship are eloquently shown in *Love's* *Burning Fever*. Here again is a painting that describes an attitude of a heroine, in this case the extreme stage of 'love in separation'. The heroine is shown in a state of such anxiety that she is ill. The dark, dominant night sky is symbolic of her anguish, and the hot orange floor is a further reference to her feverish state. A servant fans her; her attendants have brought her cool mangoes and other refreshments, and try in vain to console her. The realistic Mughal-style portraiture and subtle shading are in marked contrast to the still-flat setting and the strong Hindu colouring. Even so, such works created at Hindu courts with Hindu subject-matter can only, in the last analysis, be termed provincial Mughal. One of Akbar's first Rajput generals was Raja Bhar Mal of Jaipur (ruled 1548–75), who even married one of his daughters to the emperor. It is therefore not surprising that the Jaipur court, close to Delhi and Agra, retained a strong Mughal flavour up to the beginning

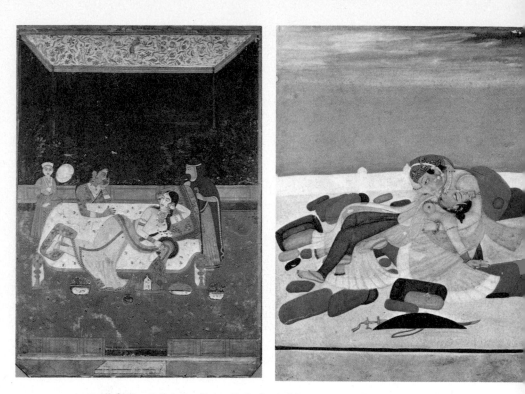

187 (left) Love's Burning Fever. Rajasthani, Jaipur, c. 1750. Paint on paper. Private Collection

188 (right) Lovers, or a Kiss at Court. Attributed to Chokha; Rajasthani, Devgarh, c. 1810. Paint on paper, $8\frac{3}{8} \times 6\frac{3}{8}$ in. (21.9 × 16.2 cm). Collection of Mr and Mrs John Gilmore Ford

of the nineteenth century, when one of the late Rajput styles flowered under Raja Pratap Singh (ruled 1779–1803).

 Occasionally high quality is found in nineteenth-century Rajput art: *188* *Lovers, or a Kiss at Court* comes from a minor court in the State of Mewar and is attributed to the artist Chokha. It is startling not only for its handsomely orchestrated colour but also for its erotic composition. Two courtly lovers, intertwined in an abandoned embrace, have scattered numerous cushions across a white marble terrace. The pale simplicity of the terrace intensifies the colours of the pillows and serves to anchor their random patterns into a bold but at the same time elegant composition.

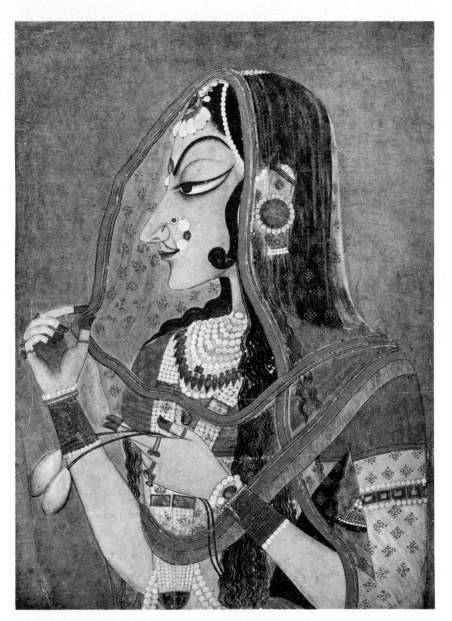

*189 Portrait of Radha. Rajasthani, Kishangarh, c. 1760. Paint on paper, 19 × 14 in.
(48.2 × 35.5 cm). Kishangarh Darbar, Rajasthan*

PAHARI PAINTING

The exact origins of the miniature-painting styles practised at the Hindu courts in the Himalayan foothills remain unknown. The mystery is intensified by the fact that the first known examples in the States of Basohli, Kahlur (Bilaspur), and Mankot, painted about 1650, are already stylistically mature. The hints of Rajasthani colour and space in these *191* works, executed in what is known as the 'Basohli Manner', have led scholars to assume a significant cultural exchange between the Punjab Hills and the Plains; but so far we have no proof. Some Pahari (Hill) rajas had to pay homage periodically to the Mughal emperor at Delhi, and on occasion they visited related Rajput families in Rajasthan. But the leading Pahari scholar, W. G. Archer, hardly believes that such casual contacts would have been enough to produce a fully developed painting style in the Hills by the middle of the seventeenth century.

A number of paintings dating from the second half of the eighteenth century which, because of their strong Central Indian qualities, were considered to be products of Malwa and Datia, are now known to have originated in Nepal. Might some earlier Hill paintings still be concealed among creations thought to be Rajasthani? In any case, the question of origin is just one of the numerous problems still to be resolved regarding dates, styles, and provenance of both Rajasthani and Pahari paintings.

The invasion of India and sack of Delhi in 1739 provided one of the catalysts for the ultimate refinement of Pahari art. As we have seen, with the collapse of Mughal power at Delhi many artists moved away and sought sympathetic patronage elsewhere. Some of them ultimately brought to the Hills elements of realism and Mughal craftsmanship from *173* the 'Muhammad Shahi Revival' which contributed significantly to the evolving Pahari aesthetic (see p. 213). The development of the Hill styles accelerated from then on. The Rajasthani Hindu courts perhaps welcomed the greatest number of displaced Mughal artists; but it was Pahari painting that would flower into India's last vital Hindu art form before the neutralizing impact of Western civilization made itself felt in the nineteenth century.

The first identifiable Pahari style, the Basohli Manner, is characterized *191* by a flat use of bold, intense colour and a distinctively aggressive profile. From Basohli it spread to the Hill States of Kulu, Mandi, Chamba,

Guler, and elsewhere. Here again what appear to be simplified Malwa 190 elements haunt us, along with echoes of other Rajasthani styles. For example, a typical eighteenth-century Plains technique for rendering pearl necklaces – to load the brush heavily with white pigment and make a line of three-dimensional dots – is found in Basohli paintings.

A Basohli painting now in London that illustrates a scene from the 191 *Rasamanjari* of Bhanudatta shows well the characteristics of the style. The regally dressed hero and heroine, in the guise of Radha and Krishna, are displayed against a flat red background and an ornate pavilion. The painting's rich colour scheme approaches the intensity of a cloisonné enamel. The use of dark, iridescent fragments of beetle wings in the jewellery is a Basohli trademark. Another feature common to a group of Basohli paintings of the late seventeenth century, though not seen here, is a gargoyle-like ornament on the base of the pavilion.

A similar style appears in a painting from the key State of Guler, south 190 of Basohli. Guler was closer to the Plains and the Mughal courts, and its earliest works already display greater finish and a much more sophisticated realism than those from Basohli. These elements would increase dramatically following the fall of Delhi in 1739, when paintings of the 'Muhammad Shahi Revival' influenced Guler artists.

One of the most renowned sets of Pahari paintings is the series known as the *Siege of Lanka*, of *c.* 1725–30, which illustrates the various activities of Rama and his animal allies before Lanka, the fortress of the demon Ravana in Sri Lanka, prior to the climactic battle of the *Ramayana* and

190 The arrest of the spies, from the Siege of Lanka episode of the Ramayana. Pahari, Guler, c. 1725–30. Paint on paper, 23¾ × 32¾ in. (60.3 × 83 cm). Museum of Fine Arts, Boston, Ross Coomaraswamy Collection

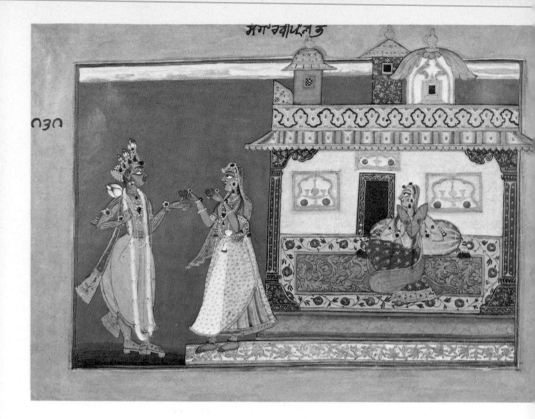

the rescue of the kidnapped Sita. A number of these unusually large paintings are known; some of them are half-finished works, while others are only drawings. They are inscribed on the reverse with the texts of the great epic poem, so it is thought that they were designed to be displayed to an audience while the text was read aloud (as was the case with the early Mughal *Hamza-nama*: see p. 202).

190 The episode depicted in the illustration is the moment when two demonic spies have been discovered in the ranks of the rescuing army. The intense orange background provides an ample field for the high, simple ramparts and the rising hills with their decorative Basohli-esque trees, which alternate downward to the silvered waters. The fish-filled sea looks strangely like a river: its painter had undoubtedly never seen the ocean. Monkey and bear warriors animate the flattened scene, which reaches a climax at the water's edge where the armoured heroes hold council.

234

191 *(opposite) Krishna arriving at Radha's House, from the Rasamanjari of Bhanudatta. Pahari, Basohli, c. 1660 70. Paint on paper, 9⅛ × 12½ in. (23.3 × 31.8 cm). Victoria and Albert Museum, London*

192 *Lady with a Hawk. Pahari, Guler, c. 1750. Paint on paper, 8⅛ × 4¼ in. (20.6 × 11 cm). Victoria and Albert Museum, London*

Soon such overt Basohli elements as are seen in the *Siege of Lanka* series gave way to a new, refined elegance, immediately apparent in the next example from Guler, *Lady with a Hawk.*

192

The painting was executed some twenty to twenty-five years later than the *Siege* set, and we can see that the decisive Mughal influence has been taken into the mainstream of the style. An elegant lady sits on a terrace, smoking her *hukka* and gazing at a hunting hawk perched on her gloved hand. The subtle tones and shading skilfully depict the opulent flesh tones, sheer fabrics, and the setting in the inner apartment of a palace. But Mughal realism has not forced out Hindu symbolism and vigour. W. G. Archer analysed the miniature in his *Indian Painting in the Punjab Hills* (1952):

Its theme and attitude illustrate a preoccupation with problems of romantic love which . . . is now far franker and more deliberate. In the present picture, this early convention [the cypress against a flaming

red ground] is once again employed but for poetic and emotional reasons. The cypresses are reduced to slim spear-like forms, while the background itself becomes a flat wash of Indian red. The cypresses reinforce the subject of the picture – a lady brooding on her absent lover – for their very shape hints at the nature of her sharp desires. At the same time the red background evokes all the ardour and passion implicit in the situation. Similar expressive imagery appears in the foreground where the open flowers are parallels for the girl's juvenescence and the hawk . . . suggests the (missing) lover.

It appears that about thirty-five States in the Punjab Hills produced miniature paintings. Some styles, such as the early one of Basohli and the later one of Kangra, dominated Pahari art during certain periods of development, but each centre also evolved its own characteristics. Paintings which portray specific individuals, such as rajas and courtiers, may be helpful in separating the styles of different courts, but many times they can be misleading: a raja would visit a neighbouring court, and as a courtesy his portrait would be painted – in an alien style.

194 An example of a Hill raja's portrait is *Raja Shamsher Sen of Mandi* [ruled 1727–81] *receiving his Son, Surma Sen*. Smoking his hukka and leaning against a bolster, his dark red *jama* loosened at the throat, the raja is attended by a servant who fans him with a cloth. The obsequious son is dressed for court and attended by a retainer bearing a sword encased in a cloth scabbard. The plain, vivid, powder-blue background and the stiff, boldly striped carpet project the main figures forward from the picture plane, and establish their importance. Although the prince is more elaborately dressed, his smaller size suggests the father's dominance and hints at his character, which has been described as 'excessively timid'. One is also tempted to see the raja's larger head as symbolic, but oversize heads had been a mannerism in Mandi painting since the seventeenth century. The attentive portraiture defines each of the individuals, including the less important retainers.

193 An unusual portrait of another Hill raja, who was a great patron of painting, is the miniature *Raja Balwant Singh of Jammu smoking alone on a Palace Roof in the Rains*. It is by the master artist of the Jammu court, Nainsukh, who painted the raja in many private and semi-private activities. Here, in what Archer has called his 'midget period', Nainsukh has set the exceedingly small figure against the massive façade and gate

236

193 Raja Balwant Singh of Jammu smoking alone on a Palace Roof in the Rains. By Nainsukh; Pahari, Jammu, July–August 1751. Paint on paper, 8⅜ × 12 in. (21.2 × 30.5 cm). Indian Museum, Calcutta.

194 Raja Shamsher Sen of Mandi with his Son, Surma Sen. Pahari, Mandi, c. 1775. Paint on paper, 7¾ × 10 in. (19.7 × 25.4 cm). University Gallery, University of Florida, Gainesville, Gift of George P. Bickford

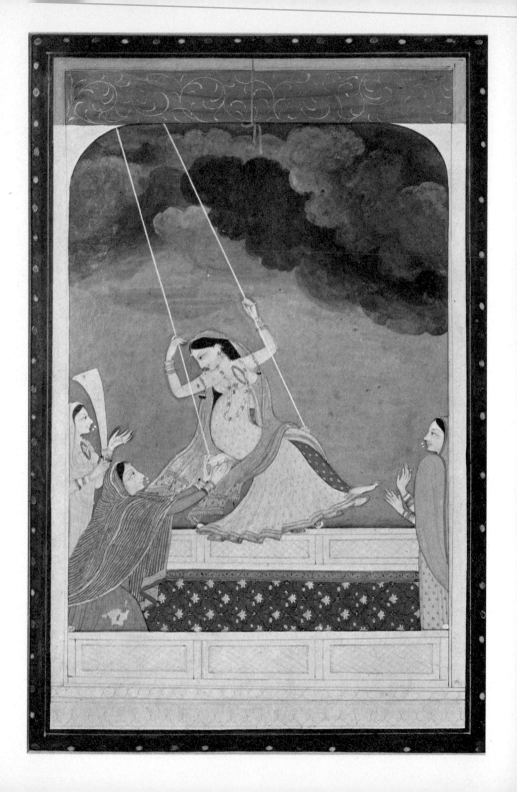

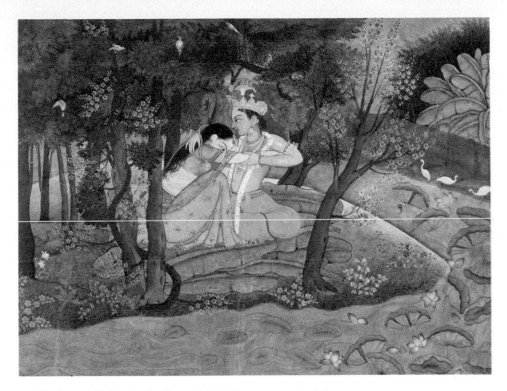

*196 Radha and Krishna in the Grove. Pahari, Kangra, c. 1780. Paint on paper,
5⅛ × 6¾ in. (13 × 17 cm). Victoria and Albert Museum, London*

of a fortress. The artist flatters his royal patron by portraying him as a
man sensitive to the beauty of lightning-filled monsoon clouds (a
rasika). But in a masterly stroke of symbolism he has also used the over-
whelming architectural setting as the visual summation of the power
focused within the one central figure both of the painting and of the
State, the raja.

In the Hill State of Kangra, in 1765, a royal patron was born who
would establish the outstanding school of painting in the Punjab Hills
in the eighteenth and nineteenth centuries. During the reign of Raja
Sansar Chand (1775–1823) the art of miniature painting in Kangra was
brought to its zenith. Its major flowering is believed to have occurred *195, 196*
between 1780 and 1805, with a second important phase from 1810 to
1823. Sansar Chand ascended the throne at the age of ten, and soon
showed an active interest in painting – a fact documented by miniatures
depicting the boy inspecting paintings with his friends and retainers.

*195 (opposite) The Swing. Pahari, Kangra, c. 1790. Paint on paper, 7⅞ × 4¾ in.
(19.6 × 12 cm). Victoria and Albert Museum, London*

Early in his reign Sansar Chand took arms to press a number of neighbouring States back under the Kangra standard. But in 1805, when Gurkha forces from near-by Nepal invaded the region, several of those States, spurred no doubt by a desire for revenge, joined in the attack. After vainly appealing to the British for aid, the raja desperately turned to the emerging Sikh power at Lahore for relief. In return for victory in 1809 the Sikhs demanded most of his kingdom: Kangra had only traded one conqueror for another.

In 1810, virtually without power and under close Sikh surveillance, Sansar Chand withdrew – accompanied only by a few retainers, but certainly with some of his artists and dancing girls – to live out the remainder of his life in small palaces at Sujanpur, Sujanpur Tira, Alampur, and Nadaun along the Beas river. There Kangra masterpieces continued to be painted until his death in 1823.

The subject-matter of Kangra miniatures shows the cult of Krishna to have been a passion with Sansar Chand. That is understandable in the context of Rajput society: where arranged marriages were the norm and where romance in the Western sense of the word was unknown, the myths of Krishna's dalliance with the gopis, and especially with Radha, a married woman, became a logical outlet for pent-up emotions. A similar phenomenon is seen in the literature of courtly love in early medieval Europe.

196 An early work from the atelier of Sansar Chand is *Radha and Krishna in the Grove*. Radha and Krishna lie on a bed of plantain leaves beside a churning stream filled with pink lotus blossoms and leaves. As the lovers unite, all nature springs to rejoice in the couple's ecstasy. Blossoms shower forth from tree branches, and all forms of plant and animal life appear in sets of twos, manifesting the dual aspect of fertility. The forms of stems and leaves find counterparts in the various features of the lovers, and their tender embrace is echoed by the vine encompassing the tree.

195 A miniature some ten years later in date depicts a Kangra beauty on a swing. The elegant female form is central to the Kangra style. The embodiment of an ideal, she is composed of rhythmically curved lines and expresses an innocent and open sensuality. This work seems at first merely a celebration of feminine beauty; but it features elements that are traditionally symbolic. The dark clouds gathering beyond the marble veranda indicate the lady's burgeoning desires. Once they flash

197 The Svayamvara of Damayanti (detail), from a Nala-Damayanti series. Pahari, Kangra, c. 1790–1800/c. 1810–14. Drawing on white primed paper, slightly coloured; detail about 9⅞ in. (25 cm) wide. Museum of Fine Arts, Boston, Ross Coomaraswamy Collection

with lightning and release their rain, they will become the symbol for the climactic act of physical love. The swing itself not only symbolizes the sex act, but had also long represented springtime.

The delight in feminine beauty which obsessed Sansar Chand is clearly seen in a series of exquisite drawings intended to illustrate the *197* poem *Naishadhacharita* by Shriharsha (discussed in detail by A. C. Eastman in *The Nala-Damayanti Drawings*). They are variously dated by scholars to *c.* 1790–1800 or within the last period of Sansar Chand's patronage, *c.* 1810–14. The drawing reproduced here depicts the moment when Damayanti is carried on a palanquin by her ladies-in-waiting to choose Nala from among her many suitors who crowd a courtyard. The event is complicated by the jealousy of four gods, who have disguised themselves as Nala and sit with the hero in a pavilion at the right. Since Nala is human, he sits solidly upon the couch, while the gods hover slightly in the air: thus they are discovered and are foiled in their attempt to gain Damayanti's hand. Eastman has convincingly suggested that the series of drawings, which contains known individuals and

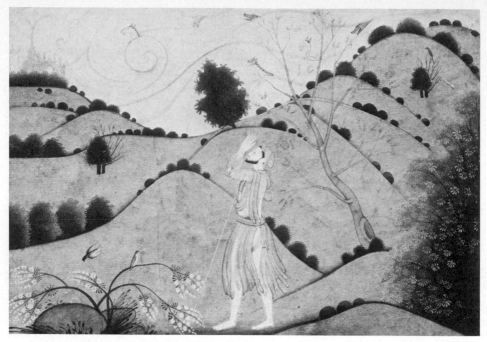

198 *The Road to Krishna. Pahari, Garhwal, c. 1780. Paint on paper, 8 × 5⅝ in. (20.3 × 14.3 cm). Victoria and Albert Museum, London*

scenery appropriate to Sansar Chand's court, embodies the raja's desire to equate his court and personality with the classical times and lives of Nala and Damayanti. This particular drawing shows the constant Kangra device of dramatically setting off the figure of a woman, with her flowing grace, against an angular architectural setting.

The Kangra style was to have considerable influence on the art of the remote State of Garhwal. There, in a more austere landscape than that of most other Hill States, a style of painting had continued without distinction from the time of the arrival of several Mughal artists in the middle of the seventeenth century. A little more than a hundred years later, with the arrival of artists perhaps from Guler, a distinctive Garhwal school emerged with Guler/Kangra overtones.

198 *The Road to Krishna*, painted about 1780, illustrates an episode from the second half of the *Bhagavata Purana*, where Krishna is portrayed as a king ruling from his golden capital of Dvaraka on the west coast of India. Driven by a nagging wife, the impoverished brahman Sudama goes in search of his friend Krishna: here, in a setting of green hills

242

edged by dotted tree forms, which are Garhwal trademarks, he has just discovered the god's lustrous city. The poetic fantasy of the painting is delightful; the painter, who had certainly never seen the ocean, has filled it with monsters and given it the swirling currents of a mountain stream.

With the death of Sansar Chand in 1823, the true inspiration for the Kangra style also expired. In 1829 Sansar Chand's son and successor, Anirodh Chand, retreated south to Tehri-Garhwal to avoid marrying his daughters to Sikhs, and a new 'Garhwal School' emerged, producing paintings in a waning Kangra style up to the 1860s. But in general Pahari painting was no more.

Our last example of a painting from the Hills is a Sikh portrait which *199* still commands some of the best qualities found in the late Guler style. By the end of the eighteenth century the warlike Sikhs, whose religion combined elements of Islam and Hinduism, not only dominated the Punjab but had also successfully moved into the Hills. There they quickly acquired a taste for paintings, but under their patronage the miniatures soon deteriorated into cheap bazaar-type productions with garish colours and little life. Here a chief or *sardar*, perfectly at ease upon his white stallion, is attended by a number of footmen, including one armed with a flintlock pistol and a blunderbuss. Crisp and elegant, this equestrian portrait looks back in style and technique to happier times in the Hills, and is ultimately indebted to Mughal portraiture for its format and image.

After the demise of the Rajput art centres and the complete domination of India by the British, miniature painting became a dead art. It is true that some petty rajas still maintained artists, but their productions were at best stiff, hollow copies of the past, and at worst were misunderstood interpretations of second-rate Western art. Some descendants of Mughal artists, in the late eighteenth and early nineteenth centuries, found employment producing paintings of flowers, animals, and exotic scenes for the British, and many of these 'Company Paintings' (so called after the East India Company) are excellent achievements within the limited scope of their genre.

The general deterioration of the Indian aesthetic was accelerated by the empire-builders' general misunderstanding and distaste for anything Indian, though some few among the 'Sahibs' had a genuine sympathy and understanding for Indian culture and were later instrumental in

aiding the Indians themselves to rediscover the excellence of their own art forms. But Major Handley's survey of the 'industrial arts of Rajputana' in *The Journal of Indian Art* in 1886 revealed a picture of confusion and decay: 'The most *advanced* artists have taken to clothing the gods in European costume with similar surroundings; thus Shiva is shown sitting in a hall lighted by candles in glass shades, and Krishna drives a Phaeton which is filled by his friends and attendants.'

One intriguing influence on Indian folk-art of the European presence appears in the paintings created at the Kali Temple in Calcutta in the second quarter of the nineteenth century. These simple 'Kalighat Paintings' were rapidly executed on thin sheets of paper and sold to pilgrims for pennies. The Kalighat artists not only adapted the technique of transparent English watercolour to create the illusion of rounded volumes, but occasionally depicted European subjects and events. But even these modest art works ultimately fell victim to the imported industrial revolution, first by being supplanted by woodcuts and finally, in the twentieth century, by cheap lithographic prints.

199 (left) A Sikh minister. Pahari, Guler, c. 1830. Paint on paper, 8 × 6⅛ in. (20.3 × 15.5 cm). Private Collection

200 (right) An Englishman shooting Tiger from an Elephant. Calcutta, Kalighat, c. 1830. Watercolour with silver on paper, 17 × 11 in. (43.2 × 28 cm). Victoria and Albert Museum, London (Crown Copyright)

200

Epilogue

Throughout Indian history the great masses who lived in the villages have (in the words of Coomaraswamy) 'worshipped, not the abstract deities of priestly theology, but local genii (*Yaksas* and *Nāgas*), and the feminine divinities of increase, and mother goddesses'. Down through time the forces of the soil have robustly spawned and fertilized the arts. In fact, the sophisticated and complex icons of Hinduism could never have been conceived and brought to fruition without the support of this rich and vital substructure.

In the light of an unbroken continuity of more than four thousand years, it is not surprising that a lively folk tradition is still producing art as India moves into the twentieth century. In the villages near modern Delhi handmade fanciful pottery and ingenuous toys can still be purchased for pennies. Villagers still worship images of the 'Great Mother', composed of cow dung, straw, and terracotta, whose ancient form has the direct simplicity of much contemporary art. In Bombay, practically in the shadow of India's first nuclear reactor, the bazaars offer fantastic kites and fiercely coloured fabrics embroidered with multi-armed deities. Today across India folk arts display the current creativity of an aged but living tradition.

That tradition is the ultimate source for all that we have reviewed here. One might at first believe that a knowledge of India's complex history and religions would be a prerequisite for an appreciation of the creations of Indian culture. We have certainly attempted here to broaden the reader's base for understanding. It is this writer's ultimate belief, however, that the vitality and directness of Indian art make it accessible to all and no knowledge other than that basic to all humanity is needed.

Bibliography

History and culture

A. L. Basham, *The Wonder That Was India*, rev. ed. 1963. J. Nehru, *The Discovery of India*, 1946. V. A. Smith, *The Oxford History of India*, 3rd ed. 1958. P. Spear, *A History of India*, II, 1968. R. Thapar, *A History of India*, I, 1966.

Surveys and catalogues

L. Ashton (ed.), *The Art of India and Pakistan*, 1950. M. Beach *et al.*, *The Arts of India and Nepal: the Nasli and Alice Heeramaneck Collection*, 1966. A. K. Coomaraswamy, *Catalogue of the Indian Collections in the Museum of Fine Arts* (Boston), pt. V, 1926; and *History of Indian and Indonesian Art*, 1927. R. C. Craven, *Miniatures and Small Sculptures from India* (catalogue, University Gallery, Gainesville, Fla.), 1966. R. Y. L. D'Argencé, *Indian and Southeast Asian Stone Sculptures from the Avery Brundage Collection* (San Francisco), 1969. L. Frédéric, *The Art of India, Temples and Sculpture*, 1959. H. Goetz, *Art and Architecture of Bikaner State*, 1950; and *Studies in the History and Art of Kashmir and the Indian Himalaya*, 1969. L. P. Gupta, *Patna Museum Catalogue of Antiquities*, 1965. E. B. Havell, *Indian Sculpture and Painting*, 1908. S. Kramrisch, *The Art of India*, 1954. S. Lee (intro.), *Ancient Sculptures from India* (exhibition catalogue, Cleveland Museum of Art), 1964; and *A History of Far Eastern Art*, 1964. J. E. van Lohuizen-de Leeuw, *Indian Sculptures* (in the Von der Heydt Collection, Zürich), 1961. B. Rowland, *Religious Art East and West* (Frank L. Weil Institute for Studies in Religion and the Humanities, Cincinnati), 1961; and *The Art and Architecture of India. Buddhist, Hindu, Jain*, 3rd ed. 1967, paperback 1970. U. P. Shah, *Studies in Jaina Art*, 1955. V. Smith, *History of Fine Art in India and Ceylon*, 3rd ed., n.d. J. P. Vogel, *Catalogue of the Museum of Archaeology at Sarnath*, 1914. H. Zimmer, *The Art of Indian Asia*, 1955.

Religion and iconography

J. N. Banerjea, *The Development of Hindu Iconography*, 2nd ed., 1956. B. Bhattacharyya, *The Indian Buddhist Iconography*, 1958. A. K. Coomaraswamy, 'The Origin of the Buddha Image', *Art Bulletin*, IX, 1927, pp. 287–329; *The Transformation of Nature in Art*, 1934; *The Dance of Siva*, 2nd ed. 1957; and *Buddha and the Gospel of Buddhism*, rev. ed. 1964. A. T. Embree (ed.), *The Hindu Tradition*, 1966. J. Finegan, *The Archaeology of World Religions*, I, II, 1952. T. A. G. Rao, *Elements of Hindu Iconography*, 1965. P. Thomas, *Epics, Myths and Legends of India*, n.d. J. P. Vogel, *Indian Serpent Lore or Nagas in Hindu Legend and Art*, 1926; and *The Goose in Indian Literature and Art*, 1962. H. Zimmer, *Philosophies of India*, 1951; and *Myths and Symbols in Indian Art and Civilization*, 1946.

Architecture

P. K. Acharya, *Indian Architecture According to Manasara*, 1946. P. Brown, *Indian Architecture. Buddhist and Hindu*, 4th ed. 1959; and *Indian Architecture. Islamic Period*, 1942. J. Fergusson, *History of Indian and Eastern Architecture*, 1899. S. Kramrisch, *The Hindu Temple*, 1946. A. Volwahsen, *Living Architecture, Indian*, 1969; and *Living Architecture: Islamic Indian*, 1970.

Chapters 1 and 2

B. and R. Allchin, *The Birth of Indian Civilization*, 1968. N. R. Banerjee and K. V. Soundara Rajan, 'Sanur 1950 and 1952: A Megalithic Site in District Chingleput', *Ancient India*, no. 15, 1959, pp. 4–42. R. R. Brooks, 'The Caves of Men', *Art Gallery Magazine*, May 1973, pp. 24–6; and 'Rock-Shelter Paintings in India', *Asia*, no. 31, 1973, pp. 44–54. J. M. Casal, *Fouilles de Mundigak*, 1961. A. K. Coomaraswamy, *Buddha and the Gospel of Buddhism*, rev. ed. 1964. Sir A. Cunningham, *Archaeological Survey of India, Report V*, 1872–3. G. F. Dales, *A Suggested Chronology for Afghanistan, Baluchistan and the Indus Valley*, reprint from *Chronologies in Old World Archeology*, 1966. B. B. Lal, *Rock Paintings of Central India. Archaeology in India*, 1950. Sir J. Marshall, *Mohenjo-Daro and the Indus Civilization*, 1931. A. Parpola *et al.*, *Decipherment of the Proto-Dravidian Inscriptions of the Indus Civilization: A First Announcement*, Scandinavian Institute of Asian Studies, no. 1, 1969. S. Piggott, *Prehistoric India*, 1950. R. L. Raikes, 'New Prehistoric Bichrome Ware from the Plains of Baluchistan (West Pakistan)', *East and West*, XIV (1–2), 1963, pp. 56–8; 'The End of the Ancient Cities of the Indus', *American Anthropologist*, LXVI, no. 2, 1964; and 'Physical Environment and Human Settlement in Prehistoric Times in the Near and Middle East: A Hydrological Approach', *East and West*, XV (3–4), 1965, pp. 179–93. S. R. Rao, 'Further Excavations at Lothal', *Lalit-Kalā*, no. 11, 1962, pp. 14–30. M. S. Vats, *Excavations at Harappā*, 1940. R. G. Wasson, *Soma, Divine Mushroom of Immortality*, 1968. Sir M. S. Wheeler, 'Harappa 1946: The Defences and Cemetery R 37', *Ancient India*, no. 3, 1947, pp. 58–130; *Early India and Pakistan*, 1959; *Civilizations of the Indus Valley and Beyond*, 1966; and *The Indus Civilization*, supplement to *The Cambridge History of India*, 3rd ed. 1968. H. Zimmer, *Philosophies of India*, 1951.

Chapter 3

J. N. Banerjea, *The Development of Hindu Iconography*, 2nd ed. 1956. P. Brown, *Indian Architecture, Buddhist and Hindu*, I, 4th ed. 1959. L. P. Gupta, *Patna Museum Catalogue of Antiquities*, 1965. J. Irwin, *The Foundations of Indian Art* (Lecture), Asia House, New York, Winter 1974. S. Kramrisch, *The Art of India*, 1954. N. A. Nikam and R. McKeon, *The Edicts of Aśoka*, 1959. N. R. Ray, *Maurya and Sunga Art*, 1945. B. Rowland, *The Art and Architecture of India. Buddhist, Hindu, Jain*, 3rd ed. 1967, paperback 1970. V. Smith, *History of Fine Art in India and Ceylon*, 3rd ed., n.d.

Sir M.S. Wheeler, *Early Indian and Pakistan*, 1959. H. Zimmer, *The Art of Indian Asia*, 1955.

Chapter 4

P. Brown, *Indian Architecture. Buddhist and Hindu*, I, 4th ed. 1959. A.K. Coomaraswamy, *La Sculpture de Barhut*, 1908; and *History of Indian and Indonesian Art*, 1927. Sir A. Cunningham, *The Stupa of Bharhut*, 1879. M.N. Deshpande, 'Important Epigraphical Record from the Chaitya Cave, Bhājā', *Lalit-Kalā*, no. 6, October 1959, pp. 30–32. A. Foucher, *Les Representations de 'Jatakas' sur les Bas-Reliefs de Barhut*, 1908. K. Khandalavala, 'The Date of Karle Chaitya' (editorial notes), *Lalit-Kalā*, nos. 3–4, April 1956–March 1957. A. Lippe, *The Freer Indian Sculptures* (Smithsonian Institution, Freer Gallery of Art, Washington, D.C.; Oriental Studies, no. 8), 1970. N.R. Ray, *Maurya and Sunga Art*, 1945. R. Thapar, *A History of India*, I, 1966. H. Zimmer, *The Art of Indian Asia*, 1955.

Chapter 5

D.E. Barrett, *Sculptures from Amaravati in the British Museum*, 1954. P. Brown, *Indian Architecture. Buddhist and Hindu*, I, 4th ed. 1959. M. Chandra, 'Ancient Indian Ivories', *Prince of Wales Museum Bulletin* (Bombay), no. 6, 1959; and 'An Ivory Figure from Ter', *Lalit-Kalā*, no. 8, October 1960, pp. 7–14. J. and Mme Hackin, *Recherches Archéologiques à Begram*, IX, 1939. J.E. van Lohuizen, 'The Date of Kaniska and Some Recently Published Images', *Papers on the Date of Kaniska*, ed. A.L. Basham, 1968. J. Marshall, *Guide to Sanchi*, 1918. T.N. Ramachandran, *The Nagapattinam and other Buddhist Bronzes in the Madras Museum*, 1965. C. Sivaramamurti, 'Amaravati Sculptures in the Madras Gov. Museum', *Bulletin of the Madras Gov. Museum*, n.s., IV, 1956. V. Smith, *History of Fine Art in India and Ceylon*, 3rd ed., n.d. R. Thapar, *A History of India*, I, 1966. A. Volwahsen, *Living Architecture, Indian*, 1969. Sir M.S. Wheeler, *Rome Beyond the Imperial Frontiers*, 1955.

Chapter 6

A.L. Basham (ed.), *Papers on the Date of Kaniska*, 1968. S. Beal (trans.), *Buddhist Records of the Western World*, 1883. A.K. Coomaraswamy, 'The Origin of the Buddha Image', *Art Bulletin*, IX, 1927, pp. 287–329. C. Fabri, 'Akhnur Terracottas', *Marg*, VIII, no. 2, 1955, pp. 53–64. C.A. Foucher, *L'Art gréco-bouddhique du Gandhāra*, 1905–18. J. and C. Hackin, *Nouvelles recherches archéologiques à Bamiyan*, III, 1933. M. Hallade, *Gandharan Art of North India*, 1968. H. Ingholt and I. Lyons, *Gandharan Art in Pakistan*, 1957. J. Legge, *A Record of Buddhist Kingdoms*, 1886. J.E. van Lohuizen, 'The Date of Kaniska and some Recently Published Images', *Papers on the Date of Kaniska*, ed. A.L. Basham, 1968. Sir J. Marshall, *The Buddhist Art of Gandhara*, 1960; and *A Guide to Taxila*, 1960. P.R. Myer, 'Again the Kaniska Casket', *Art Bulletin*, XLVIII, nos. 3 and 4, 1966. B.N. Puri, *India Under the Kushans*, 1965. J.

Rosenfield, *The Dynastic Art of the Kushans*, 1967. B. Rowland, 'The Colossal Buddhas at Bamiyan', *Journal of the Indian Society of Oriental Art*, XV, 1947, pp. 64–73; *Gandhara Sculptures from Pakistan Museums*, 1960; *Religious Art East and West* (Frank L. Weil Institute for Studies in Religion and the Humanities, Cincinnati), 1961; *The Arts of Afghanistan*, 1966; and *The Art and Architecture of India. Buddhist, Hindu, Jain*, 3rd ed. 1967, paperback 1970. D. Schlumberger, 'Surkh Kotal, a Late Hellenistic Temple in Bactria', *Archaeology*, Winter 1953, pp. 232 ff. R. Thapar, *A History of India*, I, 1966. J.P. Vogel, *The Goose in Indian Literature and Art*, 1962. Sir M.S. Wheeler, *Rome Beyond the Imperial Frontiers*, 1955. H. Zimmer, *Philosophies of India*, 1951.

Chapter 7

A.L. Basham, *The Wonder That Was India*, rev. ed. 1963. P. Brown, *Indian Architecture. Buddhist and Hindu*, I, 4th ed. 1959. M. Chandra, 'Ancient Indian Ivories', *Prince of Wales Museum Bulletin* (Bombay), no. 6, 1959. P. Chandra, *A Guide to the Elephanta Caves (Gharapuri)*, 1962. R.Y.L. D'Argencé, *Indian and Southeast Asian Stone Sculptures from the Avery Brundage Collection* (San Francisco), 1969. D. Devahuti, *Harsha, A Political Study*, 1970. O.C. Gangoly, *The Art of the Rashtrakutas*, 1958. S.R. Rao, 'A Note on the Chronology of Early Chalukyan Temples', *Lalit-Kalā*, no. 15, 1972. A. Rea, *Chalukyan Architecture*, Archaeological Survey of India, XXI, 1897, reprint 1970. B. Rowland and A.K. Coomaraswamy, *The Wall Paintings of India, Central Asia and Ceylon*, 1938. M. Singh, *India, Paintings from the Ajanta Caves*, 1954; and *The Cave Paintings of Ajanta*, 1965. R. Thapar, *A History of India*, I, 1966. A. Volwahsen, *Living Architecture, Indian*, 1969. G. Yazdani et al., *Ajanta*, 1930–55.

Chapter 8

D.E. Barrett, *Early Cola Bronzes*, 1965. R. Chanda, 'Exploration of Orissa', *Memoirs of the Archaeological Survey of India*, no. 44, 1944. A.K. Coomaraswamy, *The Dance of Siva*, 2nd ed. 1957. O.C. Gangoly, *The Art of the Pallavas*, 1957. Jainicke-Goetz, *Mamallapuram*, 1965. R. Nagaswamy, 'Rare Bronzes from Kongu Country', *Lalit-Kalā*, no. 9, April 1961, pp. 7–10. A. Rea, *Pallava Architecture*, Archaeological Survey of India, New Imperial Series, XXXIV, Southern India, XI, 1903, reprint 1970. C. Sivaramamurti, *Royal Conquests and Cultural Migrations in South India and the Deccan*, 1955; and *South Indian Bronzes*, 1963. K.R. Srinivasan, 'The Pallava Architecture of South India', *Ancient India*, no. 14, 1958, pp. 114–38. D.R. Thapar, *Icons in Bronze, An Introduction of Indian Metal Images*. n.d. R. Thapar, *A History of India*, I, 1966. A. Volwahsen, *Living Architecture, Indian*, 1969. H. Zimmer, *Myths and Symbols in Indian Art and Civilization*, 1946; and *The Art of Indian Asia*, 1955.

Chapter 9

S. Beal, *The Life of Hiuen-Tsiang*, 2nd ed. 1911. P.

Brown, *Indian Architecture. Buddhist and Hindu*, I, 4th ed. 1959. Sir A. Cunningham, *Mahābodhi or the Great Buddhist Temple at Bodh Gayā*, 1892. R. Ebersole, *Black Pagoda*, 1957. J. Fergusson, *History of Indian and Eastern Architecture*, 1899. M. Flory, *Les Temples de Khajuraho*, 1965. H. Goetz, *Art and Architecture of Bikaner State*, 1950; and *Studies in the History and Art of Kashmir and the Indian Himalaya*, 1969. S. Gorakshkar IV, 'A Bronze Shrine of Vishnu in the Freer Gallery of Art, Washington (D.C.)', *Lalit-Kalā*, no. 15, 1972, pp. 29–33. D. Hasedawa, *Konarak* (in Japanese), 1963. S. Kramrisch, *Pala and Sena Sculpture*, n.d.; and *The Hindu Temple*, 1946. J.E. van Lohuizen-de Leeuw, *Indian Sculptures* (in the Von der Heydt Collection, Zürich), 1961. P. Pal, 'A Note on the Mandala of the Eight Bodhisattvas', *Archives of Asian Art*, XXVI, 1972–3, pp. 71–3. B. Rowland, *The Art and Architecture of India. Buddhist, Hindu, Jain*, 3rd ed. 1967, paperback 1970. H. Shastri, 'The Nalanda Copper Plate of Devapāladeva', *Epigraphia Indica*, VIII, 1924, pp. 310–27. R. Thapar, *A History of India*, I, 1966. P. Thomas, *Epics, Myths and Legends of India*. E. Zanas, *Khajuraho*, 1960. H. Zimmer, *The Art of Indian Asia*, 1955.

Chapters 10 and 11
M. Archer, *Natural History Drawings in the India Office Library*, 1962. W.G. Archer, *Indian Painting in the Punjab Hills*, 1952; *Kangra Painting*, 1952; *Bazaar Paintings of Calcutta*, 1953; *Garhwal Painting*, 1954; *Central Indian Painting*, 1958; *Indian Painting in Bundi and Kotah*, 1959; *Paintings of the Sikhs*, 1966; *Indian Paintings from the Punjab Hills*, 1973; with E. Binney,3rd, *Rajput Miniatures* (catalogue), 1968. D.E. Barrett, *Paintings of the Deccan XVI–XVII Century*, 1958; with B. Gray, *Indian Painting*, 1963. E. Binney,3rd, *Indian Miniature Painting, The Mughal and Deccani Schools*, 1973. H. Blochmann (trans.), *Ā-īn-ī Akbarī by Abū'l-fazl Allāmī*, 2nd ed., 1927. P. Brown, *Indian Architecture. Islamic Period*, 1942. W.N. Brown, *The Story of Kalaka*, 1933; and *Miniature Paintings of the Jaina Kalpasūtra*, 1934. P. Chandra, *Bundi Painting*, 1959. A.K. Coomaraswamy, *Rajput Painting*, 1916; *Catalogue of the Indian Collections in the Museum of Fine Arts* (Boston), pt. V, 1926; and *History of Indian and Indonesian Art*,

1927. K.A.C. Creswell, *A Short Account of Early Muslim Architecture*, 1958. A.C. Eastman, *The Nala-Damayanti Drawings*, 1959. R. Ettinghausen, *Paintings of the Sultans and Emperors of India in American Collections*, 1961. O.C. Gangoly, *Ragas and Raginis*, 2nd ed. 1948; and *Critical Catalogue of Miniature Paintings in the Baroda Museum*, 1961. H. Goetz, *Art and Architecture of Bikaner State*, 1950. B. Gray, *Treasures of Indian Miniatures in the Bikaner Palace Collection*, 1955. Maj. T.H. Handley, 'Enamelling and other Industrial Arts of Rajputana', *The Journal of Indian Art*, II, 1886. Sir G. Hearn, *The Seven Cities of Delhi*, 2nd ed. 1928. W. Kaufmann, *Ragas of North India*, 1968. K. Khandalavala, *Pahari Miniature Painting*, 1958; with M. Chandra, *New Documents of Indian Painting – A Reappraisal*, 1969; with M. and P. Chandra, *Miniature Paintings from the Sri Motichand Khajanchi Collection* (New Delhi), 1960; with E. Dickinson, *Kishangarh Painting*, 1959. R. Krishnadasa, *Mughal Miniatures*, 1955. R. Krishnadasa, 'An Illustrated Avdhī Ms. of Laur-Chandā in the Bhārat Kalā Bhavan, Banaras', *Lalit-Kalā*, nos. 1–2, April 1955–March 1956. E. Kühnel, *Indische Miniaturen*, n.d. S. Lee, *Rajput Painting*, 1960. N.C. Mehta, *Studies in Indian Painting*, 1926; with M. Chandra, *The Golden Flute*, 1962. B.S. Miller, *Phantasies of a Love-Thief* (Bilhana), 1971. P. Pal, *Ragamala Paintings in the Museum of Fine Arts, Boston*, 1967. M.S. Randhawa, *Kangra Valley Painting*, 1954; *Basohli Painting*, 1959; *Kangra Paintings on Love*, 1962; with J.K. Galbraith, *Indian Painting: Scenes, Themes and Legends*, 1968. R. Skelton, 'The Ni'mat-Nama: a Landmark in Malwa Painting', *Marg*, XIII, no. 3, June 1959, pp. 44–8; and *Miniature Indiane dal XV al XIX Secolo*, 1960. P. Spear, *A History of India*, II, 1968. W. Spink, *Krishnamandala*, 1971. R. Thapar, *A History of India*, I, 1966. A. Volwahsen, *Living Architecture: Islamic Indian*, 1970. S.C. Welch, *The Art of Mughal India*, 1963; *God, Thrones and Peacocks*, 1963; and *A Flower from Every Meadow*, 1973. J.V.S. Wilkinson, *Mughal Painting*, 1949.

Epilogue
A.K. Coomaraswamy, *History of Indian and Indonesian Art*, 1927. S.K. Ray, *The Ritual Art of the Bratas of Bengal*, 1961.

Acknowledgments

Robert R.R. Brooks 15, Dominique Darbois 56; by courtesy of Dr Vidya Dehejia 41a; Department of Archaeology, Government of India, 19, 20, 37, 57, 110, 144, 145; Robert Ebersole 43–5, 100, 126, 138–40; W. Forman 115; Hans Hinz 1, 62, 68, 141; George F. Hull 162; Martin Hürlimann 16, 31, 61, 108, 136, 142, 170; India Office Library, London (Archaeological Survey of India) 18, 24, 27–29, 34, 35, 39, 48, 76, 79, 85, 86, 93, 95, 96, 98, 101, 102, 111, 132b, 135, 158; Victor Kennett 38, 84, 87, 118, 119, 153, 159; Josephine Powell 3–5, 7, 123; Royal Academy of Arts, London 8, 21, 22, 33, 70; Barbara Wace 150; Robert C. Williamson 132a.

Illustrations 80 and 87 are from Madanjeet Singh, *The Cave Paintings of Ajanta*, Lausanne (Edita) and London (Thames and Hudson) 1965. The following illustrations, from *The Art and Architecture of India. Buddhist, Hindu, Jain*, by Professor Benjamin Rowland, Jr (Pelican History of Art, Harmondsworth 1953, 1956, 1967, 1970), are reproduced by kind permission of Mrs Benjamin Rowland, Jr and Penguin Books: 26, 41b, 42, 47, 58, 69, 73, 90, 92, 99, 134. The following illustrations are from photographs by the author: 77, 103–7, 147–9, 151, 152, 155–7, 160, 172.

Maps drawn by Hanni Bailey

Index

Page numbers in *italic* indicate illustrations

ABDUS SAMAD 198, 202
Abu, Mount *192*, 193, 220
Abul Hasan *207*
Afghanistan, Afghans 18, 82–102 *passim*, 194, 224; style 197
Agni 30
Agra 198, *200*, 201, 209, *210*, 211, 212, 229
ahimsa 33
Ahmadnagar *200*, *214*, 216
Ahura Mazda 102
Aihole *112*, *132*, 133, 134, *134*, 135, 136, 179
Aiṟavata 30, 54, *55*
Ajanta 29, 51, *68*, 100, 111, *112*, 121–31, *122–7*, 129–30, 136, 172
Akbar 198–205, *206*, 212, 229
Akbar-nama 203, *206*
Alampur 240
Alberuni 187
Alexander the Great 33, 35, 41, 67, 202, *204*
Alexandria 72, 83, 86, 100
Amaravati *68*, 74, *75*, 77 8, *77* 9
Ambika 155
Amitabha 172, *173*
Ananta *120*, 121, 135, *135*
Andhra dynasty 56, 67–79, *66–79*, 82, 109, 145, 148, 156
animals 9, 14–16, *14–15*, 17, 19, *26*, 27, 34, 40–41, 54–5, 55, 56, *56*, 59, 60, *61*, 62, 104, 105, 127–8, *127*, 181, 184, *185* (ill. *142*), 205, *207*, 226, *227*, 227–8, *228* (r.), *233*, 234, *235*, 236, 240, *244*; *and see* bulls, deer, elephants, lions, makaras
Anirodh Chand 243
Arabs 167, 195
Arjuna 145, 149
Aruna 184, *185*
Aryans 9, 28, 29, 33
Ashoka 37–41, 46, 48, 51, 67, 68, 84, 112, 168; pillars 34, 38–43, 39, 115
Aurangabad 137
Aurangzeb 212–13
Avalokiteshvara 172–3, *173*; *and see* Padmapani
Avantipur *168*, 176

BABUR 197
Bactria, Bactrians 67, 82, 97, 102, 145
Badami *112*, 133, 135–6, *135*, *137*
Bahmani dynasty 216

Bahrein 12
Balaputradeva 169
Baluchistan 13, 19, 37
Balwant Singh 236–9, *237*
Bamiyan *83*, 97, *98*, *99*, 177
Banaras 32, 40, 82, *83*
Bani Thani 229
Barabar Hills *36*, 48, *49*, 103
Baramasas 222
Basohli *200*, 232, *234*, 235, 236
Begram 73, *73*
Belur *152*, 162
Bengal 167, *174*, 175, 219, 245
Beshnagar 70, *112*, *118*, *119*
Bhagavad Gita 31
Bhagavata Purana 222, 242, *242*
Bhaja 51, *52*, *53*, 54–5, 55, 58, *68*
Bhanudatta 233
Bhar Mal 229
Bharhut 46, *50*, 60–65, *61*, *63*, 65, *68*, 70, 72, 74, *83*, 106, 122
Bhima 149
Bhimbetka *26*
Bhopal 27, 68, 116
Bhuvaneshvar *168*, *178–80*, 179–80
Bichitr 208, *209*
Bihar 39, 48, 111, 115, 167, 172, *173*, 198, 219
Bijapur *200*, *214*, 216, 217, *217*
Bikaner 193, *200*
Bilaspur *200*, 232
Bilhana *218*, 222–3, 224
Bimaran 96, *96*
Bindusara 37
boar incarnation of Vishnu 117, *117*, 147, *167*, 176
Bodh Gaya 32, 48, 167–8, *168*, *169*
Bodhi tree 60, 88, *90*, 109, *168*, *174*
Bodhisattvas 81, 90–92, *91*, 95, 106–9, *108*, 115, 124, *126*, 127, 170, *170*, *172*, 173
Bombay 56, 115, 141, 245
Brahma 88, 95, *120*, 121, 155, 171, 194
Brahma Sutras 31
Brahmanas 30
Brahmani 154, *155*
Brindaban 229
bronze: sculpture 16, 20, *20*, 21, 115, 156–60, *159*, *161*, *166*, 170, *170*, 175, *175*, 176, *186*; technology 13, 156–7, 158; weapons 25
Buddha (Siddhartha; Shakyamuni) 28, 32, 33, 38, 39, 40, 81,

90, 167, 169, 170, 173, *175*; in art 16, 40, 46, *51*, 60–64, *61*, 77–8, *77–80*, 81, 84, *85*, 88–90, *89*, *91*, 94, 97–100, *99*, 107, 108–9, *109–10*, 111–16, *113–14*, *116*, 121, *171*, 173–4, *174*; iconography 60–61, 63–4, 76–7, 84–6, 88–90, 109, 112, 115, 170, 173–5; 'wet' Buddhas 113, *113*; *and see* Jatakas
Buddhism 28, 32–3, 37, 46, 47, 51–65, 69, 77, 79, 82, 97, 102, 121, 123, 131, 137, 167, 171–5, 219; *and see* Ajanta, Bodhisattva, Dharma, Hinayana Buddhism, Mahayana Buddhism, Vajrayana Buddhism, Wheel of the Law
bulls 14, *14*, 15, 16, 18, *26*, 27, *34* 40–41, 128, *148*, 149; *and see* Nandi
Bundelkhand 179, 187
Bundi *200*, 225, 226–7, 228, *228*
Burma, Burmese 72, 168

CALCUTTA *200*, 244
chaitya halls 38, 51–4, *52*, *53*, 56, *57*, 58, *59*, 60, 121, 122–3, 128, 133, 134, 179
chaitya arch/window motif 53, *53*, 56, *61*, 62, *134*, *178*, 179, *179*, 180, *180*
Chakra *see* Wheel of the Law
Chakravartin 41, 60, 74, *76*, 173
Chalukyan dynasty *132*, 133–6, *134*, 135, *137*, 144, 152–3, 162
Chamba *200*, 232
Chandellas 187, *188*, *190–91*
Chandra (Yakshi) 64, *65*
Chandra Gupta II 11, 112, 116
Chandragupta Maurya 35–7
Chaurapanchasika *218*, 222, 224, 225
Chawand 221, 224
Cheras 156
China, Chinese 67, 72, 73, 81, 92, 97, 101, 169, 172
Chokha 230
Cholas 16, 151–62, *152–5*, *159*, *161*
Chunar *36*, 40–42, 84, 108, *113*
coins 41, 83–4, *85*, 102, 145
'Company Paintings' 243
copper 12, *20*, *114*, 115

DARSHANA 72, 169
Dasas 9, 20, 24, 29, 30

Datia 232
Deccan 37, 67, 73, 74, 82, 111, 133, 136, 137–8, 153, 164, 167, 177, 213, 217, *217*; painting *214 15*, 216–17
deer 16, *17*, 90, *91*, *114*, 115, *221* (*ill. 182*), 225, *228* (*l.*)
Delhi 10, *161*, 164, *168*, 195, 197, 199, *200*, 213, 216, 245; Humayun's tomb *199*, 201, 209; Isa Khan's tomb *198*; Jami Masjid 212, *212*; Khani-Khanan's tomb 209; Lodi buildings 197; Qutb Minar 195–6, *196*; Quwwat ul-Islam Mosque 187, *187*, 195, *196*; Red Fort 211–12, *211*; Shahjahanabad 211–12, *211*, *212*; Tughlaq buildings 197, *197*; and miniature painting (non-Mughal) *221*, 225, 229, 232, 233
Deogarh *112*, 118, *120*, 131, 179
Devapala 169
Devgarh *200*, *230*
Devi 182
Dharma 37–40, 51, 79, 82, 95, 106, 116, 173; – Chakra, *see* Wheel of the Law
Dharmapala Hayagriva 173, *173*
Didarganj *36*, *44*, 45
Doab 29, 67, 92, 108, 131, 197
Draupadi 149
Dravidians 28, 29
Durga 147, *147*
Dvaraka 222, 242, *242*

ELEPHANTA *112*, 141–4, *141–3*
elephants 16, *17*, 40–41, 48, *49*, 59, *61*, *63*, *66*, *70*, *71*, *76*, *78*, *78*, 127–8, *127*, 138, *146*, 149, 160, 189, 203, *206*, 208, *215*, *221* (*ill. 181*), *244*; Buddha manifested as *51*, 63–4; *and see* Airavata, Ganesha
Elura *112*, 136–41, *139*, *140*, 151

'FACE OF GLORY' (*kirttimukha*) 164, *165*, *175*, 176, *185* (*ill. 142*), *186* (*ill. 146*), 187
Fatehpur Sikri *200*, 201, *201*, 202
Fondukistan *83*, 100–101, *101*

GANDHARA 35, 67, 81–100, *80*, *83*, *85*, *87*, 89, *91*, *93*, *94*, *96*, 98–9, *101*, 106, 108, 115–16, 131, 177
Ganesha 163–4, *165*
Ganga 118, *119*, 160, *161*
Ganga, Eastern, dynasty *182–3*, 184, *185–6*
Gangaikondacholapuram 154, *154*
Ganges 28, 29, 32, 37, 118, *119*, 145, *146*, 154, 160, *161*, 167

Garhwal *200*, 242–3, *242*
Ghazni 196, *200*
Gita Govinda 222
Golconda *200*, *215*, 216
goose, as symbol 95
Greece, Greeks 22, 35, 36, 37, 41, 42, *83*, 86, 95, 102, 140
Gujarat 193, *200*, 219, 245
Guldara *83*, 92–4, *93*
Guler *200*, 213, 233, *233*, 235–6, *235*, 242, 243, *244*
Gupta empire, style 29, 45, 67, 100, 108, 109, *110*, 111–31, *112*–20, *125–7*, *129–30*, *133*, 156, 170, 172, 175, 176, 184

HADDA *83*, 100
Halebid *152*, 162
Hamza-nama 202, *203*, 234
Harappa 9–12, 21, 22, 24; culture 9–25, *11*, *13–15*, *17–23*, 31, 45
Harsha 131, 136, 169
Hellenistic influence, style 22, 95
Himalayas 31, 81, 140, 188, 219, 222
Hinayana Buddhism 81
Hinduism 31, 46, 102, 131, 137, 147, 167, 174, 195, 223; painting 202, 213, 217, 220–44; temples 53, 56, 64, 118, 133, 164, 179–91
Hoysalas 162–4, *162*, 165
Hsuan-Tsang 169
Humayun 198–9, 202; tomb *199*, 201, 209
Huns, White 97, 111, 115, 131
Husayn Nizam Shah I 216
Huvishka 102

IBRAHIM ADIL SHAH II *214*, 217
Indra 9, 30, 54–5, *55*, 88, 95, 121
Indus valley culture *see* Harappa, Mohenjo-daro
Iran *see* Persia
Islam 100, 115, 131, 164, 179, 182, 187, 193, 194, 195–217; *and see* Mughals
ivory 29, 58, 72–3, *73*, 115

JAGGAYYAPETA 41, *66*, 74, *76*
Jahangir 201, 205–8, *209*, 217
Jainism, Jains 28, 32, 33, 51, 102, 135, 137, 189, 193, 194, *221*; painting *218*, 219–21, *221*, 224; *and see* Tirthankaras
Jaipur *200*, 229–30
Jammu *200*, 236–9, *237*
Jatakas 60, 64, 71, 125, 127, 128, *130*
Jaunpur 197, *197*, *200*
Java 72, 169, 172
Jayadeva 222
Jesuits 202

Jumna 29, 118, 203, 209, 229

KABUL 36, *36*, 82, *83*, 199
Kahlur 232
Kailasa, Mount 140, *140*; Kailasanatha temples, 136–41, *139*, *140*, 151, *151*
Kali 244
Kalidasa 111
Kalighat paintings 244, *244*
Kalinga *36*, 37, 67, *68*
Kalpa Sutra 218
Kama Sutra 182
Kanauj *112*, 131, 167, 177, 186
Kanchipuram *112*, 137, 150, 151, *151*, 154
Kandahar *36*, 37
Kangra *200*, 236, 239–43, *238*, *239*, 241
Kanishka 82–5, *85*, 92, 94, 101, 102, 103–4, 107; Reliquary of *94*, 95
Kankali Tila 104, *105*, 107
Kapilavastu 32
Karli 55–60, *56*, 57, *59*, *68*, 72, 144
Kashmir *36*, 82, *83*, 97, 101, *168*, 176–7, *177*, 184, 205, 222
Keshavadasa 223, 227
Khajuraho *168*, 182, 187, 188–91, *188*, *190–91*
Khamsa (Amir Khusrau) 202, *204*
kirttimukha see 'face of glory'
Kishangarh *200*, 228–9, *231*
Konarak *168*, 180–87, *183*, *185*, 189
Koran 196, 205
Kotah *200*, 227–8, *227*
Krishna 31, 102, 222, 223, 225, 226–7, 228, *228*, 229, 233, *234*, 239, 240, 242, 244
Krishna I 136
Kuanyin 172
Kubera 46, 64, *65*
Kujula Kadphises 82
Kulahdar paintings *218*, 225
Kulu *200*, 232
Kumbakonam 154
Kushans 78–9, *80*, 82–109, *83*, *85*, *87*, 89, *91*, 93–4, *96*, *103*, *105*, 111, 118, *168*, 176

LAHORE 84, 86, *200*, 211, 239
Lakshmi *120*, 121, *175*, 176, *186* (*ill. 146*), *188*, 191
Lalitaditya Muktapida 177
Lalkot 195
Laur Chanda 220, *221*, 224
Lauriya Nandangarh *36*, 39–40, *39*
Lepaksi *200*, 216
lingams 16, 133, 138, 141, *141*, *142*
lions 16, *34*, *39*, 40–41, 56, *56*, *66*,

70, 75, 103, *103*, 107, *108*, 109, *109*, 147, *147*, 149, *149*
lion incarnation of Vishnu *166*, 176
Lodi sultanate 197–8, 224
Lohanipur 43, *43*
Lokanatha *173*
Lomas Rishi cave 48, *49*, 53
Loriyan Tangai *93*
Lothal 13, *18*, 25
Lucknow 200, 213

MADRAS 74, 145
Madurai 152, *152*, 162, *163*, 164
Magadha 36, *36*, *68*
Mahabharata 30–31
Maharashtra 51
Mahavira 33
Mahayana Buddhism 62, 81, 90, 128, 171
Mahmud of Ghazni 187
Maitreya 92, 106, 107, *108*, 172
makaras 65, *65*, 118, *119*, 160, *161*, *175*, 176
Malwa 200, 216, 225, *228*, 232, 233
Mamallapuram 145 51, *146–50*, *152*
mandalas 71, 72, *98*, 100, 170, *170*
Mandi 200, 232, 236, *237*
Mandu 200, 225, *226*
Mankot 200, 232
Martand *168*, *177*, 177, 193
Mat (Tokri Tila) 102, *103*, *105*
Mathura 46, 77, 82, *83*, 86, 101, 102–3, *103*, 104–9, *105*, 107–10, 111, *112*, 116, *168*, 176, 187, 222
Mauryan empire 35–51, *36*, 68, 111; art, style *34*, 39–49, *39*, *42–4*, *47*, 84, 109, 168, 194
maya 81, 121, 125, 160, 223
Maya (mother of the Buddha) *51*, *62*, 63–4, 88
Medieval period 45, 131, 133, 140, 166–94, *166*, *169–71*, *173–5*, *177–80*, *182–3*, *185–7*, 219
Megasthenes 37, 42
Mesopotamia 12, 13, 24
Mewar 200, *221*, 224, 230
Mir Sayyid Ali 198, 202
Mithras cult 102
mithuna 57, *57*, 144, 181, *183*
Mohenjo-daro 10–12, *11*, *13–15*, *16*, *17*, 19, 20, *20*, *23*, *24*, *25*, 156
mosques 187, *187*, 195, 197, *197*, 212, *212*
'mother goddess' cults 19, *19*, 171, 245
mudras 86; abhaya m. 84, 85, *85*, 92, 106, *108*, 109, *109*, 112, 114 (r.), *116*, 160, *161*; bhumi sparsha m. *89*, 90, 174, *174*; chin m. 156, *157*; Dharma Chakra m. *114*,

115; dhyana m. 116; gaja hasta m. 160, *161*; varada m. 118, 175, *175*, *192* (*ill. 154*), 194
Mughals 100, 164, 198–213, *200*, *206*, *209*, 216, 217, 224; architecture *199*, 201, 208–12, *210–12*; painting 198, 202–8, *203–4*, *206–7*, *209*, 213, 217, 223, 229, 233, 235, 242, 243
Muhammad Adil Shah 217, *217*
Muhammad of Ghor 187, 195
Muhammad Shah 213, 232, 233
Muhammad Tughlaq 216
Mundigak 19
Murshidabad 200, 213
Muslims *see* Islam, Mughals
Mysore 37, 162

NADAUN 240
Nadir Shah 213
Nagapattinam *68*, 79, *152*, 156
Nagara style 118
Nagari Das 229
Nagarjunakonda *68*, 74
nagas (serpents) 45, *65*, 106, 128, *129*, 146, *146*, 245
Nainsukh 236–9, *237*
Naishadhacharita 241, *241*
Nala-Damayanti series 241–2, *241*
Nalanda 167, *168*, 169–70, *170–71*, 172, *173*
Nanda dynasty 35
Nandi 16, 138, 151, 153
Narasimha 176
Narasimha Varman I 145, 150
Narasimhadeva I 181, 184, *186*
Nasik *68*
Nayak dynasty *163*, 164
Nepal 32, 40, 116, 219, 232, 239
Ni'mat-nama 216, 225, *226*
Nimrud Dagh 102

ORCHA 223
Orissa 37, *168*, *178–80*, 179–87, *182–3*, *185–6*, 189, *200*
Oudh 212

PADMAPANI 124, *126*, 172–3, *173*
Pahari painting 222, 232–43, *233–5*, *237–9*, 241, *242*, 244
Palas 167, *168*, 169, 170, *170*, 172, 173, *172–3*, 175, *175*, 184, 219
Pallavas 136, 140, 145, *146–51*, 147, 152, *152*, 155, 156, 162
Pallu *168*, *192*, 193
palm-leaf painting 219, 220, *221*
Palmyra 88
Pandyas 67, *152*, *152*, 162
Parkham 46, *47*
Parthia, Parthians 82, 84, 97, 102
Parvati 140–41, *154*, *154*, 155, 156, *159*, 163

Pataliputra 35, *36*, 37, 42, *42*, 43, 111
Patna 36, 43, 45, 47
Pattadakal *112*, 137, 151
Persia (Iran) 13, 24, 81, 97, 136, 220; civilization 102; culture 197; empire 35, 195; gods 83; influence 41, 48, 84, 86, 197, 225; invasion of India 213; painting 198, 225
Peshawar 82, *83*, 88, 94, 97
pigments 28, 29, 127, 220
Pompeii, ivory from 72
Portuguese in India 144, 202
pottery, terracotta 18, *18*, 19, *19*, 24, 28, 54, 101, *101*, 245
prana 22, 58
Pratap Singh 230
Pratiharas 167, *168*
Prithvi Raj 195
Pulakesin I 136
Punjab 9, 25, 35, 36, *200*, 232; Punjab Hills painting *see* Pahari painting
Puranas 67, 106

QUTB-UD-DIN AIBAK 195

RADHA 222, 223, 225, 226–7, 228, *228*, 229, *231*, 233, *239*, 240
ragas 158, 223–4; ragamala paintings 217, *221*, 223–4, 225, *228*
Rajaraja I 152–4
Rajasthan 10, 167, *192*, 193, 213, 232; painting 205, *221*, 222–31, 227–8, *230–31*, 232
Rajatarangini 177
Rajendra I Chola 154, *154*
Rajputs 128, 195, 202, 220, 222–31, 240, 243
Rama 233, *233*
Ramayana 30, *121*, 233, *233*
Rasabhanatha 193
Rasamanjari 233, *234*
Rashtrakutas 136, *139–43*, 140, 141, 167, *168*
Rasikapriya 222, 223, 227
Ravana 140, *140*, 233
reliquaries 94–6, *94*, *96*
Rigveda 9, 20, 30, 194
rock-cut chambers 48–69, *49*, *52*, *53*, *56*, *59*, 103, 135, 145; *and see* Ajanta, Badami, Elephanta, Elura
rock-paintings *26*, 27, 28
Roma, statue of 86, *87*
Rome, Roman art 72, 81–2, *83*, 86, 96, 108, 145, 177
Rudra 16, 31

SAMARKAND 211
Sanchi *36*, 45, 46, *66*, 68–73, *69–71*,

73, 82, 94; Temple No. 17 131, 133, 179
Sansai Chand 239–43
Sanskrit 29, 30, 31, 222
Sarasvati 175, 175, 192, 193, 194
Sarnath 36, 107–8, 108, 113, 113, 114, 121, 167; Ashokan capital 34, 40–41, 56; sermon in the Deer Park 16, 32, 40, 62, 88, 90, 91, 107, 114, 115
Sassanians 97, 100
Saurashtra 10, 13, 25, 193, 245
Savant Singh 229
Scythians 67
seals 9–10, 12, 14–17, 14–15, 17, 19, 25, 28, 31
Seleucus Nicator 35, 36, 37
Senas 170, 175, 175, 184
Shah Jahan 208–12, 209, 226
Shah-ji-ki-Dheri 94–5, 94
Shah Tahmasp Safavi 198
Shaka era 82
shakti 171, 181–2
Shakyamuni see Buddha
shalabhanjikas 63, 65, 65, 70, 71, 88, 180, 184, 185
Shalendra 169
Shamsher Sen 236, 237
Sharqi dynasty 197, 197
shastras 158, 181
Shiva 16, 31, 83, 121, 133, 135, 136, 138, 140, 141, 144, 145, 147, 153, 154, 163–4, 171, 181, 189, 244; Ardhanarishvara 141, 142, 144; Bhairava 142, 143, 144; Dakshinamurti 155, 155; Gangadhara 144, 145–6; Mahadeva 142, 143, 144; Mahesamurti 141, 142, 143, 144; Nataraja 21, 144, 160, 161; Tatpurusha 144; Vamadeva 143, 144; Vinadhara 158, 159; Yogishvara 144; temples 137–44, 139, 141, 153, 154
Shriharsha 241
Shungas 45, 46, 47, 50, 51–5, 52, 53, 55, 60–65, 61, 63, 65, 67, 106, 122–3, 128
Siddhartha see Buddha

Siege of Lanka 233–4, 233, 235
Sikhs 239, 242–3, 244
Sikri stone 103, 103, 105, 107–9, 108
Simhala Adavana 128, 130
Sita 234
Slave Dynasty 196, 197
Somnath 187
Somnathpur 152, 162, 162
Sri Lanka 38, 152, 233
stucco 100, 170, 171
stupas 10, 28, 38, 48, 52, 54, 58, 59, 60, 68, 69, 72, 74, 75, 84, 92–4, 93, 104, 169–70, 170
Subhadra 90, 91
Sudama 242, 242
Sudama caves 48
Sujanpur 240; – Tira 240
Sultanganj 112, 114, 115
Sumatra 154
Sumba 155
Surkh Kotal 83, 101–2, 104
Surya 30, 55, 55, 100, 104, 105, 106, 116, 184, 185, 187; temples 177, 177, 180–87, 182–3, 185, 193
Swat valley 83, 92, 92
Syria 177, 196

Taj Mahal 144, 201, 209–11, 210
Tanjore 152, 153, 153
Tantra 97, 171, 181–2
Taras 171
Tarif i-Husayn Shahi 214, 216
Taxila 35, 36, 88, 97
Tehri 243
terracotta see pottery
Tibet 72, 219
Timurlane 198, 208, 211
Tirthankaras 16, 24, 33, 43, 189, 193, 194
Todi Ragini 225, 228
Tokri Tila see Mat
tribhanga pose 70, 70, 118, 119, 125, 126, 158, 159, 173, 173 (r.), 180, 184, 185 (ill. 143)
trishula 66, 71
Tughlaqs, 197, 197
Tun-Huang 101

Udayagiri 112, 116–18, 117
Umed Singh 227, 228
Upanishads 30, 31
Ur 12
Ushkur 83, 101
ushnisha 84, 95, 112
Uttar Pradesh 115, 116, 218, 220, 221, 224, 225

Vajrapani 90
Vajrayana Buddhism 97, 171–2, 173
Varaha 117, 117, 147, 176
Varuna 30
Vedanta 31
Vedas 9, 16, 20, 29–31, 194
Vedic religion 25, 29–31, 54
Vidudabha 61, 61, 62
viharas 51, 52, 53, 54, 55, 121, 123, 124, 125, 133
Vijayanagar 164, 216, 217
Vima Kadphises 82, 103–4, 103
Vishnu 116, 117–18, 117, 121, 135, 135, 147, 156, 157, 162, 166, 171, 175–6, 175, 184–7, 186, 191, 194, 222; Anantasayin 120, 121, 147, 150; four-faced 168, 176
Vishvakarma 106

wall-paintings 29, 51, 216; and see Ajanta
Western Indian painting 218, 219–20, 220, 222, 225
Wheel of the Law (Dharma Chakra) 16, 34, 40, 41, 59, 60, 61, 62, 71, 72, 90, 109, 114, 115; and see Chakravartin
wood-carving 29, 46, 62

yaksha, yakshi 44, 45–6, 47, 57, 63, 64, 65, 70, 70, 71, 71, 72, 73, 86, 88, 90, 106, 107, 118, 172, 184, 185, 245; and see mithuna, shalabhanjika
Yama 30
yoga 16, 22, 31–2; yogi 17, 25, 31, 109, 173
Yueh-Chi 67, 82, 102; and see Kushans

Webb groaned. "Don't rub it in!"

"So the whole thing was unnecessary," Hannah said slowly. "Erica's planning and the deaths of all those people, herself included. That's a terrible thought."

Webb took her hand. "Unfortunately, love, death is often unnecessary — accidents that could have been avoided, operations that go wrong. It seldom goes according to plan."

"Well, at least Richard Vine can relax, knowing no one was out to get him."

Webb thought of the letters and phonecalls. Someone jumping on the bandwagon, as he'd suspected.

"It gave him something to think about, anyway. That's what comes of having a guilty conscience. Perhaps he'll mend his ways in future."

"About Erica's letter," Hannah said. "You say it was postmarked Shillingham; does that mean she came here the day she died?"

"That foxed me as well, but there's a simple explanation. All the mail from the Grange is collected twice a day and brought down to the General Post Office. Another example of Vine's efficiency. So that just about wraps it up, thank God."

He leaned back against the cushions and closed his eyes.

"Poor love," Hannah said softly. "You look done in."

"I feel it."

"In need of a little TLC?"

"More than a little!"

"In that case," she said, "perhaps you'd better stay the night."

He pulled her gently towards him. "I thought you'd never ask." he said.

that got to do with anything? John didn't have *German measles!*"

The breath left Webb's body, rendering him incapable of speech.

"I remember him not being well at the party," she went on, her voice gradually gaining strength, "but it was only a touch of flu – the twenty-four hour kind – he was better the next day. The kids had it as well. I know there was German measles at the school, but my two never caught it."

There was silence in the room, as Webb floundered for something to say.

Annie straightened her shoulders and met his eyes steadily. "Chief Inspector, I'm desperately sorry about poor Libbie and her baby, but of one thing you can be quite certain: my husband was in no way responsible for their deaths."

Webb related the conversation to Hannah later that evening.

"I was poleaxed," he admitted. "There I was, trying to soften the blow for her, and she completely took the wind out of my sails."

"So we'll never know where Libbie caught it?"

"No. But if it was rampant in the town, it could have been anywhere. What's so incredible is that not only Doug Leyton but the Brownings also assumed that because Bainbridge wasn't well, and German measles was around, and Libbie caught it, he must have been the culprit. And since he and his family left town a couple of days later, they never learnt any different."

"And because they told you he had it, you believed it, too."

Oh God, Webb thought; she doesn't see the connection.

"So what happened?" Annie prompted. "Did she lose the baby?"

"It lived only a few hours, but if anything, worse was to come. Libbie was admitted to a psychiatric hospital but managed to discharge herself and – and threw herself under a train."

"No! Oh, no! It must have tipped her over the edge. Oh, how dreadful. Poor Doug. I must get in touch with him." She frowned. "It's funny, but Bill and Pat were here the other day – two of our other Heatherton friends. They never mentioned any of this. I suppose they thought I had enough on my plate at the moment."

Before she could ask why he was telling her himself, Webb said smoothly, "Were you aware that Libbie had a sister?"

"Erica, yes. She was working in the States. Libbie often spoke of her."

"She came back," Webb said shortly.

Annie Bainbridge waited, her puzzled eyes going from him to Sally and back again.

"I'm afraid, Mrs Bainbridge, that it was she who caused the coach crash."

"*Erica?*"

"You see," Webb said gently, "she blamed your husband for Libbie's death."

There was total silence. Then Annie whispered, "*What did you say?*"

"Well, you see, she kissed him goodbye at his leaving party, and he was ill at the time, wasn't he? And then, three weeks later—"

Annie's hands, reaching out blindly towards him, brought him to a halt. "But – just a minute – what's

The pile of motoring magazines had, Webb noted with relief, at last been moved. Part of the healing process, perhaps.

"Mum'll give them their tea," Annie said, coming in and closing the door. "She insisted on coming up to stay for a while, and I must say it makes a difference."

Webb introduced Sally and the two women nodded smilingly at each other.

"Now—" Annie sat down and looked at them expectantly. "Has something come up?"

"In a way." Webb paused. "I believe you knew Doug and Libbie Leyton?"

She stared at him, bewildered by the seeming irrelevance. "Of course I did," she said after a minute. "Doug worked with John in the bakery, down in Heatherton. We all used to go out together."

"But you – didn't keep in touch after you moved?"

"No. You always mean to, don't you, but you meet new people and your life changes and somehow you never get round to it. A pity, really."

Webb nodded his understanding. "Unfortunately, almost as soon as you left, things went badly wrong for them. Mrs Leyton became pregnant—" he went on speaking over her exclamation of delight "—but then she went down with German measles, and the baby was badly affected."

He looked up. Annie Bainbridge was staring at him, her face full of distress. "Oh, no! Oh, poor Libbie! She was so desperate for a baby."

Webb said carefully, "I understand German measles can be very dangerous in early pregnancy."

"Oh yes, it can. I remember now, there was an outbreak just before we left Heatherton."

unstable, and at that point she'd have been more disturbed than ever, what with grief for her sister and hatred for the man she blamed for her death. It's my guess she needed to clarify her thoughts by setting them down in black and white, to enable her to plan clearly and concisely what she wanted – what she felt she *had* – to do."

Sally nodded. "Yes, I see that. But when she actually set out to put it into operation – surely that would have been the time to destroy it?"

"It was a risk hanging on to it, certainly, but by that stage she might well have been superstitious about it – you know, as long as it was all set down, it would go according to plan."

Webb turned up Todd's Hill. "I've a feeling," he added after a minute, "that if it *had* done, she'd have read it through one last time, back in her room in Oxbury – gloating, perhaps, over her ingenuity in carrying it off – and then the notebook would have been ceremoniously destroyed."

Sally gave a little shudder and lapsed into silence.

The mist which had hung around all day was thickening with the advent of dusk. It was just after four; which meant, Webb reflected, that Mrs Bainbridge would be preparing the children's tea and getting them settled before leaving to go on the night shift at the hospital.

There were lights in the cottage at the top of the hill, and their knock was answered by a boy about eight years old.

Sally smiled at him. "Is your Mum in? Think we could have a word with her?"

Annie Bainbridge appeared in the hallway, drying her hands on a tea towel. "Oh – it's you. Would you like to go into the front room? I'll be with you in a minute."

214

Webb sat back in his chair, chilled by the total lack of emotion with which she'd planned to end a human life. No wonder she'd been careful to remove the notebook from the orbit of her landlady's prying eyes; if all had gone as expected, the crash would have been written off as an accident.

He was relieved when, his own work completed, he could pass on the case and its contents for detailed examination. He wanted no more of it or its dead owner.

Which left Annie Bainbridge. She deserved to know the outcome of the case, though it would come as a shock to learn that it was, after all, her husband who'd been the linchpin. There was no easy way to tell her, but no way to disguise it, either, since the details would be reported in the press.

Deciding that putting off the task would not make it any easier, Webb phoned DS Pierce. "I'd like you to come along, Sally," he finished, "because I'm not sure how she'll react on hearing it was her husband the killer was after."

They were on their way out of the office when the American fax, pre-empted by all that had happened in the interim, finally arrived. Running his eye down it, Webb saw that it confirmed Erica Mann's qualifications and stated that she had left their employ merely because her contract had come to an end. Which was much as he'd expected.

As they drove out along the Beckworth road, wrapped in their own thoughts, Sally said suddenly, "Wasn't it asking for trouble, Guv, writing everything down like that? Talk about damning evidence!"

"It surprised me at first," Webb agreed, "but on reflection, I think I can understand. We know she'd always been

213

ʽwas a vacancy for inspector, after which he could go ahead with his assessment. And provided Webb's own promotion was approved, Crombie was likely to be shunted up to DCI, leaving just the space Ken needed. The times, he thought, are a-changing. But perhaps, with a bit of luck, not as much as all that.

The suitcase yielded up its secrets later that day. It was mainly filled with letters from Libbie Leyton to her sister in the States. There was also an order of service from her funeral – sent, no doubt, by Leyton – a few letters of condolence, and a stack of old photographs.

Webb sifted through them, looking from one smiling face to the other. Happier days, but the instability which was to plague both sisters already lurked beneath the surface. As well they didn't know what lay ahead – but isn't it always? he thought morosely.

The most important and unexpected find was a notebook in which Erica had meticulously planned Bainbridge's death.

It appeared her first step had been to pay a visit to Beckworth immediately after seeing the Leytons in Steeple Bayliss and learning about John Bainbridge.

She noted that he lived at the top of a wooded hill which was a popular walking area, and that cars were parked at intervals all the way up, from which people set off into the woods. Her scouting out the land had therefore not warranted a second glance.

Various methods of tampering with the vehicle had been considered and discarded before she decided on the bleed valves; she had then purchased the right spanner and practised diligently on her own car until she could loosen all four in as many seconds.

212

"That as well."

"She trusted me to destroy the contents," Leyton protested.

"I'm sorry, sir, but they're now evidence in a murder case. I'm afraid it's been taken out of your hands."

He sighed. "Very well."

Perhaps he was glad to be free of the responsibility. In fact, Webb thought, he now seemed in better heart; maybe the positive steps he'd taken had gone some way towards coming to terms with what had happened, both in the immediate and the more distant past. It was to be hoped he could now put it all behind him and at last enjoy a happy marriage with a new baby.

It seemed that apart from dotting the i's and crossing the t's, the investigation was over, and Webb phoned the chief superintendent.

"So if this fella hadn't been abroad, the case would have been wrapped up at the end of last week?"

"It looks that way, yes."

"Bloody irritating. Never mind, it's all sorted now, which is what counts. Well done, Spider. Your board's this week, isn't it?"

"Yes, sir; Wednesday and Thursday."

"Well, at least you'll have the case satisfactorily behind you. Best of luck."

"Thank you, sir."

Webb replaced the phone and stared broodingly down on the mist-shrouded street. If his promotion came through, he was determined to get out of the office as much as possible, even if he'd be working with an inspector rather than Ken Jackson. Although come to think of it, Jackson had sat his written exams the previous month. Provided he passed, all he'd need

211

hers was for the nine others who'd died with him. And she asked me to pass on the letter to you."

"But you didn't," Webb pointed out.

"No," Leyton agreed, "because it seemed to me I was as much to blame as she was. She was out of reach of the law, but I wasn't, and I deserved to be punished. I still think that."

Webb brushed it aside. "How did she know about the bleed valves? It was quite a technical thing—" He managed to bite back the words *for a woman.*

"Oh, cars had always been her passion. Even at school, she had a Saturday job working in a garage." He smiled, thinking back. "Libbie was quite the opposite – didn't like getting her hands dirty. Mum said more than once that I married the wrong sister."

Webb said curiously, "What was she doing in the States, sir? And how did she get round the red tape?"

"The firm she worked for sent her out. She'd been in at the start of some programme that could revolutionise car safety, and the affiliated US company was interested. It was agreed she'd go out to set up the programme there and help them over the teething troubles. They arranged all the paperwork and out she went. Trouble was, while she was there the home company was taken over, and there wasn't a job for her when she got back."

Webb was annoyed with himself; misled by her colleague's assumption that it was 'something secretarial', he'd seriously underestimated Erica Mann. If they'd known of her expertise, they might have arrived at the solution earlier.

"We'll need the letter and its enclosures," he reminded Leyton.

"Yes, but the suitcase—"

Libbie and the baby. While she was thinking of how to go about it, she saw some course or other advertised, and couldn't believe her luck, because it was being held just down the hill from where he lived. It must have been meant, she said.

"She enrolled on the course, but went up a week early to check on his movements and establish his routine. She says she followed him round during the day and went up to his house each evening, noting that his wife always went out about seven-thirty, and after that, John was in for the night."

So much for dinner each night at the Topham, Webb thought ruefully. They'd not checked what she did before or after it.

"She'd meant to fix his car the following week, when she could just slip out from the Grange; but when she made her usual check on the Saturday, she saw the minibus outside. She thought he must have an early call the next morning, and decided to fix it then and there, so that he'd crash on his way down the hill."

Leyton looked at Webb almost pleadingly. "She set out to kill John, yes, but she never thought for a minute there'd be anyone else in the bus. When she heard what had happened – well, you can imagine. But she'd enrolled on the course and she thought it might look suspicious if she didn't turn up. She says she went through the week like a robot."

He sighed. "Added to that, she'd counted on the bus bursting into flames on impact, destroying any evidence and seeming to be an accident. Instead of which it remained intact, and when the police announced it had been sabotaged, she knew she couldn't face any more. She wrote that John's death had avenged Libbie's, and

Leyton wiped a hand over his face. "God, if I could only put the clock back! But it upset me, see, having to go through it all again, and I wasn't thinking straight. So when she was going on about how could Libbie have caught German measles at her age, I blurted out that John had had it at the party. I knew at once I shouldn't have said it. She went white as a ghost – it quite scared me. And she said, 'He went to a party, when he knew he was infectious?'

"I told her he didn't know about the baby – we didn't ourselves – but she said he knew there'd be women there, and any of them could have been pregnant. I suppose she was right, but you don't think, do you? Some time later, when she seemed to have calmed down, she asked about John – where he was, what he was doing now. Very casual she was, so like a fool I told her. And, God help me, never gave it another thought. Not until this morning, when I read her letter."

"You didn't destroy it?" Webb asked sharply.

"No. I hid it in a book, with the key to a suitcase and a left-luggage ticket which she'd also enclosed. She explained she hadn't needed the case with her, but her landlady might nose around if she left it at the flat, and there were private things in it. If everything had gone as planned, she'd have collected it on her way home. As it was, she asked me to destroy the contents unread."

"Where did she leave the case, Mr Leyton?"

"Shillingham railway station."

"And the letter? What did it say?"

Leyton shuddered. "She must have been going through hell. Parts of it were jumbled up and didn't make sense, but the gist was that she'd decided to kill John and avenge

He looked down at the table. "They said she needed special psychiatric care, and recommended a hospital in SB. So we left Heatherton and moved up there. But somehow – God knows how – she managed to discharge herself and just disappeared. All kinds of search parties were organised – helicopters, the lot. But before we could find her, she – killed herself."

"I'm very sorry," Webb said, and again felt the inadequacy of the words. There was a long silence, which he didn't like to break. Then Leyton looked up again, and his hand tightened on Sarah's.

"Libbie's parents were dead," he said flatly, "but she was very close to her sister. Erica had—"

"*Erica?*"

Leyton nodded heavily. "Erica Mann. She killed herself too, didn't she? Last week?"

"She died," Webb corrected automatically, his brain whirling.

"Yes, well as I was saying, they were very close. She'd more or less brought Libbie up after their mother's death, and thought the world of her. When Libbie died, she was in the States working for some electronics company. I phoned to tell her, of course, but she was recovering from apendicitis and there was no way she could fly back for the funeral. I think she felt she'd let Libbie down, not being there, and it seems to have preyed on her mind. She was a bundle of nerves too," he added. "It ran in the family."

"Go on."

"Well, her contract expired a few months ago and she came home. She knew I'd married again; I don't think she approved, though she didn't say anything. Anyway, she came to see us, to hear about Libbie at first-hand."

207

and we had some good times together. But just over two years ago, he told us he was leaving and moving up here. We were sorry to see him go, and threw a party for him at the pub." He stopped again, and when he continued, he was speaking more slowly. "About that time, there was an outbreak of German measles at the school, and both his kids went down with it. Then, as luck would have it, he caught it himself, and must have been feeling pretty rough. Still, he was determined not to let us down, so he came along and seemed to enjoy the evening. At the end, all the girls kissed him goodbye, Libbie included. Next thing we knew, she'd gone down with it too, and just as she was getting over it, we found out she was pregnant."

Tears were running down Sarah's cheeks and she stealthily brushed them away with her free hand.

"Well," Leyton continued, "the doctor told her what the risks were, but she refused to take any tests. We'd – been trying for years, you see, and she was desperate for a baby."

"Just a moment," Webb interrupted. "Did she realise she'd caught the illness from Mr Bainbridge?"

"I've wondered about that, but I don't think she made the connection, no. At least, she never said anything, and nor did I. What was the point?"

"Anyone else at the party go down with it?"

Leyton frowned, thinking back. "Not that I heard. Mind, I was so taken up with Libbie, I wouldn't have known if they had, but most people have it when they're kids, don't they? Anyway, to cut a long story short, the baby was born with all sorts of problems, and lived only a few hours. And Libbie went – demented. Really. Blamed herself, said she'd never brought me anything but bad luck, which of course was nonsense."

"Pity we can't charge him and use the tape," Jackson grumbled as they went down the stairs. "I've barely finished typing up the notes from his wife's interview."

"When I was a sergeant," Webb told him severely, "we had to write up *everything* – none of these new-fangled gadgets then."

"But that was in the Dark Ages, wasn't it, Guv?" Jackson grinned, his ill-humour evaporating.

"I'll pretend I didn't hear that, Sergeant."

Once again they went into the interview room. The Leytons were sitting side by side, Sarah holding tightly to her husband's hand. Both were pale and she was trembling.

Doug Leyton stood up, seeming considerably more composed than he'd been before. "Sorry to have messed you about, Chief Inspector," he said. "I'm prepared to tell you everything now. Is it – would it be all right if my wife stays?"

Webb hesitated, but with no apparent crime and no collusion, he couldn't see the harm.

"Very well, sir. Before you start, though, Sergeant Jackson here will caution you, just in case."

Jackson did so, then seated himself and resignedly took out his notebook.

Leyton began immediately, speaking in a firm voice as though glad, now, to be getting it off his chest. "I'll have to go back a bit, to fill in the background," he apologised. "I think Sarah told you my first wife was – unstable. In fact, she'd been diagnosed as manic depressive. That's really at the root of everything."

He paused, glancing at Webb to gauge his reaction, but the chief inspector's face remained impassive.

"Well, John and me worked at the bakery, as you know,

205

"He couldn't believe it, said no one could have wanted to hurt John."

"And when you told him I wanted to see him, was he alarmed?"

"No, just surprised. He said, 'I don't know how I can help them, I've not seen John for years.'"

"Right, thank you very much, Mrs Leyton. I'll have your husband brought up now, and if you can persuade him to tell us what's worrying him, it'll be a great help to everyone."

"You're going to leave them alone together?" Jackson asked, out in the reception area.

"We've no authority to do otherwise, Ken. Whatever he says, as things stand, he hasn't committed any crime."

They watched in silence as one of the uniformed officers appeared with Leyton and showed him into the interview room. He glanced across the foyer at them, but gave no sign of recognition.

When the officer re-emerged, Webb beckoned him over. "Did he make any comment, when you said his wife was here?"

The constable shook his head. "Not a word, sir."

"Let's hope she can knock some sense into him."

Webb and Jackson returned upstairs. There was a pile of papers which had been put on one side since the Beckworth deaths, but which needed going through. Webb stared down at them but his mind was elsewhere, ferreting, worrying, wondering.

It was half an hour later that the desk sergeant rang again. "Mr Leyton is ready to make a statement, sir," he said.

Webb pushed back his chair. "Cross your fingers, Alan!"

"I can't think why," she retorted, an edge creeping into her voice. He waited, and after a moment she went on hesitantly, "Well, after we'd said hello and everything and he was having his soup at the kitchen table, I said 'I'm afraid I've got some bad news; John Bainbridge has been killed in a coach crash.'"

"And what was his reaction? What did he say?"

"He looked up and said, 'Oh, no! Whatever happened?' I said it had been up at Beckworth and the minibus had gone off the road and crashed down the hill, and that the police found it had been tampered with."

"Let me stop you for a minute, Mrs Leyton. Did you say how many had been killed?"

She frowned. "I think so. Yes – because he asked if anyone else was hurt."

"And what did you tell him?" It was like drawing teeth, Webb thought, in a fever of impatience.

"Well – eleven of them, wasn't it?"

"Never mind what it was, how many did you say?" He'd spoken more sharply than he'd intended, and she flushed.

"Eleven, then. Or rather—"

"What?"

"One woman recovered, didn't she, so it was only ten."

"But what did you tell him, ten or eleven? Please try to remember, it could be important."

"I'm not sure now, you're confusing me." Her eyes filled with tears, and Webb reminded himself that not only was she worried about her husband, but she was also five months pregnant.

"I'm sorry," he said contritely, "I didn't mean to bully you. If you can't remember, never mind. What did he say about the tampering?"

203

Fourteen

What time would she get here? Webb wondered yet again. If she'd left straight after speaking to him, she should arrive any minute. And surely she *would* have left immediately; she was desperate to see her husband.

Suppose, though, she'd decided for some reason to wait till this afternoon? Should he phone to check? If she—

His internal phone interrupted him. He caught it up to hear the desk sergeant's voice.

"Mrs Leyton is here, sir. You asked to be informed."

"Thanks, Andy. Would you install her in an interview room with a cup of coffee? I'm on my way down."

As he and Jackson entered, Sarah Leyton came to her feet.

"Mr Webb – I can see Doug, can't I? You said I could."

"Yes, of course, Mrs Leyton, but first I want to ask you something. Please think very carefully before you answer. How, exactly, did you break the news of Mr Bainbridge's death to your husband?"

She looked surprised. "Well, after you'd been round I thought I'd better find out all about it, because Doug was sure to ask. So I did, and I was able to tell him what had happened."

"I need your exact words."

202

Crombie laid down his pen. "Hang on, Dave! How the hell could he have? What would he know about the woman at the Grange, when he's been away all week?"

Webb held his gaze for a minute, then reluctantly nodded. "No way he could, is there? Specially since his wife doesn't read the papers or listen to the news. Regular little mine of information she must be," he added sourly.

"I know it's a temptation to try to link the two," Crombie continued, a trifle sanctimoniously, "but we must keep the thing within bounds."

Webb bit back the hot retort which sprang to his lips. "By all means," he agreed heavily, "let's keep it within bounds."

And, ignoring Crombie's quick, penetrating glance, he returned to his papers.

"Anyone been in the last two weeks?"

"Not that I recall."

"A woman, with short dark hair?"

"No, definitely no women; I'd remember."

"Did one phone, then, asking for information – time-tables, anything like that?"

Spence said testily, "What is this? The only phonecalls we've had have been from regular customers. And come to that, the only personal callers have been your lot – another ruddy pair this morning," he added, anger coming into his voice. "Despite me asking you to put a stop to it. It's unsettling, to say the least. The boys are still edgy after John's death, and they've told you all they know."

"Thanks for your help, Mr Spence," Webb said blandly. "We'll try not to trouble you again."

Erica Mann, he thought irritably. Bloody woman; as if they'd not enough problems, with ten poor devils—

He slammed his hand down on the desk, making Crombie jump. "That's it, Alan! That's what I missed at the time! In the interview room, Leyton said he was responsible for *eleven* deaths. It passed by me, because we've been thinking in terms of eleven for days. But only ten died in the coach crash; the eleventh was Erica Mann!"

He leaned back, looking triumphantly at Crombie, who, however, didn't seem overly impressed.

"Perhaps his wife said there were eleven in the coach," he suggested. "She mightn't have told him one survived – come to that, she mightn't have known."

Webb's elation collapsed. "You're right, dammit. Well, she's on her way in to see him – I'll check exactly what she did say." He paused. "But suppose, though, just suppose Leyton was including Ms Mann in his total. What then?"

I shouldn't be surprised, the state he's in." He frowned. "You know, Alan, something's been niggling me; something Leyton said which I should have picked up, but Lord knows what it was."

The phone rang. "Bob Dawson, Guv. We're just back from another chat with Spence at the garage."

"Any joy?"

"Well, we took him word for word through everything him and Ms Mann talked about. Most of it waffle, as you'd expect. The Market, what she'd seen there, where she'd had lunch. But what did eventually come out was that she'd asked about his job. Between you and me, I think that's why he liked her; said women don't usually show much interest."

"Exactly what about his job?"

Crombie looked up at the note in Webb's voice.

"The shifts he works," Dawson was replying, "how many drivers there are, that kind of thing. I thought you'd be interested."

"She didn't ask the names of the drivers, by any chance?"

"He says not. In fact, according to Spence, it was all very casual."

"Thanks, Bob."

Like the other drivers, Spence had accounted for his movements on the day of the crash. Would that alibi stand further probing? Webb wondered. *Could* there be a connection between him and Erica other than a coincidental trip to Broadminster?

He phoned Jake Spence again. "Ever get personal enquirers calling round? Asking about the trips you run, that kind of thing?"

"Not often." Spence was wary. "It's not that easy to pop in – we're out on the bypass, remember."

199

"They're mostly bills," she said, "but there is one that looks more personal – handwritten, anyway."

"What's the postmark?"

"Shillingham, posted on the twelfth of November."

"The twelfth," Webb repeated slowly. "That'd be last Thursday. Is the letter still inside?"

"No."

"Do you recognise the writing?"

"No," she said again. Then, fearfully, "Do you think it's important?"

Very important, Webb thought grimly, if, after reading it, Leyton barely paused to shave before setting out to confess to multiple murder.

"It might be, Mrs Leyton. Could you have a quick look round and see if you can see it anywhere? Perhaps he pushed it into a drawer, or something?"

He wouldn't have it on him, Webb thought. If, as he suspected, the letter contained the truth Leyton was at pains to conceal, he'd hardly walk into the police station with it.

But nor, apparently, had he left it where his wife could find it.

"Never mind," Webb said heavily. "Thanks for your help."

"But what happens now?" she cried. "What are you going to do with him?"

"We've no reason to do anything."

"Can I see him?"

"Of course. Perhaps you could persuade him to be more helpful."

"A letter?" Crombie asked, as Webb put down the phone.

"Yep, but God knows what he's done with it. Eaten it,

He heard her gasp. "I don't believe you! What have you done to him?" Her voice was rising.

"He arrived here in a very distressed state, asking to see me—"

"Yes," she interrupted, "that's because I told him you'd called."

"—and insisting that the crash was his fault. He's demanding to be charged."

"What?"

"He's refused to leave the building, so for the moment we've put him in a cell here at the station. He's not under arrest, he simply won't go away."

"Oh my God!" It was a whisper that scarcely reached him down the wire.

"Could he have received a phonecall this morning, while you were still asleep?"

"There's a phone by the bed – it would have woken me."

"Might someone perhaps have called at the house?"

"No, I'd have heard the bell."

"What about the post, then? What time does that come?"

"Not till nearly nine – he'd gone by then. But—"

"Yes?" Webb prompted, when she didn't go on.

"There were some letters waiting for him," she said almost reluctantly, "that had come while he was away. He was too tired to look at them last night, but he must have opened them while he had a cup of tea – the envelopes are on the table."

"Could you look at them now, while I hold on, and tell me what's there?"

"All right." She sounded thoroughly frightened now. He heard her put the phone down and her footsteps moving away. A few minutes later, she was back.

197

couple of hours, by which time I hope you'll have decided to cooperate."

"What the hell do you make of that, Guv?" Jackson asked as they went back upstairs.

"He's a stubborn devil. It's obvious he's hiding something, which must mean he's protecting someone. And since I can't see his pregnant wife crawling under the minibus, I'm damned if I know who. Talking of his wife," he added, as he reached his office, "I'm going to have a word with her; see if she can shed any light on this."

He pulled the phone towards him and rang the Leyton home.

It was answered at once. "Hello?"

"Mrs Leyton? This is DCI Webb at Shillingham."

"Oh, Mr Webb. I thought it might have been Doug. He's on his way to see you."

"Yes, he's here. How did he seem when he left home?"

"I didn't see him – I was still asleep. He left a note on the kitchen table."

"How was he last night, then?"

"Very shocked to hear about John. Kept saying what a nice man he'd been."

Webb paused to weigh his words. "Did he make any other comment about his death?"

"How do you mean?"

"Hint that it could have been his fault in some way?"

"*His* fault?" she repeated indignantly. "Doug's? Of course he didn't! How could it have been? He was in France – I told you."

"The point is, Mrs Leyton, he's now claiming he was responsible for the crash."

Webb said gently, "I think – in fact, I'm sure – you know more than you're telling us. Of course we want to solve the case, but not at any price. You mightn't know it, but every time we have a murder on our books there are queues of people lining up to claim responsibility."

"Nutters," Leyton said unexpectedly, sitting back in his chair and wiping his face with his handkerchief.

"Attention-seekers, at any rate. You don't fit into that category, so I'm asking you again – why do you feel responsible?"

"Because I am. Just as surely as if I crept up and cut the cable myself."

"The cable wasn't cut, Mr Leyton," Webb said quietly. "And as I explained, unless you're prepared to give us all the facts, there's nothing we can do. You're free to go."

Leyton planted both hands on his knees and sat like a rock. "I'm not going anywhere," he said. "I killed eleven people. Isn't that enough for you? It's more than enough for me. I'm just sorry you can't hang me and put me out of my misery."

"You don't mean that, sir."

He gave a mirthless laugh. "How would you know? I tell you I'm not leaving this building. If you turn me out, I'll throw a brick through the window. You'd have to arrest me then, wouldn't you?"

Webb looked at him in exasperation. "You could certainly be charged with wasting police time."

"Call it what you like. As long as I'm banged up, I don't care what label you put on it."

Webb stood up. "Very well, Mr Leyton, if you insist, you'll be taken down to the cells. I'll see you again in a

great bloke, you know, one of the best. And now he's dead, and it's all down to me." He looked up, fixing his anguished eyes on Webb. "That's what I've come to tell you, Chief Inspector. That I'm responsible for his death, and—" his voice shook "—everyone else's who died with him, God help me."

Jackson raised his head from his note-taking and glanced at Webb. This was what they wanted, wasn't it? Then why didn't it seem right?

Webb sat in silence for a moment. Then he said, "But if, as you've just told me, you've been abroad for ten days, the crash must have happened while you were away."

Leyton shook his shaggy head. "You'll have to take my word for it. I'm responsible, and I'm ready to take the consequences. In fact, I insist on it." He stared defiantly at Webb with his bloodshot eyes. "Aren't you going to charge me?"

Webb leant forward. "You said you heard of Mr Bainbridge's death on your return, and – *that was bad enough*. Which implies something else happened later, to make you feel you were responsible. What was it?"

Leyton shook his head violently. "I caused the crash. What more do you want? Just be thankful to have the case sewn up."

"We don't want to sew you up with it."

"What do you mean?"

"Unless you indulge in out-of-body experiences, or can dematerialise at will, there is no way you could have tampered with that minibus. So what has convinced you, against all logic, that it was your fault?"

Slowly Leyton bent forward until his forehead was resting on the table. His shoulders shook as he began to weep silently, as though out of great despair.

room, Jackson bringing up the rear with his notebook. Immediately, Leyton dropped into the indicated chair and covered his face with his hands. Webb and Jackson exchanged raised eyebrows.

"Some coffee, Mr Leyton?" Webb suggested, and Jackson went outside to request some.

Webb waited till he'd returned and taken his seat. Leyton hadn't moved. "Now, sir, what did you want to see me about?"

The man raised his haggard face. "I've been abroad for ten days," he said hoarsely, "and when I got back late last night, the first thing my wife told me was that John Bainbridge is dead, killed in a coach crash. Is that true?"

"I'm afraid it is."

"And that his death is being treated as murder?"

"Yes."

Leyton closed his eyes briefly. "That was bad enough, God knows. We were the best of mates till a couple of years ago. Then everything – came apart and we lost touch. I kept meaning to look him up again, but never got round to it."

"You say everything came apart," Webb put in smoothly. "You mean you fell out over something?"

There was a tap on the door and the coffee was brought in. Leyton picked up his mug and drank thirstily, though the liquid was scalding.

"No, nothing like that," he said then, holding the mug between his hands as though grateful for its warmth. "It was a family tragedy – nothing to do with John."

Nothing to do with John. Did he really believe that? If so, why was he here?

"Anyway," Leyton was continuing, "he'd left the bakery by then and moved up here, to the coach firm. He was a

193

he turns into our gateway, drive past and leave him to us. Thank you for your cooperation."

"Yes, sir. He's just — there's a stream of traffic, but he's indicating right. Yes, he's turning into the station forecourt. He's all yours, sir. Over and out."

Webb switched off the phone and the three men stood staring at each other.

"Well," Crombie said at last, "there's a turn-up for the book."

"What was that you said about the mountain, Guv?"

Webb strode towards the door. "Come on, Ken, let's find out what the devil is going on."

They emerged through the security door just as Leyton entered the building. At least, Webb assumed it was Leyton; he was a tall man, dressed in duffle coat and jeans, a scarf loosely about his neck, and he made unswervingly for the front desk.

Webb came up in time to hear him say, "Mr Webb, please. It's very urgent."

Across the foyer, unnoticed by the man at the desk, some half-dozen men came through the swing doors, their undemanding mission accomplished. The desk sergeant, primed by Jackson's phonecall, hesitated, looking enquiringly at Webb over the man's shoulder.

"I'm DCI Webb. And you, I presume, are Mr Leyton?"

The man swung round and Webb was taken aback by his appearance. His hair was unkempt, his eyes desperate, and a nerve jumped in his cheek. A cut on his chin indicated that he'd shaved in a hurry.

"How the hell—? Well, never mind. I need to speak to you."

Webb nodded and silently guided him to an interview

192

way *up* to the Grange." Webb sighed. "The devil of it is, Ken, there's no one else in the frame. No one at all."

On which gloomy note, they made their way to the muster room for the briefing.

During the next half-hour there were a couple more reports from the police pursuers, all made on Webb's mobile number. Shadowing Leyton was becoming more difficult as they ran into heavier traffic. Once, they lost him altogether, but caught up with him again five stressful minutes later. And all the signs were he was making for Shillingham itself.

"The mountain is coming to Mohammed," Webb said grimly. "What the hell is he playing at?"

The final call, at nine twenty-five, reported that Leyton had entered the town, and from then on Webb maintained contact, following on the wall map the progress of hunters and prey.

"He's just entered Fenton Street." The constable's voice was rising with excitement.

Damm it, the man was now only a few hundred yards from Webb's desk! He was on his feet, his phone clamped to his ear, Crombie and Jackson tense at his side.

"Sir – sir! He's turned into Carrington Street! It looks like he's coming to you!"

"Just a minute." Webb put a hand over the mobile and nodded to the phone on his desk. "Ken, alert the front desk pronto. We need some men out front to monitor a blue Ford Capri, ETA any minute. Driver not to be apprehended, but ensure he enters the building. On the double." As Jackson lifted the desk phone, Webb said into his mobile, "Right, Constable. Keep on his tail. If

Surely he was due to report back at the depot after his ten days' absence?

Webb was relieved to see Jackson already in the outer office, and, motioning him to follow, filled him in with the developments of the previous day and the events of the morning to date.

"In the light of all this, I was going to check again with Johnson's Haulage, but we'll put them on hold till we see what Leyton's up to. There's also a fax due from Mann's ex-employers in the States, but realistically we can't expect it till late afternoon. Still, we mustn't forget her in all the excitement, even though I'm convinced it was suicide, note or no note. Nevertheless, Phil Spence should be seen again; we need to know *exactly* what they talked about, no matter how trivial. I'll action that at the briefing. So, Ken, what are your views on the German measles business?"

"Search me, Guv. All right, so Bainbridge was spreading germs, going to the do when he was ill, but how many of us have done that in our time, rather than miss out on a good evening? It's not a hanging offence, and he *was* the guest of honour."

"So what would Leyton be likely to do?"

"Either keep quiet, which he seems to have done up to now, or, if it had really got to him, go over to Beckworth and have it out with Bainbridge." Jackson paused. "But we don't know he *had* cottoned on, do we? About how his wife caught German measles?"

"Not to mention the fact that on Saturday he was hundreds of miles away. And even if he'd known which bus Bainbridge would use – let alone had access to it, which is very unlikely – he couldn't have fixed it before he went, because then the brakes would have failed on the

"You have him in sight now?"

"Yes, about a hundred yards ahead."

"Not in the lorry, presumably?"

"No, sir, a blue Ford Capri. I don't think he's spotted us, but another car is taking over a couple of miles down the road."

"Thank you. Keep me informed."

Webb climbed thoughtfully into the car. This was something he hadn't expected. In his heart, he'd not believed Leyton had anything to do with the crash. But if he'd arrived home at one in the morning after travelling non-stop from the continent, why should he be out again so early, unless he felt the teeth of the law snapping at his heels? Was he, after all, the answer they were looking for? Or had he something else on his conscience?

Still wrapped in conjecture, Webb drove through the lightening streets, where Shillingham's rush-hour traffic was in full swing. Where was Leyton fleeing to? If the anonymity of London, he'd drop down to join the M4 when he reached Marlton. At what stage should he be intercepted? It was unlikely, despite Hannah's colourful suggestion, that there was any accomplice for him to contact.

Webb turned into the station. It was blazing with lights and he felt his heart lift a little. At least he'd no longer be alone with his worries.

He was on the stairs leading to his office when his phone rang again. "Webb?"

"PC Robson, sir. Just to let you know Leyton's not making for the M4; he's past the turning now and is continuing south-east on the Shillingham road. We're about to peel off, and another vehicle's waiting to take over."

"Fine. Thanks." Where the devil was he making for?

Thirteen

Webb slept heavily that night, but awoke feeling unrefreshed. After an evening spent poring over his drawings, his dreams had been peopled with the caricatures he'd created rather than their real-life counterparts. In dream after dream, he'd been surrounded by small figures with large heads, tiny bodies and exaggerated noses, and the sensation had been been oddly sinister. He was grateful to find himself awake.

It was a quarter to seven. He padded through to the kitchen, made a cup of tea and drank it while he listened to a news programme. Then, still standing and with only half his mind on the radio, he ate a bowl of cereal and made himself some toast. By the time he'd showered and shaved, it was just after eight-thirty when he left the house.

As he opened the garage door his mobile phone rang. "DCI Webb," he said into it.

"SB police, sir, PC Dawkins speaking. Just to let you know the suspect left his house five minutes ago and is heading east. We're following at a discreet distance, as instructed."

"Thanks, Constable. What time did he get home last night?"

"Gone one, sir. Didn't expect him to surface so soon, to be honest."

had made Hannah envious of Gwen's sabbatical there. If she herself had gone instead, would she too have found a Canadian husband?

She looked up to meet her aunt's shrewd eyes. "I'm afraid that, as in your case, she'll have to be satisfied with academic success," she said.

"My dear, you don't want to end up a lonely, dried-up old academic like me! And don't tell me marriage would affect your career. Look at your friend Gwen – hers is about to take off in a completely new direction."

"That's very different; Bruce is in education himself. He understands her commitments."

"And your policeman wouldn't?" Charlotte's eyes narrowed. "But there *was* someone, wasn't there, a year or two back? Someone to do with the school?"

Hannah coloured. "One of the governors, yes."

"Who actually proposed, if I remember rightly?"

She gave a short laugh. "Why do I tell you these things? I should know you have the memory of an elephant!"

"What I *don't* remember is why you turned him down?"

Hannah's eyes fell as she shredded the paper napkin in her lap. "Because of David," she said after a minute.

"Has *he* asked you to marry him?"

"No."

"Would you if he did?"

"No."

"Really, Hannah, I despair of you!"

"But Aunt, dear, I'm extremely happy as I am. More so than ever at the moment, with one of my chief ambitions about to be realised."

"Headmistress of Ashbourne. Yes, that will certainly be a feather in your cap. I'm very proud of you."

Hannah leant forward and patted her hand. "And I of you, my blue-stocking aunt!"

Charlotte smiled. "Poor Valerie – she gave up on me long ago, but she's still hoping for a white wedding for her daughter!"

Hannah's mother, Charlotte's younger sister, had emigrated with her husband to Canada years ago, a fact which

he couldn't have driven to the end of the road, let alone Broadshire. We'll check, of course, but I'm sure it's yet another dead end."

Hannah said reflectively, "I met the Vine grandparents yesterday."

Webb looked up. "How are they coping?"

"Well. The girls have gone back with them for the weekend. There's talk of their going to live with their uncle, aunt and cousins in Wales, which I think would be a good thing."

"There's nothing you can think of which that Richard Vine might have done to cause all this?"

"Nothing at all – I'm sure of it."

"The trouble is, so's everyone else. Well," he got to his feet, "I mustn't intrude any longer. Nice to see you again, Miss Yates."

Hannah made an impulsive movement. "David, don't go! I'm sure Charlotte won't mind if you stay a while longer. We're only—"

"Of course not," Charlotte said quickly. "Please don't leave on my account."

Webb shook his head. "No, really, you've been very kind but I must go. It's helped, talking things over with you both. I think," he added, over Hannah's continuing protests, "that I'll return to my cartoon characters and have another go at them. Who knows, perhaps one of them will eventually put his hand up."

"He'd been hoping to stay over," Charlotte observed, when Hannah returned from seeing Webb out.

"I think so, yes. Poor lamb!"

"Why don't you marry him, and have done with it?"

Hannah laughed. "Such a romantic view of marriage! Anyway, you're a fine one to talk!"

Webb put down his plate and wiped his hands on the paper napkin. "The trouble is, we still don't know if this *was* the reason. It's our first intimation of any motive, and I'm loath to let go of it, but everything points to Leyton being on the continent last weekend."

"Could he have had an accomplice, who did the deed while he himself had a cast-iron alibi?"

"Darling!" Charlotte protested. "You sound like something out of a Penny Dreadful!"

Webb, however, answered Hannah seriously. "I've not met Leyton, but from what I hear of him, it would be out of character. If you'd suffered in silence for two years, would you suddenly not only decide to act, but pour out the whole story to another person, and ask him to wreak vengeance on your behalf?" He flashed a malicious glance at Charlotte. "More of the Penny Dreadful, I'm afraid!"

"No, you're right," she said soberly. "If he's kept quiet up to now, he must be a private man. How much does the second wife know?"

"Not, I think, the full story. She told us about the child and Libbie's suicide, but German measles wasn't mentioned. And she spoke as though her husband still regarded Bainbridge as a friend."

Hannah refilled his teacup. "Didn't you say one of the Richard Vines was a doctor, who was accused of something or other?"

Webb nodded. "Malpractice, yes. I went to Reading this morning, to see the couple who'd made the complaints. Mind you, only someone really unbalanced would have gone so far as to *kill* him for that. Ruin his career, yes – and if he were guilty, he'd deserve it – but not murder. In any case, the husband went to a football match on Saturday and then got plastered by way of celebration. As he put it,

to the plethora of victims and corresponding shortage of suspects." She paused, taking a sip of tea. "I remember your telling me that you sometimes use cartoons to solve your cases. You said: 'People's actions are in their faces, if you know how to read them.' Do you still think so?"

Webb moved in embarrassment. "I don't remember saying that, but yes, I believe it. The trouble in this case, as you remarked, is a lack of faces."

"So you came to talk it over with Hannah, and found me ensconced. Poor you!"

Webb flushed. This woman had the knack of putting her finger right on the button.

"However," Charlotte continued equably, "if you do want to unburden yourself, please feel free. I'd be most interested to hear what's happening, and needless to say it would go no further."

Hannah was watching him worriedly, unsure of his reaction to this probing. It was true he often used her as a sounding board, someone to whom he could speak freely, expounding theories he perhaps couldn't put to colleagues, and appreciative of her own ideas and comments. Usually such discussions took place in bed, after they'd made love. And she knew, suddenly, that he'd been hoping to stay the night. Poor David! It wouldn't worry Charlotte if he did, but Hannah knew that he wouldn't.

She said gently, "You really do look shattered, David. Why has today been particularly bad?"

So, reluctantly at first and then more easily, he told them of the Brownings' visit and the possible link to Doug Leyton.

"I'm glad John Bainbridge never knew about it," Hannah said, "even if it was the reason he died. It would have been a terrible burden to bear."

Charlotte Yates was Hannah's self-styled 'maiden aunt', a description which had led Webb, some years ago, to anticipate a thin-ankled, thick-stockinged old lady. Nothing could have been further from the truth. An economics lecturer at Oxford, Charlotte was tall and blonde, dressed smartly but unconventionally, and smoked the odd cigar. She could be ruthless and abrasive, but she had great charm. Webb liked her, though at the moment he did not feel up to parrying her barbed repartee.

"We're just having tea," Hannah said, pushing him towards the sitting-room and, to Charlotte, "Look who's appeared on the doorstep!"

Charlotte smiled, extending a silk-clad arm from the chair where she sat. "How nice to see you, Chief Inspector."

Taking her hand, Webb wondered fleetingly if she was remembering the last time they'd met, with the echo of a gunshot still ringing in their ears. He hoped not, but he'd long ago accepted that his profession cast shadows over his social life.

As he was passed a buttered crumpet, the point was underlined by the reminder that it was here, over tea last Sunday, that he'd learned of the minibus crash, via a phonecall from Gwen Cameron. Full circle? No, regrettably; not yet.

"You look tired," Charlotte Yates announced, her lovely grey eyes studying him.

"I am," he acknowledged simply.

"The Beckworth deaths?"

He flashed her a quick look. "Yes."

"I've been following the case in the press; too many chiefs and not enough Indians." She smiled suddenly. "Not chief *inspectors*, Chief Inspector! I was referring

And that, Webb reckoned as he put down the phone, was all he could do for now. The interview with the Brownings had depressed him, with its story of past tragedies. Nothing happened in a vacuum, he thought; people were damaged, sometimes irreparably, and resentments could smoulder for years, as he'd found more than once. All it needed was a spark to bring them to life again.

Like the prospect of another baby? Would Leyton's present wife's pregnancy have reawakened all the traumas of his first wife's, and the horror of her subsequent death?

At the very least he warranted another check, to make sure the continental alibis hadn't been rigged. But that could wait till tomorrow. He was tired, and he was going home.

By the time he reached Beechcroft Mansions, Webb knew he couldn't face another evening on his own, and decided to phone Hannah. Her company would dispel, at least for a time, the miasma of misery which still hung over him.

He garaged the car and went into the building. Even better, he thought, he'd call in on his way upstairs. Ignoring the lift, he ran up the flight of stairs to the first floor and rang her bell, aware of a surge of relief as the door opened.

"David, hello!" She sounded surprised to see him.

He kissed her, holding her against him for a moment before releasing her. "Sorry to barge in like this, but I've had a lousy day and I could do with some company."

She hesitated for a fraction of a second, then said, "Of course. Come in and join us – Charlotte's here."

He stopped. "Hannah, I'm sorry. I should have phoned to check you were free. It was just—"

"She'll be delighted to see you," Hannah said firmly, taking his arm.

181

zipped up her padded anorak; and Webb had to agree with her husband, who muttered, "You should have thought of that before!"

"Your name won't be mentioned," Webb assured them, and went back into the warmth of the station.

"Were they any help, sir?" the desk sergeant asked as he passed.

"Lord knows," Webb said despondently. He went upstairs and through the now almost deserted main office. Four o'clock on Sunday afternoon; Doug Leyton should be home. He thought for a moment, then pulled the phone towards him and punched out the number he'd got from the bakery. When Mrs Leyton answered, he asked to speak to her husband.

"He's not back yet, Chief Inspector," she told him. "I don't expect him till close on midnight. Shall I tell him you called?"

Webb thought rapidly. "No, don't bother him – he'll be exhausted. I'll phone back sometime tomorrow."

He rang off and made another call, to Steeple Bayliss police station. With no major incident to occupy them, only a skeleton staff was on duty.

"We've a possible suspect in your area," he told the duty sergeant, giving him Leyton's name and address. "I'd be grateful if you would ask DI Ledbetter to arrange for a discreet watch to be kept on him. He's due back late tonight, and his wife will tell him I've tried twice to reach him. He might take fright, and I don't want to lose him."

"Right, sir. I'll clear it with the DI to have the house watched from tonight, just in case. What do we do if he breaks cover?"

"Get on to me at once – I'll give you my mobile number – and don't let him out of your sight."

about any of it. I didn't realise till this afternoon, when she asked after them. But we'd all sort of lost touch except for Christmas cards – accidentally on purpose, perhaps. So I – just said they'd moved away. She's enough trouble of her own without hearing of other folks'."

"But did the Leytons know where Libbie had caught it?" Webb asked, aware of the importance of the question.

She shrugged. "Nothing was ever said. Mind, there was an epidemic at the school, so she *could* have got it anywhere. That's why Bill would never say anything, and I've had to drag him here now."

"But you believe she caught it from John Bainbridge?"

She nodded. "Though I still wouldn't have said so, if it hadn't been for Annie; she won't rest till she knows why he died. I felt that if there's even the slightest chance of a connection, we had to speak up."

"It's never entered her head they were after *him*," Browning put in. "She thinks he died because he was with whoever was the target."

"And she might be right," Webb conceded. "As might all the other relatives, who think the same thing."

"So if it's that wide open," Browning argued, "why point the finger at Doug? He's had his share of trouble, but he's a decent bloke and there's no way, even if he thought John was to blame, that he'd track him down like an animal and kill him."

And in any case, Webb thought, he'd been in southern France at the time. Hadn't he?

There was nothing more they could tell him. Webb switched off the tape, thanked the Brownings, and walked them through the foyer to the door.

"Doug won't know, will he, that it was us who told you?" Pat Browning asked with belated anxiety as she

179

I'm sure he'd rather have stayed home in bed, he made the effort to be there. He did try to keep his distance, mind; I remember him saying, 'Don't come too close, I've got the dreaded lurgy!'

"But it was his last day at the bakery and they were moving in a few days, and when the party broke up, all the girls wanted to kiss him goodbye. I remember Libbie, who was on one of her highs, saying 'To hell with the lurgy – come here, you gorgeous brute!' and she gave him a real smacker right on the lips."

She stopped speaking, and the only sound in the little room was the whirring of the tape.

Then she said flatly, "Only it wasn't the lurgy, was it, it was German measles, and Libbie went down with it herself a week or two later. And to cap it all, she'd finally fallen pregnant, though she didn't know it at the time."

Pat Browning bit her lip, and it was several moments before she continued. "Well, they told her, later, about the risks, but it had taken her so long to start a baby, she wouldn't listen."

Her voice broke. She cleared her throat and went on, barely above a whisper. "Anyway, the poor mite was born severely disabled and lived only a few hours. And Libbie – well, that was the last straw and she totally flipped. Doug got her into some psychiatric place near SB and left the bakery to move up near her. But the next we heard, she'd discharged herself and disappeared. They searched for her all over, but before they could find her, she'd thrown herself under a train."

There was a long silence, while all of them reflected on the tragedy. Then Pat Browning looked up, her eyes full of tears.

"John and Annie never knew," she said unsteadily, "not

"It wasn't all that often, though," she went on more slowly, "because we never knew how Libbie would be. Up one minute and down the next, she was."

"Libbie being Mr Leyton's wife?" Webb asked, knowing the answer full well.

"His first wife, yes. They say he's married again."

"You didn't get on with her?"

"Oh, she was all right, just highly-strung. She'd get these awful bouts of depression, when Doug couldn't do nothing with her. Part of the trouble was she was desperate for a baby, and hearing me and Annie talk about our kids didn't help." She bit her lip. Webb, watching her struggle for the right words, was content to wait.

"Then, out of the blue, John announced he was leaving, and coming up to Hatherley Coaches. We were gobsmacked, the lot of us; after all, him and Annie were part of the gang, plus he was popular at work, and got on well with everyone." She sighed. "Still, we'd no choice but to put a brave face on it, so we organised a leaving party at the Cat and Fiddle – no expense spared."

She stopped, reached out quickly for her mug of tea and drank from it. Browning patted her arm in a clumsy attempt at encouragement. Now, Webb thought, we're approaching the nitty-gritty.

"Yes?" he said, when she didn't immediately continue.

"Well, the week beforehand, Annie had to stay off work because the kids were ill. There was German measles around, and I remember telling her to watch out for rashes – they're easy to miss if it's a mild attack. Then, on the morning of the party, John goes down with it himself."

Webb saw that her hands were shaking, and she clutched her bag tightly to try to still them.

"But he knew we'd gone all out on the party, and though

177

"Ah! But surely you've already been interviewed?"

He coloured. "Yes, and I told 'em what I knew, not what's only gossip."

"It's more than that, Bill!" his wife said indignantly. "You know it is! You said yourself—"

They were interrupted by a uniformed constable bearing a tray with three polystyrene mugs, a sugar bowl and three spoons. Webb waited while they helped themselves to sugar, then said smoothly, "Mrs Browning, since coming here was your idea, perhaps you'd like to tell me what it's all about?" Seeing her tense and glance at the tape, he added, "There's no hurry, take your time. But start at the beginning, if you can."

She took a sip of tea, daintily wiped the corners of her mouth with a handkerchief, and hesitated again.

"Perhaps you'd be more comfortable without your coat and scarf? It's quite warm in here." It was, in fact, unpleasantly stuffy.

Pat Browning nodded, unwound the scarf and struggled out of the heavy garment. Her husband, sitting beside her, made no effort to help.

"We've been up to see Annie Bainbridge," she said in a rush, as though along with the jacket she had shed her inhibitions. "That's what decided me, seeing her again. I didn't tell *her*, mind, but I knew we had to tell the police."

"The beginning?" Webb reminded her.

She nodded again. "Well, as Bill said, him and John and Doug Leyton worked together at the bakery. They were good mates, and sometimes, if Annie and me could get babysitters, we'd go out in a sixsome for a curry." She flashed a look at her husband, but his eyes were firmly on his mug of tea.

176

Twelve

They were clearly ill at ease, and Webb, having invited them to sit down in the less than welcoming interview room, put his head round the door to ask for some tea.

The man, who introduced himself as Bill Browning, was below average height, with a receding hairline and an incipient paunch. His wife was muffled up in a thick anorak and scarf, above which her face looked small and pinched. Her hair, nondescript brown, had curled tightly in the damp air.

Webb smiled at them encouragingly. "Would you mind if I switched on the tape? My sergeant isn't here, and I'd like a record of what you have to tell me." They both looked alarmed, and he said quickly, "It's only like an electronic notebook, but if you'd rather not—"

"No, it's all right. I mean, we expected you'd take notes."

"Thank you." He did the necessary. "Now, Mr Browning?"

The man glanced at his wife. "This is Pat's idea; I'm still not at all sure—"

"We have to, Bill," she broke in quickly. "We owe it to Annie."

Browning glanced at Webb, then away again. "I'm one of the Cottage Bakeries drivers," he said.

175

A weak sun was at last breaking through as he emerged onto Franklyn Road, but it hadn't left itself much time; it would be setting in another couple of hours.

Hands in his pockets, he turned the corner into Carrington Street, glancing up at the façade of the General Hospital as he passed. Mrs Sue was still there; he must make a note to pay a courtesy visit. Someone said Richard Vine had stood her a private room.

He turned into the circular drive of the police station, skirting the pond which, in summer, sported a wealth of water lilies, but which now lay black and uninviting. How did that poem go? 'No fruits, no flowers, no leaves, no birds – November!'

He went up the steps, pushed through the door, and was immediately hailed by the desk sergeant. Webb went over to him.

"A couple to see you, sir; they've been waiting about twenty minutes. Said they've some information about John Bainbridge."

Webb drew a deep breath. Was this the break they'd been waiting for? He turned, and saw the man and woman sitting nervously on a bench.

"Right, Andy. Thanks."

As he crossed the reception area towards them, they stood up, the woman clutching her handbag to her stomach.

"Good afternoon," he said. "I'm DCI Webb. I believe you want to see me?"

people change as quickly as that? Had he met some-
one else?

She turned a sob into a cough as, behind her, she
heard her son come into the room. "Lunch is nearly
ready, darling," she said brightly. "So go and wash your
hands."

Back in Shillingham, Webb parked behind the station and
walked round the corner to the Brown Bear.

"I'll have the roast, Mabel," he told the barmaid as she
passed him a pint of beer. "What is it today?"

"Pork, Mr Webb."

"Great. Plenty of stuffing and crackling, then."

He walked over to a table and sat down. The pub on Sun-
day had a different aura from weekdays, when there was
usually a gang in from the station. Admittedly he was late
after his drive to Reading; the others might have already
eaten. Certainly quite a few of them would be working
today, with both Beckworth cases still relatively new.

"Have you got him yet?" Mabel enquired a few minutes
later, laying a succulent-looking plateful in front of him.
She prided herself on her police clientele, frequently
hinting at inside knowledge to her friends.

"Not yet, Mabel, more's the pity." Webb ladled mustard
onto his plate.

"And that woman; did she fall or was she pushed?"

"Can't tell you that either, I'm afraid."

"You'll crack it soon," she said confidently, as she
moved away. Webb could only hope she was right.

He lingered over his lunch, consciously postponing a
return to his desk and the problems that awaited him there.
They all needed a break, he thought; without one, he didn't
see how they were going to make any progress.

173

"Not really. You know I don't like you phoning me at home."

"It's just that Simon's going to a party this afternoon." Julia hesitated. "I wondered if perhaps you could come down?"

Richard was aware of irritation. "It's Sunday, Julia. The family's coming for lunch – they're due any minute."

"But later? We've met on Sundays before. And it seems a long time since we saw each other away from the office."

He stood with the phone cradled under his chin, staring down the cheerless garden. One or two birds were pecking at the food Natasha had put out earlier. Natasha, who had a lover.

He said slowly, "I think perhaps we should cool it for a while. People are beginning to talk."

At the other end of the line, Julia's hand tightened on the phone. She made herself say steadily, "Which people?"

"Adrian has his suspicions, I'm sure."

"Has he said anything?"

"Not in so many words."

"He's discreet, though, isn't he? I mean, he wouldn't—"

"Well, as I said, let's just leave it for a while and see what happens. All right? And please don't ring me here again unless it's to do with work. I'll see you tomorrow." Richard put down the phone, stood a moment longer staring out of the window, then turned on his heel and left the room.

In Shillingham, Julia fiercely brushed the tears from her eyes. You knew it would happen sometime, she told herself, going back to the kitchen to test the vegetables. But it was only last week, when he'd heard of the crash, that he'd told her how much he'd needed her. Could

ranks. We'd no proof, and no one came forward to back us up, though Denise had heard other women talking about him. So he got away with it."

"But not for long," Webb said quietly.

Parton instantly turned belligerent. "What do you mean by that?"

"I mean, Mr Parton, that he is now dead." Webb held his gaze steadily, and the man's eyes fell.

"And good riddance," he muttered after a minute.

"Where were you last Saturday, sir?" Webb asked casually.

Parton was not deceived. "I *knew* that was what you were leading up to! My God, if I'd wanted to kill him, there were chances enough to do it here!"

"Your movements, sir?"

"Went to watch the local team, didn't I? And yes, I can prove it. I was with a gang of friends and our lads won, and we all got tanked up afterwards by way of celebration. There was no way I could have driven to the end of the road, let alone to Broadshire, even if I'd known Vine had gone there, which I didn't."

So a football match had provided yet another alibi. Still, it was no more than he'd expected, Webb reflected, driving back along the motorway, and at least it was another name to cross off.

Admittedly, as Fleming had hinted, he'd had no need to go to Reading, which was why he'd not dragged Ken out. He was aware he'd been pandering to an almost obsessive need to meet witnesses and suspects face to face. Well, that he had now done, and he was satisfied. Even if not strictly necessary, it hadn't been a wasted journey.

"Richard? Can you talk?"

171

"You know, of course, why I'm here," he said, when finally they were all seated with their coffee. "I understand you made a claim of malpractice against Dr Richard Vine, who was killed last week in a coach crash. Perhaps you'd tell me the grounds for your claim?"

"I know he's dead," Parton said truculently, "but that doesn't alter what he was in life, which, not to mince matters, was a bastard. And I'm not ashamed to say so."

Webb tried another tack. "When did you meet him?"

"When we moved here three years ago."

"You knew him socially?"

"Unfortunately, yes. We met him and his wife when our next-door neighbours gave a party to introduce us to the district."

"And then you signed on with him?"

"We didn't know anyone else, and he seemed pleasant enough. Denise would have preferred his wife, but at that time her list was full."

"So what happened?" Webb addressed the question to Denise Parton, who flushed, lowering her lovely eyes.

"At first, I told myself I was imagining things – you know, his hand touching mine when he passed me a prescription, standing close against me as he showed me out; that kind of thing. Then, when I was suffering from a spell of migraines and we had trouble finding the right medication, he started dropping in here, ostensibly to bring sample pills for me to try. Once, it was only eight-thirty in the morning, and I was still in my dressing-gown."

"Then he started touching her up," Parton broke in, flushing darkly. "Filthy bastard! Old enough to be her father!"

"So you complained?"

"Bloody right we did. But you know how that lot close

170

had several stories in print. The prospect made her giddy with anticipation.

Despite Erica's death, she admitted guiltily to herself that she'd enjoyed the last week. The School always had the effect of revitalising her, making her want to get down to work straight away and put all those new ideas into practice. Now, though, she'd absorbed as much as she could; she needed time to herself in which to apply all that she'd learned, space to work out the plots jostling in her brain. Yes, it would be good to be home again, she thought happily. And Harold would be waiting.

Patrick and Denise Parton, whom Webb had phoned before leaving Shillingham, had agreed somewhat warily to see him, and their reluctance was still evident as they showed him into their sitting-room.

While the coffee was brought in and poured, Webb took the opportunity to study them. Parton was a tall, black-haired man in his forties, with deep-set eyes and thick, heavy brows. He gave the impression of being more than able to hold his own in a fight, and possibly not too reluctant to engage in one if he thought his cause justified it.

His wife appeared to be about ten years younger and was very attractive, with a good figure, glossy chestnut hair and wide green eyes which held Webb's a shade longer than necessary as she passed him his coffee. Had Dr Richard been subjected to that glance, and if so had he misconstrued it?

It must be a nightmare, Webb thought, having to watch every word and movement. No wonder most doctors insisted on the presence of a nurse during examinations; like the police, they were particularly vulnerable to attractive women crying rape.

169

to whom the audience could direct questions. This session was always disrupted by people constantly coming and going, arriving late after taking their cases down to the hall, or leaving early when their particular transport arrived.

It was as they took their seats that Myrtle dropped her bombshell. "I'm not at all sure that I'll come back next year," she said.

Betty turned to stare at her. "Really? Because of Erica, you mean?"

The suggestion was impatiently brushed aside. "Of course not; I just feel I've outgrown its usefulness. Once your work is published, you no longer need such basic instruction."

Betty was no fool; she knew she'd not been forgiven for winning the short story prize, and that Myrtle's injured pride would take some time to heal.

She said comfortably, "Well, it's a full year ahead; you've plenty of time to think about it."

Which was not the reaction Myrtle had expected. "Will you still come, if I don't?" she asked after a minute.

Oh, the bliss of a room to herself, where she wouldn't be constantly harried and bullied! "I expect so, yes. After all," Betty added innocently, "I still need all the tuition I can get, don't I?" And she pretended not to notice Myrtle's quick, suspicious glance.

So they'd come almost to the end of another School, Betty thought, as the lecturers filed onto the platform, accompanied by applause. One that had distinguished itself from all the others, first by Erica's violent death, still unresolved, and second by the supreme triumph of her prize. If Mark was right, she might be on the very verge of publication! Perhaps by this time next year, she'd have

letters and phonecalls? The doctor, accused of assaulting a patient? The parents of the schoolgirls?

Eventually, admitting he was none the wiser, Webb abandoned them in favour of Erica Mann, drawing the window from which she fell, the enigmatically missing suitcase, the people with whom she'd spent her last days.

He frowned, staring at his depiction of the tutor. According to the officer who'd interviewed Aston there'd been a slight edginess about him, as though he were concealing something. What was it? No doubt, Webb thought with a half smile, many teachers were tempted to do away with their pupils, but fortunately few carried it any further. Aston's alibi had been partially confirmed by two women, who endorsed his claim of giving them a lift back from Shillingham; however, his earlier activities that afternoon might stand further probing.

Webb massaged his aching neck. The crux, he told himself, was surely that if this latest death *was* murder, it had to be connected with the crash. The woman had been here the previous week; had she seen something which, later, might have led her to suspect the killer? Had Phil Spence, with whom she'd chatted – uncharacteristically – in Broadminster, made some slip which incriminated him? And had he realised it?

Webb pondered the possibilities, turning each over and over in his mind until he was forced to admit that exhaustion had set in. His brain had given up on him and it was time for bed.

At least, he thought, standing up and stretching, he had a list of further things to check. That would have to do for the moment.

On Sunday morning, by tradition, the final session of the Writing School took the form of a panel of lecturers

theatre that the seats Young had booked had been occupied throughout the performance.

And if *he* was in the clear, Webb thought dispiritedly, the perpetrator must surely be an outside agent, rather than anyone who'd been at the Grange legitimately.

But what risks this hypothetical stranger had taken! Firstly, there was no guarantee that the driver would leave the bus unattended, and secondly, no way of estimating how soon the passengers would come out – quite apart from the chance of being seen as he made his way up and down the drive, presumably on foot. He could have been spotted and challenged at any stage of the operation, yet had escaped undetected. Wasn't this taking the luck of the devil too far?

But dammit, *someone* had tinkered with the bus *somewhere*.

Webb abandoned the background to concentrate on the people involved. Within minutes he'd filled the sheet with lifelike caricatures like those in the cartoons which, from time to time, he submitted to the *Broadshire News*, and which left its editor clamouring for more.

This was the less easily explained phase of the operation, when he tried to 'think' himself into the people he portrayed. For long minutes he studied each in turn: Richard Vine, his retiring wife, his secretary, the deputy manager, the dead driver – drawn, since Webb had never seen him, with a blank face – and the driver's wife. Which, if any, of these people knew more than they had told him?

More importantly, who had been the target and who the killer? Which of them had either inspired or been inspired by such hatred that the cost in innocent lives had been discounted? Richard Vine himself, receiver of anonymous

166

He'd started by drawing two representations of the minibus, one parked outside the driver's home at the top of the hill, the other at the Grange.

He had then stared for some time at the first drawing, unable for the life of him to imagine how it could have been vandalised in that location. For who, other than the owner of the coach company, even knew it would be there? Strictly speaking, it should have been returned to the garage between trips. In this drawing, therefore, the bus remained unembellished, with no suspicious figure lurking near it.

In the second drawing, the Grange itself was sketched in, with matchstick figures representing, in the conference hall, Vine and his guests, and in the kitchens, staff preparing refreshments. The porter figure, Ralph, was shown talking to one depicting Bainbridge at the back door.

Here, on the face of it, there were more possibilities, but they evaporated on examination. The completed questionnaires, stating who'd been speaking to whom during the crucial time, corroborated each other exactly, and despite exhaustive searching for discrepancies, he had found none.

There was, of course, the deputy manager, Adrian Young, who had allegedly left for the theatre an hour or so before the bus's arrival. But suppose he'd not gone to the theatre at all? Or arrived late, after tampering with the bus? Or left at seven as he'd said, but slipped out during the performance? Though any of these possibilities would involve the complicity of his wife.

Tentatively, Webb drew in a Young figure beside the bus, but after a minute rubbed it out again. He made it a rule with these sketches to show only known movements, not theoretical ones. Nonetheless, he would check at the

which touched directly on the Writing School. And to add to the pressure, neither has been satisfactorily explained.

"I need hardly say how distressed we've been about all this, but I do want to thank you all for staying the course rather than returning home early, which would have been very understandable.

"I should also like publicly to thank my wife for her support, which has meant a great deal to me, as has that of my deputy manager Adrian Young and all the staff, who have made strenuous efforts to ensure that everything has gone as smoothly as possible these last few days.

"Finally, I do most sincerely hope you'll all come back again, and have a more peaceful stay than has been possible this time. Thank you."

A storm of enthusiastic applause broke out. The members of the School, relaxed by alcohol and secretly relieved to be leaving the next day, felt nothing but sympathy and support for the proprietor, and were intent on expressing their goodwill.

Natasha blinked back tears. Richard had thanked her publicly; was that a sign that from now on he would value her more highly? Or had he merely been warning off any potential lover?

Possibly neither; it might simply have seemed expedient, said in the heat of the moment. Nevertheless, there was no denying their relationship had shifted, and she had no intention, even after his gratitude faded, of letting it revert to the way it had been.

It was nearly eleven, and Webb sat on his stool surrounded by discarded sheets of paper. He was not at all sure that the exercise had achieved anything.

"Natasha! Great to see you." Adrian bent to kiss her cheek.

"Hello, Adrian, Emma. Goodness, what a crush, isn't it?"

"Not your scene, I'd have thought," Emma said, greatly daring.

"I felt that in the circumstances a united front was called for. Actually, I'm rather enjoying myself."

Richard touched her arm. "It's time for me to make my speech. Will you – be all right?"

"Perfectly!" she said.

There was a flicker behind his eyes, and she realised he was wondering if her lover were among the crowd. A sense of power surged through her. Tomorrow, Mark would be gone, never to return, but Richard wasn't to know that. And, she thought pleasurably, there was no harm in keeping him on his toes.

A bell rang for silence, and the committee chairman raised his voice. "Ladies and gentlemen, we're very pleased to have Mr and Mrs Vine here with us this evening, and now I'm going to ask Mr Vine to say a few words."

There was sporadic applause and Richard took the microphone.

"Good evening," he began. "Usually on these occasions, I make some reference to my pleasure in having you all here at the Grange, hoping you've enjoyed your stay and that we'll see you again next year. Of course, that still applies, but this year I think more is required of me."

He paused, and there was silence throughout the room.

"I'm sure you will appreciate that this has been a very difficult week for me, my family, and the staff of the Grange. We have had not one but two tragedies, one of

surveyed its contents. Though he enjoyed cooking, using elaborate recipes as therapy when embroiled in a case, he was now impatient to make a start on his drawing. A convenience pack, kept for emergencies, would fit the bill admirably.

While the flat filled with the odour of chicken tikka, he set up the easel and took out paper and crayons, his mind already turning over statements and alibis. Back to square one, then, he told himself. Who had had both the opportunity and the motive to tinker with the minibus?

Emma Young caught suddenly at her husband's arm.

"Good Lord – look over there! Natasha's here!"

"What?" Adrian spun in the direction she indicated. "I don't believe it! Whatever's got into her? Perhaps she's nervous of being left alone."

"She doesn't *look* nervous," Emma said.

Young had to admit she was right; in fact, he'd never seen Natasha so at ease. There was a new assurance in her smile, the turn of her head as Richard introduced her to the guest lecturer and members of the committee.

"Perhaps murder gives her a buzz?" Emma suggested, but her husband frowned.

"Don't talk like that!"

"Darling, *something*'s happened, obviously. Look at old Richard; he's watching her as though he can't believe she's real."

"Well, all I can say is, good for her. It's time she came out of her shell and put a stop to our Julia's little games."

Behind them, someone said, "Is that Mrs Vine? I haven't seen her here before. She's attractive, isn't she?"

Adrian and Emma exchanged an amused glance and went over to greet her.

of background for the woman; no one here seems to know anything about her."

"Not even in her home town?"

"We've no idea where that was; her birth certificate gives a Southampton address, but there's no trace of any Manns there now, and the occupants of the house where they lived bought it from someone called Didcott ten years ago." He paused. "She told her landlady she'd no ties in this country, so we might be on a hiding to nothing."

"A puzzler."

"Yes, sir."

"Um. So what's your next step?"

"A sideways one, on the coach crash. I'm intending to drive to Reading tomorrow, to interview the couple who made the claims against Dr Richard Vine."

"Haven't the local boys already seen them?"

"Yes, sir, but sometimes things come out at a second interview – they start to get rattled. It's possible they harboured a grudge and took drastic action." Though it seemed unlikely, he admitted privately, hoping his doubts didn't sound in his voice; the chief super liked an upbeat approach at all times.

He waited, and finally Fleming said, "Right, Spider; keep me informed of progress," and rang off.

Webb stood irresolute, strongly tempted to check if Hannah were free. But he felt restless and unsettled, and it'd be unfair to inflict his mood on her.

Instead, he decided to set up his easel and sketch what he knew of the two incidents. Very often, seeing the scenes in black and white in front of him, his subconscious gave him a nudge in the right direction. He could only hope it would again.

Having reached a decision, he opened the freezer and

Eleven

It was six o'clock by the time Webb reached his flat, and his first action was to pour himself a whisky. He stood in the kitchen drinking it slowly, savouring each mouthful and the warmth of its passage down his throat, his eyes on the illuminated room in the dark square of the window.

Then, with a shrug, he phoned the chief super as instructed.

"So you think this second suitcase might be significant?" Fleming enquired. Webb could visualise him, grey eyes alert, head on one side in what Webb thought of as his sparrow mode.

"Could contain something she didn't want seen, sir. But what the devil she's done with it is anyone's guess."

"You're sure there was no receipt for it anywhere? Stuffed in a pocket, at the back of a drawer at the Grange?"

"Everywhere and everything has been meticulously searched several times; there's no sign of it. We've also faxed the American firm where Mann worked. Among other things, I'm curious to know how she managed to obtain a green card – they're not easy to come by. However, they'll no doubt be closed over the weekend, so it'll be Monday afternoon before we can expect a reply. With luck, they might help us establish some kind

160

"I told you you wouldn't want to know."

He was looking at her in total bemusement. There was anger, certainly, in his eyes, and shock, but also an unwilling reappraisal.

"Do you still want me to come with you this evening?" she asked.

He got to his feet then, and stood looking searchingly down at her. "Most certainly," he said. "It's some time since I've been out with a *femme fatale*."

myself together, stood on my own feet, and all the rest of it."

"But why, suddenly? What triggered it?"

She shook her head, not meeting his eyes.

He leant forward, his elbows on his knees. "Something must have; I'd like to know what."

"I don't think you would," she said quietly.

"I've just asked you, haven't I? Come on – out with it."

She raised her head, meeting his eyes. "Whatever it is?"

"Whatever," he answered confidently.

"Very well, then." She sat perfectly still, her eyes on the clasped hands in her lap. "I went to bed with someone," she said.

Silence stretched between them, measured by her heart-beats. She didn't dare raise her head. Eventually, aeons later, he said in a strangled voice, "You *what?*"

She looked at him then, the colour burning in her cheeks and making her, he thought inconsequentially, look about twenty years younger. "I said, I went to bed with someone."

"Who?"

She shook her head.

"Anyone I know, damn it?"

"No."

It was almost true. He was breathing heavily, as flushed, now, as she was herself.

"And are you going to make a habit of it?"

"I shouldn't think so."

"You – shouldn't – think so!"

He gave a shout, part anger, part laughter, and flung himself back in his chair, his hand to his head.

move apart before the door opened to admit a couple of committee members and the trolley of afternoon tea.

"I can't say I'm looking forward to the farewell drinks," Richard remarked, switching off the sports results. "I hope to God no one corners me, demanding answers."

"Why should they think you have any?"

"Well, no one else seems to, least of all the police." He stirred his tea moodily. "Do you realise this time last week, we were getting ready for the 'Names' party? My God, if we'd known what lay ahead!"

This time last week – a lifetime away. And a lifetime ended, too, for eleven people. An old rhyme came into Natasha's head: 'Eleven for the eleven that went up to Heaven.' She gave a little shiver.

"Would it help if I came with you?" she asked.

Richard put down his cup and stared in amazement. "You?"

She gave a light laugh. "You could try to sound more enthusiastic."

"I can't believe my ears, that's all. It's the first time in our married life that you've *volunteered* to go to any kind of function, let alone as moral support."

"You've never seemed to need it before," she said. "It was just a thought; if you'd rather I didn't . . ."

"No," he said slowly, "I should be delighted to have your company." He paused. "You know, it's all very strange, but since I came back from Manchester, we seem to have switched roles. This is the second time you've offered support – comfort, even. Are you going to tell me what's brought about this sea change?"

A faint flush coloured her face. "I've finally done what you've been telling me to do for years: pulled

157

"I decided it might be fun," he said, "to award two small prizes this year; one for what I consider to be the most progress made during the week, and the other for the best short story."

There was a murmur of excited anticipation. He produced two gift-wrapped boxes of chocolates and laid them on the table at his side. "So – the winner of the progress prize goes to Barbara. A very encouraging week's work; mind you keep up the momentum when you get home."

Blushing, she accepted her prize amid generous applause. Out of the corner of his eye, Mark saw Myrtle lay her handbag on the floor prior to rising to claim the other prize.

"And that for the best short story," he continued, "goes to Betty, for *The Man with Blue Eyes*." He smiled at her total surprise and delight. "Well done, Betty, an excellent effort. I'd bet even money that story will be in print within the next month or two."

It was, he noted, several seconds before Myrtle joined in the applause.

Angelique was alone in the tutors' lounge when he reached it, and ridiculously he hesitated on the threshold.

"Hello, stranger," she said in her attractive drawl. "Why do I get the impression you've been avoiding me?"

Hell, why play the shrinking violet? He was going home tomorrow, and never likely to see her again. It would do no harm to indulge her. He might even enjoy it.

"I can't imagine," he answered smoothly, "but let me correct it at once."

And walking over to her, he slipped an arm round her and kissed her on the mouth. They had just time to

assured that Miss Mann had only one suitcase with her. Both the hotel porter and the chambermaid confirmed it.

"So there we are. Somewhere between Oxbury and the Topham, she dropped it off. Why? And equally important, where? The obvious answer would be at a left-luggage office, but in that case there'd have been a receipt among her things, and there wasn't. God, Ken, the more we discover about this woman, the more of an enigma she becomes."

It was, though as yet no one but himself knew it, the last class Mark would hold at Bellingham Grange. As he handed back the submitted short stories, offering suggestions and commendations as appropriate, he was aware of underlying regret. More dominant, though, was relief at a decision taken and the prospect of a new life opening out.

South Africa, he'd decided. Cape Town, to be more precise. He would rent out his London flat and go there for a year, make it the setting for his next book. And if he liked it – or met the right woman – he might well come back only to sell up and move out there permanently.

Of course he would miss seeing his children, but at sixteen and almost eighteen they had their own lives now; Ben was hoping to go to university next year. And they could fly out for holidays. If he made an attractive home there, he might even see more of them than he did at present, with Lucy jealously counting every minute he spent with them.

He handed out the last manuscript and looked round at the familiar faces: Jim Benson, who, though keen, would never make the grade; his wife Josie, blinking nervously behind her spectacles; Myrtle Hardwick, in one of her beautifully knitted sweaters, and all the others he'd come to know over the years.

Hands were shaken all round, more thanks expressed, and Gwen and Hannah left the room. Outside in the hall the two girls were waiting. They greeted their head and her deputy with strained smiles.

"Your grandparents are in my study," Gwen told them.

Hannah turned to watch them go down the corridor, and saw Victoria's hand reach out for her sister's.

"I hope it all works out," she said softly.

"I'm sure it will," Gwen replied.

"What did she do with that second suitcase, Ken?" Webb asked, as they drove back to Shillingham.

"Search me, Guv. If she only wanted the small one while she was away, why not leave the other where it was? Specially since it was such a hassle humping it up and down the stairs."

"Exactly," Webb agreed. "Of course, there might have been valuables in it, or things she didn't want Mrs Haines to see. Perhaps she didn't trust her not to look inside.

"A pity, though," he added, "that we can't tie down more closely when she arrived at the Topham. If she'd driven straight there, it should have been between two-forty-five and three, depending on the traffic. The first thing to establish is, did she have both cases with her at the hotel?"

He fished his mobile phone out of his pocket. "Could you do something for me, Andy?" he asked as the station sergeant answered. "Look up the number of the Topham Hotel on Westgate, and ring me back? Thanks."

Two minutes later the phone rang and Webb noted the number in his diary. "Cheers, Andy. If anyone's looking for me, tell them I'll be back around four-thirty."

In another two minutes, they had been categorically

the girls a home with them. They have children about the same age, and we feel it would be better for them than living with two old fogeys, much as we love them. In time, depending on how Abby and Victoria feel, they might consider adoption, but that can wait for the moment. The point is, though, that with their living so far away, the girls would have to continue to board. Would that be a problem?"

"None at all. They've had a trial period this term, and both settled down very happily."

"Then that's fine. You'll understand, I'm sure, that the final decision will rest with the girls; we'll be discussing everything in detail this weekend. However, I don't foresee any problems."

Amanda tapped on the door and came in with a tray of coffee, which she handed round. When the door closed behind her, Mrs Pleasance said diffidently, "I believe there's been more trouble up at the Grange?"

"Yes, I'm afraid so." Gwen did not elaborate.

"Have they discovered yet what lay behind the crash? It might be easier if – if we'd some idea . . ."

"I appreciate that, but as yet nothing has come to light. Obviously, as soon as there's any news, I'll let you know."

The talk turned to less emotional matters while they had their coffee, and when they'd finished, Gwen rose to her feet. "I've arranged for the girls to come over here, so that you can greet them in private. Please feel free to use this room for as long as you like. When you're ready, their cases will be brought out to your car. I don't know if you're familiar with exeat weekends, but they're due back at their House by six-thirty tomorrow evening."

"They'll be there."

It was her husband who spoke first. "Before we start, Mrs Cameron, I should like to say how grateful we are for all that you and your staff have done for the girls. We knew they couldn't be in better hands, and it was a great comfort to us."

"Thank you, Mr Pleasance." Gwen gestured to them to sit down. "I think you've met Miss James, who will be taking over from me in September? I felt she should be present to hear what is decided."

"Of course." They both smiled at Hannah.

"How are Abby and Victoria?" Mrs Pleasance asked, clasping her hands tightly.

"Being very brave. You were wise to leave them here this last week; the familiar routine and the support of their friends have worked wonders in helping them to cope."

Mrs Pleasance smiled. "You're too modest, Mrs Cameron. As I remember, it was you who persuaded me – I was all for rushing over and folding them into my bosom. As it is, we've all had a breathing space, time to begin to come to terms. Not, of course—" She broke off as her eyes filled, and, opening her handbag, took out a handkerchief. "It's all right," she said quickly, dabbing at her eyes, "I'm not going to break down."

"Of course you're not, my dear." Her husband patted her hand, and turned back to Gwen. "I imagine that with the death of a parent, financial considerations can sometimes weigh heavy. Happily, that doesn't arise in this instance, so let me say at once that Anne and Richard were delighted with the girls' progress here, and intended that they should stay till they were eighteen. We shall honour those intentions.

"However, there is another factor: our younger daughter and her husband, who live in north Wales, have offered

switched off at weekends, had been turned on again but not yet had time to dispel a creeping chill. She shuddered and walked down the corridor to Gwen's office, which would soon be her own. She tapped on the door, and at Gwen's invitation, went inside.

"Thanks for coming, Hannah; I'll be glad of the back-up. I was hoping we might have had some more news about the crash before now."

"Yes. Incidentally, Dilys gave her lecture at the Grange last night. She said the atmosphere was creepy, but then, you know Dilys!"

Gwen smiled. "All the same, that other woman dying does rather make one wonder. *Has* someone got a down on the Grange, and all who sail in her?"

"Not you, too!" Hannah protested.

Gwen looked out of the window as the sound of tyres on the gravel reached them.

"Here they are now. I asked Amanda to come in this morning – she'll show them in."

Amanda Graves, the headmistress's secretary, was a pleasant, efficient young woman, whose friendly manner was designed to put even the most nervous parent at ease. Seldom, though, had she had to deal officially with bereavement, and Hannah found time to admire the air of quiet solicitude with which she ushered Mr and Mrs Pleasance into the room.

Hannah's first feeling was of relief that both seemed composed, her second of surprise: they were younger than she'd expected. The woman in particular, who looked disturbingly like her dead daughter, was tall and slim, her fair hair blending almost unnoticeably into grey. Her face was pale, her eyes luminous from weeping, but not red-rimmed.

151

"Well, thank you, Mrs Haines." Webb took a last look round the unrevealing room. "You've been very helpful."

"But – what happens now?" the woman asked. "I mean, I'm obliged to leave things as they are till the end of the month, the room being paid for and all, but after that I'll need to relet it."

"If I were you, I'd parcel her things up. Then they'll be out of your way, and as soon as we've established where they should be sent, we'll let you know."

She nodded and, locking the door behind them, led the way downstairs again. Erica Mann had left no impression on her temporary home, and consequently it offered no insight into why she had died.

That morning, while Webb was engaged with the press briefing, Hannah had walked down to the school. She disliked being there on a Saturday; the building which buzzed and hummed with activity all week seemed deserted, with the teaching staff and day-girls at home and boarders over at the two houses, Brontë and Austen. Though since this weekend was an exeat, most of them would have gone home, too.

But at ten o'clock Mr and Mrs Pleasance, Mrs Vine's parents, would be calling to see Gwen and discuss their granddaughters' future. And Gwen had requested that, as her successor, Hannah should sit in on the discussion.

It was bound to be a difficult meeting, Hannah thought, walking along Montpellier Gardens to the school at the far end. Gwen had said the poor woman was distraught on the phone; it was to be hoped her composure wouldn't break down again on seeing the girls.

Gwen's little red car was drawn up at the front door and Hannah went inside. The central heating, normally

see to that. A quick flick through the stubs revealed no significant transactions. With Mrs Haines's assent, Webb pocketed it.

Otherwise, the room was as impersonal as a hotel bedroom occupied for just a night. The analogy of a hotel prompted him to ask, "How much luggage did she have with her?"

"Two cases," Mrs Haines answered promptly. "A big one which she had to get my Jimmy to help her with, and a smaller, weekend one."

"And did she take them both with her when she left last week?"

"Yes; yes, she did. We had trouble getting the big one back down the stairs."

Webb exchanged a look with Jackson, but made no comment. There had been only one smallish case in Ms Mann's bedroom at the Grange.

"Can you remember what time she left?"

"Yes, because she knocked on our door for help with the case. Only just caught Jimmy; he'd got his coat on, and was watching the end of *A Country Practice* before going back to work. On the telly," she added, seeing Webb's blank look.

"Which would make it—?"

"Around half-one."

Webb thought for a moment. It was over an hour's drive to Shillingham, and Ms Mann had arrived at the Topham sometime during the afternoon. Had she had the suitcase with her at the hotel, or shed it somewhere on the way?

"Did she say where she came from originally?" he enquired.

"No; I didn't ask and she didn't volunteer. Though I'd guess hereabouts, else why should she come back?"

"Well, like I said to the other lot, I'm coming with you. Until I hear different, I'm responsible for what she left in this house."

"Quite right," Webb said approvingly, and she looked pleased.

"I'll get the key, then. First floor back, she was."

They went in single file up the wide, scuffed staircase to the first landing and Mrs Haines opened one of the doors facing them.

The word 'flat', Webb thought, was an exaggeration. They found themselves in a fairly large room furnished as a bedsitter, with sofa, chairs, table, television and bookshelves. There was a bed in one corner next to an insubstantial-looking wardrobe, and a pine chest which didn't match the rest of the furniture.

A door led off to the right, opening into a minute shower room-cum-lavatory, and the kitchen, such as it was, was simply an alcove concealed behind a flowered curtain and containing sink, gas hob and a floor-standing oven.

Webb turned his eyes from the basics to the personal, and found little. Admittedly Oxbury police had already been over it, but according to their report had removed nothing. Everything was therefore as Erica Mann had left it when she set out for Shillingham and, had she but known it, her death.

There were a few clothes in the chest, some dresses hanging in the rickety wardrobe. But there was still no sign of a diary, address or telephone book, nor personal papers of any kind. The only find was a stapled wad of cheque stubs at the back of a drawer. It gave no indication of which bank had issued it, but at least suggested that Erica Mann had had an account somewhere. Which would mean enquiring at all the Oxbury banks, but the local force could

hand it to her, going off on her own like that halfway round the world. But then she seemed to prefer her own company anyway." There was a touch of bitterness in the last words; perhaps the landlady's overtures had been spurned.

"Any idea who she worked for?"

She nodded. "Gave me their name as a reference. I always insist on references, but I wasn't going to waste postage writing to America, was I? Still, she's a respectable woman, that I will say, and no trouble."

"If we could have their name and address?"

Mrs Haines made a tutting sound of impatience, and pushed open the door nearest to them. Webb had an impression of a large, untidy room, with newspapers lying around and some unidentifiable garments drying on a radiator. She reappeared with a piece of paper on which was written: 'Hudson Electronics, 2197 Main Street, Smithsville, Maryland 59786, USA.'

"Thank you. May we keep it?"

She shrugged. "No use to me. And if you're looking for her, she's not here; told me she'd be away two weeks, due back Sunday night."

Webb made a decision. "I'm afraid she won't be coming back, Mrs Haines; Miss Mann was the lady who fell from a window in Beckworth the night before last."

The woman's hand went to her mouth and her small, hard eyes widened. "She never!"

"I'm sorry; that's why we're interested in looking through her things; we hoped we might find the address of relatives, though from what you say that seems unlikely."

"Well, I never did! Made me go all shaky, that has."

"Perhaps you'd like to sit down?"

She shook her head. "You want to go up, then?"

"Yes, please."

"I believe Ms Erica Mann had a flat in this building?"

"You're the second lot asking about her. The others wanted a key. Wouldn't say why, though. Not in any trouble, is she?"

The victim's name hadn't been released, pending a search for relatives – a precaution, Webb gathered, which had led to a spate of worried phonecalls to the Grange – but it was beginning to look as though there were no relatives to find.

He sidestepped the question, shivering as an icy blast fingered its way under his collar. "Do you think we could come in, Mrs—?"

"Haines." She stepped aside, graciously allowing them as far as the hall. The parquet floor was scuffed and unpolished, and the doors and balustrades had also seen better days.

"You're the owner of the house?" he asked, when it became clear this was all the hospitality that was on offer.

"Yes, it was going cheap some years back. Shocking state it was in. Me and my husband bought it, did it up, and turned it into flats."

Webb wondered what *doing it up* had entailed. Not much, that he could see.

"How long has Ms Mann been with you?"

"Couple of months or so. She's renting on a monthly basis, payable in advance."

"So she wasn't intending to stay?"

Mrs Haines shrugged. "She's just back from overseas, and if you ask me, sorry she came home. She's had no luck finding a job, and she hasn't any ties here now."

So they were wasting their time looking for any.

"Had she any relatives in the States, do you know?"

"No, it was the job that took her there. You have to

Ten

The last time Webb had been in Oxbury was during the summer when he'd spent a weekend here with Hannah, hoping at the same time to shed some light on a current case. They'd taken a boat on the river and strolled lazily along the streets in the summer dusk.

It was very different now. Thick mist drifted up from the water to swirl between the buildings, and people hurried along with their heads down, wrapped up in scarves.

Salisbury House was a large detached building at the north end of the High Street. It stood in a forlorn-looking garden too small for it, most of the original grounds having been sold off for development – the same development that now encroached on its very walls: a filling station, an Indian takeaway, a few desultory shops.

Webb pressed the bell for one of the ground-floor flats, hoping to locate either the owner or a caretaker. After some minutes the door was opened by a thin-faced woman in her fifties. She was wearing a tailored suit with white shirt, but the businesslike effect was marred by fluffy blue bedroom slippers.

"Yes?" she said.

Webb produced his warrant card. "Shillingham CID, ma'am. DCI Webb and DS Jackson."

"Well?"

"So it's Oxbury, then?"

"Yep. Sorry to keep you from Millie and the kids on a Saturday."

"Not your fault, Guv."

"The local lads went to the flat yesterday, but drew a blank. I'm not saying they missed anything, but I'd like to take a look myself."

Jackson nodded. The governor was a great one for what he'd heard referred to as 'spirit of place', seeming to draw something indefinable from the atmosphere which gave an insight into the character of the owner, be he victim or suspect. On a par, really, with his drawing, which Jackson regarded with almost superstitious awe.

For Webb's practice of making sketches of the background to a crime, peopled with the suspects in the positions they'd stated themselves to be in, had more than once led to the solution of a case. It was known at the station as his 'drawing conclusions'.

"Funny," Jackson said after a minute, chewing meditatively, "the Mann woman being so talkative, all of a sudden."

"Yes. Perhaps she felt more at home with our Phil than the mob up at the Grange."

"Well, at least we've linked her with the coach company."

"And much good it's done us," Webb said despondently. "She wanted to go to the Market, Ken. The fact that Hatherley Coaches ran the trip rather than the corporation was totally immaterial."

"Did she ask for any other directions?"

Phil Spence put another loaded forkful in his mouth and shook his head.

"Or mention that she was meeting anyone?"

Another shake as the powerful jaws champed. Jackson, Webb noted, was eyeing the heaped plate with envy.

"Was she on the return journey?" he persevered.

Spence took a long drink of Coke and wiped the back of his hand across his mouth. "Yeh. She arrived early and we had quite a chat."

Webb raised his eyebrows. This was the first they'd heard of Erica Mann being forthcoming.

"What about?"

"She was on about the Market. Very impressed, she was. Said she was just back from America, where they go in for things like that in a big way."

"Did she say anything else about herself? What she was doing in Shillingham, for instance?"

"No, it was just general chitchat."

Webb made one final attempt. "She didn't mention Bellingham Grange at all?"

Spence looked at him quickly, his curiosity at last aroused. "It's her that fell from that window?"

"I'm afraid so, yes," Webb admitted.

Spence chomped in silence for a while, digesting the information along with his food. "I'm sorry to hear that," he said at last. "She was a nice woman."

And that was all they could get out of him. They repaired to the Brown Bear for their own lunch.

"I doubt if it's worth going to Broadminster, after all," Webb said reflectively over his steak and kidney. "I'll fax the photo to DCI Horn and ask him to circulate it. It's a long shot, but we might strike lucky."

"We're trying to trace the movements of the woman who died up at the Grange. It seems she took the bus to Broadminster last Wednesday."

"Well, if that's all you've got, there's no saying she was with us; the county buses run their regular service day in, day out."

Webb frowned and turned to Jackson, who flushed.

"Sorry, sir, but according to the barman she took the excursion bus to the Christmas Market. And when I rang Broadshire Buses, they told me—"

"If it was the Excursion Special, it would have been us," Spence conceded. "Have you got a photograph?"

Webb nodded.

"The driver might recognise her. Worth a try, anyway."

"Who was the driver on Wednesday?"

Spence consulted his schedule. "My nephew, Phil."

"Any chance of a word with him?"

"You're in luck, he's just in for lunch. You'll find him in the canteen."

Phil Spence was a large, broad-shouldered young man with a red face and shaggy brown hair. He nodded pleasantly enough as the detectives joined him, but didn't allow them to interrupt his meal.

He nodded a second time when Jackson produced the photograph. "Yeh, I saw her," he confirmed with his mouth full. "Nice woman. When she was getting off, she asked the way to the Market, best place to eat, and that."

"And where did you suggest?"

"Told her food was laid on there."

"Where's the Christmas Market held?"

"In the Old Market Hall. We drop 'em off in the High Street."

your lads were here yesterday, ferreting about and asking questions. Now here you are again."

And yesterday's questioning had drawn a blank, Webb reflected. The men could all account for themselves on Saturday afternoon; they'd either been at the match with friends, or at home with their families. None, it seemed, had had the chance to go up to Beckworth and tinker with the minibus, even if they'd wanted to. Moreover, the same applied to the bakery drivers, who would have had to absent themselves for several hours to perform the same task.

"All we're asking now, Mr Spence," Webb said placatingly, "is how this trip to Broadminster was organised, whether it was necessary to reserve a seat, and so on."

"Well, I can fill you in on that one. The Christmas Market lasts three days, and we run a special bus each day – have done for years. The trip's advertised in the local press and there are notices all over town. It's not bookable – first come, first served."

"What time does it leave Shillingham?"

"Nine-thirty, arriving Broadminster ten-fifteen."

"And coming back?"

"Leaves at four-thirty, back here five-fifteen."

"Suppose there aren't enough passengers to make it worthwhile?"

Spence gave a short laugh. "Believe me, mate, we've no trouble filling a fifty-three seater. Very popular, the Market is, and since Broadminster's packed out with visitors, folks here are glad enough to get a lift there and back and not have to worry about parking." He surveyed them thoughtfully. "Are you going to tell me what all this is about?"

141

analysed." He leaned back in his chair. "You know, Ken, I'm convinced these deaths are connected, but I'm damned if I see how. *Did* this woman see or hear something she shouldn't, which would have identified the killer? And if so, when? During the time she spent in Shillingham? We know she came up a week before she was due. Why? To look at the scenery, as you suggested? Perhaps, but she was in for lunch every day but one." He paused, frowning. "And on that one, why go to Broadminster?"

"There was a Christmas Market, wasn't there? Perhaps she wanted to look for presents."

"She didn't buy any. I wonder how much time she had there; might she have met someone, for instance? Perhaps the Market excursion was simply a means of getting there."

"She had her car," Jackson pointed out.

"True. Anyway, get on to Broadshire Buses and find out the details. And can you arrange for some photographs? No doubt they'll have to pretty her up a bit first. I'd intended going to Oxbury this afternoon, but on reflection, Broadminster's probably more urgent."

Jackson nodded and went out, leaving Webb brooding over his papers. Five minutes later, he was back.

"Something interesting here, Guv. It wasn't Broadshire Buses who ran the Christmas Market trip; it was Hatherley Coaches."

Webb let out his breath in a low whistle. Then he pushed back his chair. "That's worth following up – let's get on to it right away. Bainbridge could even have been the driver."

Jake Spence was not pleased to see them.

"It's bad enough losing one of my drivers, without you lot keep coming round," he grumbled. "A couple of

in first if it hadn't been for the press call. Now, Ken, before we concentrate on Ms Mann, I want to sound out a few ideas. How's this for a scenario? Richard Vine himself scuppered the bus outside the Grange. Motive unknown. He then wrote himself the anonymous letter and made the mysterious phonecall to his wife, possibly from Manchester. A whisper is almost impossible to recognise."

"But if he was in Manchester, he couldn't have topped Ms Mann."

"*If* he was in Manchester; I'm waiting for that to be confirmed. Because let's face it, if she was pushed – and we still don't know that she was – it would have to have been by someone at the Grange. No one else could have got in unchallenged, let alone known which was her room."

Jackson moved uncomfortably. "You want my opinion on all that, Guv?"

"Of course; how does it grab you?"

"Well, I suppose it's just possible Vine could have done for the bus, written the letter and so on. But when we get to Ms Mann, how do you know someone couldn't get into the Grange unchallenged? It's not an armed fortress and there aren't guards on the door. At least, there weren't then. Anyone with enough brass neck could have waltzed in, without anyone batting an eyelid."

"You could be right, at that."

"And if they *did* get in, it would have been easy enough to find her. There's a list of names and room numbers on a board in the committee room – I saw it."

"Well, they'd have had to get into the committee room, then. Question: would it have been deserted on Thursday? Answer: probably, since it was a free afternoon. We won't know for certain till all the statements have been

the weekend, and take the opportunity of discussing their future with Gwen. It would have been good to have had something positive to pass on to them.

There was another press conference first thing the next morning, which Webb could well have done without. He disliked having to parry questions to which he had no answers, and this death following so quickly on the others had aroused national interest. Still, good relations with the press must be maintained, and often they were able to pass on titbits of real importance.

When it was over he repaired to his office, intending to discuss the previous day's findings with Jackson. However, no sooner had they seated themselves than the phone rang, and Webb was subjected to a long and tetchy call from the chief superintendent, demanding a detailed report on how the investigation was proceeding.

"Nearly a week since the crash, Spider, and the top brass are breathing down my neck. Now this bloody woman has to get herself killed."

"She might have topped herself, sir," Webb put in.

"Whatever. How quickly can you clear it up?"

Webb bit back a stringent reply. "We're pulling out all the stops, sir."

"Any suggestion of a motive?"

"Not as yet."

"Well, get a move on, there's a good chap. Report to me at home before you go off duty."

"Yes, sir."

"Three bags full, sir!" added Jackson with a grin, as Webb put down the phone. "Giving you a hard time, is he, Guv?"

Webb grimaced. "Only to be expected; I'd have got

Hannah turned down the sound on the television and picked up the phone.

"It's me," said Dilys's voice, "reporting back, now that I'm safely home."

"How did it go?"

"It was the weirdest sensation, Hannah. Like the band playing as the *Titanic* went down."

Hannah laughed. "You and your dramatisation!"

"No, really. Everyone was trying so hard to pretend there was nothing wrong, and at the same time looking over their shoulders."

"You survived the hairpin bends, anyway."

"I closed my eyes," Dilys said frankly. "At least the fog had lifted a little, though it will probably come down again overnight. Anyway, if ever I earned my fee, I did this evening!"

"Did you see Richard Vine?"

"No, I gather he only puts in an appearance on the last night, which is tomorrow. If, that is, they're allowed to go home while all this is going on. And provided another of them hasn't been bumped off in the meantime."

"Oh, come on, Dilys!"

"Well, there must be a jinx on the place, mustn't there? I wish to goodness the police would arrest someone, and get it over."

"I'm sure they're doing their best. They must hate all this publicity; there was a long piece about it on the news this evening."

When, a few minutes later, Dilys rang off, Hannah considered giving Webb a call, but decided against it. He'd have enough on his mind, without her continually asking if there were any developments. But tomorrow, Mrs Vine's parents were coming to collect the girls for

"Because there was an implied threat in it. Something like: you might have escaped once, but they'd get you next time."

There was a brief pause. "And what was the police reaction?"

"They said they'd look into it, compare it with others they have on file."

He stared at her, at a loss for words.

"And then there was the phonecall," she added, almost casually. "Well after midnight."

His heart missed a beat. "What kind of call? Did anyone speak?"

"Not at first, but as I was putting the phone down, he asked for you."

Richard swallowed. "What did you say?"

"That you weren't here."

"That was bloody silly; he'd know you were alone."

"I realised that, but if it was you he wanted, he was unlikely to come after me."

"You're pretty damn blasé about it, I must say!" he accused her.

"I reported that, too. You had a call yourself, didn't you, the other evening? The phone rang after I'd gone to bed."

He leant forward and put his head in his hands. "This is becoming a nightmare."

She looked at him for a minute, her fingers still caressing the cat. "Try not to worry," she said quietly. "The police are keeping an eye on us. Finish your drink, then I'll get supper."

He raised his head, meeting her untroubled gaze. "Are you on Valium or something?" he demanded harshly.

She smiled. "Nothing so drastic," she said.

*　　*　　*

136

He turned from the drinks cabinet, staring at her in surprise. "You know about it?"

"Adrian Young phoned." After, as it happened, Mark had broken the news.

"You don't seem very perturbed about it." Illogically, he was annoyed that she'd spared him the expected trauma.

"I'm extremely sorry, of course, but after all, I didn't know her."

Bewildered by her attitude, he turned back to the array of bottles. "Like a drink?"

"Yes, G and T, please." She lifted the sleeping cat from a chair and sat down with it on her lap, stroking its sleek fur.

"All things considered," he went on after a minute, "it's just as well you were safely tucked up at Jonathan's."

She took the glass with a nod of thanks. "Actually, I wasn't," she said.

He frowned. "But I thought—"

"I changed my mind; it was ridiculous at my age to make such a fuss about spending the night alone."

He looked searchingly at her. There was some other quality underlying her composure, but he couldn't pinpoint it.

"Things have been happening here, too," she continued, sipping her drink. "First, there was some post for you yesterday and I opened it, thinking it was the cheque. But it wasn't."

He frowned. "Well, what was it, then?"

"A rather unpleasant anonymous letter."

He caught his breath. God, not again. "Where is it? Let me have a look at it."

"I took it to the police."

"You—!" He fought to control himself. "Why the devil did you do that?"

135

"Promise me you'll lock your door, and take care never to be alone anywhere, day or night?"

"Except in the bathroom!" she said with a giggle.

"It's no laughing matter, Betty. I've been out of my mind with worry. If anything happened to you, I'd never forgive myself."

"Harold love, listen – the place is full of policemen. We're safer now than we've ever been. And anyway, I'm very anxious to hear what Mark thought of the story I submitted. I'm sure it's the best I've ever done." She heard his sigh along the wire, reminiscent of his heavy patience with what he called her 'scribbling'.

"You and your stories," he said.

She drew a tentative breath of relief. "It's all right, then? I can stay till Sunday?"

"I suppose so, if you really want to. But give me a ring tomorrow evening, to let me know you're all right."

"I will." She hesitated. "I miss you," she added.

"I miss you, too," he said gruffly. "Take care, love."

"Hello, I'm back!"

Richard found he was bracing himself for meeting his wife. This latest death would have panicked her still further; she'd take quite a bit of calming, which was the last thing he felt like doing at the moment.

To his surprise, though, she appeared from the kitchen looking quite composed. "Hello, dear. How was the trip?"

Oh God, he thought, she hasn't heard! Even worse – now he'd have to take the brunt of her shock.

"It went well," he said shortly, kissing her cheek and going past her into the sitting-room. "But all hell broke out while I was away."

"That woman's death? Yes, it was terrible."

134

staring into his glass, "and all connected with me in some way."

"Only very loosely in this last case."

"I don't agree; it happened at the Grange, and let's face it, I *am* the Grange." He tossed back the rest of his drink, setting the glass down on the desk. "Well, I'd better be getting home; Natasha will be wondering where I am."

Betty Fife shut the door of the kiosk behind her and nervously picked up the phone. She'd been called out of dinner to take the call.

"Betty?" demanded an agitated male voice. "Is that you?"

"Oh, Harold!" She closed her eyes on a wave of relief. "It is good to hear you!"

"Look, I'm coming straight down to collect you. You're not staying at that place a day longer!"

"Oh, love, it's all right. There's no need for that."

"There's every need. If I'd known the bus crash wasn't an accident, I'd never have let you go there in the first place. Now this. Have you got some kind of maniac loose down there?"

Betty bit her lip; her husband did not yet know it was she who had found the body, and this was not the time to enlighten him.

"There's only tomorrow anyway," she pleaded. "It would be such a long drive for you, specially when I have my return ticket. There's no need to worry, love, really. Let's just leave it that I come home Sunday afternoon as planned."

There was a brief pause. "Are you sharing a room with Myrtle?"

"Yes."

Adrian Young shot him a quick look. "You think that's what happened?"

"It's a fifty-fifty chance – perhaps higher, since you say no note was found. Still, it all seems pretty calm out there, considering; have things been carrying on much as normal?"

"Yes, the police were happy to comply, since it kept everyone occupied. Dilys Hayward's due to give tonight's lecture – a local celebrity, for once." He looked at his watch. "She'll be here any minute, in time for dinner. Have you read her books?" Richard shook his head. "Nor have I, though I've seen a couple on TV. Good storylines."

Vine ran a hand through his hair. "God, what a day – I'm totally shattered. Talk about Friday the thirteenth! And coming on top of a late and boozy night, what's more."

"But it went well, the meeting?"

"Yes, I think I've persuaded them to try us for their next conference. It would be great if we could make regular clients of them." He went to the cabinet against the wall. "I'm in need of the hair of the dog; will you join me?"

Young hesitated. "Well, just a small one, thanks."

Richard splashed whisky into two glasses. "Tell me if I'm becoming paranoid, Adrian," he said abruptly, "but has there been any suggestion this death, as well as the others, might have been directed against me?"

Young stared at him in astonishment. "How do you mean?"

"Coming on top of the crash, it could be the death knell for the Grange."

"Nonsense!" Young said roundly. "Once it's cleared up, it'll be a nine days' wonder, then everyone will forget it."

"Eleven dead in the last week," Vine said broodingly,

the outcome of which could have long-lasting effects for them all.

He was shrugging out of his coat when Adrian Young came down the stairs.

"Richard! Thank God!"

"Any further developments?"

"No, things are winding down for the moment. Amazingly enough, everyone's had their statement taken – pretty good going, wouldn't you say? The police will be leaving in a few minutes."

The two men walked down the corridor to Vine's office. "So who was this woman, and what happened to her?"

"All we know is that according to the committee chairman she was a late applicant, and the police say she's been in the area for about ten days."

Richard frowned, glancing through the pile of mail on his desk. "Is that regarded as significant?"

"Only, I suppose, if she saw something incriminating relating to the minibus. Mr Webb was asking if she called in here last week."

Richard looked up, startled. "She didn't, did she?"

"Not to anyone's knowledge."

"Anything more on the bus itself?"

Young shook his head. "Julia sent flowers to Mrs Susan, as you instructed. I believe the police have already seen her."

"They don't waste much time, do they?"

"Which is all to the good, surely; the sooner everything's cleared up, the better. The Salvation Army's due on Monday, remember."

"Well, at least they're not likely to start pushing each other out of windows."

131

Nine

As Richard Vine drove past his house, he swore under his breath; in the beam of his headlights he could see that the reporters who'd besieged the Grange earlier in the week had returned in force. Just as well Adrian's phonecall had forewarned him.

On seeing his car they surged forward, blocking his path with a jostling, thrusting mass of bodies. Richard, no stranger to press attention, kept the car moving, his finger on the horn and the window uncompromisingly closed, until of necessity they moved aside, still shouting inaudible questions and dazzling him with their flashlights.

To his surprised relief, however, they didn't follow him down the drive, an omission explained a minute later by the materialisation of two uniformed figures, who stopped him and checked his identity before waving him on.

The line of cars outside the house increased his irritation; why couldn't they use the car park, like everyone else? He swerved past them, coming to an abrupt stop outside the front door, gravel flying from his wheels.

It was six-thirty, and as he went through the front door, the usual hum of conversation reached him from the bar. Yet despite its familiarity and the unchanged elegance of the hall, the atmosphere was subtly different. For behind those closed doors a police investigation was under way,

"For the moment," she said after a pause. "But on my own terms."

He nodded, satisfied, and rose to his feet. "Then there doesn't seem anything more to say."

"No. Except, thank you."

"And you too." He took her hand and raised it to his lips. "Good luck, Natasha. You deserve it."

She led the way to the kitchen, opened the back door for him, and watched him walk down the path to the gate in the wall. Then, shivering in the cold, she closed the door.

"You're not wildly, passionately in love with me?" She laughed with genuine amusement. "Good heavens, I never thought you were!"

He said quietly, "I feel all kinds of a fool."

"No!" She laid a hand lightly on his arm. "You mustn't. Really. You might find this hard to understand, but I owe you a great deal. The time we had together was special, wasn't it? You did feel that?"

Her eyes were on his, anxious, almost pleading. So after all she did need something from him. "Of course I did," he answered truthfully.

"It was perfect," she said, "perfect and unique. I knew it would never happen again; it couldn't, and I probably wouldn't want it to. The blessing is that it happened when I most needed it – and perhaps you did too?"

He nodded; she was right.

"It's given me confidence, Mark; made me feel I'm worth something after all."

"Which is what I've been trying to tell you. I'm so glad you see it that way; I've been worrying how you'd feel in the cold light of day." He looked down at his clasped hands. "There's something else I must tell you; I shan't be coming back to the Grange." As he spoke, he wondered at what point the decision had been reached.

"Oh?"

"Not only because of what's happened, but because it's time I moved on. I've been thinking for some time of going abroad for a year, writing a book set in Australia or perhaps South Africa. Now seems as good a time as any."

She nodded gravely.

He looked up at her. "Don't answer if you'd rather not, but will you stay with Richard?"

"What news?"

"One of the students at the Grange was found dead this morning."

"*What?*"

"Someone on my course, as it happens. She – fell out of a window."

"Fell?" Natasha repeated aridly.

"That's the point, we don't know. The police are up there in force, asking questions and making notes. Incidentally, I came through the garden – I hope you don't mind; the front way was a bit public, what with all the comings and goings, and reporters milling around."

She nodded, barely taking in what he was saying.

"The point is," he continued awkwardly, "the woman – Erica Mann – hadn't been seen since lunchtime yesterday. So everyone's being asked their movements during the afternoon."

To his annoyance, Mark felt himself flush. God, this was even harder than he'd expected.

"I see," Natasha said quietly. "And what did you tell them?"

Damn it, she was a lot calmer about it than he was! "That I'd looked round the shops and the art gallery, which is quite true. But then they asked if I'd seen anyone I knew, and I said no." His colour deepened. "Natasha, about yesterday—"

"It's all right, Mark, you don't have to say anything."

"But I must! I can't let you think—"

"Look, if you're about to apologise, please don't. I was as much to blame as you were – if, that is, you're thinking in terms of blame?"

He floundered again. "I admire you very much, you know that, and I enjoy your company. But—"

127

The barman considered. "Must have been the Wednes-day, because Ted was off and Bill was helping out."

Webb nodded his thanks and took his leave, unsure whether the information held any significance. "She doesn't seem to have any friends in the neighbourhood," he commented as they went back to the car, "so why was she hanging round here for a week before the School started?"

"Perhaps she just wanted to explore the area," Jackson suggested, starting up the engine.

"But she couldn't have gone far afield, if she came back for lunch. What we've got to establish, Ken, is whether the fact that she was here last week has anything to do with her death. And at the moment, we've damn all to go on."

Natasha stood with her hands in a bowl of soapy water, staring out at the dreary, mist-filled garden. She would enrol for some Further Education classes, she decided; they'd offer new interests and she might make some friends. The present term must be half over, with Christmas only six weeks away, but in January she'd make a positive start to broaden her horizons.

The doorbell rang and, drying her hands, she went to answer it, startled to see Mark standing on the step.

"Can you spare me a minute?" he asked quickly. "Some-thing's happened."

Alarm leapt into her eyes. "Has someone—?"

"It's nothing personal, but I have to speak to you."

"You'd better come in." She led the way to the sitting-room at the back of the house. "Can I get you anything? Tea, coffee?"

"No, thanks, I can't stay long. I – gather you haven't heard the news?"

"The name sounds familiar, sir. Just a moment, I'll check."

While she pressed buttons on her computer, Webb turned the register to face him, flicking the pages back to the previous week, and almost at once struck gold – an E. Mann had signed in on the second of November, the car registration tallying with that at the Grange. He drew a deep breath of thankfulness; so far, so good.

Two minutes later, they also knew that she had checked out on Monday the ninth – presumably to drive the ten miles to Bellingham Grange – had eaten dinner in the hotel restaurant every evening, always alone, and paid her bill by credit card. There had been no mail for her during her stay, and she had neither made nor received any phonecalls.

"Could you tell us what time of day she arrived on the second?" Webb asked.

"It must have been during the afternoon, sir. Rooms don't become available till twelve noon, and I would remember if there'd been a delay before she could be shown up."

Webb thanked her and he and Jackson went into the bar. The barman nodded on seeing the till receipt. "Yeh, I remember her. Regular customer at lunchtime she was, and her order never varied – deep-fried mushrooms with tartare sauce and a glass of lager."

"Anyone ever join her?"

"No, she was a very quiet lady, kept herself to herself. I never saw her speak to anyone."

"You say she came in regularly; you mean every day of her stay?"

"Bar one. Told us she'd taken the excursion bus to Broadminster, to the Christmas Market."

"Which day was that, do you remember?"

in-built lie detectors in their brains? He'd kept his eyes unwaveringly on the man, who, however, was looking down making notes. Then the questioning turned to Mark's impressions of Erica, and he'd allowed himself to relax.

So far, so good. But, there was no help for it; he'd have to see Natasha today, before Vine returned home. Warn her, in case by some wild chance she should be interviewed herself. Come to that, he remembered, the police already knew she'd been in Shillingham, because she'd called in to see them.

"Do we still have to do the story you set us?" Josie Benson's voice cut into his thoughts, and he roused himself.

"Certainly. Tomorrow's the last day of the course, remember, and we need to complete the syllabus. Anyway," he added, "it will help to take your minds off what's happened."

The Topham was a modest hotel on Westgate catering mainly for business reps, though due to its proximity to the Grand Theatre, actors and actresses who were playing there could sometimes be spotted in the hotel bar, which gave it a vicarious glamour.

"The receipt doesn't mean she was staying here," Jackson cautioned as they drew up outside and he propped his log book on the dashboard. "She could have just gone in for a bar lunch."

"We'll try the hotel first, anyway," Webb replied, and, bypassing the separate bar entrance, he pushed his way into the foyer. The young woman behind the reception desk looked up, her smile fading at the sight of his warrant card. "I'm making enquiries about a Miss Mann," he began. "Could you tell me if she stayed here last week?"

an engagement diary. Most women carry them, surely? Certainly women who have jobs."

"You said she's just back from abroad; perhaps she hasn't got a job yet."

"No cheque book, either." Webb opened the wallet and extracted its contents. There were two £20 notes, one £10 and one £5, a credit card and some crumpled-up receipts. He smoothed out the latter on the desk.

"They don't—" Jackson began, and was interrupted by Webb's sudden, "Hang on!"

Jackson bent closer. "What is it, Guv?"

"When are they all supposed to have arrived here?"

"Monday, wasn't it? The ninth."

"Monday the ninth," Webb said slowly. "Then can you tell me, Ken, how it is that there's a bar receipt here from the Topham Hotel dated the fifth?"

The members of the short story course were not in the mood for work; they were restless and unsettled, disturbed by the sudden death in their midst and on edge waiting for the call to be interviewed.

Mark sympathised with them, feeling little better himself. As Erica's tutor, his had been among the earlier interviews, and as far as he could judge, it can gone well. He'd said merely that he'd gone into Shillingham after lunch, looked round the art gallery and the shops, and eventually, just as he was about to return to the Grange, bumped into two ladies on his course and given them a lift back. They'd got in just before five-thirty.

"Did you see anyone else you knew in Shillingham, sir?" asked the uniformed officer.

Mark didn't hesitate. "No, no one."

God, could they tell if he was lying? Did the police have

123

"If you want to be a writer, my dear, you need a splinter of ice in your heart. Observe everything, and file it away. You never know when it might come in useful."

When they went to the dining-room for lunch, several people crowded round Betty to ask what had happened, thereby displeasing Myrtle still further.

"There's nothing more to be said," she stated firmly. "Betty's had a nasty experience but the police are in charge now." And taking Betty by the arm, she led her away from them.

"Eureka!" Jackson exclaimed, holding up a black leather handbag. "SOCO have finished with it, so it's all ours."

Webb reached for it. "Well done, Ken; thanks. Any news on a suicide note?"

"Not a sign of one. Dick Hodges said there were scuff marks under the window and on the sill, but nothing conclusive."

"They're not handing it to us on a plate, are they? Anything of interest in her room?"

"Dick said she seemed to be a walker; there was a padded jacket, boots and warm trousers. A torch, too, though that could have been for indoors; Millie always takes one when we go away, in case she needs it in the night."

Webb turned the bag round in his hands. It was in reasonable condition though worn on the corners, and had the ubiquitous strap for hanging from the shoulder. He unfastened the flap and tipped it upside down on Young's desk. What he thought of as the usual clutter fell out: comb, powder compact, lipstick, a purse and wallet, a bunch of keys, a handkerchief.

"I'd hoped for the odd letter," he said, "or at the very least

with it? And while you're there, see if they found a note."

"Sure." Jackson stood up. "Where does she come from, do we know?"

"Oxbury, according to her application form. Number 2a Salisbury House, High Street. Sounds like a flat. I'll ring the lads down there when I get a chance, and ask them to do some sniffing around. Find out what the neighbours thought of her and so on. Seems she was abroad until quite recently."

"Right, well, I'll go and see what I can get out of SOCO," Jackson said, and left Webb to his sorting.

Myrtle was furious to have missed out on all the excitement. "Why didn't you tell *me* when you found her?" she demanded. "You knew where I was – you'd just left me in our room."

"But you'd only have said we must find someone in authority," Betty defended herself. "Anyway, I wasn't thinking straight. I couldn't bear being the only one who knew – I wanted to hand over the responsibility as soon as possible, and the first person I saw when I went through the swing-doors was Mr Young."

"Then what happened?"

"Well, of course he wanted to see for himself and I had to take him to her, though I kept well back that time. He bent down and felt for a pulse, but it was quite obvious she was dead." Betty shuddered. "I'll probably be dreaming about it for the rest of my life."

"Nonsense!" said Myrtle robustly. "After a while, when you've had time to digest it, you can use it in a story."

Betty regarded her with horror. "Myrtle, how can you say such a thing?"

wearing any – you don't think of it in buses, she said – and they all scrabbled frantically, trying to find them and put them on, but there just wasn't time. They were thrown all over the place as the bus careered down the hill, then it went off the road and started turning over and over as it rolled down the slope. The lights went out, she was aware of intense pain, then nothing else." He paused. "It freaked her, being the only one left alive."

"I can imagine."

"So – what's been happening here?"

Webb quickly filled him in.

"What do you reckon, then? Murder or suicide?"

Webb shrugged. "The open window doesn't mean a thing; even if she was pushed, the killer would have left it, to make it look like suicide. Doc Pringle leans towards murder, but I'm not sure; by all accounts she was a bit neurotic, and some of the women thought she seemed frightened."

"Ah-ha! Any note?"

"Not that I've heard, but I haven't spoken to SOCO since they started on the room. If there is one, it would at least close this case for us. On the other hand, if it's murder, it has to be someone connected with the Grange, which would finger them for the minibus job, too, unless we have two homicidal maniacs on the loose."

"You reckon she saw something, then?"

"Seems the most likely explanation, and it had also occurred to the women here. Trouble is, no one arrived till Monday, two days after the crash. Her car's been examined, but there's nothing of use there. What I'd really like to get hold of is her handbag; it wasn't with the body, so presumably it's still in her room. Would you go along, Ken, and ask SOCO if they've finished

To his deep shame, Mark's first thought was for himself. For if, as seemed likely, police interest were to be focused on yesterday afternoon, was there any way that his unforgivable lapse could be kept hidden?

Admittedly, should any suspicion attach to him as the dead woman's tutor, Fife and Hardwick could confirm he was in Shillingham; but they'd only his word that he'd not arrived there shortly before they met. And if he were required to account for his movements earlier, what in heaven's name could he say?

He forced himself to think clearly. With the place full of policemen he'd automatically assumed foul play, but there'd been no suggestion of that. The woman had obviously killed herself – Lord knows, she was unstable enough. So why should his movements, or anyone else's, be of interest to the police? All they'd be concerned with would be establishing the time of death.

He began to breathe more easily.

Scenes of crime officers were engaged in examining the bedroom, and interviews were under way in several of the lounges. As a result of all this activity, various snippets of information were filtering through and Webb, who with Young's agreement had taken over his study, was sorting through them when, shortly after midday, Jackson was shown in. Webb was glad to see him.

"I got your message, Guv; all go, isn't it?"

"You might say that. How's Mrs Sue?"

Jackson pulled a face. "Weepy, as you'd expect, but Sally coaxed her along. She said they'd all been chatting about the evening and exchanging addresses, when suddenly the minibus lurched forward and the driver shouted something about brakes and seat belts. None of them were

Webb turned to Young. "You realise, of course, that we'll have to interview everyone in the building?"

Young raised his eyebrows. "Everyone? But – good Lord! – including the staff, that's about eighty!"

"I've arranged for a team of officers to be drafted in. It should all be completed by the end of the day."

There was a tap on the door and one of the porters appeared. "Excuse me, Mr Young, the pathologist has arrived. Is it all right if—?"

"Thank you, Jack; no doubt Mr Webb will want to see him."

Bob Gregory cleared his throat. "I think an announcement should be made as soon as possible, or rumours will start circulating." He glanced at his watch. "Once the coffee break's over everyone will separate, so I ought to go down now, while they're still in one place." He hesitated. "I take it we're free to go?"

Webb stood up. "Yes, of course; we'll need official statements, but those can be taken along with the others. You might also make it clear, sir, that everyone is asked to stay in the building until they've been interviewed. As I say, it shouldn't take too long."

Gregory nodded. "What about the timetable? Do we continue as normal?"

"No reason why not; people can be excused as necessary to be interviewed."

"Right." Gregory came to his feet, turning to Penny and Betty. "Come along, then, you two; you'll still be in time for your courses."

Sombrely, avoiding each other's eyes, they left the room and, with Webb and Young bringing up the rear, went down the broad staircase to the hall.

* * *

She blanched and said quickly, "But of course, it might have been a spur of the moment decision."

Webb looked at Penny. "You shared a room with her, Mrs Graham; did you learn anything about her background?"

Penny moistened her lips. "She said she'd been working in the States for three years. She hasn't been back long."

"What kind of work?"

"I didn't ask, but I assumed something secretarial."

Webb pursed his lips. "It's not easy to get work permits over there, and strings would have to be pulled. I'd be surprised if secretarial skills qualified." He thought for a minute. "She didn't say why she came back?"

"No, but she'd probably gone for a set time."

"What else did she tell you?"

Penny cast around in her mind. "That's about it, really. Mostly we just talked about the course, and Mr Aston's method of conducting it."

"Mr Aston being your tutor?"

Penny nodded. "To be brutally honest," she blurted out, "I found her heavy going. It wasn't easy, trying to make conversation with her."

Webb looked at Bob Gregory, sitting staring miserably at the floor. "Was this Miss Mann's first attendance at the Writing School?"

"Yes; in fact, it was a late application – we only received it last month. Normally we wouldn't have accepted it after the closing date, but there'd been a cancellation, and as all those on the waiting list were in pairs, we were able to slot in an odd single."

Webb smiled wryly. "Which, no doubt, you now regret."

"You can say that again!"

afternoon; also, whoever has the room directly beneath. They might have heard something without paying it much attention. So – what was the last time Miss Mann was seen alive?"

Penny and Betty looked at each other. "Lunchtime, as far as we know. She was on our table."

"And how did she seem?"

"Fine," said Penny, at the same time as Betty was saying, "Much as usual."

Webb turned to her. "And what was 'usual', ma'am?"

Betty flushed as everyone looked at her. "Well, we had been rather anxious about her, Mrs Hardwick and I. She seemed so nervy and – frightened, almost."

Webb's eyes narrowed. "Frightened of what?"

"Well, when we heard the minibus crash hadn't been an accident, she nearly passed out." •

"Did she, now."

"She said it brought back her brother's death under similar circumstances."

"But you thought it was more than that?"

"We – we did wonder if she might have seen something," Betty said awkwardly, "but of course she couldn't have, because she didn't arrive here till Monday."

"You say you thought she was frightened. To the extent of taking her own life?"

Betty caught her breath. "How can I answer that?"

"Just an opinion, ma'am?"

"Well, she seemed nervous and withdrawn, if that's any guide. But there was a kind of strength about her, too. And," she added eagerly, as the memory came, "she ordered a book from Jackie Prentiss. Why should she do that, if she intended killing herself?" Only as she saw the expression on their faces did the alternative to suicide occur to her.

116

Time crawled past, but a furtive look at her watch showed Betty, to her surprise, that it was only a quarter to eleven. The coffee break would be in fifteen minutes. Would Myrtle come looking for her?

Then the door opened and Mr Young stood there with a tall, stern-looking man whom he identified as DCI Webb. They were introduced in their turn, more tea was produced, and they all self-consciously sat down.

Webb turned at once to Betty. "Now, Mrs Fife," he began pleasantly, putting her at her ease, "I believe it was you who found Miss Mann; were you specifically looking for her?"

Betty shook her head, explaining about her headache and that she had merely been in search of some air.

"But Miss Mann had been missing since last evening, hadn't she? Hadn't there been any kind of search?"

Penny spoke up. "We assumed she'd gone to the theatre – she'd been talking about it. I'm sure, though, that she spent the afternoon in our room, because her book was lying face-down on her bed and the window was wide open."

"The window was open?" Webb repeated sharply.

Penny paled, belatedly seeing the significance. "Yes, but I didn't think anything of it, just cursed her for letting the room get cold." She glanced at him guiltily. "Isn't that awful? But Erica was always leaving the window open; she said the room was stuffy and she couldn't breathe."

"It's on the first floor?"

"Yes."

"Who's on either side of you?"

"Mr and Mrs Benson, and Mr and Mrs Lock."

Webb turned to Young, who, all the chairs being occupied, had perched on a corner of his desk. "I'll need to speak to them next, sir, find out where they were yesterday

Eight

P enny Graham was close to tears, though from shock rather than grief.

"Imagine her lying there all night!" she exclaimed for the second time, blowing her nose. Betty, still frozen with shock herself, could only nod agreement. In the conference room, she was thinking, the lecture would be going ahead, the audience all unknowing. No doubt Myrtle, with an empty seat beside her, was wondering where she was.

Bob Gregory, the chairman of the Autumn School committee, had been discreetly winkled out of the lecture to be given the news, and since Penny was sitting next to him and had shared a room with Erica, she'd been extracted as well, on the assumption that the police would want to speak to her.

They'd just arrived, apparently, and Mr Young had gone down to meet them, leaving the three of them sitting there awkwardly holding the cups of hot tea with which they'd been supplied.

The image of the broken body on the cold paving haunted Betty, and she wished Erica could be brought indoors and decently laid on a bed somewhere. However, the doctor who'd come to check on her had said this wasn't possible. Not, she reminded herself, that it would make any difference to Erica.

"I've phoned Dr Stapleton, sir," Smithers said, "and arranged for the undertakers to stand by."

"Thanks, Brian. I'd like SOCO to give her the once-over before she's moved."

"It seems Richard Vine's away," Pringle said as he and Webb made their way to the main building, "but his deputy's waiting to speak to you." He gave a short laugh. "He's in a lather about adverse publicity. Incidentally, I've seen the woman who found the body. She was shaken, naturally, but didn't need medication. You'll be wanting a word with her – she's up in Young's office, with the dead woman's room-mate."

Webb nodded. "Fine; first, though, I'll get on the blower and draft some men up here; everyone will have to be interviewed, heaven help us."

"That'll keep you busy!" Pringle said with a grin.

Adrian Young was waiting for them in the hall and came hurriedly forward. "Chief Inspector. What can I do to help?"

"I've a few phonecalls to make, Mr Young, then I'd like to see the woman who found the deceased."

"Of course; Mr Vine's study's vacant – you can phone from there, and when you've finished I'll take you to see Mrs Fife. She's in my room on the first floor."

A sudden imperative bleeping made them all pause and Pringle, apologising, extracted his mobile phone and moved a few feet away from them. When he'd finished speaking, he came back. "An urgent call, I'm afraid. Have you finished with me for the moment, Chief Inspector?"

"Yes of course, doctor. Thank you for your help."

And as Pringle hurried through the front door, Webb turned and followed Adrian Young up the wide staircase.

As they were talking, the two men had cut across the grass to join the driveway leading to the car park which, on its way, skirted the far side of the bedroom wing. The ground floor was screened by a prickly-looking hedge, but there was a gap halfway along giving access. Beside the gap, solidly impassive, stood a uniformed police officer.

"What have we got then, Alec?" Webb asked the doctor.

"Woman seems to have fallen from a first-floor window. It's closed now, of course, but whether by her murderer or her roommate is for you to discover – always supposing they're not one and the same."

"Could it have been an accident?"

"No way; the windows are above waist height. So we have the familiar poser, did she fall, or the other thing."

"What's your opinion?"

Pringle shrugged. "I'd say she came down head first, which is pretty unusual in a suicide."

"It's been known, if they want to be sure of making a good job of it."

"More likely, though, if they're tipped out head first."

Webb nodded to the man on duty, who said briskly, "Along the path to your left, sir. Coroner's officer arrived a few minutes ago."

The body wasn't visible until they had walked some way towards it, at which point they could also make out the figure of PC Smithers. The three men, used to meeting in such grisly circumstances, exchanged greetings.

Webb looked at the woman on the ground. She was lying face down with her feet towards the building, though her legs were bent beneath her and her neck was twisted at an unnatural angle. She had short dark hair and looked to be about forty years old. A pool of blood, now dark and dry, had spread over the surrounding paving stones.

mildly. "I'm a police surgeon as well as a GP, so I know what I'm talking about."

"What about the woman who found the body? She's in my office at the moment, partly because she's suffering from shock, and partly because I didn't want her blurting out what had happened till I'd some idea of how to handle it."

"I'll take a look at her, but first I'll make these phonecalls so that things can start rolling."

What in the name of heaven had got into Beckworth? Webb thought irritably, as he drove up the increasingly familiar Todd's Hill. Multiple murder, anonymous letters, midnight phonecalls and now another death, all in the space of seven days. Were some or all of those incidents linked, and if so, how many and in what way? Time alone would tell.

The verge where the bus had left the road was now lined for several yards with bunches of flowers, lighting the murky morning with splashes of colour. Webb drove past them and turned into the shrouded gateway of the Grange, recognising Pringle's green Metro as he came up the drive. The doctor emerged from the front door and walked over to great him.

"Busy week up here, eh, Dave? Who opened Pandora's Box, do you reckon?"

"Whoever it was, I wish they'd bloody well close it again," Webb said testily.

"The trusty Jackson not with you?"

"He hadn't got back from the hospital when I left. Went to interview the crash survivor."

"Yes, I heard she'd pulled through. Thank God for that, at least. I wouldn't have given much for her chances last Sunday."

whispering, "No! Oh, please, no!" she forced herself forward. But in truth she already knew that she had found Erica.

Adrian Young, shivering in his suit, stared uncomprehendingly at the doctor. "I don't understand," he said. "What do you mean, you're not satisfied? She's dead, isn't she? Surely you can certify that?"

Dr Pringle got to his feet, dusting off the knees of his trousers. "Oh, she's dead all right," he replied cheerfully, "but even if she committed suicide, it counts as a suspicious death and is a matter for the police."

Young moistened his lips. "What do you mean, *even*? You're not saying there's some doubt about it?" God, he thought, why did this have to happen with Richard away? He'd have known what to do.

"There's always doubt, Mr Young, until we have all the loose ends tied up. I'll get on to the coroner's officer and then give Mr Webb a call; I don't doubt he'll want the woman's room examined. In the meantime, no one should go in there."

Young looked doubtfully at the pathetic heap that had been Erica Mann. "Can she be moved now?" he asked. "We can't leave—"

"Most certainly not. Not until the police and probably the pathologist have seen her. I suggest you recruit responsible members of staff to keep everyone away until they arrive. And if you could lock her room, it'd be a wise precaution."

Young led the way back into the bedroom wing. "If you say so, though I don't like the implications. If all this gets out, God knows how it will affect the Grange."

"Sudden death is seldom convenient," Pringle said

opposite each other gave onto the gardens, and it was these Betty was making for.

She'd intended to let herself out of the right-hand one, so that, after her breather, she could go in the main entrance of the Grange to the lecture. However, as she drew level with it, she saw several people huddled outside smoking, and turned instead to the door on the left.

She pulled it shut behind her, shivering. Myrtle was right, she thought, drawing her jacket closer as the chill mist seeped over her; it wasn't the weather to be outdoors. Nevertheless, the air felt blessedly cold after the stifling heat inside.

She paused on the crazy paving which ran the length of the wing, realising that even if the day were clear, she wouldn't see much from where she stood. For just beyond the paving, a six-foot briar hedge ran parallel with it, screening the downstairs windows – which were set at quite a height from the ground – from anyone either strolling in the garden or driving to and from the car park.

Betty began to walk along the path, lifting her face to the cold, damp mist. She could see only about twenty yards in front of her, and such sounds as reached her, from the other side of the hedge, were distorted and disorientating.

There was little pleasure in this, she decided, and was already turning to go back when the shifting mist gave a brief glimpse of something dark on the path ahead of her. Frowning, she moved slowly forward, her eyes straining to penetrate the thick air. Then she stopped abruptly, and her heart set up a loud thumping. It looked as though something – or someone – was lying on the ground.

She put a hand on the wall to steady herself. Then,

at a serious threat, or merely harassment? With murder on our hands, we can't afford to take chances. I told her we'll put a tap on the phone, but with these infernal mobiles proliferating, it mightn't get us very far." He paused, and added reflectively, "She seemed very calm about it, considering. I had her down as a nervous little thing."

Betty Fife had awoken with a headache, and was belatedly realising it would have been wiser not to have coffee with her breakfast. The pain had increased tenfold, and was now pounding inside her head with a persistence that made her wince. Nor was the heat in the bedroom helping, but when she'd tried to open a window, Myrtle had shivered elaborately and asked her to close it.

Betty looked at the clock on her dressing-table. She had ten minutes before the lecture started at nine-thirty.

"I'm going outside for a breath of fresh air," she told Myrtle, taking a jacket from the wardrobe.

"In this weather? I'd hardly call it fresh!"

Betty looked doubtfully at the mist pressing against the window. "All the same, it might help clear my head. Save me a place when you go down – I shan't be long."

The bedroom wing was a two-storey building at right angles to the Grange, its brickwork and general style conforming as closely as possible to that of the old house. Inside, however, it was totally modern, with en suite bathrooms and tea-making equipment in every room. More five-star hotel than conference centre, it was these touches, as Richard Vine well knew, which contributed to the Grange's popularity.

Betty and Myrtle's room was on the ground floor, and at the far end of the corridor, double swing-doors led directly into the main building. Halfway along, though, two doors

himself demolished a similar theory of Jackson's. "Still, it's the first indication we've had that the whole lot of them weren't candidates for sainthood."

Crombie grinned. "Something else might turn up," he said.

"Let's hope so. In the meantime, Ken and Sally Pierce have gone next door to interview Mrs Sue. I doubt if she can tell us much, but at least we'll have a first-hand account of what happened."

"A bit traumatic for the poor woman, after losing her husband and everything."

"That's why I picked Sally; she's a natural in these cases."

Webb leaned over to retrieve the ringing phone. "Speaking. Good morning, Mrs Vine." He raised his eyebrows at Crombie. "What can I do for you?"

Crombie, leaning back in his chair, saw him frown.

"When exactly was this? . . . And that's all he said, just your husband's name?"

Crombie could hear the distorted voice along the wire, but was unable to distinguish the words.

"I thought you were going to spend the night with your son?" Webb was saying, and then, "Has your husband had calls like this before?"

Crombie waited, doodling on his pad, and after a few more comments Webb rang off.

"What was all that about?" he asked curiously.

"Phonecall at about one a.m. All the caller said was, 'Richard Vine?' The phone also rang the previous night after she'd gone to bed, but her husband was still downstairs and he took it."

"Stepping up the campaign," Crombie commented.

"It's beginning to look like it. Question is, are we looking

"I suppose she must have been," Penny said defensively. "I went up soon after you looked in last night, and fell asleep straight away. I thought she'd be there when I woke this morning, but – she wasn't."

"Oh, God," said Jackie tonelessly.

"You don't think something's happened to her?" Betty whispered, round-eyed.

"Well, obviously *something*'s happened. I'll get Mr Young to check if her car's here; I wish I'd thought of that last night. If it is, we'll have to inform the police and organise a search party. She might have gone for a walk in the woods and had an accident." Jackie had an uncomfortable picture of the gulleys lining the road, one of which had accounted for the minibus, and turned hastily away to put her plans into operation.

Anxious and subdued, the little group followed the rest of the members into the dining-room for breakfast.

"At last we've got something on one of the Richard Vines," Webb told Crombie. "The doctor, no less, from Reading – accusations of malpractice a few months ago. They didn't come to anything, but there was a lot of talk at the time, so his neighbours say. Tony Trent's getting on to the local rag, to see what else he can glean."

"Malpractice in what form?" Crombie asked, looking over the top of his spectacles. "Fondling women patients?"

"That kind of thing, yes. Could be a husband wasn't satisfied with the outcome and took matters into his own hands."

"You mean he followed him from Reading, somehow found his way to the Grange, and never gave a thought to the other poor blighters in the bus?"

"All right, so it's not very convincing." Webb had

now subtly different. Had she the strength to make that difference permanent, never to slip back to being the shy, spineless creature she had been only yesterday?

In the adjoining bedroom the phone shattered her musings, making her jump. Richard? No, he wouldn't ring at this hour, he'd expect her to be asleep. The police, then? Had something happened to him? Catching up her dressing-gown, she ran into the bedroom and lifted the instrument.

"Yes? Hello? Who is it?"

No one answered. Silence crept along the wire, a heavy, listening silence.

"Who's there?" Natasha said sharply.

Still silence. Both nervous and annoyed, she was about to put the phone down when a voice, scarcely above a whisper, sounded in her ear.

"Richard Vine?"

"He's not here," Natasha answered, and at once regretted it. Now this sinister caller knew she was alone.

"Who's speaking?" she demanded.

Somewhere out in the night, the connection was broken.

She stood clutching the phone, her heart labouring in loud, uneven beats. So much for her new-found confidence. Then a crooked logic came to her. Whoever it had been – the writer of that letter, perhaps? – had wanted Richard, not herself. So, knowing he was away, he was unlikely to make any move tonight. And in the morning, she'd tell Mr Webb.

She waited for her heartbeats to quieten, then climbed into her side of the bed and switched off the light.

"You mean she's been out all night?" Jackie Prentiss stared at the nervous little group in front of her.

walk in the woods, some to take the bus into Shillingham, some to read or catch up on their set work. No one, it soon emerged, had seen Erica since lunchtime.

"I think she spent the afternoon in our room," Penny volunteered. "Her book's on her bed."

"At lunch we were discussing a play that's on in Shillingham," Barbara Dean put in. "Erica said she'd like to see it; perhaps she decided to go."

Jackie looked doubtful. "You'd think she'd have told someone, particularly if it meant missing dinner. I'll try the other lounges – someone there might know something – but when she does surface, will you tell her I'm looking for her?"

She went out, leaving an air of vague disquiet behind her.

Natasha had spent a restless evening, unable to settle to anything. Both the children had phoned: Polly, because she'd heard of the developments and was anxious about her parents, and Jonathan when he found her note; he'd offered to come and spend the night with her, but, though grateful, she had declined. From now on, she was determined to stand on her own feet.

As for those incredible hours with Mark – the catalyst behind that determination – it was hard, now, to believe they'd happened. Not that she had any regrets, she assured herself; thanks to their time together she had come alive again, become a person in her own right. And the realisation suddenly came that she, Natasha Vine, had a lover! She laughed aloud at the sheer absurdity of it.

Eventually, about midnight, she went upstairs for a long, luxurious bath, and afterwards, rubbing a circle in the steamy mirror, stared at the familiar face that was

the last any of them had seen of him. Or so they say." Webb took a sip of his drink. "One of the drivers has since left and moved to SB, so Jackson and I went there this afternoon."

He told her of his visit to Sarah Leyton. "In other words," he finished, "we got more than we bargained for, but it doesn't look as if it will do us much good. It's been confirmed that Leyton really did sail for Dieppe last Friday, and made his scheduled calls on Saturday, so there's no way he could have been responsible."

"Then I hope you'll leave him alone," Hannah said severely. "It sounds as if he's had enough trouble, poor man, losing his first wife and baby under such distressing circumstances."

She put her glass down and stood up. "I must go and let you get to bed. Thanks for the drink, and I hope you get a break soon."

Jackie Prentiss, a member of the Autumn School committee, appeared in the doorway of the green lounge, where several discussion groups were in progress.

"Sorry to interrupt," she said, raising her voice above the hum of conversation, "but has anyone seen Erica Mann?"

Some thirty faces turned towards her, then glanced around the room in case the woman was, after all, among them.

"No, sorry."

"Was she at dinner?" Jackie asked. "I didn't see her, and I was looking out for her, because I've a book she ordered. Who does she usually sit with?"

Myrtle spoke up. "No one in particular; she was on our table at lunch."

"Anyone see her this afternoon?"

But they'd all scattered during their free time, some to

103

suppose. The girls have been at school for about five years, and the family was new to the area then. They came from Sussex; Mrs Vine told me once that her mother had been seriously ill, and when Richard was offered a job here, it seemed a good idea to move closer. Her parents live in Bath."

"What line was he in?"

"Chartered surveyor – well thought of, I believe. The London assignment was a great feather in his cap. Mrs Vine agonised over letting the girls board, but it was a chance he couldn't afford to miss, and of course she wanted to be with him."

"They were close, then?"

"Very, as far as I could see." She paused. "They were the only locals, weren't they, apart from the reporter?"

"The reporter," Webb repeated slowly. "A good point – we mustn't rule him out; he could have written something which upset someone."

"But if he was a *local* local – that is, still living here – he wouldn't have been using the minibus, would he? Wouldn't the killer have known that?"

"Oh God, I suppose so. I'm obviously still half asleep! Anyway, apart from him, there was the driver."

"Of course – I was forgetting. What was *his* background?"

"Unimpeachable, like the rest of them. Used to work at Cottage Bakeries in Heatherton. The manager was singing his praises yesterday but I missed the drivers, so one of the local lads saw them today. Nothing to get our teeth into, though; all full of what a nice guy he was, and what a great time they'd had at his leaving party. Apparently he was slightly under the weather – flu or something – but he'd gone along anyway, rather than let them down. That was

"Come on, Dil," Monica chided her, "relax! No one's out to get you! Why ever should they be?"

"Why the Vines, for that matter?" Dilys retorted. "There *are* killers, you know, whose only motive is the sheer pleasure of killing."

Gwen shuddered. "Stop it, please. Tonight is supposed to be a celebration."

So they put dark thoughts behind them and enjoyed their meal. But on returning home, Hannah took the lift to the floor above her own and tapped on Webb's door. He opened it looking sleepy and dishevelled, with his tie off and his shirt open at the neck.

"Oh, I'm sorry!" she exclaimed. "Did I wake you?"

He grinned ruefully. "I'd have had to wake up soon, in order to go to bed." He registered the silk dress under her coat. "Of course – your celebration dinner. How did it go?"

"A bit sombre, actually. Dilys is lecturing at the Grange tomorrow, and fears for life and limb."

"Tell her lightning doesn't strike twice." He turned to the drinks table. "Nightcap?"

"I'd love one." She sat down in her usual chair, staring at the imitation coals of the gas fire. "Are you making any progress?"

He shook his head, handed her a glass and sat down opposite her. "Not so that you'd notice. At the moment, we're concentrating on the local victims, so, as a matter of interest, what can you tell me about your Vines? All right—" he held up a hand as she moved in protest "—I know they were a charming couple, and all that. But their background, I mean. Exactly how much do you know about them?"

Hannah thought for a minute. "Put like that, not a lot, I

Seven

Hannah's celebration dinner at the King's Head was, unavoidably, somewhat muted, since the deaths of Anne and Richard Vine hung over them, even more upsetting now they were known to have been murder.

These regular meetings were a long-established ritual between the four of them, all single, independent women, ex-pupils of Ashbourne who'd each been successful in her field. They usually took the form of visits to concerts and theatres, or dinner at each other's houses.

Now, however, only two of them remained single. Last year, Monica had become Mrs George Latimer and was not always free to join them, and now Gwen had married her professor and would be leaving for Canada with him at the end of the summer term. They were coming, Hannah reflected sadly, to the end of an era.

Dilys Hayward, the fourth member of the group, was a well-known novelist with an enviable list of television adaptations to her credit.

"I'm the guest lecturer at the Grange tomorrow," she told them, sipping her champagne, "but I can't say I'm looking forward to it. You know my imagination – I'll be seeing figures lurking behind every bush. They're sending a car for me, and I don't fancy that either, driving up that particular road after dark."

he'd denied it. Truthfully, as it happened; thanks to some trick his body had played on him, he'd wanted her as much as he'd ever wanted any woman, and there was no denying the love-making itself had been good.

Damn it, he thought angrily, he was *fond* of her! All right, so she wasn't the type he usually went for, but she was sweet and kind and he didn't doubt she'd had a lot to put up with from her lousy husband. *You're special*, he'd told her, and had meant it. *Don't underrate yourself*, he'd said. Was he now, by what he had to say to her, about to destroy her confidence still further?

Oh, *God*! Why had he gone into Shillingham that afternoon? What mischievous fate had led to her being on that corner as he came out of the art gallery? Why hadn't he simply fallen in with Angelique's wishes? That way, there'd have been no repercussions.

He glanced at his watch. Ten to six. He'd have a wash, then it would be time to go down to the bar. Any further deliberations would have to wait till after dinner.

What in heaven's name had possessed him? She was, after all, an unlikely object of desire, probably a year or two his senior and not outstandingly attractive, though there was a certain air about her of which she was patently unconscious. Her main attributes were her lovely eyes and that sudden, radiant smile. It had been her smile, he remembered, that had first aroused his interest rather than merely his concern, that day in Lethbridge. Though in his wildest dreams, he'd never imagined going to bed with her.

But she needn't have acquiesced, he argued in his defence. She could have slapped his face at the first kiss; or, being Natasha, blushed, muttered that she had to be going, and fled. That would have left him with no more than a red face. Whereas now . . .

What was she thinking at this moment? Would she be home yet, in that house across the garden? What would she expect him to do?

There was nothing for it, Mark thought despairingly, he'd have to go and see her. But to say what? 'I hope you didn't mind what happened, but you do realise it was a one-off'?

Over their hastily drunk cup of tea, they'd said little, avoiding any suggestion of meeting again. But he'd have to say *something*, end it decently, and it must be soon; there were only two full days of the School left.

Tonight, then? Vine, he knew, was away, but he couldn't go round *now*. For one thing he couldn't face her yet, and for another she might think he'd come for another session. On the other hand, if he left it till tomorrow, Vine could well be there. Should he phone? Or would that be taking the easy way out?

Was it because you felt sorry for me? she'd asked, and

98

Mark had had the same impression, but was not going to say so. "It's probably just shyness," he answered evasively.

"But Penny, who shares a room with her, says when she wakes in the night she hears Erica crying."

Unable to think of a suitable reply to this, Mark didn't attempt one.

The twenty-minute drive passed in a blur. He drove on autopilot, aware of the wash of the women's voices against his eardrums and periodically making sounds of agreement which he hoped were apposite. Then at last he was turning off the Beckworth road onto Todd's Hill and the final approach to the Grange.

He dropped his passengers, drove round to the car park and then, hoping not to meet anyone he knew, hurried into the building. He was in luck, and reached the privacy of his room unmolested. It was five-thirty. He badly wanted a drink, but the bar didn't open till six.

He shrugged off his coat and went to the window, staring out at the reflection of the lighted room behind him. And now, when there was no longer any way to block off memory, the enormity of what he'd done swept over him, drenching him in a scalding wave of sweat.

God, he must have been out of his mind! Had he really made love to Richard Vine's wife? That shy, pleasant little woman he'd felt sorry for? And what the hell interpretation would she have put on it? Had she – he groaned aloud – taken it as a declaration of love?

His fingers clenched convulsively in his hair. What was totally unforgivable was that when she'd been at her most vulnerable, weeping in his arms, he had blatantly taken advantage of her, behaving like some sex-crazed adolescent.

it was a reasonable request, and one he could hardly refuse.

"Of course," he said, aware of sounding ungracious. "The car's in the multistorey up the road." Then, resigning himself to the inevitable, added, "Let me take some of those parcels. You seem to have had a successful afternoon."

"How kind!" Myrtle beamed, promptly loading a precarious pile into his arms, which neatly precluded his relieving Betty of any of hers.

Betty, however, did not seem perturbed. "We've been Christmas shopping," she explained, trotting beside him as he started walking again. "Funny how when you're away, the shops always seem more interesting than those at home."

"Even though they're pretty well the same selection," Myrtle said drily. "But what have you been doing, Mark? Not shopping, obviously."

"Oh, just wandering around. I spent some time in the art gallery; there's an exhibition of Matisse – well worth a visit."

They turned into the multistorey and the lift bore them up to the third floor. The stone building felt dank and cold and he shivered involuntarily.

"What did you think of that story of Erica's?" Myrtle asked, settling herself in the front seat and leaving Betty to climb in the back.

"It was unusual, wasn't it?" Mark said diplomatically, starting the car. Erica and her eccentricities seemed, at the moment, a million miles away.

Myrtle gave an exaggerated shudder. "I thought it was sick," she said.

Betty leant forward. "We're a bit worried about her," she confided. "We think she's frightened of something."

sailed out that day. For though he'd spoken of contacting Bainbridge, he'd made no move to do so; the show of camaraderie could have been camouflage. All of which, Webb reminded himself, was academic if the blasted man really had been the other side of the Channel last Saturday.

Mark's sense of unreality was still with him as he wove between the jostling crowds on the pavement, but, like Natasha, he intended to block off any in-depth soul-searching till he was in the privacy of his own room, preferably with a glass in his hand.

He cut down Carrington Street, passing the corner where he had found her and, on the other side of the road, the forbidding exteriors of Shillingham General Hospital and the police station. What had the police made of that letter? he wondered. Did it have any bearing on what had happened?

Lost in his thoughts, he turned into Duke Street and cannoned straight into two women who had stopped suddenly to look in a shop window.

On hearing his name, he broke off his apologies and found, to his dismay, that he was face to face with Myrtle Hardwick and Betty Fife.

"I'm so sorry," he said again. "It's the nose-to-the-stables syndrome; I was so intent on collecting my car, I wasn't looking where I was going."

The women exchanged glances. "You're on your way back to the Grange?" Myrtle asked tentatively, adding, as he cautiously nodded, "Any chance of our cadging a lift? We came down by bus, but the return trip isn't for half an hour yet, and our feet are killing us."

Mark swore silently. The last thing he needed just now was the company of two chattering women. However,

images. "Oh yes, they were great friends. Doug said the place wasn't the same once John left. He keeps saying they must get in touch, but I don't think he's done anything about it."

"Well, it's too late now," Webb said, and, seeing her blank look, added, "Mr Bainbridge was killed in that minibus crash last weekend."

She frowned. "Crash?"

"Haven't you heard about it?" He'd been so involved with it all week that it was hard to believe anyone living in the county could be ignorant of it.

"I don't read papers or watch the news," she said, seeing his surprise, "it's too depressing. John's been killed, you say? That's awful – Doug will be devastated."

There was no tactful way of putting his next question, but since she knew no details of the crash, Webb hoped she wouldn't read any implications into it.

"You say your husband's on a long-haul? Where exactly has he gone?"

"France and Spain. He had to drive right down to Gibraltar."

Webb felt his heart begin to sink as yet another line of enquiry looked like petering out. "When did he leave, Mrs Leyton?"

"Last Friday, why?"

He let out his breath in a long sigh and caught Jackson's sympathetic glance as he rose to his feet.

"It doesn't matter. Thanks for your help. When your husband gets back, would you ask him to call in at your local police station, just to clear up a few loose ends."

He'd prime Chris Ledbetter about this, he thought privately. Leyton's itinerary would have to be checked with his employers, and confirmation obtained that he really had

Webb said hesitantly, "We understood he left because of family problems?"

"That would be Libbie, yes." Seeing their bewilderment, she added, "She was his first wife; I'm his second, Sarah. I didn't meet Doug till after she died."

"His first wife *died*?" 'Problems' seemed an odd word to describe that.

Sarah nodded. "She had a baby, you see." She bit her lip, her hands going protectively and, Webb was sure, unconsciously, over her stomach. "But it was — severely handicapped and lived only a few hours."

"And then she died herself?" he prompted, when she did not go on.

"No, not straight away." She looked up at him earnestly. "You have to understand, Mr – Webb, is it? – she'd always been very moody, swinging from high to low for no reason anyone could see, and likely to go into hysterics at the drop of a hat. Doug's never said so, but he must have had a very hard time with her. They'd been trying for a baby for some time, and when it died she just – fell apart. In the end, he had to have her admitted to a special hospital, up near here. That's why they left Heatherton."

"And she didn't get better?" Webb asked, trying to assimilate this flood of unexpected information.

"No," Sarah Leyton said in a low voice. "She managed to get out somehow, and – threw herself under a train."

The bald little statement, with all the tragedy behind it, lay heavy in the silent room.

"I'm sorry," Webb said inadequately. There was a brief silence, and he cleared his throat. "Mrs Leyton, has your husband ever spoken of a colleague called John Bainbridge?"

She brightened at once, glad to relinquish distressing

93

It was in fact three forty-five when they drew up outside number nine Down Close, in a little cul-de-sac off the main Gloucester road. Some variegated ivy trailed from a window box and there were frilly net curtains at the windows.

"Family problems resolved, wouldn't you say?" Webb commented as they walked up the path. "Doesn't look like a batchelor establishment to me."

This statement seemed to be confirmed when, seconds later, the door was opened by a pretty young woman some five months pregnant.

She looked somewhat apprehensive on seeing their warrant cards. "My husband isn't here," she told them.

"What time are you expecting him back?"

"Oh, not till the weekend; he's on a long-haul."

Webb swore silently. They seemed doomed to miss the bakery men. "Then perhaps we could have a word with you?" he asked, and, as she hesitated, added, "We won't keep you long."

She nodded reluctantly and led the way to a room overlooking a neat back garden. A large bowl of copper-coloured chrysanthemums stood on a table and the television was flickering in one corner. She switched it off.

"I don't know how I can help you," she said, motioning them to sit down. "Doug doesn't say much about his work."

"Who is he with now?" Webb asked, as Jackson took out his notebook.

"Johnson's Haulage."

"Still driving, then. We got his address from Cottage Bakeries in Heatherton."

Her face cleared. "Oh, I see. I was afraid something had gone wrong up here."

92

particular spanner on him – he'd surely have known Vine wasn't going on that bus."

"Fair enough. Well, some knowledge of cars seems indicated, and out of all the people we've seen so far, two groups immediately spring to mind: the bakery drivers down in Heatherton, and the lads at Hatherley Coaches. So it would be interesting to know which of them were free on Saturday afternoon."

"Assuming the target to have been Bainbridge?"

"Well, logically the driver of the bus has to be a prime candidate, even if he *is* Mr Nice Guy. It's possible there was a bloke in either group who resented his popularity or had some grudge against him. I asked Heatherton nick to send someone to see the bakery boys when they get back today. At this end, we'll have another go at Hatherley's and see if we can dig a bit deeper. Which leaves only the man who moved on the year after Bainbridge."

He pulled his notes towards him. "Doug Leyton, now living in Steeple Bayliss. The manager said he had family problems; it's just possible Bainbridge had a hand in them, in which case, a word wouldn't be out of place. When we've got that sorted, we'll turn our attention to the Anne Vines and see if they stand closer investigation."

"Good luck," Crombie said, returning to his files.

Webb pushed back his chair and, with a glance at the overcast sky, lifted his raincoat from its hook. "Thanks, I don't doubt we'll need it."

"OK, Ken," he said, going into the outer office, "we're off to SB; I want a word with this other driver. If we get our skates on we can be there by three-thirty, by which time, provided he's working the same hours, he should be home."

"Thanks."

This was the first day of the rest of her life, she told herself, and, smiling at the cliché, went down the corridor for her shower.

When Natasha had gone, Webb had sat for some time staring down at the letter she'd handed him. It would be compared for style and content with others they had on file, though as he well knew, 90 per cent of such letters never reached the police. And as he'd told Mrs Vine, the same percentage – or higher – never came to anything.

He went back to his own office, took out the previous day's notes and reread them, after which he again listened to the tape Ricky Vine had lent him. It was no more helpful than it had been before. He tilted his chair back and stared at the ceiling.

DI Crombie looked across at him. "OK, Archimedes, what have you come up with?"

Webb grinned and returned the front legs of his chair to terra firma. "Nothing, really. But wouldn't you say, Alan, that since the crime – i.e. the tinkering with the bus – was committed here, the most likely supposition is that the target was also local?"

"Sounds reasonable."

"Which, if the killer got it right, means either the 'Anne Vines', as Mrs Marshall calls them, who were only temporarily in London, or Bainbridge the driver. And if he got it wrong, we can include Richard Vine himself, who, I admit, seems the most likely candidate. His wife's just handed over an anonymous letter, by the way, and apparently it wasn't his first."

"Hang on, though, Dave; if the crime was meticulously planned – and it must have been, for him to have had that

destroying in the process all the negative feelings she'd been harbouring for so long.

You've a lot going for you, Mark had said. Could it be true? All she knew was that for the first time in years, she felt confident of handling whatever lay ahead.

Calmly and simply, she told him what had been in the letter and Webb's reactions to it. "So you see I was coming here anyway, to avoid spending the night alone. I shan't stay now, though. You're right – it's time I stopped running away, and in any case I'm not nervous any more. Perhaps I have you to thank for that." She glanced at the bedside clock. "It's four now. I'll make a cup of tea and then I think we should leave – separately. The bathroom's the second door down. You go first, while I tidy up."

"Will it be all right if I use the shower, or—?"

"Of course – there are clean towels in the airing cupboard; Jonathan brings his washing home anyway, so I'll just add them to the rest."

She stripped and remade the bed, folded the jeans, took the mug to the kitchen and rinsed it under the tap. Then she wrote on the pad Jonathan used for his shopping list: 'I was going to invite myself for the night as Dad's away, but decided to go home after all. Have changed the bed and taken the linen for washing. See you Sunday. Lots of love, Mum.'

She read through what she had written, and propped it up where it would catch his attention. *Decided to go home after all.* Such a commonplace phrase. Jonathan would have no inkling of the cataclysmic events which lay behind it. Later, when she'd had time to absorb them, she'd go back over the afternoon's experiences, but for the moment she was content to hug them to her, unanalysed.

Mark's voice reached her. "Bathroom's free."

"Where can we go?" he asked unevenly.

"My son's flat; it's only two minutes away."

The busy streets and jostling crowds had a dream-like quality as they hurried without speaking down one road and across another to a small estate he'd not even known existed. He took the key from her and turned it in the lock. Then they were in the bedroom, where the curtains were still drawn, a mug half full of coffee stood on the chest, and jeans lay crumpled on the floor.

And the suspension of reality continued throughout the next, chaotic half-hour. He was at the same time humbled by her tenderness, elated by her passion and, above all, stunned by the circumstances that had overtaken them.

When it was over, she turned her head on the pillow to look at him. "Tell me something – was this because you felt sorry for me?"

He smiled. "It was not; I assure you I don't carry sympathy this far! Nor, as I hope you realise, am I in the habit of seducing ladies I barely know."

"Then I'm flattered!" she said.

"So you should be." He propped himself on one elbow and looked down at her. "You're a very special person, Natasha, you know that?"

"No, I most certainly don't!"

"I mean it; you're attractive and intelligent – yes, you *are*!" he repeated at her involuntary movement of protest. "You've a lot going for you, and it's time you stopped underrating yourself." He kissed her gently and lay down again. "End of lecture. Now, tell me about this letter."

She'd totally forgotten it, and braced herself for a return of the fear and uncertainty she'd felt before. It didn't materialise; the welter of emotions, mental and physical, which had battered her that afternoon had burned themselves out,

88

Distractedly, she began wiping her eyes with her fingers, but now the tears had started, she'd no way of stemming them. The frustrations and disappointments of years, pent up and kept firmly hidden, were loosened in one torrential flood which left her helpless and buffeted by its onslaught.

Mark took rapid stock of the situation. Alongside them was an alley between two buildings, with what looked like a recessed door in the wall halfway along. Gently he steered her to its shelter, where they were at least screened from the street. She was now so distraught she could barely stand and he put his arms round her and held her, murmuring comfort.

When, he wondered wryly, had he last stood in a doorway with a woman in his arms? Before he had a car, certainly. It must have been when he was nineteen, with Sally what's-her-name. And perhaps by some association of ideas – for Sally had been the first girl he'd slept with – his concern for Natasha was suddenly, and to his total astonishment, swallowed in an overwhelming wave of desire.

For a brief, appalled moment he fought it, but it had already fused with his existing feelings for her – protectiveness and a tender, pitying affection. Now, it was no longer enough simply to comfort her; he wanted, urgently, to make love to her.

Sensing his partial withdrawal, she moved back and looked up at him, her eyes widening as they registered his expression. Hardly knowing what he was doing, he took her tear-stained face in his hands and began to kiss it, first her brow, then her cheeks, tasting the salt, and finally her cold, uncertain mouth. She said, "Mark!" and he silenced her with his lips. He felt her hands beat ineffectually against his chest before, with a little moan, she capitulated.

of the letter had changed her mind about staying with Jonathan, and before leaving home, she'd slipped a nightdress and toothbrush into her bag. As Richard said, he wouldn't mind, and it would save her going home to the empty house.

However, it was only two-thirty and he wouldn't be back till six, and although she had a key to the flat, the prospect of waiting there alone was not tempting. But nor, on this cold, damp day, was the thought of trailing round the shops for more than three hours.

She started to walk slowly along Carrington Street and paused again on the corner. Oh God, if only there was someone she could talk to!

"Natasha! What are you doing here?"

She spun round to see Mark Aston smiling down at her.

"You were miles away, weren't you? Surely it's a bit cold for daydreaming?"

"Oh, Mark!" she exclaimed, "I *am* glad to see you!"

"And I you," he replied, surprised by her fervency.

The humiliating colour flooded her face. "I'm sorry, I—"

"Don't be. Are you Christmas shopping?"

"No, I've – been to the police station."

He said quickly, "Something wrong?"

"Richard's had a poison pen letter, but he's not here – he's gone up to Manchester. I – didn't know what to do."

The familiar protectiveness rose in him. "How rotten for you. Look, you're shivering; let's find somewhere warm to sit, and you can tell me about it."

His kindness was her undoing. To her horror, tears rushed into her eyes and started pouring down her cheeks. "Oh God," she gasped. "I'm sorry. I'm so sorry – people will wonder—"

she asked fearfully. "And that they'll try again? Will they know he's gone to Manchester?"

"I very much doubt it. Has he received letters like this before?"

"Once or twice," she said reluctantly, "when he was in business. He threw them in the fire."

"What did they say?"

She flushed. "Similar things – that he'd cheated someone and they'd be taking their revenge."

"And were the threats ever carried out?"

"No."

"Believe me, they seldom are. But if you're nervous, perhaps there's someone who could stay with you while he's away?"

"My husband suggested I go to my son's for the night. He has a flat in Oakacre."

"Very sensible."

Webb looked down at the sheet in his hand. It wasn't the usual type of anonymous letter; though the writing was uneven, it seemed deliberately so, and it was his guess that an educated person had written it. The apostrophes were in the right places, even the correct usage of 'might' instead of the more common and slapdash 'may' pointed to that.

He disliked anonymous letters on principle – they were always the work of cowards – but he didn't believe she was in danger; nor, for that matter, her husband either. The purpose of such letters was to get the writers' grievance off their chests and alarm the recipients, but they seldom went further.

"Try to put it out of your mind," he advised her, "and in the meantime we'll do our best to get to the bottom of it."

Out on the pavement, Natasha stood irresolute. The arrival

He collected Jackson on his way through the outer office, and they emerged together from the security door into the foyer. Natasha Vine stood by the desk, gripping a large handbag in both hands. Webb wondered fancifully if she had a bomb in it.

"Good afternoon, Mrs Vine. You wanted to see me?"

"Oh – yes, yes, I did. I mean, do."

"Let's go and sit down then," he suggested, leading the way to the interview room where they'd spoken to the reporter. "You've remembered something about the other evening?" he asked hopefully, but she shook her head.

"No, it's not that." She drew a deep, steadying breath. "My husband left early this morning, to fly up to Manchester. He was expecting a cheque in the post, and asked if I'd pay it straight into his account. He – he thought the company concerned might be going bankrupt."

"Yes?" Webb said encouragingly.

"Well, there wasn't an early delivery, but a letter came for him at midday, so I opened it." She took a buff-coloured envelope out of her bag and held it out to him. "You'd better read it for yourself."

Webb wrapped a handkerchief round his fingers and took it from her. 'You're a dirty, lying cheat, Vine,' he read in uneven capitals, 'and it's time you got your deserts. You might have escaped last week, but there'll be other chances. Now it's your turn to keep looking over your shoulder.'

It was, of course, unsigned. Webb looked up, meeting the woman's frightened eyes. "How very unpleasant," he said. "You did the right thing bringing it in, Mrs Vine. We'll do tests on it and see what we come up with. With luck, we might get a DNA sample from the stamp or the gum of the envelope."

"But does it mean they were after Richard all the time?"

information as possible from and about those who'd been at the reception, but the multiplicity of Richard Vines made them difficult reading. At first glance, though, it seemed that everyone who stated where he or she had been at the given time (while the minibus was waiting at the Grange) was able to supply another name as corroborator – 'I was talking to Richard Vine from Reading – or Cheltenham – or Stratford – or Bristol'.

No one could say whether any of their number had slipped out between the time when Vine announced the bus's arrival and when the doomed passengers left in a group. And none of them, naturally, volunteered any information which might have led to themselves being the target of an attack.

One or two had asked for police protection, but that would not be sanctioned unless events took a more serious turn.

The staff at the Grange, both those present on Saturday and the remainder who'd been off-duty, had also been exhaustively interviewed. No one admitted being at the front of the building while the empty minibus stood awaiting its passengers.

Although, Webb reminded himself, it had also been left unattended outside the driver's house. Wicks had confirmed that even if the damage had been done there, the fluid would have been escaping so slowly that the brakes would have been unlikely to fail until harsh braking on the steep slope used up all the reserve.

It was two o'clock, and Webb had just returned from lunch at the Brown Bear, when the station sergeant phoned to say a Mrs Vine was at the desk asking for him.

"Thanks, Andy, I'll come down."

83

Six

Mark sat at the desk in his room, the group's short stories in a neat pile in front of him. Today, they were going to discuss Erica Mann's offering, and he admitted to being disturbed by it.

From a literary viewpoint, the writing was undisciplined – passages of flowery prose divided by clumsy, unnatural dialogue – but that was common enough among novices and could be corrected. It was the plot that worried him, dealing as it did with the death of an old man, a difficult subject even in skilful hands. In Erica's, it veered between the maudlin and the sordid, and made uncomfortable reading. He wondered fleetingly what a psychiatrist would make of it.

Still, he was the tutor, and it was up to him to consider the story dispassionately on its merits, and that he would attempt to do. After which, he thought with a smile, gathering up the manuscripts, he would have more than earned the free afternoon which lay ahead.

The pile of completed questionnaires lay on Webb's desk. Local police forces had distributed the forms both to survivors of the ill-fated gathering and to the victims' relatives, and now most of them had been returned.

The official questions were designed to extract as much

82

Silence.

"Hello? This is Richard Vine. Who's that?"

No one responded and his breathing began to quicken. "Are you there?" he demanded stridently. "What do you want?"

After a moment, there was the sound of the connection being cut. Richard's hand was slippery with sweat. Rapidly he punched out the numbers 1471, but the metallic voice in his ear was no help.

"The caller withheld their number. Please hang up."

"Damn!" he said aloud, and, crashing the phone down, went to pour himself another whisky.

A wrong number, for God's sake, he told himself edgily, that's all it was. And then: so why didn't they say so? As to the withheld number, there was nothing necessarily sinister about it; several of his friends, for various reasons, withheld theirs.

He frowned, trying to remember exactly *which* of his friends. Was it possible that they—?

If he wasn't careful, he'd become paranoid. Swallowing the drink in one gulp, he set down the glass and went up to bed.

caught. Quite apart from our personal vulnerability with this madman on the loose, having the police nosing around the Grange isn't doing our reputation any good. Heaven knows how the people at the Writing School are reacting to all this."

The Writing School. Natasha's thoughts went to Mark and the afternoon they'd spent together, remembering how relaxed and at ease she'd felt in his company. It was too bad that his visits to the Grange were so brief; she'd have liked him for a friend.

Richard had developed the habit of sitting down with a whisky when Natasha went to bed, and either reading or watching television for an hour. They seldom made love these days; it was Julia who satisfied his needs in that direction, and he wondered impatiently how long her husband would be at home. Perhaps by the weekend he'd be off on his travels again.

He leant his head back, staring up at the shadowed ceiling. It would do him good to get away for a couple of days; the horror and guilt of the crash was ever present just below the surface, and filled his nights with disturbing dreams.

Had he himself been an intended victim? It was an unpleasant thought, and he sifted through the names of those who, over the years, might have wished him ill. There were, he acknowledged, quite a number of them, but none of recent vintage. Surely no one would have nursed a grudge for ten years without making a move?

The telephone rang suddenly in the still room, and his eyes went to the clock on the mantel. Eleven-thirty. Whoever could be ringing at this hour?

He picked up the receiver and said brusquely, "Richard Vine."

while I remember, would you pack my case tonight? I have to be away by seven, for the eight-thirty shuttle."

She seized gratefully on the change of subject. "Will you want a lift to the airport?"

"No, thanks; I've a couple of calls to make on the way home, so I'll need the car. It'll be all right in the long-term car park."

She nodded, and after a moment remarked, "The police were here again today."

"I did warn you. Were you able to give them any help?"

"Not really."

"I can't say I'm surprised, since you were in one of your blue funks that evening. You looked as if you'd been flung in the lions' den – God knows what everyone thought."

She said tightly, "You should have brought Julia in to act as your hostess. She wouldn't have disgraced you."

He flung her a startled look, but her eyes were on her soup.

"Julia's responsibilities end at five-thirty," he said stiffly. "It's the wife's duty, not the secretary's, to accompany her husband to social functions."

"You sound like a Victorian *pater familias*," Natasha retorted, and saw that she'd surprised him.

They finished the soup, she removed their plates and brought in the next course. As she set it down, he said, "Are the police making any progress, did you gather?"

"They didn't volunteer anything, except that the woman in hospital is off the danger list."

"Well, thank God for that, at least. I'll have her moved to a private room as soon as she's well enough. Perhaps by the time I get back from Manchester, she'll be able to receive non-family visitors." He poured some more wine. "And I sincerely hope that by then, the perpetrator will have been

"Christmas?" She looked at him blankly, and he laughed.

"Sorry; the pub where we had lunch thinks it's just around the corner. It must be catching." He paused. "And talking of lunch, it seems an awfully long time ago!"

"Point taken," Hannah smiled, setting down her glass. "Come on, you look as though you could do with a plate of hotpot!"

Only too happy to comply, Webb followed her into the dining-room.

"Did Mrs Payne iron my dress shirt?" Richard Vine asked abruptly, as Natasha set a bowl of steaming bortsch in front of him.

"Yes, of course, but – you're not still going to Manchester, surely?"

"Of course I'm going; why shouldn't I?"

"Well, I just thought, in the circumstances . . ."

"What good would my hanging round here do any-one? Besides, it's been arranged for months." He glanced shrewdly at his wife, guessing what was on her mind. "Are you nervous about being alone in the house overnight?"

Natasha seated herself and passed him the sour cream. "No, of course not." But her voice wavered a little.

"Get Jonathan to come up," he said briskly, picking up his soup spoon. "Or, if you prefer, stay the night at his flat."

"Oh, I couldn't do that," she demurred, flushing.

"Why ever not?" Noting her heightened colour, he gave a brief laugh. "Because of the girlfriend? Good lord, it wouldn't worry them. In any case, you'd be conveniently out of their way on the sofa."

Natasha's colour deepened. "No, really, I'll be all right."

"*I* know that, it's you who didn't seem sure. Oh, and

"I heard about the crash not being accidental," Hannah said, when they were seated by the fire. "It's totally – unbelievable."

"Yes. How are the girls coping?"

"Numb with shock, poor loves. It's been one blow on top of another. Who could have wanted to hurt the Vines, I can't imagine. They were a charming couple, with a wide circle of friends."

Webb said heavily, "Which will probably be the verdict on all eleven of them. From the questionnaires we've had back from relatives, it has been so far."

"Then it's all the more inexplicable. Are you *sure* it couldn't have been an accident?"

"My love, all four bleed nipples had been loosened – one behind each wheel. The bus had been serviced only the previous week, and there's no way they could have come loose unaided."

"Could it have been simply vandalism, then, a nasty trick going badly wrong?"

"I suppose it's just possible, though anyone with enough knowledge to loosen the screws should have been aware of the consequences."

She sighed. "I suppose so. Do you think they were after the local Richard Vine?"

"Quite possibly; the murderer might have thought he'd be on the minibus, but what about the rest of them? It was, if you'll forgive the pun, overkill by anyone's reckoning." He leant forward to top up her glass. "Now, do you think we could change the subject?"

"Yes, of course; I'm sorry."

"I was wondering about Christmas; will you be spending it with Charlotte this year, or is there a chance of our going away?"

"David – you're coming for supper?" There was, he thought, a note of excitement in her voice.

"I'd love to; I've had one hell of a day."

"Not been out in the fog, have you?"

"Down in Heatherton, for our sins. The journey back was a nightmare."

"Poor love. Well, come whenever you're ready."

He had a quick wash, changed into casual clothes, and went downstairs.

"You must be telepathic," he greeted her. "If I could have chosen—" He broke off as his eyes fell on the bottle of champagne waiting in an ice bucket, and turned to meet her smiling face.

"I thought you sounded cock-a-hoop on the phone. What are we celebrating?"

"You are looking at the future head of Ashbourne School for Girls!" she told him. "It was confirmed today."

"Hannah, that's wonderful!" He caught hold of her and hugged her. "Congratulations! You certainly deserve it!"

"I was invited to lunch with Gwen and the governors on Monday, and fairly put through my paces. My fingers have been crossed ever since, and I heard this morning that I'd got it. Gwen's delighted, bless her; she says she can now go to Canada with a clear conscience! We're going out to celebrate tomorrow, with Dilys and Monica."

"Well, I needed cheering up this evening, and you've certainly hit the jackpot. Want me to open the bottle?"

"Please." She watched him while he unfastened the wire round the stopper and twisted the bottle free of it. There was a satisfying pop and he directed the foaming liquid into the glasses.

"Here's to a long and successful career!" Webb toasted, and they raised their glasses to each other.

the police station, and as an early darkness fell it became impenetrable.

Webb sat morosely silent, lost in his thoughts. In the canteen, they'd run into DI Stanley Bates, who had worked with him on a case some years ago, and about whom he still felt uncomfortable. He'd not cared for Bates, becoming increasingly impatient with his continual resort to indigestion tablets. Then the man had collapsed on the job with a perforated ulcer and was rushed to hospital, leaving Webb with a resentful feeling of guilt.

Today, Bates had greeted him with the remembered oiliness which resurrected both his distaste and his bad conscience, and as a result he'd over-compensated with hearty friendliness. No wonder he'd caught Ken's puzzled eyes on him more than once.

Jackson himself was creeping cautiously along, his fog lamps almost useless, making what use he could of the nearside hedgerows as a less than reliable guideline. The end result was that a journey normally lasting just over an hour took almost twice as long, and both men were feeling the strain when the car finally drew up at Beechcroft Mansions and Webb thankfully got out.

"Well done, Ken. Have a stiff drink when you get in – I intend to!"

Jackson gave him a tired grin. "See you in the morning, Guv."

Webb let himself into the house and took the lift up to his flat on the top floor. He found a note lying just inside the door, and stooped to pick it up.

'There's Lancashire hotpot in the oven,' he read in Hannah's writing. 'If you'd like to join me, give me a ring when you get in.'

He picked up the phone before even taking off his coat.

their orders. His smile slipped only momentarily when Webb produced his warrant card.

"Do the men from the bakery up the road come here?" he asked. The barman agreed that they did.

"Know their names, do you?"

"Some of them," he answered cagily.

"Remember a John Bainbridge? About two years, it must be, since he was in these parts."

The barman shook his head. "Before my time, mate. I've only worked here since September."

"Never mind, it was worth a try." Webb ordered cottage pie for himself and burger and chips for Jackson, and they took their beers to a corner table.

"What a soul-destroying place," Webb commented. "Remind me not to come here again."

He did, however, mitigate his verdict later, since the food was surprisingly good, and they emerged from the pub well fortified to continue their enquiries.

The Bainbridges' previous home was a semi-detached house on an estate to the north of town, but their visit proved unproductive; there was no reply to their knocks, at either the house itself, those on each side, or that directly opposite.

"Probably all the women are at work," Jackson opined. "Not likely to be back till the kids come out of school."

Webb turned up his coat collar. "Well, we're not hanging around that long. We'll look in at the station to put them in the picture – and with luck scrounge a cup of tea – then we'll head for home."

The man at the bakery was right; the fog which had been hovering all day was already thickening when they left

window. "And you've a long drive ahead of you, gentlemen. Watch how you go."

"When would be the best time to catch them all together?"

"Normally between three and four, when they return from their rounds. They meet in the canteen for a cuppa before going home. But they'll be lucky to be back much before six today."

"Right, thanks. We might call in again, then."

"You're welcome any time," the manager assured them, standing up with them. "And do please give my condolences to Annie and the kids."

Webb and Jackson walked back to the car in silence but as he fastened his seat belt, Webb said, "You've got their old address on you, haven't you?"

"Yes, Guv."

"We'd better go and see their neighbours while we're here, be told yet again what a wonderful bloke he was. Still, we'll have lunch first. Stop at the first pub you come to, Ken; with luck it'll be the one the lads from the bakery use."

The Cat and Fiddle, some hundred yards down the road, had recently been modernised. It now boasted an outdoor play area complete with bouncy castle looming out of the mist, and, inside, a family room, where two small boys were chasing each other between the tables while a baby wailed in a pushchair.

The bar itself was all bright lights and fruit machines, to Webb's mind totally devoid of atmosphere. Moreover, there was an artificial Christmas tree, and streamers hung from the ceiling, which increased his irritation. It was only the second week in November.

Behind the bar, a determinedly cheerful barman took

that. And John Bainbridge wasn't even a Vine, poor devil."

"Perhaps," said Jackson, "he was considered expendable."

They were approaching Heatherton now and a few fringe-of-town shops began to appear along the road. Webb sat forward.

"The bakery should be along here somewhere, on the right. Yep, there it is, that cluster of buildings behind the wall. There's the sign – Cottage Bakeries. Pull in here, Ken; there's room behind that delivery van."

The office manager remembered Bainbridge well and was horrified to hear of his death. "I read about the crash, of course, but I'd no idea John was involved. That *is* dreadful; he was such a nice man – would put himself out for anyone."

"Had he any particular friends among the lads?" Webb fished.

"Not really; they all got on well together."

"Are the rest of them still here?"

"All except Doug Leyton; he left about a year after John. Family problems."

"Any idea where he went?"

"Steeple Bayliss, I think. He wrote asking for a reference. I could look it up, if you like."

"It'd be helpful," Webb said, and waited while the man went to a cabinet and flicked through some files.

"Yes, here we are. His home address is number nine Down Close, phone number SB 84321."

"Thanks. Any of the men around at the moment?"

"No, they won't be back till late afternoon. There was thick fog here this morning, so they were late starting out. Shouldn't be surprised if it comes down again tonight, either," he added, looking at the whiteness outside his

had warned him, nothing remotely pertinent was said. Webb reluctantly had to agree with him that the tape was useless.

"Let's leave the Vines for the moment," he said to Jackson, "and consider John Bainbridge. Ridley and Carter had no luck at the coach firm, and I reckon we've got all we can out of the wife, so we'll take a drive down to Heatherton and sniff around there. I've a feeling the roots to all this lie in the past somewhere."

It was a grey, misty morning – not, in Jackson's eyes, the ideal weather to embark on a forty-mile drive cross-country on what, in any case, was likely to prove a wild-goose chase. However, his not to reason why. He set off stoically, Webb silent at his side, taking the Heatherton turning just short of the town of Erlesborough.

"I'm damned if I can think of any feasible motive," Webb said eventually, staring moodily out at the blurred landscape. "It's the number that's the stumbling block, all the time. Could someone conceivably have something against all eleven of them? And how, when there was no unifying factor except their names?"

"Perhaps it was a serial killer with a difference," Jackson suggested, his eyes on the road. "If he had a name fetish, it might have seemed a golden opportunity."

"A name fetish?" Webb repeated incredulously. "Good God, Ken, where did you dream that up?"

"Suppose someone called Richard Vine had done this bloke a terrible wrong, so he decided to take out as many of them as he could?"

"It would still, as I said earlier, have been more profitable to have thrown a bomb into the Grange – that way he'd have got about twenty. How the devil did he know about the minibus, anyway? We keep coming back to

71

And by that time, it would have been too late for anyone to do anything."

"On the contrary," Webb corrected him. "That's exactly when we're assuming the damage was done. The driver left the bus unattended at least twice during that short time."

Ricky looked startled. "It wouldn't have taken much fiddling, then?"

"No; using a special spanner – which is widely available – the screws could have been loosened in seconds."

"So it was premeditated?"

"No question." Webb paused. "Did you speak to everybody?"

"Oh yes, I made sure of that; I'm supposed to be writing an article – or are you putting the kibosh on it?" Webb shook his head, and Ricky went on, "We spent most of the time, though, with Richard and Sue. They were nearer our age than the others, and we got on really well. And now," he added soberly, "he's dead and she's in Intensive Care. Debbie, my girlfriend, is really cut up about it."

Webb nodded sympathetically. "And you can't think of anything that was said – anything at all – which could have a bearing on what happened?"

"Absolutely not. We've played the tape over and over—"

"You've a recording?" Webb interrupted.

"Yes, for the article. I've brought it with me, but the quality's not good, because of all the noise going on." He put a cassette down on the table.

"That's very good of you," Webb said, picking it up. "I'll see you get it back as soon as possible."

But although each interviewee was identified, the abundance of Richard Vines combined with the background noise merely added to the confusion, and as the reporter

all along, in a prime position to gauge local reaction. Was there any interest in the event, would you say, among the general public?"

Ricky shook his head. "Not that I noticed. I did a small piece about it last week, but there wasn't much comeback." He hesitated. "He's not very popular, you know, Mr Vine. Sold out his business interests some years ago at enormous profit, and quite a lot of people went under. So there were the odd snide remarks."

Webb leaned forward. "Who made these remarks? Can you give us any names?"

"Afraid not," Ricky said apologetically, "it was just what I heard in the pub." He frowned. "But why the interest in Vine? Surely you don't—"

"We're looking into everyone who was there that night. Any of you could have done it, you know."

Ricky Vine frowned, then shook his head vigorously. "You wouldn't think that if you'd met them, Mr Webb. I'd stake my life none of the guests had anything to do with it. Damn it, they didn't even *know* each other – why would they want to kill them?"

"*As far as we know*, they didn't know each other," Webb conceded. "For instance, some of the couples could have been related."

"No, Mr Vine checked that at the start of the evening."

Webb sat back in his chair, tapping his pen on the table. "Was it general knowledge which couples had arrived in the minibus?"

Ricky shrugged. "It could have come up in conversation. If they said they came from London or wherever, they might have added that they'd got the train down. Otherwise it would only have been at the end, when Mr Vine called out that the bus had arrived and they went to get their things.

Webb finished for him. "No, it doesn't, but a lot of water's gone under the bridge, all the same."

Ricky Vine was an earnest young man in horn-rimmed spectacles, patently eager to be of whatever help he could.

"Before we start on the reception," Webb began, when they were all seated in the interview room, "have you, in your reporting capacity, had any previous dealings with Richard Vine?"

Ricky shook his head. "I'd heard plenty about him, of course, but I'd never met him. His activities don't normally come into the sphere I write about."

"So you were surprised when he contacted you?"

"Very, till he explained what it was all about. He asked if I was prepared to give him a bit of publicity which might rub off on the Grange, and filled me in with some of its background."

"Did you meet at that stage?"

"No, it was all done over the phone. We didn't come face to face till Saturday evening."

"And did your impression of him change?"

"I purposely hadn't prejudged him, I like to make up my own mind. He was pleasant enough, but I can't say I took to him. He didn't strike me as sincere, somehow."

Webb nodded thoughtfully. "You're in a unique position, you see, having known about the get-together from the beginning. In fact, if it hadn't been for you and that student— Hang on! The student, Richard Vine – he's not one of the mob up there at the moment, is he?"

"No, he'd been at the Grange on a business course. I had quite a long chat with him."

"Right. Well, as I was saying, you've been on the spot

Five

The next morning, for the first time, there was guarded optimism from the hospital: Sue Vine had briefly regained consciousness, and it was hoped it might be possible to interview her within the next day or so.

By nine o'clock Webb was on the phone to Michael Romilly, editor of the local *Broadshire News*.

"This lad Ricky Vine," he began, when they'd exchanged pleasantries, "where can I track him down?"

"He's here at the moment, writing up a report," Romilly said. "Want me to send him over?"

"That would certainly save time," Webb said gratefully. "Thanks, Mike." He paused. "How are Kate and Josh?"

"Fine, fine. Did I tell you Josh is playing for St Benedict's under-fifteens?"

"Great – congratulate him for me. Perhaps one of these days I'll get down to watch a game.

"Young Josh Romilly's growing up," he remarked to DI Crombie as he put down the phone. "Playing rugby for the school, no less. He must be about twelve now."

Crombie looked up from his desk. "Seems no time, does it, since Mike and Kate went through that sticky patch, and she took off for Broadminster with the kid."

"And got mixed up in the Delilah murders for her pains,"

His wife made an instinctive movement of protest but Marshall, oblivious of undercurrents, was already answering. "Didn't get the chance, unfortunately. I only arrived back yesterday from a long-haul flight to Singapore. I'm a commercial pilot," he added, seeing their surprise.

Away for conveniently long periods, no doubt, noted Webb's devious mind. Looking at the lovely young woman in front of him and remembering the self-effacing Mrs Vine, it wasn't too difficult to put two and two together. Which could mean that not all the resentments against Vine lay safely in the past.

"Must be an interesting job," he said, and, nodding at Jackson, stood up. They'd get no more out of her today. Not that it was any of his business if she was sleeping with her boss, except that it would give this jovial-seeming husband of hers a legitimate cause for antagonism. Though by the look of him, he didn't seem to be harbouring suspicions any more than Mrs Vine did.

Julia Marshall, tight-lipped, saw them to the door.

"Thanks, Mrs Marshall, we'll be in touch again."

And, going down the path with Jackson, Webb smiled to himself at the sharp, angry little sound of the closing door.

they'd be paying a call on him first thing in the morning, or his name wasn't Ken Jackson.

"How long have you been working for Mr Vine, Mrs Marshall?"

She glanced at Webb quickly, momentarily disconcerted by the change of direction. "Four years now. It's amazing how the time goes."

"I do realise the confidential nature of your work, but is there anything to your knowledge that might have made him the butt of any attack?"

That shook her. "Good heavens, no!"

"No one even had a bad word to say about him?" queried Webb with lifted brow.

She flushed angrily. "That's not what I meant. Successful men always arouse hostility, Mr Webb, as I'm sure you know. Mr Vine has had his share, people who resent his money and his position."

"Can you name any?"

"I can't, as it happens." She held his gaze.

And wouldn't if she could, Webb thought. Ten to one she was in love with the man. His mind went to the husband who was listening to the news, and as if by telepathy the door opened and he stood there staring at them, a large, broad-faced man with a shock of curly, greying hair.

"Julia?" he said. "What's happening?"

"These men are detectives, darling," she answered quickly. "Mr Webb and – and Sergeant Jackson. My husband, Robert Marshall."

The man nodded at them. "About the minibus, is it? Shocking business."

"It is indeed, Mr Marshall," Webb said easily. "You didn't by any chance take a walk up there yourself at the weekend?"

65

confusion. The Anne Vines had intended coming down on Friday, spending the weekend at home, and making their own way to the Grange. But at the last minute a meeting was arranged on Friday evening which Mr Vine had to attend, so his wife phoned to ask if they could be included in the train party." Julia looked down at her clasped hands. "But for that meeting, they at least would still be alive."

"Did you discuss the reception with anyone? Your husband, perhaps, or your friends?"

"There was no secret about it," she said, instantly defensive. "It had even been in the paper."

Webb waited, and after a minute's silence she went on, "I did mention it, of course; it was quite a talking point. People were intrigued to hear how we'd tracked them all down."

"And how had you?"

"Oh, telephone directories, election registers, word of mouth sometimes. It all just snowballed, but Mr Vine decided to call a halt at twenty."

"Did that twenty include himself?"

"No, there were twenty couples apart from him and Mrs Vine – forty guests."

"What percentage of them were married?"

"Oh, much the majority. I think there were four couples who weren't, one of whom was the *News* reporter and his girlfriend."

"Was there any hesitancy when you first approached them, an unwillingness to take part?"

"Far from it – everyone was intrigued at the idea."

"No hint that perhaps some would prefer to take a back seat, not be interviewed or have their photographs taken?"

"No, nothing like that. In fact, Mr Vine was saying this morning that they were all chatting to the reporter."

Which meant, Jackson thought, busy scribbling, that

Julia Marshall opened the door to them wearing an apron and with a spatula in her hand. She seemed, Webb thought with satisfaction, taken aback to see them.

"Oh – Mr Webb, isn't it? What can I do for you?"

"We'd like a word, Mrs Marshall, if it's convenient."

Patently it wasn't, but she could hardly say so. "Please come in," she said, the professional secretary overcoming the wife's irritation.

The hall was large and warm and homely, with a bright red carpet and modern prints on the wall. From the room on the left came the sound of the television news. She showed them into an empty dining-room, in which, noticeably, the heating had not been switched on, excused herself briefly, and returned without the apron and spatula.

"Sorry about the chill," she said, switching on the radiator. "It'll soon warm up."

"Mrs Marshall, I believe it was you who contacted the guests, and later corresponded with them, sorted out travel arrangements and so on?"

"Yes," she answered. She'd changed out of the neat suit she'd been wearing that morning into narrow, coffee-coloured trousers and a pale blue sweater which matched her eyes. Before he could stop himself, Jackson thought how attractive she looked.

"Did you meet any of them personally?"

"No, I wasn't at the reception. It was a social rather than a business engagement."

"Did you speak to them on the phone, then?"

"One or two of them. The Anne Vines actually lived in Shillingham, and—"

"The Anne Vines?" Webb repeated.

"Sorry; with all the gentlemen being called Richard, we referred to the couples by the wives' names, to avoid

"But that would have drawn attention to her, *proved* she saw something," Betty insisted stubbornly.

Myrtle surveyed herself in the full-length mirror. "Then she'd have told the police. Mind you, *someone* might have seen something without realising – one of the staff, say, who was on duty that night. No doubt that's why the police are still ferreting around. When are you going to stop fiddling with your hair and get dressed?" she added, without a change in tone. "The bar will be open by now."

"And where did you get to this afternoon?"

Mark turned from the bar in the tutors' lounge to meet Angelique's smilingly questioning eyes. She looked delectable, he had to admit, gold hair shining, pretty face flawlessly made-up, and wearing what was surely a designer dress. He had a brief mental picture of Natasha Vine as she'd been that afternoon, her bobbed hair damp and wind-tossed and a smudge of mud on her nose.

"Angelique," he greeted her smoothly. "What can I get you to drink?"

"G and T, please, darling." She slipped an arm through his and her scent brought a tweak of remembered desire. "I'd hoped we could have had an hour or two all to ourselves," she murmured.

"I'm sorry, I had to go out." I must be mad! he thought, aware of the envious glances cast in his direction.

"No matter," she said complacently, "there'll be other times."

He smiled non-committally, handing her her glass, and turned with relief as the evening's speaker came into the room, accompanied by the appointed host and hostess, and ending any chance of private conversation.

* * *

She decided that it was; he cared about his characters, was concerned for them, and though some were overtaken by violence, he treated them with compassion.

She looked at her watch. "I really should be going; Richard will be back soon, and he'll wonder where I am."

"Of course; I'll get the bill."

They talked sporadically on the return journey, and Mark dropped her off at her gate. "We must do it again," he said in response to her thanks, and as he continued the few hundred yards to the Grange, realised that the phrase hadn't been mere convention. He'd enjoyed Natasha Vine's company, and that sudden, mischievous smile had startled him, showing him a side to her he had never suspected and which he'd like to explore further. Yes, if he got the chance, he'd try to arrange another meeting.

Mark was not alone in wondering about Erica's reaction to the crash. Betty and Myrtle discussed it in their room that evening as they prepared for dinner.

"She went as white as a sheet, did you notice?" Betty said, trying inexpertly to coax her straggly locks round the hot brush.

Myrtle snorted. "That's not saying much; she's *always* as white as a sheet. Looks as though she's going to jump out of her skin any minute."

"But perhaps it's because she saw someone tinkering with the minibus, and he knows she saw him! Or if not actually tinkering, at least in the vicinity of it."

"Don't be silly, Betty," Myrtle said impatiently. "She wasn't here, was she? None of us were. Anyway, if that was the case, she'd hardly have stayed for the School, she'd have scuttled off home."

In point of fact, he was not too happy about one of them, the woman, Erica Mann. She gave the impression of a tightly coiled spring, ready to fly apart at any moment, and when this morning all the talk was of the crash being murder, he'd thought she was going to faint. Later, she'd explained it had brought back her brother's death in a driving accident, which was reasonable enough. All the same, if the crash hadn't happened before any of them arrived, he'd have wondered if she'd seen something.

Natasha was aware of his reticence and respected it. She shouldn't have tried to pump him, she chided herself; but she felt so comfortable in his company, she'd spoken without thinking.

Now, taking advantage of his preoccupation, she studied him closely for the first time. At a guess a few years younger than herself, he had an interesting face, lean and intelligent, the cheekbones slightly hollowed, the mouth sensitive. As she knew from their previous meeting, he was a kind man as well as a clever one – qualities that were not compatible in Richard.

Mark looked up, meeting her gaze, and she said quickly, "I read one of your books."

He lifted an eyebrow. "I'm flattered; which one?"

"I can't remember the title. About the man who went to Colombia and fell in love with a woman involved in the drug trade."

"Ah yes. Dare I ask if you enjoyed it?"

Natasha smiled, looking suddenly years younger. "Of course, or I shouldn't have mentioned it!"

She had, in fact, picked it off a library shelf soon after the greenhouse episode; in some confused way, she'd wanted to prolong the association, to see whether the innate kindness she'd sensed in the man was carried into his work.

"Come along and find out!"

She gave a spurt of laughter. "You'd have an uphill task turning me into a writer. I'm all right with my hands – cooking, gardening, and so on – but I never attempt so much as a letter unless I'm forced to. Julia said the same people apply year after year; however do you think of something new to say?"

"That's my main worry," he admitted. "But to answer your first question, they bring a short story with them, maximum two thousand words. During the week, we go through each one, making suggestions, seeing how improvements could be made, helping them to look at it from different angles. By the end of the week, if we're lucky, all the stories should be marketable."

"That's wonderful – it must give you a great sense of achievement."

"Except," he said wryly, "that they don't put what they've learned into practice once they get home. Which means they continue making the same mistakes, and most of the stories remain unpolished and, alas, unpublished."

"Oh dear. You obviously know them all pretty well by now."

"The regulars, yes, though new faces appear from time to time; which is just as well, as it leavens the group. We have two this week, as it happens."

"And do they show any promise?"

"I've barely had time to judge; they never volunteer much till they've settled in a bit. It's understandable – some of the others are pretty vociferous."

Mark stirred his tea reflectively. He had, of course, formed his first impressions, but they were not for handing casually on to the proprietor's wife, however pleasant she might be.

to circulate, but I couldn't tell you which of that sea of faces belonged to those who were killed, and I'm glad I can't. Isn't that cowardly?"

"It's very natural. But if it's such an ordeal for you, why did you go? Surely you could have found an excuse?"

She shook her head. "Richard has no patience with what he calls my foibles. He says they're ridiculous in a woman my age, and he's right."

There was an awkward pause as each of them remembered the circumstances of their last meeting.

"Mrs Vine—"

"Natasha, please."

"And I'm Mark. Natasha, then; I realise it's none of my business, but things *are* all right between you, aren't they?"

"Yes, they're all right," she said flatly.

"I'm sorry – I'm not trying to pry, it's just that I couldn't forget seeing you like that. I kept feeling I should have done something."

"Nothing needed doing," she said. "As I told you, that was the first time he'd hit me, and it hasn't happened since."

"Thank goodness."

She added quietly, "It's kind of you to be concerned, but really, you needn't be."

"Fine, then we can change the subject. Where do you suggest we go for tea?"

The conversation became lighter and they both relaxed. Half an hour later, they were seated opposite each other in the Singing Kettle, grateful for its light and warmth after the darkening streets outside.

"What do you actually do on your course?" Natasha asked, as the promised teacake, oozing butter, was placed before her. "I've often wondered."

to her feet and gesturing at the small rosemary bush, newly planted in the muddy soil. "I dug it out of the garden."

"Rosemary for remembrance," he said. "A nice thought. Have you finished?"

"Yes." She stood up, dusting some scraps of mud off her trousers, though the newspaper she'd been kneeling on had for the most part protected them.

"Then," he said, entirely on impulse, "how about coming for a cup of tea and a toasted teacake?"

"Like this? I look like a tramp!"

"Nonsense, you're fine. Put the newspaper and spade in the boot – it's unlocked – then you can wipe your hands on a freshener pad. There are some in the glove compartment." She was still hesitating, and he added coaxingly, "It would do you good to get right away from here for a bit."

"All right!" Natasha said, surprising herself. "Thanks, I'd love to."

"Shillingham or Lethbridge?" he asked, as she climbed in beside him. "You decide. They're equidistant, aren't they?"

"Just about. Lethbridge, then; the parking's easier."

"Fine."

They reached the main road at the bottom of the hill, and as he turned right, away from Shillingham, he glanced sideways at her. "This must have come as an awful shock for you."

"It's terrible," she said, a quiver in her voice. "They were all so *alive*, talking and drinking and laughing. And then, immediately afterwards, finito."

"You hadn't met any of them before?"

"No, and I hate parties at the best of times. I loathe having to make conversation with people I don't know – I go all stiff and awkward, which embarrasses them. I did my best

of anything else. Murder, and right on their doorstep! What writer could resist it?

He envisaged a host of similar stories hitting the market over the next few months, and wondered, with a grim smile, whether any of their authors would stumble on the true motive.

But there was a second, less explicable, reason for his escape: to avoid the attentions of Angelique Bertram, the course leader of the romantic novels group.

They'd met here last year, when she'd made no secret of her interest in him, and he'd been content to play along. It had, in fact, been quite enjoyable, since she was a practised and innovative lover. Since then, there'd been no contact between them, partly because neither had taken the liaison seriously and partly because the Autumn School was the only one she attended.

Now, however, she was clearly set to resume the relationship, and his unwillingness to comply had surprised him. She was an attractive woman, and since his divorce his sex life had not been so prodigious that he could be blasé about such offers; quite apart from the fact that any reluctance on his part could lead to tensions in the tutors' lounge.

His musings had brought him to the steep incline where the crash had occurred, and he braked instinctively. Below him on the verge, at the point where the bus had left the road, a figure was kneeling on the grass patting the ground, and as he approached more slowly, he saw to his surprise that it was Mrs Vine. She turned as she heard the car approach, and he pulled in beside her.

"Hello!" he said.

"Mr Aston." She was smiling, but he thought she looked strained. "I felt I had to do something," she added, getting

"Here's that piece you wanted from the *News*, Guv," Jackson said, laying it on Webb's desk. "I thought Millie would have it – she keeps the papers for recycling. I gave her a bell and asked her to hand it in at the front desk. Not that there's much in it we didn't know."

Webb, who had opted to do some paperwork prior to calling on Julia Marshall, pulled it towards him. The byline, he saw, was Ricky Vine.

'A human Vineyard comes to Bellingham Grange,' he read. 'Richard Vine, proprietor of the prestigious conference centre at Beckworth, will be giving an unusual party there next Saturday. Twenty men called Richard Vine (including your reporter) have been invited, together with their partners, to attend a reception to celebrate their joint name. Mr Vine tells me that attendees will be coming from as far away as Scotland and the Channel Isles. A full report of the evening will appear in next week's *Weekend News*.

'The Grange, established as a conference centre ten years ago, is going from strength to strength and is booked more or less solidly from one year to the next. Courses on offer vary from—'

Webb looked up. "Singing for his supper," he said.

"Yes. You reckon the killer saw it?"

"Search me. But it does mean the event was common knowledge, in this area at least. We'll keep it on file, and I'll have a word later with this Ricky Vine. An observant young journalist could be useful. Thank Millie from me, will you, Ken?"

Mark Aston felt a surge of relief as the cluster of reporters at the gate fell away behind him. Since learning that the crash had been engineered, no one at the Grange could talk

55

shapes wind-tossed against the pale sky.

When Richard had come back for lunch, he'd told her the reason for the detectives' visit, and she was still numb with shock. Those poor people had not, as she'd thought, died in a terrible accident, but because, unbelievably, someone had wished them dead.

"The police say there's a chance they were after me," he'd added jerkily, pouring himself a stiff whisky. "Not a pleasant thought, is it?"

"But – but why?"

"Revenge for my business methods," he replied, with a twist to his mouth. "That's what they implied, anyway, but who would wait this long? Dammit, it's ten years since I left the rat race."

Even so, Natasha thought, many people had been out of work ever since they'd been made redundant, and more than a few had gone bankrupt. Perhaps despair had built on resentment until something snapped?

"Surely, though, if someone *had* been after you, it would have been easy to get you without killing all the others."

"No doubt. Anyway, everyone's going to be interviewed, including you, so be warned."

She'd looked at him in astonishment. "What could I possibly tell them?"

"You were at the reception, weren't you? You're in it as much as anyone. God, I hope they clear it up soon."

Amen to that, Natasha thought now, in the windy garden. For the sake of all those grieving relatives and that poor woman still fighting for her life in hospital.

She looked about her, considering. Then, making up her mind, picked up the spade and the sheet of newspaper she'd brought out with her and walked briskly across the grass.

* * *

"In view of the windows?"

"Well yes, but it would have been dark, wouldn't it, and the curtains drawn." She frowned suddenly. "Why? You don't think someone came up here to – to fix it?"

"It's possible, that's all."

"But if the screws were loosened as you said, wouldn't he have crashed straight away, before he even got to the Grange? The road's steep enough downhill."

"They were only marginally released, Mrs Bainbridge; it would take repeated braking to make them go, which, of course, they'd get on this road. Harsh braking in particular would do it – if the driver was in a hurry, for instance. And they said at the Grange he was worried they might miss the train."

She didn't make any comment, merely sat with bent head, somehow apart from them in her misery.

"And there wasn't anyone your husband fell out with?" he asked again, though without much hope. "Someone, perhaps, who resented his popularity?"

But as he'd known she would, she stuck to her denial. "No, I told you, there was no one. John would have done anything for anyone, and they knew it."

Webb thought dispiritedly that they would get much the same answer from all the relatives. No one was likely to admit that the dear departed had been anything but squeaky clean. But one of the eleven people on that bus had inspired such a fierce hatred that someone was willing to despatch ten others at the same time, rather than lose the chance of getting even. Which one of them was it?

Natasha Vine stood in the middle of her garden, shivering in the wind. Around her, trees lifted skeletal arms and the air was filled with the cawing of rooks, their ragged black

"It seems so; I'm very sorry." He paused. "I believe you were away last weekend?"

She nodded, still seemingly paralysed with shock. Then she said with an effort, "I took the kids to see Mum. She's still in Heatherton, and misses them now we're up here. So once a month, we go down. If John hasn't anything on he comes with us, but on Saturday he had the two trips booked, to and from the station."

She squeezed her eyes tight shut, and Webb waited while she composed herself, admiring her courage. To give her time, he got up and went to look at a photograph on the television. It was a family group, but it was the man who held his attention. He was seated on a rock, with an arm round each of the children, and he was laughing, his hair blowing in the wind. He looked, Webb thought, an ordinary, decent family man, and now, like his passengers, he was dead. Why?

He turned back to Mrs Bainbridge. "Did you know he brought the minibus back here between trips?"

She blew her nose. "Yes, he told me on the phone."

"When was that?" Webb asked quickly.

"Saturday evening, about six-thirty. He always phoned me at Mum's when we were away, and I rang him as we were leaving, to say when to expect us." Her hands clutched her handkerchief. "But this time, of course, there was no reply."

"What did he say about bringing the bus home?"

"Just that it had seemed silly, driving all the way down to Shillingham and then all the way back again to collect them. So he'd cleared it with the boss, who said it would be all right just this once."

"Where would he have parked it?"

She glanced out of the window. "Just there – where your car is."

52

Her hands clenched, but she said steadily, "Yes; what do you want to know?"

"For a start, how long have you lived here?"

"Two years last September."

"And before that?"

"Down in Heatherton. He was a delivery man for Cottage Bakeries."

"How long was he with them?"

"Oh, ten years or more."

"So why did he leave?"

"He was ready for a change, for one thing, and the kids are growing up. There's not much in the way of secondary schools down there, we thought they'd do better in Shillingham."

"You're quite a way out of Shillingham here."

She smiled slightly. "This cottage belonged to a friend who was moving. We got it cheap, no agents. Anyway, it's nice up here. Hardly any traffic, and safe for the kids to play. And as it happens, it's a bonus being next door to Meg. She's been a good friend."

"The bakery would have been sorry to let him go?"

"Yes; everyone liked John, not only his mates, but the customers as well. He'd a smile and a word for everyone. When he left, they gave him a farewell party at the pub." She looked at them defiantly. "He wasn't to blame for the accident, you know. I won't have anyone saying different. He was an excellent driver – it must have been the bus."

"It was," Webb confirmed quietly, and her eyes widened. "I have to tell you, Mrs Bainbridge, that someone had loosened the bleed valves behind all four wheels."

She gripped the arms of her chair. "It was *deliberate*?" she whispered. "Someone *wanted* to kill them?"

51

car magazines on the floor, which Webb found particularly poignant. It seemed she couldn't bring herself to move them.

He studied her with some concern. Her mid-brown hair was caught back in a ponytail, giving her a youthful appearance though she must have been well into her thirties. Her face was pale but calm, her eyes red-rimmed.

"How are you feeling, Mrs Bainbridge?"

"All right," she said. "Oh—" she looked down at her dressing-gown. "I'm not ill, it's just that I'm on nights at the General. I sleep during the day, while the kids are at school."

"You've gone back to work?" The word 'already' hung in vague accusation on the air, and she flushed.

"Better than sitting by myself watching telly. At least I have company at the hospital, and can do something useful."

"Of course. But have you no relatives who could come and stay for a bit?"

She shrugged. "Mum's offered, and I do need someone here overnight. So far, Meg's eldest from next door has been sleeping here – she's fifteen – but I'll have to make more permanent arrangements. The trouble is, I wouldn't be much company for Mum – asleep all day and out all night, and it'd be lonely for her up here. I get the children ready for bed, then go to work. I'm on duty from eight till eight. John used to give them their breakfast and take turns with Meg to drop them and her three at school on his way to work. This week, she's been doing it. Sorry," she added awkwardly, "I'm not thinking straight; can I get you anything? A cup of tea?"

"No, thanks, we've just had coffee. Do you feel up to talking about your husband, Mrs Bainbridge?"

Four

"Why did you say we hadn't time to see the secretary, Guv?" Jackson asked curiously as they drove up the hill to the Bainbridge house.

"Because, Ken, I'd rather see her in her own surroundings, where she's not wondering if her boss is listening behind the door. Also, she'd have been expecting us now; later, she'll be off her guard. It's always possible in a case like this that she's cherishing some deep hatred towards him – or the other thing, of course. Either way, I don't want any prepared speeches."

As they drew up outside the driver's cottage, they saw that the upstairs curtains were still drawn.

"Reckon she's taken to her bed?" Jackson asked anxiously.

"Whatever, we'll have to disturb her. Nick Jessop said the neighbour was keeping an eye on her."

It was some time before the door was opened, by a bleary-eyed woman in a dressing-gown.

"Mrs Bainbridge?"

She nodded.

"Sorry to disturb you, but could we have a word? Shillingham CID – DCI Webb and Sergeant Jackson."

Still in silence she stood aside for them to enter and gestured towards the front room. There was a pile of

49

"Your secretary's name is Marshall, I think you said, Mr Vine?" Webb commented, as they walked round to the front of the house and their waiting car.

"That's right. Mrs Julia Marshall."

"And her address?"

He frowned. "Why do you need that? Can't you speak to her here?"

"We haven't time at the moment," Webb replied smoothly, and waited.

"Number three hundred and fifty-seven Lethbridge Road," Vine said, a little reluctantly.

"Fine." Webb opened the car door. "Some officers will be round shortly to interview the staff. I'd be grateful if they could be given full cooperation. In the meantime, thanks for your help; no doubt we'll meet again."

As they turned into the bend of the drive, Webb saw Vine in the wing mirror, still standing where they'd left him and looking after them. Well, he thought with satisfaction, we've given him something to think about, all right.

thin man with greasy hair. He confirmed that John, as he called him, had twice knocked on the door, the first time to announce his arrival and again a few minutes later, to ask Ralph if he could 'chivvy them up a bit'.

"Said they'd miss the train if they weren't careful. I told Mrs Rimmer, and she went to the conference hall to see what she could do."

Webb glanced at Vine, who nodded. "The housekeeper. Yes, she did look in."

"And the driver stayed talking to you?" Webb asked the porter.

"For a minute or two, yes. We were talking about the football match, and moaning that neither of us had been able to see it."

"You knew Mr Bainbridge quite well?"

"Yeh, he often brought the guests up from the station."

"In the minibus?"

"Depended how many. Sometimes one of the big coaches."

"And he always came round for a word with you?"

"Often came to see if there was a cuppa going, yeh."

"But not anything stronger?" Webb asked, with a glance at Vine, silent beside him. Even a snatched glass of something could have slowed down his reactions.

"'Course not!" Ralph was indignant on behalf of his dead friend. "John was fond enough of a pint, but he never touched a drop while he was driving. Everything depended on him having a clean record."

The times of the bus's arrival and eventual departure were noted, and the men went out of the back door into a cobbled courtyard which had once been the mews. Over to one side, a large paved area provided ample parking space.

on shrubs and flower-beds and, to the left, a two-storey wing which abutted the side of the house. Skirting it, and just visible from these windows, ran the path which led to the car park. "Where did the bus park? Round the back?"

With an effort, Vine found his voice. "No, since it was the only vehicle that day, he came to the front door."

"So where was it that this conversation took place between the driver and your man Ralph?"

"We can ask, but I imagine he must have walked round the back and knocked on the staff door."

"Out of sight of the bus?"

"Yes." Vine regarded him steadily.

"And everyone in the house was either in this room, overlooking the side gardens, or at the back, in the kitchens or staff quarters?"

"Correct."

"So anybody could have come along and tampered with the bus and no one would be any the wiser?"

"It's possible. But who the devil was it? Someone lurking in the shrubbery, awaiting his chance? He couldn't have know the man would leave the bus."

"Does anyone live permanently in the building?"

"Yes, my deputy manager has a flat on the top floor."

"His name?"

"Young – Adrian Young."

"Was he at home on Saturday?"

"Not at the time the bus left; he'd taken his wife to the theatre in Shillingham."

"When did he leave?"

"I should think about halfway through the reception, around seven. So he wouldn't have seen anything, either."

Ralph proved to be one of the kitchen porters, a tall,

"I believe I'm right in thinking that before you opened this centre, you owned several prosperous companies?"

"That's right."

"I also seem to recall hearing of a number of hostile takeovers you were engaged in."

Vine shrugged. "Business is business. There's no room for sentiment."

"Quite. But it's possible you made quite a few enemies."

Vine stared at him, dawning horror in his eyes. "You don't imagine this ghastly business was a way of getting at *me*?"

"We have to consider every angle, sir. It's even possible that the perpetrator thought you might be travelling on the bus yourself."

Vine moistened his lips. "And now he knows that I wasn't?"

"This is all very hypothetical, you understand."

"But?" Vine prompted aridly.

"But, always supposing that *was* the scenario, now that he's discovered you're still alive, it's just possible he might try again." Webb paused. "I'm not trying to frighten you, but can you think of anyone who might want to kill you?"

"Good God, no!" Vine said explosively. "All right, so I might not be everyone's flavour of the month, and I might have trodden on a few toes on the way up, but who in my position hasn't? That doesn't make us all potential murder victims, I hope?"

"Of course not. It's just that I'm trying to see why so many of your namesakes should have been targeted. If someone hated you enough, it would be like killing you five times over. Now—" Leaving Vine staring after him, aghast, Webb walked over to the windows and looked out

He waited while Vine reluctantly gave his son and daughter's addresses and Jackson noted them down.

"I shall also need the names of everyone who was on duty during the function. They might have noticed something significant. In the meantime, we'd like to see the room where it was held, where the bus was parked, and so on, and have a word with this man – Ralph, did you say? – who spoke to the driver."

"Very well." Resignedly Vine pushed back his chair. "This is a nightmare," he commented, leading the way out of his office. "It was bad enough when we thought it was an accident, but now!"

They followed him back across the hall and along several corridors to a large room at the end of the house. It was set out for a lecture, with rows of seats facing a stage at the far end. There were four floor-to-ceiling windows, two of which formed a doorway leading outside.

"This room's frequently let on a daily basis, and is more or less self-contained," Vine said. "There are cloakrooms over there, where the guests left their coats."

"But they'd have come in at the main entrance?" Webb asked, eyeing the French windows.

"In this instance, yes. My wife and I received them in the hall. There was a fairly substantial buffet laid on." He gestured to several long tables, now standing against a wall. "Some of them had come from quite a distance."

"And I understand there was no one in the building except the guests and the staff serving them?"

"Correct."

Webb thought for a minute, then said abruptly, "You're a very successful man, Mr Vine."

Richard Vine looked at him in surprise.

"And you've no idea who could have had anything against them?"

"Of course not. The whole idea's ludicrous."

There was a tap on the interconnecting door and the secretary appeared with a tray of coffee. She glanced at the three grim faces, handed out the cups, and left the room again.

"How many people knew who was expected?" Webb asked, as the door closed behind her.

"How do you mean?"

"Well, obviously your wife and family were aware you were giving this party and that all the men would be called Richard Vine. But did they have any specific details about the guests – what they did, where they lived, and so on?"

Vine said stiffly, "I can't imagine what my family has to do with this, but no, they did not. The only person working closely with me on the selection of the guests was my secretary whom you've just met, Julia Marshall."

"How many are there in your family, Mr Vine?"

"Just my son and daughter."

"Do they live at home?"

"No," Vine said baldly.

"Then we'll need their addresses, too."

"There's no reason to go harassing my children, for God's sake. They weren't involved in any way."

"It's not a question of involvement at this stage," Webb said patiently, "merely trying to gather as much information as we can about the background to the evening. We'll need to speak to your wife, too. You could have made some comment months ago, which didn't seem important to any of you at the time, but in the light of what has happened, might now be relevant."

it would be interesting to meet a whole clutch of people with the same name as myself. I thought *they* would find it interesting, and they seemed to. The party," he added bitterly, "was a huge success."

"You'd never met any of them before?"

"No. I knew of one who'd attended a course here last year, and another who writes for the *News*. I phoned him, and he agreed to give the event some publicity. In fact, it was because these two had come to my notice that I set out to look for more. I wish to God I hadn't; it seems I played right into someone's hands."

"How long was the minibus waiting outside? There must have been a time lapse between its arrival and rounding up all ten people who were going to board it – while they collected their coats, said their goodbyes and so on."

"There was a slight delay, yes. One of the staff said the driver was getting edgy, because time was moving on and they had a train to catch."

"Where was he waiting? In the bus?"

"I don't think he could have been," Vine said slowly. "Not if he asked Ralph to hurry them up. He knew the staff here quite well – we always use that firm."

"You managed to talk to all your guests, I take it?"

"Of course; I made a point of doing so."

"Did any of them seem nervous, anxious about anything?"

Vine considered, then shook his head. "They were all slightly reserved to start with, but the ice was soon broken and they began to enjoy themselves."

"Can you specifically remember those who died?"

Vine nodded, his face tense. "I can't get them out of my head."

Richard Vine rose from behind an enormous mahogany desk and waited while they crossed the expanse of carpet towards him. He raised an enquiring eyebrow. "Gentlemen?"

Webb repeated his introduction, sat down at Vine's invitation, and in level tones informed him of the findings on the minibus.

While he did so, Jackson, curious to see in the flesh the man about whom he'd heard for years, studied him covertly. So this was Richard Vine, 'the Man with the Midas Touch', as the *News* had once dubbed him.

Aged around fifty, his hair was thick and mid-brown, as yet untouched by grey, and his face the craggy kind which women seemed to find attractive. He had a broad nose, sharp grey eyes – at the moment fixed on the governor – and grooves in his cheeks which would deepen when he smiled.

He was not smiling now. He sat unmoving after Webb had finished, staring into his face. Then he said flatly, "I don't believe it!"

"I assure you it's true, Mr Vine," Webb said smoothly. "The bleed screws behind each wheel had been loosened to allow the brake fluid to escape; not enough to cause immediate failure, but with repeated braking – inevitable on this road – it would all be used up before he reached the bottom of the hill."

Vine passed a hand over his face and repeated, "I don't – I *can't* – believe it. Really. I mean, who would do such a thing?"

"Someone who intended to kill everyone on the bus." Webb paused. "What was the purpose of the gathering you held, Mr Vine?"

He lifted his shoulders. "Fun. Novelty value. I thought

41

park, round the back of the house. Webb ignored it. "Go to the front, Ken," he instructed, and, with a flourish he couldn't resist, Jackson drew up on the sweep of drive directly opposite the front door.

"Wow!" he said, looking about him at the manicured lawns and immaculate flower-beds, the distant tennis courts and miniature golf green.

"Exactly," Webb agreed, getting out of the car and ringing the bell.

The door was opened by a harassed-looking woman in an overall. "Mr Vine? Yes, of course. Come inside and I'll fetch his secretary."

The two men found themselves in the wide hallway, with its scattered rugs, its oak table and its handsome staircase. Half a dozen people were holding a discussion group in an alcove and eyed them curiously. From a half-open door to the left came the sound of a man's voice and farther away, a burst of laughter.

The woman who'd admitted them hurried down a corridor to the right and knocked on one of the doors. A brief exchange took place, then she withdrew and continued down the passage in the opposite direction. A minute later another woman, blonde and attractive, emerged from the room and came towards them.

"I'm Mr Vine's secretary," she said. "Can I help you?"

"We'd like to see him, please. Chief Inspector Webb and Sergeant Jackson, CID."

She frowned, looking from one to the other. "Detectives?"

"That's right, ma'am."

"But I thought—" She hesitated, but when Webb made no attempt to elucidate, flushed a little and said quickly, "I'll tell him you're here."

Richard Vine, his wife informed them, was over at the Grange.

"Is it—" she hesitated, her eyes going from Webb's face to Jackson's and back again. "Is there any news of the two in hospital?"

"I'm afraid the man died yesterday," Webb told her. "The woman is still holding her own."

Natasha gazed at them numbly and her eyes filled with tears. "I just can't take it in. All those happy, laughing people we were talking to, and then, minutes later—" She broke off, dabbing ineffectually at her eyes. "I'm sorry, I'm holding you up. If you drive on to the next entrance, you'll come to the Grange. I'm sure Richard will give you all the help he can."

"Not quite the wife I'd have expected for him," Webb commented as they got into the car again. "A nice little thing, but hardly Vine's type, I'd have thought."

The reporters who'd flocked here on learning of the crash had drifted away, but it would be only a temporary break: once news of murder broke, they'd be back in droves. In the meantime, their entrance to the Grange was unimpeded, and Jackson turned in between imposing wrought-iron gates, fortunately standing open, and gave a low whistle.

Ahead of them, trees lined an immaculately gravelled driveway for several hundred yards, and only as they rounded a bend did Bellingham Grange itself come into sight, placidly set amid its parkland.

"Quite a pile," commented Webb, eyeing the turrets and towers. "How would you fancy living here, Ken?"

Jackson grinned. "Give me number fifteen Broadminster Road any day!"

As they drew nearer, a sign directed them to the car

We'll check it out with everything else, but I reckon it's too far-fetched. Though I'm damned if I can think of a better explanation. As you say, whoever did it had to have the means to get away afterwards."

"Unless he was at the party himself?"

Webb stared at him with narrowed eyes. "Go on."

"Suppose," Jackson continued, warming to his theme, "Richard Vine himself wanted one of his namesakes out of the way? It would be a good cover to get a whole bunch of them there at the same time."

"I repeat, it's too cold-blooded, killing the wives as well. I don't think much of Richard Vine, but I can't see him doing that."

"All the same, the tampering must have been done at the Grange, mustn't it, or the driver wouldn't have made it up the hill in the first place?"

Webb flicked through some papers. "As it happens, not necessarily. According to the owner of Hatherley's, Bainbridge didn't return to the garage between trips but went back to his house and filled in the time there. He lived just further up the road."

"And you think someone could have got at it there?"

"Theoretically, but how did they know he'd be at home? It was a special concession, and had never happened before. It's just our luck the rain washed away any traces of leakage, either there or at the Grange."

Webb pushed back his chair. "Anyway, enough theorising. Let's make a start by driving up to Beckworth. We'll take a look at the scene, have a word with mine host, then go on to Bainbridge's house and have a scout round. We need to speak to his wife in any case, if she's up to it, poor woman."

* * *

before, so what common motive could there be in killing them?"

"A hatred for men called Richard Vine?" Jackson suggested, only half seriously.

"Stranger things have happened, Ken. He'd have had bigger pickings, though, if he'd targeted them at the Grange. We can only thank God he didn't."

"But he must have known about it in advance, mustn't he? The party, I mean."

"Yes," Webb said reflectively, "I suppose he must. John Baker said it was mentioned in the *News* last week. Did you happen to see it?"

Jackson grinned. "I only read the sports pages, Guv – ask Millie!"

"See if you can dig out a copy when we've finished here. If not, get on to Mike Romilly and ask him to send one over a.s.a.p."

"Suppose someone had something against one of the Richard Vines, and thought he'd have less chance of being discovered if he killed several of them? Confuse the issue, like."

"A bit cold-blooded, even for a killer."

"He could have tailed his man onto the train, then seen them all get into the minibus, and followed it."

"How?" Webb interrupted. "He wouldn't have his own transport."

"Taxi?" But Jackson's voice was less certain.

"Wouldn't dare, would he? It would blow his cover."

"Suppose he had an accomplice, then? Someone who met him with a car and drove him back down afterwards."

Webb shook his head. "I'm not convinced, Ken. And how would he know his quarry was going to the party?

all five couples seem to have been decent, law-abiding folk. No obvious motive for bumping them off.

"Richard and Sue Vine were the youngest pair – in their thirties, by all accounts. It's Sue who's hanging on in Intensive Care. He was a computer salesman, she teaches at a primary school, and they live in Barnes. No children. Her parents are with her now."

"Any jealous ex-boy or girlfriends?"

"No, they were childhood sweethearts, her mother says."

Webb grunted. "Next?"

"Well, there's Richard and Monique, from St Helier in Jersey. He was a retired schoolmaster."

Webb grunted. "Didn't think teachers earned enough to be tax exiles!"

"No, Guv, they'd always lived there. Two sons, both married. Then there's Richard and Anne; they're actually local, but he's been working in London, so they joined the train party."

The parents of Hannah's girls, Webb thought, and wondered fleetingly how the children were coping, poor little devils.

Jackson continued with his list. "Richard and Pat were both doctors, from Reading, and finally there's Dick and Jo, who owned a newsagent's in Glasgow. He's the one who's just died."

"And the driver?"

"John Bainbridge. Married with two kids. Popular bloke, according to his boss."

"Aren't they all, once they're dead?" Webb frowned down at his list. "The devil of it is, they seem to have nothing in common except their names. Our resident Richard Vine said none of them had ever even met

36

opinion, was one of the most satisfying aspects of the School. At home, no one was really interested in your writing, but here you could talk about it to your heart's content, and always find a willing audience.

As her friends chatted to the new recruit, Betty found herself studying the woman. She was younger than they were – mid forties, perhaps – tall and slim, and dressed in a tailored suit rather than the semi-cocktail dresses the other women wore in the evenings. Her hair was very short, covering her head like a smooth black cap, and she wore no jewellery. But it was her large dark eyes that were her outstanding feature, and Betty shifted uncomfortably. For when she'd met their unguarded gaze in the queue at the bar, there'd been something in them that had disturbed her. Now, belatedly, she tried to analyse it. Apprehension? Tension? Fear?

Betty shook herself impatiently. That imagination of hers! And she remembered her own misgivings, that first evening five years ago, alone in a room full of people who knew each other. No doubt Erica simply felt the same. She'll soon settle down, Betty told herself comfortably.

Rising above the hubbub of voices came the resounding boom of the dinner gong and she looked round for somewhere to lay down her glass. After the meal, there would be Mr Vine's welcome speech and then dancing in the conference hall. The autumn School was under way. Happily, Betty moved slowly with her friends towards the door.

"Right, Ken, what have we got so far?"

DS Jackson pulled his chair closer in to Webb's desk, looking at his notes. "Not a lot, Guv. From first reports,

Children? She'd find out, but she couldn't inundate the woman with questions at this stage.

Finding herself at the front of the queue, she placed her order. "And what can I get you?" she asked her new acquaintance, but Erica Mann shook her head.

"It's kind of you, but no thanks, I'll get my own."

"But I—"

"Really, I'd rather."

"Very well." Betty felt slightly rebuffed, uncertain now whether the woman wanted her sponsorship. However, having secured her glass of wine, she followed meekly enough to where a group of Betty's friends stood chatting.

"This is Erica," Betty said brightly. "Erica, meet Myrtle, Ted and Freda, and Penny. We've all been coming for years, but you'll soon feel at home."

Penny said, "We've already met briefly; we're sharing a room." A fact Erica acknowledged with an abrupt little nod.

The others made welcoming noises. "I must say," Ted Lock remarked, "this is the first time we've had to fight our way in through a crowd of journalists! I thought my fame had gone before me, but it turns out it was Mr Vine they were after."

His wife turned to the new arrival. "Because of the minibus crash," she explained. "Perhaps you heard about it? It had just left here on Saturday when it went off the road." But before Erica could reply, Freda, tired of discussing the crash, interrupted with a more pertinent question. "What course have you enrolled in?"

"The short story."

"Same as us! Welcome to the club!"

The conversation slid into the 'shop' talk that, in Betty's

Three

The bar at the Grange was doing a roaring trade and the noise level rose accordingly. Betty waited in the queue, looking eagerly about her to spot friends she hadn't seen for a year, and, glancing over her shoulder, encountered the solemn gaze of the woman directly behind her – a face she didn't recognise.

She made a laughing little *moue*. "Can't hear yourself think, can you?"

The woman smiled fleetingly.

"Seems to get noisier every year, doesn't it?" Betty fished, and the bait was taken.

"Actually, this is my first time."

"I thought I hadn't seen you before. I'm Betty Fife."

"Erica Mann."

"It's a bit daunting when you don't know anyone, but you soon will. I'll introduce you to my friends when we've got our drinks."

"I don't want to butt in," Erica Mann said flatly.

"Nonsense – we were all new once. Have you had anything published?" The inevitable first question.

The woman shook her head. "I've only started writing in the last few months; I never had time before."

Betty glanced at her hand but there was no wedding ring. Divorced, perhaps, she thought. A full-time job?

Webb frowned. "What did you find?"

"All four bleed screws had been loosened, which means that when the driver came to that steep slope and tried to brake, he'd lose all his reserve of fluid and his foot would go right down to the floor. He hadn't a hope of staying on the road.

"I had my suspicions, back at the scene. No skid marks, see. The natural thing would have been to brake going into that bend, specially if he was veering towards the edge. You'd expect a row of deep scores in the ground and on the grass verge, but there was nothing – no sign he'd tried to brake at all. I thought he must either have been drunk or fallen asleep at the wheel, and since he'd only just started out, nodding off didn't seem too likely. But it wasn't either of those, poor devil."

Webb said slowly, "You're saying someone deliberately set out to kill the lot of them?"

"Looks that way."

"Well, thanks, Terry. I can see we'll have our work cut out."

"Yep. I'll have a word with Inspector Baker, just to put him in the picture."

Webb grunted agreement, replaced his phone, and stared down at his desk, taking in the implications of what he'd heard. He was still sitting there five minutes later when, after a tap on the door, John Baker came in.

"I take it you've heard the news?"

"Yes. Seems it was murder, nine times over."

"Ten, actually. Word just came from the hospital. Dick Vine died without regaining consciousness." Baker dropped the file he was carrying onto the desk with a thump. "So it's over to you, Dave, the whole vineyard, root and branch. And the best of British luck!"

a dislike which had intensified after his encounter with Vine's wife last summer.

It had been during one of his free periods and he'd been walking in the grounds when he was caught by a sudden shower, and had sought refuge in the greenhouse. It had been a full minute before he realised he was not alone; Mrs Vine was at the far end, her back to him, engaged in picking tomatoes off a plant.

"Hello!" he'd said. "Sorry, I didn't see you down there!"

Startled, she'd spun round, and he'd seen the red imprint of a hand across her face and the tears in her eyes. At his instinctive exclamation, she'd launched into an incoherent story about it all being her own fault, that she'd done something stupid, and anyway this had never happened before, he must believe her.

Helplessly, realising that his concern was simply adding to her distress, he had pretended understanding and left her, going out again into the now heavy rain. But the unpleasant little incident had lodged in his mind, coupled with the obscure conviction that he should have done something about it.

If he got the chance, he told himself now, he'd check discreetly that all was well with her, and that what she'd insisted was Vine's first blow had also been his last.

His mouth set in a grim line, he turned off the Lethbridge road and began to climb the hill towards the Grange.

At four o'clock that afternoon, Webb had a phonecall from PC Wicks, the traffic accident investigator.

"Yes, Terry?"

"Got some news for you, sir. The minibus crash – it was no accident."

some measure by rotating the programmes between the seasons.

In his mind's eye he could picture the autumn lot now, as they would be facing him tomorrow: Betty and Myrtle in their usual seats by the radiator; Jim Benson and his wife Josie at the front, Barbara and Margaret behind them, Ted and Freda, Penny and Pauline.

These formed the hard core, to which were added members who switched their preferences from year to year, joining the short story course as a change from romantic novels or writing for children. And occasionally there were first-time attenders, harbouring who knew what potential promise. There were two this time, he remembered. The average age was around fifty, the average success rate depressingly low – apart, that is, from Myrtle, with her three or four published stories per year.

Yet some of them really had talent, he thought with frustration, if he could only dig deep enough to extract it, and they had the perseverance to keep trying in the face of editorial rejection.

Turning off the motorway, his mind slipped sideways to the minibus crash that had been in the news, with its bizarrely named occupants. Imagine, he though ironically, *twenty* Richard Vines in the same room! One was more than enough.

Thankfully, the proprietor of the Grange had very little to do with the Writing Schools, the running of which was organised by their own committees. Apart from his welcome speech on the first evening and farewell drinks at the end of the week, he kept out of their way. Which suited Mark very well. He hadn't given much thought to Richard Vine over the years, and it had surprised him, when he did, to discover how much he disliked him –

"It'll be interesting," she went on, "to see if he mentions it this evening, in his welcome speech." Impulsively she leaned forward and placed her large, strong hand over Betty's small, pudgy one. "It *is* good to see you again," she said with genuine warmth.

And Betty, ashamed of her critical reflections earlier, replied with equal sincerity, "Same here!"

Mark Aston, his eyes on the busy motorway ahead, ejected one cassette and inserted another, settling back in his seat as music once more filled the car. The Shillingham exit would be coming up shortly, which meant he should be at the Grange in about half an hour.

It would be his sixth visit, and he still marvelled at the immense popularity of the School. Originally intended as an annual summer event, demand had immediately outstripped the limited accommodation on offer. A larger venue seemed the obvious solution, but the proposal had brought immediate and vociferous protest from the members, who preferred the smaller numbers – a maximum of seventy compared with the three hundred-odd catered for by other Schools.

So by popular vote, and with Richard Vine's enthusiastic support, the same course was repeated at an Autumn School the following November. By the fourth year it had become a quarterly event, and now each season was self-supporting, with its own faithful band of returning members. And there was a waiting-list for each one.

Mark, himself a modestly successful novelist, was one of the few tutors who attended all four Schools, and his continuing challenge was to make his curriculum sufficiently different each year to appeal to the same, perpetually returning, groups, a task he accomplished in

time to waste. The train goes in five minutes. Nice to see you again," she added over her shoulder as she strode ahead, leaving Betty to trot after her, humping the heavy case. "Doesn't seem a year, does it?"

Their reserved carriage was right at the front of the train, and Betty was out of breath by the time she'd struggled on board, stowed her case, and taken her place opposite Myrtle. They'd only just settled themselves when the train gave a shudder and began to chug its way slowly out of the station. They were on their way.

"Did you hear about the crash?" Myrtle asked, slipping off her coat to reveal yet another of her hand-knitted sweaters, resplendent with birds and exotic flowers. Betty, still panting, shook her head, and she continued, "A minibus – probably one of the ones that ferry us. They'd been up at the Grange, anyway, at Mr Vine's party. Nine killed, it said on the news."

"A crash at *Beckworth*?" Betty demanded, eyes round with concern.

"I just said so, didn't I? Gave me quite a turn, hearing about it like that, while I was actually packing to go there. It could so easily have been us." She gave a little shiver.

"But that's terrible! Poor Mr Vine! It's a wonder he hasn't cancelled the School."

"He could hardly do that," Myrtle said briskly, "when we've all paid and it's been arranged for so long. Anyway, it didn't sound as though they were close friends of his. The weird thing, though, is that four of the dead were also called Richard Vine, and there's another one in hospital. Decidedly odd, if you ask me."

Betty stared at her uncomprehendingly, but it seemed Myrtle wasn't expecting any comment.

With a rueful grimace, she returned to her work.

The newspaper stall at Paddington; the rendezvous they'd used for the last five years. Betty Fife put down her suitcase and looked about her. No sign of Myrtle as yet. Just as well they'd reserved seats, since people were flooding through the barrier onto the platform.

It would be good to be back at the Grange, she thought, and see everyone again. Pretty well the same crowd came year after year. She wondered if Margaret had finished that novel she was writing, and how Barbara's daughter's wedding had gone.

Then she gave a small sigh, admitting to herself that she'd enjoy the week even more if she didn't have to share a room with Myrtle. But there was no way, now, that she could escape it; everyone seemed to bracket them together, simply because they'd started attending in the same year.

The truth was that apart from their writing, they'd really nothing in common. Myrtle was a widow, who had moved to the Sussex coast to be near her son and his family. Betty'd wondered more than once how said family had reacted to this, since she was inclined to be overbearing, and paid scant attention to anyone else's wishes.

Myrtle also considered herself a better writer than the rest of them, having had some of her stories published in the national magazines. By contrast, Betty's only triumph to date was a poem printed in the local rag, for which the prize had been a tin of tea. To be *paid* for her work had been a lifelong, but now rapidly receding, goal.

"There you are!" called a voice behind her, as though it were Betty who had been late, and Myrtle's tall, ungainly figure bore down on her. "Come along, dear, we've no

"Seriously, Richard, it's pointless to blame yourself. These things happen, unfortunately, and there's nothing we can do about it. Tying yourself in knots won't help either you or them."

There was a brief silence. She suspected he'd wanted more from her, that she'd somehow failed him, but what else could she offer?

"Right," he said at last, his return to brusqueness proof of her shortcoming. "See you tomorrow, no doubt." And he rang off, giving her no chance to reply.

Why the hell, Julia asked herself wearily, had she let herself fall for Richard? She should have foreseen the pitfalls, for not only was he fifteen years older than herself, but he had a pleasant wife of whom she was genuinely fond. Quite apart, of course, from the fact that she was married herself, to a man who loved her, and who hadn't changed in any respect since the day she'd fallen in love with him.

Which, of course, was the problem. Rob, a commercial air pilot, was, she sometimes felt, caught in a time warp, being as exbuberant, noisy – irresponsible, really – as he'd been in his early twenties. After sixteen years of marriage, his idea of a good night out was still a few pints with the lads, his main topic of conversation the fortunes of the local football team. And he was forty, for heaven's sake! Julia thought with a spurt of irritation. No wonder he compared unfavourably with Richard's easy, sophisticated charm.

Still, guilty conscience or not, there was no threat to either Rob or Natasha – or, more importantly, to ten-year-old Simon – for Richard had no plans to alter the status quo. Their present arrangement suited him admirably, and if it was not enough for her, that was simply her bad luck.

Instead, she said, "I really am sorry about it."

"Yes, it's damnable, but life must go on. For the rest of us, anyway. I've been down to the hospital, but there's no change. I'd intended having them transferred to private rooms, but they're both in Intensive Care. Still, I was able to have a word with the relatives."

"That couldn't have been easy."

"No. Look, is there anything urgent needing my attention?"

"Nothing urgent, no."

"Everything's on track for the Writing School?"

"Yes, their committee's here and they're busy setting things up."

"Well, as long as it's all ticking over I shan't bother coming in. I'll be there as usual for the welcome meeting around eight-thirty."

"Right, I'll tell them."

There was a pause. "All well at home?"

"Yes, fine." Was that an oblique way of asking if Rob was there, or merely an attempt at conversation? Probably the latter; he'd too much on his mind for romantic dalliance. Not for the first time, she wished she could switch her own emotions on and off as easily.

But as the thought came, he confounded her – as he so often did – by saying rapidly in a lowered tone, "I damn nearly rang you yesterday, when the police had gone. I've never felt so down. It was my fault, Julia, that's what I can't come to terms with. If we hadn't held that bloody reception, they'd still be alive."

"Or they'd have crashed their own cars, or walked under a bus."

He gave a harsh laugh. "I never took you for a fatalist."

"It was trailed in the *News* last week, apparently. I bet he'll think twice before pulling another gimmick like this."

"Oh, I don't know," Webb remarked drily. "They say there's no such thing as bad publicity."

"He'll have the chance to find out; we're already being besieged by the press. There's a conference at three o'clock. With luck, we'll know a bit more by then."

"Julia."

Julia Marshall's hand tightened on the telephone. "Richard! I wasn't sure if you'd be coming in today. What a perfectly ghastly thing to happen!"

"Yes."

He sounded tired, she thought; probably hadn't had much sleep last night. For that matter, neither had she. She'd been expecting him to phone ever since hearing of the crash, but was hesitant to call herself because, after all, what was there to say?

"Did you come over yesterday?" she asked, when he did not elaborate.

"Yes, why?"

"Just that when I took the file out, the papers weren't quite as I left them."

"The police wanted addresses. I photocopied the list."

"You should have called me; I could have—"

"I'm perfectly capable of using the photocopier."

She bit her lip, understanding his edginess. She'd have liked to ask if the evening itself had been a success – she had, after all, spent a considerable time organising it. But in the circumstances, such a question would come into the 'Apart from that, Mrs Lincoln, did you enjoy the play?' category.

but the concept goes further – the rest of them are like family too. John was one of us – this'll hit us all."

And with a sigh, he led the two policemen out of the office into the raw, damp afternoon.

It wasn't until he arrived at the station the next morning that Webb learned firstly that there had been two survivors of the crash, and secondly that all the men except the driver had the same name.

"It's been the devil of a job sorting them out," John Baker told him. "We've got the names and addresses, but matching them up is another matter. All the men, thank God, had their driving licences on them, but as you can imagine, the women's handbags had been flung all over the place and it was anyone's guess whose was whose. On top of that, none of the bags contained any addresses and in some cases not even the name of the owner."

"A nightmare," Webb sympathised. "And two are still alive?"

"Only just; a Richard, naturally, from Glasgow, and a Susan from God knows where. Might be his wife, might not. All this confusion didn't help the local forces, I can tell you, having to ask relatives for photos. But we couldn't risk bringing them down to ID the body, and wheeling out the wrong one."

"What I don't get is why there were five blokes with the same name at the party."

Inspector Baker snorted. "Five? There were *twenty*, Dave. The bright idea of our very own Richard Vine, at Bellingham Grange."

"Ye gods! Isn't that egocentricity gone mad?"

"Or the reverse, stressing he's not unique."

"Unlikely, I'd say."

"And they're out today?"

"One coach was; took a church group down to Broadminster for a special service, followed by lunch. He got back shortly before you arrived. In fact you only just caught me – I was about to lock up and go home."

"But you didn't wait for Bainbridge last night?"

Spence flushed. "Wouldn't you know it? Break the habit of a lifetime, and this is what happens. Wife wanted to go to the cinema, so for once I didn't. Wish to God I had, though I don't suppose it would have made much difference."

"When you came in today, though, you must have noticed the bus wasn't here?"

"Of course I noticed, man! I was surprised, to be honest. Wasn't like John to take advantage. I did try to phone him, but when there was no reply I decided to leave it, and give him a rocket when he got in tomorrow."

"I suppose you had references, when you hired him, like?"

"Of course I bloody had references!" Spence burst out. "Think I'd take on any old cowboy, no questions asked?" He rubbed a hand over his face. "Sorry," he mumbled. "This has hit me pretty hard."

Ridley nodded to Carter and stood up. "We won't keep you any longer, Mr Spence. Sorry to be the bearer of bad news."

"Does his wife know?"

"Yes, a couple of officers went to see her."

Spence levered himself to his feet. "I'll look in on her later, it's the least I can do. This is a family business, Sergeant," he went on, picking up the bunch of keys from his desk. "Oh, I've a son and a nephew working for me,

"Had the driver been with you long, sir?" asked Sergeant Ridley.

"About two years, I suppose. A great guy, John – got on with everyone, and I'm not just saying that because he's dead. Totally dependable, he was; I'd have trusted him with a new-born babe."

"And the bus? When was it last serviced?"

"A week ago – you can see for yourself." He indicated the papers in front of him. "God in heaven, what can have *happened*?"

"He wouldn't have nipped in for a quick drink while he was waiting for them?" PC Carter asked diffidently.

"No, he wouldn't," snapped Spence. "None of my men would even contemplate drinking on the job."

"Was it him who met them off the train earlier?"

"That's right, he was down for both runs – it's on the chart. Meet the 5.35 London train, take ten passengers to Bellingham Grange, and bring them back in time for the 9.05."

"Where would he go after he'd dropped them off?"

Spence regarded them under lowered brows. "As it happens, he'd asked permission to go home. OK, so it was bending the rules; they're supposed to come back here between jobs – for insurance reasons as much as anything. But since he lived just up the road from his drop-off and was due to collect them again barely two hours later, I couldn't see the harm in it. He could clean the bus there as easily as here."

Ridley nodded. "Do you often work on a Sunday, Mr Spence? We expected to find you at home."

"If anyone's out, I make a point of seeing 'em off and clocking 'em back in again. I like to keep an eye on things."

"Good God! When did that happen?"

"Last night, I think; they'd been at a party up at Beckworth."

"So who's with the girls now?"

"That's the point – they're at school; poor Gwen's having to break the news to them. As luck would have it, they're boarding just for this term, because their father had a six-month contract in London and his wife went with him. The girls were up there last week, for half-term."

"How old are they?"

"Twelve and fourteen. Much too young to lose their parents like this. They were such a nice couple, too," she added. "What a waste."

"Death usually is. You say nine were killed? Must have been one hell of a crash. If they were coming from Beckworth, it probably happened in the Forest; there are a lot of hairpin bends up there, and if the bus missed one of them, it would have gone careering down the hill." He glanced at her anxious face. "Look, love, you might as well sit down and finish your tea. Your turn will come later, helping those poor kids to adjust."

"I know," she acknowledged, returning to her chair, "but it's such a shock. Unlike you, I'm not used to sudden death."

He shook his head. "You never get used to it, even in my job. If the day ever comes when it doesn't bother me, I'll know it's time to pack it in."

Jake Spence, proprietor of Hatherley Coaches, sat back in his chair, slowly shaking his head.

"I just can't take it in," he said. "We've never had *any* accident before, let alone a fatal one – and *nine* dead! It's – mind-blowing."

"Have you heard about the crash?" Her voice sounded off-key.

"No," Hannah frowned, "what crash?"

"A minibus, taking some people to the station. They'd been at a party up near Beckworth."

"That's awful, but—"

"Nine people were killed, including the Vines – Abby and Victoria's parents. Mrs Vine's mother's just rung."

"Oh Gwen, no!"

"Bruce is driving me over straight away, to break the news."

"Is there anything I can do?"

"Not at the moment. Mrs Pleasance was all for coming to collect the girls and taking them back with her, but I managed to dissuade her. She was very emotional, poor woman, and I really feel it would be better for them to stay where they are till the first shock's over. Work and a familiar timetable will help to steady them, give them something to hold on to."

"Where do they live, the grandparents?"

"Bath. I promised to ring her back when I've spoken to them."

"Are you sure you wouldn't like me to come over?"

"No, really, there's nothing you can do. But their respective classes will have to be warned tomorrow. If you could see to that?"

"Of course."

"I must go – Bruce is getting the car out. I'll see you in the morning." And she rang off.

"What was all that about?" Webb asked.

Hannah replaced the phone and turned to face him. "Very bad news, I'm afraid; nine people have been killed in a minibus, among them the parents of two of our girls."

19

"Oh my God!" she said shakily. "Poor Annie – and those little souls, left without a father!"

"We'll wait in the car," Jessop said. "But if you could be on hand, later?"

"Of course. Anything at all I can do." Then, rallying, she straightened her shoulders. "Of course," she repeated more firmly. "Don't worry, I'll take care of her."

Silently the two officers returned to the car. Though officially there was another hour till lighting-up time, the rain earlier had darkened the afternoon, and already, down the road where the trees were thicker, dusk was encroaching. From where they sat there would doubtless be a lovely view in summer, but now mist obscured the distance and only a few winking lights lit the gloom.

"Lonely sort of place," Jessop remarked, turning the ignition to start the heater. "I wouldn't live in the country for a pension."

Crossley wasn't listening. "She'll have the kids with her," she said, staring ahead out of the windscreen. "We'll have to winkle her away from them. I wonder how old they are."

Down among the trees headlights suddenly blossomed and they both turned to watch them approach. It didn't need saying, but Jessop said it all the same. "Here she is now."

Bracing themselves for what lay ahead, they got out of the car.

"Hannah?"

"Gwen – hello." Hannah raised her eyebrows at Webb, who was sitting across from her with a plate of buttered crumpet on his knee. It was unusual for Gwen to phone during a weekend, especially since her marriage.

18

But though they knocked and rang the bell repeatedly, no one came to the door. They were about to walk round the back when a woman appeared in the next-door garden. She stopped short and frowned on seeing them.

"Something wrong?" she asked apprehensively.

"We're looking for Mrs Bainbridge," Jessop told her.

"Well, she won't be back yet. It's her weekend for taking the kids to her mother's. Never gets home till Sunday teatime. John should be in, though," she added helpfully, nodding towards the lighted window.

He must have left it on last night, poor bugger, Jessop thought. He wouldn't have expected to be much more than an hour, and it would have been a bit of cheer to come home to, with his family away.

"Teatime, you said," he repeated, glancing at his watch. It was three-thirty. "Would that be nearer four or five?"

"Now the clocks have gone back, about four – she doesn't like driving in the dark. Shouldn't be long, but John could tell you – she always rings him when she's about to leave."

The police officers exchanged glances.

"You are Mrs—?"

"Grogan, why?"

"Friend of Mrs Bainbridge's, are you?"

"Yes, we take it in turns picking the kids up from school."

"Mrs Grogan, she might well be needing you; I'm afraid we're here with bad news. Mr Bainbridge has been killed in a road accident."

The woman stared at them in horrified disbelief. Then her eyes went to the lighted window.

"He must have left it on last night."

17

Two

The reason there had been no phonecall from the driver's wife became apparent when Jessop and WPC Crossley arrived at his house a couple of hours later.

By this stage the grim business of breaking news to relatives was already under way, but since the five couples had all come from a distance, only the driver's family fell to Broadshire Constabulary.

It seemed he had not, as they'd assumed, lived in Shillingham, but in one of the cottages at the top of Todd's Hill, where the accident had happened.

"I always dread this," Jessop remarked as he turned up towards the Grange. "It never gets any easier; someone opens the door all unsuspecting, and wham! you send everything crashing about their ears."

He swore suddenly, hitting the brake as they came out of a bend to find themselves face to face with a recovery vehicle bearing the stricken minibus. Cautiously he backed a few yards to a passing place and the van edged past them with inches to spare and a salute from the mechanic at the wheel.

Sobered by the encounter, neither of them spoke again until they pulled up outside the cottage. "Someone's in, at any rate," Sue Crossley commented then. "There's a light in the front room."

16

"This is what I was looking for: the names of those to be met at the station."

"You mentioned girlfriends earlier, sir; were this lot all married?"

"It seems so, yes." Vine moved to the photocopier and switched it on. "Hatherley Coaches will no doubt supply you with the driver's details. Their garage is on the ring-road."

"Odd that his wife didn't phone in, when he was out all night," Thomson commented, watching as the sheet slid smoothly out of the machine. He took it from Vine and ran his eye quickly down it. "Thank you, sir, that's most helpful. We won't keep you from your lunch any longer; if we need anything else, we'll be in touch."

From the window, Richard Vine watched the policemen walk back across the gardens to the gate in the wall. Then, with hands that were suddenly shaking, he stuffed the file back in the cabinet. That quick glance at the list had conjured up for him the pleasant people who'd been here with him last night. But for what Polly termed his 'gimmick', they would still be alive. God, what a way for the evening to end, skidding off the road like that.

He glanced at the phone on Julia's desk and hesitated. No, better not. He went hurriedly back along the corridor and let himself out of the empty house. Though no longer hungry, he could do with a stiff drink. Perhaps that would dispel this paralysing sense of shock.

Belatedly aware of the chill November wind, he shivered suddenly and, turning up his jacket collar, set off at a run for the gate in the wall.

wing. Not large as conference centres go, but we're booked pretty well throughout the year."

"Is there something on at the moment?" Thomson enquired, as they approached the front door.

"No, which is why I was able to entertain here last night. The next influx is due tomorrow."

They found themselves in a large hallway with a highly polished floor, on which were scattered various rugs in dark reds and blues. There was a heavy oak table in the centre with a selection of glossy magazines laid out on it, and a reception desk to one side. A magnificent staircase rose straight ahead of them.

Kenworthy caught Thomson's eye and raised his eyebrows. More like a five-star hotel than any conference centre he'd seen.

"Along here," Vine instructed, setting off down a corridor to the right. He opened a door to reveal a pleasant room equipped with the basic components of any modern office – photocopier, fax, computer and printer. Rows of filing cabinets lined one wall. By the window was a desk, on which stood a vase of flowers.

"My secretary's office," Vine said. "I hope I can find what you want without having to disturb her. I'm not much of a hand at the computer, I'm afraid, which is why I insist on printouts of everything."

He went to the cabinets and after a moment extracted a file and laid it on the desk. Looking over his shoulder, Thomson saw that it contained correspondence with those invited to the gathering, together with a master list of their addresses. Vine riffled through the sheets of paper and, coming on one headed 'Transport', gave a satisfied exclamation.

and without awaiting her reaction, opened the front door and strode outside, the two policemen at his heels.

It wasn't immediately apparent where they were going. Vine had turned sharp right and started down a path running along the side of the house which presumably led to the back gardens. On their left was a seven-foot wall, partially screened by the row of trees which had been planted in front of it.

Vine stopped suddenly, fished in his pocket for a key, and unlocked a wooden door. They passed through it into another, more spacious, garden – more like a park, in fact, with its graceful old trees, its steps and terraces. There were even tennis courts behind some high netting over to the right. And ahead of them, at a distance of some 200 yards, sprawled a large Victorian house, resplendent with turrets and gables.

"My family home," Vine said shortly. "I grew up here, and when I married, my parents built us a house in the grounds, expecting we'd move back here when they died. Frankly, though, that was never the plan. It's much too big for us, and we're happy where we are."

They started to walk towards the building. On all sides of them the grounds stretched away, lush and well cared for. Thanks to a mild autumn, dahlias and chrysanthemums still blazed in the flowerbeds.

"All the same, there was no way I'd have sold it," Vine continued. "Not when it's been in the family over eighty years. So I hit on the idea of turning it into a conference centre, and letting it pay its own way."

"How many does it accommodate?" Kenworthy asked, eyeing the pile in front of him and trying to imagine one family living there.

"We can sleep seventy, now we've built on the bedroom

"What time did they leave?"

"God, I don't know, I—" He made an obvious attempt to pull himself together and got to his feet again, rubbing his hands down his trousers. "I'm sorry, Officer. This has shaken me considerably, as you can see. I feel responsible, in a way."

"I'm sure you can't blame yourself, sir. But if you could—"

Vine made an impatient gesture. "Eight-fifteen, eight-twenty, something like that. They were going for the 9.05 from Shillingham. It was only a buffet party, six till eight officially, though quite a few of them stayed on." He frowned as another thought struck him. "Did it catch fire?"

"No, why do you ask?"

"I was wondering why those who left later didn't notice it."

"You'll have all their addresses, presumably?"

"Well – yes, somewhere. My secretary sent out the invitations."

"Perhaps you'd get them for us."

"Now?"

"Please; relatives will have to be contacted, and so on. We can't release the names till that's been done."

"Of course. Well, all the correspondence is over at the Grange. I suppose you'd better come across."

He opened the study door, and his wife appeared in the hall. "Richard, what is it?"

"I'm taking these officers over to the Grange. The minibus crashed on its way to the station, and they need the passengers' addresses."

Her hand went to her mouth. "Oh, no! Was—?"

"Nine dead, two seriously injured," Vine said brutally,

crashed right down to the bottom." He hesitated, meeting the man's eyes. "In fact, there were nine fatalities, and the remaining two are on the critical list."

Vine had paled. "But that's terrible! When did it happen?"

"We've not established that yet, but sometime yesterday, we believe. It wasn't discovered till this morning."

"So they were lying there all night?"

Thomson nodded. The news had shaken the man out of his pomposity, at any rate. He added tentatively, "Funny thing, sir – five of the men had the same name as yourself."

Richard Vine sat down suddenly and put his head in his hands. "It *was* them, then. I'd been hoping against hope – God, what an appalling thing to happen."

"If you can give us any information—"

"Yes, yes of course." Vine cleared his throat. "I gave a party last evening – twenty men called Richard Vine, with their wives and girlfriends."

"*Twenty?*"

"Most of them arrived under their own steam, but five couples were coming from farther afield. I arranged for a minibus to meet their train and bring them here."

"And run them back to the station afterwards?" Thomson prompted, when he didn't go on.

Vine nodded.

"The driver wasn't one of them, was he, sir? One of the Richard Vines at the party?"

"You mean had he been drinking? No, nothing like that. It's a firm I use all the time, to ferry people to and from the courses we run here. Hatherley Coaches – completely reliable."

"Really!" Richard exploded. "What a time to call – one o'clock on a Sunday!"

"I'll go," Jonathan volunteered. "I'll tell them we're eating."

But as he reached the hall and glanced through the window, his voice changed. "It's the police, Dad."

Richard frowned and came quickly forward. "What the hell do they want? You've not been speeding again, have you?" He opened the door to confront the two uniformed men on the step.

"Afternoon, sir. Sergeant Thomson and PC Kenworthy, from Shillingham." They held up their warrant cards, which Richard ignored. "Sorry to disturb you; I wonder if we could have a word?"

"It's not very convenient," Richard said testily. "Can't it wait? We're just about to have lunch."

"We'll be as brief as possible," the man said impassively.

Richard sighed. "Ask your mother to put it back in the oven," he told Jonathan, and ushered the two men into the study.

"Well?" he demanded, turning to face them. He'd not invited them to sit, and the three of them stood facing each other in the centre of the room.

Thomson cleared his throat. "Perhaps we could start by asking your name, sir?"

"Richard Vine." His eyes narrowed as the two men exchanged a startled glance. "Anything wrong with that?"

"There's been an accident," Thomson continued after a moment. "A minibus went off the road about a mile from here."

"A mini—? Good God! Was anyone hurt?"

"Unfortunately, yes, sir. Nothing broke its fall and it

"What gave you the idea, Dad?" Jonathan asked, topping up his tankard.

"I suppose the seed was sown when we received an application for one of the courses from someone called Richard Vine." He finished his drink. "It's a funny thing, you know; although subconsciously we accept we're not unique, we don't expect to come up against someone with exactly the same name. It's a blow to our *amour-propre*."

He leant forward to put his glass on the coffee table. "Then, only a week or two later, I saw an article in the *News* by another Richard – or at least—" he grimaced – "'*Ricky*' Vine, and I thought, hell, how many of us are there? So I decided to find out."

"How?"

"Oh, reference directories, phone books, asking around. It became quite an obsession; everywhere I went, I checked to see if there were any Richard Vines in the area, and made a note of their addresses. Then, when I'd collected about twenty, I began to wonder what to do with them."

"And," Polly put in severely, "you decided to turn it into a publicity gimmick."

"How well you know me, little one!" Richard said with a grin.

"Were the student and the reporter at the party?"

"Of course."

Natasha appeared in the doorway. "Lunch is ready, everyone. If you'd like to come through, I'll bring it in."

"Want a hand, Mum?" Polly uncurled from her chair, but before her mother could reply the front door bell rang.

9

"Looks like they came from the conference centre, then," commented Sergeant Thomson.

Baker nodded. "Get a house-to-house under way, will you, Bernie? Shouldn't be too protracted, since the population's so thin on the ground."

Down below, the firemen had now wedged the bus with blocks to prevent it tipping, and the police surgeon crawled inside, followed by the paramedics. The rest of them waited tensely while the grim examinations took place. They seemed to take a very long time, and the policemen up on the path periodically stamped their feet to keep warm. Eventually the police surgeon emerged from the bus and made his way precariously back up the slope towards them.

"Nine dead," he reported tersely. "Two are alive, but only just. We've stabilised them, but it'll probably take the best part of an hour to get them out. There's one hell of a mess in there; couldn't have been wearing seat belts, any of them. Wicks is trying to establish which was the driver, but they were thrown all over the place. We'll probably need SOCO to match the blood on the steering wheel."

He turned and looked back down the slope. "An odd thing: I had a quick look for ID as you requested, and according to their credit cards, five of the six men had the same name. What do you make of that, eh?"

"Jones?" hazarded Baker, with a faint grin.

"No, I mean *exactly* the same. They were all called Richard Vine."

"They got on remarkably well," Richard was saying, "considering their diverse backgrounds. We had doctors, computer salesmen, company directors, newsagents – you name it."

8

morning, by a man walking his dog. Twenty minutes later, the narrow road had been closed and a line of emergency vehicles stretched down the hill – two ambulances, a fire engine and tender, assorted police cars and, at the end of the line, the fondly nicknamed 'jam sandwich' – a white car with orange stripe, belonging to the traffic accident investigator.

It was PC Jessop who'd responded to the 999 call, and had the uneviable task of scrambling down the bank to assess the seriousness of the situation.

"The chap only happened to see it because he threw a stick for his dog and it went over the edge," he told his colleagues later, as they stood watching the activity below them. "The dog started to run after it, then stopped and began to bark, so he went to see what was up."

"How many are inside?" asked Inspector Baker.

"Gawd knows, sir – they're all piled on top of each other on the ceiling. I couldn't see any sign of movement."

"Local resident, was he, the chap that phoned in?"

"Not local enough to be much help. He lives in Beckworth village."

The road they were on, known as Todd's Hill, branched off the main one to the village, winding up through the Forest at a different angle and with apparently only a few widely spaced houses along it.

"I did ask him what's further up the road," Jessop added, glancing up the slope, "and he said there's some sort of conference centre – they run courses and so on – and the bloke who owns it lives next door. A bit further along there's a place selling logs and fencing, and right at the top some cottages – a newish development, he said, completed about five years ago."

patiently waiting while his wife worked out her academic year's notice.

"Heard any more about your own prospects?" Webb prompted.

"Only that I've made it to the shortlist. I suppose that's something, though they did warn me it's unusual to appoint someone from within the school. Still, we won't have long to wait; they'll make the announcement before the end of term." Hannah sighed, returning the now laden plates to the oven and switching on the coffee. "Meanwhile, it's an unsettling time for everyone, including the girls."

"My money's on you," Webb said stoutly. "Dammit, you ran the place while Gwen was away. They'd be mad not to appoint you."

"Thanks for the vote of confidence! What about you, anyway? Did—" She broke off and turned towards him quickly, her eyes widening in concern. "David – your Board! You haven't had it yet, have you?"

Despite prompting over the years from his superiors, Webb had been unwilling to apply for promotion, afraid that the rank of superintendent would confine him to a desk. Finally, though, the continual pressure, coupled with Hannah's urging, had achieved their effect and he'd sent in his application.

"No, but it's rapidly approaching – Wednesday and Thursday week; two days of grilling at HQ, for my sins. Unlike you, though, at least I'll know the result almost at once."

"Then let's drink to our joint success!" And she handed him a glass of orange juice.

The minibus was not discovered until eleven o'clock that

It was true, and Webb reflected yet again how perfectly this arrangement suited them both. They were friends, neighbours, lovers, as the mood took them, and a particularly intense period could well be followed by their not seeing each other for weeks, even though they lived in the same building. They were content that it should be so. And since such meetings as they had did not entail stepping outdoors, even their closest friends were unaware of the relationship.

"We've just wrapped up the Robertson business," he said in answer to her question. "He and his pal Smithers went down for eight years, I'm glad to say."

He watched her as she slid a couple of eggs into the pan. She looked pale, he thought, and there were shadows under her eyes. He hoped this business at the school wasn't getting her down.

For it was a time of change at Ashbourne; Gwen Rutherford, headmistress to Hannah's deputy, had, during the summer holidays, not only accepted the headship of the school in Toronto where she'd spent a year's sabbatical, but had unexpectedly married a Canadian professor. Her friends were still reeling from the double bombshell, but, more prosaically, the post she would soon vacate was now being advertised and a shortlist of applicants drawn up. Webb knew how desperately Hannah wanted that post.

"What about you?" he asked quietly. "How's it going?"

"Well enough," she answered, taking two plates out of the oven, "though it has to be said Gwen's mind's not really on the job. School used to be her life, but now, not surprisingly, Bruce takes precedence. At the end of lessons, for instance, when we used to get so much sorted out, she can't wait to get home."

Professor Cameron was taking a sabbatical in his turn,

5

wide mouth and deep-set grey eyes which even now, under her own scrutiny, appeared defensive. Natasha, indeed!

She turned away with a sigh. Well, she couldn't spend the next week hiding from Mark Aston. He'd probably have forgotten the incident anyway.

The cat wound itself sinuously about her legs, nearly tripping her.

"Yes, all right," she told it, and went to refill its bowl.

Sunday morning, and the prospect of a lazy day with Hannah. DCI David Webb stretched luxuriously and glanced at the clock. Only seven, dammit. Why did he always wake early, even on his days off? "Come about eleven, in time for brunch," she'd said. Which, he thought philosophically, gave him time for a leisurely read of the papers.

He collected them from the hall mat, made himself a cup of tea, and returned to bed, where he remained until he'd read all the different sections, and the dregs in the mug were stone cold. After which he shaved, showered, and, comfortably attired in sweater and flannels, ran lightly down the flight of stairs to Hannah's floor.

As she opened the door to him, the smell of frying bacon reached him and he sniffed appreciatively.

"Takes me back!" he commented. "Mother wouldn't let us out of the house without a cooked breakfast, but Lord knows when I last had one."

"Just as well, healthwise, but once in while won't hurt," Hannah replied, returning ahead of him to her kitchen. "How are things? I haven't seen you for a week or two."

Jonathan, on the other hand, had a flat down in Shillingham, near enough to bring his washing home, which he had no compunction about doing. Though Richard never failed to remonstrate, Natasha was secretly glad to feel needed; glad, too – though she felt guilty about this – that so far his girlfriend had not been included in the weekly visits home.

The day ahead, then, should pass pleasantly enough, without herself and Richard being thrown exclusively into each other's company. Then, tomorrow, the Writing School would begin, and the large house over the wall would fill with eager 'wannabes' – and, of course, their tutors, among whom would be Mark Aston.

Natasha drew a deep breath and lifted the whistling kettle off the hob. There'd been an embarrassing incident on his last visit; he'd come upon her unawares in the greenhouse, her eyes still filled with tears of shock and the imprint of Richard's hand across her face. His horror and concern had added to her distress, and she could only hope that her babbling explanations had made clear that this was the only time Richard had ever struck her.

Which was true, she reflected now, making the tea, though he'd come close to it once or twice. She could quite see why she irritated him; she irritated herself sometimes, and had long ago decided that the fault lay in her name, which by its connotations gave rise to expectations she'd no hope of fulfilling. A Natasha should be tall, beautiful and self-confident. Each time she introduced herself, she was sure the other person must think her name as incongruous as she did.

The hot mug between her hands, she went to the mirror and resignedly studied her reflection: straight fair hair, already touched with grey, hanging in a bob at chin-level;

3

reporter promise there'd be full-page coverage in the *Broadshire News*.

For herself, though, such occasions were an ordeal. Confronted with a roomful of people, even those she knew, she became awkward and tongue-tied, blushing like a schoolgirl when anyone spoke to her and miserably convinced everyone was asking themselves what an attractive, successful man like Richard Vine could possibly have seen in her.

Impatiently she turned her head on the pillow. Surely it must be nearly morning? Her mouth was dry after the wine, and a fluttering behind her eyes warned her that a headache was imminent. The bedside glass of water had long since been drained, and it was becoming imperative that she have a drink.

She slid carefully off the bed, pulling up the blanket to cover her empty place. Richard stirred, grunted, and settled back into sleep. Catching up her dressing-gown and thrusting her feet into slippers, Natasha let herself quietly out of the room.

A low-wattage lamp burned on the landing, and by its light she made her way downstairs to the Aga-warmed kitchen. The clock on the wall pointed to five forty-five.

She took down a glass and filled it under the tap, drinking the icy liquid in one draught. Then, thirst slightly assuaged, she filled the kettle. The cat, resigned to the inevitable, jumped down from the back of the Aga and proceeded to wash itself in the middle of the floor.

It was Sunday, which meant that Jonathan would be coming for lunch, and possibly Polly too; she'd said on the phone that she'd try to get over. At nineteen, Polly was part-way through a course on media studies at Broadshire University, a fifty-minute drive away.

One

After all the tumult – the gathering speed of the runaway vehicle, the screams of the passengers, and the crashing, bouncing roar of its descent – there was an eerie silence.

At the bottom of the bank the minibus lay on its roof like a broken toy, its wheels spinning helplessly in the air. Inside it, there was neither sound nor movement. Petrol bled from the shattered tank, deepening the darkness of rocks and branches like lifeblood draining into the earth.

As the shock waves of the crash receded, birds which had been startled from their night-time roostings began cautiously to return, and a rustling, uneasy quiet settled over Chantock Forest.

Natasha Vine lay motionless in the wide bed, listening to the deep, rhythmic breathing of her husband and reflecting on the previous evening.

Thank God it was over. The prospect of entertaining forty people who didn't know each other had filled her with panic for weeks beforehand, but it seemed to have passed off quite well. Richard, of course, loved parties, and from his viewpoint it had been a spectacular success – an unusual gathering which at the same time discreetly promoted the Grange. She'd heard that young

1

GREEN GROW THE RUSHES-O

I'll sing you one-O!
(Chorus) Green grow the rushes-O!
What is your one-O?
One is one and all alone and evermore shall be so.

I'll sing you two-O!
(Chorus) Green grow the rushes-O!
What are your two-O?
Two, two, the lily-white Boys, clothed all in green-O,
(Chorus) One is one and all alone and evermore
shall be so.

I'll sing you three-O!
(Chorus) Green grow the rushes-O!
What are your three-O?
Three, three, the Rivals,
(Chorus) Two, two, the lily-white Boys, clothed all in
green-O,
One is one and all alone and evermore shall be so.

Four for the Gospel-makers.
Five for the Symbols at your door.
Six for the six proud Walkers.
Seven for the seven Stars in the sky.
Eight for the April Rainers.
Nine for the nine bright Shiners.
Ten for the ten Commandments.
Eleven for the eleven that went up to Heaven.
Twelve for the twelve Apostles.

This first world edition published in Great Britain 1999 by
SEVERN HOUSE PUBLISHERS LTD of
9–15 High Street, Sutton, Surrey SM1 1DF.

First published in the USA 1999 by
SEVERN HOUSE PUBLISHERS INC., of
595 Madison Avenue, New York, NY 10022.

British Library Cataloguing in Publication Data

Fraser, Anthea
 Eleven that went up to heaven
 1. Webb, Chief Inspector (Fictitious character) - Fiction
 2. Police - Fiction
 3. Detective and mystery stories
 1. Title
 823.9'14 [F]

 ISBN 0-7278-5402-X

Typeset by Palimpsest Book Production Ltd
Polmont, Stirlingshire, Scotland.
Printed and bound in Great Britain by
MPG Books Ltd, Bodmin, Cornwall.

ELEVEN THAT WENT UP TO HEAVEN

Anthea Fraser

Recent Titles by Anthea Fraser

The Detective Chief Inspector Webb Mysteries
(in order of appearance)

A SHROUD FOR DELILAH
A NECESSARY END
PRETTY MAIDS ALL IN A ROW
DEATH SPEAKS SOFTLY
THE NINE BRIGHT SHINERS
SIX PROUD WALKERS
THE APRIL RAINERS
SYMBOLS AT YOUR DOOR
THE LILY-WHITE BOYS
THREE, THREE, THE RIVALS
THE GOSPEL MAKERS
THE SEVEN STARS
ONE IS ONE AND ALL ALONE
THE TEN COMMANDMENTS
ELEVEN THAT WENT UP TO HEAVEN *

Other Titles

PRESENCE OF MIND *
THE MACBETH PROPHECY *
BREATH OF BRIMSTONE *
MOTIVE FOR MURDER *
DANGEROUS DECEPTION *

available from Severn House

feudal law, were gradually eroded. The town councils, dominated by merchants, incorporated the new legal principles into municipal law and set about dealing with all the implications of this transferal—for the rules on the husband and wife's shared responsibility for debt repayments and the security of the wife's dowry should her husband fall into debt; division of property and in extreme cases divorce due to proven business malpractice on the part of the husband; and the relaxation of the merchant woman's legal obligation to be present in her home town during the tax-collecting period.

The legal backing given to the tradeswoman helped considerably to increase her sense of responsibility and independence, whether in dealings with trade partners, her husband, her family, or the town community. In this way the joint activities of husband and wife in west and central European trade and export centres strengthened the merchants as an economically influential group, in the interests of both the merchant-dominated town councils and the great feudal lords who were especially interested in improving the internal structures of their territories.

Women in the Crafts and Other Town Trades

The development of the town economy was not limited to trade alone but was also closely bound up with the specialisation and intensification of craft production. And since trade stimulated the demographic growth of the towns, new demands began to be made in the inn-keeping and services sector, medical and social services, town administration, and construction. The complex network of trade and cultural links between towns with economies based on either long-distance trade, export, or mining, and the corresponding increase in the obligations and duties of the prosperous burghers, further stimulated the cultural needs and educational aspirations of town dwellers. What was the situation with the other professions, those not connected with merchant trading, in the medieval European town? Did their growth encourage the professional employment of women to the same extent that the economic development of the towns and their partial liberation from the rule of the feudal town lords did?

* In the case of merchants we had such obvious and informative sources as account books and business letters. This is not the case for the town craftworker. Neither do wills offer such detailed information. There are various reasons for this: the majority of the craftsmen, in order to remain competitive, had to draw on the labour of the whole family—for work in the house and workshop and for selling their products—and could hardly benefit from the increase in secular educational opportunities that occurred from the thirteenth century onward. On

the other hand, it was not necessary for them to keep regular or strict accounts due to their modest turnover and limited circle of customers. In the official town legislation, which, with few exceptions, usually reflected the interests of the patrician and merchant strata, craftworkers and those working in other trades are given scant attention, being mentioned only in the context of guild legislation or in a list of their obligations in terms of services they had to provide to the town. The customs and laws of the craft guilds do, however, provide an extremely important form of source material and are revealing with regard to the living conditions of the craft families. They outline the legal conditions for women's participation in the crafts. In other words, they sketch the potential for women in this sphere, but they do not, unfortunately, permit us to estimate the extent to which this potential was exploited. The guild legislation was, moreover, mainly concerned with explaining such rules and customs which experience had shown were not automatically respected and which might, therefore, cause conflict. In short, as a source, the official guild legislation is not sufficient: to gain a picture that corresponds more closely to historical reality, it has to be supplemented by sources that provide a picture of how legal regulations were actually interpreted in daily life. These supplementary sources are provided above all by the rich archival material recording the sentences passed in court proceedings. The town and court records contain reports of court sentences for offences against property, the premature ending of employment,

complaints with regard to outstanding wage payments, compensation for medical costs and failure to pay wages, apprentice contracts, and so on. Such sources are just beginning to be explored and analysed.

We have very rich and informative sources for the capital of France, a country in which feudalism developed in a particularly typical fashion. The 'Book of Trades' *(Livre des métiers)*, drawn up and edited by the royal judge, Etienne Boileau, in 1270, probably on the order of King Louis IX (1226–1270), contains descriptions of the duties and rights of 100 Parisian craft guilds. The extent to which the trades listed in this book were actually practised can be roughly gauged by making a comparison with the Paris tax registers *(Livres de la taille)* of 1292, 1300, and 1313, which also list the number of independent working women. The woman's profession is frequently different from that of her husband. These registers are not totally reliable, since they cover only those crafts that were organised by a guild. Not all the professions practised by women had a guild organisation, and the actual number of professional women was therefore probably higher than the tax register tallys.

Bearing in mind the limitations of the Paris sources, we can still draw certain conclusions from them with regard to female occupations. One of the oldest practised exclusively by women in Paris was the beating, teasing, and carding of flax and hemp for textile making. The production of linen yarn took place in a mixed guild, with both men and women workers. Apprentices of both sexes had to undergo a six-year training. Flax and hemp spinning was also carried out in a mixed guild. It probably dated from the late thirteenth century, since Philip VI pronounced his approval of its constitution in 1349. The tax registers of 1292 and 1300 list 11 representatives of this profession, but do not state whether they are male or female. Likewise it is impossible to determine the proportion of female members and the position of the female members in the linen-weavers' guild that existed in Paris at the end of the thirteenth century.

There are 2 female wool spinners entered in the 1292 tax register under the auxiliary trades for woollen cloth production and 2 female woolworkers and 1 female carder in the 1300 registers. Among the clothmakers themselves, widows were the only women to have the status of master. This tallies with the number of women entered in the 1300 tax list: there were only 10 women compared to 350 men.

It was normal in the textile trades for women to help their husbands. The work of the cloth fuller, however, was so physically strenuous that the guild actually forbade the fullers' wives to help with their husbands' work. Widows were allowed to carry on their husbands' trade with the help of two apprentices and the children from the first or later marriages. But judging from the tax registers they do not seem to have made use of this right.

Women masters or workers were also a rarity among feltmakers. The 1300 tax register is the only one that mentions two female feltmakers *(feutrières)*. On the other hand, the ribbon- and braid-weaving guild, which incorporated members working with silk, twirl, wool, and cotton, had numerous female masters who could also be responsible for the training of apprentices. Widows of masters could carry on their trade independently, and since the tax registers of 1292 and 1300 list only 9 women and no men, it can be assumed that unmarried women were also allowed to work in this craft. On the other hand, men dominated the crafting of gold ribbon until the beginning of the fourteenth century. (This probably involved the beating of gold and production of a fine gold-leaf.) By 1400 the guild had almost doubled its membership and included 27 male and female masters, but the proportions are not known.

The Paris silk-manufacturing trade, which flourished until the late fifteenth century, produced some sizeable guilds that were an exclusively female domain. This was the time of the two separate silk-spinner guilds: one for those using large spindles and one for those using the smaller ones which produced stronger thread. The silk

spinners using the big spindles were professionally independent in every sense. They had the right to take on and train apprentices and to employ in their workshops their own children as well as the children of their husband's previous marriages. The husbands were obviously employed in different professions. The exclusively female guild had two male overseers who were commissioners from the town council (prud'hommes jurés). The guild for the small spindle silk spinners was open to men. According to its statutes, apprentices of both sexes could be trained in the craft over a period of seven years. This craft association seems to have been overseen by two male masters and two specially appointed women from the trade (preudesfames du mestier). Activities such as apprentice training could be supervised by female journeymen. In practice, however, the craft of silk spinning with small spindles seems to have been an exclusively female occupation. The 1292 tax register contains a joint entry for the tax payments of both the spinning guilds. The tax payers in this register include 8 female silk spinners; in the 1300 register, 36.

The number of tax-paying female silk weavers was also relatively high and they too formed an exclusively female guild. In order to be granted the title of master in this guild, a woman had to complete an apprenticeship successfully and practise the trade for one year with a spotless record. The guild was supervised by 3 male masters and 3 female masters (maîtresses-jurées). It is strange, however, that the tax register for the year 1300 lists 38 female journeymen (ouvrières de soie) and only 1 female (master) silk cloth producer. The category ouvrières de, female workers in such and such a trade, is often met in the source material and corresponds to a female journeyman, a term used in several senses in the Middle Ages. The strange disproportion between 1 female master and 38 female journeymen in the tax register can only be explained if one surmises that some rich female silk producers paid their taxes all in one go, handing over large sums of money to the council for this purpose, or that some female masters had large debts, which meant that they were incapable of paying taxes. Both of these suppositions are feasible in medieval European towns.

The Paris purse-makers' guild (faiseuses d'aumendières sarrazinoises) was another purely female organisation. Like the silk makers they were also obliged to complete a year as journeyman after the apprenticeship training before they could become masters. This was unusual for the time (thirteenth century), although it became the norm later on, in the fifteenth century. Finally, the silk hat makers is another example of a Parisian female guild. Paris also had a series of mixed guilds in which men and women could be masters with equal rights—the embroidery, pearl hat-maker, and yarn-maker guilds.

The female guilds all represented trades which required, apart from taste and a sense of fashion, a certain manual dexterity, particularly given the relatively underdeveloped level of the equipment used. The granting to women of the right to form their own guild was enough to stimulate female participation in this trade and must have had an overall positive influence on the quality of the goods produced.

Widows had the right to occupy the position of master in the butcher, pancake-baker, fishmonger, baker, rosarymaker, bagmaker, hatmaker, beltmaker, leathercrafter (cordouaniers), cutler, glass-grinder, tailor, and dyer trades. Of the 321 professions to be found within the trade and crafts sector of the second half of the thirteenth and early fourteenth centuries, and which are known due to the Paris Livre des métiers and tax register, 108 were practised by women, either as widows of masters, independent masters, wives of masters, journeymen, or apprentices. Apart from this, numerous serving girls were taken on as untrained labour when the workload required extra hands. Since Paris was the royal residence and the country's administrative centre, women were also employed to satisfy the various requirements of the court. The elevated status of these women can be guessed at from the legal sentences passed by the royal court.

It would certainly be misleading to make generalisations about the rest of Europe on the basis of the impressively independent work activity of the Paris women and their participation in the production of craft goods and services within the overall framework of the guilds. Paris was a royal residence, a city with a tradition of trading, business, and academic links with the rest of the world. Also, with a population of almost 80,000 in the fourteenth century, there was a high level of demand for craft goods in general, as well as for luxury goods, groceries, skilled services, and manpower. Even the less well-off had plenty of opportunities to acquire a modest level of training or education. Thus the possibilities for the female inhabitants of the city to be active in certain crafts and to produce them independently were unusual, and marked the peak of what could be achieved with regard to female professional work within the medieval town guilds of western and central Europe.

In the English guilds, the attitude toward women compared badly with that of the Paris guilds, which on the whole had a positive effect on the position of women in the economic life of the town. In England it was, in some cases, strictly forbidden to take on women as auxiliary workers unless they were wives of a master or her maid. This was the case, for example, in the first half of the fourteenth century in the London belt-maker guild or in the second half of the fifteenth century for the weavers' guild in Bristol. The cloth fullers of Lincoln demanded in about 1297 that no one should work in the craft except the wife of the master or her maid. Yet because of demands made on craft production in everyday English town life, the strict rules limiting female participation were not always observed. Wills show that craftsmen left money—among other things—for the professional training of their daughters. The wife of a London cutler had to swear in 1364 that she would provide her girl apprentice with clothing and not punish her with a stick or a knife. London silk producers also had apprentice contracts. They have not been organised in a guild, but whenever a matter such as foreign competi-

tion posed a threat to their craft, they would arrange agreements and in 1368 and 1455 even managed to arrange royal audiences. On these occasions, they argued in the following vein: 'Sheweth unto your great wisdoms and also prayen and beseechen the Silkwomen and Throwstres of the Crafts and occupation of silkwork w'in the City of London, which be and have been crafts of women w'in the same city of time that no mind runneth to the contrary—that where upon the same crafts, before this time, many a worshipful woman within the city have lived full honourably and therewith many good households kept and many gentlewomen and others in great number like as there be more than 1000, have been drawn under them in learning the same crafts and occupation full virtuously under the plesaunce of God, whereby afterwards they have grown to great worship'.[11]

Until relatively recent times, the reputation of an honourable woman in western and central Europe depended to a large extent on whether she could provide her family and her house with textiles, clothes, and other necessities. Thus we can safely assume that the above-mentioned 'noblewomen and many others' learned to work with silk not in order to make their living from the trade but to enhance their reputation as lady of the house or as potential marriage candidates.

The fact that the guild legislation in England did less to promote female work than that in other developed European countries, and that it was particularly unfavourable with regard to women working independently as masters, can be explained partly in economic and partly in political terms. Since the fourteenth century, wool, England's main export item, had been processed largely in rural textile centres, which had developed rapidly thanks to royally backed Flemish immigration. The old guild towns, on the other hand, went into decline. Their guilds lacked economic drive and thus the motivation to react in a positive way to the new demands of international trade. They remained conservative. The political situation in English towns thus di-

verged from that in Italian, French, and German towns. They remained firmly under the control of certain feudal lords or the king and as a result the guilds of London, for example, were dependent on the king and his officials.

One consequence of this conservative attitude on the part of the guilds was that the female inhabitants took on several subsidiary jobs. Many were forced by circumstances to contribute to the family income, to provide for the family alone, or simply to look out for themselves. William Langland describes such a woman, Rose, the wife of Avarice, in his *Piers Plowman*: 'My wife was a weaver and woollen cloth made. She spake to the spinners to spinnen it out. . . . I bought her barley malt, she brew it to sell. . . . Rose the Regrater was her right name. She hath holden huckstery all her life time'.[12]

The royal kingdom itself provided a certain amount of protection for professional female labour. A 1363 statute states: 'But the intent of the King and his Council is that Women, that is to say Brewers, Bakers, Carders, Spinners and Workers as well of Wool as of Linen Cloth and of Silk, Brawdesters and Breakers of Wool and all other that do use and work all handy works may freely use and work as they have done before this time without any impeachment or being restrained by this Ordinance'.[13] Such regulations were primarily to the advantage of the developing system of early capitalism in the textile trade and thus against the interests of the English town guilds, which were doomed to decline.

From the end of the thirteenth century to the second half of the fifteenth century independent female activity in the crafts became widely established in a number of western and central European maritime trade and export centres—the large towns of northern France, Flanders, northern Italy, the Rhine, southern and central Germany, Austria, Switzerland, and, to a lesser extent, in Poland and Bohemia. This development even spread to the medium-sized trade and manufacturing towns and also the smaller towns, whenever at least one branch of trade managed to specialise in export goods. It was usually the textile trade which did this.

* It tended to be the producers of clothing and luxury goods that formed guilds with free entry for women as apprentices, journeymen, and masters. These included the hemp-, linen-, and wool-processing trades—those who made rope, haircloth, cloth, towels, veils, braids, gloves, and hats; tailors, furriers, and saddle and purse makers; the belt makers; and gold-thread spinners and silk embroiderers.

One of the earliest guild organisations to grant equal rights to men and women was that of the furriers in Basle in the year 1226. Once they were members of the guild, women were allowed to work, buy, and sell in the same way as men. Women were also equal members of the furriers' guilds in Cologne, Frankfurt on Main, Regensburg, Lübeck, and Quedlinburg; and they were subject to the same regulations for the practice of the trade as the male members. Female inhabitants in the towns of Florence, Frankfurt on Main, Nuremberg, Munich, Mainz, Speyer, Cologne, Erfurt, Mühlhausen in Thuringia, and Nordhausen were active in the leather-processing trades—in the production of belts, purses, saddles, shoes, and parchment. In 1423 the guilds of Nuremberg, Munich, Mainz, Speyer, Frankfurt on Main, Basle, Worms, Fritzlar, and Strasbourg got together to formulate a ruling on the parchment trade, which gives permission in principle for the female inhabitants to practise the trade. The permission does not, however, extend to those women who marry outside the parchment trade: a clause designed to prevent individual guild members from enjoying economic advantages. Although the town of Erfurt was in no way affected by this joint agreement between southwest German towns, the Erfurt town council passed a ruling on their own town parchment trade in 1427 which forbade one female member to continue practising because she had married a man who was of a different trade and came from a different town, carrying out his business in Arnstadt. The Erfurt woman was banned from practising the parchment trade as long as her husband lived in Arnstadt and had a house and property there. The

female felt hat producers in Lübeck got full rights as members of the guild organisations during the fourteenth century, those of Frankfurt on Main in 1407.[14] In the Nuremberg regulations of 1398, 1400, 1417, and 1420 the widows of hat makers are mentioned; each year, there was one female master, and in 1430 there were two.

According to the public records of Strasbourg, in the years 1445–1469, among various women given citizens' rights there were 3 who had the obligation to serve in the guild of the clothmakers and cloth shearers. In 1334 there were already 39 unmarried women and widows who were members of the Strasbourg wool-weaver and clothmaker guild. The town council in 1330 had already decided that women who weave woollen cloth or cotton cloth or loom cloth or employ a lad had to be members of the weavers' guild. Lists of members and contracts of the Strasbourg clothmaker guild contain 37 female names for the years 1400–1434. These women were, in all probability, active as independent masters within the cloth-producing trade. They included some dyers and some glove makers. In the fourteenth century, both sexes could also be members of the wool-weavers' guild of Frankfurt on Main. They are mentioned in the wool-weaver decree of 1377 (dyers and wool or yarn spinners came under the umbrella of this guild). The constitution of the Hamburg wool-weavers' guild, which dates from the first half of the fifteenth century, permitted only the widows of masters to enjoy the rights of a master, so long as they had no sons and did not remarry. In Munich and Stuttgart there was a guild for the whole weaving trade, and female masters of the three types of weaving in the town—wool, veil, and linen—were admitted. Apart from a few towns, such as Hamburg and Munich, it was usually the case in Germany that veil, fustian, and linen weaving remained outside the guild organisations until the fifteenth century, when guild membership became compulsory in these branches of the textile trade in, for example, Frankfurt on Main, Hildesheim, Ulm, Duderstadt, Neuss, and Strasbourg.

All these guilds were dependent on women's involvement. This was officially recognized in the masters' regulations of Munich, Frankfurt on Main, Stuttgart, Strasbourg, Hamburg (limited to the so-called small work), and Ulm, as long as the woman and her children had been citizens of the town for five years 'with house and goods'. In Neuss the linen weavers received statutes, which were obviously designed to promote women's independent work within the trade, since single women in the linen-weaving trade were entitled to a 50-percent reduction in the guild membership fee. The statutes also permitted the masters to take on their wives and children as apprentices. This must certainly have consolidated the position of the master's wife within the trade. Should she be widowed, she could be sure of being recognized as a fully qualified master. According to the sources, in the Ghent textile trade too, the husband had the right to train his wife. In the medium-sized merchant and manufacturing towns, where there was probably more fear of competition from lower-paid female labour than in the big trading and manufacturing centres, it was more difficult for women to be active in the trades. Sources relating to the history of Bamberg, Trier, Mühlhausen (Thuringia), Zwickau, and Chemnitz hint at maids being employed in the trades; there is less evidence of independent female masters, other than widows of masters in the textile trade.

Before we turn to the subject of female labour in other trades, it is worth pausing for a moment to consider the position of women in the Cologne textile trade, since it is particularly well covered by historical documents and research. The textile trade was one of the most important branches of the medieval trades in Cologne. 'Women were well represented in the textile guilds and their subsidiary trades and the very nature of this trade served to promote female employment. They did here in an organised manner what they had had to do for centuries: spinning, weaving, bleaching, wool carding, burling and similar work'.[15] Yarn and silk were produced exclusively by women. They had the rigth to belong to

the linen-weaving and the fustian- and blanket-weaving guilds. On the other hand, independent female masters seem to have been the exception in the cloth-cutting, wool-weaving, and dying guilds. Generally, as we have mentioned, the right to be a master was limited to masters' widows, who were allowed to carry on the trade with a boy helper. The Cologne tailor trade also belonged to the textile-processing sector in a broader sense. Widows, daughters, and wives of masters were admitted to the tailors' guild. Others were permitted to take on female apprentices without leaving their status of seamstresses. Thus the Cologne tailors were subject to employment restrictions that were not observed in other large towns, such as Lübeck and Frankfurt on Main, or even in medium-sized towns, such as Siegburg and Überlingen. The drastic employment restrictions for female tailors were laid down in a 1426 town council decision, which was followed by a similar council decree in 1440. This actually suggests that these restrictions were difficult to implement. According to the decree, women were only allowed to remodel old petticoats or produce new ones made of patterned fustian or light material. The seamstresses were strictly excluded from the production of silk or woollen clothes, which would have been a much more lucrative occupation. Similar restrictions on female employment are found for the seamstresses of the town of Constance at the beginning of the second half of the fifteenth century. The Mainz tailors' guild's book of regulations dating from 1369 to 1447 gives us reason to believe that in fact the guild rules were, in practice, subject to the individual interpretation of the masters. This was true of the membership fee and the way in which this was paid; also of the permissible volume of work and the right to train female apprentices.

Despite certain restrictions on female labour in some branches of the textile trade, female guilds were formed in both Cologne and Paris. Particular mention should be made of the female yarn-makers' guild, which came into existence between 1370 and 1397. Cologne yarn—

'a linen thread, which was usually dyed blue and was distinguished by the way it was treated and finished and by the trueness of its colour'[16]—was a quality item for which there was international demand. The female yarn makers who formed the guild finished the linen, which had already been prepared by the twisters. Strict control ensured that no one mixed extraneous yarn (Erfurt yarn is mentioned frequently) with the native yarn.

According to an official charter dating from 1397, the size of the craft workshops was determined in such a way that every female master could introduce only one of her daughters to the guild. The mother, as master, was allowed to employ three female apprentices or waged workers trained in the profession, but the official charter allowed the daughter to employ only two such workers. In addition, the independent yarn maker could have the fabric processed outside her home over a period of fourteen days (with the possibility of an extension on this time limit).

The gold spinners were a part of the goldsmith trade that specialised in the production of fine thread through the beating and stretching of gold and silver. Metal threads made from gold, silver, silver-coated copper, or leather coated with metal were used immediately for weaving or were passed on to the gold spinners to be mixed with a base thread of silk, linen, or cotton. A tribute to the quality of the Cologne gold thread, which could be identified by a special marking, is provided by the fact that, in 1382, the highly developed silk trade in the northern Italian town of Lucca forbade the use of foreign silk or other materials for the production of its materials but made an exception in the case of the Cologne gold and silver thread—which was expressly called for in the most exclusive types of brocade. Like the yarn makers, the gold spinners and gold beaters were granted a guild charter. And as with the yarn makers, an attempt was made to create equal opportunities for the members of the guild through a ruling on the size of workshops. Unmarried female gold spinners were allowed to take on four girl helpers. If a female gold spinner was married

to a gold beater, her husband was allowed to employ three girl spinners to help her.

A female guild was also formed within the Cologne silk trade, which dates from the mid-thirteenth century. The female silk-maker guild was called the *Seidamt* (silk office) in local dialect. This guild was formed in 1437 and originally incorporated the silk spinners, before they were granted their own guild organisation in 1456.

The silk trade included the silk dyers and two other specialised categories which were particularly important in attracting foreign trade: the silk embroiderers, who mainly produced liturgical garments, bishops' mitres, and ladies' bonnets (Cologne *ransen*), and the heraldic embroiderers. According to the official charter of 1397, men and women had equal rights as members of the guild of heraldic embroiderers.

The guild charters and supplementary rulings on all female and mixed guilds within the Cologne textile trade contained, primarily, regulations on the quality of the manufactured goods destined for export. Thus article 1 of the Cologne yarn-makers' charter, dated 14 April 1397, states: 'Whosoever, woman or maiden, wishes to learn the yarn trade in Cologne, should serve four years and no less, so that she learns to make and prepare export goods'. According to article 3, on completion of the apprentice period, 'the women who have been sworn in should check her work to establish whether it is worthy of export or not'. For the same reason the charters of the silk makers contained numerous regulations on permissible raw materials. The use of twisted silk or silk dyed with woad was forbidden. Silk cord was to be made only from brocade silk or good silk thread. No one could be permitted to fraudulently mix dyed or undyed yarn with the brocade or thread. The goldsmiths or beaters, male and female, had to ensure that they worked with good-quality precious metal.

A very different picture from that of Cologne and the other towns and regions considered so far is presented by the Italian towns of Florence, Siena, and Perugia in the fourteenth and fifteenth centuries. Here the social position of professional women engaged in goods production was not consolidated and reflected in the guild structure. Against a background of a strong early capitalist development in the main textile centres, the character of the guilds had gone through a fundamental change. They served to bolster the political-economic interests of early capitalist entrepreneurs and the town oligarchies. Under these conditions the women employed in the textile trades were doomed to remain at the level of journeymen, unskilled auxiliary staff, or, to a greater or lesser degree, wage labour. Their position was especially disadvantageous due to the abundant supply of rural labour for early capitalist enterprises.

Although the combined individual branches of the textile trade made up the sector with the most intensive export links within town goods production until the late Middle Ages, it would be wrong to assume that this was the sole area where women were employed professionally and wherein particular skilled female labour could be found.

* Some of the grocery trades were often practised independently by women: baking, with all its specialisations (cakes, unleavened bread, pastries); the butcher's trade; river and lake fishing; oil pressing; market gardening; and beer brewing. We know, for example, that there were female bakers in Constance, Basle, Troyes, Regensburg, Cologne, Hildesheim, Hanover, Frankfurt on Main, Görlitz, Striegau, and Halberstadt. Some idea of their importance to the supply of a large city is conveyed by the register of deaths in the Nuremberg St. Sebald parish, according to which 27 female bakers died within a period of 79 years—between 1439 and 1517. Of these, however, only 8 died between 1439 and 1477, although Nuremberg was particularly badly hit by the plague and the female mortality rate in the St. Sebald parish peaked in 1448 (at 48.6 percent) and 1449 (52.4 percent). The relative increase for the period 1477 to 1517 suggests that there was a large increase in female employment in baking in the late fifteenth century. A

regulation concerning bakers and millers in Neumarkt (Silesia) toward the end of the fifteenth century decrees that baking bread, bread transportation and selling should only be practised by those men and women who had learned the trade properly from a skilled master. Female millers existed in Strasbourg, Nuremberg, Görlitz, Baden, Hildesheim, Brunswick, and Mühlhausen. One can, however, not prove if they ran the business independently. We shall ignore here the large number of women who acquired parts of mills in the form of life annuities.

Independent female master butchers are less common. In Frankfurt on Main they could only practise if they were widows and ran their dead husband's business with the help of a journeyman. The 1397 charter of the Cologne butchers granted men and women an equal position in the guild as long as they had Cologne citizenship. The Leipzig town council passed a regulation on butchers seventy years later. It allowed not only the widows of butchers but other women familiar with the trade to be active in the guild, without any restrictions. This was connected with the abolition of an extremely old custom—a sort of unwritten guild law that had until then been strictly observed—whereby journeymen and servants were not allowed to cut up or distribute meat for retail trade, even when the master was present. Because this was a trade that required a certain amount of physical strength, it had been impossible before this new regulation for widows or other independent tradeswomen to practise in Leipzig, and probably elsewhere as well. The considerable increase in the number of female butchers in Nuremberg between the years 1479 and 1517 points to a similar waiving of unwritten guild rules. There are records of fisherwomen in Nuremberg, Frankfurt on Main, Görlitz, Warsaw, and Plau (Mecklenburg). They, like their butcher counterparts, were dependent to a large degree on the labour of their sons and servants, for the catching of the fish and sometimes the selling of it, since strict market regulations excluded women from trading in fish. Yet in those places where fishing and fish processing were important for export, as for example Scania, female labour was indispensable.

Market gardening only became a trade in its own right in the more heavily populated medieval towns, since in the medium- and small-sized towns the people were still self-sufficient in garden produce and could sell what they did not need at the market. Nuremberg, Strasbourg, Hamburg, Lübeck, Danzig, and Ulm each had a population of over 20,000 in the fifteenth century and thus counted among the most densely populated medieval towns. The two towns first mentioned had gardeners' guilds. Between 1446 and 1453, 6 women in Strasbourg acquired the right of citizenship in order to be admitted to this guild—a number never surpassed by any other guild in Strasbourg. In the same period, a total of 14 women were admitted to 12 other guilds. In the tailors' guild only 2 new women members were admitted. The St. Sebald (Nuremberg) parish death register lists five female gardeners for the period 1439 to 1477.

The trade most commonly practised by women in western and central Europe apart from textile work was beer production. This seems to have thrived in every type of town, from mining settlements to maritime or export-manufacturing towns. Women were strongly represented in this trade because of the traditional division of labour between husband and wife, whereby all work done in the house was performed by the latter. It was essential that the female citizen be firmly established as a house- and landowner, since brewing rights were linked to house and property rights. Since the town council and the houseowner could not always agree on whether a house had brewing rights, the councils began to have lists drawn up by the town clerk of all the approved brewing places. This was also the basis upon which the town council demanded the brewing fee, which represented a by no means insignificant part of its income from taxes. In the annual accounts of the town budget of the Thuringian town of Mühlhausen there are, at the beginning of the fifteenth century, en-

tries for a whole series of female citizens, many of them widows, paying such fees. Some wills testify to the value of income from brewing in making provision for widowed women. Thus we have two wills from Stralsund for the year 1347 which, before listing all the other legacies left to the wives, state that the brewing apparatus (the brewing or malt house with the brewing vessel, or just the brewing vessel and vat) should not be shared with anyone, not even with the children. The significance of brewing right for town families and unmarried women is underlined by the fact that female members of the town community joined in a conflict over the right to brew beer and to serve wine that took place in Jena in 1404 between the patrician upper stratum and the town burghers.

Records for the Saxon textile and mining town of Zwickau for the period 1503 to 1521 show that 24 women held brewing rights; some made full use of them and had a lad to help them. Among those were women by the names of the Vilberin, the Bernwalderin, the Herselmüllerin, and the Ceyslerin. Six of the 24 women are listed over the whole period among the Zwickau brewers. Of these, 3 held the malt award, the mark of quality that brewers who dealt in wholesale trade had to have branded on their beer barrels. The above-mentioned death register of the St. Sebald parish in Nuremberg mentions a number of brewers, just slightly fewer than the number of female bakers. Of the 22 female brewers buried, 17 are entered for the second period of 1479 to 1517. The Hanseatic city of Hamburg had a beer-brewing trade geared to export and likewise incorporated a considerable number of professionally independent women.

A sign of the status resulting from the particular quality of the beer produced by individual female brewers can be seen in a contract drawn up on 10 October 1420 between the town of Cologne and Fygin von Broikhusen and her husband, who was obviously present as her legal guardian. With this contract Fygin commits herself to teach two Cologne brewers how to produce *grut*[17]:

'Thus that I, the aforementioned Fygin with the knowledge, approval and permission of my aforementioned husband have agreed with the honourable wise gentlemen mayors and town council of Cologne . . . that I shall loyally and industriously and to the best of my ability teach two men to make good *grut*. These two men shall be appointed by them. They have appointed a man by the name of Hermann von Aiche, the brewer upstream near Airsbuch, whom I have already begun to teach and whom I shall continue to teach and another, whom they still have to appoint . . . without dishonestly withholding any of my knowledge of making the aforementioned *grut*. With this document I have obliged and committed myself to do this for the aforementioned gentlemen and the town of Cologne for eight consecutive years, beginning with the date of this document. And whenever they let me know that they need me for their *grut* making I shall, unless I am ill, come to their town of Cologne to instruct and teach. And for every day that I leave my house and live in Cologne for this reason they shall give me one mark of the Cologne currency to cover my labour and my upkeep'.[18] Further on, a fee of 115 Rhine guilders is mentioned, to be paid by the Cologne council by way of remuneration for Fygin's efforts. The husband vouches for his wife's reliability in honouring the contract. He states that he is prepared to offer himself as a hostage if necessary, and, as such to lodge himself, one manservant, and two horses at his own expense in one of Cologne's 'respectable inns'. The Cologne council's partners in this contract were obviously not town citizens. It is possible that they were country nobility who had fallen onto bad times—which shows up the close connection between the town and the surrounding countryside, and the fact that women from the country would sometimes come to town to make their living.

Brewing was not a guild trade everywhere. However, it always took on guild status when it moved from local trade to export business, as was the case in Lübeck, Lüneburg, Göttingen, and Magdeburg. Like the women

in the textile and grocery trades, the female members of the brewing guilds could occupy various positions. For example, women by the names of de Heenyngesche and de Radesche were masters in Lüneburg; in Göttingen women employed as auxiliary helpers to carry the vats got 'nothing apart from eight pfennigs and their keep for one course of brewing'.

* One quite often comes across references to female labour in the physically more demanding professions. Of course, women worked in such service trades as laundering and bleaching, but they were also employed in trades usually practised by men—the various specialised trades within metal processing; barrel and crate making; building; and dispatch. We could add to this list rope making, soap boiling and candle making, basket making, broom and brush making, wooden and earthenware dish production, bookbinding, and doll painting.

Women were employed in metal processing if there was a thriving export trade. In Germany this was the case in Cologne, Nuremberg, and Frankfurt on Main. The St. Sebald parish in Nuremberg registers, between 1439 and 1477, 9 female coppersmiths, 7 brass mounters, 1 cutler, 1 thimble maker, 1 wiredrawer, 3 tinsmiths, 1 compass maker, and 6 pewterers. A Nuremberg town council resolution of 1535 informs us that women were commonly employed as cutlers until the early sixteenth century. As early as 1349, a council decree refers to the labour of masters' wives and daughters in the glove-making and pressing trades. Here there is explicit reference to 'any work done with a hammer', which only these women are permitted to do. In Cologne in the fifteenth century it was common for women to work as auxiliary helpers in the harness- or breast-plate-making trades. The Nuremberg thimble makers gave masters permission in 1535 to employ women but only as piece workers—that is, they were to be paid for each piece of finished work. At about the same time, guild members among the Nuremberg needle

makers were granted permission to train their offspring, both male and female, in their trade. This was also the case in Lübeck. Provided women could prove that they were born within wedlock and had an untarnished reputation they were admitted to the guild as early as 1356. Fairly liberal rules governed the use of female labour among the Cologne needle makers. They took on young men and women as apprentices and did not insist, as most other guilds did, on evidence that they were of legitimate birth. This was, however, only the case at apprenticeship level; the rules on admittance of female masters were different. Other branches of metal processing in Cologne, such as the copper mounters and pewterers, granted 'widows' rights' and allowed widows to continue the work of their husbands' workshop with the help of male employees. The copper mounters allowed the master's daughter to continue the business on his death. The guild charters of the smiths and sword makers suggest that they neither granted 'widows' rights' nor allowed women to be employed in the trade. By way of contradiction, however, we find that three female smiths—of whom one at least, Fya upper Bach, the 'smithy of Siberg', seems to have been an independent master—held office in 1389 and 1417. When she was granted Cologne citizenship from 1389 to 1398, she was already entered as a smith. We also have evidence of 'widows' rights' in the sword-maker trade at the end of the fifteenth century. In Frankfurt on Main in the fourteenth and fifteenth centuries there were women working as metal casters, cutlers, bolt makers, scythe smiths, sieve makers, and knife grinders; in Augsburg they were active among the wheel makers, cutlers, blacksmiths, and locksmiths. Even a modest central German town such as Grimma had a regulation concerning male and female masters of smiths' shops in the middle of the fifteenth century, designed in particular to regulate the mutual poaching of apprentices and servants. According to a 1492 ruling on masters and journeymen in the small hammersmith workshops of St. Gallen in Switzerland, women were admitted to the trade, participated as

equal members at the annual general meetings, and had an equal say in economic decisions.

If we take the pronounced division of labour within the house of the craftsman into account, it can be assumed that by no means could all these economically independent female craftworkers spend their work days in the workshop. A female master or the wife of a master must have been in a position to evaluate the quality of the work and to provide facilities in which careful and profitable work could be carried out. Moreover, they had to oversee the sale of the wares produced in the workshop.

In towns that lay on trading routes and in the large sea-trading towns, the most important professions, apart from the grocery and textile ones, were those related to trading—crate making, strap and wheel making, rope making, coopery, and dispatch. These required significant manpower and provided another source of employment for economically independent women. Thus, for example, the ruling on the Lübeck crate makers of 1508 permits old and ailing widows to carry on their husband's trade with the help of a male journeyman until their own death. The council charges them only one-third of the guild membership fee. These widows were allowed to continue employing an apprentice. If there was a son, the widow was supposed to work with him until he was of age and could do the work independently. 'Widows' rights' were still valid in the Lübeck wheel-makers' guild until the beginning of the sixteenth century, although they only applied to women who were no longer of an age when they were likely to remarry. In the mid- to late fifteenth century there was a female member of the Strasbourg cartwrights' guild. The rope-maker trade was practised by female citizens of Frankfurt on Main, Nuremberg, Leipzig, and Erfurt. In 1425 the Erfurt council negotiated a contract between rope makers and beaker makers according to which the wives of the latter could produce hoisting ropes and sell them elsewhere. Source material relating to the transport and dispatch trades refers to female wool packers

working in England in 1507. These women were based in Southampton and had formed an organisation similar to that of a guild that was run by two chairpersons elected annually from their own ranks. In Frankfurt on Main, female cart loaders were represented in the transport trades. Both of these packing and loading trades undoubtedly required a lot of physical strength; this is underlined by a source relating to the wool packers which states that 'they lifted the bales and sacks with their own hands'.

Without attempting to give an exhaustive list of the guild trades practised by women, it is worth giving brief mention to the women members of the guilds in the building trade, who come up fairly frequently in the source material. A 1271 ruling on the masons, plasterers, carpenters, coopers, cartwrights, winnowers, and wood turners of Basle allows women to join the guild as long as their husbands are still alive, and providing that they remain widows should their husbands die. This ruling can hardly refer to women doing professional work in the trade. It is more likely to refer to those who joined the guild but had only co-operative and social duties. This was, however, no longer the case in the building and building-related trades in the late Middle Ages. Written and pictorial sources suggest that women were employed in the hard physical work involved in the building, mortar-mixing, roof-making, and glazier trades. In Frankfurt on Main there were female claywall makers and women employed in the lime works; in Nuremberg there were female glaziers. In Mühlhausen (Thuringia) there is a record of a woman clay transporter in the fifteenth century and a maid who was injured by a servant while lifting clay from a pit. In 1437 this woman demanded compensation and repayment of the medical costs; she was represented in court by her brother. In Strasbourg from 1452 to 1453, two women joined the masons' guild and were simultaneously granted the right to town citizenship. Women were employed in the ore works in mining towns, and although we only have pictorial sources as evidence for

this, they state the case quite eloquently. Thus Hans Hesse, for example, depicts on the reverse side of the Annaberg mine altar a female worker, in one scene hard at work and in another dressed in holiday clothing. Another, somewhat earlier pictorial representation of a female worker at the ore mines comes from Kuttenberg in Bohemia and dates from the fifteenth century. Pictorial sources from the middle of the following century, such as the illustrations for the works of Georgius Agricola *(De re metallica, On Mining)*, show women sorters at silver mines.

* Before we go on to look at the female professions not directly connected with the trade and the craft life of the town, it is worth reflecting for a moment on the effect that guild membership had on the status and position of the female craftworker in the town community. Here we first have to make the distinction between full membership and part membership. The former concerns the economically independent craftworker, who would usually be independently entitled to town citizenship but would have to apply for it if she were a stranger to the town. As with members of the purely female guilds in Paris, Cologne, and Zurich, full membership was conditional on completion of a guild-approved apprenticeship training. Part membership was particularly common amongst widows, who on account of 'widows' rights' were tolerated in the guilds. In England, a man's right to town citizenship could be passed on to his widow. The fact that numerous guild rulings on the 'widows' rights' state that she must have a competent journeyman in order to carry on her husband's profession would suggest that professional experience could not always be taken for granted.

Finally, another form of female membership existed and was probably the most common—a joint membership that included the wives of the male guild members and both expressed the fraternal-religious aspect of the guilds and acknowledged the role played by the wives in all the town trades. This included supervision and care of the maids, journeymen, and apprentices who were part of the master's household and provided competent back-up in the workshop.

Full membership meant for the economically independent female craftworker that she had to fulfill the same duties as her male colleagues. This involved, in the first place, meeting the usual terms of admittance, such as producing a birth certificate that proved that she was born in wedlock and testified to her untarnished reputation and, of course, payment of the membership fee. Daughters of local masters were usually entitled to a 50-percent reduction of the fee and exempted from having to produce a birth certificate. (In the fifteenth century, women who were strangers to the guild sometimes had to prove that not only they but their parents and grandparents were of good repute.) The economically independent female craftworker had to perform the duties that were required to varying extents by the different guilds. She had to contribute to the guard and defence duties of the guild members, not in person but through her financial contributions. Defence duty was regulated in such a way that one had to equip a representative, either by oneself or with other women, or keep a horse, again by oneself or with others. Details on the horse and pieces of armoury that had to be supplied are available for the Strasbourg clothmakers' and weavers' guild and for the citizens of the towns of Mühlhausen (Thuringia) and Görlitz. In some towns, women had not only the right but also the obligation to take part in the guild meetings. Thus article 12 of the Hamburg linen-weavers' decree of 1375 states that men or women who fail to attend the guild meeting are liable to a fine of six pfennigs and ten shillings, unless their absence is due to illness. If they failed to appear at the meetings more than three times they could be deprived of their title of master for one year. An updating of the bakers' statute in Striegau (Silesia) dating from 1393 likewise lists a penalty for the failure of men and women to attend guild meetings. Female masters of the yarn-drawer trade in this town were also present at guild meetings.

Widows were admitted to a large number of guilds and granted membership for a limited period or for life. These craftworkers, who produced their wares alone or with a son who was still under-age (an apprentice boy or a journeyman), were presumably also subject to the above-mentioned duties for economically independent female masters. A greater degree of security and more recognition was guaranteed, of course, by the master title, achievement of which was based on the successful completion of a recognized period of learning—which could be accomplished, for example, by apprenticing oneself to one's husband or father: the Neuss linen weavers, for example, decided in 1461, when trade was prospering, to allow themselves to take on their wives and children as apprentices.

The third type of guild membership stems from the co-operative nature of the guilds, which is reflected in the duty to support elderly and invalid members or relatives of members, and also in the communal celebration of a religious ceremony. Funeral attendance was, in particular, mandatory for guild members. Although the activity of the master's wife tended to be limited to this religious/co-operative side of guild life, it still served to enrich the lives of many female citizens, giving them the opportunity to leave their own four walls. The responsibility of the master's wife for all matters concerning the house and the workshop of the master was recognized by, for example, the Zurich town council when, in 1429, it obliged masters who could not attend meetings in person to send their wives as their representatives.

The number of economically independent females who on completion of an apprenticeship or by virtue of 'widows' rights' could practise a profession was, in the larger central European towns and in a considerable number of the medium-sized trading and manufacturing towns, quite significant. The reasons for this are varied, but all derive more or less from the economic make-up of the town economies in the late Middle Ages—a significant feature of which was the poverty suffered by craft families who begat more children than they could afford to support. Thus several women and one wool weaver, Jörg Bermenter, submitted the following written plea to the town council of Heilbronn in 1509: 'If now one of us or one of our husbands falls ill, it is obvious that we all of us are needy and poor people, among whom many have not received three farthings and some none at all from their parents, so that we have to keep ourselves through our own strenuous labour. And if it be forbidden for us to do the work we have done since childhood, then we will have to resort to begging in order to feed our children as well as the sick husband'.[19] Such poverty is underlined by the phenomenon of child labour, not only in yarn preparation and spinning, work for which even four- to five-year-old children were employed, but for work as shepherds and as cheap labour for domestic help and in vineyards.

The increase in the number of women working independently of their husbands was due, too, to the often sizable gaps in the labour supply brought about by high mortality rates in the towns as a result of the plague, overwork, and malnutrition. Male mortality rates seem not to be higher than the female ones and are sometimes even lower. The victims among the male population probably included independent masters, or journeymen who had completed their apprenticeships. The gaps that their deaths left in the labour force were filled not only by the widows of masters but by circumspect women whose husbands had different professions. Another fact to bear in mind is that the flow of women from the agricultural population to the towns continued unabated throughout the Middle Ages.

A certain, although perhaps only secondary, influence might have been exercised by the instability of the marriage bonds/vows, which we will come back to later. It was not uncommon for men to live in bigamy and for married couples to live and work separated by the town walls.

If we want to cover the position of women within the guild crafts, we cannot ignore those women whose work was most common and who, moreover, provided

a back-up for the rest of the professional structure of the medieval town. These were the female domestic staff, who had no set professional status and whose duties covered a wide range of tasks, which included providing auxiliary labour in the workshop. Numerous sources also describe them as performing the tasks of female journeymen or wage labour.

A recent examination of the classification of the female population in the social structure of the medieval trading and manufacturing town of Trier, carried out on the basis of the tax registers of 1364 and their topographical breakdown, has shown that women are most highly represented, at 51 percent, in the lower economic strata. In certain districts of the town, near charitable or religious establishments and in the weaver districts, women represent 70 or even 100 percent of the population in the lower strata. Obviously we are dealing here primarily with female workers in the weaver trade. Likewise in Basle in 1454 and Frankfurt on Main in 1495, the proportion of women in the lowest tax category is relatively high. In Basle 69.5 percent of this category (covering 1,072 people) in possession of 1 to 30 guilders are women and 45 percent are men; in Frankfurt on Main, out of 979 people liable for tax and in possession of up to 20 guilders 61.9 percent are female and 35.3 percent male. On the other hand, three districts of the town of Augsburg have records of an almost equal number of servant lads and maids. They record 334 servant lads (including 25 merchants' manservants) as opposed to 339 maids.

Results of available socio-statistical surveys indicate that overseas and overland trading towns in the late Middle Ages with a relatively broad upper stratum of long-distance and wholesale traders and scholars had a relatively large number of maids, whereas manufacturing towns had a larger proportion of servant lads.[20] There are clear indications that different wages were paid female and male domestic staff in professions such as wine making or construction. Thus female workers in the vineyards of Mühlhausen (Thuringia) were paid half

a man's (i.e., a child's) wage. Even under such pay conditions, female employment rates were high. On Würzburg building sites, for example, a large amount of female labour was employed on a daily basis between 1428 and 1524. The low-skill labourers received the following average wage, reckoned in pfennigs:

Year	Number of female workers	Wage	Number of male workers	Wage
1428 to 1449	323	7.7	13	11.6
1450 to 1474	1472	9.0	381	12.6
1475 to 1499	209	8.3	131	11.2
1500 to 1524	429	9.2	237	12.7

The pay conditions in the Würzburg building trade were no exception. This can be seen in a decree on maximum prices and wages issued to all towns and markets in the Steiermark, according to which serving lads, who carried stones or mortar, were paid 8 pfennigs per day and women doing similar work were to be paid only 7 pfennigs. A similar disparity in the wages paid to male and female workers is seen in the calculation of the average weekly and annual wage for two church parishes in Basle for the year 1451. The average weekly wage has been calculated for 123 maids and 157 (male) journeymen, and comes to 20.3 pfennigs for the former and 38.7 for the latter. The average annual pay for maids was 3.8 Rhine gold guilders and for serving lads 7.3. The pay for maids who had completed an apprenticeship and were actually female journeymen was better. Thus, for example, the female haircloth makers in Mühlhausen were paid the same piece-wage as the men. The real domestic maids were also at a disadvantage because part of their wage was kept back to buy them clothing (coats, shoes, skirts) or bed-linen and was only paid at the employers' discretion or after a legal complaint had been lodged.

In an earlier period, the Franciscan friar Bertold von Regensburg (1220–1272) had attacked in his preaching those who deprive 'working people of their well-earned wage' and who lend usurer's money instead of re-

munerating work done. The situation in the fourteenth and fifteenth centuries had certainly not changed for the better.

* Let us now turn to those professions not directly connected with the crafts or merchant trading, or tangential to them. In the overseas and overland trading towns, large manufacturing centres, and medium-sized and smaller towns situated close to important trading routes, the tavern- and innkeeper was indispensable to commerce; she could arrange cash loans or credit, and often helped store and organise the transportation of goods. An inn of good repute offered accommodation for long periods of time and had spacious storerooms and stables. Well-known inns served as meeting places for business and trade partners during trade fairs and markets; a tale by Ruprecht von Würzburg, written around 1300, tells of the rich Verdun merchant Bertram, who came to a well-known inn in Provins. When Bertram has finished his meal, so reports Ruprecht, the innkeeper insists on gossiping about wives and the merchant ends up having to prove his wife's loyalty by engaging in a wager.

The running of inns and taverns certainly required the help and co-operation of the innkeeper's wife. If she fell ill or died, her absence was felt by the guest as much as by the husband. One guest's regret is expressed in a letter from Martin Behaim, dated 17 September 1455, to his brother Lienhart, in which he announces the death of a lady innkeeper in Salzburg by the name of Turmeckerin.

Members of the ruling patricians' town council met in the inns attached to the town houses, and citizens would go there to seek information on town affairs. Likewise, taprooms and ale-houses were designed to meet social and information needs—both of through-travellers and of local inhabitants.

Particular discretion was required of innkeepers. One very plucky woman of Erfurt, Katharina Johans, who dared to write letters badgering a well-known customer into paying his drinking debts, had to make a public apology for her behaviour at a council meeting. The incident was recorded in the town records, since it was a matter of upholding the honour and good name of a citizen.

The successful female tavern-keepers with large hostelries had to be well versed in many aspects of life. They not only had to cater to the physical well-being of their

Husband and wife carry a large stone which will complete the roof of a chapel.
Woodcut, printed by Peter Drach, Speyer, early sixteenth century.
In: Albert Schramm, *Der Bilderschmuck der Frühdrucke*. Vol. XVI. Leipzig, 1933, ill. 450.

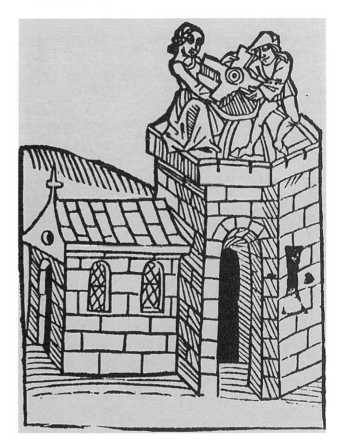

guests but were expected to provide entertainment for them. They would gather information on the currency exchange rates and political events and pass these on; and they arranged credit, acted as pawn-brokers, and mediated in commercial transactions. In a letter dated 24 October 1417, one guest does not hesitate to approach Zwickau innkeeper Dorothea Storchin (later the wife of Bastian 'aus der Müntze') as a 'respectable wise woman' in order to arrange credit. The diverse activities of the female innkeeper can be seen even more clearly in the reports of the most frequently mentioned Görlitz innkeeper, a lady by the name of Bleckerynne. She put up the guests who came for the woad trade, as well as guests of the town council, church officials, and, in emergencies, even the town mercenaries. Another large tavern was run by Orthey Rorerynne, who on several occasions received payments from the town council to cover the expenses of servants of the crown and who could, when necessary, put up fifty mercenaries with fifty horses. Another woman called 'old Rychterin' is recorded as possessing farmsteads and lodging woad transporters and mercenaries.

A female distiller.
Woodcut, printed by Johann Zainer, Augsburg, 1498. In: Albert Schramm, *Der Bilderschmuck der Frühdrucke.* Vol. V. Leipzig, 1922, ill. 452.

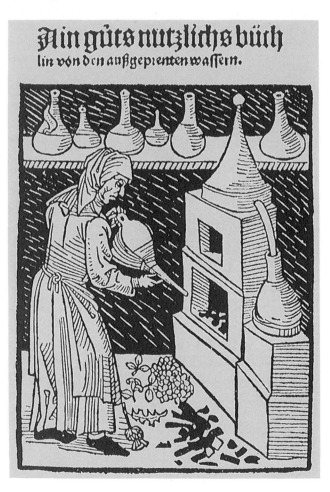

In contrast to the prosperous female innkeepers, the woman who had only a taproom/ale-house often had to cope without the help of a serving boy or girl; the Marseilles town council, for one, decreed in the thirteenth century that only the owner or the owner's spouse could serve beer or wine. There were other problems as well, such as conflicts between taproom owners and those citizens who had brewing rights, since the latter would serve the ever-popular ale in their own houses.

Women who ran the modest taverns and inns sometimes tried to supplement their income by treating minor ailments. Johannes Butzbach, recalling his travels in the 1490s, tells of a Nuremberg innkeeper who could fully heal his feet, which caused him great pain. He also attributes his timely homecoming to the intelligence of a Bohemian innkeeper in Karlsbad, one of whose spa guests—a Nuremberg merchant taking the waters with his family whom the innkeeper gave detailed information on Butzbach's financial straits—agreed to take Butzbach to Nuremberg in his carriage. A very different picture of the female innkeeper is painted by the Englishman John Gower (ca. 1330–1400)—a friend of Geoffrey Chaucer (ca. 1343–1400)—in his *Mirour de l'Omme.* He characterises an equally enterprising woman as follows: 'But to say the truth in this instance

the trade of regratery belongeth by right the rather to women. But if a woman be at it she in her stinginess useth much more machination and deceit than a man; for never alloweth she the profit on a single crumb to escape her, nor faileth to hold her neighbour to paying his price. All who beseech her do but lose their time, for nothing doth she by courtesy, as anyone who drinketh in her house knoweth full well'.[21]

✱ Social work and medical services—apart from in the English towns with a relatively small number of nuns and female religious bodies—was performed by establishments such as convents and Beguine houses, and by women outside the religious orders—doctors, midwives, their helpers and apprentices, bathkeepers, and others, especially those familiar with folk medicine. Both groups were indispensable until men began to be given medical training at universities, and consequently formed a professional body of doctors with a sound theoretical knowledge. Women were excluded from this new professional body, the one exception being a certain Francisca, wife of Mattheus Romano, who was granted recognition and approval as a surgeon with university training by the Duke of Calabria, Charles. The fourteenth and fifteenth centuries seem to be a transition period during which women's gradual squeezing out of health care only just began.

It was in Paris, one of the university centres of western Europe, where the medical faculty, deaf to all criticism, was particularly vigorous in its attempts to ban females from the medical profession. Here the thirty-year-old Jacqueline Felicie de Alemania was accused as early as 1322 of not respecting the ban which forbade anyone not in possession of a faculty decree and the approval of the Sorbonne rector from practising in Paris and the surrounding area. This ban also affected a Jewish woman, Johanna Belota, as well as Margarete von Ypernn, both of whom were well-known surgeons. In Germany a number of female doctors did enjoy the recognition of the town councils. In 1394, for example,

Religious upbringing meant that a doctor could be called only when women of good repute were present.
Miniature from *Chirurgia*, by Gerard of Cremona, twelfth century, Codex Series Nova 2641, fol. 60 r. Österreichische National-bibliothek, Vienna

the daughter of a since-deceased town doctor in Frankfurt on Main twice received remuneration from the town council for the healing of wounded soldiers. A medieval female army surgeon is also recorded in the Swiss *Spiezer Bilder-Chronik* (Spiez pictorial chronicle) of Diebold Schilling. In the fifteenth century, sixteen female doctors are mentioned in Frankfurt on Main, but their actual number is unknown. Most frequent mention is given to Jewish doctors and opticians. In 1457 the council refused a female Jewish doctor the right to stay in the town. On the other hand, in 1492, 1494, 1496, and

A midwife and an assistant stand by at the birth of twins (fol. 41 v.).

A midwife supervises the afterbirth (fol. 43 r.).
Miniatures from *Chirurgia*, by Gerard of Cremona, twelfth century,
Codex Series Nova 2641. Österreichische Nationalbibliothek,
Vienna

1499 the council allowed one, apparently very popular, female Jewish doctor to stay in the town without demanding the payment usually required from Jewish strangers for overnight stays. The female doctor's request to be allowed to live outside the Jewish quarter was, however, refused. In 1494 another ban was imposed on a Jewish female doctor. One female doctor and a married couple, both of whom were doctors, had practices in Hildesheim in the late fifteenth century. In 1477 a woman with medical knowledge received payment for looking after the wounded. The Görlitz town council's accounts record the employment of another woman, Tauwaldynne, for the healing of the town clerk's infirmities. According to Hermann Weinsberg, one woman was regularly consulted on medical matters in Cologne until the mid-sixteenth century.

We have plenty of examples, but it remains impossible to establish the extent to which these female 'doctors', with no formal medical training, could draw on medical knowledge to treat the various ailments.

One area of medicine where women's contribution was indispensable throughout the Middle Ages was in the treatment of female ailments. While the Catholic church forbade doctors to do practical examinations of women, and the women themselves were often too shy to go to a doctor, women would turn to a member of their own sex.

The midwife tended to be the great authority on female health care. Obviously she could draw on her practical experience, which from a very early date had been coupled with the theoretical knowledge of the doctor. The early miniatures in Gerard of Cremona's (ca. 1114–1187) *Chirurgia* show birth scenes, which confirms that this was the case.[22] The famous medieval work on female health care, the *Liber Trotula*, the origin of which is still unknown, leads us to surmise that there was a connection between the doctor and the female folk doctor, or the midwife.

It seems that such co-operation was common in Flanders, where it was not unusual for doctor and midwife

A woman is treated simultaneously with a herbal bath and herbal drink.
From *Liber Trotula*, 1446/66, Hs. 593, fol. 15 v. Municipal Library, Bruges

Women assist in the treatment of a patient laid out on an extension bed. Miniature from *Chirurgia*, by Gerard of Cremona, twelfth century, Codex Series Nova 2641, fol. 76 v. Österreichische Nationalbibliothek, Vienna

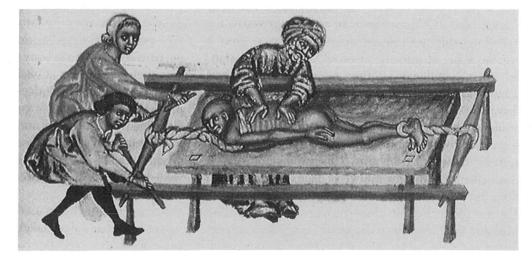

to be married. This is known to have been the case in Mons and Ghent. In the fifteenth century a Latin and a local dialect version of the *Liber Trotula* appeared in Flanders.

An English dialect version of the work is known to have existed in the fourteenth century. The author, in his introduction to the translation, makes the educational purpose clear: 'As women of our own tongue do better read and understand this language than any other, and every woman lettered read it to other unlettered and help them and counsel them in their maladies withouten showing their disease to man, I have this drawn and written in English'.[23]

The efforts of doctors and midwives to improve the health awareness and medical care of the female population were supported in numerous central European towns by the town councils. They employed town doctors and tried to lighten the load of the midwives.

The latter were not obliged to pay town taxes or perform guard duties, they were supplied with firewood, and in some towns the midwife's husband was excused from guard duty. The births on the whole took place at home. Those who gave birth in hospital did so through chance. This explains the minimal capacity in the Paris maternity home (*office d'accouchées*), which in the fifteenth century had twenty-four beds, with two to three women with babies per bed. In some large towns the midwives employed by the town council were given a regular wage. In 1381 the town of Nuremberg guaranteed them 1 guilder every three months. In Bruges their wage was calculated at 12 groschen per day provided that they worked 270 days per year. In other towns the midwives had to fight longer for a guaranteed regular income and lived from the voluntary payments made by grateful fathers or from gifts. This had the unfortunate consequence that some midwives neglected the women from the lower social stratum of the town. There is evidence of this in the Ulm decree on midwives dating from 1491 and the Nördlingen decree of 1517. These strictly forbid any union of midwives, since such unions could

Women place cupping glasses.
Miniature from *Chirurgia*, by Gerard of Cremona, twelfth century, Codex Series Nova 2641, fol. 62 v. Österreichische Nationalbibliothek, Vienna

hurt the common folk. The decrees guaranteed the town council more influence over the methods used by the midwives and were an attempt to ensure that the townswomen could be guaranteed competent help during delivery. Midwives were required to sit an entrance exam before the town council and experienced women of the town. The apprentice midwives and the helpers present at the birth were guaranteed a gift of money from the new mother's family which the midwife was forbidden to 'pocket'. The regulations also covered the careful training of the helpers, who were not to be prevented from performing their duties by work in the midwife's house.

The town council also used the midwives as a form of social control and demanded reports from them of any lapses in the moral standards of the town. Such midwife

decrees came into force in Regensburg in 1452, in Heilbronn in the fifteenth century, and in Constance in 1525. A number of other towns required that midwives swear on oath that they would perform those duties listed by the town. This was the case in Colmar in the fifteenth century and Würzburg in 1480.

The social tasks of the town citizens also included the care of foundlings and young orphans, either in their own houses or in homes established for the purpose. The records of the Ulm orphan and foundling home give us some idea of the importance of this work. In the fifteenth century it housed on average 120 to 150 children per year. According to a decree of 1491 only those children could be admitted whose parents had been resident in the town for 10 years; in 1503 this period was extended to 20 years. The women of the town would also help in the care of the elderly and sick, in the running of hospitals and in the organisation of funerals.

The picture of late medieval town life, especially in the large and medium-sized towns, would remain incomplete if we failed to mention the attempts of female citizens to make their way into the intellectual-artistic professions. Such attempts were usually in line with the specific interests of their families, since contributions by the wife and children to the husband's profession were not limited to trade and craftwork. Women helped with book illumination, scribe and teaching work, and the running of town offices. This meant, however, that the women and girls had to have a certain degree of education. This was usually provided by private tutors, in particular by church scholars without benefice, but in some cases the parents themselves would devote time to their daughters' upbringing and education. Beguine houses and convents also had a share in offering young girls a general education.

* The development of the secular schools undoubtedly had a favourable influence on the provision of education for the young girls of the towns. At the end of the thirteenth century, educational establishments in Flanders and Paris allowed the daughters of the upper social stratum to receive outside the parental home the elementary education in reading, writing, and arithmetic that was becoming increasingly necessary. Thus the future abbess of the Cistercian convent Nazareth, a patrician's daughter by the name of Beatrijs van Tienen, had been sent to school at the age of seven to learn the 'free arts'. Before this she had been given instruction by her mother, an early thirteenth-century 'merchant woman'. Another thirteenth-century Cistercian nun in Flanders, Ida Lewenis (b. 1260), was educated in a secular school that taught children of both sexes. In 1320 Duke John of Lorraine gave permission for five schools to be opened in Brussels to give girl pupils a basic education. Brussels actually already had, apart from the boys' school, one primary school for girls, which, however, gave instruction in the mother tongue only. Paris at the end of the thirteenth century had twenty-one female school teachers who acted as headmistresses for such elementary girls' schools. They were under the authority of the choirmaster of Notre Dame, whose permission was required by teachers before they could give instruction. Apart from these, Paris in the fourteenth century had even lower-level mixed schools, separate schools for girls and boys being first introduced in 1357.

The fourteenth-century French crown lawyer and political publicist Pierre Dubois in his reformist pamphlet 'On Recapturing the Holy Land' (De recuperatione terrae sanctae), which reads like a medieval peace programme, gives clear confirmation of women's access to a minimum education and of a desire among those in the leading town upper stratum for a more advanced level of education. His programme includes a proposal for educational reform, and it is typical of this bourgeois reformer to include in it the education of girls. In order to ensure France's leading role over all the other major powers, in Europe, Byzantium, and the Orient, Dubois worked out a detailed plan for the education of boys and girls from the age of four or six to six-

teen or eighteen years. According to his plan, 100 or more pupils, male and female, were to be installed in boarding schools (which were buildings confiscated from the Order of the Knight Templars or of the Knights of St. John of Jerusalem). The plan abolished the only elementary-level education for the girls. Like the boys, the girls had to acquire a sound knowledge of Latin and one other foreign language. The curriculum also envisaged an introductory course to the natural sciences, especially medicine and surgery, and instruction in some aspects of pharmacy.

There is little evidence of girls attending the elementary public schools in England. The author of the fourteenth-century English version of the *Liber Trotula* counts on literate English women to pass on the book's medical hints to their compatriots, which suggests that women's education here was a matter of individual endeavour. The prosperous Italian town burghers also employed private tutors for their daughters.

A large number of citizens, probably those from the middle strata of the town burghers, sent their children to the elementary schools, mainly to learn to read. (Villani in 1338 gives a figure of eight to ten thousand male and female school pupils for Florence, which gives some indication of how common provision of this level of education was.)

In Germany and Switzerland one can trace the beginnings of private and public (in the sense that the town council had some influence over them) school education back to the turn of the fourteenth and fifteenth centuries. Around 1400 the town council of Memmingen sent a certain Martin Huber to teach in a girls' school. He had to swear on oath before the town council that he would behave in a manner befitting the position and that he would not give instruction to any male pupils. There was still a strict separation of the sexes in the schools. In Emmerich the girls' school in 1445 was still formally under the aegis of the church, which had the right to enrol and dismiss the female teachers, but the town council had the right to nominate candidates for teaching

posts. It could make further nominations should the deacon and the chapter object to its original candidates. The Bamberg school decree of 1491 requires that German primary schoolteachers marry other teachers. This school decree also expressly requires that only those schoolmistresses who were really 'learned' be hired to teach children reading, writing, singing, and the general moral and ethical norms based on Catholic theology.

The traveller's diary *(Wanderbüchlein)* of Johannes Butzbach informs us that both Nuremberg and Bamberg, because of their high level of schooling, attracted pupils from other towns. Nuremberg also seems to have had numerous lower-level elementary schools toward the end of the fifteenth century. A chronicle recording the singing of the Nuremberg schoolchildren during the visit of Kaiser Frederick III tells us that male and female schoolteachers had pupils of both sexes: 'In the year 1487, German schoolmasters with their boys and girls and likewise the schoolmistresses with their boys and girls went to the Nuremberg fortress and into the chapel of the castle and sang German songs therein and afterwards they sang under the lime trees in the castle courtyard'. The Kaiser rewarded them with a sum of guilders which was afterward taken from the schoolmasters and mistresses by the Nuremberg town council, demonstrating the teaching staff's subordination to the town council. The Kaiser must have come to hear of the council's action, because he ordered all the schoolchildren to appear before him on the following Sunday. 'And thereafter, on the Sunday, about four thousand schoolchildren gathered, as ordered, below the castle walls and were given gingerbread, flat cakes, wine and beer'.[24] Even if one allows for the tendency in medieval reporting to exaggerate, it can still be assumed that Nuremberg had a large number of schoolchildren and that the chronicler took a certain pride in Nuremberg's flourishing school education.

A primary school under the authority of the town council also existed in the Saxon textile and mining town of Zwickau in the early fifteenth century. At the begin-

12 Mary, wearing a crown and portrayed as a temple virgin, works with a weaving shuttle and shaft at a loom.
Window with Mary as a temple virgin, ca. 1350/60, from Strassengel, near Graz. Österreichisches Museum für angewandte Kunst

Following pages

13 Pious members of the lay community of the Humiliates work with a pedal loom and spinning wheel.
Miniature from *Historia ordinis Humiliatorum*, ca. 1421, Codex 301 fol. 3 r. Biblioteca Ambrosiana, Milan

14 A woman uses bellows in a joiner's workshop.
Miniature from the Codex of Baltazar Behem, 1505, plate 14. University Library, Cracow

Capitlm vm:

Dalis quedā matrone ex deuocione ostrū fecerūt q̄ plures cenobia de
uosar̄ i diūsis p̄tib; acenobne virox p̄xīmcias sepatā ut fecerūt ma
cone pōnus forox de blasono mediolani paugmētatione ordinis. Et q̄ue
obmittebāt ex ercieiu manuale p sūbstētacione vite sue. Hec philere qui
sru ōsciolus p̄sto usiq ad susceptionē ōnini osteri ex regule eorū so
lyrie canonicie pascebāt Et metter p̄dictc̄ sorores de blasono i iste
eligebāt ministru qm obediebāt ut matrē:

15 Women also participated in hard physical work, such as washing ore in the mines.
Panel painting by Hans Hesse, 'The Ore Washer', 1521, Annaberg Altar, detail. Church of St. Anne, Annaberg-Buchholz

Following pages

16 Woman giving birth attended by a midwife and her assistant.
Incunabulum from Alexis Guillaume, *Passe-temps de toute homme*, Paris, by Antoine Verard, 1505, Vellum 2249. Bibliothèque Nationale, Paris

17 Pregnant woman undergoing treatment with coriander in order to speed up labour. The midwives are wearing round bonnets, and two assistants are in attendance.
From Pseudo-Apuleius, *De herbarium virtutibus*, *Codex Vindobonensis* 93, fol. 102 v. Österreichische Nationalbibliothek, Vienna

18 Nursing mother receives a drink from the midwife; an assistant attends to the child.
Painting by Hans Süss of Kulmbach, 'Birth of the Virgin', 1510/11. Museum der bildenden Künste, Leipzig

19 While two women attend to a corpse, alms are distributed in the background for the salvation of the dead person's soul.
Miniature from a manuscript, ca. 1430, Ms. lat. 1158, fol. 137. Bibliothèque Nationale, Paris

Car sur noz piedz ne nous tenons
Et nul lieu nallons ne venons
Et ne vsons de vertu humaine
Jusqua long temps et a grant paine

¶ Du cry de lenfant haultement
Et des douleurs denfantement

Pour la misere de na=
ture
Demostrer toute crea
ture
Humaine crie a sa naiss
ance
Cest de douleur vraye congnoissance

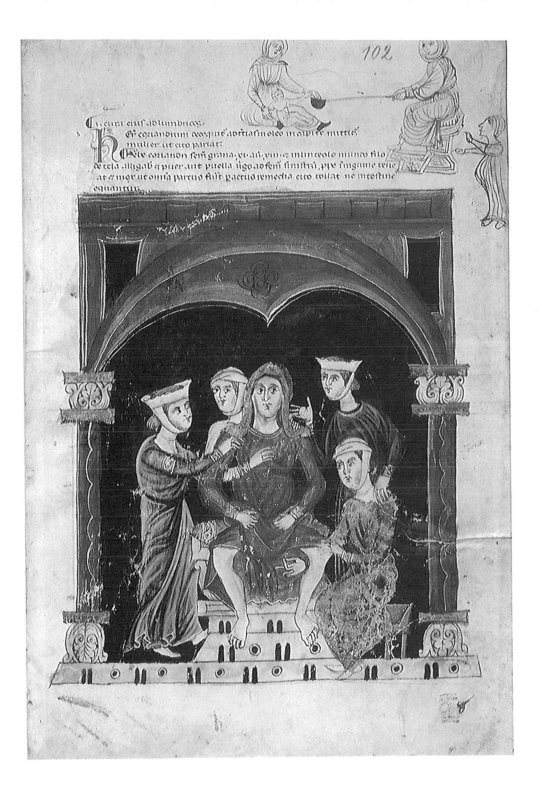

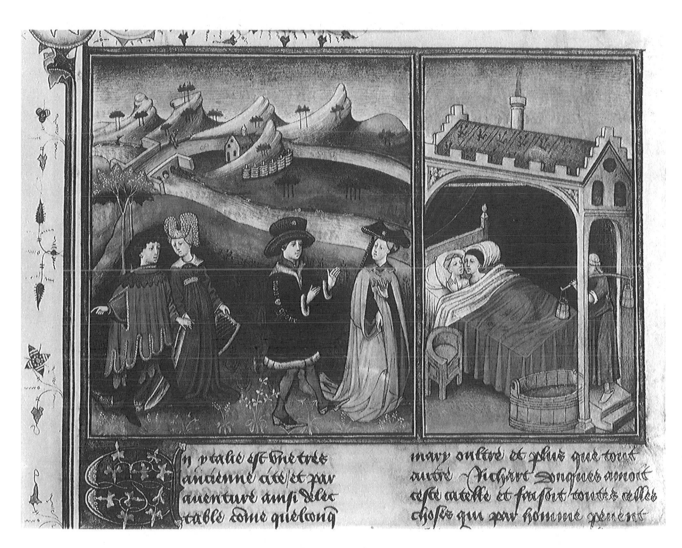

24 Kitchen in a town burgher's house with stove, open fire and chimney. Kitchen maid and servant are distinguished from each other by their dress. Both are bonnetless—that is, they are unmarried.
Painting by the Master of the Scots Altar, 'Birth of the Virgin', ca. 1470, detail. Benedictine Abbey of the Scots, Vienna

25 'Priests' women', concubines and housekeepers of the clerics, were taken into custody by the town in 1405. The council expected the clerics to pay good money for their release.
Miniature from Diebold Schilling, *Spiezer Bilder-Chronik*, 1485, plate 239. Municipal and University Library, Berne

Do man zalt von gottes gebürt/ as/ ttt/ v̄ Cov warent
vil pfaffen dieuer im lande · Vñ herren die von
Bern die gewin von Tuen getan · Do meinten die
priestter man hette so dieuen nit ze straffen noch
von Anen ze wisen · Do gebutten die von Bern
den pfaffen dienen allen von Anen ze gan · By
einer pene do wurden si envas witos von Tuen
vnd knelten das nit lang · Do liess man die selben
alle varhen vnd wurden in die besten geleit so
in der vitgloeken turen ist · Ze stund kamen ot
lich priestero vnd werbürgeten die wen vss/ die aber
nit vss kamen/ denen erging es als harnach stat

26 Shepherdess who—judging by her clothes—may also have been in the service of the town.
Panel painting by Giovanni Santi, 'Mary with Child Worshipped by a Shepherdess and St. Sebastian', second half of the fifteenth century, detail. Staatliches Lindenau Museum, Altenburg

27 A female sutler in the service of the Bernese army carries a halberd.
Miniature from Diebold Schilling, *Spiezer Bilder-Chronik*, 1485, plate 145, Municipal and University Library, Berne

o man zalt von gottes gebure ał/ tt̃ zclij Jare hat
der Turre graf von Safoy groß krieg mit etlichen
welschen herren ennert laurach an der leitdenn
vnd von siner bite wegen zanten zu die wornn
wornn ein groß hilf mit einer pares / Vnd
was venner Niclaus von diespach / Also zugen
die von wornn zu̇ an wol nortzig mile / Aber
bald darnach zanten ß zu̇ hilf gen Sant Berman
vider zion zin zu̇ dmie hand dannocht die von
worri einer horstzaft von Safoy vast gedienet Tn
welchs land vnd tatent das gen wann es inen we
mals aucz geholfen hat da ß von aller menglichem
verlassen warent ~

28 Amongst beggars receiving alms there is a woman in the background.
Miniature from *Grandes Chroniques de France*, fifteenth century, Ms. fr. 2609, fol. 230v. Bibliothèque Nationale, Paris

29 The illuminator uses the story of the Trojan Horse to illustrate the horrors of war in general, and in particular its dangers for women and children.
Book illustration in a version of Orosius, 'The Trojan Horse', ca. 1390/1410, Ms. fr. 301, fol. 147. Bibliothèque Nationale, Paris

30 Women entering Rostock through the Zingel gate; at the same time other women leave the town by coach.
Vicke-Schorler-Rolle, 1578/86, detail. Stadtarchiv Rostock

31 Depictions such as this give us an insight into the lives of women painters in the late Middle Ages. The daughter or wife of a painter was undoubtedly involved in helping to create a background or touch up a painting.
Miniature from Ms. fr. 12420, fol. 92 v., 1402. Bibliothèque Nationale, Paris

Cy aps lenfiut ly ffoire
de cyrene femme de tra
na? voi loifici tub riche
s lanoir mon
le yrene fut fe
me greque ou
le par aage vel
qui longue
ment certam
neft pas toutenoies on croit
mieulx quelle fut creque et

tues comme bien parees honno
rees comme nobles comme pu
issantes et a plusieurs grans
dommages et plusieurs gñs
prouffis de cecy si sont venus
et ensuis. ¶ Et pour certai
ne maudiroie lorgueil qui de
ce cy est ensui. se par les fem
mes ou leurs prieres la fran
chise rommaine ne demou
rast. ¶ Mais la liberalite
du senat trop grande et trop
excessiue et la demeure par
tant de siecles moult doma
geuse ne puis loer. ¶ Car
contemptes de mendre dons
eussent este. ¶ Il est bien po
uray sembloit tresgrant cho
se du temple fonde et en richi
a femme fortune ¶ Mais
que puет ce estre le monde est
feminin et les hommes sont
feminins. ¶ Car pour cer
tain ce qui a este contraire
aux hommes et les choses mi
proffitables que le grant a
age si a destruites na peu del
tiune ne a prisier le droit aux
femmes que garde ne la seurt
tresfort et vertueusement.
¶ Les femmes aduocas
a victurie rendirent loenges
et honnourerent son nom
et sa merite toutes les fois
que leurs cheueux quelles

ont moult chiers de pourpre et
dor sont atournez et que les
hommes quant elles vulent
le lieuent contre elles et que
a elles opseules grans substã
ces seulent venir de ceulx qui
meurent.

cy deuisant de thamar la
tresnoble paintresse su
le deuisant. la xliii rebriche.

hamar en so
temps et en so
aage fut tres
noble paintre
ресse et se il est
ainsi que le
grant temps nous ait oste
moult grandement de la cou
uenance de sa vertu et de son
bien. ¶ Et Toutevoies son
noble nom par la cause de so
artifice encore oster ne nons

32 Artist
painting a picture of
Mary. She also has
an assistant at her
disposal.
Miniature from Ms.
fr. 12420, fol. 86,
1402. Bibliothèque
Nationale, Paris

33 Woman paint-
ing a self-portrait.
Her simple working
clothes suggest she
is a professional
artist.
Miniature from
Ms. fr. 12420,
fol. 101 v., 1402.
Bibliothèque
Nationale, Paris

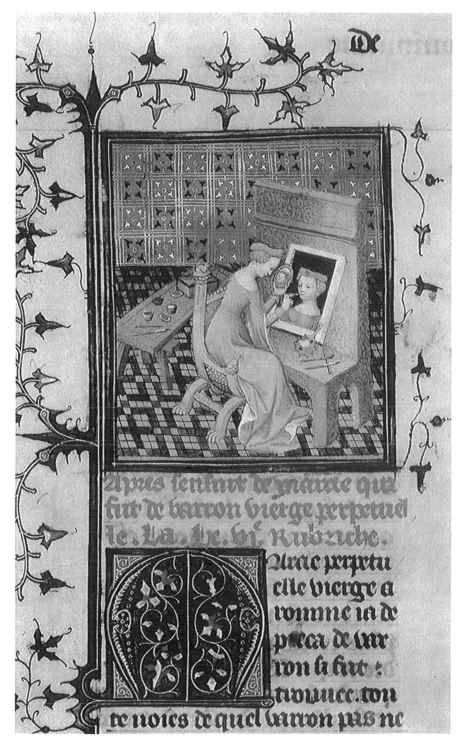

34 Women, bottom right of picture, in a chapel such as may have been found in a convent.
Illustration of Psalm 67, Ms. lat. 8846, fol. 114, thirteenth century.
Bibliothèque Nationale, Paris

ning of the following century, prosperous citizens founded a school fraternity here, in order to promote the further development of the town's school education. From 1518 onward women are listed among those members of the fraternity who made financial contributions. This, as well as the fact that the citizens of fifteenth-century Zwickau not only wrote letters and receipts but were also in a position to draft and even write out their own wills, leads us to the conclusion that women and girls were given a thorough grounding in the elementary subjects.

Apart from the elementary schooling provided by the church or the burghers, the daughters of less prosperous town inhabitants could choose another way to acquire the basic knowledge required for their professional life. In the fourteenth and fifteenth centuries, numerous so-called corner schools sprang up. Here women—commissioned only by the parents of the children—gave instruction in reading, writing, and arithmetic. Such small private schools existed, for example, in Strasbourg, Frankfurt on Main, Augsburg, Überlingen, Speyer, Stuttgart, Hamburg, Lübben, Breslau, Berne, Zurich, and Basle. A signboard by Hans Holbein the Younger advertising the services of a schoolmaster and schoolmistress in Basle who had opened such a private school has the following text: 'If there is anyone here, who would like to learn how to read-and write in German in the shortest possible time, whereby anyone who previously did not know one letter of the alphabet can quickly master the basics, so that afterwards it will be possible to write and read whatever is due to him; and should anyone be too dull-witted to learn this, he will be taught for nothing and no recompense will be demanded, whether he be burgher or craft journeyman, woman or maiden. Whoever be in need of instruction should step inside and teaching will be given for a reasonable fee. The young boys and girls will, however, be admitted, as is customary after Ember days. 1516'.[25] Sometimes female shopkeepers, for example in Strasbourg, gave private lessons. Elderly women, for example in Hamburg, also took on some teaching of reading, writing, and arithmetic. There is evidence that the schoolmistresses could in some circumstances—presumably due to the fact that their teaching matter would be more related to practical life—represent competition to the male schoolteachers of the higher-level schools. This is seen in a contract drawn up between the schoolmaster of the Überlingen secondary school and the local female schoolteacher who gave private lessons. In order that the former did not suffer too much from the fact that some citizens wanted to send their children to Wantzenrutinin, the female schoolteacher had to undertake to pay him a certain amount for every boy pupil she took on per year.

The Brussels school decree of 1320 gives us some idea of the wages paid to the teaching staff in the town primary schools. According to the decree, male and female schoolteachers could both take 12 shillings' worth of coins for every pupil per year. About a third of this, however, had to be handed over to an official who acted as a type of headmaster.

If up till now we have only mentioned primary school education for girls, this is not because girls were generally excluded from higher-level education or from the Latin schools. In Brussels, according to the 1320 school decree, parents could send any number of their sons and daughters to the secondary school. It is doubtful whether girls could be prevented from overstepping the border to higher education in the course of time. It is, however, clear that in the Walloon town of Valenciennes, both girls and boys attended the Latin school. In Emmerich the 1445 contract obviously guaranteed girls access to the higher-level school. There is, however, little evidence of any practical effects. In all the European countries, even in Italy, the number of well-educated women outside of the religious orders who displayed a lively interest in science and politics remained extraordinarily low. On the rare occasions that we do come across such women—for example Heloise, the pupil, lover, and wife of Peter Abelard (1079–1142), the famous theologist

and philosopher—we find that they were educated either by private tutors or by members of their own family.

The motivation behind campaigns to encourage female town inhabitants to learn how to read, write, and do simple arithmetic in the more important urban centres of the late Middle Ages—one is almost tempted to speak of a late Middle Ages literacy campaign—was primarily the requirements of town life, in particular the growing demands of trade and manufacturing, administration and public welfare.

Not only did the enlightened attitude toward primary education for girls lead women of the towns to become better equipped to participate in trade and craftwork at all levels; it also allowed them to take on more important duties in the service of the town community. Perhaps this was at the back of the mind of Sarah, a Jewish inhabitant of Görlitz, when in 1388 she donated a house that had been left by her to a fellow Jew, Isaac, to be used as a school for future generations of Jewish children.

✳ Since the qualifications required of teachers were comparable to those for German clerks, it should come as no surprise to find that women were also employed as clerks in the fifteenth century. One of the earliest records of women working as secular scribes comes from Basle, where, in 1297, a woman called Irwina was paid for making copies of documents. In the fourteenth and fifteenth centuries at least two more female clerks were employed in this town; others are known to have been employed in Cologne, Esslingen, Nuremberg, and Augsburg. A female clerk in Esslingen called Mechthild was married to a cloth shearer in the second half of the fourteenth century. It is known that Adelheid, another clerk from Esslingen, this time unmarried, not only had money and property but could employ a housekeeper and was thus in an ideal position to practise her profession. Another clerk, from Augsburg, Clara Hätzler, had her own studio from 1452 to 1476. In Nuremberg, the death registers of the St. Sebald parish for the years

1439–1517 provide evidence of specialisation within the profession. It records five female clerks, one female guilder scribe, three female clerks of court, three female tax clerks, and two female town council clerks. Probably all of them, with the exception of the guilder scribe, who seems to have been paid for each individual piece of work completed, were employed by the town council. (These five, like the male 'German clerks', probably also worked as teachers in the lower-level schools; there are fourteen female clerks recorded in the death register and only three female schoolteachers.)

Cologne had a particularly high number of women in the employment of the town council. Thus the High Court employed one female clerk (Schryverse) and a female assessor of pledges paid to the court. In Cologne it was very common for women to be sworn in at court in order to be employed as assessors. For the period around 1460 alone, eight are mentioned by name. It was the task of these so-called 'businesswomen' to assess assets and fines as well as to organise the sale of pledges in their stalls next to the mint and the delivery of the proceeds to the court. Female middlemen or brokers were also sworn in as town employees. They would store goods in order to sell them on behalf of others, usually foreign merchants. From the second half of the fourteenth century to the end of the following century, more than ten women were independently entrusted in Cologne with raising custom duty and road tolls. There are further records of women performing these tasks in the Saxon mining town of Freiberg in the fifteenth century, in Frankfurt on Main at the end of the fourteenth century, and in Augsburg and Innsbruck in the sixteenth century. Unlike Nuremberg, where the wife of the customs officer tended to be sworn in with her husband and was thus obviously only there to help see that things ran smoothly or to step in for her husband when necessary, the women mentioned previously were employed independently for these posts. A female farmer of customs could delegate her work to a son. It was also possible for a female farmer of customs to work

for a male one. There are records of both such situations in Cologne.

The sources also mention cases, for example in Saxony and Cologne, of female customs officers or road toll collectors being robbed or assaulted. Yet a report dating from the mid-sixteenth century and written by a town council officer in Augsburg, which describes the work of a local female customs officer, presents quite a different picture. 'We have informed ourselves in the country and have found that the hunter's wife has a good reputation and has accomplished more [as a customs officer] with her good words than before, when there was much quarrelling and disagreement. She is also unbending in her attitude to the customs officer of the bishop, when he wants to introduce a new payment [for the benefit of his master] and does not want to permit this'.[26] Another service sometimes entrusted to women in the employment of the town community was that of the approved salt seller and measurer (*Salzmuter, Salzcherin*). Thus the 1376 Pettau town law makes provision for twenty-four female salt traders. In Coblenz, too, the town salt trade was dominated by women. The same was true of the grain trade in Strasbourg, and we have already seen that married couples ran the grain trade in Marseilles. Women were found in other town offices—a female currency changer has already been mentioned. There are examples of females occupying the posts of tax collector, foundling-home officer, field guard, porter, tower guard, town keeper-of-the-keys, town musician, messenger of socage duties, and town shepherdess. Other posts were held jointly by married couples—bridge officer, and keeper or caretaker of the town measuring scales, the town hospital, the prison, the town general store, and the town house.

* There is evidence that women worked as illuminators in France, Germany, and the Netherlands. They embellished the individual letters and initials in the copies made of valuable books. This was certainly a continuation of an old convent tradition, but it became part of

town artistic activity, because the master would, as a matter of course, fall back on the help of his wife and children. At the end of the thirteenth century a Paris book illustrator, Master Honoré, opened a school for book illustration in Paris with the help of his daughter and son-in-law. (The names of the daughter and son-in-law are not known.) In the fourteenth century the Parisian artist Jean le Noir introduced his daughter to the

Jugglers on the road.
Coloured woodcut by an anonymous artist, broadsheet, ca. 1450.
Herzog Anton Ulrich Museum, Brunswick

art of illumination. Another female book illustrator, Thomasse, worked in Paris around 1292, at the same time running an inn. High praise is given by writer Christine de Pisan to another illuminator working in Paris: 'I know a woman today, named Anastasia, who is so learned and skilled in painting manuscript borders and miniature backgrounds that one cannot find an artisan in all the city of Paris—where the best in the world are found—who can surpass her, nor who can paint flowers and details as delicately as she does, nor whose work is more highly esteemed, no matter how rich or precious the book is'.[27] In Cologne in the fourteenth century a married couple worked together as book illustrators, and in Lille there were female illustrators as well. One is recorded in Bologna as early as 1271. In Bruges, the secular miniature painter Grietkin Scheppers opened a workshop in a convent. In 1476 another woman from Bruges, Elisabeth Scepers, carried on the work of a workshop with the wife of her deceased teacher and in the same year was admitted to the artists' guild of the town.

Women in the west and southwest German towns were also employed in the handicrafts. They would paint playing cards and dolls, print letters, and do woodcarvings. In copies of antique works we often come across representations of female painters at their easels, a scene which is rooted in the environment of the late medieval town. This suggests that women also tried their hand at more elevated forms of art. On the whole, however, the female artist would be employed as auxiliary help in her father's or husband's workshop to do groundwork or to paint in areas that were already defined.

One area of female artistic activity not recognized by the town councils or the upper social strata of the towns was that of theatrical and musical performances. Only a very few female musicians and singers were given official approval. A singer and harp player was fetched by Wenceslas I, King of Bohemia, to play at his court, and a church singer was granted a daily wage by the Görlitz town council in the fifteenth century. Here and there one also finds mention of female town musicians. The majority of musically gifted women, whether they were dancers, acrobats, flute players, fiddlers, harpists, fife players, lute and cymbal players, carriers of Turkish jingles, or vielle players, had to make their living with the travelling performers, were ostracised from town society and liable to be persecuted as sorceresses or witches, and many of them lost their lives.

* And so we come to the darker side of women's employment outside the home, namely prostitution. Numerous women in the large and medium-sized trade and manufacturing towns made a living as prostitutes. Detailed studies of Florentine prostitution in the fifteenth century have shown that the brothels mainly recruited among foreign women or women from different towns. The sources give us no clue as to why these women chose this profession. Certainly the brothel owners and their agents would find it easier to tempt women in foreign countries with promises of an easy life, or to use deceit in order to entice them away from their homes. For many prostitutes, however, it was not always a matter of choice. Often relatives, foster parents, and sometimes their own parents would give the girls over to this profession when they were still children. The court records of big European trading towns such as Florence list cases in which women were accused of sending out their daughters to 'work'. In the medium-sized town of Mühlhausen (Thuringia) we find a court record of a female inhabitant being punished for sending her adolescent daughter to a brothel. The Mühlhausen town council rebukes one father for sending his under-age daughter to the 'marriage bed' with a stranger and records punishments meted out to the owners of brothels who had abducted children to work as prostitutes.

On the subject of prostitution, much has been written on the church's strikingly tolerant attitude toward it and the peculiar legal and social position of the prostitutes

themselves. Reports exist of the high income of some of these 'beauties' who were clever enough to exploit meetings of the secular and church nobility, such as meetings of the German *Reichstag*, and church council meetings, as do reports of the brutal measures taken by such prostitutes to defend their privileges against unorganised competition. This approach has tended to trivialise the actual destitution of these women. Evidence of this is provided by the occasional mention given to brothel customers being punished for maltreatment of the women, as well as by the fact that the women would attend church services to try to escape their work, and would be accompanied by the brothel owner and his male servants on these occasions. In towns where prostitution was practised quite freely, guild statutes and town council regulations ensured that these women remained social outcasts. These included measures such as making them recognizable through their clothing, banning them from the drinking and social establishments of the town, and making them as invisible as possible by forcing them to live in housing on the outskirts of the town. On the whole, however, the attitude of the town councils toward prostitution was benevolent, and they tended to intervene only in cases of maltreatment of under-age girls (those under twelve years old). The councils encouraged the opening of brothels and most of the bigger towns had more than one. The councils also organised supervision of the brothels; in the Austrian towns this was one of the duties of the hangman. The reasons behind this attitude on the part of the councils are complex. The economic aspect was important. The income from these establishments represented a steady source of income for the town budget and found its way to the coffers of some burghers. They were therefore mainly concerned to suppress the underground, uncontrolled prostitution and the activities of pimps, unless this could be brought under council control. The income from brothels and the brothels themselves were sometimes donated to religious establishments and were even accepted by con-

A prostitute in Sicily, who has taken money from a young merchant, lends it back to him so that he can conduct his business. In: Albert Schramm, *Der Bilderschmuck der Frühdrucke*. Vol. IV. Leipzig, 1921, ill. 2908.

vents. This is true of a convent in Esslingen *(zum Kreuz Sirnau)*, which in 1433 charged two Stuttgart brothels an annual interest rate of one pound's worth of farthings, which, it must be said, was then passed on to others. Apart from their hopes of financial gain, the burghers and town councils were concerned to protect their own marriages and families from the nobility, celibate clergy, foreign merchants, and scholars. Such considerations lurk behind the generosity they showed toward prostitutes when the king and his entourage came

on visits to the royal boroughs, and also explain the greater freedom prostitutes enjoyed in the towns that were either royal seats of residence or leading European trade centres. The town councils were moreover concerned to offer some sort of compensation for the marriage restrictions placed on journeymen and servants by the guilds and by individual masters. In the late Middle Ages married men were forbidden to set foot in brothels and the wealthier burghers would therefore exploit the dependent position of maids or, in the Mediterranean countries, of the slaves, to compensate for failed marriages or for their wives' repressed sexuality.

If we look back at the wide spectrum of female professional employment in the late Middle Ages and compare this to the position at the beginning of the commune movement, we find that in the four centuries from the second half of the eleventh century to the eve of the early bourgeois revolution, women's position as one of the family breadwinners was firmly established.

The demands of economic life in the late Middle Ages as trade was extended and intensified dictated that women participate at all levels in family trade. Sometimes this led to women taking over, should the family business be threatened due to the husband leaving his family, falling ill or dying, or should the husband prove to be unreliable or incompetent. A different development can be discerned in the crafts, which now had to meet the growing demand for export goods and for trade in mass consumption goods. As the division of labour between goods production and the sale of goods grew, the wives of masters and the maids became indispensable for the sales side of the business. The increasing social differentiation within and between the guilds, however, made it necessary for women from the crafts to look for a supplementary income or wage labour. Finally, women's economic independence led to at least a limited circle of the female town citizens' leaving the restricted world of their own homes to take part in the life of the town community. The entry of some women into town life was encouraged by the co-operative character of the trades and crafts guilds, which tended to incorporate the whole family.

We can find considerable confirmation for the above statements if we examine the role of women in town economic life from the point of view of the accumulation of wealth, or the proportion of women among the owners of mobile and immobile property and their ability to use this property gainfully in trading or craft activities. One decisive prerequisite for the many-sided involvement of numerous townswomen in the professional and economic life of the large and medium-sized towns was the considerable expansion of education facilities for women in the late Middle Ages. When girls began to be admitted to elementary schooling, the daughter of the average town burgher could more or less be guaranteed a minimum amount of education. Previously such burghers would not have been able to afford a private tutor or a convent school. This helped the daughters to develop skills and facilitated their entry to professional life.

Women's Position under Town Law and in Marriage and Family

For all women who were involved in some way or other in trade there were special legal arrangements made which covered an area from Italy via Switzerland, France, Germany, Flanders, and Denmark to England. It has already been mentioned that women operating independently could acquire citizens' rights in the late Middle Ages. This suggests a considerable divergence from the previous legal position of women as outlined in Chapter 1. Other changes, too, occurred in the legal status of women in towns from the end of the thirteenth century onward. How wide was the scope for a change in the legal position of women, once the medieval town was fully developed; and to what extent were the women's social status and their marital role affected?

✷ It is, of course, difficult enough to attain a consistent picture of the position of women in one town, let alone in a larger area, or indeed in all the leading states in medieval Europe. What follows are findings for the German-speaking parts of Europe, supplemented by examples from other European countries which are intended to point to parallel or specific developments.

Legal practice in European towns was based partly on prevailing legal theories as taught at universities and partly on records of regional juridical practice as contained in documents like the *Sachsenspiegel* and the *Schwabenspiegel* in Germany. In Italy and southern France, the shaping of law of the high Middle Ages was considerably influenced by Roman law, whereas in Germany this influence came from Frankish and Sax-

on law. Town law grew out of prevailing theory and records of legal cases, but also included elements of local common law. This was sometimes the case even when a fully developed legal system was handed down by one town to another—as often happened. Thus while there was a certain consistency of legal systems grouped around any town that had a significant legal tradition, there was still room for variation in the settling of basic questions. As there was no codified civil law in general, common law and law of contract—despite the increasing influence of Roman law—continued to play an important role.

Even when one has access to the information contained in municipal legal statutes and other records, one still does not necessarily have a reliable key to the actual juridical practice in the town concerned. Apart from the possibility of subjective interpretation of the laws, there is, especially where property matters are concerned, much scope for modification by means of individual contracts or wills—in particular the right of testament, which was enshrined in municipal legislation as an inalienable right of the individual.

✷ It is the legal position of married women that we will concentrate on, as one can assume that the majority of women in towns married, despite restrictions imposed by guilds and employers on journeymen, servants, and labourers, and despite the celibacy required of members of the clergy. In the towns there was a gradual change away from the early feudal system and toward the church

system of both partners having the right to decide on marriage for themselves. This was expressed in the informal declaration of marriage by the priest, who symbolically brought together the hands of the bride and groom. This simple ceremony—which was only replaced by more elaborate forms in the sixteenth century—often took place in front of the doors of the church, making it a public declaration. This was necessary as a result of the spread of church marriage law, for once the principle of free marriage without the permission of parents, relatives, or guardians was announced, there was a spate of secret weddings. A relevant factor was the fact that, at least at the outset, parents and relatives were not prepared to refrain from viewing marriage as largely a matter of family interest.

The practice of secret marriages brought with it certain dangers for the principle of monogamy promulgated by the Catholic church, and meant an additional load for the church courts. Some figures will make this clear. Between November 1372 and May 1375 in Canterbury there were 78 cases to achieve recognition of marriages that had taken place in secret. Forty-one such cases were recorded in Paris between 1384 and 1387. One hundred of two hundred cases in Augsburg in 1350 were of this kind. About three-quarters of the plaintiffs were women, who usually were the ones who suffered most from such secret marriages, by defloration and pregnancy. In Regensburg in 1490 no fewer than 119 women brought cases for legalisation of such liaisons, damages, or alimony payments. In contrast to the Eng-

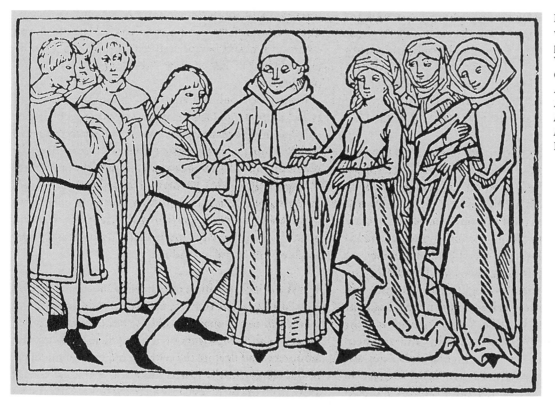

Marriage ceremony with priest, in the presence of witnesses. Woodcut, printed by Günther Zainer, Augsburg, 1477. In: Albert Schramm, *Der Bilderschmuck der Frühdrucke*. Vol. II. Leipzig, 1920, ill. 710.

Mutual consent to marriage in the presence of the king. The man and woman imitate the gestures of affirmation made by the king and in this manner declare themselves ready to submit to his judicial ruling.
Miniature from a French translation of the *Codex Justinianeus*, early fourteenth century, Ms. 392, fol. 66 v. Bibliothèque Municipale, Orléans

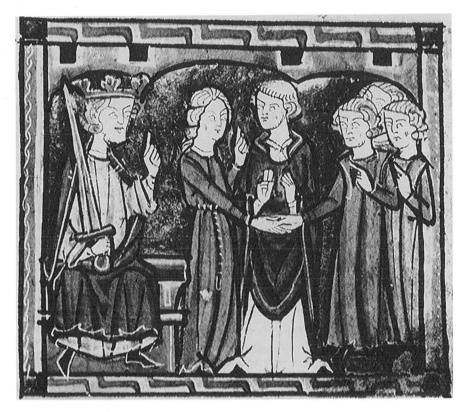

lish and French examples, judgements in favour of the plaintiff in Augsburg and Regensburg did not insist on the married couple sanctifying their marriage in church. It would appear that it was feared there would be resistance from the parents, relatives, masters, or employers. The town councillors almost always opposed marriages carried out without the agreement of the parents, relatives, and employers, and also marriages where the bride was abducted or eloped, which still occurred. Thus the town laws of Alès and Metz ordered that a woman could not take a husband without seeking the advice of her parents or guardian. In a number of towns, partners who decided upon marriage independently were punished when it came to inheritance: if they were not completely disinherited—as in Brünn and Leutkirchen—their in-

heritance might be withheld while the parents were still alive, or they might be banished for a year from the town and fined two marks, as in Mühlhausen (Thuringia). (In Brünn and Cracow it was only necessary for the daughter to receive permission to marry up to the age of 25. Thereafter she was free to act on her own will and was not fined for doing so.)

That there was a strong tradition of nonlegalised marriages can be seen from the statutes of Strasbourg in 1322. According to these, all those who lived 'openly in a state of marriage' within the city or the city precincts were exhorted to legalise their position. Those not prepared to do so, because one or the other had already married elsewhere, were to split up and divide their goods up between them according to the advice of the

council. On separation, two-thirds of the children went to the man and one-third to the woman for further up-bringing and education. Anyone who resisted this demand by the council had to reckon with sequestration of half his assets, 'in atonement for such a sin'.[28] At the same time the Strasbourg council was moved to take action against the worst form of bigamy, by threatening any man who took another woman into his house in addition to his wife with five years' banishment from the town. This also applied to the second woman. Men and women who kept their marriage secret and took another marriage partner were threatened with having their eyes put out. The fact that, despite such harsh penalties, illegal marriages continued, is proved by an agreement reached in Strasbourg in 1411 between master craftsmen and the town council which threatened all those who did not relinquish concubinage by the following Sunday with the sanctions contained in the town statutes. Cases where first marriages had been concealed or bigamy was openly committed were not rare; couples were continuing an unbroken tradition of the so-called *Friedelehe*. The additional statutes added to the Mühlhausen imperial law-book of 1351 to include contemporary legal practice explain how a woman can free herself of her partner simply by making a declaration to him before witnesses—which is precisely what was practised in a *Friedelehe*. In one case a New Year's gift is mentioned which only was to be given to maids and wives in a *Friedelehe*; otherwise the man was punished with an amount of one pound's worth of farthings or four weeks in prison. If we look at the laws on property and inheritance we see how secret marriage, which often was the only possibility which maids, journeymen, and servants had of living together, endangered not only the interests of families but also of women in the more wealthy classes.

* In the legislation covering the rights of property and inheritance within marriage the basic principle underlying feudal family law in central and western Europe was that of the man having sole powers of disposal. This principle spread, thanks to Italian legal scholars in the thirteenth century and, in the German-speaking world, contemporary writings, in particular the *Sachsenspiegel* and the *Schwabenspiegel*.

Both these books provided the basis for the legislation of many German towns. The *Sachsenspiegel* served as a model chiefly for towns that adopted Magdeburg laws, while the *Schwabenspiegel* was taken by towns in upper Germany. These books outline the husband's sole right to dispose of property and assets. Generally speaking, the man is confirmed as having the guardianship over the woman.[29] Above all this applies to assets: 'When a man takes a woman, he takes into his possession and acquires disposal rights over all her property.

Woman bathing in a tub and drinking from a goblet. A man is making music.
Woodcut, printed by Johann Blaubirer, Augsburg, 1481. In: Albert Schramm, *Der Bilderschmuck der Frühdrucke*. Vol. XXIII. Leipzig, 1943, ill. 727.

Priest and a woman in the stocks. The danger of adultery with a clergyman was particularly great, since he, as the person responsible for spiritual welfare, could exert influence over the psyche of the woman.

Marginal drawing from a copy of the *Smithfield Decretals*, early fourteenth century, Ms. Roy, 10 E IV, fol. 287 r. British Museum, London

For this reason no woman may make her husband a present of her property or moveable assets'.[30] This right of disposal even applies in the case of women marrying men of lower social status: 'Even if a man be not of the same birth as a woman, he nevertheless has rights over her and she is his equal and acquires his legal status if she enters his bed'.[31] If widowed, the woman returned to her old legal status. The man always had chief say in matters relating to goods and assets: 'A woman may also not give away any of her property without the permission of her husband, nor may she buy property nor dispose of *Leibgedinge* [personal assets made over to her for her lifetime] because he is also an owner of that property'.[32]

The law of inheritance according to the *Sachsenspiegel* gave the woman half the provisions, the dowry, and the *Morgengabe*—the gift she received from her husband after the wedding night. The latter could consist of animals or *Leibgedinge*. Possible elements in the dowry are named as being: 'all sheep and geese, boxes with curved lids, all yarn, beds, featherbeds, pillows, linen sheets, table-cloths, cloths, towels, bowls and candlesticks, linen and all female clothing, rings and bracelets, head-ornaments, psalters and all books used in church services, chairs and chests, carpets, curtains and tapestries and all ribbons. This is what belongs to the dowry. And various miscellaneous objects which', writes the author, 'I shall not enumerate, such as brushes and scissors and mirrors'.[33] The law as enshrined in the *Schwabenspiegel* gives the woman the right to inherit the *Morgengabe* and *Leibgedinge*, as well as the right to have the goods returned to her which she brought into the marriage.[34] Instead of the dowry, she has the right to inherit all moveable assets. Should there be any moveable assets the couple had acquired together the widow had a due claim to them. However, if her husband had left no other instructions in his will, these assets had to be shared with any children.[35] Thus in the *Schwabenspiegel*, guardianship over assets is already slightly modified, as the agreement of the wife had to be given to certain decisions of the husband.[36] According to widespread legal practice this applied to transfers of land.

If her husband was behaving irresponsibly with goods and property she had brought into the marriage, the woman could go to court with a representative of her own selection.[37]

Even some special cases were regulated in favour of the wife. Thus, for example, the *Sachsenspiegel* protected a widow who was pregnant in her full property rights until the child was born.[38] If a woman was legally separated she retained half the provisions, dowry, and *Leibgedinge*.[39] The latter also remained hers when her husband lost his assets because he committed a crime.[40] A woman who had been properly legally married had a certain security as regards property and inheritance, despite her husband's guardianship. In addition to this she was not, in the case of pregnancy, under the same additional moral pressure put on a woman living in secret marriage.

* As already mentioned, the town laws combined traditions handed down in the form of law-books with those of a more local nature. The Lübeck town laws of 1294 gave the woman the dowry that she brought into the marriage. In the case of childless couples the next heirs of the husband received half of what was left. According to Magdeburg law the widow was left her clothing and jewellery and the goods she had brought into the marriage. The husband's real estate and moveable assets went to the nearest relatives. The oldest law-book of the imperial city of Mühlhausen (1220) also gives the land property to the family of the deceased husband; but the wife could use the family property for her lifetime. These inheritance rights of the relatives were preserved through the fourteenth and fifteenth centuries in town laws such as those of Regensburg; here, after subtracting what the wife had brought into the marriage, the household goods and any jewellery, the church received a third of the residue and two-thirds went to the relatives. In Constance, from 1472 onward, relatives of the deceased received one-third of the assets of the couple. Strasbourg law gave the relatives half the inheritance.

On the other hand, in Ulm and Göttingen, control of the entire inheritance went to the wife in the case of childless couples.

In the case of couples with children, the principle applied to both men and women that the survivor took personal property from the estate—the woman, her clothing and jewellery; the man, the *Hergewäte*, his personal clothes and breastplate, all his weapons and armour. There was variation from town to town in what the women could retain. All the rest passed in equal amounts to the surviving partner and relatives of the deceased. Usually no differentiation was made between children of a first marriage and those of a second. Distribution of the inheritance occurred when the children came of age (boys usually between 12 and 14, girls between 11 and 12), or married, or when they left the parental home—sometimes years after they had married. But town laws sometimes also specifically laid down that distribution among the children had to take place before the surviving partner remarried, or later changes could only occur with agreement of the children or their guardians.

The marital and property rights of men were largely retained in town laws. Thus, for example, the Mühlhausen imperial law-book (*Reichsrechtsbuch*) gives a narrow interpretation of the rights of the man and his nearest relatives, inasmuch as the son of the deceased, whether he be from that marriage or from another, had the right of guardianship over the widow. The husband's guardianship over the person and the property of his wife was also retained in Magdeburg and Lübeck. This had far-reaching consequences, as these towns influenced the law in regions beyond the borders of the medieval German state. But for some towns, such as Schlettstadt, Göttingen, Munich, Esslingen, Brakkenheim, Nuremberg, Constance, and Hamburg, the rights of the husband only covered assets. A regulation passed by the imperial city of Esslingen for Brakkenheim, in Württemberg in 1280, gives a short and to-the-point summary of the situation: 'The man could

give all that he and his wife had . . . [whether they had children or not] personal goods, a fief or moveable assets to whomsoever he wished. Neither the wife nor the child nor the heirs had any right of appeal'.[41]

The number of towns whose laws deviated from these basic principles seems to have been very limited. Only Cologne, Regensburg, and Munich, among the larger German cities, did not spell out the husband's guardianship rights, while the position in Ulm, Göttingen, and Constance was not entirely clear. Very little information is found in the town laws about divorces. These were largely a matter for the churches, and were only occasionally dealt with among inheritance matters by the town councils of Göttingen, Zwickau, and Erfurt in the fifteenth century.

It should be noted that the majority of town laws, at the latest by the fourteenth and fifteenth centuries, guaranteed widows a significant portion of the inheritance (a third, a half or two-thirds of the total). In marriages with children, the mother, if she did not remarry, was allowed to use the children's portion of the inheritance, at least until they came of age. This was undoubtedly to the woman's advantage, for she thus enjoyed the fruits of what had been earned or acquired during the marriage. Widows from well-off families were thus guaranteed an adequate standard of living if their husband died early, and this was supplemented in many cases by the acquisition of life annuities. A fatherless family had sufficient funds to pay for schooling or an apprenticeship for the children, mainly the sons, and the woman could perhaps take up work of her own. On the other hand, town laws, with few exceptions, maintained the husband's right of guardianship over his wife during the marriage, at least in matters of inheritance—which surely led to difficulties: How could the wife of a merchant take on legal responsibilities for her husband during his frequent absences? How could the wife of a craftsman look after local sales if she was not able to collect debts herself and, if necessary, sue for payment? How could a linen weaver supply herself with thread if she was not allowed to apply for credit without a guardian? How could the wife of any burgher invest money on behalf of her family at good and safe interest rates without rights to dispose of assets? And, finally, how could an innkeeper store her customers' wares, carry out business, or lend money against security?

Again, solutions to such problems varied from town to town. In Basle in the second half of the thirteenth century the woman gained full rights over real estate from the *Morgengabe*. Yet the fact that common rights over assets of the married couple were recognized did not lead to the woman having equal inheritance rights. The husband retained chief rights, despite the fact that the wife increasingly shared responsibility for legal transactions. Basle town law provided for the husband to inherit two-thirds, the wife one-third of the total inheritance. This covered what had been acquired during the marriage. According to Viennese law the woman had a right to half the inheritance. But neither in Vienna nor in Basle, neither in north German Hanseatic towns nor in central German towns was this consistent practice.

In the late Middle Ages marriage contracts (agreements), property or annuities transfers, and special provisions in the wills of the husband or the woman's blood relatives provided important ways and means of women building up assets over which they had more or less complete control. Marriage contracts had, for families with considerable wealth or social prestige, special significance. Often the future husband was a member of a high social stratum within the urban bourgeoisie—for example, burghers with feudal fiefs, families from whose ranks the town councillors were chosen, or families with mining businesses—and by marrying their son to a rich heiress from the burghers the family hoped to improve their financial position or solve a passing financial crisis. In such a social constellation the parents of the bride will have put emphasis on securing their daughter's situation.

Light is thrown on such considerations by a retrospective cross-examination of a witness by the town

judges of Zwickau. In the marriage arranged between Frau Anna and Jorg Montzer, the latter's brother, Hanss Montzer, had made the following commitment to his future sister-in-law: If her husband did not provide for her he would give her 200 Rhenish guilders out of his own pocket, so that her future was assured. The members of the council and burghers who were questioned confirmed under oath in 1487 that this was the arrangement which had been made.

Marriage contracts, when signed by two people of equal social standing, secured a certain independence for each partner in property matters. This comes out in the contract signed in 1483 for Elspeth Rauhenperger of Salzburg and the Viennese burgher Blasius Ennglhartsteter. It laid down the dowry and *Morgengabe*, which, according to Viennese law, usually amounted to 300 pounds and 250 pounds of the best currency, respectively. All goods other than the dowry which the woman brought into the marriage the husband was to have, use, and enjoy. But the highly significant innovation was the following restriction: the husband had to guarantee that his wife could dispose of her assets as she wished, by selling, transferring, or donating them, or by giving them away 'without the intervention or interference of Ennglhartsteter's, her husband, or his heirs or any other person'. The same rights are given to the husband. Other contracts, wills, and transfers of assets—above all an enormous number of life annuity agreements made for both partners or for the wife alone—guaranteed for the wife assets over and above the usual one-third inheritance. In addition to the aforementioned annuities these could take the form of additional real estate, a single cash payment, jewellery, artefacts made of precious metals, or other objects. In some wills the wife even is given a half, rather than a third share of the inheritance, lifetime guarantees against claims by her children, or claims by her husband's relatives if she should receive the entire inheritance. Total mutual inheritance seems to have occurred mainly among craftwork couples where the partners worked independently or where there was a division of labour between manufacture and selling—a relative rarity in centres of long-distance trade such as Lübeck, Bremen, and Stralsund, where the relatives' inheritance rights were important. Among traders the extended family needed to remain close-knit even beyond the confines of one town or region in a way that was not so necessary for those involved in craftwork, among whom, it develops, family businesses were relatively short-lived, which was even further aggravated by the travelling of the journeymen in the late Middle Ages.

Many late-medieval towns offer examples of wives who had partial control over the family's assets: Erfurt, Halle, Magdeburg, Halberstadt, Eger, Bamberg, Görlitz, Vienna, Sterzing, Basle, Genoa, Venice, Nuremberg, Regensburg, Cologne, Lübeck, Bremen, Ghent, and many others. These examples cover more than just those women who ran independent businesses or practised a craft. Even in England, where, as we have already seen, women could work independently only when they were regarded for legal purposes as unmarried, the husband could give his wife verbal authority to carry out certain matters relating to property. In Italy, where the tradition of Roman law gave particular emphasis to the position of the husband as head of the family, partial rights for the woman over the family assets were guaranteed by special laws covering assets—that is, parts of the dowry or inheritances of various kinds. As wives gained greater control over family assets, they were able to take part in transactions on the town securities market, play a role in business, and even operate independently in the trading sector.

* According to town laws unmarried women and widows usually had full rights over assets and the freedom to carry out legal transactions independently. Exceptions to this occurred only when the town council feared the possibility of assets getting into the hands of the church or the hands of outsiders who did not have citizens' rights. The council of Dortmund decreed that

Elisabeth Honiss, burgher and merchant, has her will drawn up legally in 1470 by the public notary. At bottom left, the mark of the notary's office. Extract from document no. 1122. Stadt- und Kreisarchiv Mühlhausen/ Thuringia

In a will drawn up in 1438, Elisabeth Grossen, a burgher of Mühlhausen, bequeaths a house behind the All Saints' Church to the mendicant friars of the Dominican Order. Extract from document no. 849. Stadt- und Kreisarchiv Mühlhausen/Thuringia

widows and parentless spinsters receive a guardian only when the council or the relatives deemed it necessary to preserve the assets and for the good of the heirs. In Strasbourg, in 1322, unmarried women and widows who possessed land were given men of good reputation from among their relatives as stewards. Relatives with rights of inheritance were excluded. If no suitable person could be found among the blood relatives, it was further stated, the council would appoint a steward. These stewards, quasi-guardians, had the task of ensuring that no annuities or possessions be removed and put to ordinary use. The women concerned should only receive the interest accruing from their assets. In cases of particular hardship the spinster or widow had the right to appeal to the council.

On the whole, however, without the need for a guardian, or with a legal representative whom they had themselves chosen (a development from the steward during the fourteenth century), women were able to sign contracts and acquire or pass on property and land. This covered, among other things, mills, shares of mills, brickworks, and market stalls. Women also received user's rights of various kinds either as women's fees for their lifetime or as men's fee that was inheritable. This included annuities from town offices, income from customs and the courts, shares in the town mint, in mines, salt springs, grazing and arable land, and fruit gardens. Various wills give an impressive picture of the assets that female heirs possessed. An outstanding example, inasmuch as it was drawn up and written entirely by herself—which illustrates the level of education achieved by an inhabitant of what was a highly successful mining and cloth trade town—is the 1469 will of Anna Truhenschmidt, a citizen of Zwickau. The document confirms indirectly the existence in Zwickau of the principle of the one-third inheritance: the widow makes frequent reference to the third she received from her husband. In addition to paying the family of her dead son Paul a certain share of the inheritance in advance, she mentions a daughter, Maidalen, a widow with three

daughters and three sons. This daughter, who, with the guardianship of two burghers, has the task of acting as executor of the will, receives an annuity of 20 guilders per year, which Anna acquired by paying 1,200 guilders to the Nuremberg council. If this daughter remarries, the son-in-law is excluded from benefitting from the annuity. Maidalen, who as executor is required to meet any outstanding debts, also receives the remaining assets. Another daughter, Martha, is already dead. She received 500 gold guilders for the purchase of an annuity of 25 guilders a year from the Nuremberg council. Her five children receive a further 300 guilders under Anna's will, which are also to be invested for annuities. The writer of the will assumes that the Nuremberg son-in-law will deny the inheritance. Her poor opinion of him can also be seen from her statement that the bed-linen which went with the daughter is requested to be returned and will become part of the final assets disposed of after the death of the writer.

Not having a large fortune at her disposal, Anna makes modest donations—between 2 and 30 guilders—to the fraternity of cloth makers, shopkeepers, the religious fraternities of the *Heilige Leichnam* and *Kaland* in Zwickau, and the Franciscans of Nuremberg. Just as the family of this citizen of Zwickau acquires annuities in Nuremberg, so many other female burghers from other towns invested sums in the town of Zwickau. Receipts in the Zwickau archives identify them as coming from Nuremberg, Eger, Freiberg, Oschatz, Eisleben, Rochlitz, Leipzig, Halle, and, of course, Zwickau itself.

The regulations in many towns for widows and widowers who wished to remarry proved to be a major factor preventing families of town citizens from accumulating large sums. Inheritance allowances were usually lost if the widow 'put away her widow's chair', as remarrying was described in wills. Sometimes the family house had to be vacated for the children, who would be represented by one or more guardians. As often as not, though, the widow's share of the inheritance was reduced to the same as the children's. In many

towns, all matters of children's inheritance had to be settled before the surviving partner remarried and he/she was reduced to the same share as the children. This was bound to have an effect on people's marriage plans; the chronicle of Tilesio of Mühlhausen (late sixteenth century) states: 'In the year 1336 here in Mühlhausen the arbitrary and onerous statute was applied whereby fathers or mothers were not allowed to take more of their goods than the children's share of the inheritance. This reduced many a man to poverty. Many were also thereby discouraged from remarrying'.[42]

These practices may well have been one reason for the attitude, particularly in wealthy families, held toward newborns, which can only be described as careless. A baby was often entrusted to nurses who by no means guaranteed proper care for the infant. The regulations on children's inheritance rights before remarriage were not designed to increase a family's interest in having a large number of children. In craftsmen's families, as, for example in the Saxon textile centre of Chemnitz, the stepfather or stepmother often used the money the children had inherited for the necessary day-to-day expenses of the business. The children were given a piece of arable land or a house as security and to satisfy the laws of the town.

* The majority of unmarried or widowed women—who constituted between 8 and 38 percent of the town's taxpayers—were of interest to the town councillors mainly in terms of how their assets could be used for the town budget.

These women, as members of local families, shared indirectly the citizens' rights of their fathers or husbands. A widespread common law stated that the rights of the deceased husband passed to the widow—even in England, where women were allowed to join guilds but were categorically denied the right to acquire citizens' rights. In a few rare cases the councillors demanded that the widow and those of her children who were of age take the oath. In Schlettstadt the law demanded that the widow of a citizen who had lived outside the town walls take over her husband's rights within a month of his death; otherwise she could only receive such rights 'as though she had never been a citizen'—in other words, she would get no special treatment. Strasbourg town law of 1322 appears to have been directed more at young people. Men and women aged 20 are called upon to be sworn in as citizens if their main domicile and their most valuable property are in town, whether or not they live with the father, mother, or relatives. Clearly this statute takes into account the fact that young married people often lived for years under the same roof as the parents and single women often lived with relatives. But it did not cover the considerable number of unmarried or widowed women and those fleeing from unfortunate marriages who were moving in increasing numbers to town. These were not just relatively poor women, such as maids, nurses, and wayfaring people, but often those who had sufficient wealth to earn their own living from trade or craftwork. These women, according to the laws of medium- and large-sized towns in the German-speaking countries, were obliged to take up independent citizens' rights. The Zwickau statutes of the fourteenth century make this very clear.

According to Zwickau law, a wealthy woman who moves to town without intending to marry must apply for citizenship. If the move occurs because of a marriage she receives the husband's rights 'if she enters his bed'. The Mühlhausen (Thuringia) law-book states much the same thing. The Schlettstadt laws of the end of the fourteenth century, mentioned elsewhere in this book, demand of all who move to the town to live and settle there that they become within a month of their arrival either a *Bürger* (citizen) or a *Seldener* (citizen with reduced rights) in order to serve the town and to remain obedient. Everyone—man or woman—is expected to enter a guild and serve it. The notion of 'service' would appear to apply to the town watch service and the defence of the town, which were organised by the guilds. All those who fail to meet this requirement receive no help and

enjoy none of the rights and freedoms of the town of Schlettstadt. The town of Miltenberg required of men and women who acquired citizens' rights 3 guilders or a crossbow of the same value; however, it encouraged a rapid growth of its citizenry by waiving this payment for all outsiders who married into town families. An agreement between Lindau and Isny reveals that both towns accepted female citizens of the other town as their own citizens, thus following the principle 'town air makes one free'. If the woman moving into one town intended to marry, she had to have had citizens' rights in the other town for six weeks and two days. The same in reverse, incidentally, held for the husband.

Acquisition of citizens' rights involved the payment of a fee and the taking of a vow. For women, too, the duty of paying taxes and serving the watch and defence of the town were involved. The latter duties could be carried out by proxy or replaced by a special payment. Such an arrangement for female citizens can be seen, for example, in Erfurt, where in 1357 the council recorded that Gysela von Mittelhusen and Ermengard von Ilmene were, for the duration of their life and residence in Erfurt, 'released from all payments and watch duties on the walls and all other services which citizens have to provide, because they have given the town 19 pounds and 6 shillings' annual duty'.

Citizens books, which contain the names of all new people acquiring rights—those from Soest, Lübeck, Cologne, Frankfurt on Main, Freiberg (Saxony), Berlin, Stralsund, Dortmund, Strasbourg, Nuremberg, Dresden, Görlitz, Memmingen, Northeim, Emmerich, Fulda, and Reval are extant—show that cases of women acquiring citizens' rights were by no means isolated. The list for Soest between 1302 and 1449 contains the

Citizens' registers from the town of Stralsund record the names of women who were granted citizens' rights—Tilse Calen, Wobbeke Langhe, Katherina de Lobeze, etc.
Extract from the second oldest citizens' register of the Hanseatic town of Stralsund, 1349–1571, fol. 33b (1385). Stadtarchiv Stralsund

names of 5,623 citizens, of which 345 (that is, over 6 percent) are women. In Stralsund the figures for 1370 to 1373 reveal a proportion of over 5 percent. In Cologne between 1356 and 1399 only 3 percent of the new citizens were women; in the fifteenth century there were even fewer. Strasbourg took on 8 percent in 1452, and then, in 1459, 9 women out of 79 applicants. On the other hand, there were years when the proportion of women was under 1 percent or when none at all were taken on.

The women who had acquired citizens' rights had special privileges over those 'ordinary' inhabitants who had no such rights, although they were still excluded from council elections. A Görlitz Jewess, Adasse, mentioned in 1348 as the possessor of a promissory note for 71 marks, was one of the main town creditors. In Graz some Jewish widows were members of a financial syndicate, and in Vienna two Jewish women ran a public laundry with female paid workers. In Mühlhausen another Jewish businesswoman negotiated a settlement for herself, her husband, and her heirs concerning some goods that had been taken from them. Women could carry out legal business, complete contracts, act as guarantors, witnesses, executors, and sometimes as guardians for children or grandchildren. They could go to court to secure their property and could pursue debts in courts in other towns, without a guardian but with the support of their town council. This support from the council also was forthcoming for day-to-day legal affairs, to protect female citizens from prosecution in ecclesiastical courts, in cases where the husband had been deceitful in matters of property, or where marriage contracts and vows were concerned. Property contracts were completed by female citizens in Mühlhausen (Thuringia), Zwickau, Görlitz, and Stralsund. In the latter town women are mentioned eleven times between 1370 and 1382 as guarantors in affairs concerning citizens' rights.

In Nuremberg, on the other hand, this only occurred ten times between 1302 and 1448. In Zwickau, Mühl-hausen, and Stralsund women were cross-examined as witnesses in inheritance and property matters. In the previous chapter we have already mentioned the role of women as court witnesses in matters concerning securities. Women executors are mentioned in the Zwickau, Regensburg, Wiener Neustadt, Cologne, and London records. Mothers or grandmothers acted as guardians for children or grandchildren in Freiberg, Chemnitz, Zwickau, Halle, Görlitz, Nuremberg, and the French town of Périgueux.

The sometimes considerable wealth of female citizens brought tax advantages, for if the women made substantial private loans to the council or passed on coveted fiefs they could be granted exemption from paying taxes for several years. Such an arrangement was made by the widow of Herman von Levede, of Goslar, who for four years beginning in 1373 formally gave up interest payments due to her from the steward's office in return for tax exemption during the same period. She had only to remain living in Goslar; in addition to this she was to receive each week a shilling in Goslar pfennigs. Similar examples can be found in Görlitz and Lübeck.

Records show that in times of economic prosperity and labour shortages for certain urban professions, citizens' rights were used as a demographic device and bestowed even upon less wealthy arrivals, including women.

And there is evidence that councils filled the town coffers by raising money from maids who moved to the towns. Generally speaking, however, the same applied to citizens' rights as applied to property rights: they gave many women the necessary encouragement and support to enter town life more fully, whether the rights were acquired through the husband or, in the case of unmarried women, independently. On the whole, only women from the upper strata of society or from the wealthy middle classes could meet the requirements laid down by the councils for the acquisition of the full citizens' rights—by paying taxes punctually or purchasing proxies for watch and defence services.

✻ In his *Wanderbüchlein* Johannes Butzbach gives a description of an incident that occurred between his usually very cooperative stepfather and his mother. The cause of the incident was Johannes' decision to return to his studies. 'My father', he writes, 'was not a little pleased at this decision and immediately put the money for the journey at my disposal. He gave me five guilders. He also knew that my mother had a good guilder from her dowry which was called her own; with it he had become engaged to her. With all forcefulness he demanded that she give it to me. But my mother did not wish to hand it over. Instead she had given me another guilder behind my father's back. The matter soon became the cause of a lively argument between the two which ended in his beating my mother and pulling her hair. When I observed this I threw down my pack and the money

An adulteress is punished privately. She is tied to a pillar and forced to spend a sleepless night, while her husband sleeps soundly.
Woodcut, printed by Hans Hauser, Ulm, 1483. In: Albert Schramm, *Der Bilderschmuck der Frühdrucke.* Vol. VII. Leipzig, 1923. ill. 55.

and, together with my brother and sister, hurried to her aid. I managed to drag her away from him. . . . My father calmed himself. When he had come to his senses he started to be racked by his conscience. He hastened through the town in search of me. When he had found me he begged me from the bottom of his heart not to give up my resolve. He also entreated me to forgive the sin he had committed out of his desire to be good to me. So saying he handed me the guilder which he had forced into his possession by his violence. For the sake of peace I accepted it, but later returned it secretly to my mother, who had accompanied me to the ship'.[43]

Such a scene, occurring as it did in a family of by no means badly-off craftsmen, was no isolated case. Court reports from late-medieval towns contain countless judgements in cases where wives had been mistreated by their husbands, blood relatives, or even strangers. Wives' or their relatives' complaints ranged from her being threatened with a knife, beaten, turned out of the house to rough treatment by the husband's relatives and strangers invading the family home. There are cases of both women and men murdering their spouse. This sort of situation has to be seen as proof of the discrepancy that existed between the increased importance of female town dwellers in economic life and the continued survival of patriarchal attitudes toward the role of women within the marriage, the origins of which can be found in legal tradition and, as we will see, in religious ways of thinking.

Those town laws that for a long time preserved the husband's predominance over the woman in the form of guardianship also gave him the right to beat her—sometimes merely forbidding an excess of blows. The husband could pay off debts by selling his wife's belongings—coat, veil, pillows, jewellery. A case was recorded in Mühlhausen of a woman's only coat being pawned. If the wife was caught in flagranti breaking her marriage vows the law sanctioned brutal measures, right down to murder. In Dortmund a man who had murdered his wife and fled from the town afterward was allowed to retain not only his inheritance but that of his dead wife.

Cases of rape brought before the law were dealt with in a manner that almost always operated in the man's favour. The following statute was found in the Mühlhausen imperial law-book: 'If a man lie with a woman against her will and without her agreement, and she be thereby importuned, she should defend herself by crying out and should immediately report the matter with torn clothing, with wringing of hands and with weeping and with dishevelled hair'. If this occurs all persons should follow her to the judge, 'wherever he be found'.[44] Only seldom were the two witnesses required forthcoming. A respected citizen could easily, with the help of the council, silence any accusations against him, while the woman—who usually was from humbler social circumstances—found it much more difficult to defend her reputation.

As far as actual jurisdiction was concerned it is important to differentiate between the treatment meted out to female citizens and that given to members of the lower strata, noncitizens, and others. Criminal cases were treated in a manner very much against the interests of the accused if the latter was a rather poor inhabitant of the town without citizens' rights, and of course most punishments, with the exception of the death penalty, could be deflected by financial means. Town courts displayed particular cruelty (not just toward women; it was a general feature of medieval justice) in cases of theft, often irrespective of the value of the goods stolen. In Nuremberg and Augsburg during the years 1461, 1500, and 1503, three women found guilty of theft were buried alive. The Stralsund legal records register similar punishments for 1507 and 1513. Some women were drowned. In Görlitz, Freiberg, and Zwickau punishment could consist merely of banishment from the town for life. Judges showed particular harshness in their treatment of women in cases with political significance or those in which an example was to be made for others. In 1378, Agnes von Virbeke of Dortmund was burned as a sympathiser of the aristocracy, which was hostile to the town.

In marriage courts, which some councils set up in competition with the ecclesiastical courts, it appears that judgements had to take into account the rapid spread among all strata of unregulated sexual relations. Court records from Görlitz during the years 1370 and 1447 (*Liber proscriptionum* II) are very explicit on this: 'There are in the whole of Görlitz but few married people, fewer than twelve, who are not guilty of adultery; if one were to pillory all adulterers here in Görlitz then the new market place would be far too small to accommodate them all'.[45] Such a situation probably is the explanation for the ruling on illegitimate children made by the councils of Constance and Regensburg. In Constance a woman who had a child by an unmarried man could put the child in his care, but the child would not have inheritance rights. In Regensburg the mother always had the right to give the father an illegitimate child to care for a year after its birth. Clearly the council, by this ruling, was attempting to do something about the large number of foundlings who, in the end, were a strain on the town budget. A mother who killed her child was dealt with without mercy and without any thought to her partner—she was drowned or burned. Similarly, a woman who was proved to have killed her husband was punished by death.

* Does this gloomy picture of the relationship between the sexes inside and outside marriage, gleaned largely from law-books, court judgements, and general historical records, give an accurate reflection of everyday life in the late Middle Ages? To answer this question it is necessary to look at other sources of information— literary, autobiographical, and pictorial accounts. And in fact, we find that the negative examples portrayed above are balanced by many cases of close and harmonious relations within marriages and families. Certain women from the patriciate—like the wife, mother, and sister of the Munich chronicler Jörg Kazmair, who came into conflict with the council in 1398—went to extremes to preserve the wealth and reputation of their family.

They tackled the council themselves and risked being transported out of the town with a stone round their necks—a punishment reserved for rebellious and slanderous women. Their arguments used before the council reveal that they were not acting under Jörg Kazmair's guardianship but were themselves clearly knowledgeable in legal matters.

Many solemn oaths and attestations (*Verschwörbriefe* and *Urfehdebriefe* in German) from citizens arrested and condemned by councils and forbidden to enter the town and do any ill to its citizens were specifically required to be signed by the wife. In some cases such documents reveal that the wife was involved in activities directed against the council and therefore had to share the imprisonment. In the internal feuding that beset Halle between 1478 and 1479 women from the ranks of the wealthy salt panners were put under house arrest because they had joined their husbands in revolting against the council.

What can be said about the women from the upper strata goes for the wives of the guild craftsmen and merchants. Here, too, many wives gave loyal and steadfast support to their husbands when they were involved in municipal or commercial affairs. The wife of Johannes Mauersperling of Halberstadt, when her husband was unsuccessful in a lawsuit against the St. Paul's seminary, herself pursued the matter through the town courts. The subject of the dispute was her property rights over a stand near the graveyard of St. Martin's church. Because her husband did not accept the judgement he was excommunicated, and for her pains the Halberstadt ecclesiastical authorities threatened her with a similar punishment.

On a number of occasions women in the Saxon mining town of Freiberg joined their husband, son, or daughter in protesting against guilds and council. An interesting example is that of the Deynhard family. It was said of the wife of Deynhard, the Deynhardinne, that she had said 'unseemly words' to citizens in the council chamber and had refused to return one of their weapons.

Reinfried and another member of the family were also punished for disobedience and unseemly words toward the council. The same happened to the stepson of Reinfried Deynhard in 1427.[46]

In Brunswick the role played by wife and family emerges in the revolt of Ludeke Hollant against the council between 1487 and 1499. After the execution of a conspirator, the shopkeeper Wolter Holthusen, his betrayer felt so threatened by the wives of some of the rebels that he managed to have them banned from the town. Some of those banned were 'Wolter Holthusen's wife, Ludeke Ereke's wife with her daughter, and Jasper Bossen's wife and Kersten Flugge's wife and various other women'. The wife of Holthusen (who had been gruesomely executed) did not let the matter rest there. She lodged a claim of unlawful killing and dispossession of her house and property with the curia in Rome and thus managed to have the council called to Rome to account for itself.

Women played a prominent part above all when there was an external threat to the town. This can be seen from Adolphus of Nassau's report of the taking of Mainz, from which the burghers' wives were banished with only the clothes they wore, because they had thrown stones at the enemy and poured hot water over them from their houses.

According to one report by Cafarus, the men and women of Genoa worked day and night to build up the defence structures of their town when, after the Imperial Diet of Roncaglia in 1158, an attack by the Emperor Frederick I seemed imminent. No less significant is female involvement in times of emergency, as recorded in the diary of an anonymous citizen of Paris dating from the first half of the fifteenth century. According to this diary the wives and daughters of Paris citizens went to the wife of the regent, the duchess of Burgundy, and asked her to help restore peace. She apparently replied that this was also her greatest desire, and assured them that the duke was determined to do his utmost to achieve peace, suggesting that the Paris women presented their case well. The peace treaty of Arras signed in the same year by the duke of Burgundy and King Charles VII allowed joint action to be taken against the English occupying forces and represented a turning point in the Hundred Years' War (1337–1453) between England and France.

There are examples of men standing up for wives who have come into conflict with the law or broken with societal norms. Thus we find that Merten Helbig, a Görlitz master clothmaker, followed his wife, who was banished from the town as a punishment for a theft she had committed two years previously. A Görlitz tailor, Frantz Hiller, whose wife had left with a journeyman because she had been mistreated, took her in again, even though this brought him into conflict with the guild, which excluded him from their ranks for his action. The chancellor of the king of Bohemia pleaded with the council that the pair should be allowed to remain in Görlitz, but the guild was unmoved. Hiller protested against the mayor of the town, was arrested, and had, with his wife, to swear an oath never to return and finally leave town. In Mühlhausen (Thuringia) in the early fifteenth century five citizens swore an oath in support of Tile Vorsprache, who had been called before the council on account of a statement he was alleged to have made to the effect that he would avenge his wife if harm befell her in the town prison.

Such examples show that in a situation where men and women were functioning both economically and socially as partners, it was possible for deep human relationships to develop. These first beginnings of a new concept of love and marriage are well expressed in the first words in Geoffrey Chaucer's *Franklin's Tale* of his *Canterbury Tales:*

35 First page of the third municipal record of Stralsund, in which transfers of property to, or by women are recorded.
Liber de hereditatum venditione et resignatione, 1385–1418, fol. 1.
Stadtarchiv Stralsund

[A]nno dñi millesimo
tricentesimo octuage
simo quinto · circa fes
tum beati mychahelis
archangeli Impositus
est iste liber de hereditatum ven
dicacione · et rsignacione ∞∞∞∞ ~

Nicolaus prius scar hereditariam diuisionem suis pueris nicolao et alheydi de pa-
terna hereditate in hunc modum ita qᵉ dedit et assignauit dois suis pueris pueris
suis a dicte Buden
fuit a dco ipsorum parte nicolao quantum de paterna hereditate ipsorum ...

Item alheydis relicta willekini holt scar hereditariam diuisionem nicolao et andree suis pueris
de paterna hereditate ipsorum in hunc modum ita qᵉ dedit et assignauit dois suis pueris ...
... quondam pueris ex omnibus
... alheydis qᵉ ... monstra ... pueris
hereditate ipsorum penitus diuis et septa

Item
Hermannus holtorp emit a katherina relicta henrici steynenam grais bodie pennas
... ... sub dois certis bodie pennas

Katherina relicta henrici steynenawes ... scar hereditariam diuisione henrico twinckessest
suis pueris in ... modum ita qᵉ dedit et assiguauit dois suis pueris
... ... paterna dois suis pueris henri-
...
pueris de paterna hereditate ipsorum penitus diuis et separat

36 In accordance with Saxon law, adulterers were buried alive and impaled.
Miniature from the Zwickau book of town law, 1348. Stadt- und Kreisarchiv Zwickau

37 The home of a wrongdoer, who has kidnapped a woman, is destroyed by fellow citizens.
Miniature from the Zwickau book of town law, 1348. Stadt- und Kreisarchiv Zwickau

38 A woman takes an oath before the Graz town judge.
Painting by an unknown master, 'Picture of the Town Judge', 1478, detail. Stadtmuseum, Graz

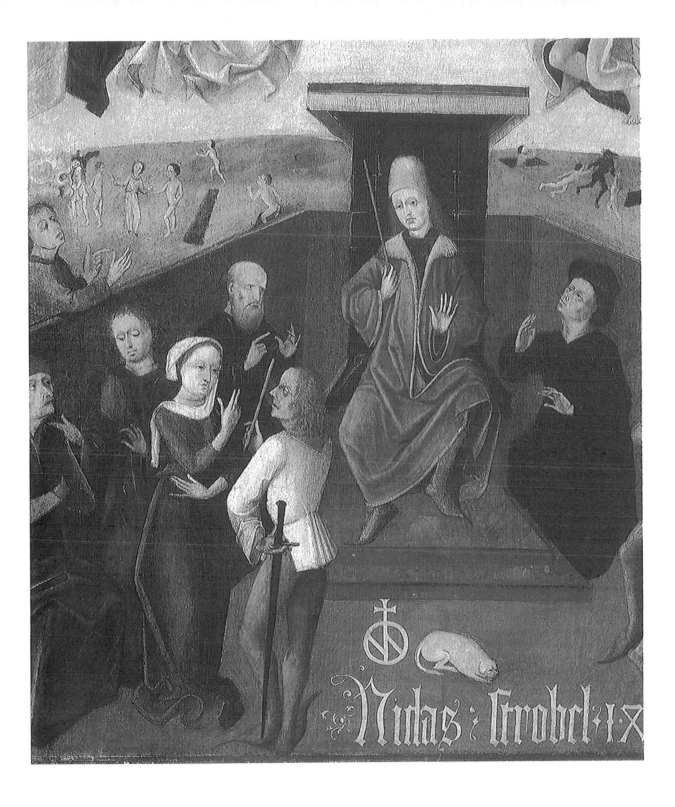

Niclas Strobel · 1 · 7

39 The court has ordered a dispute to be settled by open combat, in which the woman's weapon is a stone wrapped in a cloth. In order to counterbalance the physical superiority of the male, limits are placed on his freedom of movement.
Miniature from Heinrich von Neustadt's *Appolonius von Tyrland*, southern German manuscript, post 1400, Chart. A 689. Forschungsbibliothek Gotha

40 In an outdoor open combat between man and woman, the woman, armed with sword and spear, obviously has the upper hand.
Miniature from Diebold Schilling, *Spiezer Bilder-Chronik*, 1485, plate 36. Municipal and University Library, Berne

Following pages

41 Joachim and Anne, the parents of Mary, Mother of God, are depicted in front of the town gate of Jerusalem, dressed in the fashion of fifteenth-century Halberstadt burghers.
Ambulatory window, 'Anne and Joachim before the Golden Gate', ca. 1420. Halberstadt Cathedral

42 Double image of Philip the Younger of Hanau-Münzenberg, with his wife Margret Weisskirchner, who came from a middle-class background.
Painting on lime wood by the Master of the House Book, 'Pair of Lovers', ca. 1480. Museen der Stadt Gotha

43 Joachim, the father of Mary, provides the young mother with food. Such representations of men from the holy family in scenes involving mother and child provide evidence of the changes in marital and family relations which took place in the late Middle Ages.
Painting by the Master of the Scots Altar, 'Birth of the Virgin', ca. 1470, detail. Benedictine Abbey of the Scots, Vienna

44 It is unusual for men, here presumably the husband and the doctor, under whom the midwife is working, to be depicted in birth scenes.
Miniature from Pseudo-Jaquemart, 'Birth of the Virgin', late four-teenth century, Ms. lat. 919, fol. 28. Bibliothèque Nationale, Paris

Das ein man vnd ein frow an der
matten ze Bern mitenandern kämpfte

Do man zalt / 1465 jar an dem ach
tenden tag der kindlen / bestach ein kampff an
der matten an der statt do nu des bischoffs mure
statt vnd kämpften ein man vnd ein frow mit
einandern vnd lag die frow ob .

45 Daily maternal care in a busy scene.
Painting by an unknown artist, 'The Holy Family', 1510/20.
Museum of Fine Arts, Budapest

46 Portrait of a young Italian woman.
Painting by Sebastiano Mainardi, 'Half-length Portrait of a Young
Woman', ca. 1500. Staatliches Lindenau Museum, Altenburg

47 Scenes from Roman history on a chest, such as was commonly
found in the houses of the upper stratum of the town population.
Picture on a chest by Nicolo Giolfino, ca. 1530. Staatliches
Lindenau Museum,

48 The interior of the house of an Italian burgher: Mary is sitting
on a chest; to the left there is a lectern, to the right, in the alcove, a
bed.
Panel painting by Barnaba da Modena, 'The Annunciation', first
half of the fifteenth century, detail. Staatliches Lindenau Museum,
Altenburg

49 Typical cupboard from an urban household with crenelation and tracery.
Painting by the Master of Maria am Gestade, 'The Annunciation', ca. 1460, detail. Church of the Redemptorists Maria am Gestade, Vienna

50 The interior of this well-to-do burgher's house contains a chest and a majolica jug. By the side of a bench with tracery work, there are wooden-soled slippers with leather straps, in the foreground an open cash-box.
Painting by the Master of Maria am Gestade, 'The Annunciation', ca. 1460, detail. Church of the Redemptorists Maria am Gestade, Vienna

51 French town burghers at dinner. The illumination is based on the wedding feast at Cana. A maid is lifting one of the jugs. At the lower edge of the picture the poor are being fed.
Miniature by the Master of the Parament (workshop), late fourteenth century, Nouv. acq. lat. 3093. Bibliothèque Nationale, Paris

52 Interior of a bedchamber: a wide wooden bed with the obligatory wooden ledge, a footstool, a small wooden chest.
Miniature 'Consummation' from Aegidius Colonna, *The Trojan War*, in the version by Martinus Opifex, 1445/50, Hs. 2273, fol. 18 r. Österreichische Nationalbibliothek, Vienna

53 St. Dorothy is given a fashionable hairstyle, a delicate pearl chain, and elegant collar; the upper part of her dress is sewn with pearls.
Painting by the Master of the Rottal Epitaph, ca. 1500. Old Gallery of the Landesmuseum Joanneum, Graz

54 The women accompanying Mary are dressed in the style of the urban upper classes of the second half of the fifteenth century. Note the person in the centre, whose headdress is skilfully built up into a peaked shape.
Painting by the Master of the Scots Altar, 'Marriage of Mary', ca. 1470. Benedictine Abbey of the Scots, Vienna

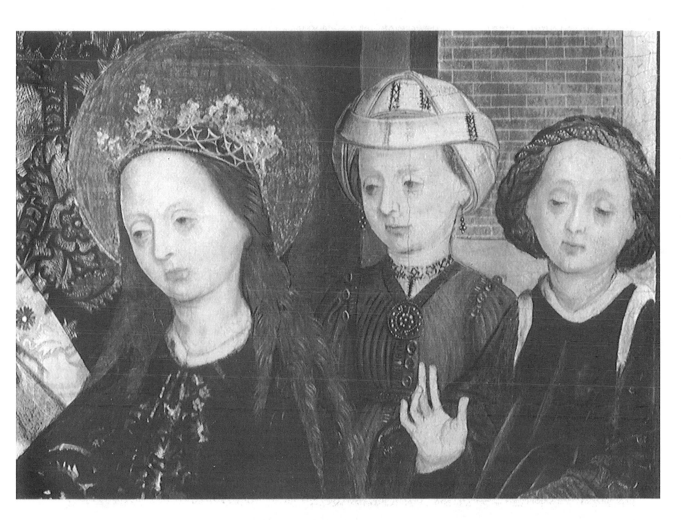

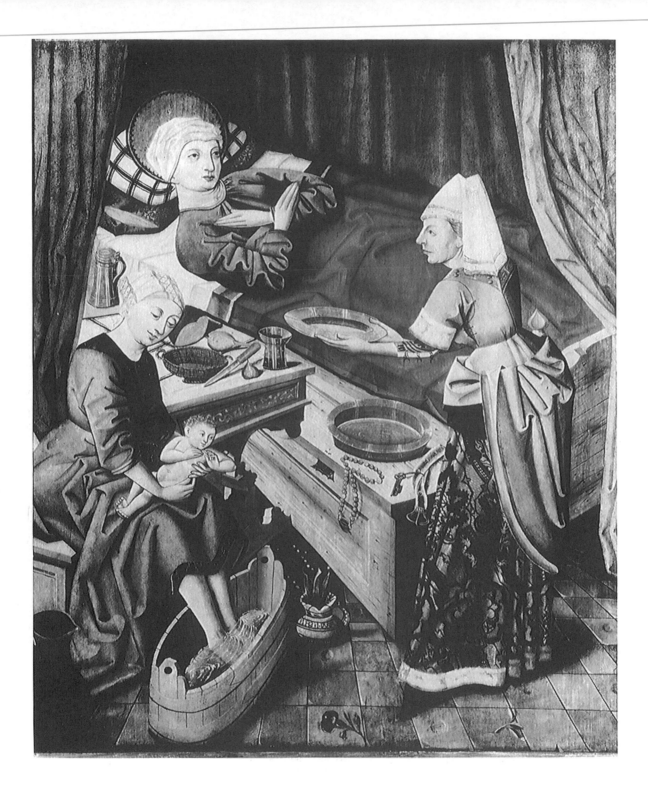

55 This picture of Mary displays countless details of the interior of a prosperous burgher's house: the bed with side curtains, and in front of it a chest and table. The clothes are made of fine materials. Painting by the Master of the Eggelsberg Altar, 'Birth of the Virgin', 1481, detail. Schlossmuseum, Linz

56 The elegant clothes worn by Mary and Joseph are barely distinguishable from those of the kneeling king. This scene from the life of Mary has been set in the milieu of the urban upper stratum. Panel painting from the Lübeck Altar of Mary, ca. 1500, detail. Church of the Virgin Mary, Parchim

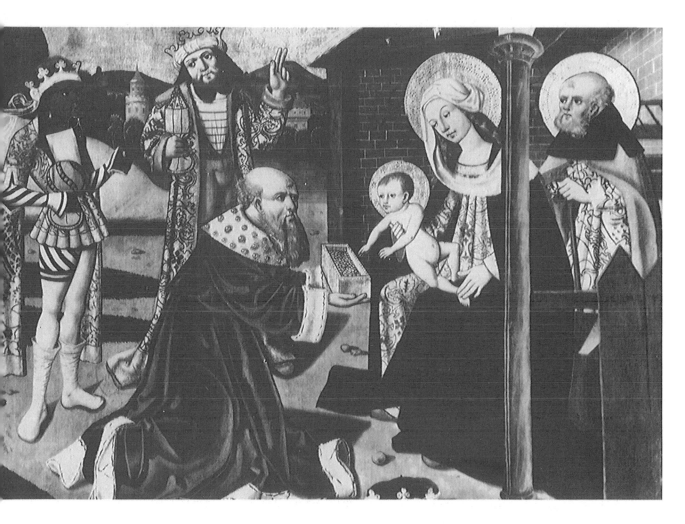

57 Burghers enjoy themselves while dancing and bathing in the countryside.
Picture for the month of May, from the manuscript HS 3085, fol. 4r., ca. 1475. Österreichische Nationalbibliothek, Vienna

58 The duties of a wife included accompanying her husband when he had a tooth extracted.
Pen drawing from a manual of chess, Codex poet., 1467. Württembergische Landesbibliothek, Stuttgart

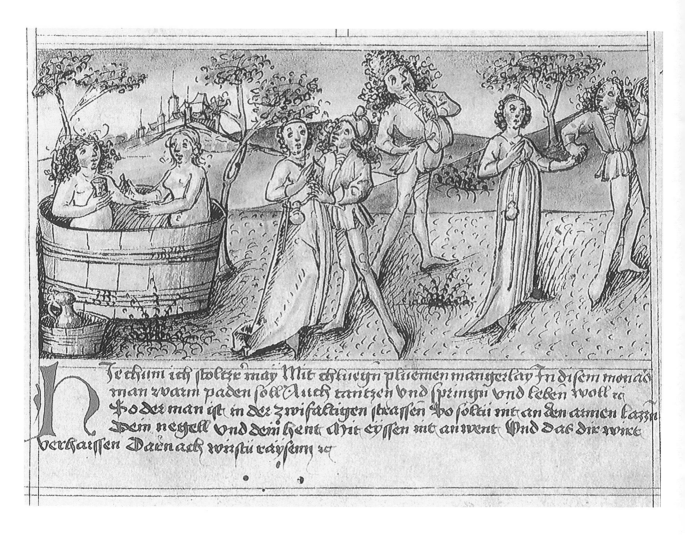

Der ob sy wurt gewar
Vnd jres verswaig so gar
Wann das sie jms seitte me
Vor scham ich muß sagen hie
Von einer die tet der vngtlich
Als ich hort wan jch
An dem buch mit hant
es wart mir von sagen erkant
Ein bischafft wie ein frowe jren man dar
Zu brocht das er ließ den vierden zan vß brechen

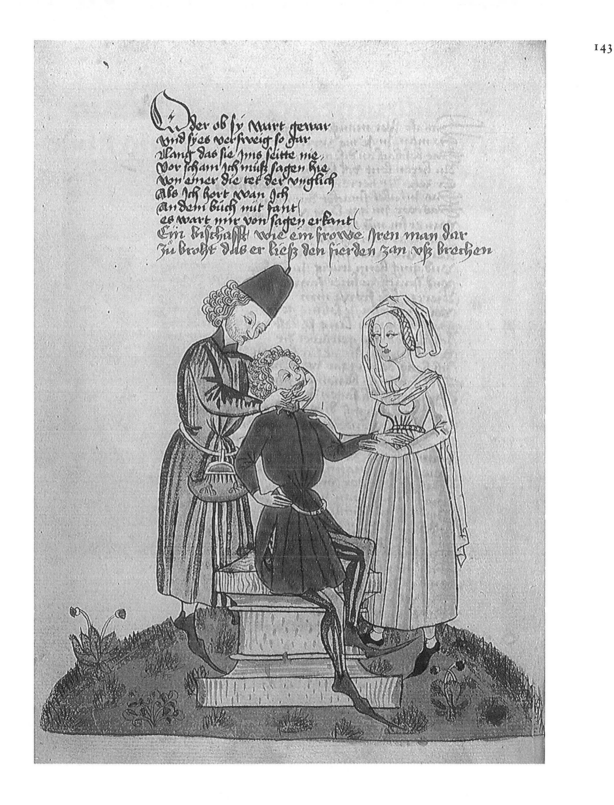

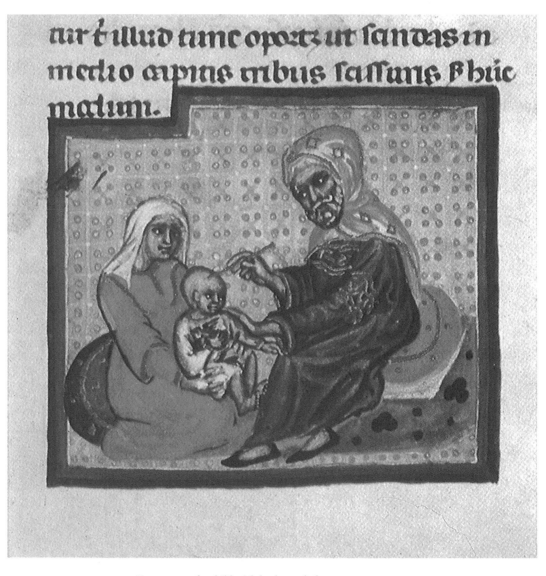

59 Treatment of a child with hydrocephalus.
Miniature from *Chirurgia,* by Gerard of Cremona, twelfth century, Codex Series Nova 2641, book 2, fol. 17r. Österreichische Nationalbibliothek, Vienna

For a thyng, sires, saufly dar I seye,
That freendes everych oother moot obeye,
If they wol longe holden compaignye.
Love wol nat been constreyned by maistrye.
Whan maistrie comth, the God of Love anon
Beteth his wynges, and farewel, he is gon!
Love is a thyng as any spirit free.
Wommen, of kynde, desiren libertee,
And nat to been constreyned as a thral;
And so doon men, if I sooth seyen shal.

Revealing remarks with regard to the changing relations between the sexes appear in Chaucer's *Clerk's Tale* of his *Canterbury Tales* concerning the Griselda motif. (The Griselda tale is a strong advocation of the domination of man in marriage.) Chaucer writes that it would be surprising if one would still find two or three Griseldas in one town who would willingly tolerate such torment.[47]

* The autobiographical writings of three women from the upper classes of medieval towns—Christine de Pisan, Helene Kottanerin, and Alessandra Macinghi degli Strozzi—tell of a very close relationship with their husbands. Christine de Pisan describes her husband, who was nine years her elder and died at an early age, as an extremely considerate man who, she says, never lied to her and supported her in all she did. Alessandra Macinghi degli Strozzi, too, in her letters, communicates to her sons nothing but respect for her husband, who died after thirteen years of marriage. Her second son fulfilled one of her greatest wishes when he called one of his legitimate sons Matteo, after the grandfather. Who were these women whose own hands have left us the very fullest accounts of their lives?

Christine de Pisan, born in Venice in 1364, was the daughter of the doctor and astrologist Tommaso di Benvenuto, an extremely successful citizen. He occupied the chair of medicine at the university of Bologna and was connected by marriage with the city-state of Venice.

The father followed a call from the French king Charles V (1364–1380) and moved, in December 1368, to Paris. Christine was more thirsty for knowledge than her two younger brothers and, as she became older, made good use of the better opportunities for education offered to her by her new surroundings. She learned French and Latin, arithmetic and geometry; and librarian Gilles Malet gave her access to the treasures he had in his care.

At the age of fifteen Christine was married to the royal secretary Etienne du Castel, thereby joining the ranks of those women from the upper strata of town society who were linked to the royal court. She bears witness to the way in which individual women were able, through such links, to play a very active role in the social life of their time beyond the boundaries of their town. The early death of her husband left Christine not only in great despair but also in considerable financial difficulties. She began to write in order to lessen her grief. She also had, because of her precarious financial situation, to educate her children Marie and Jean herself. She wrote for them the 'Book of Wisdom' (*Livre de Prudence à l'enseignement de bien vivre*). Her following book, 'The Epistle of Othea' (*L'Epistre d'Othéa*), on the advice of a friend, she managed to sell to the Duke of Burgundy, Philip the Bold, for a considerable sum of money. Against all odds she became known as a writer and won much interest for her books. She dealt in them with important contemporary issues, as in her 'Book of Peace' (*Livre de la Paix*) and the 'Book of the City of the Ladies' (*La cité des dames*), in which she joined the debate about women's capabilities and criticised the attitude that regarded women as inferior. In the 'Book of the Three Virtues' (*Livre des Trois Vertus*) she drew up, from the point of view of her own social environment, a concept of education for women of all social ranks; in her own social milieu she was in favour of thorough education for women.

Helene Kottanerin, widow of the *Bürgermeister* of Ödenburg, Peter Székeles, who then married the gentleman-in-waiting of the provost of St. Stephen's Cathe-

dral, Vienna, became lady-in-waiting of the queen consort of King Albert II (1438–1439). On the sudden death of the Habsburg monarch in 1439 the aristocracy in Hungary and Bohemia were concerned to find their own candidate for the throne, and rejected the idea of the infant Habsburg prince Ladislas Posthumus's succeeding to the throne. The king's widow, Elizabeth, approached her lady-in-waiting with an extraordinary request: Helene was to steal the throne insignia for Elizabeth's son Ladislas, who had been born after the death of his father. The barely three months' old boy would thus have a better chance of successfully pursuing his claim to the throne against the rival candidate put forward by the Hungarian aristocracy, Wladyslaw of Poland. The coup was successful and, for a brief period raised the hopes of success of the Habsburgs. However, these were soon dashed by the death of the queen.

In contrast to the rich variety of writings created by Christine de Pisan, the autobiography of Helene Kottanerin is concerned mainly with political affairs and her own role as lady-in-waiting and confidante of the queen. From the point of view of the social role of patrician women her account of the birth of Ladislas is of interest. The queen chose as assistants two honest widows from Ofen. They brought with them a midwife and another woman from Ofen, who was to be the child's nurse and had brought along her own baby. But Helene Kottanerin makes it quite clear that she herself was in a position to assist the queen. Widows from the town aristocracy were at times used fairly peremptorily. Thus the child Ladislas was put up in the house of the widow of an Ödenburg citizen without notice, and the owner had to leave her home without being able to take any of her possessions with her. It was only when the son-in-law of the widow concerned protested that Elizabeth ordered that she be offered appropriate lodging in the house of an Ödenburg patrician.

The third of the three women we have mentioned, Alessandra Macinghi degli Strozzi, was born into a merchant family in Florence in 1406. At the age of sixteen she was married to Matteo Strozzi. Her husband, who held important offices in the city, was sent into banishment during the political upheavals between 1433 and 1434 which finally resulted in Cosimo de' Medici coming to power. His wife followed him with their seven children. In the two years before her husband's death she lost three of them. In 1436, now a widow, but once more pregnant, she returned with two boys and two girls to Florence. When the two boys came of age they too were subject to banishment. Only the youngest son, born after the death of his father, remained with his mother and two sisters for some time after he, too, had come of age; then the eldest of the sons, who lived in Naples, required him to join him to support him and to be trained in the family business. It is because of this splitting up of the family that posterity has been left 72 letters from Alessandra from the years 1447 to 1469. These give an excellent insight into the everyday life of this woman who, finding herself in an unusual situation, used all her resources, wisdom, ingenuity, and determination to do the best by her family, not hiding her own suffering but bravely coming to terms with it and devoting her entire energies to those closest to her. She endeavours, by reducing her own needs to a modest level, and through skillful management of her tax affairs and occasional business deals, to retain what is left of the family fortune in Florence and make a new start abroad easier for her sons. She carries out complicated negotiations for the marriage of her daughters and keeps an eye open for suitable apprentices for her sons' businesses. When appropriate she writes advice to her sons, produces linen, towels, shirts, and fashionable collars for them at home, and sends them delicacies. At the same time she follows political developments in Florence and establishes contacts with influential people in the town council whose names, however, are only mentioned in code in her letters. Among other things she gives a lecture to the second son who is taking a rather unserious attitude toward his apprenticeship in Bruges, and refuses to answer to his extravagant needs. Above all,

wishing to have grandchildren, she urges her sons to marry. On the other hand she displays tolerance of their illegitimate adventures with house slaves and makes arrangements for their offspring to be cared for. In one letter to her eldest son, Filippo, she writes, exasperated by his constant plans for marriage which never come to fruition: 'I pray God that he should free you from your fears, for if all men were so afraid of marriage as you are, the world would long since have died out! This is why we must help you to realise that the devil is not as black as he is made out to be, and must release you from your fears'. When her eldest finally does marry and the fifteen-year-old daughter-in-law is living under her roof, Alessandra proves to be an understanding support for the young woman and a faithful companion in her subsequent pregnancies. As is usual in upper-class urban families, the baby is given to nurses (either in the home or outside it) who are carefully chosen from women from the surrounding countryside. Once the child has been weaned it comes under the care of the grandmother, for the young, by no means robust mother is already expecting the next child. In connection with the extra work involved in her daughter-in-law's second pregnancy Alessandra writes: 'If I had no other interruptions in my work than Alfonso [the grandchild] that would be more than enough, but I have much pleasure from it; he follows me everywhere like a chicken following a hen'.

For all her sterling qualities Alessandra is every bit a lady of the wealthy town burghers. This does not emerge in her attitude to the slaves working in her own household. Toward them, with their close access to what is going on in the family, she displays a certain reserve, lest they betray something about the household, especially the marriageability of the daughters! Care is not displayed in her dealings with the poor tenants on her country properties. Thus she writes, in 1465: 'Piero and Mona Cilio are still alive, but they are both very sickly. I have leased out the property for next year, for I am concerned that it should be kept in good condition.

And if the two old people do not die, they will have to go begging. May God care for them'.[48]

* Alessandra Macinghi's correspondence, which reveals so much about her relationship with her children, prompts us to ask whether what she wrote is of general validity. Historical sources—lives of saints, court records, wills, letters, and chronicles—give us only chance impressions. What is clear, however, is that children, even those in the urban upper strata, were not always as well off as those of the younger Strozzi generation, who grew up in a relatively small family. Often—particularly in the households of the urban upper strata—a large number of children from various marriages of the father (more rarely of the mother) lived together. Even illegiti-

Woman bathing a child.
Woodcut, printed by Heinrich Laufenberg, Augsburg, 1491. In: Albert Schramm, *Der Bilderschmuck der Frühdrucke*. Vol. XXIII. Leipzig, 1943, ill. 382.

A woman helps a child learn to walk with a special apparatus. Such three-wheeled apparatuses were widespread elsewhere—for example, in Poland.
Woodcut, printed by Heinrich Laufenberg, Augsburg, 1491. In: Albert Schramm, *Der Bilderschmuck der Frühdrucke*. Vol. XXIII. Leipzig, 1943, ill. 385.

mate offspring of the husband—as often as not dating from a long period of bachelorhood before marriage—formed part of the household. In Italy their mothers were often household slaves, in northern countries, maids and housekeepers. In such large families, where infants were usually given to a nurse for the first two years of their lives, and boys started school or an apprenticeship in a merchant family (relatives or friends) when they were six or seven, an individual child often went without the close attention of its mother. She had often married young and was physically not in a position to care for her children intensively. Not infrequently, she died early, in childbirth or from sheer physical exhaustion, and was succeeded by a very young wife.

Thus, the chances of a close bond between mother and child evaporated. Or, circumstances changed through the early death of the father and remarriage of the mother. The stepfather demanded much attention for himself, his business, and possibly his own children whom he brought with him into the marriage, so that the mother had little time for an individual child. At best this role was taken by older brothers or sisters, close relatives or tutors. Johannes Butzbach reports of his own childhood: '. . .When my mother became pregnant again and was expecting my sister Margarete, I was taken from her breast at the age of nine months. My aunt, who was childless, took me as her child, and brought me up for many years with great tenderness and love until her death'.[49] His was by no means an isolated case. Nevertheless, a child often had a close relationship with its mother. Many wills testify to a close concern of sons for their mothers. The late age at which men married was to the advantage of mother-son relationships. In 1421, the mother of Henneke Behr, who had been gruesomely executed in Stralsund, persuaded Duke Magnus of Saxe-Lauenburg to gain the Stralsund council's permission for her to take down her son's body from the wheel and bury it.

In wills from the towns of the Hanseatic League the aunt on the mother's side *(matertera)* is often given special consideration. Thus the 1346 will of a male citizen of Stralsund makes provision only for his sister, his aunt, and the latter's two children. The daughter receives a mark and two cushions, the son a mark and a chest, the aunt linen, a mark, and the money for a pilgrimage to Aachen. The writer of the will thus gives her an important task to carry out for his soul, and allows her to request the necessary finances for this. In another Stralsund will the aunt receives a fur—elsewhere the fee for a nurse—and her sister one good and one old skirt.

Growing up in a town family did not, on the whole, spoil the children, and it gave them an early appreciation of the realities of life. When the childless wife of a rich Italian merchant from Prato, Francesco Datini, takes in

Parents are encouraged to bring up their children strictly.
Woodcut by an unknown master, 'The Bad Upbringing'. In: Johann Schwartzenberg, *Memorial der Tugend*. Augsburg, 1535.

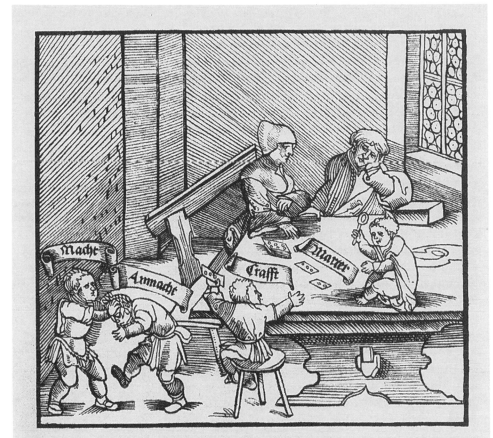

Wer jungen kinder spart dj rüt/
　Der leßen findt man selten güt.
Wann alter hund zü aller frist/
　Nit pändig recht zemachen ist.
Drumb wölt jr kinder haben eer/
　Bey zeit gewent sy gütter ler.
Pflegt jr mit zucht vnd rechter trew/
　Deß hj vnd dort gewint jr rew.
Wer päsen kinden waich erscheint/
　Der ist jr aller größter feint/
Vnd lacht yetzt deß jr nachmals greint.

her seven-year-old niece for a long period, the child's father writes: 'I am pleased that Tina wishes to read. I would ask you to put her right and punish her, for I think that she needs this'.[50] In addition to the girl Tina, in the Datini household there is the child of a household slave, who receives a careful education and eventually a good marriage. Italian moralists, like Paolo da Certaldo, tell parents to teach their daughters all the household skills—baking of bread, cleaning of poultry, sieving of flour, cooking and washing, making beds, spinning and weaving, embroidering silk, making linen and wool clothing, and darning stockings.[51] These were no empty demands; in the twelfth century, ten-year-old Bona from Pisa was selling her own spun silk at the appropriate price on the market.

In the middle and lower strata of town society, where the mother had to feed the infant herself, the mother-child bond was a close one, but the physical vulnerability of both was probably greater. Families such as that of Saint Catherine of Siena, who was the twenty-fourth child of a dyer, were not the norm, but the social position of such families forced the mother to be on a constant lookout for additional ways of earning money. One possibility was to offer her services as a nurse. The terrible circumstances that sometimes lay behind such transactions are suggested in a letter from the wife of the above-mentioned merchant Francesco Datini, who sometimes helped friends and customers find nurses. She writes: 'They seem to have disappeared from the face of the earth, for I can find none. And some whom I used to have, whose own children were near to death, now say that they are well. . . . I found one whose milk is now two months old. She has promised me that if her child, who is near to death, dies tonight she will come as soon as it has been buried'.[52] Above all, in poorer families, childhood ended at the age of four or five, when a child had to start looking after its younger brothers or sisters, help with the spinning, look after geese for payment, and help out in the household, garden, and vineyards. If the child did not carry out its

tasks properly the mother could be summoned before the town court to answer for it.

✱ If we try to gain an overview of the position of female town dwellers under law, in marriage, and in the family from the second half of the eleventh to the second half of the fifteenth centuries, what stands out compared with earlier times are significant changes in marriage and

Woman dressed in the costume of Basle.
Engraving by Hans Holbein the Younger. In: Georg Hirth, *Kulturgeschichtliches Bilderbuch aus vier Jahrhunderten.* Vol. I. Munich, 1923.

family law. But records of town laws do not always reflect these changes. The Catholic church's demand for marriage to be based on consent of the two people concerned largely benefitted the less well-off and the poor inhabitants of the towns, as it was their employers who insisted on the right to give permission for marriages, after they had freed themselves from their feudal lords where this restriction was concerned. For the children of the upper classes and the middle bourgeoisie the statutes relating to disinheritance constituted a severe restriction of their right to marry as they liked. They were still largely at the mercy of the marriage conventions of their social surroundings. Sometimes they attempted to avoid these restrictions through secret marriages.

For most female town dwellers what was of great significance, particularly in view of the very young age at which many married, were the changes in family inheritance law. The portion of the inheritance which was dependent on growth of the family fortune—usually a third but sometimes half, or even two-thirds—which the wife now received in addition to her dowry, raised her interest in her husband's financial affairs, and any work she did in the family business was rewarded. In cases where the husband was dependent on his wife's contribution, particularly in the case of craftsmen, the will often gave the wife access to the complete fortune.

One severe restriction for a woman with a large family was the reduction of her inheritance to the level of the children if she remarried after her husband's death. For the children's care and education, distribution of the inheritance had definite positive effects given the risk that remarriage could represent. It also forced marriage partners to give careful thought to their actions, and encouraged marriage based on genuine partnership and love. One aspect of the changes that occurred in the law in the late Middle Ages was the liberalisation of the guardianship of the husband over his wife. In many European large and medium-sized towns the wife received, during her husband's lifetime, the right of disposal of part of the family fortune (dowry, *Morgengabe*,

property transferred by the husband, annuities, inheritance from parents, brothers or sisters, or other relatives, bequests transferred during lifetime), although seldom over the entire fortune. She was able to dispose of these freely in her own will. Upper-class ladies also acquired property, houses, rents, and even fiefs, or they invested their cash in loans to the town or in businesses. In middle-class families the women now had the means to operate independently as shopkeepers, carry out business transactions, operate with small sums of money on the town bond market, build up their daughters' trousseaux or supplement the travel money of sons who were at school or serving an apprenticeship. In this way the position of married women was no longer different from that of widows or unmarried ones, although the latter were forced to have greater economic independence and, as a result of their rights and duties as citizens in their own right, were more closely concerned with the problems and affairs of the trades and crafts guilds and the town.

Hand in hand with women's partnership in property matters and the loosening of their husbands' power to speak and act on their behalf went an increasing recognition of their ability to take an active role in legal affairs. This applied, for example, to their involvement as parties to contracts, as executors of wills, as guardians, and as witnesses. Biographical accounts by urban upper-class women—we have seen portions of Alessandra Macinghi degli Strozzi's—demonstrate the extent to which a well-educated and experienced woman could play a central role in a family with very varied needs and demands.

It goes without saying that this progress in marital and family law hardly benefitted young wives who were exhausted by the birth of one child after another and the demands made on them by a large household with many children. And for the poorer families without citizens' rights the situation was obviously also different. In these circles the age at which girls married was probably higher. There was not the intellectual separation be-

tween husband and wife that existed in patrician families as a result of the difference in age and level of education of the two. Shared responsibility for children and household among the lower classes rendered the husband's naturally predominant position less obvious.

Despite the positive changes that occurred for the majority of female citizens and ordinary town dwellers as regards their legal position, the guardianship of husbands remained as a principle that could be invoked to regain rights already ceded. This situation remained, al-though the economic and social interests of the town burghers were pointing in another direction. This can partly be explained by the deeply rooted legal tradition and the tendency for the urban upper strata to imitate the life-style of the aristocracy as manifested in their emphasis, in marriage matters, on the importance of maintaining lineage. But in order to delve further into the complex reasons for this apparent paradox we will now look at the religious justification for the predominant position of the husband.

Religion
and Religiousness

The female town dweller's role in marriage, the family, the guild, and the community was determined not only by prevailing economic and social relations but by religious belief and custom. In Christianity, early attitudes toward women were inconsistent. Throughout the persecution, Christianity relied to a considerable extent on women's support; in the New Testament, Christ treats male and female members of the ancient Christian communities with a certain degree of equality. The Gospels record certain aspects of his behaviour which must have contravened then-current patriarchal practice and which were thus initially misunderstood by the disciples; we have, for example, the condemnation of the arbitrary repudiation of the wife by the husband (Matthew 19.1–19.11, Mark 10.1–10.12); the salvation of the adultress (John 8.1–8.11); allowing a woman to anoint the body or feet, a right that was usually performed by the man of the house (Matthew 26.6–26.13, Mark 14.3 14.9, John 12.1–12.8, Luke 7.36–7.50); and the treatment of woman as a conversation partner in her own right, as in the report in John of the conversion of the Samaritans (John 4.5–4.41). All the disciples mention Jesus' numerous female supporters (Matthew 27.55, Luke 8.2f., 23.55, 24.10f., Mark 15.40f.), and the active role played by female members of the community is well documented for the first three centuries A.D. The names of Saint Mary Magdalene, Junia, Saint Priscilla, and Paul's pupil Saint Thecla have been passed down to us as important female personalities in the early Christian communities. Thus we have the beginnings of

a tradition that was to have a very positive effect on the shaping of the Christian image of the female, a tradition that could later be revived.

In the fourth and fifth centuries, an important phase in the development of the ruling Catholic theology—the religious doctrine which was to dominate the whole of the Middle Ages, and the period in which Christianity was being transformed from a religion of the persecuted into a state religion—the elements within Christianity sympathetic to women gradually disappeared. According to St. Paul (Corinthians 1, 11.5), women could make prophetic statements to the community only when wearing a veil, and they were thus forced into remaining anonymous. The picture of the two sexes propagated by the early Church fathers was influenced by neo-Platonism and was of great significance for the image of woman projected by the Catholic church. It equated women with sensuality, the body, the imperfect, and the transitory, and men with the soul striving to reach God. Since women were guilty of original sin and of continual attempts to dominate man's soul, they were considered to be sinful and inferior beings.

The equality of man and woman (Matthew 19.4ff., Mark 10.6ff.), deriving from the story of creation (Genesis 1.26–1.28), was substituted for a feminine elitist picture based on the ascetic ideal of lifelong virginity. The theologians of the fourth and fifth centuries were unanimous in their demand that the majority of women be submissive and obedient in all matters, man being the 'head' of the woman. This demand was based

The snake with a woman's head is a symbol of
woman's sinful nature.
Representation of the Fall of Man from *Biblia
Pauperum, Codex Vindobonensis* 1198, fol. 3 r.,
detail. Österreichische Nationalbibliothek, Vienna

on the claim that woman derives from man—which
again runs contrary to the first report of creation and the
corresponding passages from Matthew and Mark—and
that woman, unlike man, is not made in the image of
God and that Eve, when she seduced Adam, brought sin
into the world. Christian women were encouraged to
live in awareness of original sin, and men not to let them-
selves get entangled in the sinfulness of women. Another
warning to men to beware of women stems from practi-
cal rather than theological considerations and is found
in the writings of Saint John Chrysostom dating from
the second half of the fourth century. Having expressed
undisguised regret at the loss of the greater freedom men
had in their relations with women in the pre-Christian
era, when they were still permitted to 'have two women
at the same time'[53] and could spurn a woman they no
longer loved without being accused of adultery, he goes
on to argue how difficult it is for the man to adhere to
the Christian commandments, due to domestic cares,
the bustle of secular affairs and—in the worst cases—a
nasty, bitter, or difficult wife.

Both St. Augustine (A.D. 354–430) and St. Jerome
(ca. 347–ca. 420) advise Christian wives to lead an ascet-
ic life. Augustine, however, who had a particularly
strong influence on medieval theology, handles with ex-
traordinary sensitivity in *The Marriage Estate* the ques-
tion of marriage for the purpose of producing offspring,
and of discouraging promiscuous sexual activity. He
even concedes that, according to the Bible (Corinthians
1, 7.4ff.), woman like man has the right 'to the body of
the marriage partner and to be the active partner in the
relationship and vice versa'.

✳ In the time of the development of the medieval towns
the theological understanding of relations between the
sexes was already firmly established, and it was not par-
ticularly favourable to women. The writings of indi-
viduals who voiced somewhat less unfavourable com-
ments on women did not have any long-lasting effect.
These included the letters of scholastic philosopher and

theologian Peter Abelard to Heloise (his lover and the mother of his son, Astrolabus; as a consequence of her affair with Abelard, Heloise entered a convent and became abbess of Paraklet), which mention numerous positive female figures from the Bible. Such a less-prejudiced attitude toward woman can also be found in the works of Hugh of St. Victor (1096–1141) and Peter Lombard (ca. 1100–1160), both of whom emphasise partnership in marriage. The reasoning of Peter Lombard in this matter is particularly interesting. According to him God did not create woman from Adam's head, because she was not to be his ruler, nor from his foot, because she was not to be his slave, but from his side, because she was to be his companion and friend. Peter Abelard and Saint Hildegard (1098–1179) differ from the majority of their contemporaries, who had extremely conservative attitudes toward relations between the sexes, partly because they do not assess the human being's sexual behaviour in a completely negative manner but regard it as a biological necessity, vital for the reproduction of the human race.

The most influential theologians of the thirteenth century, especially Saint Albertus Magnus (ca. 1200 to 1280) and Saint Thomas Aquinas (1225–1274), took up the negative statements made by the Church fathers on the nature of woman, and treat her as an inferior being in the spiritual, physical, and ethical sense. They, like the Church fathers before them, base woman's subordination on her origin as part of man's body, and her role in original sin. She is advised by them to be totally obedient and to conduct all business through men.[54]

This Catholic-theological schematisation remained valid for the medieval town of western and central Europe; the commune movement of the town burghers aimed at, and achieved, far-reaching socio-economic, legal, and political freedoms but not spiritual emancipation. The fact that the burghers before the late Middle Ages hardly made any effort to bring marriage jurisdiction within its sphere of influence proved to be particularly disadvantageous for the female town dweller. The authority of the church was extensively recognized, but this church-legal systematisation, which began with Gratian's book of decrees in circa 1140, was derived 'on the whole from the negative statements of the patricians, which were used to justify the restrictions placed on women, rather than to champion their rights'.[55]

The low value attached to the female personality by theologians left its traces in other important ideological areas. In Italian and old French poetry we find verse dat-

The Holy Family on the return journey from Egypt are dressed in simple clothing, similar to that worn by the middle and lower strata of the town population.
Illustration from *Biblia Pauperum, Codex Vindobonensis* 1198, fol. 3 r. Österreichische Nationalbibliothek, Vienna

ing from early thirteenth century specifically designed to warn men against the wiles of women, and listing the negative aspects of the female character. The anonymous author of *Proverbia quae dicuntur super natura feminarum*, a long epistle on the evil and falsehood of women, draws inspiration from the animal kingdom:

A stubborn horse is not to be ridden at festival times, but to be kept in its stable or used as a beast of burden. . . . One cannot hope to change the nature of the pig, the cat, nor to spin silk from wool. It is also a waste of effort to try and coax a woman with mild or with hard words. . . . The fox has several exits to his lair; if the hunter thinks he has it already trapped, the animal flees into one and out through another. So too do women have plenty of loopholes and tricks. . . . The wolf changes his coat in summer, but he never changes his evil character. A woman may sometimes act simple and pious like a nun, but when it suits her, she may give her fancy free reign. . . . The basilisk kills with his poisonous look; the lustful eye of a woman brings scandal to man and dries him out like hay. It is a mirror of the devil; woe be unto even the most religious man, who looks in it too often. . . . He who trusts a snake is a fool; yet the snake deceived Eve and was condemned to crawl over stones and thistles. No man should trust a woman, after she deceived Adam, for which reason she should be made to cover her head and forehead, in order to show her shame. Woman's love is no love, but only bitterness; it should rather be called a school for fools.[56]

Verse containing more or less open anti-female sentiment could also be found in France and Switzerland, for example in the work of Peire de Bussignac, Jean de Meung, and the Bernese Dominican monk Ulrich Boner.

Just how deeply embedded the dominant role of man is in the consciousness of the town population can be seen in the less-prejudiced fourteenth-century didactic literature for women. Even such an understanding husband as 'The Parisian Housekeeper' (*Le menagier de Paris*), as he calls himself in his pamphlet on the training of a young wife, demands from his own wife the submissiveness almost of a dog. She has to carry out all his demands, whether they be important or not so important, reasonable or unreasonable, in unquestioning obedience. The pictorial arts of this time are likewise full of images showing the inferiority of woman and her sinful character. Finally, the degradation of women was aided in an ethical and moral sense by the expansion of prostitution, which was encouraged by the secular and spiritual nobility, individual citizens, and numerous town councils.[57]

* The convent offered women a seemingly alternative way of life within the framework of the Catholic church, since a completely ascetic life and the overcoming of her 'feminity' could make her position within the sex hierarchy more bearable. Entering a convent was in the twelfth and thirteenth centuries almost the only way in which to gain a certain degree—in some of the convents a high degree—of education; the German and Italian mystics Saint Hildegard, Saint Catherine of Siena, Christina Ebner, and Adelheid Langmann even managed to gain public recognition. This route was, however, open to a relatively small number of the total female population. In England in the middle of the fourteenth century, there were only 3,500 nuns. Of the 111 female

60 The woman riding on the back of the philosopher Aristotle is avenging herself cunningly for the separation from her lover. Detail from the Malter carpet, 'Aristotle and Phyllis', ca. 1310/20. Städtische Museen, Freiburg im Breisgau

61 Temptation of
St. Justina by the devil
dressed as a woman.
Painting by Friedrich
Pacher, end of fifteenth
century. Parish Church
St. Justina

62 Nuns from the
Order of St. Clare are
deep in meditation.
Painting by Giovanni
del Biondo, 'St. Jerome
with the Lion and Three
Adoring Nuns', ca. 1365,
detail. Staatliches
Lindenau Museum,
Altenburg

Following pages

63 Depiction of a well-
ordered convent.
Miniature from Ms.
Add. 39843, fol. 6 v.,
French, ca. 1300. British
Museum, London

64 Representation of
hell. Devils bring in
members of all the social
estates in horse-drawn
carriages, carts, baskets,
and by rope.
Miniature by the Master
of the Brussels Initial
from Add. 29433, fol. 89,
late fourteenth century.
British Museum,
London

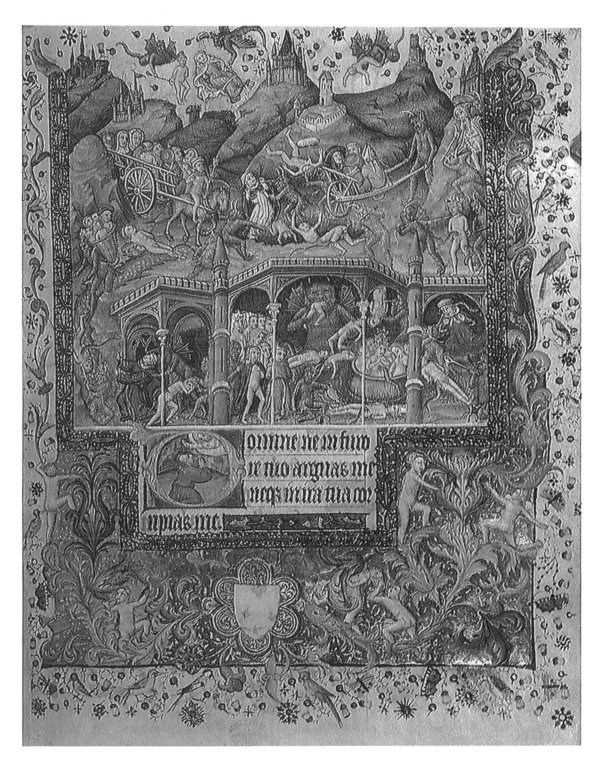

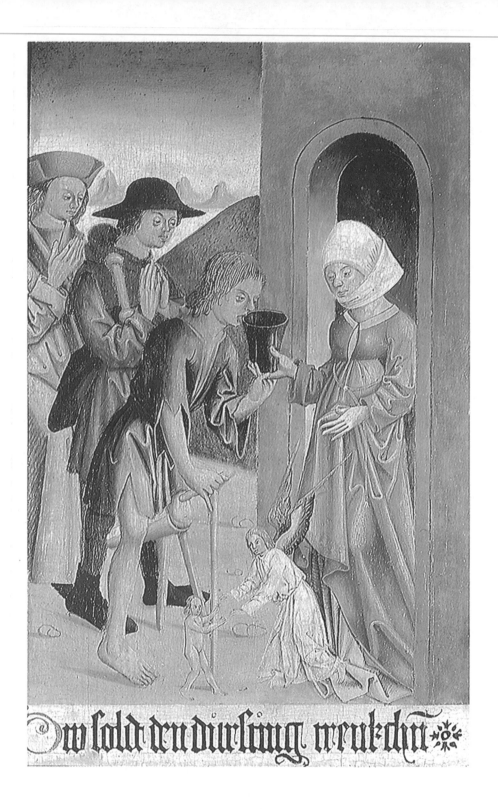

w sold den dursting trenk dm

65 Charitable deeds were part of the religious duties to be performed by the prosperous female town dwellers as well as by ladies of the nobility.
Miniature by the Master SH of 1485, 'Good Deeds', ca. 1500. Oberösterreichisches Landesmuseum, Linz

66 Scene from the life of Mary. To the left of the picture there is a representation of St. Catherine of Siena.
Panel painting by Sano di Pietro, 'Mary's Return from the Temple', ca. 1450. Staatliches Lindenau Museum, Altenburg

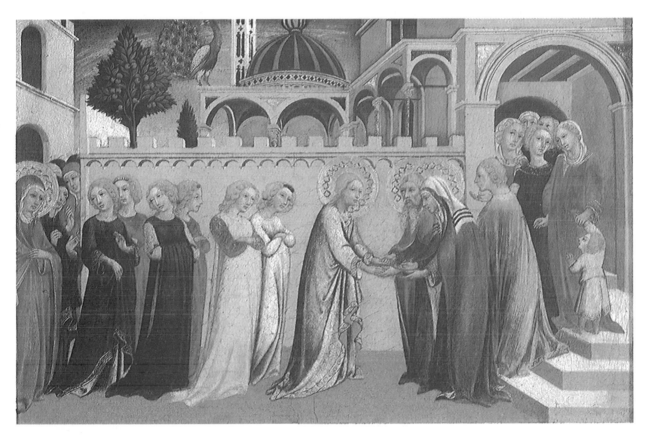

67 'Adoration of the Magi'.
Picture by an unknown artist from Lippova (?), 1510/20. Museum of Fine Arts, Budapest

68 'Mary and the Young Boy John Adore the Child Jesus'.
Panel painting by Pseudo-Pier Francesco Fiorentino, ca. 1460. Staatliches Lindenau Museum, Altenburg

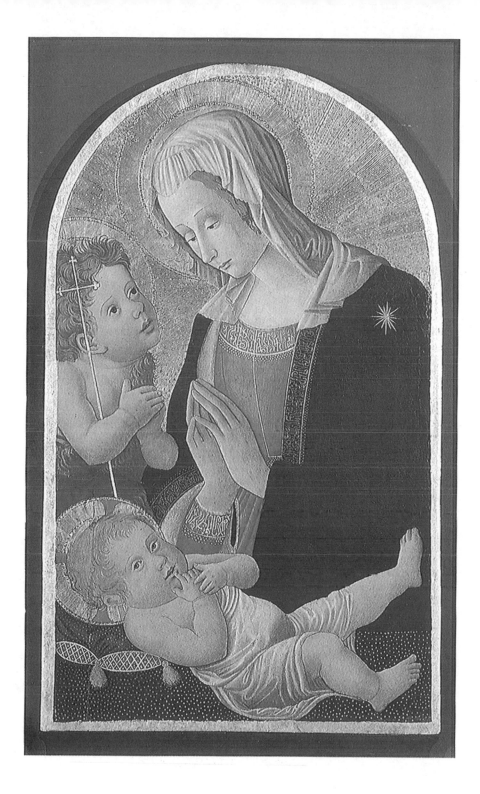

69 The sculpture 'St. Anne with Mary and the Child Jesus' was part of the work commissioned by the successful merchant Hans Frenzel (1436–1526), who, when his wish he had made as a child was fulfilled, donated 8,500 Rhenish guilders for the foundation of a chapel.
Outside wall of the Chapel of St. Anne, Görlitz

70 Mary as the all-forgiving protectress is an image firmly embedded in the religiousness of the people. Representatives of all the social estates find shelter under her cloak.
Painting by an unknown artist, Upper Austria, ca. 1500. Stiftsgalerie, Kremsmünster

Following page

71 Owing to Renaissance influence, the representation of Eve indicates a reappraisal of this figure. Here, the over-proportionally large, majestic figure gives an impression of sovereignty and suggests that she is an important figure for the people situated to the left of the picture.
Fresco, 'Eve as the Mother of Mankind', Southern Tyrol, 1475/85. Filiale Church St. Nicolas, Klerant, Southern Tyrol

The devil on the long train suggests vanity and arrogance.
Woodcut, printed by Hans Vintler, Augsburg, 1486. In: Albert Schramm, *Der Bilderschmuck der Frühdrucke.* Vol. XXIII. Leipzig, 1943, ill. 705.

convents that existed in England in the late Middle Ages, 63 had fewer than 10 nuns in them.[58] In Germany there was a large influx into the convents in the twelfth and thirteenth centuries; the Dominican mendicant order alone had, apart from 49 monasteries, 63 convents in upper Germany. In the same area, numerous convents came under the Franciscan order. But if one bears in mind that they were not always positioned in the big town centres and that the number of nuns in any one convent could be quite small, one gets a more realistic picture of their modest scale.

Regulations prescribed strict seclusion for the majority of women in convents. The nuns of the order of St. Clare could receive a visitor once every fourteen days, but the presence of another respected sister was required and the conversationalists had to speak through a grill. Only once a year could the grill be removed and the nun be seen by the outside world. The convents under the mendicant orders could not make, or improve, their living through begging. Since, however, the spiritual leaders of these orders were concerned to ensure that the convents remain economically solvent, the intake of women was manipulated in such a way that women from wealthy and generous families were admitted—i.e., families that could 'buy in' their daughter. The obligatory payment for admittance to the St. Clare convents throughout the whole of the southern German, Austrian, and Swiss area was an annuity of 3 marks or 40 pounds of pfennigs, which in the middle of the fourteenth century corresponded approximately to an income of 220 guilders.[59] Some less wealthy lay sisters could also be admitted; they acted as servants, performing various duties in order to allow the other nuns to enjoy prayer and contemplation. It was thus

that most of the convents remained the reserve of the daughters of the nobility and the town patricians. From the twelfth and thirteenth centuries onward the nobility also sent its unmarried daughters and widows into semi-religious convents or religious communities which did not require the women to take vows or enforce strict rules with regard to seclusion.

✳ In a period that saw, on the one hand, the intensive development of the internal structures of their territories by the powerful feudal lords and the rapid expansion of trade and goods production, and on the other the retention by certain obstinate town lords of their traditional privileges, we find that there was understandably in the twelfth and thirteenth centuries movement and unrest among the people. In such circumstances, many were open to new religious doctrines. It was around this time that the heretic movement of the Cathari, the 'pure', gained ground in western Europe. These sects had their own centres from the end of the 1260s onward in the towns of northern Italy and southern France, and on the transport routes between these regions. Attempts to extend the movement to England failed. Men and women alike were allowed to make their way into the core of these sects; through strict adherence to all the doctrines they could become one of the 'perfect' (perfecti), who were regarded as the real bearers of the spirit. In comparison to the Catholic church the Cathari had a more positive attitude to women, through which they acquired numerous active supporters and sympathisers among the female town citizens. The duty of a 'perfect' was to lead an exemplary ascetic life in accordance with the Catharist doctrine—to disseminate and preach the basic ideas of the heresy. Women (perfectae) originally participated in the missionary work and preaching. However, once a spiritual hierarchy formed within the sects, women were excluded. There were no female Catharist deacons and bishops, but this did not lead to any significant reduction in the attraction of the sects among women—who

supported the basic principles of the Cathari: their demands for a poor church and the rejection of the Catholic church with its accumulation of wealth. Another group, the Waldenses, a pauper movement which was founded circa 1177 by the Lyon merchant Valdes, tended to attract women, particularly those of the middle and lower classes. Throughout the twelfth century it spread to southern France, northern Italy, and the area around Toul and Metz, until in the late Middle Ages it was a truly popular religion.

For the vast majority of female town citizens, however, the possibility of joining a sect was no real escape route. Only a few were willing to expose themselves to the dangers arising through the persecution of the heretic movement by the Catholic church. The crusade against the Cathari in southern France in 1209–1229 was a cruel example of this, and the persecution increased with the organisation of the papal inquisition in 1231. Certain elements of the Catharist doctrine, for example that of celibacy, and the rejection of procreation, probably served in the long run to alienate female citizens. In this respect their most fundamental interests were probably better represented by the Catholic church, which insisted on monogamy.

✳ In the early thirteenth century within the Catholic church there developed, with the mendicant orders of the Dominicans and the Franciscans, which we have already mentioned in another context, an institution tailored to meet the religious needs of the towns and destined to have a strong influence on the female population. The Franciscans, in particular, dealt in their preachings with the position of women and marital relations. Their close contact with the people put them in a position to identify and tackle important social evils, and often to hit the nail on the head, as did Bertold von Regensburg in his sermons on marriage in 1275. He refers to the town custom of marrying off girls of twelve to sixteen years to men who were in their prime or already on the brink of old age, which was based on the

assumption that young, untouched women were particularly suited to bearing strong healthy children, and which caused permanent social damage in the life of the town. Many young women could not stand the physical strain of frequent childbearing and died early. The average female life expectancy was thirty years. The children had to go without the care of mothers and often suffered psychologically as a result. Marital conflicts arose due to the difference in sexual maturity between man and wife, and these in turn led sometimes to criminal acts, but more frequently to lapses in Christian marital and sexual mores. Bertold von Regensburg, as a priest who heard confession, was well acquainted with the predictable scenarios arising out of marriages between young girls and old men. Such unions supplied subject matter for many a medieval comic farce and were the impetus too for attempts undertaken by some town councils in the late Middle Ages to curb child abuse. Von Regensburg tackles this sorry state of affairs early on and without beating around the bush: 'I only want to advise you on one matter, which is not forbidden by God, but I bid you to take heed of my advice, which is given to you in good faith. Because we can see and hear the suffering caused by you giving young children to old men, I advise you to give a young maiden to a young man and an old one to an older man'. At another point he tackles the problem of unhappy marriages using question-and-answer form:

> Brother Bertold! But you say that the wife should be subordinate to the husband, and he should be her master. That is also correct, you should be her master and she your housewife; but this does not mean you should always pull her hair for no reason and beat her as often as you like, and curse and swear and mistreat her. You also should not wear good clothes and dress her in old rags; she should dress, eat, and drink in the same manner as you. For she has replaced God in your heart

and should therefore be dear to you. Anyone who does not care for his spouse in word and deed is far from the kingdom of heaven.[60]

It would be a mistake to conclude from these statements that a basic reorientation of Catholic theology with regard to the roles of the two sexes occurred in the late Middle Ages. Bertold von Regensburg and other theologians like him who were basically sympathetic to women's problems did not question the dominant role of the man in marriage, and indeed condemned any independent attempts by women to improve their lot. What they were concerned with, on the whole, was the elimination of the most negative consequences of man's dominant role in marriage, which was discrediting the church-sanctioned marriage, and the spiritual leaders who advocated it. Experience had shown that this could lead to women turning away from the Catholic church, or to attempts to develop within the framework of the church new ways of life that were difficult for the authorities to control. The latter, however, happened despite their efforts to achieve the contrary.

✳ One obvious example of this is the Beguine movement, which gathered strength in the northern French and Rhenish area around 1200. The Beguines, like the Waldenses, were a section of the town pauper movement which was striving for a poor and purified church. These women, who came from all strata of the town population, united to form independent religious convents and lived according to rules set by themselves. Their common banner was the striving toward a virtuous life based on the ideal of poverty. The women guaranteed their material security through textile work, trade, care of the elderly and sick, by working as maids, performing funeral services, and by begging. Others lived from donations made by relatives or supporters. The Beguine convents came under the town jurisdiction and were organic members of the town community; some of their members had citizens' rights.

The Beguine phenomenon provided a religious way of life for women that was completely compatible with town life, and it thus spread quickly to Saxony, Thuringia, and Bohemia. It is reckoned that in the large European export towns, such as Ghent, Cologne, Basle, and Strasbourg, there were several hundred Beguines; we have concrete numbers for Mainz, which had 90 Beguines; Strasbourg, which had 160; and Cologne, which had 600. The latter were divided into approximately 60 Beguine homes. Even in the early thirteenth century the English monk and chronicler, Matthew Paris, expressed his astonishment at the large number of Beguines in Cologne. He writes: 'And their number grew in a short period of time to such an extent, that there were two thousand of them in the town of Cologne and in the surrounding area'.[61] As with other medieval chroniclers, the figures cited by Matthew Paris are exaggerated, but they do show that the Beguines in Cologne were a highly visible group. Average-sized trade and manufacturing towns such as Trier, Speyer, Ulm, Dortmund, and the maritime towns of Hamburg, Lübeck, and Bremen counted only a few dozen Beguines among their inhabitants.

The strong Beguine presence in some of the larger medieval towns bears witness to a striving among numerous unprovided-for female town dwellers, or among women who were anxious to avoid the male domination in marriage, to form alternative communities in order to lead a life that provided economic security without being overdominated by religious precepts. Beguines did not have to take strict vows, and house rules varied from convent to convent. Often the houses were so strongly allied with the textile trade that they represented serious competition for the guilds. One sentence pronounced by the Cologne council in a case involving emblem embroiderers and the Beguines

Thomas Aquinas meets a mystic, perhaps a Beguine. Woodcut, printed by Hans Vintler, Augsburg, 1486. In: Albert Schramm, *Der Bilderschmuck der Frühdrucke.* Vol. XXIII. Leipzig, 1943, ill. 665.

of the Schelen convent shows how serious these conflicts could be. It seems that in 1482, the emblem embroiderers forced their way into the Beguine convent in order to carry out a house search. This was duly condemned by the council as an act of violence, but the council nevertheless forbade the Beguines to carry on with emblem embroidery. In 1421 the Beguines of this convent had already been banned from the cotton-weaving trade, and were allowed to operate only six linen-weaving looms. Toward the end of the fifteenth century the Cologne Beguines were also subject to the ban placed on all spiritual institutions with regard to hat embroidery and beer brewing. A counterpart to the Beguine movement sprang up in the towns of the Netherlands and lower Germany in the form of communities of Sisters of the Common Life, founded by Geert Grote (1340 to 1384). They were also involved in textile production. In Deventer, where the movement began, it is reckoned that there were approximately 150 sisters at the beginning of the fifteenth century. In the same period there were about 700 living and working in Hertogenbos.

Within the Beguine movement, there were those who were heavily involved in the economic life of the towns, but there was also a smaller group of women who were born rich and could devote themselves to religious questions. In correspondence with the longings of large groups of the population their activities were aimed at the internalisation of their faith which had been discredited by the grievances within the Catholic church. The most famous of these were the German mystic Mechthild von Magdeburg who was, however, firmly entrenched in the Catholic church; the Englishwoman Margery Kempe; and Marguerite Porète, who wrote *The Mirror of the Simple Souls* and was burned at the stake in 1310 as a heretic. Such Beguines are also mentioned by the Franciscan Simon of Tournai when he writes, in 1273: 'We have among us women, who call themselves Beguines, some of whom are very sharp and open to new ideas. They have succeeded in translating the secrets of the holy word, which even people well acquainted with the Bible find hard to decipher, into the French dialect'.[62] He adds that he himself had read and possessed a copy of such a Bible, which was on sale to the public in Paris bookshops, and denounces this translation as being full of heresy, errors, and doubts.

Marguerite Porète and the Beguines mentioned above were subject to close observation and persecution. The Catholic church opposed the Beguines because experience had shown that sections of the movement gave open support to the radical representatives of the pauper movement within the church, such as the Franciscan Spiritualists in southern France at the turn of the thirteenth and fourteenth centuries, who were uncompromising in their support of this ideal, attacking even the Pope. Moreover the Beguines who came from the poorer sections of town, lacked a secure social position, and were not attached to one particular convent proved to be highly susceptible to heretical doctrines such as 'free spiritual heresy'. They, like their male counterparts, the Beghards, who were also influenced by free spiritual heresy, were subject to persecution during the Inquisition. The majority of the Beguines, however, attached themselves to the Franciscan and Dominican mendicant orders, which were the orders closest to their ideals of a poor, purified church, and led a religious life while trying to avoid any direct confrontation with the church. Many originally Beguine convents seem to have been completely incorporated into the Franciscan orders and thus appear as the Third Order (Tertiaries) of the Franciscans. The Tertiaries were religious communities composed of women who led a religious life in the towns without taking vows, so that they could at any time leave the Order and devote themselves to the care of the elderly and sick. They are part of the numerous religious-cooperative associations that were formed by broad strata of the town population, and particularly by women, in the late Middle Ages. Another example of such a movement was the Kaland movement, which was widespread in Germany and was joined of both priests and laymen.

✳ Despite the relatively intense involvement of town women in the heretic movements of the Middle Ages, most female town dwellers, and in particular married women, remained within the orbit of the Catholic church. And judging from the wills and testimonies they left, their attachment to this institution was by no means halfhearted—one reason being that the church courts were willing to intervene in questions of marital law in their defence if the municipal court had refused support. More to the point, however, favourable de-

Stonemasons with a customer, who, judging by her clothing, comes from the upper stratum of the town population.
Miniature from the French novel of the Holy Grail, fol. 55 v., early fourteenth century. British Museum, London

The creation of Eve from Adam's rib. Of note are both the youthful appearance of God and the representation of Eve as Adam's equal, rather than a helpless female.
Illustration from *Biblia Pauperum, Codex Vindobonensis* 1198, fol. 3 r., detail. Österreichische Nationalbibliothek, Vienna

velopments in women's professional and economic situation gave them the self-confidence not to take too seriously the doctrine of the contemporary Catholic church with regard to man being the dominant sex. The idea was to manage to adapt the strict religious formula on how they should conduct their lives to their social circumstances. Both the wives of the town burghers and the economically independent women, as members of guild-type associations, saw that in order to enhance both their own social prestige and that of their family they must fulfill their religious duties conscientiously. We find in the wills of women from the prosperous burghers generous endowments being left not only to religious communities, churches, and priests but for the construction of churches, altars, hospitals, chaplaincies, and Beguine houses. At the same time we find prosperous female burghers embarking on long pilgrimages, possibly in part to satisfy their growing needs for broader education and experience. The Beguine Margery Kempe, mentioned above, travelled all over Europe. In Stralsund, several wills dating from the first half of the fourteenth century mention pilgrimages undertaken by female citizens. One of the most common destinations named is the Holy Virgin in Aachen. In the fourteenth century two women set off independent of each other from Görlitz to Rome. The Görlitz merchant Agnes Fingerin went all the way to Jerusalem on horseback, using country roads and sometimes in the company of nobility.

By the late Middle Ages many female town dwellers had, like Agnes Fingerin, adjusted their life aspirations to fit in with the Catholic faith. Hardly any of the secu-

With the consent of her heirs, the widow Anna Swelenburg from Mühlhausen leaves money for the building of an altar in the Bridge Convent.

Document no. 1114, Stadt- und Kreisarchiv, Mühlhausen/Thuringia

lar female town burghers would have thought to spend less on clothes as penance for Eve's original fall into sin. Wedding festivities were extremely extravagant, and the baptising of a child was an occasion for celebration, especially for the female relatives and acquaintances. Council decrees on the rules governing weddings, baptism, and clothes, as well as numerous moralising edicts, fought against these phenomena, but without any apparent success. The religious life of the late Middle Ages represents a synthesis of a religious attitude which was adapted to the everyday life of the majority of the town population and which was often very superficial, and a deep piety taken to its extreme by the mystics and the representatives of the pauper movement.

The position of women grew precarious with the introduction of the papal edict, or 'bull', *Summis desiderantes affectibus*, on the eve of the early bourgeois revolution in 1484, and in 1486 with the publication of the 'Witches' hammer' *(Malleus maleficarum)*, an infamous compendium for the introduction of inquisition proceedings against women suspected of being witches. This latter image persisted in all areas of life affected by ideology, although not all members of the clergy agreed to it.[63]

Outlook

The medieval towns as a whole witnessed a series of positive changes for all, including the female town dwellers. The extent of these changes varied according to the type of town, but they were the result of more favourable conditions, which allowed the town economy to flourish and facilitated the rise of the town burgher. Female inhabitants achieved a recognized position in the economic life of the town, limited legal competency[64], and the possibility to acquire the right of citizenship independently.

The women in the lower strata of town life in particular made a significant contribution to the family income by working and providing back-up for the family workshop, or by finding work outside the workshop, usually as wage labour and in small-scale trade. In the large manufacturing export and long-distance trading centres, as well as in the medium-sized trading towns exporting their manufactured goods, the small-scale female traders were undoubtedly one of the stalwarts of the internal market. In cases where the demand for labour exceeded supply, women from the lower strata of the towns often took on heavy physical work in construction or in smithies.[65] Many of these women also tried to earn on the side to improve the family income. The most vulnerable fell prey to prostitution.[66]

Women from the more wealthy town strata found work in trade, in currency exchange offices, in town offices and in craftwork. Despite the numerous limitations imposed by the guilds they could become masters, either in the exclusively female guilds, or in the mixed guilds of the textile trade. Other trades, such as oil pressers, rope makers, parchment makers, butchers, cobblers or bakers appear on occasion to have admitted individual female masters on a regionally limited basis.

Until the second half of the fifteenth century, in some cases to the end of the sixteenth century, there seems to have been a series of favourable conditions, encouraging independent female professional work, some of which disappeared in the early modern times. The main prerequisites for this were:

the geographical vicinity of home and the family business;[67]

the availability of cheap labour to help in the homes due to the relatively low demand for labour;

the interest of the town councils in providing the destitute women streaming into the towns with work, in order to lessen the burden on the town social services;[68]

the possibility of using the wife's professional activity to allow the man to devote himself to a town appointment;[69]

and not least the trend toward distribution in the leading export-manufacturing towns. (The combination of the husband working in trade and the woman doing the manufacturing, as in the Cologne silk trade, was typical of this trend.)[70]

The female town dwellers proved to be reliable family props in times of need, such as the death of the husband,

demographic crises and conflicts within the towns. But also in normal town life, the efforts of the women served to secure and improve the family income, the social status of the family, the education of the children, the care and training of serving boys and maids, of apprentices, apprentice girls, unmarried journeymen and trade assistants, in that they lived in the house as part of the family.[71] Women were enabled to do so by participating to a certain degree in the commercial activity of the male members of the family, and in the daily events of town life. Moreover, the possibility of getting a primary education furthered their activity. Women from the numerically small upper stratum of the towns had already acquired a sound education mainly from private tutors. Long business journeys and pilgrimages broadened the horizons of some women. Their general cultural level, experience in medicinal, dietetic, and cosmetic matters, imposive life-style and impressive education meant that women from the town upper stratum in the late Middle Ages were in demand at the courts of the feudal nobility and as, we now know, allowed some of them to even express an opinion on public affairs. Christine de Pisan deserves a special mention, since she raised her voice publically in favour of political reforms that should help the French monarchy to reestablish peace in the country. For this committed person, who was acquainted with the Gospels as well as with the works of classical authors and of the Church fathers, peace was 'the epitome of all virtue, . . . the goal and the sum of all our efforts and work'. She acted in the conviction that 'without peace one cannot live with due propriety and moral fortitude'. Concerned with bringing peace to the kingdom of France, she tried, through such works as *Livre des Trois Vertus*, to influence her fellow women to act in this spirit. And in *Le Ditié de Jehanne d'Arc* (1429), following a temporary phase of resignation, she reaffirmed her militant philosophy, which was characterised by patriotism, staunch loyalty toward the French Crown, and a strong desire for peace. Christine de Pisan was also the first woman in medieval Europe to use her writings to protest against the degradation of her sex in literature and in the work of the school masters.[72]

As a preliminary summing-up, we can see from the above observations that the life of the female town dweller in the Middle Ages was not one long series of humiliations but included their active seizure of historical opportunities.[73]

Women's history has only recently been accepted as a discipline by the general body of historians, rather than being merely the research concern of individual historians. At present we only have a very sketchy idea of the life of women in the medieval towns. We can still not say anything definite on the scale of the changes for the better, and the extent to which they affected women from the various social strata. The extent and objectives of female activity on the town bond market, and the significance of female activity within the framework of the town economic and social structure have not been adequately explained. The same can be said of the reasons for the gradual retreat from the position gained by women in professional and economic life from the late fifteenth century onward, which is particularly notable at the end of the sixteenth century.[74] Many regional studies are necessary and many archives still have to be systematically searched, using new research methods. We can certainly expect an even greater differentiation with regard to time, place and type of the trends such as have been described here. On the other hand, a greater amount of local regional material will allow historical comparisons, which in turn will allow us to see more clearly sets of conditions underlying common trends. Those spiritual forces which acted as a forward-driving dynamism or as a brake must also be more clearly defined.

Questions with regard to the actual participation of merchant women in the life of the trade guilds[75] and the effect of those changes, positive for the female town dweller, on the women from the rural areas are as yet unanswered. The significance of the entry of women

from the town upper stratum to the courts of the principalities[76]—as a result of the alliance of the influential town burghers with the local ruler in the late Middle Ages—still has to be evaluated. Another problem which has not yet been tackled is the relationship of the female town dweller to the medieval peace movements.[77] Likewise, the role of the Jewess in the European medieval town[78] has not yet been studied to any significant degree. If 'the full extent of women's influence on the form and movement of society is to be recognized',[79] one will have to delve deeper into the history of medieval women, in particular the questions raised here will have to be studied in all their multifarious aspects in separate branches of history.

Appendix

Notes

1 *Die Gesetze der Langobarden.* Ed. by
F. Beyerle. Weimar, 1947, p. 389.
2 Alpert von Metz, 'De diversitate temporum', in:
Monumenta Germaniae historica ss. IV, p. 719;
translated into German by K. Kroeschell, in:
Deutsche Rechtsgeschichte. Vol. 1. Hamburg,
1972, p. 121.
3 K. Kroeschell, *Deutsche Rechtsgeschichte.*
Vol. 1. Hamburg, 1972, p. 229.
4 *Ibid.*, p. 161.
5 E. Ennen, *Frauen im Mittelalter.* Munich, 1984,
p. 92 f.
6 'Chronik des Matthias von Neuenburg', in:
Die Geschichtsschreiber der deutschen Vorzeit.
2nd complete edition, vol. 84. Translated by
G. Grandaur. Leipzig, no date, p. 10.
7 Of the women concerned, 82.2 percent acted
independently, that is, not as part of a family
company. Cf. G. Jehel, 'Le rôle des femmes et du
milieu familial à Gênes dans les activités commer-
ciales au cours de la première moitié du XIIIᵉ siè-
cle', in: *Revue d'histoire économique et sociale*
(1975) 2/3, pp. 193–215.
8 Cf. S. Rust'aveli, *The Man in the Panther's Skin.*
Old Georgian Epic. Translated into English by
M. S. Wardrop, 1912.
9 Document 1148 of the Stadt- und Kreisarchiv
Mühlhausen/Thuringia.

10 *Das Stadtbuch von Augsburg.* Ed. by
C. Meyer. Augsburg, 1872, p. 228 f.; *Das alte
Lübische Recht.* Ed. by J. F. Hach. Lübeck, 1839,
p. 291 f.; translated by P. Ketsch, in: *Frauen
im Mittelalter. Quellen und Materialien.*
Vol. 2. Düsseldorf, 1984, p. 182 f.
11 Quoted after E. Power, *Medieval Women.*
Cambridge, 1975, p. 61.
12 Quoted after *ibid.*, p. 62.
13 Quoted after *ibid.*, pp. 39–40.
14 P. Ketsch, *Frauen im Mittelalter. Quellen und
Materialien.* Vol. 1. Düsseldorf, 1983, p. 204.
15 M. Wensky, *Die Stellung der Frau in der
stadtkölnischen Wirtschaft im Spätmittelalter.*
Cologne, Vienna, 1980, p. 37 (= *Quellen und
Darstellungen zur Hansischen Geschichte.* New
series 26).
16 *Ibid.*, p. 61.
17 *Grut* is a type of wild rosemary that was used
for beer making until the mid-fifteenth century.
The word *gruten* came to refer to the whole
brewing process. *Grimms Deutsches Wörterbuch*
10, 2, 2. Leipzig, 1922.
18 *Quellen zur Geschichte des Kölner Handels und
Verkehrs im Mittelalter.* Ed. by B. Kuske. Vol. 1,
no. 652. Bonn, 1923, p. 223 f. (= *Publikationen der
Gesellschaft für Rheinische Geschichtskunde.*
Vol. 33, 1); translated by P. Ketsch, in: *Frauen
im Mittelalter. Quellen und Materialien.* Vol. 1.
Düsseldorf, 1983, p. 161 f.

19 *Urkundenbuch der Stadt Heilbronn.* Rev. by
M. von Rauch. 4 vols. Stuttgart, 1904–1922 (=
*Württembergische Geschichtsquellen.*Vols. 5, 15,
19, 20). Vol. 3, no. 2084 b, p. 162 f.; translated by
P. Ketsch, in: *Frauen im Mittelalter. Quellen und
Materialien.* Vol. 1. Düsseldorf, 1983, p. 177 f.

20 A useful collection of material is offered by
P. Ketsch, *Frauen im Mittelalter. Quellen und
Materialien.* Vol. 1. Düsseldorf, 1983, pp. 25 ff.

21 Quoted after E. Power, *Medieval Women.*
Cambridge, 1975, p. 68.

22 Gerard of Cremona was one of the most impor-
tant language scholars at the translators' school in
Toledo. His *Chirurgia,* which appeared in the
twelfth century, is the translation of the surgical
tract of the work of the Arabo-Spanish physician,
Abul Kasim, *Altasrif.* Complete facsimile version
in the original format of Codex Series Nova 2641
of the Austrian National Library, Graz, 1979.

23 Quoted after E. Power, *Medieval Women.*
Cambridge, 1975, p. 86.

24 *Die Chroniken der deutschen Städte vom 14.
bis 16. Jahrhundert.* Ed. by the Historische
Kommission bei der Bayerischen Akademie der
Wissenschaften. III: *Die Chroniken
der fränkischen Städte.* Vol. 4. Leipzig, 1862/74,
p. 382 f.; translated by P. Ketsch, in: *Frauen
im Mittelalter. Quellen und Materialien.* Vol. 2.
Düsseldorf, 1984, p. 263.

25 R. Alt, *Bilderatlas zur Schul- und Erziehungs-
geschichte.* Vol. 1. Berlin, 1960, p. 198 f.

26 Translated by P. Ketsch in: *Frauen im
Mittelalter. Quellen und Materialien.* Vol. 1.
Düsseldorf, 1983, no. 401, p. 256.

27 Christine de Pisan, *The Book of the City of
the Ladies.* Translated by Earl Jeffrey Richards.
London, 1983, p. 85.

28 *Urkundenbuch der Stadt Strassburg.* Rev. by
A. Schulte and G. Wolfgram. Vol. 4.2. Strasbourg,
1888, p. 139.

29 *Sachsenspiegel,* III, 45, para. 3.

30 *Ibid.,* I, 31, para. 2.

31 *Ibid.,* I, 45, para. 1.

32 *Ibid.,* I, 45, para. 2.

33 *Ibid.,* I, 24, para. 3.

34 *Schwabenspiegel,* para. 26.

35 *Ibid.,* para. 5a.

36 *Ibid.,* para. 34.

37 *Ibid.,* para. 76.

38 *Sachsenspiegel,* III, 38, para. 2.

39 *Ibid.,* III, 74.

40 *Schwabenspiegel,* para. 21.

41 M. Kleinbub, *Das Recht der Übertragung und
Verpfändung von Liegenschaften in der
Reichsstadt Ulm bis 1548.* Ulm, 1961, p. 88, A 552
(= *Forschungen zur Geschichte der Stadt Ulm.*
Vol. 3).

42 *Chroniken* A. 1, no. 2, fol. 68 v°, 69. Stadt- und
Kreisarchiv Mühlhausen/Thuringia.

43 *Wanderbüchlein des Johannes Butzbach
genannt Piemontanus.* Ed. by L. Hoffmann.
Berlin, no date, p. 158 f.

44 *Das Mühlhäuser Reichsrechtsbuch.* Ed. by
H. Mayer, 2nd ed. Weimar, 1934, p. 107.

45 *Libri proscriptionum* II, fol. 73. Ratsarchiv
Görlitz.

46 *Urkundenbuch der Stadt Freiberg in Sachsen.*
Ed. by H. Ermisch. Vol. 3, no. 674. Leipzig,
1891, p. 212 (= *Codex diplomaticus Saxoniae
Regiae* 2, 14).

47 F. N. Robinson, *The Works of Geoffrey
Chaucer.* 2nd ed. London, 1957.

48 Alessandra Macinghi degli Strozzi, *Lettere di
una gentildonna fiorentina del sec. XV ai figliuoli
esuli.* Ed. by C. Guasti. Florence, Sansoni, 1877;
German translation: Macinghi degli Strozzi,
Alessandra, *Briefe.* Edited and introduced by
A. Doren. Jena, 1927 (= *Das Zeitalter der
Renaissance* 1, 10), no. 72, p. 313, no. 62, p. 268.

49 *Wanderbüchlein des Johannes Butzbach*

genannt Piemontanus. Ed. by L. Hoffmann. Berlin, no date, pp. 9 ff.

[50] Quoted after James Bruce Ross, 'Das Bürgerkind in den italienischen Stadtkulturen zwischen dem vierzehnten und dem frühen sechzehnten Jahrhundert', in: *Hört ihr die Kinder weinen? Eine psychogenetische Geschichte der Kindheit.* Ed. by L. de Mause. Frankfurt on Main, 1979, p. 296.

[51] Quoted after *ibid.*, p. 295.

[52] Quoted after *ibid.*, p. 271.

[53] 'Johannes Chrysostomos über die von der Frau ausgehenden Gefahren', in: P. Ketsch, *Frauen im Mittelalter. Quellen und Materialien.* Vol. 2, Düsseldorf, 1984, p. 48.

[54] E. Gössmann, *Die streitbaren Schwestern. Was will die feministische Theologie?* Freiburg im Breisgau, 1981, p. 84.

[55] *Ibid.*, p. 82.

[56] 'Proverbia quae dicuntur super natura feminarum'. Translated into German and edited by A. Tobler, in: *Zeitschrift für romanische Philologie* (1885) IX, pp. 287 ff.

[57] The numerous penitent and Magdalene convents founded in the thirteenth century to give shelter to former prostitutes did not serve this function for long. In the late Middle Ages they became refuges for the unmarried daughters of the patricians and of the nobility.

[58] E. Power, *Medieval Women.* Cambridge, 1975, p. 89.

[59] Only 14 percent of the population of Basle was taxed on an income of this size. Cf. V. Gerz von Büren, *Geschichte des Clarissenklosters St. Clara in Kleinbasel 1266–1529.* Basle, 1969, p. 57.

[60] *Die Predigten des Franziskaners Bertold von Regensburg.* Translated and completely edited by F. Göbel, 5th ed. Regensburg, 1929, pp. 285–306.

[61] Excerpts from the greater chronicle of Matthew Paris, translated into German by G. Grandaur and W. Wattenbach, in: *Die Geschichtsschreiber der deutschen Vorzeit* 73. Leipzig, 1896, p. 155.

[62] Warning given by the Franciscan friar Simon of Tournai on the dangers of the Beguines, 1273, in: H. Grundmann, *Religiöse Bewegungen im Mittelalter. Untersuchungen über den geschichtlichen Zusammenhang zwischen Ketzerei, den Bettelorden und der religiösen Frauenbewegung im 12./13. Jahrhundert und über die Grundlagen der deutschen Mystik.* 3rd ed. Darmstadt, 1970, p. 338; translated by P. Ketsch, in: *Frauen im Mittelalter. Quellen und Materialien.* Vol. 2. Düsseldorf, 1984, p. 349.

[63] Among those who advocated greater respect for women were Jean Gerson (1363–1429), Albrecht von Eyb (1420–1475), the author of the 1452 *Apellatio mulieris Bambergensium*, and Agrippa von Nettesheim. For more on the role of these three men, see H. D. Heimann, 'Über Alltag und Ansehen der Frau im späten Mittelalter—oder: Vom Lob der Frau im Angesicht der Hexe', in: *Frau im spätmittelalterlichen Alltag. Internationaler Kongress, Krems an der Donau 2. bis 5. Oktober 1984, Sitzungsberichte der Österreichischen Akademie der Wissenschaften, Philologisch-historische Klasse.* Vol. 473. Vienna, 1986 (= *Veröffentlichungen des Instituts für Mittelalterliche Realienkunde Österreichs.* No. 9), pp. 271 ff.

[64] G. Kocher points out the strong regional differences in the legal position of the medieval woman, and also the legal advantages for unmarried women. Cf. 'Die Frau im spätmittelalterlichen Rechtsleben', in: *Ibid.*, p. 485 f.

[65] Women also participated in the building of the Périgord college in Toulouse 1365–1371; almost half of those who worked on the construction were women. They transported stones and tiles, helped demolish walls and dig out ditches. Their pay, however, was well below that of the male workers. Cf. J. Verdon, 'La vie quotidienne de la

femme en France au bas moyen âge', in:
Ibid., p. 365f.

[66] In Dijon 50 percent of these women were forced into this form of existence because of violence (of these 27 percent were rape victims) and 25 percent were pressured into it by their families. Only 15 percent chose it more or less of their own free will. 'La misère qu'elle fût directe (ouvrières) ou indirecte (difficultés de réinsertion après viol, problèmes familiaux) constituait ainsi le principal facteur'. Cf. J. Verdon, 'La vie quotidienne de la femme en France au bas moyen âge', in: *Ibid.*, p. 370.

[67] Cf. E. Ennen, 'Die Frau in der mittelalterlichen Stadt', in: *Mensch und Umwelt im Mittelalter*. Ed. by B. Herrmann. Stuttgart, 1986, p. 47.

[68] For the extent and causes of female migration cf. M. Mitterauer, 'Familie und Arbeitsorganisation in städtischen Gesellschaften des späten Mittelalters und der frühen Neuzeit', in: *Haus und Familie in der spätmittelalterlichen Stadt*. Ed. by A. Haverkamp. Cologne, Vienna, 1984 (= *Städteforschung*. Series A, vol. 18), p. 18f.

[69] M. Wensky claims that 'almost 30 percent of the registered female silk makers' had members of their family sitting in the town council. Cf. 'Die Frau in Handel und Gewerbe vom Mittelalter bis zur frühen Neuzeit', in: *Die Frau in der deutschen Wirtschaft*. Ed. by H. Pohl. Stuttgart, 1985 (= *Zeitschrift für Unternehmensgeschichte*. Vol. 35), p. 41.

[70] E. Ennen, 'Die Frau in der mittelalterlichen Stadt', in: *Mensch und Umwelt im Mittelalter*. Ed. by B. Herrmann. Stuttgart, 1986, p. 45f.

[71] From the second half of the fourteenth century onward a journeyman movement can be detected in the European towns; in Germany it was stronger at the turn of the century (fourteenth/fifteenth). From this point onward one can no longer see the family as a 'family of the whole house'. According to Knut Schulz, research has not yet come up with sufficient evidence to prove that journeymen were integrated in the house and family of the master craftsman even in the previous period. Cf. 'Die Stellung der Gesellen in der spätmittelalterlichen Stadt', in: *Haus und Familie in der spätmittelalterlichen Stadt*. Ed. by A. Haverkamp. Cologne, Vienna, 1984 (= *Städteforschung*. Series A, vol. 18), p. 315f.

[72] Cf. *Le Livre de la paix of Christine de Pisan*. Ed. by C. C. Willard. The Hague, 1958; Christine de Pisan, *Le Ditié de Jehanne d'Arc*. Ed. by A. F. Kennedy and K. Varty. Oxford, 1978; Thomas Hoccleve, 'The Letter of Cupid', in: *Hoccleve's Minor Poems*. London, 1932.

[73] H. Wunder, who in a recent study goes into conceptional questions, and speaks out against the separation of women's history from the history of society, also criticises traditional research for reducing the history of women 'to the history of either their oppression or their emancipation'. Cf. 'Frauen in der Gesellschaft Mitteleuropas im späten Mittelalter und in der Frühen Neuzeit (15. bis 18. Jahrhundert)', in: *Hexen und Zauberer. Die grosse Verfolgung—ein europäisches Phänomen in der Steiermark*. Ed. by H. Valentinitsch. Graz, Vienna, 1987, p. 123.

[74] Further research possibilities are presented in the above cited essay by H. Wunder.

[75] Membership is made open to women for example in the statutes of the trade guilds of York (1430) and in the town law of the German town of Göttingen. Cf. C. Gross, *The guild merchant—a contribution to British municipal history*. Vol. 2, Oxford, 1890, p. 57; *Göttinger Statuten. Akten zur Geschichte der Verwaltung und des Gildewesens der Stadt Göttingen bis zum Ausgang des Mittelalters*. Rev. by G. Freiherr von der Ropp. Hanover, Leipzig, 1907 (= *Quellen und Darstellungen zur Geschichte Niedersachsens.*

Ed. by Historischer Verein für Niedersachsen. Vol. XXV), no. 264, p. 444.

[76] Cf. H. Ebner, 'Die soziale Stellung der Frau im spätmittelalterlichen Österreich', in: *Frau im spätmittelalterlichen Alltag.* Vienna, 1986, p. 536.

[77] In this connection we should mention the idea of peace propagated by the Tertiary, Catherine of Siena (1347–1379), who came from and worked in the milieu of the town burgher.

[78] This question has been tackled in recent works by E. Ennen and H. Ebner. Cf. E. Ennen, 'Die Frau in der mittelalterlichen Stadt', in: *Mensch und Umwelt im Mittelalter.* Ed. by B. Herrmann. Stuttgart, 1986, pp. 42ff.; H. Ebner, 'Die soziale Stellung der Frau im spätmittelalterlichen Österreich', in: *Frau im spätmittelalterlichen Alltag.* Vienna, 1986, pp. 529ff.

[79] This qualified task was formulated by W. Affeldt in 'Einführung. Frühmittelalter und historische Frauenforschung', in: *Interdisziplinäre Studien zur Geschichte der Frauen im Frühmittelalter. Methoden—Probleme—Ergebnisse.* Ed. by W. Affeldt and Annette Kuhn, Düsseldorf, 1986 (= *Frauen in der Geschichte*; 7/ *Geschichtsdidaktik: Studien, Materialien.* Vol. 39), p. 21.

Sources

Unpublished sources

Ratsarchiv Görlitz
*Bereit von Jüterbog's Annalen der Stadt Görlitz
 (1418–1419)*
Briefbücher (1487–1491)
Hans Brückners Krämerbuch
Magdeburger Schöppensprüche
Urkundenregesten des Ratsarchivs

Staatsarchiv Dresden
Schöffenbuch from Chemnitz
Memorialbuch from Lössnitz
Stadtbuch II from Mittweida

Stadtarchiv Erfurt
Liber causarum (1424–1435)
Stadtbuch (1482–1492) (private disputes)

Stadtarchiv Leipzig
Ratsbuch (1466–1489)

Stadt- und Kreisarchiv Mühlhausen/Thuringia
Bruchbücher (1460–1500)
Chronicon Mühlhusinum
Copialbücher (1382–1391)
Gerichtsbücher (1431f., 1437, 1447–1449)
Kämmereiregister (1418–1420)
Kataster (1400, 1414, 1470)
Notulbücher (1371f., 1415ff.–1444)
Urfehdebücher (1441ff.–1470)
Urkunden

Stadtarchiv Stralsund
Bruchstücke des alten Kataster
*Testamente (Regesten des Stadtarchivs Stralsund)
 (1416–1457)*
Das zweitälteste Bürgerbuch (1349–1571)

Stadt- und Kreisarchiv Zwickau
Amtsbücher (1503f., 1516–1521)
Konzeptbuch (1490f., 1506)
Liber Proscriptionum de anno 1367 ad annum 1536
Quittungen und Briefe (1401–1490)
Stadtbuch I–III
Testamente (15.Jahrhundert)

Published sources

*Die Acht-, Verbots- und Fehdebücher Nürnbergs von
 1285–1400.* Rev. by W. Schultheiss. Nuremberg,
 1959 (= *Nürnberger Rechtsquellen* 1–2).
Altdeutsches Decamerone. Ed. by W. Spiewok. Berlin,
 no date.
Das älteste Berliner Bürgerbuch 1453–1700. Ed. by
 P. Gebhardt. Berlin, 1927.
Das älteste Bürgerbuch der Stadt Soest 1302–1449. Ed.
 by H. Rothert. Münster, 1958 (= *Veröffentlichungen
 der Historischen Kommission für Westfalen* XXVII).
*Die ältesten Osnabrückischen Gildeurkunden (bis
 1500).* Ed by F. Philippi. Osnabrück, 1890.
Das älteste Stralsunder Bürgerbuch (1319–1348). Rev.
 by R. Ebeling. Stettin, 1926 (= *Veröffentlichungen
 der Historischen Kommission für Pommern*).
Das älteste Wismarsche Stadtbuch. Ed. by F. Techen.
 Wismar, 1912.
*Amtsbuch der Reichsstadt Nordhausen 1312–1345.
 Liber privilegiorum et album civium.* Ed. by
 W. Müller. Nordhausen, 1956.
Etienne Boileau, *Le livre des métiers. Les métiers
 et corporations de la ville de Paris.* Ed. by
 R. Lespinasse and F. Bonnardot. Paris, 1877.
A. von Brandt, *Regesten Lübecker Bürgertestamente.*
 Lübeck, 1973 (= *Veröffentlichungen zur Geschichte
 der Hansestadt Lübeck.* Vol. 24).
Die Chronik des Matthias von Neuenburg. Translated
 by G. Grandaur. Leipzig, no date (= *Die Geschichts-
 schreiber der deutschen Vorzeit.* 2nd complete ed.,
 vol. 84).

Die Chroniken der deutschen Städte vom 14. bis 16. Jahrhundert. Leipzig, 1862–1931.

Codex diplomaticus Lusatiae superioris II–VI. Görlitz, 1896–1931.

Colmarer Stadtrechte. Rev. by P. W. Finsterwalder. Heidelberg, 1938 (= *Oberrheinische Stadtrechte III, 3*).

Die Denkwürdigkeiten der Helene Kottanerin (1439 bis 1446). Ed. by K. Mollay. Vienna, 1972 (= *Wiener Neudrucke, Neuausgaben und Erstdrucke deutscher literarischer Texte.* Vol. 2).

B. Diestelkamp, 'Quellensammlung zur Frühgeschichte der deutschen Stadt (bis 1250)', in: *Elenchus fontium hist. urb. quem edendum curaverunt C. van de Kieft et J. E. Niermeyer.* Leiden, 1967.

'Frauenarbeit im Mittelalter. Quellen und Materialien'. Compilation and introduction by P. Ketsch, in: *Frauen im Mittelalter.* Ed. by A. Kuhn. Vol. 1. Düsseldorf, 1983.

'Frauenbild und Frauenrechte in Kirche und Gesellschaft. Quellen und Materialien'. Compilation and introduction by P. Ketsch, in: *Frauen im Mittelalter.* Ed. by A. Kuhn. Vol. 2, Düsseldorf, 1984.

Göttinger Statuten. Akten zur Geschichte der Verwaltung und des Gildewesens der Stadt Göttingen bis zum Ausgang des Mittelalters. Rev. by G. Freiherr von der Ropp. Hanover, Leipzig, 1907 (= *Quellen und Darstellungen zur Geschichte Niedersachsens.* Ed. by Historischer Verein für Niedersachsen. Vol. XXV).

Hamburgische Burspraken 1346–1594 mit Nachträgen bis 1699. Rev. by J. Bolland. Parts 1 and 2. Hamburg, 1960 (= *Veröffentlichungen aus den Staatsarchiven der Freien und Hansestadt Hamburg.* Vol. VI)

Hamburgische Chroniken in niedersächsischer Sprache. Ed. by J. M. Lappenberg, Hamburg, 1861 (Reprint Niederwalluf, 1971).

Handel und Verkehr über die Bündner Pässe im Mittelalter zwischen Deutschland, der Schweiz und Oberitalien. Rev. by W. Schnyder. Vol. 1. Zurich, 1973.

F. Keutgen, *Urkunden zur städtischen Verfassungsgeschichte.* Berlin, 1899.

Das Konstanzer Leinengewerbe. Part 2: Quellen. Rev. by F. Wielandt. Constance, 1953 (= *Konstanzer Stadtrechtsquellen III*).

Die Leibdingbücher der Freien Reichsstadt Augsburg 1330–1500. Ed. by A. Haemmerle. Munich, 1958.

Le livre de Bourgeoisie de la ville de Strasbourg. Ed. by C. Wittmer and G. C. Meyer. Strasbourg, Zurich, 1948.

Le Menagier de Paris. Ed. by J. Pichon. Vol. 1. Paris, 1846.

Das Mühlhäuser Reichsrechtsbuch. Ed. by H. Mayer. Weimar, 1934.

Das Neue Testament. Revised after the translation by Martin Luther, revised text, 1975. Evangelische Haupt-Bibelgesellschaft zu Berlin und Altenburg, no date.

Nuovi Documenti del Commercio Veneto dei sec. XI–XIII. Ed. by A. Lombardo and R. Morazzo della Rocca. Venice, 1953 (= *Monumenti storici.* New series, vol. VII).

Die Nürnberger Bürgerbücher. Die Pergamentenen Neubürgerlisten 1302–1448. Ed. by Stadtarchiv Nürnberg. Nuremberg, 1974 (= *Quellen zur Geschichte und Kultur der Stadt Nürnberg.* Vol. 9).

Nürnberger Polizeiordnungen aus dem 13. bis 15. Jahrhundert. Ed. by K. Bader. Stuttgart, 1861 (= *Bibliothek des literarischen Vereins Stuttgart.* Vol. 62).

Nürnberger Totengeläutbücher I, St. Sebald 1439–1517. Rev. by H. Bürger. Neustadt, 1961.

Das Ofener Stadtrecht. Eine deutschsprachige Rechtssammlung des 15. Jahrhunderts. Ed. by K. Mollay. Weimar, 1959.

O. Pickl, *Das älteste Geschäftsbuch Österreichs. Die Gewölberegister der Wiener Neustädter Firma Alexius Funck (1516–1538) und verwandtes Material zur Geschichte des steirischen Handels im 15./16. Jahrhundert.* Graz, 1966 (= *Forschungen zur geschichtlichen Landeskunde der Steiermark.* Vol. 23).

O. Pickl, 'Innerösterreichische Handelsbeziehungen zu Süddeutschland und Venedig im Spiegel von Behaim-Handelsbriefen der Jahre 1418 bis 1457', in: *Festschrift für F. Hausmann.* Ed. by H. Ebner. Graz, 1977, pp. 379–408.

Christine de Pisan, *Le chemin de long estude.* Ed. by R. Püschel. Berlin, Paris, 1881.

Christine de Pisan, *Les épistres sur le roman de la rose.* Ed. by F. Beck. Neuberg, 1888.

Christine de Pisan, *Le livre de la paix.* Ed. by C. C. Willard. The Hague, 1958.

'Proverbia quae dicuntur super natura feminarum'. Ed. by A. Tobler, in: *Zeitschrift für romanische Philologie* (1885) IX, pp. 287–331.

S. Rust'aveli, *The Man in the Panther's Skin. Old Georgian Epic.* Translated into English by M. S. Wardrop, 1912.

Sanct-Ulrichs-Bruderschaft Augsburg: Mitglieds-Verzeichnis 1466–1521. Ed. by A. Haemmerle. Munich, 1949.

D. Schilling, *Spiezer Bilder-Chronik 1485.* Berne, 1939.

Schlettstadter Stadtrechte. Vol. 1. Rev. by J. Gény. Heidelberg, 1902 (= *Oberrheinische Stadtrechte* III, 1).

Schriftdenkmäler des steirischen Gewerbes. Rev. by F. Popelka. Graz, 1950.

Les statuts municipaux de Marseille. Ed. by R. Pernoud. Monaco, Paris, 1949.

O. Staudinger, 'Löbauer Urkunden-Regesten', in: *Löbauer Heimatblätter.* Annual sets 1933–1935, nos. 113–148.

Die Steuerbücher von Stadt und Landschaft Zürich des XIV. und XV. Jahrhunderts. Rev. by H. Nabholz and F. Hegi. Zurich, 1918.

Alessandra Macinghi degli Strozzi, *Briefe.* Ed. by A. Doren. Jena, 1927 (= *Das Zeitalter der Renaissance. Ausgewählte Quellen zur Geschichte der italienischen Kultur* 1, 10).

Überlinger Einwohnerbuch 1444–1800. Ed. by F. Harzendorf. Überlingen, 1968.

Ulmisches Urkundenbuch. Vol. 1. Ed. by F. Pressel. Stuttgart, 1873.

Urkundenbuch der ehemals freien Reichsstadt Mühlhausen in Thüringen. Rev. by K. Herquet. Halle, 1874.

Urkundenbuch der Stadt Bielefeld und des Stifts Bielefeld. Ed. by B. Vollmer. Bielefeld, Leipzig, 1937.

Urkundenbuch der Stadt Erfurt. Vol. 1. Rev. by C. Beyer. Halle, 1889 (= *Geschichtsquellen der Provinz Sachsen und angrenzender Gebiete.* Vol. 23).

Urkundenbuch der Stadt Esslingen. Rev. by A. Diehl. Vol. 1. Stuttgart, 1899 (= *Württembergische Geschichtsquellen.* Vol. 4).

Urkundenbuch der Stadt Freiberg in Sachsen. Ed. by H. Ermisch. Vol. 3. Leipzig, 1891 (= *Codex diplomaticus Saxoniae Regiae* 2, 14).

Urkundenbuch der Stadt Freiburg im Breisgau. Rev. by F. Hefele. Freiburg im Breisgau, 1940.

Urkundenbuch der Stadt Friedberg. Vol. 1 (1216–1410). Rev. by M. Foltz. Marburg, 1904 (= *Veröffentlichungen der Historischen Kommission für Hessen und Waldeck*).

Urkundenbuch der Stadt Goslar. Vol. 5. Rev. by G. Bode. Halle, 1922.

Urkundenbuch der Stadt Grimma und des Klosters Nimbschen. Rev. by L. Schmidt. Leipzig, 1895 (= *Codex diplomaticus Saxoniae Regiae* 2, 15).

Urkundenbuch der Stadt Halberstadt. Vol. 1. Rev. by G. Schmidt. Halle, 1878 (= *Geschichtsquellen der Provinz Sachsen.* Vol. 7).

Urkundenbuch der Stadt Jena und ihrer geistlichen Anstalten. Vol. 1 (1182–1405). Ed. by J. E. A. Martin. Jena, 1888 (= *Thüringische Geschichtsquellen.* New series, 3).

Urkundenbuch der Stadt Magdeburg. Rev. by G. Hertel. 3 vols. Halle, 1892–1896 (= *Geschichtsquellen der Provinz Sachsen und angrenzender Gebiete.* Vols. 26–28).

Urkundenbuch der Stadt Regensburg. Vol. 2 (1351 to 1378). Rev. by F. Bastian and J. Widmann.

Munich, 1956 (= *Monumenta Boica*. New series, vol. 8).

Urkundenbuch der Stadt Strassburg. Vol. 1. Rev. by W. Wiegand. Strasbourg, 1879.

Urkundenbuch der Stadt Stuttgart. Ed. by A. Rapp. Stuttgart, 1892 (= *Württembergische Geschichtsquellen*. Vol. 13).

Urkunden und Briefe des Stadtarchivs Mellingen bis zum Jahre 1550. Rev. by H. Rohr. Aarau, 1960 (= *Quellen zur Aargauischen Geschichte 1*).

Das Verfestungsbuch der Stadt Stralsund. Ed. by O. Francke. Halle, 1875 (= *Hansische Geschichtsquellen*. Vol. 1).

Wanderbüchlein des Johannes Butzbach genannt Piemontanus. Ed. by L. Hoffmann. Berlin, no date.

A. Wendgraf, 'Aus den Denkwürdigkeiten der Helene Kottanerin 1439–1440', in: *Ungarische Rundschau für historische und soziale Wissenschaften* (1914) 3.

Wie ein Mann ein fromm Weib soll machen. Mittelalterliche Lehren über Ehe und Haushalt. Ed. by M. Della-piazza. Frankfurt on Main, 1984 (= *Insel Taschenbuch 745*).

Das Wiener Neustädter Stadtrecht. Ed. by G. Winkler. Vienna, 1880.

Zwickauer Rechtsbuch. Ed. in collaboration with E. Planitz, rev. by G. Ulbrich. Weimar, 1941.

Bibliography

Only a selection of the available literature is given here. In the case of collected volumes, the overall title is given, that is, individual contributions are not listed separately.

Adenauer, G.: *Das Ehe- und Familienrecht im Mühlhäuser Reichsrechtsbuch.* (Doctoral thesis.) Bonn, 1963.

Albistur, M., and D. Armogathe: *Histoire du féminisme français du Moyen Age à nos jours.* Paris, 1977.

Alltag im Spätmittelalter. Ed. by H. Kühnel in collaboration with H. Hundsbichler. Graz, Vienna, 1984.

Arnold, K.: *Kind und Gesellschaft in Mittelalter und Renaissance. Beiträge und Texte zur Geschichte der Kindheit.* Paderborn, 1980.

Bardèche, M.: *Histoire des femmes.* Vol. 1. Paris, 1968.

Bastian, F.: 'Das Manual des Regensburger Kaufhauses Runtinger und die mittelalterliche Frauenfrage', in: *Jahrbücher für Nationalökonomie und Statistik, 115/1920,* pp. 385–442.

Beard, H. R.: *Woman as force in history. A study in traditions and relations.* Chapter 13: 'An Illustrated Bibliography'. New York, 1962, pp. 341–369.

Bec, C.: *Les marchands écrivains à Florence 1375–1434.* Paris, 1967.

Behagel, W.: *Gewerbliche Stellung der Frau im mittelalterlichen Köln.* Berlin, 1910.

Bernards, M.: *Speculum Virginum—Geistigkeit und Seelenleben der Frau im Hochmittelalter.* Cologne, Graz, 1955.

Blockmans-Delva, A.: 'Het vlaamse 15de Eeuwse liber trotula, een praktijkboek van en voor vroedvrouwen', in: *Farmaceutisch tijdschrift voor België 58* (1981) 5/6.

Blöcker, M.: 'Die Geschichte der Frauen: erlebt, erlitten, vergessen?', in: *Frau—Realität und Utopie.* Ed. by C. Köppel and R. Sommerauer. Zurich, 1984, pp. 123–146.

Boesch, H.: *Kinderleben in der deutschen Vergangenheit.* Leipzig, 1900 (= *Monographien zur deutschen Kulturgeschichte.* Vol. 5).

Bogucka, M.: *Das alte Danzig. Alltagsleben vom 15. bis 17. Jahrhundert.* Leipzig, 1980.

Brodmeier, B.: *Die Frau im Handwerk in historischer und moderner Sicht.* Münster, 1963 (= *Forschungsberichte aus dem Handwerk.* Vol. 9).

De Bruin, C. C., E. Persons, and A. G. Weiler: *Geert Grote en de moderne devotie.* 2nd ed. Deventer, Zutphen, 1985.

Bücher, K.: *Die Berufe der Stadt Frankfurt am Main im Mittelalter.* Leipzig, 1914 (= *Abhandlungen der Philologisch-historischen Klasse der Königlich-Sächsischen Gesellschaft der Wissenschaften.* Vol. 30, 3).

Bücher, K.: *Die Frauenfrage im Mittelalter.* Tübingen, 1910.

Burckhard, G.: *Die deutschen Hebammenordnungen von ihren ersten Anfängen bis auf die Neuzeit.* Leipzig, 1912 (= *Studien zur Geschichte des Hebammenwesens I, 1*).

Delva, A.: 'Vrouwengeneeskunde in Vlandern tijdens de late middeleuwen met mitgave van het Brugse Liber Trotula', in: *Vlaamse Historische Studies 2.* Bruges, 1983.

Demelius, H.: *Eheliches Güterrecht im spätmittelalterlichen Wien.* Vienna, 1970 (= *Österreichische Akademie der Wissenschaften, Philologisch-historische Klasse, Sitzungsberichte 265, Abhandlung 4*).

Dienst, H.: 'Männerarbeit—Frauenarbeit im Mittelalter', in: *Beiträge zur historischen Sozialkunde* (1981) 3, pp. 88–90.

Dienst, H.: 'Rollenaspekte von Männern und Frauen im Mittelalter in zeitgenössischer Theorie und Praxis', in: *Weiblichkeit oder Feminismus? Beiträge zur interdisziplinären Frauentagung Konstanz 1983.* Ed. by C. Opitz. Weingarten, 1984, pp. 137–158.

Diepgen, P.: *Frau und Frauenheilkunde in der Kultur des Mittelalters.* Stuttgart, 1963.

Doren, A.: *Die Florentiner Wolltuchindustrie vom 14. bis zum 16. Jahrhundert*. Stuttgart, 1901.

Doren, A.: *Das Florentiner Zunftwesen vom 14. bis zum 16. Jahrhundert*. Stuttgart, 1908.

Dronke, P.: *Women Writers of the Middle Ages. A Critical Study of Texts from Perpetua († 203) to Marguerite Porète († 1310)*. Cambridge etc., 1984.

Duby, G.: *Le chevalier, la femme et le prêtre. Le mariage dans la France féodale*. Paris, 1981.

Dübeck, I.: *Købekoner og konkurrence: studier over myndighets-og erhvervsrettens udvikling med stadigt henblick på kvinders historiske retstilling*. Copenhagen, 1978 (= *Skrifter fra det retsvidenskabelige Institut ved Københavns Universitet* 19).

Ellermeyer, J.: *Stade 1300–1399, Liegenschaften und Renten in Stadt und Land. Untersuchungen zur Wirtschafts- und Sozialstruktur einer Hansischen Landstadt im Spätmittelalter*. Stade, 1975.

Enders, L., and F. Beck: 'Zur Geschichte des Nonnenklosters in Prenzlau und seiner Überlieferung', in: *Jahrbuch für Geschichte des Feudalismus*. Vol. 8. Berlin, 1984, pp. 158–190.

Ennen, E.: 'Die Frau in der Landwirtschaft vom Mittelalter bis zur frühen Neuzeit', in: *Die Frau in der deutschen Wirtschaft*. Stuttgart, 1985 (= *Zeitschrift für Unternehmensgeschichte*. Supplement 35).

Ennen, E.: 'Die Frau in der mittelalterlichen Stadtgesellschaft Mitteleuropas', in: *Hansische Geschichtsblätter*. Vol. 100. 1980.

Ennen, E.: 'Die Frau im Mittelalter. Eine Forschungsaufgabe unserer Tage', in: *Kurtriersches Jahrbuch* 21 (1981).

Ennen, E.: *Frauen im Mittelalter*. Munich, 1984.

Erbstösser, M., and E. Werner: *Ideologische Probleme des mittelalterlichen Plebejertums. Die freigeistige Häresie und ihre Wurzeln*. Berlin, 1960.

Erbstösser, M.: *Ketzer im Mittelalter*. Leipzig, 1984.

Erichson, C., and K. Casey: 'Women in the Middle Ages. A Working Bibliography', in: *Medieval Studies*. Vol. XXXVIII. 1976.

Fabian, E.: 'Die Zwickauer Schulbrüderschaft (Fraternitas Scholarium)', in: *Mitteilungen des Altertumsvereins für Zwickau und Umgebung* (1891) 3.

Familie und Gesellschaftsstruktur. Materialien zu den sozio-ökonomischen Bedingungen von Familienformen. Ed. and introduced by H. Rosenbaum. Frankfurt on Main, 1974.

Felser, R.: *Herkunft und soziale Schichtung der Bürgerschaft obersteirischer Städte und Märkte unter besonderer Berücksichtigung der Bürger der Stadt Judenburg*. (Doctoral thesis at Graz University, 38.) Vienna, 1977.

La femme. Vol. 3. Brussels, 1962 (= *Recueils de la société Jean Bodin* 12).

'La femme dans les civilisations des Xe–XIIIe siècles. Actes du Colloque tenu à Poitiers les 23–25e Septembre 1976', in: *Cahiers de Civilisations Médiévales*. Vol. 20. 1977.

Frank, K. S.: *Das Klarissenkloster Söflingen. Ein Beitrag zur franziskanischen Ordensgeschichte Süddeutschlands und zur Ulmer Kirchengeschichte*. Ulm, 1980 (= *Forschungen zur Geschichte der Stadt Ulm*. Vol. 20).

Frau im spätmittelalterlichen Alltag. Vienna, 1986 (= *Veröffentlichungen des Instituts für Mittelalterliche Realienkunde Österreichs, Österreichische Akademie der Wissenschaften, Philosophisch-historische Klasse. Sitzungsberichte*. 473rd vol.).

Fritz, W. D.: 'Die Neuverleihung des Colmarer Stadtrechts an Kaysersberg, Münster und Türkheim im Jahre 1354', in: *Stadt- und Städtebürgertum in der deutschen Geschichte des 13. Jahrhunderts*. Ed. by B. Töpfer. Berlin, 1976, pp. 372–388 (= *Forschungen zur mittelalterlichen Geschichte*. Vol. 24).

Gerz von Büren, V.: *Geschichte des Clarissenklosters St. Clara in Kleinbasel 1266–1529.* Basle, 1969.

Gloger, B., and W. Zöllner: *Teufelsglauben und Hexenwahn.* Leipzig, 1983.

Gössmann, E.: *Die streitbaren Schwestern. Was will die feministische Theologie?* Freiburg im Breisgau, 1981 (= *Herderbücherei 879*).

Greer, G.: *Das unterdrückte Talent. Die Rolle der Frauen in der bildenden Kunst.* Berlin, Vienna, 1979.

Grimm, P.: 'Zwei bemerkenswerte Gebäude in der Pfalz Tilleda. Eine zweite Tuchmacherei', in: *Prähistorische Zeitschrift* (1963) 41.

Gross, C.: *The guild merchant—a contribution to British municipal history.* Vol. 1, 2. Oxford, 1964 (Reprint of the 1st ed. Oxford, 1890).

Grundmann, H.: *Religiöse Bewegungen im Mittelalter.* Hildesheim, 1961.

Händler-Lachmann, B.: 'Die Berufstätigkeit der Frau in den deutschen Städten des Spätmittelalters und der beginnenden Neuzeit', in: *Hessisches Jahrbuch für Landesgeschichte* 30. 1980.

Hagemann, H. R.: 'Basler Stadtrecht im Spätmittelalter', in: *Zeitschrift der Savigny-Stiftung für Rechtsgeschichte, Germanistische Abteilung* (1961) 78.

Harksen, S.: *Die Frau im Mittelalter.* Leipzig, 1974.

Hartwig, J.: 'Die Frauenfrage im mittelalterlichen Lübeck', in: *Hansische Geschichtsblätter* 14. 1908.

Haus und Familie in der spätmittelalterlichen Stadt. Ed. by A. Haverkamp. Cologne, Vienna, 1984 (= *Städteforschung.* Series A, vol. 18).

Herlihy, D.: 'Land, family and women in Continental Europe 700–1200', in: *Traditio* (1962) 18, pp. 89 to 120.

Herlihy, D.: *Woman in Medieval Society.* Houston, 1971 (= *The Smith History Lecture* 14).

Herlihy, D.: 'The medieval marriage market', in: *Medieval and Renaissance Studies* VI. 1976, pp. 3–27.

Herlihy, D., and C. Klapisch-Zuber: *Les Toscans et leurs familles. Une étude du Catasto florentin de 1427.* Paris, 1978.

Hess, L.: *Die deutschen Frauenberufe des Mittelalters.* Munich, 1940.

Histoire mondiale de la femme. Ed. by P. Grimal. Vol. 2. Paris, 1966.

Höher, F.: 'Hexe, Maria und Hausmutter. Zur Geschichte der Weiblichkeit im Spätmittelalter', in: *Frauen in der Geschichte.* Vol. 3. Ed. by A. Kuhn and J. Rüsen. Düsseldorf, 1983.

Hurd-Mead, K. C.: *A history of women in medicine.* Haddam, Conn., 1938.

Jaritz, G.: 'Österreichische Bürgertestamente als Quelle zur Erforschung städtischer Lebensformen des Spätmittelalters', in: *Jahrbuch für Geschichte des Feudalismus.* Vol. 8. Berlin, 1984, pp. 249–264.

Jastrebickaja, A. L.: 'Die Familie als soziale Gruppe der mittelalterlichen Gesellschaft', in: *Jahrbuch für Geschichte des Feudalismus.* Vol. 6. Berlin, 1982, pp. 185–193.

Jastrebickaja, A. L.: 'Über einige Gesichtspunkte der Familienstruktur und der Verwandtschaftsbeziehungen in der mittelalterlichen Stadt', in: *Jahrbuch für Geschichte des Feudalismus.* Vol. 8. Berlin, 1984, pp. 191–204.

Jehel, G.: 'Le rôle des femmes et du milieu familial à Gênes dans les activités commerciales au cours de la première moitié du XIIIᵉ siècle', in: *Revue d'histoire économique et sociale* (1975) 53, pp. 193ff.

Kaminsky, H. H.: 'Die Frau in Recht und Gesellschaft des Mittelalters', in: *Frauen in der Geschichte.* Vol. 1. Ed. by A. Kuhn and G. Schneider. Düsseldorf, 1979, pp. 295–313.

Ketsch, P.: 'Aspekte der rechtlichen und politisch-gesellschaftlichen Situation von Frauen im frühen Mittelalter (500–1150)', in: *Frauen in der Geschichte.* Vol. 2. Ed. by A. Kuhn and J. Rüsen. Düsseldorf, 1982, pp. 11–72.

Kirshner, J., and S. Wemple: *Women of the Medieval World*. Oxford, 1985.

Kleinbub, M.: *Das Recht der Übertragung und Verpfändung von Liegenschaften in der Reichsstadt Ulm bis 1548*. Ulm, 1961 (= *Forschungen zur Geschichte der Stadt Ulm*. Vol. 3).

Koch, G.: *Frauenfrage und Ketzertum im Mittelalter. Die Frauenbewegungen im Rahmen des Katharismus und des Waldensertums und ihre sozialen Wurzeln (12.–14. Jahrhundert)*. Berlin, 1962 (= *Forschungen zur mittelalterlichen Geschichte*. Vol. 9).

'Kongress "Frau und spätmittelalterlicher Alltag". Zusammenfassung', in: *Medium Aevum Quotidianum. Newsletter 4*. Krems, 1984.

Kotel'nikova, L. A.: 'Sel'skoe chozjajstvo na zemljach Strozzi—krupnoj popolanskoj semi Toskany XV v. (Po materialam Gosudarstvennogo archiva Florencii)', in: *Srednie Veka*. Moscow (1984) 47.

Kroemer, B.: 'Von Kauffrauen, Beamtinnen, Ärztinnen. Erwerbstätige Frauen in deutschen mittelalterlichen Städten', in: *Frauen in der Geschichte*. Vol. 2. Düsseldorf, 1982.

Kroeschell, K.: *Deutsche Rechtsgeschichte*. 2 vols. Hamburg, 1972–1983 (= *rororo studium 8–9*).

Kuehn, T.: 'Women, marriage and "patria potestas" in late medieval Florence', in: *Revue d'histoire du droit* (1981) 49, pp. 127–147.

Küttler, W.: 'Stadt und Bürgertum im Feudalismus. Zu theoretischen Problemen der Stadtgeschichtsforschung in der DDR', in: *Jahrbuch für Geschichte des Feudalismus*. Vol. 4. Berlin, 1980, pp. 75–112.

Lambert, E.: *Die Rathsgesetzgebung der freien Reichsstadt Mühlhausen in Thüringen im 14. Jahrhundert*. Halle, 1870.

Lambert, M.: *Ketzerei im Mittelalter. Häresien von Bogumil bis Hus*. Munich, 1981.

Lauterer-Pirner, H.: 'Vom "Frauenspiegel" zu Luthers Schrift "Vom ehelichen Leben". Das Bild der Ehefrau im Spiegel einiger Zeugnisse des 15. und 16. Jahrhun-

derts', in: *Frauen in der Geschichte*. Vol. 3. Düsseldorf, 1983, pp. 63–85.

Le Goff, J.: 'Petits enfants dans la littérature des XIIᵉ–XIIIᵉ siècles', in: *Annales de Démographie Historique*. 1973, pp. 129–132.

Lehmann, A.: *Le rôle de la femme dans l'histoire de France au Moyen Age*. Paris, 1952.

Lehnert, M.: 'Geoffrey Chaucer—Der Dichter der Liebe', in: *Realismus und literarische Kommunikation. Dem Wirken Rita Schobers gewidmet* (= *Sitzungsberichte der Akademie der Wissenschaften der DDR/Gesellschaftswissenschaften 8/G*). Berlin, 1984, pp. 61–77.

Leipoldt, J.: *Die Frau in der antiken Welt und im Urchristentum*. Leipzig, 1954.

Lendorff, G.: *Kleine Geschichte der Baslerin*. Basle, Stuttgart, 1966.

Lévy, J. P.: 'L'officialité de Paris et les questions familiales à la fin du XIVᵉ siècle', in: *Études d'histoire du droit canonique dédiées à Gabriel Le Bras*. Vol. 2. Paris, 1965, pp. 1265–1294.

Loose, H. C.: 'Erwerbstätigkeit der Frau im Spiegel Lübecker und Hamburger Testamente', in: *Zeitschrift des Vereins für Lübeckische Geschichts- und Altertumskunde* 60. 1980, pp. 9–20.

Lorenzen-Schmidt, K. J.: 'Zur Stellung der Frauen in der frühneuzeitlichen Städtegesellschaft Schleswigs und Holsteins', in: *Archiv für Kulturgeschichte* 61. 1979, pp. 316–339.

Lüers, G.: *Die Sprache der deutschen Mystik des Mittelalters im Werke der Mechthild von Magdeburg*. Darmstadt, 1966.

Maertens, R.: *Wertorientierungen und wirtschaftliches Erfolgsstreben mittelalterlicher Grosskaufleute. Das Beispiel Gent im 13. Jahrhundert*. Cologne, Vienna, 1976 (= *Kollektive Einstellungen und sozialer Wandel im Mittelalter*. Ed. by R. Sprandel. Vol. 5).

Maschke, E.: 'Die Familie in der deutschen Stadt des späten Mittelalters', in: *Sitzungsberichte der Heidel-*

berger Akademie der Wissenschaften, Philosophisch-historische Klasse. Annual set 1980.

Mölk, U.: 'Die literarische Entdeckung der Stadt im französischen Mittelalter', in: Über Bürger, Stadt und städtische Literatur im Spätmittelalter. Bericht über Kolloquien der Kommission zur Erforschung der Kultur des Spätmittelalters 1975–1977. Ed. by J. Fleckenstein and K. Stackmann. Göttingen, 1980.

Mutschlechner, G.: 'Frauen als Bergbauunternehmer im ehemaligen Berggericht Sterzing', in: Schlern. Zeitschrift für Heimat- und Volkskunde. 37th annual set. Bozen, 1963.

Nicholas, D.: The Domestic Life of a Medieval City-Woman. Children and the Family in Fourteenth-Century Ghent. Lincoln, London, 1985.

Nübel, O.: Mittelalterliche Beginen- und Sozialsiedlungen in den Niederlanden. Tübingen, 1970.

Opitz, C.: Frauenalltag im Mittelalter. Biographien des 13. und 14. Jahrhunderts. Weinheim, Basle, 1985 (= Ergebnisse der Frauenforschung. Vol. 5).

Osterloh, J.: Die Rechtsstellung der Handelsfrau. (Doctoral thesis.) Eutin, 1919.

Quast, J.: 'Vrouwenarbeid omstreeks 1500 in enkele Nederlandse steden', in: Jaarboek voor vrouwengeschiedenis. 1980, pp. 50–60.

Riemer, E. S.: Women in the Medieval City. Sources and uses of wealth by Sienese women in the thirteenth century. (Doctoral thesis.) New York, 1975.

The Role of Woman in the Middle Ages. Ed. by R. T. Morewedge. Albany, 1975.

Rüdiger, B.: 'Zur Reflexion der Frauenfrage in der deutschen Frauenmystik des 13./14. Jahrhunderts', in: Untersuchungen zur gesellschaftlichen Stellung der Frau im Feudalismus. Magdeburg, 1981 (= Magdeburger Beiträge zur Stadtgeschichte. No. 3).

Schildhauer, J.: 'Zur Lebensweise und Kultur der hansestädtischen Bevölkerung—auf der Grundlage der Stralsunder Bürgertestamente (Anfang 14. bis Ende 16. Jahrhundert)', in: Wissenschaftliche Zeitschrift der Ernst-Moritz-Arndt-Universität Greifswald (1981) 1/2.

Schmidt, G.: Die berufstätige Frau in der Reichsstadt Nürnberg bis zum Ende des 16. Jahrhunderts. Erlangen, 1950.

Schmoller, G.: Die Strassburger Tucher- und Weberzunft. Urkunden und Darstellung, nebst Regesten und Glossar. Ein Beitrag zur Geschichte der deutschen Weberei und des deutschen Gewerberechts vom 13.–17. Jahrhundert. Strasbourg, 1879.

Schneider, A.: 'Frauen in den Flugschriften der frühen Reformationsbewegung', in: Jahrbuch für Geschichte des Feudalismus. Vol. 7. Berlin, 1983, pp. 247–264.

Schraut, E., and C. Opitz: Frauen und Kunst im Mittelalter. Exhibition catalogue. Brunswick, 1983.

Schubart-Fikentscher, G.: 'Das Brünner Schöffenbuch. Beiträge zur spätmittelalterlichen Rechts- und Kulturgeschichte', in: Deutsches Archiv für Geschichte des Mittelalters 1. 1937, pp. 457–498.

Schuchhardt, W.: Weibliche Handwerkskunst im deutschen Mittelalter. Berlin, 1941.

Schuler, T.: 'Familien im Mittelalter', in: Die Familie in der Geschichte. Ed. by H. Reif. Göttingen, 1982 (= Kleine Vandenhoeck-Reihe 1474).

Schuller, H.: 'Das-Praebenda-Peculium', in: Festschrift für F. Hausmann. Ed. by H. Ebner. Graz, 1977, pp. 453–487.

Schultheiss, W.: Die Münchner Gewerbeverfassung im Mittelalter. Munich, 1936.

Schuster, D.: Die Stellung der Frau in der Zunftverfassung. Berlin, 1927.

Shahar, S.: Die Frau im Mittelalter. Translated by R. Achlama. Königstein/Taunus, 1981.

Stam, S. M.: 'Die ökonomischen Grundlagen der Herausbildung und Entwicklung der mittelalter-

lichen Stadt in West- und Mitteleuropa', in: *Jahrbuch für Geschichte des Feudalismus*. Vol. 2. Berlin, 1978.

Stenton, M.D.: *The English Woman in History*. New York, 1977.

Trexler, R.D.: 'La prostitution florentine au XV^e siècle. Review', in: *Annales. Economies, Sociétés, Civilisations*. Paris 38 (1981) 6.

Uitz, E.: 'Die Frau im Berufsleben der spätmittelalterlichen Stadt, untersucht am Beispiel von Städten auf dem Gebiet der Deutschen Demokratischen Republik', in: *Frau im spätmittelalterlichen Alltag*. Vienna, 1986, pp. 439–473 (= *Veröffentlichungen des Instituts für Mittelalterliche Realienkunde Österreichs, Österreichische Akademie der Wissenschaften, Philologisch-historische Klasse. Sitzungsberichte*. 473rd vol.).

Uitz, E.: 'Frau und gesellschaftlicher Fortschritt in der mittelalterlichen Stadt', in: *Zeitschrift für Geschichtswissenschaft* (1984) 12, pp. 1071–1083.

Uitz, E.: 'Zu einigen Aspekten der gesellschaftlichen Stellung der Frau in der mittelalterlichen Stadt', in: *Jahrbuch für Geschichte des Feudalismus*. Vol. 5. Berlin, 1981, pp. 57–88.

Uitz, E.: 'Zur Darstellung der Stadtbürgerin, ihrer Rolle in Ehe, Familie und Öffentlichkeit in der Chronistik und in den Rechtsquellen der spätmittelalterlichen deutschen Stadt', in: *Jahrbuch für Geschichte des Feudalismus*. Vol. 7. Berlin, 1983, pp. 130–156.

Uitz, E.: 'Zur gesellschaftlichen Stellung der Frau in der mittelalterlichen Stadt (Die Situation im Erzbistum Magdeburg)', in: *Magdeburger Beiträge zur Stadtgeschichte*. Magdeburg (1977) 1, pp. 20–42.

'Untersuchungen zur gesellschaftlichen Stellung der Frau im Feudalismus'. Ed. by Historikergesellschaft der Deutschen Demokratischen Republik, in: *Magdeburger Beiträge zur Stadtgeschichte*. Magdeburg (1981) 3.

Vetter, A.: *Bevölkerungselemente der ehemals Freien Reichsstadt Mühlhausen in Thüringen im XV. und XVI. Jahrhundert*. Leipzig, 1910 (= *Leipziger Historische Abhandlungen*. No. XVII).

Wachendorf, H.: *Die wirtschaftliche Stellung der Frau in den deutschen Städten des späten Mittelalters*. Hamburg, 1934.

Weber, M.: *Ehefrau und Mutter in der Rechtsentwicklung. Eine Einführung*. Tübingen, 1907.

Weber-Kellermann, I.: *Die deutsche Familie. Versuch einer Sozialgeschichte*. Frankfurt on Main, 1974.

Wensky, M.: 'Die Frau in Handel und Gewerbe vom Mittelalter bis zur frühen Neuzeit', in: *Die Frau in der deutschen Wirtschaft*. Stuttgart, 1985, pp. 30–44 (= *Zeitschrift für Unternehmensgeschichte*. Supplement 35).

Wensky, M.: *Die Stellung der Frau in der stadtkölnischen Wirtschaft im Spätmittelalter*. Cologne, Vienna, 1980 (= *Quellen und Darstellungen zur Hansischen Geschichte*. New series. Vol. XXVI).

Werner, E.: *Pauperes Christi*. Leipzig, 1956.

Werner, E.: 'Vita religiosa als vita humana einer aussergewöhnlichen Frau—Heloise mit und ohne Abaelard', in: *Realismus und literarische Kommunikation. Dem Wirken Rita Schobers gewidmet*. Berlin, 1984, pp. 52–60 (= *Sitzungsberichte der Akademie der Wissenschaften der DDR, Gesellschaftswissenschaften 8/G*).

Werner, E.: *Stadt und Geistesleben im Hochmittelalter. 11. bis 13. Jahrhundert*. Weimar, 1980 (= *Forschungen zur mittelalterlichen Geschichte*. Vol. 30).

Wesoly, K.: 'Der weibliche Bevölkerungsanteil in spätmittelalterlichen und frühneuzeitlichen Städten und die Betätigung von Frauen im zünftigen Handwerk (insbesondere am Mittel- und Oberrhein)', in: *Zeitschrift für die Geschichte des Oberrheins* 128. 1980, pp. 69–117.

Winter, A.: 'Studien zur sozialen Situation der Frauen in der Stadt Trier nach der Steuerliste von 1364. Die

Unterschicht', in: *Kurtriersches Jahrbuch* 15 (1975), pp. 20–45.

Winter, G.: *Das eheliche Güterrecht im älteren hamburgischen Recht. Dargestellt an Stadtbucheintragungen aus dem 13./14. Jahrhundert.* Hamburg, 1958.

Wolf-Graaf, A.: *Die verborgene Geschichte der Frauenarbeit. Eine Bildchronik.* Weinheim, Basle, 1983.

Wulff, A.: *Die frauenfeindlichen Dichtungen in der romanischen Literatur des Mittelalters bis zum Ende des 13. Jahrhunderts.* Halle, 1914 (= *Romanische Arbeiten* 4).

Aus der Zeit der Verzweiflung. Zur Genese und Aktualität des Hexenbildes. Published under the editorship of G. Busch, 2nd ed. Frankfurt on Main, 1978 (= *edition suhrkamp* 840).

Index of Names and Places

Unitalicised figures refer to pages, figures in italics to illustration numbers.

Aachen 19, 148, 175
Abelard, Peter (Abaelardus, Petrus; Abailard or Abélard, Pierre), theologian 97, 155
Adasse, female creditor of the town of Görlitz 116
Adelheid, woman clerk 98
Adolphus of Nassau 120
Agricola, Georgius 62
Aiche, Hermann von, brewer 59
Ailheyd von Dryveltz, woman merchant 47
Albert II, German king 146
Albertus Magnus, Saint, theologian 155
Alemania, Jacqueline Felicie de, woman surgeon 67
Alès 105
Alexandria 37
Alheyd von Bremen, woman merchant 44, 48
Alpert von Metz 15
Ambulet, Bernard, associate of a trading company 38
Amiens 19
Amlingyn, Katherina, head of a woad trading company, and her daughter 39
Anastasia, woman book illustrator 100
Annaberg 62; 15
Anne, Saint, mother of the Holy Virgin 41, 69
Antimonus, Rubaldus de, and his widow 24
Antwerp 47
Anweiler 21
Aquinas, Saint Thomas, theologian 155, 172
Aregis, prince of Benevento 15
Aristotle 60
Arles 17
Arras 23, 120
Astrolabus, son of Abelard and Heloise 155
Augsburg 16, 23, 48, 60, 64, 97, 98, 99, 104, 105, 118
Augustine, Saint, Church father 154

Bach, Fya upper, woman smith 60
Baden 58
Bamberg 40, 42, 55, 72, 110
Basle 12, 18, 40, 41, 44, 54, 57, 61, 64, 97, 98, 109, 110, 150, 172
Bastian 'aus der Müntze', husband of Dorothea Storchin 66
Behaim, Martin, merchant, and his brother Lienhart 41, 65
Behr, Henneke, and his mother 148
Beinheim 44
Belota, Johanna, woman surgeon 67
Benvenuto, Tommaso di, surgeon and astrologist 145
Bergen 21
Berlin 115
Bermenter, Jörg, wool weaver 63
Berne 97, 156; 2, 27
Bernwalderin, woman brewer 59
Bertold von Regensburg, Franciscan preacher 64, 170, 171
Bingen 47
Bleckerynne, woman innkeeper 66
Boileau, Etienne, judge 51
Bologna 100, 145
Bona, girl from Pisa 150
Boner, Ulrich, theologian 156
Bossen, Jasper, and his wife 120
Brackenheim 108
Bremen 20, 44, 110, 172
Breslau 46, 97
Bristol 53
Broikhusen, Fygin von, woman brewer, and her husband 59
Brückner, Hans, shopkeeper, and his wife 44, 45, 46
Bruges 12, 23, 41, 70, 100, 146
Brünn 105
Brunswick 19, 58, 120
Brussels 71, 97
Burchard II, bishop of Halberstadt 20
Burford, Rose of, woman merchant and wool trader 40
Burg, Grietgen van der, woman merchant 41
Busch, Ennel von, woman associate 41
Bussignac, Peire de, poet 156
Butzbach, Johannes, Benedictine monk, humanist 66, 72, 117, 148

Cafarus, consul of Genoa 120
Calais 40
Calen, Tilse 115
Caluvrio, Vendramo de, and his wife Auticara, woman associate of a trading company 37
Canterbury 104
Castel, Etienne du 145
Catherine of Siena, Saint 150, 156; 66
Certaldo, Paolo da, philosopher and moralist 150
Ceuta 24, 37
Ceyslerin, woman brewer 59
Charles, duke of Calabria 67
Charles V, king of France 145
Charles VII, king of France 120
Chaucer, Geoffrey, poet 66, 120, 145
Chemnitz 55, 114, 116
Chrysostom, Saint John 154
Cilio, Piero, tenant of the Strozzi family, and his wife Mona 147
Coblenz 99
Colmar 71
Cologne 12, 17, 23, 39, 40, 41, 43, 45, 46, 47, 54, 55, 56, 57, 58, 59, 60, 62, 68, 98, 99, 100, 109, 110, 115, 116, 172, 173, 177
Conrad, duke of Zähringen 20, 21
Constance 23, 56, 57, 71, 108, 109, 119; 8
Constantinople 37
Copenhagen 47
Cracow 105
Crispini, Bonus Vasallus, and his wife Juleta 37
Czachmannin, woman shopkeeper 45

Danzig 40, 47, 58
Datini, Francesco, merchant, his wife and his niece Tina 148, 150
daughter of the town doctor of Frankfurt on Main, woman doctor 67
Deventer 173
Deynhard, Reinfried 120
Deynhardinne 119
Diest 47
Dorothy, Saint 53
Dortmund 19, 110, 115, 118, 172
Douai 23, 38
Dresden 115
Dubois, Pierre, crown lawyer and publicist 71
Duderstadt 55

Eberlein, Barbara, woman wool trader, and her husband Simon 40
Ebner, Christina, woman mystic 156
Edward II, king of England 40
Eger 110, 113
Eisleben 113
Eleanor, queen consort of Henry II of England and duchess of Aquitaine 21
Elizabeth, queen consort of King Albert II 146
Emmerich 72, 97, 115
Ennglhartsteter, Blasius 110
Enns 21
Ereke, Ludeke, and his wife and daughter 120
Erfurt 39, 44, 47, 54, 61, 65, 109, 110, 115
Esslingen 47, 98, 101, 108

Fingerin, Agnes, woman merchant 40, 175
Florence 54, 57, 72, 100, 146
Flugge, Kersten, and his wife 120
Frankfurt on Main 12, 18, 21, 40, 41, 47, 54, 55, 56, 57, 60, 61, 64, 67, 97, 98, 115
Frederick I Barbarossa, Holy Roman emperor 20, 21, 120
Frederick II, Holy Roman emperor 21
Frederick III, Holy Roman emperor 72
Freiberg (Saxony) 98, 113, 115, 116, 118, 119
Freiburg im Breisgau 19, 20, 22, 43, 48
Frenzel, Hans, great merchant 69
Fribourg in Uechtland 21
Friedberg 21
Fritzlar 54
Friutera, wife of a merchant 37
Fryge, Hanns Rudolff, and his wife 41
Fulda 115
Funck, Margarete, woman merchant, and her husband Alexius 41, 46
Fyncke, Elisabeth, wife of the wine merchant Heintz Fyncke 42

Galetta, Rubaldus, associate of a trading company 37
Gelnhausen 21
Genoa 23, 24, 40, 110, 120
Geraardsbergen/Grammont 20
Gerard of Cremona, translator 68; 59
Ghent 12, 55, 70, 110, 172

Görlitz 39, 40, 42, 44, 45, 46, 57, 58, 62, 66, 68, 98, 100, 110, 115, 116, 118, 119, 120, 175
Goslar 43, 48, 116
Göttingen 59, 60, 108, 109
Gower, John, poet 66
Gratian, lawyer 155
Graz 116; 38
Grenoble 17
Grimma 60
Grossen, Elisabeth, citizen 112
Grote, Geert, theologian 173

Haimburg 22
Halberstadt 20, 57, 110, 119; 41
Halle on the Saale 22, 110, 113, 116, 119
Hamburg 22, 55, 58, 59, 62, 97, 108, 172
Hanover 57
Hätzler, Clara, woman clerk 98
Heenyngesche, de, woman brewer 60
Heilbronn 63, 71
Heinrich, son of the count of Freiburg 22
Helbig, Merten, clothmaker, and his wife 120
Helmslegern, Karyssa under, woman merchant 39, 46
Heloise, abbess 97, 155
Henry II, king of England 21
Henry V, German king 20, 21
Herbotesheim, Frau von, woman shopkeeper 44
Herselmüllerin, woman brewer 59
Hertogenbos 173
Hesse, Hans, painter 62; 15
Hildegard, Saint, female theologian 155, 156
Hildesheim 55, 57, 58, 68
Hiller, Frantz, tailor, and his wife 120
Hinseworth (Herfordshire) 11
Holbein, Hans (the Younger), painter 97, 150
Hollant, Ludeke 120
Holthusen, Wolter, and his wife 120
Honiss, Elisabeth, woman merchant 111
Honoré, book illustrator, his daughter and his son-in-law 99
Huber, Martin, head of a girls' school 72
Hugh of St. Victor, theologian 155

Ilmene, Ermengard von 115
Innsbruck 98
Irwina, woman clerk 98

Isaac, citizen of Görlitz 98
Isener, Linhart, factor 42
Isny 23, 115

Jena 39, 59
Jerome, Saint, Church father 154
Jerusalem 175; 41
Joachim, Saint, father of St. Mary 41, 43
Johans, Katharina, woman innkeeper 65
John, Saint, evangelist 153
John, duke of Lorraine 71
Joseph, Saint 56
Judenburg 42
Junia, important personality of the early Christian community 153
Justina, Saint 61

Karlsbad 66
Kasel, Ludwig von, and his widow 47
Kazmair, Jörg, his wife, his mother, and his sister 119
Kempe, Margery, Beguine, wife of a merchant 43, 173, 175
Kempten 23
Kollers, Druitgen, woman associate of a cloth trading company 39
Kottanerin, Helene, lady-in-waiting 145, 146
Kuttenberg (Bohemia) 62

Ladislas Posthumus, son of King Albert and Queen Elizabeth 146
Lafont, Guillaume, associate of a trading company 37
Laibach 41, 42
Langhe, Wobbeke 115
Langland, William, poet 54
Langmann, Adelheid, woman mystic 156
Laon 18, 20, 21, 47
Lecavela, Otto, and his mother Mabilia, associate of a trading company 24
Leipzig 47, 58, 61, 113
Lettel, assistant 41
Lettelin, his wife and assistant 41
Leutkirchen 105
Levede (Lewede), Hermann von, and his widow 116
Lewenis, Ida, Cistercian nun 71
Liège 23, 47

Lille 100
Lincoln 48, 53
Lindau 115
Lobeze, Katherina de 115
Lombard, Johan, silk trader and councillor, and his wife Anne 11
Lombard, Peter, theologian 155
London 12, 23, 38, 40, 53, 54, 116
Loon 47
Louis IX (Saint Louis), king of France 38, 51
Lubbe, woman associate of a trading company 39
Lübeck 12, 18, 23, 39, 41, 44, 46, 48, 54, 55, 56, 58, 59, 60, 61, 108, 110, 115, 116, 172
Lucca 56
Luke, Saint, evangelist 153
Lüneburg 46, 59, 60
Lungus, Obertus, associate of a trading company 37
Lynenweiffers, Elss 47
Lynn 40, 43, 47
Lyon 170

Magdeburg 18, 20, 39, 40, 42, 47, 59, 106, 108, 110
Magnus, duke of Saxe-Lauenburg 148
Magnus Harkonarson, king of Norway 21
Mainz 17, 47, 54, 56, 120, 172
Malet, Gilles, royal librarian 145
Margaretha, duchess of Brunswick and Lüneburg, countess of Henneberg 42
Mark, Saint, evangelist 153, 154
Marseilles 23, 24, 37, 38, 40, 66, 99
Mary (Virgin Mary, The) 175; 1, 12, 18, 32, 41, 43, 48, 54, 55, 56, 66, 68, 70
Mary Magdalene, Saint, disciple of Jesus 153
Matthew, Saint, evangelist 153, 154
Matthias von Neuenburg, chronicler 22
Mauermann, Barbara, and her father Andreas 42
Mauersperling, Johannes, and his wife 119
Mechthild, woman clerk 98
Mechthild von Bremen, woman shopkeeper 39, 44
Mechthild von Magdeburg, woman mystic 173
Medici, Cosimo de' 146

Meiningen 42
Memmingen 72, 115
Metz 105, 170
Meung, Jean de, philosopher and poet 156
Miltenberg 115
Mittelhusen, Gysela von 115
Mons 70
Montzer, Anna, her husband Jorg and her brother-in-law Hanss 110
Mühlhausen (Thuringia) 42, 43, 44, 46, 47, 48, 54, 55, 58, 61, 62, 64, 100, 105, 106, 108, 112, 114, 116, 118, 120, 175
Munich 54, 55, 108, 109, 119
Murbach, abbey 21

Naples 146
Neuenburg 22
Neumarkt (Silesia) 22, 58
Neuss 39, 55, 63
Nogent, Guibert of 19
Noir, Jean le, book illustrator, and his daughter 99
Nordhausen 54
Nördlingen 70
Northeim 115
Nuremberg 12, 18, 40, 41, 46, 54, 55, 57, 58, 59, 60, 61, 66, 70, 72, 98, 108, 110, 113, 115, 116, 118

Ödenburg 145, 146
Ofen 46, 146
Oflaterin, Cristina, woman shopkeeper 44
Oschatz 113

Pamplona 20
Paris 12, 23, 51, 52, 53, 56, 62, 67, 70, 71, 99, 100, 104, 120, 145, 173; back endpaper
Paris, Matthew, theologian 172
Paul, Saint, apostle 153
Pengel, merchant, and his wife 47
Périgueux 116
Perugia 57
Pettau 99
Philip VI, king of France 51
Philip the Bold, duke of Burgundy, and his wife 145
Philip the Younger of Hanau-Münzenberg 42
Pisa 23, 150

Pisan, Christine de, and her children Marie and Jean 11, 100, 145, 146, 178
Plau (Mecklenburg) 58
Poitiers 21
Porète, Marguerite, Beguine 173
Prague 12
Prato 148
Praun, Hans, merchant, and his wife 41
Priscilla, Saint, important personality of the early Christian community 153
Provins 23, 65

Quedlinburg 54

Radesche, de, woman brewer 60
Raoline, Béatrix 37
Rauhenperger, Elspeth, woman citizen 110
Ravensburg 39
Regensburg 12, 39, 40, 41, 46, 54, 57, 71, 104, 105, 108, 109, 110, 116, 119
Reichenau, abbey 17
Reims 18
Reval 115
Revele, Grete von, woman shopkeeper 44
Rialto islands 37
Rochlitz 113
Rode, Alheid de, woman merchant 41
Romano, Francisca, woman surgeon, and her husband Mattheus 67
Rome 11, 40, 120, 175
Roncaglia 120
Rorerynne, Orthey, woman innkeeper 66
Rostock 30
Rouen 23
Roux, Cécile, woman trader 37
Runtinger, Matthias, merchant, and his wife, the Runtingerin 39, 41, 46
Ruprecht von Würzburg, poet 65
Rust' aveli, Sho'ta, poet 38
'Rychterin, old', woman innkeeper 66

St. Gallen 23, 60
Saint-Jean-d'Acre 37
Saintonge, ancient province of France 21
St. Saturnin, suburb of Pamplona 20
St. Wolfgang 41
Salzburg 41, 65, 110
Sancho, king of Navarre 20

Sarah, woman citizen of Görlitz 98
Scania 41, 58
Scepers, Elisabeth, woman miniature painter 100
Scheppers, Grietkin, woman miniature painter 100
Schilling, Diebold 67; *2, 3, 25, 27, 40*
Schlettstadt 108, 114, 115
Schwäbisch-Hall 39
Siberg 60
Siegburg 56
Siena 57, 150, 156
Simon of Tournai 173
Soest 19, 115
Southampton 61
Speyer 18, 20, 21, 54, 97, 172
Stade 20, 42, 46
Staffelsee 16, 17
Sterzing 110
Stockholm 41
Storchin, Dorothea, woman innkeeper 66
Stralsund 47, 59, 110, 115, 116, 118, 148, 175; *35*
Strasbourg 12, 18, 40, 41, 47, 48, 54, 55, 58, 61, 62, 97, 99, 105, 106, 108, 113, 114, 115, 116, 172
Striegau (Silesia) 57, 62
Strozzi, Alessandra Macinghi degli 43, 145, 146, 147, 151
 her daughter Alessandra 43
 her daughter-in-law Fiametta 147
 her grandson Alfonso 147
 her husband Matteo 145, 146
 her son Filippo 147
Stuttgart 47, 55, 97, 101
Swelenburg, Anna 175
Syburg, Fygin von, woman merchant 47

Székeles, Peter, mayor of Ödenburg 145

Tamara, queen of Georgia 38
Tauwaldynne, woman with medical knowledge 68
Thecla, Saint, important personality of the early Christian community 153
Thomasse, woman book illustrator and innkeeper 100
Tiel 16
Tienen, Beatrijs van, abbess 71
Tilesio, chronicler 114
Tilleda, Ottonic palatinate 16
Toul 170
Tournai 23
Trier 55, 64, 172
Troyes 57
Truhenschmidt, Anna, woman citizen, her daughters Maidalen and Martha and her son Paul 113
Turmeckerin, woman innkeeper 65

Überlingen 56, 97
Ulm 23, 46, 55, 58, 70, 71, 108, 109, 172
Utrecht 18

Valdes, merchant 170
Valence, Marie, woman associate of a trading company 38
Valenciennes 97
Venice 23, 24, 37, 40, 110, 145
Venier, Stefano, business partner of Friutera 37
Venlo, Dorothea, woman cloth merchant 47
Verdun 65
Viadro, Tommaso, business partner of Maria Ziani 37

Vienna 12, 17, 19, 41, 47, 109, 110, 116, 146
Vilberin, woman brewer 59
Villani, Giovanni, historian 72
Virbeke, Agnes von, woman citizen 118
Vischer, Michael, business partner of the Behaim brothers, and his wife 41
Völkermarkt on the Drava 40, 41, 42
Vorsprache, Tile, and his wife 120
Vurberg, Druidgen, woman associate of a trading company, and her husband Heinrich, merchant 41

Wantzenrutinin, woman teacher 97
Warsaw 58
Weinsberg, Hermann, chronicler 68
Weisskirchner, Margaret 42
Wenceslas I, king of Bohemia 100
Werden on the Ruhr 16
Wetzlar 21
Wickenhausen 17
Wiener Neustadt 22, 40, 41, 46, 116
Winterthur 21
Wittenborch, Vico, husband of Alheyd von Bremen 44
Wladyslaw III, king of Poland 146
Worms 20, 21, 45, 54
Würzburg 64, 71

Ypernn, Margarete von, woman surgeon 67
Yss, Niesgin, woman merchant 47

Ziani, Maria, wife of a doge 37
Zopff, Nyclas, council courier 42
Zurich 12, 62, 63, 97; *10*
Zwickau 22, 42, 55, 59, 66, 72, 109, 110, 113, 114, 116, 118; *36, 37*

Sources of Illustrations

Illustrations in the text are
given with the respective page numbers;
all other figures refer to the numbers of
illustrations.

Klaus G. Beyer, Weimar 1, 26, 46, 47, 48, 62, 66, 68

Bibliothèque de l'Arsenal, Paris 20, 21

Bibliothèque Historique de la ville de Paris back endpaper

Bibliothèque Municipale, Orléans p. 105

Bibliothèque Nationale, Paris 16, 19, 28, 29, 31, 32, 33, 34, 44, 51

British Museum, London 63, 64, p. 107, p. 174

Church of the Virgin Mary, Parchim 56

Forschungsbibliothek Gotha 39

Herzog Anton Ulrich Museum, Brunswick p. 99

Institut für Denkmalspflege of the German Democratic Republic, Berlin 41

Institut für mittelalterliche Realienkunde Österreichs, Krems 4, 12, 22, 23, 24, 49, 50, 53, 54, 55, 61, 65, 70, 71

Rainer Kitte, Görlitz 69

Bertram Kober, Leipzig front endpaper p. 4, p. 8, p. 45, p. 65, p. 66, p. 101, p. 104, p. 106, p. 117, p. 147, p. 148, p. 169, p. 172

Württembergische Landesbibliothek, Stuttgart 58

Municipal and University Library, Berne 2, 3, 25, 27, 40

Municipal Library, Bruges p. 69

Museen der Stadt Gotha 42

Museum der bildenden Künste, Leipzig 18

Museum of Fine Arts, Budapest 43, 45, 67

Österreichische Nationalbibliothek, Vienna 6, 17, 52, 57, 59, p. 67, p. 68 below, p. 69 below, p. 70, p. 154, p. 155, p. 174 right

Joachim Petri, Mölkau near Leipzig p. 149, p. 150

Janusz Podlecki, Cracow 5, 14

Publisher's Archives 11, 13, 15

Rosgartenmuseum, Constance 8, 9

Schweizerisches Landesmuseum, Zurich 10

Staatliche Museen zu Berlin, Picture Gallery 7

Stadtarchiv Rostock 30

Stadtarchiv Stralsund 35, p. 115

Städtische Museen, Freiberg im Breisgau 60

Stadtmuseum, Graz 38

Stadt- und Kreisarchiv Mühlhausen/Thuringia p. 111, p. 112, p. 175

Stadt- und Kreisarchiv Zwickau 36, 37